ART OF THE BALTICS

THE DODGE SOVIET NONCONFORMIST ART PUBLICATION SERIES

Copublished by the Jane Voorhees Zimmerli Art Museum and Rutgers University Press

The Norton and Nancy Dodge Collection of Nonconformist Art from the Soviet Union, 1956–1986, which comprises nearly twenty thousand works, is part of the Jane Voorhees Zimmerli Art Museum at Rutgers University, New Brunswick, New Jersey

The Struggle for Freedom
of Artistic Expression
under the Soviets, 1945–1991

ART of the
BALTICS

Alla Rosenfeld AND Norton T. Dodge GENERAL EDITORS

A Copublication of Rutgers University Press
New Brunswick, New Jersey, and London
and The Jane Voorhees Zimmerli Art Museum
Rutgers, The State University of New Jersey

This book has been published in conjunction with the exhibition *The Art of the Baltics under the Soviets* at the Jane Voorhees Zimmerli Art Museum at Rutgers University, New Brunswick, New Jersey, December 9, 2001–March 17, 2002.

In the credit lines for the illustrations, the abbreviation Dodge Collection, ZAM is used for the Norton and Nancy Dodge Collection of Nonconformist Art from the Soviet Union, 1956–1986, Jane Voorhees Zimmerli Art Museum, Rutgers, The State University of New Jersey.

PAGE 2: Detail from *Posters in the Spring*, 1984, by Kostas Dereškevičius (fig. 239).
PAGE 32: Detail from the series *Under the Sky*, 1973, by Raul Meel (fig. 49B).
PAGE 170: Detail from *Raphael and Polis*, n.d., by Miervaldis Polis (fig. 161).
PAGE 288: Detail from *Interior X*, 1981, by Romanas Vilkauskas (fig. 251).

LIBRARY OF CONGRESS CATALOGING-IN-PUBLICATION DATA
Art of the Baltics : the struggle for freedom of artistic expression under the Soviets, 1945–1991 / Alla Rosenfeld and Norton T. Dodge, general editors.
 p. cm. — (Dodge Soviet nonconformist art publication series)
 This book is tied to an exhibition at the Jane Voorhees Zimmerli Art Museum.
 Includes bibliographical references and index.
 ISBN 0-8135-3042-3 (cloth : alk. paper)
 1. Art, Baltic—20th century. 2. Dissident art—Soviet Union.
I. Rosenfeld, Alla. II. Dodge, Norton T. III. Jane Voorhees Zimmerli Art Museum. IV. Series.
N7255.B285 A78 2001
709´.479´07474942—dc21 2001031782

British Cataloging-in-Publication information is available from the British Library.

Produced by Wilsted & Taylor Publishing Services
 Copyediting by Melody Lacina
 Design by Melissa Ehn
 Composition by Jeff Clark
 Production management by Christine Taylor

Manufactured in Great Britain

Contents

Foreword

The primary responsibility of a university art museum — in contrast to that of a museum with no academic affiliation — is to educate. Thus, in an ideal world, a university art museum's collection serves as a visual library that through research, selection, and, finally, display challenges the status quo and illuminates heretofore little-known or underappreciated realms of art. All too often, practicalities — size, breadth, and quality of collections, in particular — inhibit the success of these efforts. Thanks, however, to the Zimmerli's "Norton and Nancy Dodge Collection of Nonconformist Art from the Soviet Union, 1956–1986," the museum is able to broach the ideal world of museology in its investigation of art of the Baltics during the post-Stalin Soviet years. The Dodge Collection is, in fact, the largest and most comprehensive of its kind in the world, with art of Estonia, Latvia, and Lithuania extremely well represented.

The purposes of this publication and its coinciding exhibition are to objectively and broadly document the great variety of artistic alternatives that evolved in the Baltics during the last thirty years of Soviet hegemony — alternatives that often, but not always, countered the officially sanctioned art of Socialist Realism — and to evaluate the greater levels of artistic freedom permissible in the Baltics versus the rigid control over artists exercised by the Soviets in their centers of governmental/military strength: Moscow and Leningrad.

This project was initiated, essentially, in 1995 with the Zimmerli's publication *From Gulag to Glasnost*, which still serves as the best overview of the Dodge Collection. We knew then that we had only begun to comprehend the variety of ways that Baltic artists reacted to Soviet domination and to what degree they were aware of and responded to Western art, both European and American. Since 1995, the Zimmerli's Baltic holdings have been tremendously augmented by the systematic acquisition of Estonian, Latvian, and Lithuanian art with the assistance of numerous colleagues and friends from the Baltics and the financial support of Norton and Nancy Dodge. This comprehensive study of "nonconformist art" of the Baltics is therefore the result of achieving as nearly as possible an academically ideal representation of the many facets of artistic production in the Baltics during the second half of the twentieth century. I am much indebted to Norton Dodge, Alla Rosenfeld, and their art-historian colleagues for accomplishing in this publication what only six years ago we thought might take a lifetime.

PHILLIP DENNIS CATE
Director

Preface

It felt very strange to have my papers checked by customs officers with barking dogs when I recently crossed the border between Russia and Estonia—a border established after Estonia finally gained its long-sought independence from the Soviet Union. As a teenager in the 1970s living in Leningrad (Russia), I could easily go to Tallinn (Estonia) for a weekend to visit a friend. Later, as an art student, I traveled to Tallinn to see exhibitions, which seemed so Western-like and avant-garde to us in Leningrad, where it was almost impossible to exhibit openly what they were showing in Estonia. I spent my honeymoon in Vilnius, Lithuania, which in my youth also seemed like a Western city, and many of our vacations were spent near Rīga, Latvia. Today, however, any Russian citizen who wants to go to the Baltics needs an official invitation from a friend or a relative in the Baltics and has to apply for a visa. The same is true for the people in the Baltics who want to visit Russia. Friends, artists, and art curators in the Baltics tell me it is now easier for them to travel to see exhibitions in Stockholm or Copenhagen than to visit exhibitions in Russia.

In 1998, the International Partnership Among Museums (IPAM) program—funded by the Samuel H. Kress Foundation and the Bureau of Education and Cultural Affairs of the United States Information Agency and administered by the Department of International Programs of the American Association of Museums—underwrote my research and extensive travels to the cities of Tallinn, Tartu, Vilnius, and Rīga. When I mentioned my trip to the Baltics to American friends, they often responded, "What? Where?" which made me realize how little people in the United States know about the Baltic region. Therefore, I felt strongly that in order to introduce people in America to this relatively unknown culture, it was important to include in this volume not only essays on the Baltic art of the 1960s and 1980s, which reflect the holdings of the Dodges' collection, but also essays on pre-Soviet art of the Baltics as well as those covering a period of fundamental social and political change after the Baltics' independence in 1991.

Art historians from the Baltics always stress the great cultural diversity within the Baltic region, noting that Estonian, Latvian, and Lithuanian art did not develop in similar ways. For instance, as Sirje Helme points out, Estonia had closer contact with the Scandinavian countries and received a large part of its cultural information through them, while Lithuania was clearly part of Central Europe, with a specifically Polish orientation.

The present volume consists of four parts. The first part compares the art of the three Baltic countries, providing a general analysis that emphasizes the interrelation between national and specific aspects of the art of the Baltic countries, on the one hand, and the interdependent historical and sociopolitical roots of the art of these countries, on the other. Such a comparative overview highlights the interplay of regional unity and national diversity that is evident in a variety of re-

sponses of Baltic artists to common concerns and pre-occupations. The following three parts are devoted to the art of the individual countries—Estonia, Latvia, and Lithuania—and examine historical and aesthetic specificity of their national arts. The volume includes appendices containing chronological tables that provide necessary background information and offset the analytical studies presented earlier in the book.

This book presents the first coherent survey of the development of Baltic art for an English-speaking audience.[1] However, for many reasons, not every Baltic artist is discussed. There is still work to be done.

It was thrilling to encounter literally hundreds of talented artists in each of the Baltic cities during my trip. As I ventured from one studio to the next, each time toasting with glasses of wine and having long conversations with artists about their lives and art under the Soviets, and the many problems they now face, I began to realize that these meetings gave me a vivid sense of Baltic art and history that no textbook could rival. As my knowledge of Baltic art and culture increased, the uniqueness and importance of the Norton and Nancy Dodge Collection of Baltic art became more and more obvious to me.

I look on those special days of my trip to the Baltics with great fondness and feel honored to present the results of Norton and Nancy Dodge's many years of involvement with Baltic art in this landmark event— the exhibition of Baltic art and this publication.

Many people have contributed to the successful organization of this project. First of all, I would like to thank my graduate research assistants, Ashley Atkins and Natalia Kariaeva, Ph.D. candidates in the departments of art history and linguistics, respectively, at Rutgers University, who assisted with the editing and coordinated the intricate details of this publication. I would also like to acknowledge the assistance of Natalia Kolodzei, the museum's intern and an art history graduate student at Rutgers, who helped immensely with photography coordination and correspondence with the authors. She and her mother, Tatiana, have assembled an important collection of nonconformist Soviet art, including many works from the Baltics. Dr.

Elena Kornetchuk, president of International Images, played an especially important role in adding to the Dodges' collection during the late 1970s and 1980s. Visvaldas Neniškis, Lithuanian art collector, has ably assisted Dr. Dodge in selecting and bringing the works from Lithuania. Dr. Eda Sepp, art historian from Canada, has advised Dr. Dodge on Estonian art and supplied him with various pieces, thus helping to fill many gaps in the Estonian part of the collection. Mark Svede, at Ohio State University, played a similar role with Latvian art. Of crucial importance was the assistance of Mr. Charles Fick at Cremona. Mr. Fick and his assistants helped to process, photograph, and catalog all Baltic acquisitions before shipping them to the Zimmerli.

A project of this scope and complexity could not have been achieved without the cooperation of my colleagues from the three Baltic countries. I am particularly grateful to Sirje Helme, director of the Soros Foundation in Tallinn; Eha Komissarov, chief curator of the State Art Museum, Tallinn; Viktoras Liutkus, chief curator of the State Art Museum, Vilnius; and Visvaldas Neniškis, a collector of Lithuanian art, for sharing their knowledge of Baltic art. My special thanks go to Juta Kivimäe, my partner in Tallinn at the International Partnership Among Museums exchange program, who spent hours scheduling my appointments with artists and critics, helping me with accommodations in Tallinn, and showing me many sights and exhibitions; and to Irēna Bužinska, curator of the State Latvian Art Museum in Rīga, who met my train from Vilnius to Rīga at 5 A.M., arranged various important meetings for me, and made my stay in Rīga unforgettable.

Finally, I would like to thank Nancy Dodge for her continuing support of this project and Norton Dodge for the days that accumulated into months spent working on the editorial and organizational aspects of this publication.

ALLA ROSENFELD
Director, Department of Russian
and Soviet Nonconformist Art

NOTE

1. No major historical account of Baltic art exists in English; hopefully this book will fill that unfortunate gap. Among recent publications in English that have made important contributions to various aspects of Baltic art are the following exhibition catalogues: Bojana Pejić and David Elliott, eds., *After the Wall: Art and Culture in Post-Communist Europe* (Stockholm: Moderna Museet/Modern Museum, 1999); Hamid Ladjevardi, ed., *Baltic Art: Contemporary Paintings and Sculptures* (Washington, D.C.: U.S.-Baltic Foundation, 1999); *Tallinn-Moskva/Moskva-Tallinn, 1957–1985* (Tallinn: Tallinn Art Hall, 1996); Anda Rottenberg et al., eds., *Personal Time: Art of Estonia, Latvia and Lithuania, 1945–1996*, 3 vols. (Warsaw: The Zacheta Gallery of Contemporary Art, 1996); Barbara Straka and Kurt Nievers, eds., *The Memory of Images: Baltic Photo Art Today* (Kiel: Nieswand Verlag and Ars Baltica, 1993); and Norton T. Dodge, ed., *Baltic Art during the Brezhnev Era: Nonconformist Art in Estonia, Latvia and Lithuania* (Mechanicsville, Md.: Cremona Foundation, 1992). However, most of these publications focus on a special area of research dedicated to specific Baltic artists. *Modern Art in Eastern Europe: From the Baltic to the Balkans, ca. 1890–1939* (Cambridge, Eng.: Cambridge University Press, 1999) by S. A. Mansbach also includes chapters on modern art of Estonia, Latvia, and Lithuania.

1

THE BALTICS: GENERAL OVERVIEW

LIET

ŽIOS

SCEN

Centriniuose rūmuose

Norton Dodge

INTRODUCTION

Collecting Baltic Art
of the Cold War Period

THE ESTONIAN, Latvian, and Lithuanian Republics are now independent, sovereign states. This status of the Baltic countries marks the dramatic culmination of a long fight for freedom that accompanied and contributed to the decay and collapse of the authority and power of both the Tsarist Russian and Soviet empires.

A struggle by nonconformist artists for freedom of expression emerged during the cultural thaw following Stalin's death in 1953 and was further encouraged by Khrushchev's attack on Stalin in a secret speech to the Twentieth Party Congress in 1956. This resistance by artists to the authority and ideological control of the Communist Party represented some of the earliest cracks to appear in the monolithic Soviet system. These cracks, initially small, grew in the following years into large fissures that, together with other manifestations of dissent, contributed to the ultimate shattering and final collapse of the entire Stalinist edifice. These courageous nonconformist artists—men and women who spoke the truth through their art—were, like the child in Hans Christian Andersen's fairy tale who dared cry out that the emperor wore no clothes, unlikely but effective heroes.

As Joan Vastokas has stated, the greatest threat to any totalitarian state is the individual.[1] Assertion of individuality requires independence of thought and expression. Such independence fosters criticism and dissent. Hence the Soviet state emphasized above all else the repression of individual expression in the arts. Strict adherence to a uniform, official art policy—Socialist Realism—was required. In the visual arts this meant glorification of the party, the state, and the factory and farm workers by the use of stereotypical, heroic figures and images.

During the Khrushchev thaw, Western ideas and

influences began to penetrate and spread behind the Iron Curtain. Baltic artists in particular were exposed to influences from nearby Finland to the north and from Soviet bloc countries, such as Poland and Czechoslovakia, to the south. This initial step toward openness set the stage for Gorbachev's introduction of glasnost and for the eventual achievement of freedom in the early 1990s. In the meantime, however, Brezhnev's policies of renewed censorship threatened artists of every description—writers, painters, sculptors—and forced them to adjust or to face the threat of loss of employment or income from commissions, imprisonment, assignment to a psychiatric ward, or even death. For those few surviving Baltic artists who were Jewish, emigration was possible though difficult. Artists could sometimes dissent at less risk by employing satire, parody, irony, humor, or guile in work that challenged or mocked Communist Party policies, economic inequities, and sociopolitical injustices. Carefully calculated gradations in degrees of nonconformism were required for this, as circumstances dictated.[2]

When I first visited the Soviet Union in 1955 as a graduate student in Soviet economics at Harvard's Russian Research Center, the cultural thaw there had already begun. My month-long trip included a visit of several days to Rīga, but I had no opportunity to meet dissident artists, since tour guides who routinely reported to the KGB were with us throughout our entire stay. Although dissident, samizdat (self-published) literary works were being smuggled to the West and then translated, published, and discussed in university seminars and at scholarly conferences, no similar effort was being made to publicize and discuss underground nonconformist art. At that time, few if any Western art historians, critics, museum curators, or art dealers showed an interest in uncovering and publicizing this fascinating and important, but little-known, art. The task of preserving the efforts of these talented artists for world art history seemed to fall to me by default.

On my second trip to the Soviet Union in 1962, an unpublicized goal (in addition to the publicized one of economic research) was to find, photograph, and, if possible, collect prime examples of nonconformist art to bring back to the West. Fortunately, George Costakis, the noted Moscow collector of Russian avant-garde art of the teens and twenties who had also amassed a collection of nonconformist art, was willing

to help me, as were a number of Western diplomats, correspondents, and exchange students.

Following a third trip to the Soviet Union in 1965, I made a number of short trips in the 1970s, including several visits to Estonia, during which I was often unable to make contact with the best artists or to find first-rate works available. Hence, chance played a considerable role in what I collected firsthand. But in the years that followed, I have been able to fill in many of the gaps through an ever-evolving network of suppliers.[3]

Some eight hundred works had been assembled from several regions of the Soviet Union when a first exhibition of forty-eight works on paper, including fifteen Baltic works by artists such as Leonhard Lapin, Malle Leis, Raul Meel, Tõnis Vint, and Vladas Žilius, was displayed at the American Association for the Advancement of Slavic Studies (AAASS) convention in St. Louis in 1976. A year later a much more comprehensive exhibition with a catalogue, *New Art from the Soviet Union*, was presented in connection with the AAASS convention in Washington, D.C. This 127-page catalogue included a timely piece on nonconformist Estonian art by Professor Stephen Feinstein, who had introduced me to a number of major nonconformist artists on my first visit to Tallinn. A slightly modified version of the exhibition then traveled to Cornell University and a number of other colleges and universities. The first exhibitions of exclusively Baltic nonconformist art were held in the Contemporary Russian Art Center of America, which I established in New York City in 1981–82 with Margarita and Victor Tupitsyn. In the mid-1980s, an Estonian and a Latvian exhibition in collaboration with Elena Kornetchuk, an early dealer and scholar of Soviet art, took place at the nonprofit Firebird Gallery in Alexandria, Virginia. Next, in cooperation with Eda Sepp, an exhibition of nonconformist Baltic art was held in Toronto, Canada, at the John B. Aird Gallery at the time of the convention of the Association for the Advancement of Baltic Studies (AABS) in June 1992. This exhibition was accompanied by a thirty-two-page illustrated catalogue, *Baltic Art of the Brezhnev Era*.

In 1991 my wife, Nancy, and I were pleased to donate our collection to the Zimmerli Art Museum at Rutgers University in New Brunswick, New Jersey, about thirty-five miles south of New York City. An inaugural exhibition of selections from the collection

opened in October 1995 and was accompanied by a 360-page catalogue, of which sixty-two pages were specifically devoted to the nonconformist art of the Baltics. At the end of 1997, Tallinn, Estonia, was the third stop of a five-city European tour of selections from our collection organized by the Zimmerli Art Museum. In Tallinn the exhibition was augmented by additional Estonian artworks from the collection, which impressively filled the second floor of the Salt Storage Building of the Art Museum of Estonia, while the rest of the exhibition filled the first. It was a great thrill for Nancy and me to attend this exhibition and visit artists I had met twenty years earlier, as well as additional artists whom we had never met but whose works had become a prized part of the collection.

The present exhibition of Baltic art, inaugurated at the Zimmerli Art Museum with this four-part volume, represents a well-deserved and much more comprehensive coverage of nonconformist Baltic art from Estonia, Latvia, and Lithuania during the Cold War years. My ultimate aim had always been to assemble a collection of nonconformist art from all parts of the Soviet Union, not just Moscow and Leningrad, so that

the effect of cultural and historical differences, as well as differences in political control by the center, could be examined. From the beginning I had found Baltic art especially interesting and exciting. Moscow control was weakened in the Baltic republics by their remoteness—geographic, linguistic, and cultural.

The art for this exhibition was selected from some 3,200 Baltic artworks, which, together with 16,000 works from other regions of the former Soviet Union, comprise the Norton and Nancy Dodge Collection at the Zimmerli Art Museum.[4] A number of future exhibitions drawn from the collection will focus on nonconformist art from other regions of the collapsed Soviet empire. This collection, together with the Riabov Collection of Russian works from the sixteenth to the mid-twentieth century, which was donated by George Riabov, will enable Rutgers to serve as an important center for research and exhibition of Russian and nonconformist Soviet art, with a special emphasis on the struggle for freedom of expression during the postwar period from Stalin's death to Gorbachev's introduction of glasnost.

NOTES

1. See Joan Vastokas, "Nationalism and Dissent: Art and Politics in the Baltic during the Brezhnev Era," in *Baltic Art during the Brezhnev Era: Nonconformist Art in Estonia, Latvia and Lithuania*, ed. Norton T. Dodge (Mechanicsville, Md.: Cremona Foundation, 1992).

2. See Alfonsas Andriuškevičius, "Semi-Nonconformist Lithuanian Painting," in *From Gulag to Glasnost: Nonconformist Art from the Soviet Union*, eds. Alla Rosenfeld and Norton T. Dodge (New York: Thames and Hudson, 1995).

3. For more details on collecting, see Norton T. Dodge, "Notes on Collecting Nonconformist Soviet Art," ibid.

4. Since the late 1970s the Baltic collection has grown

more systematically with the help of the late Garig Basmadijian, Elena Kornetchuk (Estonia, Latvia), Eda Sepp (Estonia), Mark Svede (Latvia), and Visvaldas Neniškis (Lithuania). Nailya Alexander has been very helpful with photography, as has been Boris Mangolds. A number of U.S. and Canadian visitors to the Baltic also helped enlarge the collection, which now includes some 3,200 works (1,500 Estonian, 600 Latvian, and 1,100 Lithuanian) by 374 artists (122 Estonian, 131 Latvian, and 121 Lithuanian). The collection is composed of approximately 1,500 prints, 1,000 paintings and drawings, 500 photographs, and 170 sculptural works.

Sirje Helme

NATIONALISM AND DISSENT

Art and Politics in Estonia, Latvia, and Lithuania under the Soviets

ART HISTORIANS in the West use two dichotomies to describe art of the former Soviet Union—Socialist Realism versus dissident or nonconformist art. Art that did not accept official Socialist Realist canons and that was not recognized by the Soviet authorities was termed dissident, underground, unofficial, or nonconformist. Resistance to the authorities took many forms, and a variety of styles were encompassed within these terms. All of these terms indicate a reduced lifestyle for nonconformist artists because of the denial of access to direct and indirect support by the state, which distributed even the most elementary materials needed to make art. These supplies were provided only to members of the Artists' Union, including members of the Youth Section.

Scholars from the West and Western institutions often have initiated symposia and conferences dedicated to the problems faced by artists in the postwar Soviet Union. However, only a few conferences have attempted a theoretical discussion addressing the variations in the degree of conformity with official sanctions and the changes in these during the period following World War II. The few historians who have addressed the issue, including Boris Groys, have written their works on the basis of Russian experience and have not dealt with the so-called Baltic "borderlands."[1]

The situation in different areas within the borders of the Soviet Union varied greatly. Dissidence in art was most powerfully manifested in Moscow for many reasons. Because the people of the Baltic republics have different histories, traditions, languages, motivations, and fears, the dissidence in these countries differs from that of Moscow.

First, in the mid-1950s, at the time of the so-called "thaw," the Soviet regime had been in place in the

Baltics for only fifteen years, as opposed to Russia, where it had existed for about thirty-nine years. The "cleansing" of the Baltic intelligentsia and artists had affected one generation, whereas Soviet intelligentsia in the rest of the Soviet Union had lived through many waves of assassinations and arrests. Second, the generation of Estonians that can be linked to nonconformist thinking at the end of the 1950s had lived during the time of the previous regime when their teachers had worked and taught in the non-Soviet political system and received their education in Western Europe. Hence, the influence of Western ways of life and culture proved to be strong in the Baltic republics regardless of the degree of fear. Third, the conflict between the Russian avant-garde and old intelligentsia split the Russian cultural intelligentsia into two warring camps during the first few years of the Soviet regime. In contrast, the avant-garde of the 1920s in Estonia and Latvia, which was milder and less political than the Russian avant-garde, was not in conflict with traditional Estonian culture. Also, in the 1960s and 1970s, the younger generation used a post-cubist style in innovative ways as justification to break free of realism.

Estonia and the other Baltic states were clearly a separate part of the Soviet Union and were frequently referred to as "the Soviet West." Although the political structure of the Soviet Union was without a doubt one of a unified empire, various regions, including the Baltic states, Caucasus, and Central Asia, had unique characteristics that the central power did not feel impelled to obliterate. Historians continue to search through archives, trying to understand the exact role that had been prescribed for those borderlands. What was the actual goal and what was supposed to be the exterior image of these countries? The ideology that was introduced to the local inhabitants after 1940 was significantly more complex than the initial postrevolutionary concept of simply instilling the spirit of the so-called Communist ideals. Postwar manipulation went to a higher level, drawing on nationalist sentiment and traditions. For instance, under the guise of preserving national uniqueness, the use of the decorative aspects of folk traditions was permitted—national folk costumes were allowed on festive occasions, mass choral songs were sung in Estonia and Latvia, and so on. For the central power, it was undoubtedly politically significant to create for the rest of the world a picture of a peaceful melting pot of national and international cul-

ture. Allowing such minimal nationalistic activity was also a way to control opposition movements.

These activities were maintained with great care, and through them a national control was established to ensure a balance between what was permitted and what was considered confrontational. People were willing to make many sacrifices in the name of saving what little they had. Defense mechanisms that operated in the Baltic countries to maintain some national culture could not develop in the long-Sovietized large Russian centers. The most cynical forms of manipulation were numerous insinuations, especially perpetuated among intelligentsia, such as the activities of *Rahvarinne* (the People's Front). The People's Front has already been analyzed on many occasions as a movement first organized and controlled by the KGB that eventually got out of its control. Therefore, due to the differences in the history of political and social systems, the state of nonconformism in the Soviet Union's metropolises of Leningrad and especially Moscow cannot be easily compared to that in Tallinn, Rīga, or Vilnius.

The material making up the multiple layers of postwar culture has not yet been thoroughly studied, since so many facts are coming to light only now. People who own archives as well as artists of the older generation have begun to recount events and stories that they have carefully guarded for years. Local museums have started to collect works from the 1950s, and these works have been pulled literally from beneath beds and from atop wardrobes, although much art was destroyed because people did not dare to keep it. New material emerging from such caches every day changes the image of postwar Baltic art. Art historians and scholars of Estonia, Latvia, and Lithuania face an enormous task. The postwar art history of the Baltics must be rewritten using all the newfound, previously suppressed materials.

The plans to "Sovietize" the art of the Baltics were comparable in all three countries, and most issues that arose in opposition to Moscow were similar. One must keep in mind that the problems of nonconformist cultures did not occur simultaneously, and their manifestation was not uniform because, even though the Baltic countries shared a similar political history for centuries, they constitute three very different cultural regions. One cannot generalize and claim that an art of "the Baltic region" exists. Estonian, Latvian, and

Lithuanian art did not develop in the same way, despite the narrow room left by the Soviet authorities.

Each country's location was important to this development of cultural diversity within the Baltic region. Estonia had closer contacts with the Scandinavian countries and received a large part of its cultural information through them. Finnish television broadcasts that were accessible in Estonia and understandable to Estonians because of the similarity of their languages were especially essential during the 1970s and 1980s. Lithuania, however, was clearly part of Central Europe, with a specifically Polish orientation. A large number of the Lithuanian educated class spoke Polish, and progressive-minded Polish cultural literature was accessible. Lithuania was also particularly influenced by the Catholic mode of thought and tradition. The main subjects of Lithuanian national wooden sculpture were Catholic saints or the Virgin Mary with the Christ child. The same diversity characterized indigenous art. For example, Lithuanian artists love folklore's playfulness and improvisation. Even a spirit of the carnival has reached fine art there.

New cultural developments arose in the Baltic countries at different times, in a wave-like movement from one country to the next (they were able to develop only from the second half of the 1950s). Many examples of such waves can be cited. Printmaking developed intensely at the end of the 1960s in Estonia. In 1968, the tradition of print triennials began in Tallinn, and Estonia was proclaimed "the land of printmaking." A noticeable rise in Latvian printmaking took place in the early 1980s when artists Boriss Bērziņš and Ilmārs Blumbergs conquered the scene with their large format and free drawing style. Major differences, however, developed in the sphere of painting, which has been held in high regard in all three countries. When the values of the School of Paris were reintroduced into Estonia in the later half of the 1950s, monumental painting, with its large surfaces and decorativeness, was the most popular painting form in Latvia. In the 1970s, "geometric painting" (an analog of hard-edge painting and pop art) was popular in Estonia, initiated at the end of the 1960s by young art students such as Andres Tolts, Ando Keskküla, and Leonhard Lapin. In contrast, major changes in Lithuanian art began to take place in the late 1970s only when the traditional expressive style of painting reached intensive neo-expressionism. The long-awaited rise of Latvian painting began in the early 1980s, when Aija Zariņa, Ieva Iltnere, and others began to exhibit their works. Estonia was the first Soviet Socialist Republic where "hyperrealist" (photorealist) works were allowed to be displayed, and Latvian artists were quick to follow. In Lithuania, this variation of new realism, or "new documentalism,"[2] was melded with expressive figurative painting and never gained popularity in its pure form. Estonian art became known as innovative in the late 1960s and carried that reputation for a long time. In the mid-1980s, Latvian innovative art flourished, including such forms as performance art, photography, and monumental printmaking. Late in that decade, Latvian metaphoric installations were added, exemplified by the work of Ojārs Pētersons, Juris Putrāms, and Oļegs Tillbergs. Lithuanian art started to develop rapidly in the second half of the 1980s. Mindaugas Navakas was one of the first artists whose art responded to object art, conceptual art, and actionism.

Local critics have questioned the importance of nonconformism as well as its level of seriousness in the Baltic countries in the 1960s and 1970s.[3] Their main criticism is that the artists made so many compromises in their work and lifestyle that they should not be labeled dissidents. Kestutis Kuizinas, a Lithuanian critic and curator, writes, "It is reasonable to mention here that in Lithuanian art there was no strong underground culture. In relation to the freedom concerning the choice of themes, images and politically oriented concepts, the new generation greatly surpasses its predecessors who avoided speaking in their works about the conditioning of art by the historical-political context."[4] The younger generation of Estonian critics has also attacked "old-school avant-garde artists" and found that their opposition to the Soviet regime has been exaggerated. The Moscow underground has hinted at its being the only true group of nonconformists who were totally unwilling to compromise. An adequate comparison with the Moscow underground is not possible for many reasons, as mentioned above. Besides, the Moscow underground was not a homogeneous movement. The fact that a small national group such as Estonia is characterized by a collective, subconscious survival instinct that does not encourage extremes in its culture does not imply that its culture lacks radical artists.

SOCIAL NEST

With the "unification" of the Baltic states with the Soviet Union in August 1940, the first step taken by the Soviet authorities was the elimination of free art associations. Stalin had already succeeded in creating in the rest of the Soviet Union a totalitarian system of directing and controlling art reminiscent of the feudal order. Characteristic of this system was the grouping of artists into clearly delineated art associations, or Artists' Unions, in each republic. On October 7, 1940, the Council of People's Commissars of the Estonian Soviet Socialist Republic passed a resolution concerning the founding of the Artists' Union.[5] All previous artists' organizations were eliminated on November 15, 1940, and an Arts Government was founded. The same steps were taken in Latvia and Lithuania. The Baltic art scene was thereby directly linked to the Union-wide system. However, even before this formal decision was made, existing art organizations functioned under the control of Soviet authorities carrying out the orders of the new regime. As early as August 18, 1940, the governmental Fine Arts Foundation in Estonia announced a competition to select works of art to decorate public buildings, and soon afterwards, preparations were made for the special Estonian art exhibition in Moscow scheduled for 1941.

During the first years of occupation, the authorities did not invest much effort in establishing Socialist Realist canons because political loyalty took priority on the agenda. World War II had already begun, and the people of the Baltic countries hoped for political changes and new freedom because of the German expulsion of the Soviets. While they waited for such change to occur, they attempted to preserve their internal identity unaffected by the Soviet ideology, even if this meant having to adapt on the surface. In the first year following the war, when the Soviets reoccupied Estonia, cultural politics were relatively moderate, and renowned cultural figures were left untouched by the first wave of Soviet terror.

A severe change took place after the Party resolutions of 1946 and 1948, when war was declared against Western cultural influences (with which artists of the Baltic countries continued to identify themselves), the local national culture was dismantled, and the program of Sovietization began.[6] In 1949, a wave of terror broke out, and its victims included students and the educated. Those young art students from the Tartu State Art Institute sent to Siberian prison camps included Ülo Sooster, who later became important to the Moscow nonconformist movement. At the Estonian Communist Party's Central Committee plenary meeting held in 1950, the "June Communists"—artists who had joined the ranks of the new regime in 1940—were among those accused of "nationalism." The mildest punishment, being cast out of the Artists' Union, meant the end to any chance of professional advancement. These artists were no longer provided with art supplies, were left without any financial means, and worst of all were declared "parasites," because they did not work. In 1951, the art school in Tartu was shut down and higher art education was restricted to Tallinn, where the Estonian Soviet Socialist Republic's State Art Institute was founded. This action was organized in order to shatter Tartu as an intellectual center and breeding ground for nonconformist thinking. Very few works of artistic merit dating from 1950 to 1953 can be found in Tartu museums, and this situation is the same in the museums of Rīga and Vilnius.

True nonconformist thinking in Estonian art and culture emerged only after the death of Stalin in 1953. The Communist Party resolution of 1955, condemning excessive Stalinist taste in architecture, was pivotal for the intelligentsia.[7] The Academy of Architecture's activities during the time of Stalin were labeled excessive—above all, the use of classical and eclectic décor and the attempt to transform the buildings into symbols of the Soviet ideology. This resolution marked the beginning of changes in other cultural areas as well. From that point, artists could once again favorably address the art of the prewar period, which was previously not allowed because of its incompatibility with the ideology of Socialist Realism. The aesthetic search was rekindled, and the development of the autonomy of the aesthetic sphere can be viewed as an important part of the process of modernization, which in the Soviet Union started in the second half of the 1950s and made rational argumentation possible.

Before Stalin's death, any attempt to assert oneself as an independent, creative individual ended in a long-term prison sentence, relocation, or execution. In the course of thirteen years, however, the authorities did not succeed in completely changing the artistic way of thinking and getting Estonian, Latvian, and Lithuanian artists to paint in the style of Socialist Real-

ism. Works that have survived clearly reveal the technical weakness and unimaginative nature of even the topmost artists of the time. But an atmosphere of collective control and fear had been instilled, and it served as a basis for ongoing brainwashing.

Changes occurring after the death of Stalin did not affect Estonian culture immediately or directly. Only in the second half of the 1950s, with the beginning of the "thaw," did changes begin that determined the artistic development of the Baltic countries for many decades to come. During this time it was impossible to separate the political "thaw" from the cultural "thaw," which did not last very long. Following the Manege exhibition of 1962 in Moscow, a severe campaign against formalism and abstraction was launched. Khrushchev announced to the offending artists at the Manege, "Gentlemen, we are declaring war on you," and the period of thaw was over.[8] L. K. Ilytchev, the main speaker at the Soviet Union Communist Party's Central Committee meeting of 1963, stated, "There can be no cease-fire or agreement. Our opponents with different ideals have taken such weapons as formalism, abstractionism, and decadence into their arsenal."[9] In Moscow, as well as in the borderlands, a mass-media campaign was launched against any art straying from the narrow position of realism, and it was once again hard for young artists to gain access to exhibitions. But the years of the "thaw" had provided sufficient time to breathe and for small, relatively closed organisms—local art models—to be formed. These models, unique to the Baltic countries, were strong enough to continue until the 1980s. During these years when simultaneously prewar values were rekindled and challenged, artists began to move beyond the narrow rules of Socialist Realism. As the true character of Estonian art began to develop and was observed closely by Estonians as well as by their neighbors, understanding as well as opposition evolved.

In all of the Baltic countries, the creation of new trends began by reviving old values. In Estonia, however, open-minded thinking and daring innovations were accelerated by Sooster's role as intermediary between the Estonian art community and Moscow's nonconformist artists. An exhibition of mostly abstracted forms organized by Silvia Jõgever was held in 1960 at the Tartu VIII Secondary School. This exhibition was shut down, and its closure was accompanied by a major scandal. Such official sanctions were the main reason Tartu artists began to isolate themselves.

The reawakening of Lithuanian art occurred in the mid-1960s. As Raminta Jurenaite noted,

In the Soviet period, following 1945, Lithuania had neither a well-developed school of socialist realism (it was represented only by individual works) nor an active or consistent dissident culture. The development of unofficial art was slow due to the gap which emerged after the massive emigration of artists, fearing a repeat of the deportations that took place in 1940 under Soviet occupation, to the West in the footsteps of the fleeing German troops. Time seemed to have stopped until the middle of the 1960s. The totalitarian regime in Lithuania slowed down and crippled the development of art for a long time rather than actually altering it.[10]

Helēna Demakova stresses that the mid-1960s were also a breaking point in Latvian art and mentions the influence of *Project*, a Polish art magazine that was then accessible.[11] The period was a relatively optimistic time. People's living conditions improved, and the belief grew that even in the Soviet Union something could change for the better. Yet after 1968, when Soviet tanks entered Prague, any illusions of the likelihood of political change and the development of real freedom were difficult to maintain.

The period from the end of the 1960s until the mid-1980s was like a trip up a down-winding staircase. While the early 1970s were still characterized by an innovative relation to culture, in the latter half of the 1980s the heavy pressure of stagnation almost achieved what the campaign against artistic expression had set out to accomplish. The art of Estonia and the other Baltic states was no longer capable of moving forward. This was marked by a development of various types of graphic and applied arts, including the flourishing of poster art in Estonia and book design in Lithuania. Any attempt at installation art, happenings, or other art beyond the prescribed was out of the question. The pressure on creative and educated people became increasingly strong in the 1980s, which led to creative as well as personal crises among many artists. Alcoholism was never more prevalent among the intelligentsia than in the 1980s. The exhibition title *Who went mad, who ran away . . .* that I once saw perfectly characterizes the situation in Estonia at the time, although the exhibition did not deal with Estonia in any way.

When trying to describe nonconformism in the art of the Baltic countries, one must mention two more things. First, the form of opposition kept changing ac-

cording to shifts in the pressures of the time. The fears of the 1950s cannot be compared to the cockiness of the 1970s' rebellious youth. Second, as noted earlier, analogous processes occurred in the three countries at various times, and the rise of innovative art signified a form of opposition. Artists did not need to think in terms of political categories; their interests were mostly related to the exploration of art's various expressive forms. Yet inevitably each step that was taken against the prescribed canons was also a political decision.

THE MANY MEANINGS OF "BECOMING SILENT"

Prior to 1953, the people of the Baltic countries were threatened by the real possibility of extermination. The fear of the weaker before the physically stronger, which still existed at the end of the 1950s, resulted in forced alternative behavioral strategies such as silence. Yet these variations of behavior contain an essential moral question. If one could not threaten or openly oppose, there was the alternative to be silent.

There are many reasons for being silent: fear, degradation, or the desire to avoid accusations, unprofessional criticism, or rude demands. These kinds of silence characterized artists in the 1950s. In Estonia, Latvia, and Lithuania, some artists whose professional careers began before the war no longer participated in exhibitions during the 1950s. For some, this lack was a result of having been thrown out of the Artists' Union and the display of their work being obstructed in every way. But others were "voluntarily silent." Tartu painter Alfred Kongo began painting again only in 1957 following a ten-year silence.

Isolation and silence characterized the entire Tartu art colony that continued working in the postwar period. The arrests and threats, which were targeted at the artists of Tartu more than those from Tallinn, caused a narrow, closed circle whose layers of defense are hard to penetrate to this day. And yet such artists as Valve Janov, Silvia Jõgever, Kaja Kärner, and Lembit Saarts dared to paint abstract motifs and make collages at the time. They most likely did not receive any of the advantages that the Soviet regime had established for artists. This kind of relinquishing—not going along with the "great ideas" of the time—was definitely a form of opposition and naturally had its dangers. Such a voluntary enclosure is generally not able to create anything constructive even within its own circle. It clings to the ideals of its own universe and does not accept any other possibilities.

Another possibility was to make an ethical statement by staying away and not participating. The best example of this stance is that of Tõnis Vint, who in 1964 was the main ideologist behind the creative group ANK 64, composed of students from Tallinn's State Art Institute. Vint developed a system of refined, arranged, abstract structures in his drawings and printmaking in the early 1970s that did not fit the official art doctrine. The influence of Vint's empty space in his prints was far-reaching. His principles were used extensively in a large number of prints as well as in book design. Vint's connection to his era is extraordinarily multifaceted. His works lack the slightest reference to the society in which he resided and which surrounded him like a nightmare (due to his numerous guests from abroad, his apartment was under constant surveillance). He gathered around him young people who were interested in both Eastern cultures and the latest trends in European culture. His name and circle became synonymous with alternative art opposition in Estonia, Latvia, and Lithuania. Vint and his followers also developed close ties with the Moscow underground, especially such artists as Ilya Kabakov, Yuri Sobolev, and Vladimir Yankilevsky.

With the intelligentsia, this silence was accompanied by Estonia's increasing desire for privacy. During this time, many workers from throughout the Soviet Union were brought into Estonia to build factories without any economic justification. The real goal was to change the structure of the local population by reducing the proportion of ethnic Estonians, which resulted in a growth of the locals' need for isolation. Many ways of escape did exist—for instance, a boom in the construction of small individual residences began in the late 1950s. Every Estonian's dream was to have an opportunity to get away, to find a space where they could decide things for themselves. As small and obvious as such privacy may seem, it became very important. The areas surrounding Tallinn and Vilnius are full of tiny private homes that were built during this period.

Privacy was reflected in art through neutral themes —still lifes, landscapes, and portraits of family members. In newspapers, artists were scolded for not going along with the demands of the new order.[12] The Soviet art establishment was constantly criticizing Estonian artists for not painting monumental works on contem-

porary Soviet themes and for focusing on their own small problems. Yet this did not always help. The extent of the constraining demands on artists could be exemplified by the words of Rudzitis in 1948: "One may still paint an apple, but it must be a Soviet apple."[13] Of course, every artist who painted landscapes or flowers in a vase and did not present works for exhibition glorifying Soviet labor was not acting as a rebel. Instead, such art was the main material for the development of internal defense mechanisms. The previously mentioned local, closed art models are in fact based on the idea of protection (of defense mechanisms).

MYTHS AND DEFENSE

The situation that was established in the mid-1950s can be considered as both the regeneration process in art and the beginning of the creation of defense mechanisms. Not only were Estonian painting, sculpture, and graphic arts included in this process, but also decorative art and interior design. As part of these defense mechanisms, certain aspects of art were emphasized, such as the sense of color and form characteristic of the School of Paris, which was seen in Estonia, or the strong influence of German expressionism on Lithuanian art. With the right to recreate tradition that had been gained during the period of the "thaw," artists began creating their image of national art, the goal of which was undoubtedly to emphasize its difference from Socialist Realism. Initially, appearing in the form of didactic, narrative, and moralizing art, Socialist Realism quickly became charged with pathos and decorativeness in the 1960s.

Estonia's image within the Soviet Union was tied to the harsh northland. Generally, calling a work "Estonian" art meant that it was simplified in form, with color schemes based on grayish, brownish, bluish, and black hues, and it was rationally composed, as opposed to being emotionally controlled. The Estonian myth comprised technical accuracy, intellectuality, and cool privacy. This vision of Estonian art provided a niche that sheltered it from the demands of Soviet ideology.

The Lithuanian myth concerned inspiration and painting. Like the legend of Estonian art, this idea flourished especially in the 1970s and 1980s, although it had been born in the early 1960s. Alfonsas Andriuškevičius stated,

> Its [the Lithuanian myth's] essence is as follows: an artist is only a medium, who performs certain subconscious movements, when he is told to do so by a higher power; the moment of order is called Inspiration. It is not true to say that this myth was supported by Lithuanian power. On the contrary, instead of talent and inspiration it was constantly offering labor and the studies of social and natural reality. Thus, the myth should be considered as a kind of antipode of the doctrine regarding the official art creation.[14]

It is difficult to distinguish between a myth and a defense mechanism—one was a part of the other and vice versa. Their positive impact was significant; they helped to overcome the identity crises born in the 1940s and to revitalize both aesthetic values in art and the idea of an artwork's sovereignty. Although hidden, they still constituted a collective form of opposition, a desperate attempt to maintain something of one's own and not melt in the all-Union cauldron of prescriptions and predictions. They were a virtual collection of opinions and beliefs that were difficult to attack from the outside, since a formally observed thesis existed in the Soviet Union—culture had to be Socialist in content but nationalist in form. Although completely hypocritical, this thesis helped secure the myths.

Yet these myths also had their negative aspects. In the 1970s, when radical young artists in Estonia who had entered the arena in 1969 began exhibiting, this same defense mechanism—the legend of the national character and values in Estonian art—became a restraining force. In the mid-1970s, the art bureaucracy's criticism attacked mostly the young and left small shifts in art unnoticed. The main idea was that nothing would make Estonians somehow stand out in Moscow. In Estonia, an unwritten agreement with Soviet authorities maintained that Estonian artists were allowed a certain amount of radical ideas, but they had to keep three promises in return. First, they were prohibited from sending their works to foreign exhibitions. However, secretly, with the help of foreigners, sending prints to international exhibitions was a widespread practice. In 1977, many Estonians participated in the exhibition *New Art from the Soviet Union*, which took place in Washington, D.C., and was organized by Professor Norton Dodge. In addition, Estonian artists

were not allowed to send their most radical works to all-Union exhibitions, nor were they permitted to have underground artists from Moscow and Leningrad participate in their exhibitions. In spite of this, leading Moscow avant-garde artists, such as Eric Bulatov, Ilya Kabakov, and Francisco Infante, participated in the exhibition *Photography and Art* at the Tartu Art Museum in 1984.

These relations were not changed by the fact that severe Russification politics were implemented in the final years of the 1970s, further limiting the rights of the republics, which were already illusionary. Soviet ideology, obviously getting closer to bankruptcy every day, started to be replaced by Russian chauvinism. Wider use of the Russian language and greater consideration of examples of Russian culture were demanded. Naturally, Estonian national art then received the title of "preserver of national identity." The public at large and the majority of artists in these circumstances supported more conservative art rather than the so-called "radical" style. Extremes were rejected because they could have destroyed the carefully constructed balance. Thus in the early 1970s, many young artists in Estonia realized that any radical step beyond the balanced system not only signified opposition to the art dictated by the Soviets, but also was an assault on the local defense mechanism against the Soviets and placed the entire balanced system in jeopardy. "Silent modernism" was the witty description given to this phenomenon.

THE MANY MEANINGS OF INTERFERENCE

The 1970s saw the outright disregard of dogmas of official Soviet art, a continuation of resistance, and further development of nonconformist art—processes no one had the power to stop once they had begun. Young people who were born after World War II reached maturity then, and postwar issues that had been repressed emerged in the art scene. This new generation lacked the fear of deportation and imprisonment, and the rest of the world's level of knowledge was markedly greater than in the mid-1960s. Information was still hard to access, and very little literature was in circulation, although everything that was received was read thoroughly. The magazine *Kunst*, published in Estonia, used every opportunity to introduce information about modernist art. In 1979, it printed the first article in Estonian about the work of the Russian avant-garde artist Kazimir Malevich. Printed material saturated with the West greatly influenced Estonian art. Such information transferred via the print media had a significant influence on artists' impressions and judgments concerning Western art and led to numerous forms of synthesis unparalleled elsewhere. This is one reason paradoxes find their place in the art of the time—the aesthetic starting point combined with anti-aesthetic ideas of avant-garde ideology, or, figuratively speaking, *arte povera* was beautifully framed. I have described this paradoxical state of art as repro-avant-gardism.

For Estonia, the early 1970s was an especially active time on the art scene. The influence of the Tartu group Visarid could still be felt. Founded in 1967, the group held its last exhibition in 1972. Kaljo Põllu (b. 1934), the spiritual leader of the Visarid, revived collage, assemblage, and printmaking in Estonian art. The group that gathered around the art department at the University of Tartu distributed to interested colleagues translated writings, which had been typed and retyped many times, on Western contemporary art criticism and philosophy. Those were the last few good years for the representatives of Tartu intelligentsia. In the mid-1970s, the sociology department that had gained notoriety for its dissident views was shut down, and the semiotics department, led by Professor Juri Lotman (1922–1993), was greatly constrained despite its highly respected reputation all over the Soviet Union and in the West. The art department was moved from its central location to an old residence building, Põllu moved to Tallinn, and the department's influence decreased significantly. The colony of rebellious artists in Tartu was thereby eliminated.

In Tallinn, in 1969, art students Keskküla, Tolts, and Lapin and others showed their works at the *SOUP-69* exhibition held at the regular meeting place of the young intelligentsia—the Pegasus Café. The garish objects on view were provocative, and naturally the exhibition was immediately shut down. The closure changed no one's feelings. The happening held at the Pirita beach in 1969 ended with the arrest of Keskküla, Tolts, and Vilen Künnapuu. Thanks only to Künnapuu's relative who was a member of the Communist Party were they spared from being expelled from school. This group, consisting mostly of design and architecture students, brought pop art to Estonia. Pop art

did not evolve into a long-term or dogmatic trend but impelled creative and experimental young people to move in varying directions. In the ironic and absurd collages and assemblages that he created starting in 1969, Tolts turned to what was later called "sots" art, which eventually became known in the West as the art initiated by Moscow nonconformist artists. Lapin produced his erotic-absurd kitsch bunny kisses and comic strip *Benno Bladikorn's Discoveries, Lust for Life and Thoughtless Death in the "Pellergia" Café* (1970). Around this time, Raul Meel (b. 1941) began his abstract typewriter drawings based on letter combinations. Meel, who had not studied at the art academy, was forced to endure severe criticism. While his works had been successfully featured at many international exhibitions, he was refused membership in the Estonian Artists' Union and consequently did not receive the privilege to use a studio for any extended period of time. In contrast to most Estonian artists, who somehow managed to survive as freelancers, Meel earned a living working for the state and later as an apiarist. Lapin did not gain access to the Artists' Union as a painter, but he was accepted under the guise of exhibition designer—the only way for him to get his membership approved by Moscow. In the Soviet Union, one needed to be a member of the Artists' Union in order to avoid the militia's charge of being a "parasite," since everyone who did not belong to the Artists' Union and was not otherwise employed was considered legally a "parasite" and faced possible imprisonment even as late as the 1980s.

Two exhibitions that were important to nonconformist art in Estonia took place in 1973 and 1975 in Saku and Harku, small towns outside of Tallinn where institutes of the Academy of Sciences and their residences were located. At Saku, the main participants were members of the older group ANK 64; the exhibition served as both statement and summary of their work. Two years later, at Harku, the younger generation showed their pop installations and conceptual works. Naturally, no mention of these events appeared in the press, and art officials were outraged. The 1979 exhibition of prints by Lapin, Meel, Jüri Okas, and Tõnis Vint at the Rīga Planetarium was also significant.[15] Jānis Borgs, critic, organizer, and artist, helped maintain ties between Estonian and Latvian young radicals in Rīga.

In the mid-1970s, the hyperrealist (photorealist) trend, sometimes referred to in Estonia as "slide painting," developed quickly. Keskküla, who influenced many artists of his generation as well as younger artists, led this movement. If in the Western world photorealism was not considered a part of cutting-edge contemporary art, things were different in the Soviet Union. While the first photorealist paintings were being exhibited, a heated discussion over the "extremely dangerous" nature of false realism was at its height in all-Union publications. The main accusation was that such works concealed Western influences particularly well, and that they were not as easily labeled anti-Soviet as were abstraction or pop art. Hyperrealism was not understood as simply a fashionable trend, which provided the opportunity to deal with the surrounding environment with a new perception of space. In the case of hyperrealism, famous mimicry of socialist clichés was also employed. To avoid calling things by their real names and getting punished for it, people across the Soviet Union used the term "new documentalism" to identify a relatively broad range of art, from photorealist painting to photography. Hyperrealism was well developed in Estonian art, becoming a rather "domesticated" phenomenon by the early 1980s. Yet the hyperrealism of the mid-1970s can be considered the last manifestation of Estonian avant-garde.

Both "radicalism" and "nonconformism" in art were represented by Vint's circle and Soup '69. These artists were by far the most clear-cut opposition to Soviet-style art. This restless and pretentious crowd constantly had run-ins with the art bureaucracy and ideological control mechanisms, while a silent opposition found other ways to show dissent. One of these ways was irony and the grotesque in painting, which became a vehicle for expressing dissent, contrasting with the demanded atmosphere of overall optimism. Irony and the grotesque spoke of the opposite: skepticism, lack of trust, and entrapment. The grotesque was considered a manifestation of distrust in the accepted norms.[16] In the early 1970s and 1980s, the grotesque became infused with surrealism in the art of all Baltic countries. Yet compared to Estonia, where hyperrealism was extremely popular, and Latvia, where retrospection stemming from classicism combined with decorativeness dictated the tune, Lithuania had the best conditions for the development of the grotesque and irony in art. The interest in the grotesque was catalyzed by the traditions of painterly expressiveness and

expressionism. Its roots go back to Lithuanian folklore, which led to playfulness, improvisation, and a festive carnival feeling. Moreover, Lithuanian art has always focused on the human being to express the pain of the world. Paintings from the late 1970s and early 1980s by such artists as Mindaugas Skudutis, Raimundas Sližys, and Bronius Gražys were particularly disturbing, full of nightmarish beasts and chaos. The synthesis of all these elements turned Lithuanian painting of this period into an intense and personal art. Two extremes within a single discourse were evident: Lithuanian emotional openness and self-exposure at one end and Estonian cool distancing and restraint at the other.

The correlation between political dissidence and artistic nonconformism will continue to be questioned. During the 1970s, many influential factors were at play. On the one hand, the surrounding environment changed, ideals and positions altered, and the world seemed to be opening up slightly; on the other hand, the fear of persecution was gaining ground. Young people's reaction against aesthetics in the culture at the end of the 1960s and the beginning of the 1970s was first of all an internal movement in art—an inevitable move without which the culture would have been condemned to long-term stagnation and withering. Stagnation started taking its grip on the culture in the 1980s, and within years, only a mixed and cynical demagogy remained. Naturally, artists experienced this first and foremost. In 1985, Raivo Kelomees wrote in a typewritten publication, "Today artists' works are basically a recreated compilation—they are not full of discovery. . . . Steps on an artist's road to success while being engaged by the state do not always serve as a way of expressing his or her creativity (nor do they always disguise it). Significantly, however, they very often demonstrate artists' reputation, work potential, abilities, education, ambition, and sense of conjecture."[17] Thus, artists felt resigned to Soviet power in the 1980s. This state of affairs did not change until the last third of the 1980s, as a result of Mikhail Gorbachev's glasnost.

Nonconformist art in Estonia, Latvia, and Lithuania began in the 1960s and continued into the 1970s. The earlier abstract painting of the end of the 1950s and the 1960s was in fact a continuation of prewar art, which paralleled the development of certain art forms in 1950s France and Scandinavia. Nonconformist art from the end of the 1960s and 1970s, however, was by definition in conflict with Soviet power; separating dissidence in politics from nonconformism in art was impossible. Nonconformism was a way of life. Large numbers of typewritten collections of essays, short texts, absurd poems, and critical debates were distributed. A small booklet compiled in 1977 by Urmas Mikk was appropriately entitled *End of the Avant-Garde*.

The various opinions and interpretations that divided artists, separating the main trend from alternative directions, were always less significant than opposing a common enemy. Opposition to this enemy united even those whose art differed both aesthetically and ideologically. Serious conflicts in the art world of the Baltics did not occur until the 1990s.

Questions of opposition to the Soviet regime will no doubt remain the subject of discussion for a long time to come. The new generation of young artists may wonder why we speak so much about nonconformist thinking when it had no power for political change. Are we romanticizing rebellion? I am sure that this is not the case. How culture and society relate to each other, what part was played by collective energy and thought, and what influence cultural opposition to the society at large played still require thorough analysis. The giant beast called "socialist culture" may yet offer many surprises.

Translated by Riina Kindlam

NOTES

1. Boris Groys's book *Utopia and Lie* (Moscow: Znak Publishing House, 1993), in Russian, does not pay attention to art communities outside of Soviet metropolises.

2. This term was first used by Ando Keskküla in an interview with A. Korzhukhin and was later used across the Soviet Union instead of "photorealism."

3. Holger Rajavee, "Harku 75," *Postimees*, March 4, 1996.

4. Kestutis Kuizinas, "Implications of Context (In Lithuanian Contemporary Art)," *Kontura* 31/32 (1994).

5. *Art of the Soviet Estonia from 1940 to 1965*, vol. 2 of *The History of Estonian Art in Two Volumes* (Tallinn: Kirjastus Kunst, 1970).

6. Ibid., 43.

7. *Eesti Arhitektuuri ajalugu* (The history of Estonian architecture) (Tallinn: The Academy of Science of Estonian Soviet Socialist Republic, 1965), 463.

8. M. Kiis, "Maneezhi intsidendi kajastumine ja abstraktsionismivastane kampaania Eesti NSV kunstimaailmas, detsember 1962–oktoober 1964." Peaseminaritöö, Tartu, 1998. Käsikiri TÜ kunstiajaloo õppetooli raamatukogus ("The campaign against abstract art after the Manege exhibition and the influence in the Estonian art world and press, December 1962–October 1964." Seminar paper, 1998. Manuscript in the Library of the Department of Art History of Tartu University).

9. Ibid.

10. Raminta Jurenaite, "Between Compromise and Innovation," in *Personal Time: Art of Estonia, Latvia and Lithuania, 1945–1996,* Lithuanian volume, eds. Anda Rottenberg et al. (Warsaw: The Zacheta Gallery of Contemporary Art, 1996), 16.

11. Helēna Demakova, "The Apple Harvest, or Art in Latvia, 1945–1995: Between Personal and Ideological Time," in *Personal Time: Art of Estonia, Latvia and Lithuania, 1945–1996,* Latvian volume, 13.

12. See, for example, Boris Lukats's speech of July 18, 1946, in the plenum of the Estonian Communist Party, reported in *Sirp ja Vasar,* August 3, 1946; and Eduard Einmann, "Palju on veel lahendada" (Much has to be done), *Sirp ja Vasar* 8 (1957).

13. Helena Demakova, "The Apple Harvest," in *Personal Time,* Latvian volume, 10.

14. Alfonsas Andriuškevičius, "Dvieju mitu likumas" (Destiny of two myths), in *Lieetuviu daile, 1975–1995* (Vilnius: Akademija, 1997).

15. For radical artists, having an exhibition in another city was a big chance to exchange ideas and gain experience.

16. Viktoras Liutkus, "Iroonia ja grotesk Baltimaade maalikunstis" (Irony and grotesque in the painting of the Baltic countries), *Kunst* 72, no. 2 (February 1988): 10–14.

17. Raivo Kelomees, "House. Playful Ritual and Suicide," unpublished manuscript.

Mark Allen Svede

WHEN WORLDS COLLIDE

On Comparing Three Baltic Art Scenarios

N 1996, the Zimmerli Art Museum hosted a symposium on the topic of nonconformist art, and in one session twelve eminent unofficial artists from St. Petersburg and Moscow took the podium to offer autobiographical perspectives on the phenomenon. During the discussion, the director of one of the departments in a key St. Petersburg museum declared quite abruptly that Baltic artists had experienced nothing resembling an underground movement and thus could not be termed true nonconformists. Maybe he was inspired to make this generalization after overhearing a diatribe by a well-known Muscovite painter while touring the inaugural installation of the Dodge Collection the day before. The painter was dismayed by significant amounts of non-Russian artwork in the exhibition, believing it an insignificant aspect of Soviet nonconformist art. Maybe the museum official was emboldened by the

absence of Ilya Kabakov at the symposium, for, as a well-traveled elder of the tribe, Kabakov could have invoked the memory of Ülo Sooster, his Estonian friend who played an integral role in the Moscow underground long before the department director had begun supervising the active collection of such work. Maybe he simply didn't know better.

In the audience, Kharkhiv-born and -trained painter Zoya Frolova took keenest offense at these remarks. Having married a Latvian and endured a measure of ethnic marginalization during the years she worked in Rīga's somewhat insular artist community, Frolova was qualified to dispute such polemic. In particular, she was galled by russocentric assumptions regarding what constituted an underground because, several years earlier, she herself had witnessed a peculiar but revelatory incident in Leningrad. While Frolova was visiting the studio of a prominent noncon-

formist painter, the gathering of predominantly Russian artists learned that a distinguished collector from the West was en route to the studio. The assembled personalities sprang into action at this potentially lucrative announcement. Western liquor and cigarettes were swept from the table and replaced by inferior Soviet products; the host changed from stylish foreign-made clothing into something more suitably drab and frumpy; the urbane atmosphere dampened instantly and palpably. After all, one needed to preserve the mystique of the unofficial artist persevering under late communism. But, if anything, the incident proved that proprietary rights to the designation "underground" and its concomitant claim on higher moral ground are disputable.

Alas, reductive characterizations of Baltic nonconformist art-making are not solely the labor of non-Balts eager to valorize their own milieux. To paraphrase the Cole Porter lyric: Lithuanians and Letts do it; Estonians, too. Differentiating Estonian from Latvian from Lithuanian art can be difficult enough without the added hindrance of making such comparisons with incomplete information about the neighboring subjects, a common handicap because the work of writing these nations' respective, recent art histories is just now beginning. Worse still, when differentiating art made under difficult circumstances—namely, under conditions of official restrictions and active interference—there is the distinct risk of comparative martyrology superseding comparative stylistics. Even when stylistic matters are kept in focus and there seems to be an awareness of what was happening elsewhere in the Baltic region, comparisons frequently assume the character of a footrace: "We tired of hyperrealism before *they* even knew what it was." And this becomes tiresome indeed, not to mention self-defeating, given how often East European contemporary art suffers from Western curatorial and scholarly disregard predicated on myths of priority and, ergo, primacy.

WHEN WORLDS COLLUDE: SNUBBING THE CENTER

The urgency of distinguishing one culture from another often corresponds to the threat, real or perceived, of impending cultural loss. This urgency assumed specifically national forms in the Baltic region because, in addition to the all-too-real leveling forces of

Sovietization, central authorities tended to perceive Estonia, Latvia, and Lithuania as a homogenized sociopolitical construct called, in Russian, *Pribaltika*. As a result, identity-conscious Latvians sought to accentuate their differences not only from *homo sovieticus* but also from *homo lituanus* and *estonius*—issues of self-definition largely uncontemplated before Soviet annexation. (Of course, Lithuanians and Estonians—especially Estonians—also endeavored to demarcate national differences.) At the same time, however, this *Pribaltika* concept expedited Moscow's endorsement in the late 1960s of newly proposed triennial exhibitions of Baltic painting and graphics (and later, sculpture quadrennials and triennials showcasing young Baltic artists), which helped facilitate this differentiation of the three republics' supposedly representative artworks, even as it reinforced perceptions of the region as an aesthetic polity unto itself.[1] On the other hand, impressions of complete autonomy were undercut in these exhibitions by the omnipresent contingent of Moscow or Leningrad artists, dutifully accompanying their "junior partners" in artistic progress. However, Russian participation became less conspicuous as the survey tradition evolved, while relations between Baltic and non-Baltic artists became more interpersonal and equitable. Yet even during the initial stages, local reviews of these exhibitions rarely mentioned the obligatory Russian presence, and readers could be forgiven for believing that the Balts had been left to themselves.

Critiques of these essentially international shows, published dependably in the Latvian journal *Māksla*, divined the ways in which Latvian art diverged from that of its neighbors. Year after year, commonplaces of Baltic art historiography were parroted: Estonian art is precise and rational; Latvian, monumental and classicist; Lithuanian, colorful and expressive. Estonians excel at graphic art; Lithuanians at sculpture; and so on.[2] But a careful reading of the best Latvian criticism from this time reveals startling amendments to these received notions, and, even more surprising, they were rarely self-congratulatory. In one essay titled "The Painterly Essential," critic Herberts Dubiņš observed that Lithuanian paintings at the 1969 Vilnius Triennial achieved their salient expressive qualities through the inclusion of photo- and kinographic elements, collage, and experimental facture, securing "emotional compensation for rational clarity, technical precision, and

refinement." Meanwhile, that year's selection of Estonian paintings hinted at a rebellion against their national school's renowned "severely constructive direction":

> At present, Estonian painters seeking to get the better of this rationalism bring to the center of attention, as the "painterly essential," the irrational [of Elmar Kits], dubiously peculiar symbolism [Enn Põldroos], shriekingly gaudy decorativism [Malle Leis], and microuniversal naturalism [Ilmar Malin]. These compositional and coloristic experiments are rather shallow and already anachronistic. Apparent in each piece are attempts to overcome illustrationism and cliché in painting, to oppose academic deftness with the self-worth of creative principle.

Even given such mixed results in the Estonian and Lithuanian work, Dubiņš deemed Latvia's section the least "attractive," noting that "a known stagnation prevails in our painting,"[3] though this acute judgment was tempered with genuine appreciation for the strengths of the individual artists.

Of course, the biggest problems of such comparison stem from the pre-selection of individual participants on the republican level by cultural officials even before their work went to jury, so a republic's "best" art was invariably skewed by political exigencies, favoritism, and other subjective forces (which, admittedly, have always shaped national representations at, say, the Venice or São Paulo biennales). But in the Baltic context, the most experimental were usually excluded—especially from Latvian and Lithuanian groupings—rendering any qualitative evaluation unreflective of actual levels of accomplishment. Instead, one could derive a reliable accounting of the respective curatorial teams' sophistication and audacity, at which the Estonians clearly succeeded. But Estonians also tended to excel at solipsistic interpretations of historical interactions between the various art worlds within the Soviet sphere. Years hence, Berlin-based curator Barbara Straka could make the bemused observation about a pan-Baltic photography exhibition,

> With comparative reading, differences and national characteristics are evident in both the self-representation of the artists and their representation by the curators. The [catalogue] reader might be astonished that, for example, an exhibition in a furnishing store in a provincial Austrian town is mentioned, whilst Estonian photo art, in contrast to Lithuanian, has apparently never been exhibited in Moscow.[4]

This inclination to give a partial account unwittingly mirrors Soviet historiographic practices, reversing the previous bias toward Russian personalities and influences. An understandable enough response on the part of a threatened culture, this tendency nevertheless illustrates the feminist adage about being overly defined by one's oppressors, just as it dishonors the vital network that developed among nonconformist artists without regard to ethnic background.[5]

WHEN WORLDS COINCIDE: COMMONALITIES AND INTERACTIONS

Appropriately, some of the strongest correctives to this willed myopia were also Estonian. Collector Matti Milius, christened "the one and probably only manifestation of Finno-Ugric expansionism,"[6] amassed over twelve hundred nonconformist artworks from Armenia, Estonia, Latvia, Lithuania, Russia, and Ukraine, a number made all the more impressive by his claim on Latvian television in 1992 that he'd purchased only five, the rest having been donated by the artists themselves.[7] His collecting purview first crossed Estonian borders in 1974 after Milius saw Latvian painter Līvija Endzelīna's solo exhibition at the Tartu Art Museum; he vacationed in Rīga that summer, buying a hyperrealist painting by Miervaldis Polis[8] and receiving a gift portrait of himself by Māris Ārgalis,[9] the first of 113 works by 47 Latvian artists represented in his collection. The following summer in Vilnius, he acquired a painting by Algimantas Kuras, the first of 32 works by 22 Lithuanian artists, and he also ventured to Moscow in 1975, beginning his extensive Russian holdings. Before long, Milius exerted a cross-pollinating effect. From 1977, his Latvian and Lithuanian artworks were exhibited in nontraditional venues across Estonia; from 1983, his Estonian works were shown in Armenia and Latvia. As his reputation spread among nonconformist circles, Milius himself became the subject of others' work, including an extraordinary cinematic portrait by Haralds Elcers, *The Unreasonable Manifesto of Matti Milius* (1985, Rīga's ZA Tautas kinostudija production). A portrayal of the collector, his Actions, and Soviet authorities' sometimes punitive reactions, Elcers's film also documents Milius creating a surro-

gate exhibition: ten white canvases signed with Latvian painters' names, including F[rančeska] Kirke, L[īga] Purmale, and B[runo] Vasiļevskis, are displayed against a snowy expanse. Whether these tabulae rasae were placeholders soliciting future donations, allusions to the virtual invisibility of certain artists within the larger Soviet context, or a reference to Malevich's *Suprematist Composition (White on White)* at a time when suprematism was modish among certain Estonian artists, Milius demonstrated his humorous determination to breach boundaries drawn by diplomats, cultural apparatchiki, and historians.

Dialogue between Estonian and Latvian artists deepened as the 1970s advanced. Leonhard Lapin's recollection of his Soviet Army conscription partly spent in Rīga among "Latvian avant-gardists" in 1972 underscores that contacts among Baltic artists were not always precipitated by high-minded cultural diplomacy.[10] By decade's end, the communities were consistently interacting on an intellectual plane. Latvian artists such as Jānis Borgs and Valdis Celms, busy recovering the constructivist legacy of native son Gustav Klucis, found kindred interests among key Estonian contemporaries resurrecting the work of Estonian modernists, so in 1978, Lapin, Jüri Okas, Tõnis Vint, and several Tallinn architects were invited to participate in Latvia's first Architecture Days festival. Dramatizing the encounter, one Rīga newspaper juxtaposed Borgs's provocative article, "Fourteen Meditations Between New York and Ķengarags," illustrated with dynamic Estonian architectural images (including Lapin's *To Each His Own Skyscraper*), with an arid philosophical "meditation" citing tired Brezhnevian architectural aperçus.[11] The following year, Lapin, Okas, Vint, and Raul Meel exhibited their graphic works at the Rīga Planetarium, a deconsecrated Orthodox cathedral and venue for progressive Latvian design exhibitions. This significant importation of geometric abstraction was reminiscent of the 1924 *Exhibition of Baltic Cubists*, a much earlier Estonian-Latvian artist-brokered union. If anything, this proved that Balts could be convivial and mutually supportive—every fifty-five years, needed or not. Vint also impressed his hosts with an erudite lecture on Latvian folk ornament from an ethnographic perspective at a time when few Latvian contemporary artists had such extensive knowledge of the subject.[12]

Latvian artists benefited from a similar curatorial nexus in Moscow in the 1970s, when collector Tania Kolodzei introduced Borgs to Russian nonconformists with whom she was acquainted. Years later, when Borgs assumed the editorship of *Māksla*, the liberal imprint of the unofficial art realm became evident in his choice of illustrations glossing textual passages that alluded to, but couldn't fully explicate, experimental artistic trends. Jazz musician Vladimir Tarasov recalls that the artist networks occasioned by Kolodzei and other Moscow collectors of new art from Leningrad, Rīga, and Tallinn proved even more influential for Lithuanian artists, who had worked in comparatively greater isolation before the 1970s.[13] This triangulation through Moscow, a true symptom (however benign) of Soviet imperialism, was soon superseded by direct personal ties between Latvian and Lithuanian nonconformists.

Beginning in 1972, young artists of both nations worked as architectural restorers at the Rastrelli-designed Rundāle Palace near the republics' common border, and though this restoration was their official occupation, many recall the decidedly unofficial spirit that reigned on the premises. In that same moment, maverick theater director Modris Tenisons, friend of several Rundāle restorers and other emergent visual artists, was pressured to leave Rīga when authorities closed his production of *Jesus Christ Superstar* after its opening night, so he founded a pantomime group at the Kaunas Drama Theater. This venue became a new locus for discreet nonconformist activity—that is, until a performance of the musical *Hair!* on May 14, 1972, inspired nineteen-year-old Romas Kalanta to stage his internationally scandalous self-immolation in protest against Soviet occupation. Held culpable by authorities, Tenisons was then forced to relocate to Moscow, but the informal Rīga-Kaunas network of artists remained (now with yet another Moscow-Rīga correspondent). Four years later, but on a formal level, the establishment of the *Young Baltic Artists* triennial exhibitions reinforced this new generation's sense that, poised on the periphery of the empire, they were operating independently of Kremlin authorities on artistic matters.

WHEN WORLDS ELIDE: MINIMIZING DIFFERENCES WITH THE INNOVATORS NEXT DOOR

The peril of making nationality-based aesthetic generalizations can only increase when the common characteristic of the individuals to be generalized was nonconformism not only against Soviet standards but also, in many cases, narrow nationalistic views of culture. The other potential pitfall is that nonconformist artists, in their eagerness to reconnect with contemporary world culture, may be less representative of the aesthetic sensibility of a national school than their more conservative, ethnocentric compatriots. Still, any attempt to correlate separate developments in the three Baltic states is a worthwhile exercise.

The original nonconformist shibboleth, abstraction, is as good a place as any to start. Throughout the Baltic in the immediately post-Stalin period, mild abstraction of form and heightened colorism became common in painting, serving somewhat as a default setting after Socialist Realism interrupted the tendency in all three nations toward an *École de Paris*–derived decorativism, itself a conservative reaction in the 1930s against the cubo-constructivist Baltic modernism of the 1920s. This tendency persisted longer in Latvia than in Estonia, thanks largely to the prestige conferred on it by the once-persecuted francophilic painter Rūdolfs Pinnis, and it lasted even longer in Lithuania, probably because charismatic painters of the esteemed prewar group ARS inculcated in a new generation those values they themselves acquired as students in Paris.

Despite this lingering quasi-fauvism, nonobjective abstraction began emerging in all three republics during the 1960s, and from the outset, assigning national attributes to such work is problematic. For example, within the geometrically structured *Compositions* (1965–67) of Estonian Henn Roode, the exuberant application of high-chroma paint fully qualifies as expressionistic (the adjective typically reserved for Lithuanians). Likewise, in the abstract works of Elmar Kits, circa 1966, the violently scrubbed pigment belies any prototypic Estonian reticence. On the other hand, in Latvia at this time, Kurts Fridrihsons and Oļǵerts Jaunarājs were painting soberly structured, somberly colored abstract compositions, and in Lithuania Vin-

cas Kisarauskas produced paintings whose geometric forms of solid, saturated hue were heavily outlined with black—hardly expressionistic in overall effect, and not unlike certain works done by Latvian Leonīds Āriņš. Conversely, while the pure geometry and clear, flat color of Sirje Runge's abstract compositions from the 1970s tally with what we're told is quintessentially Estonian, the same rigorous geometry and vibrant, unmodulated palette can be found in compositions by Latvian Valdis Celms and Lithuanian Juozas Pilipavičius. The op-influenced geometric abstractions of Estonian Leonhard Lapin have counterparts in certain lithographs by Lithuanian Vaidilutė Grišeckaitė; the psychedelic qualities of Estonian Viive Tolli's graphic work can also be found in drawings by Latvian Eižens Valpēteris; and so on.

If distinctions must be made, they would arise more from abstract art's relative pervasiveness within each community, its public visibility, and those mediums with which it was predominantly realized. Estonia had the most practitioners overall, principally painters and graphic artists, and their work found regular exposure in exhibitions and publications, first within Estonia, but soon elsewhere, notably (and surreptitiously) outside the Soviet Union. Latvia's initial contribution to abstraction as a nonconformist phenomenon was primarily in the realm of decorative arts. All-Union survey exhibitions of decorative art and progressive periodicals such as *Dekorativnoye iskusstvo* SSSR featured installation-scaled fiberworks and ceramic garden sculpture from Latvia. At the same time, abstract compositions were reproduced in monographs on Latvian watercolor painting, a medium whose traditional subalternity confirms that abstraction was best practiced below the sweep of the censors' radar—unless one happened to be Ojārs Ābols, a darling of the establishment who nevertheless championed unofficial aesthetics and openly exhibited his abstract oil paintings. In contrast, paintings by Latvia's most radical abstractionist, Zenta Logina, remained hidden until after her death; weavings based on these paintings were exhibited instead. As for Lithuania in the late 1960s, pure abstraction's most public moments seem to have been enjoyed by the designers of certain extraordinary architectural interiors, such as the Ben Nicholsonian surfaces of the Kaunas café, *Tris mirgulys*.[14] Of course, ten years later, the cultural climate had liberalized in

all three republics to the extent that abstract art's status and character changed profoundly: as Boriss Bērziņš and Eugenijus Antanas Cukermanas were providing Latvian and Lithuanian abstraction new metaphysical direction and depth, the latest Estonian adaptations of suprematism depleted its original spiritual dimension in favor of pop-oriented witticisms.

With figural styles, differentiation of the three national groups becomes easier, though one should not automatically assume that, say, a coarsely rendered, richly colored image of a Baroque church portal is from "Catholic" Lithuania, but may in fact be Evi Tihemets's 1971 lithograph *Door*; or that the architectonic landscape of open cubes receding toward a barren horizon is from "analytical" Estonia, but may in fact be Algirdas Steponavičius's circa-1968 lithograph *Constructions*.[15] Granted, some contemporary Lithuanian woodcuts evoke indigenous ecclesiastical traditions, just as some Estonian works of the 1980s incorporated the colors of the outlawed national flag as a shorthand expression of patriotism, but these sorts of references are rarely sufficiently engaging to warrant cross-cultural comparison—except, perhaps, to note that self-reflexivity in Lithuanian art often depended on literary archetypes, such as medieval illuminated manuscripts, while Estonians tended to embrace the purely visual, and Latvians, such as Andris Breže, Ojārs Feldbergs, Jānis Mitrēvics, and Oļegs Tillbergs, the actual matter of their physical surroundings. Naturally, key exceptions such as the mythopoeic works of Estonian Jüri Arrak and Latvian Ilmārs Blumbergs, or the semiotic maximalism of Lithuanian Romanas Vilkauskas's tricolor *Garage Door*, make these generalizations acutely problematic, too.

A figural style as ostensibly impassive as hyperrealism may seem the least eligible for individuation, but its appearance widely differed within the Baltic region, and, once again, its variable timbre challenges assumptions about national temperaments. In earliest examples—consider Latvian Imants Lancmanis's 1971 urban-scape *Suvarov Street*—hyperrealism closely resembled Western photorealism in its replication of casual photographic effects: blurring of focus, denaturalized color, accidental composition, and banal content. This dispassionate manner of rendering was especially present in Latvia, as evidenced by the early works of Miervaldis Polis and Līga Purmale, though their choice of subjects was anything but banal. Polis, for

example, painted an actual double-exposure photo as a commentary on Soviet photographic equipment, while a monumental close-up of his knuckles became the springboard for an entire career of self-mythologizing that applied verisimilitude's persuasiveness to wholly fictional ends—much like official Soviet photo retouchers did. Ando Keskküla, Estonia's foremost hyperrealist, quickly graduated from deadpan duplication of photographic effects to the embellishment of such works with trompe l'oeil ink splatters, sprayed paint, and other graphic intrusions that underscored the nonphotographic media used to effect photorealism. This postmodernist mannerism was widely emulated in Estonia and Russia during the late 1970s and 1980s, looking almost indistinguishable from New Wave commercial illustration in the West. Jaan Elken, who has been said to continue the tradition of Keskküla, actually recovered hyperrealism's original concision, expanding its powers of social critique with a subtlety rarely seen in Estonian art. His 1978 close-up image of hotel signage, *In the Kalinin District*, diverges tellingly from Richard Estes's neon vision of commercialism: for Elken, the spaulding stucco, peeling paint, and provisional electrical wiring alongside the neon tubing become the real subject.[16] Although hyperrealism was practiced least of all in Lithuania, there it attained a narrative complexity rarely seen elsewhere, and certainly not elsewhere in the Baltics. An image of yellowing newspapers pasted to an apartment wall in preparation for wallpaper that was evidently unaffordable or unavailable, Romanas Vilkauskas's 1981 *Interior X* articulates Lithuania's multiple reversals of political fate during World War II via the most economical pictorial means. Once again, we have a Lithuanian excelling at what Estonians supposedly did best.

The point of all this equivocation and arbitration is not to dispute that Estonian art exists distinctly from Latvian art; Latvian art, distinctly from Lithuanian; etcetera. Current theories of intersubjectivity aside, the fact remains that each artistic culture operated more or less autonomously, reacting in its own way, in varying degrees, to external influences and interferences, calibrating behavior according to self-image. Indeed, distinctions between the Baltic art worlds are many, and often extreme. Estonian surrealism, exemplified by Ülo Sooster's paintings and Olav Maran's collages, utilized an elemental, elegant lexicon to powerful effect, while Latvian surrealism, typified by

Juris Dimiters's paintings and Lolita Zikmane's etchings, derived its impact from seemingly gratuitous juxtapositions of objects, the tension of incongruity heightened by technical refinement. Expressionistic Latvian painting, like that of Maija Tabaka, verges on the histrionic because of explicit narrative, while the paragons of Lithuanian expressionism, Ričardas Bartkevičius and Arūnas Vaitkūnas, upstage whatever narrative content exists in their work with paint's formidable formal qualities. In the realm of socially parodic work, the sublime discretion of Estonians Urmas Ploomipuu and Peeter Ulas is countered by the court-jester hilarity of Latvians Ivars Poikāns and Ivars Mailītis, while the whimsical phantasms of Vello Vinn are hardly the whimsical fantasies of Auseklis Baušķenieks. The Latvian Actions of Andris Grinbergs, who fetishizes the body, could not be more unlike the ritualistic Happenings of Siim-Tanel Annus, fetishistic about his props. (On the other hand, the Fluxus spirit that inaugurated Lithuanian performance by the likes of Vytautas Landsbergis was also somewhat evident in concurrent Estonian Happenings involving Arvo Pärt, just as the mid-1980s performances of Latvia's Workshop for the Restoration of Nonexistent Sensations often resembled those organized by students at Tallinn's School of Architecture roughly ten years before.)

All of this is to say: If a more complete, nuanced understanding of the artistic cultures of the three Baltic states is to be reached, the ethnic essentialism that has steered most historical examinations of the subject heretofore needs to surrender to an appreciation of the diversity within each culture that sometimes draws stronger connections between individual artists of different nationalities than it proves some sort of ur-Estonianness, echt-Latvianness, ultra-Lithuanianness. In the era when Baltic nonconformist artists were revitalizing their native cultures, there was no lack of respect on their behalf for artists engaged in similar projects in adjacent republics. For us to write their history by downplaying the accomplishments of their colleagues in other parts of the Baltic region—or, indeed, the former Soviet Union—is not only disingenuous but gravely misrepresenting the spirit of nonconformism itself.

NOTES

1. The irony of this phenomenon is that the Soviet system, imposed on the Baltic states in 1940 on the pretense that they had formed an alliance against the Soviet Union, succeeded in drawing together three national cultures—albeit only visual—that had hitherto united infrequently, sporadically, and only bilaterally (never trilaterally). The *post-Soviet* irony is that the designation "Baltic" (against which Estonians particularly chafe, as proven in their current pitches for EU accession) has afforded the three nations' artists enough critical mass that they enjoy more curatorial exposure abroad than they would have if their nations were perceived as, say, another Belgium or Iceland.

2. The latter correlations are found most often in reviews of pan-Baltic exhibitions held in Russia, probably because the survey exhibitions held in Rīga, Tallinn, and Vilnius were specific to sculpture, graphic art, or painting, affording less cross-comparison. For examples of such Moscow-based criticism, see Platon Pavlov's "Baltijas mākslinieku meklējumu skate," *Māksla* 2 (1966): 3–11, or Anatoli Kantor's "Baltijas republiku mākslas skate Maskavā," *Māksla* 1 (1974): 6.

3. Herberts Dubiņš, "Glezznieciski būtiskais," *Māksla* 3 (1969): 10–11.

4. Straka cautions against regarding this as simple "falsification," calling it instead a process of reconnecting to Europe "at the cost of self-denial"; Barbara Straka, "Redaktionelle Nachbemerkung," in *Das Gedächtnis der Bilder. Baltische Photokunst heute* (Kiel: Nieswand, 1993), 197.

5. In fairness, mention must be made of the superlative 1996–97 Tallinna Kunstihoones exhibition *Tallinn-Moskva/Moskva-Tallinn, 1956–1985*, conceived by Leonhard Lapin and Anu Liivak, two personalities who have long demonstrated an expanded perspective on cultural debt and dynamics.

6. Raivo Kelomees, "Matti Milius—konglomeraat, fenomen ja isik," in *Matti Miliuse kunstikogu* (Tallinn: Tallinna Raamatutrükikojas, 1998), 3.

7. Recollected by Miervaldis Polis in "Miervaldis Polis meenutab," in *Matti Miliuse kunstikogu*, 11.

8. Ibid.

9. Milius, "Curriculum vitae," in *Matti Miliuse kunstikogu*, 11. This is the source of other uncited data on Milius.

10. See Lapin's *Pimeydestä valoon. Viron taiteen avantgarde neuvostomiehityksen aikana* (Helsinki: Kustannusosakeyhtiö Otava, 1996), 32.

11. Ķengarags is an industrialized suburb of Rīga. Borgs, "14 Meditādijas starp Ņujorku un Ķengaragu," and Kaspars Kalnciems, "Cilvēks un viņa pasaules uzskats," *Padomju Jaunatne*, August 8, 1978, p. 4.

12. He eventually scripted the 1980 documentary *Liel-vardes josta* (The belt of Lielvarde), directed by Ansis Epners. According to historian Irēna Bužinska, Lapin also delighted Rīga audiences with two lectures on prewar Estonian modernism (interview July 1, 1992).

13. Interview with Valentinas Antanavičius in *Tylusis modernizmas Lietuvoje, 1962–1982*, ed. Elona Lubytė (Vilnius: Tyto alba, 1997), 267.

14. The minimalistic 1968 interior is reproduced in V. M. Vasilenko et al., eds., *Sovetskoe dekorativnoe iskusstvo, 1945–1975* (Moscow: Iskusstvo, 1989), n.p. There the name is transliterated as "tris myargyalis," so my retransliteration here (which coarsely translates as "three sparkles") may be incorrect.

15. Reproduced in *Eesti graafika, 1970–1971* (Tallinn: Kunst, 1973), pl. 51, and *Lietuvių grafika: 1968, 1969, 1970* (Vilnius: Vaga, 1971), pl. 154, respectively.

16. Reproduced in *Jaunystė: Katalogas pirmoji Pabaltijo jaunųjų dailininkų vaizduojamosios dailės paroda* (Vilnius: Lietuvos TSR Dailės muziejus, 1979), pl. 1.

Alfonsas Andriuškevičius

THE PHENOMENON of NONCONFORMIST ART

SOURCES OF NONCONFORMIST ART

When speaking about the origins of nonconformist art, two sources are most frequently mentioned: "inner necessity" (to use Wassily Kandinsky's term) that urges an artist to work in an officially prohibited art idiom, and the artist's skeptical attitude toward the Soviet regime that leads him or her to criticize it through art. A closer look, however, reveals three additional sources: 1) *resentment* (I am borrowing this term from Friedrich Nietzsche, who used it to define the origin of Christianity), or squaring accounts with certain officials due to specific personal reasons; 2) material profit, i.e., seeking to benefit from one's nonconformist position; and 3) professional restrictions.

The main source of nonconformist art in Lithuania was the desire of artists to use a wider range of artistic styles than was officially allowed: those related to the prewar tradition of Lithuanian art, particularly expressionism, and those that had not received the status of

tradition but enjoyed popularity in Western art around the middle part of the twentieth century—for example, surrealism and abstraction. In Latvia and Estonia, the *aesthetic or artistic* source of nonconformism was predominant, too. However, in the Baltics the range of prohibited art styles varied. For instance, the Estonian prewar tradition contained the rudiments of surrealism, and Estonian nonconformists took greater interest in hyperrealism than Lithuanians and Latvians. The situation was different in Moscow, where artists started to show interest quite early in certain developments in Western art in the second half of the twentieth century, such as conceptualism. Thus, the aesthetic source of nonconformism was also important there. However, Muscovites such as Eric Bulatov, Vitaly Komar and Alexander Melamid, Boris Orlov, and Ivan Chuikov often produced overtly politicized art, which was rare in the Baltic countries.

Naturally, the question arises as to how Lithuanian artists became acquainted with the prohibited modern Western styles. This knowledge can be traced to three main sources. Books and catalogues on Western art reached Lithuania in a variety of ways. Artists made trips to neighboring Poland, where the development of art was far less restricted and where exhibitions of both Polish and foreign avant-garde art were held; such visits were easier for Lithuanians than for Latvians or Estonians. Finally, exhibitions of modern and contemporary Western artists were held occasionally in the Soviet Union. An exhibition staged in Moscow in 1957 during the Sixth World Festival of Youth and Students had a great influence on Vincas Kisarauskas, one of the most outstanding Lithuanian nonconformist artists.[1] To a certain degree, nonconformists learned from each other, but the contacts between Lithuanian artists and Russian artists from Moscow and Leningrad were much weaker than those between Lithuanian, Estonian, and Latvian artists.

One could call the second source of nonconformist art *ideological* because it criticized the Soviet regime. In their work, artists expressed prohibited political, religious, and philosophical ideas. This aspect of nonconformist art should be considered separately from the first, since artists could express critical ideas while working in the officially approved realist style. In Lithuanian art, the political aspect did not manifest itself extensively. In contrast, Russian artists, particularly the creators of so-called "sots" art, used political criticism far more frequently. When employing prohibited ideas, Lithuanian nonconformists gave preference to philosophical and religious themes and avoided political ones. Such ideas were seldom expressed overtly and far more often took a concealed, indirect form. Thus, religious sculpture created by Antanas Kmieliauskas and Vytautas Šerys exhibits direct expression of prohibited religious ideas, whereas abstract paintings by Kazimiera Zimblytė can be regarded as indirect expressions of religious ideas.

The source of nonconformism that I call *resentment* was not a major influence in Lithuania, either. However, some young Lithuanian artists tried to get official commissions to paint portraits of Lenin or scenes of "building communism," but when the authorities did not find them talented enough and refused to give them commissions, these artists were pushed toward nonconformist art.

At first, it might seem strange that material profit could become a source for encouraging nonconformist art. This did not happen in Lithuania. However, in Moscow, where foreign diplomats bought nonconformist artworks by the hundreds, the drive for profit was often manifest.[2]

Finally, in Soviet times (though at the end of the Soviet period things took a different turn), a person not trained as a professional artist was not allowed to exhibit his or her paintings at official art exhibitions. Because of these professional restrictions, people felt free to ignore the official art canons. Such was the case for Linas Katinas and Eugenijus Antanas Cukermanas, nonconformist artists who were officially trained as architects, not as painters.

THE STRUCTURE OF NONCONFORMIST ART

Nonconformist art during the Soviet period, as far as it concerns form, can be divided into art that was officially prohibited, tolerated, or allowed. Artists were allowed and encouraged to use the realistic principles in their art. The authorities welcomed motifs, symbols, and narratives that corresponded to the Soviet mythology and prohibited those related to other mythologies, particularly to religious themes. Representations of nature and artificial objects were tolerated but without enthusiasm. A moderate expressionist mode was accepted in Lithuania, especially at the end of the Soviet period, which was due to the prewar artistic traditions that authorities could not totally ignore. Abstraction and surrealism were strictly prohibited. In Estonia, however, surrealist art had more possibilities for acceptance than in Lithuania.

Lithuanian nonconformist artists made limited use of political and social motifs. In this respect, nonconformist works by Moscow and Leningrad artists are markedly different. They abound in political and social motifs, such as slogans, "portraits" of leaders, and military paraphernalia. In Estonia and Latvia, the situation was similar to that of Lithuania. Only a few artists, including Valentinas Antanavičius, Antanas Kmieliauskas, and Arvydas Šaltenis, ventured to use prohibited motifs in their works—of course, without any hope of showing them to the public.

In the work of certain Soviet artists, form is often opposed to content. An artist who was nonconformist in style could be a conformist in subject matter and

vice versa. For example, Jonas Švažas, Silvestras Džiaukštas, and Leonardas Tuleikis tended to break formal restrictions but partly redeemed themselves by using motifs and subjects that satisfied the Party authorities. On the other hand, Antanas Kmieliauskas, who sculpted the statue of St. Christopher for one of the Vilnius Catholic churchyards, used acceptable Renaissance principles of formal arrangement, but he violated the limits of the allowed motifs and was expelled from the Artists' Union. The juxtaposition of conflicting style and subject matter enabled artists to play with the titles of their works. Since a title usually expressed the subject or narrative, a work that was given a certain title that appealed to the authorities could be legitimized even if composed of semi-abstract forms. In contrast, a similar or even the same artwork with a more nonconformist title could not even dream of acceptance.

Artists who exhibited or wished to exhibit their works in official venues followed acceptable patterns of behavior. Those artists who showed their works in semi-official, or "marginal" venues, such as the Club of the Writers' Union, the corridor of the Conservatory, and halls and corridors of scientific research institutes in Vilnius, were tolerated. The attitude of the artists who exhibited their works in private apartments or "salons" was considered unacceptable.

The most famous salon in Vilnius was hosted by Judita Šerienė,[3] but such apartment salons were rare in the Baltic countries. In Moscow and Leningrad, however, nonconformist artists exhibited their works in numerous apartments; moreover, many of them did not even attempt to exhibit their works in official venues. In contrast, in Vilnius, as in Rīga and Tallinn, such apartment exhibitions were infrequent, and the majority of artists who showed their works there also exhibited in official venues.[4] Thus, in the Baltics the line between official and unofficial art was less clearly drawn.

The authorities held in higher esteem those nonconformist artists who shared and tried to explain their problems to various "comrades." Nonconformist artists of this kind could be found in Vilnius, Rīga, and Tallinn, as well as in Moscow. The best-known example in Moscow was Ernst Neizvestny, who was one of the first to be engaged in a public debate with Nikita Khrushchev. Neizvestny was "defeated" but was asked later to create a tombstone for the overthrown first secretary. Neizvestny also invited members of the Central

Committee of the Communist Party of the Soviet Union (CPSU) to his studio in an effort to "enlighten" them. In Lithuania, Jonas Švažas, the leader of the first generation that opposed the Stalinist canons, also maintained close contacts with the party authorities. He was not only a nonconformist painter but also a member of the CPSU beginning in 1952, a member of the board of the Artists' Union of the Soviet Union, and the chairman of the Painting Section of the Artists' Union of the Lithuanian Soviet Socialist Republic.[5]

In addition, the attitude characterized by the stance of silence was tolerated. Indeed, nonconformist artists of this kind constituted the majority in Lithuania, Latvia, and Estonia. Certainly, among like-minded friends and associates, they did not keep silent and engaged in all kinds of discussions. However, they neither tried to "enlighten" the authorities nor publicly discussed art issues with them. To oppose the authorities openly was unacceptable. This is not to say that artists in Lithuania did not try to tell the authorities the truth. One of the earliest acts of this kind was the speech by Justinas Vienožinskis in defense of M. K. Čiurlionis's work, delivered during the rule of Stalin in 1950, at a meeting held with the sole purpose of condemning Čiurlionis.[6] Here we may also mention the statement of painter Antanas Gudaitis, one of the most outstanding figures in Lithuanian art in the postwar period, to the Central Committee of the Lithuanian Communist Party and the minister of culture of the Lithuanian Soviet Socialist Republic regarding the creating of a hostile atmosphere around him and his work.[7] In the 1970s, as a result of his conflict with the authorities, the artist Vladas Žilius emigrated to the West.

From the viewpoint of nonconformism, contradictions of attitude were also possible. An artist exhibiting work in private apartments could keep as silent as the grave, while an artist showing work in official venues could make certain claims to the authorities. Therefore, it is possible to fully characterize a person only bearing in mind both constituent parts of his behavior.

On the basis of the criteria defined above, we can construct an image of an ideal nonconformist. He would use a form of prohibited art idiom, employ prohibited (related to anti-Soviet mythologies) motifs, symbols, and narratives, exhibit his works exclusively in private apartments, and criticize the art policy carried out by the authorities by every means possible. On

the other hand, an ideal conformist would make use of both allowed idioms, exhibit his works exclusively in official venues, and miss no opportunity to have a friendly chat with the authorities on art issues. However, such "pure types" rarely exist in real life, and, if they did, paradoxically, they would be regarded as an anomaly rather than a norm. Life is full of mixed types. For that reason, I call the majority of Lithuanian artists who worked industriously during the Soviet period *semi-nonconformists*.[8] Latvian and Estonian art critics also speak about the difficulty of drawing a clear line between conformism and nonconformism in the Baltic countries.[9] The difference between Russian conformists and nonconformists was more clear-cut.

THE VALUE OF NONCONFORMIST ART

Nonconformist art is a category of both art criticism and politics; therefore the very phenomenon of nonconformist art should be discussed and assessed in both artistic and political terms. Let us first turn to the political aspects.[10]

The very term "nonconformism" points to a connection with something prohibited by a concrete political system and thus implies a political turn. Nonconformist art was opposed to the Soviet system, and this resistance creates its political value. However, the former political system collapsed, and a new one has been built. In the new political context, the old nonconformist art lost its political value, which is certainly true in the Baltic countries. In Russia, however, where setbacks of the system are still possible, nonconformist art still retains part of its former political significance.

Looking at nonconformist art as art, we may predict that it will not lose its significance for a long time to come, due to the specific character of its "art material" (the term of Jacques Maritain). This material can be divided into two parts: 1) objects that are locally made and relate to everyday life and have been used in making artworks; and 2) motifs dictated by a concrete social, political, and artistic environment. As to employing objects in making art, several nonconformists, such as Ilya Kabakov, a Muscovite, and Valentinas Antanavičius and Vincas Kisarauskas, both Lithuanians, widely used the techniques of collage and assemblage. Thus, in their works, objects of the Soviet way of life

were fossilized like insects in amber. As to motifs, when dealing with certain themes, many nonconformist artists reinterpreted, connected, and emphasized motifs taken from the local environment. The major contributions in this field seem to be made by Russian artists: Ilya Kabakov, Grisha Bruskin, Rostislav Lebedev, Eric Bulatov, Boris Orlov, Ivan Chuikov, and others. Lithuanian, Latvian, and Estonian artists—Romanas Vilkauskas, Algis Griškevičius, Valentinas Antanavičius, Peteris Smagiņš, and Leonhard Lapin— also worked in the same direction.

However, the question still remains as to what extent nonconformist art contributed to the development of world art and how many masterpieces, bound to survive in art history due to their aesthetic value, were created by nonconformist artists. From the viewpoint of participation in the process of world art, we should note that the majority of artistic ideas in the former Soviet Union were certainly borrowed from the West (abstraction, surrealism, and conceptualism) and interpreted in a more or less original way. Therefore, such art did not *give* almost anything—it only *took*. Still, the new interpretation of these artistic ideas conditioned by the local context is not insignificant. Maybe some stimuli from this side could also have existed. For example, could exhibitions in communal apartments have in some way contributed to the emergence of the idea of the famous exhibition in Chambre d'Amis in Ghent, curated by Jan Hoet in 1986? In my opinion, few masterpieces were created, and artists' talent rather than their conformist or nonconformist attitude determined the works' aesthetic importance.

We can thus draw several conclusions. Nonconformist art thrived in Moscow and Leningrad and took a more radical form there; nonconformist art created in Vilnius, Rīga, and Tallinn should perhaps more appropriately be called semi-nonconformist. Russian nonconformism equally manifested itself both in the aspect of form (specific art idiom) and political and social ideas (nonspecific idiom); Baltic nonconformists relied more on the form. Exhibiting this kind of art in communal apartments was a phenomenon typical of Moscow rather than of Vilnius, Rīga, and Tallinn. The future value of nonconformist art is conditioned by the "art material" that it used rather than its aesthetic level, though the latter is quite high in some works by representatives of this form of art.

NOTES

1. *72 lietuvių dailininkai apie dailę* (72 Lithuanian artists on art), ed. Alfonsas Andriuškevičius (Vilnius: VDA, 1998), 148.

2. I am referring to the statements by Moscow art critics and historians made during the conference "Politics as Art/Art as Politics" that took place in Budapest in 1997. This conference was hosted by the Open Society Archives and organized in conjunction with the exhibition *A Celebration of the Forbidden: Rebel Artists and Their Work from the Soviet Union.*

3. *Tylusis modernizmas Lietuvoje* (Quiet modernism in Lithuania), ed. Elona Lubytė (Vilnius: Tyto alba, 1997), 211.

4. At the conference "Politics as Art/Art as Politics," special emphasis was given to the importance of exhibitions held in private apartments within the structural framework of nonconformist art. For example, Boris Groys stated that a communal apartment was the true exhibition space of nonconformist art, and this art in principle was not created for public display. Ekaterina Dyogot and others ardently supported this opinion.

5. I. Kostkevičiûtė, *Jonas Švažas* (Vilnius: Vaga, 1985), 201.

6. *Kulturos barai* 3 (1989): 35.

7. *Tylusis modernizmas Lietuvoje*, 88.

8. Alfonsas Andriuškevičius, "Semi-Nonconformist Lithuanian Painting," in *From Gulag to Glasnost: Nonconformist Art from the Soviet Union*, eds. Alla Rosenfeld and Norton T. Dodge (New York: Thames and Hudson, 1995), 218.

9. Mark Allen Svede, "Nonconformist Art in Latvia," in *From Gulag to Glasnost*, 189.

10. If we accept the statement of Konstantin Akinsha made at the above-mentioned Budapest conference that "unofficial art" was first of all necessary for KGB and FBI agents, who were the main spectators of such art, then we should regard this art as a political rather than an artistic phenomenon. Applying this statement to the situation in Vilnius, Rīga, and Tallinn is questionable, which does not mean that nonconformist art of the Baltic countries was completely devoid of political involvement.

2
ART of ESTONIA

Juta Kivimäe

ESTONIAN ART BEFORE WORLD WAR II

STONIAN ART history and Estonian literary culture as well as the development of art as a field for professional Estonian artists are relatively young. National art history as a field of study began only in the nineteenth century. The activities of nationalist intellectuals in the last decades of that century gave it a further belated impetus. Development of a national culture was held back for a number of reasons. For many centuries, the geopolitical location of Estonia caused the area to be a theater of war for different foreign powers. From the late Middle Ages on, foreign control and influence were substantial. Such sociopolitical circumstances continuously delayed the development of Estonia's national and cultural self-determination and caused efforts for self-determination to be timidly cautious and conservative from the start.

The Germans who migrated to Estonia in the foot-steps of the German order of Teutonic knights that conquered Estonia in the thirteenth century constituted the dominant local elite—the landlords and officers of justice, the manor and guild handicraftsmen—for about seven hundred years. Even at the beginning of the eighteenth century, after the country was united with Russia by Peter the Great (1682–1725), the Germans who were settled in the Baltics preserved the so-called "special Baltic regime" that lasted until the innovative laws of the 1860s. These new laws significantly increased the administrative protection of the peasant population and essentially opened all kinds of opportunities for its social growth and education. In a few decades, literacy became widespread among the Estonian rural population. The growth of and remarkable achievements in public education, literature, and music—especially in choral music—at the end of the nineteenth century were made possible by the Herrn-

luther theological movement that the masses themselves initiated and by the conditions created by the German Estophiles who lived in Estonia. The ideology of the Baltic-German Estophiles emerged from the eighteenth century's philosophy of Enlightenment and from the direct contacts of this distant European province with such representatives of the Western European Enlightenment in philosophy and culture as Johann Gottfried Herder.

The painter Johann Köler (1826–1899), who lived and worked in St. Petersburg, the capital of the Russian empire, initiated the development of Estonian professional art. Of peasant background, he received his art education from 1848 to 1855 at the St. Petersburg Academy of Fine Arts in Professor Aleksei Markov's studio. His studies at the academy as well as his acquaintance with the Italian classical art heritage helped Köler develop into an admirable colorist. He was a full professor at the St. Petersburg Academy and was also granted the title of academician. Köler is remembered for many successful intimate female portraits and for heroic landscapes set in the Crimea, which he visited many times in his capacity of teacher of drawing for the Tsar's family.

Sculptor August Weizenberg (1837–1921), founder of Estonian national sculpture and a follower of classicist style, received his education in Berlin and St. Petersburg, and at the Munich Academies of Fine Arts. His contemporary, the sculptor Amandus Heinrich Adamson (1855–1929), worked in an academic style and created salon paintings in the neo-Baroque style imported to Estonia from the St. Petersburg Academy and from Paris during the final decades of the nineteenth century.

Another popular place for Estonian artists to study was the Düsseldorf Academy of Fine Arts, where mainly young Baltic artists of German background studied. Although the Düsseldorf Academy had already lost its glamorous reputation by the end of the nineteenth century, it remained popular among Baltic students because many of its instructors came from the Baltic region. The Düsseldorf Academy developed academic art into a moderate form of realism that emulated the seventeenth-century Dutch masters.

Paul Raud (1865–1930) graduated from the Düsseldorf Academy in 1894 as a student of E. von Gebhardt, a painter of historical and religious compositions and a famous master of the time. After his return to Estonia, Raud became the first Estonian artist to make his living as a portraitist. Raud, who was close to the Baltic-German circles and painted portraits of the groups' members before World War I, stayed away from the Estonian independence movement of the beginning of the century. He not only painted portraits on commission but also created portraits of peasants for their own sake in a free, impressionistic manner. In addition, he made small, open-air landscape paintings on the Estonian islands, exploring the variations in light and atmospheric conditions. With the intimate works that were left on his studio walls and not exhibited during his lifetime, Raud paved the road for impressionism and open-air painting in Estonian art.

The Russian Revolution of 1905 brought together democratically thinking Estonian intellectuals, and national self-consciousness grew rapidly with the awakening of social awareness. Poet Gustav Suits, the ideologist of Young Estonia, the first Estonian literary group established in 1905, put into words the aims of the national intelligentsia in a programmatic article from the group's first collection of writings: "Let us remain Estonians but also become Europeans."[1]

The developing intelligentsia searched for contacts with European cultural centers, realizing their important national mission in developing local cultural and artistic life. Young Estonians in Paris, Munich, and other centers of modern art began to grapple with new ideas, but their lack of comprehensive education and adequate financial resources prevented most of them from receiving a systematic higher education. Of necessity, they studied in the studio schools of distinguished artists and in the free academies. The aesthetic ideals of the artists associated with the Young Estonia generation at the turn of the nineteenth century were close to those of the Scandinavian countries, especially Finland and Norway, and were characterized by art-nouveau stylization combined with national folk motifs and symbolist themes.

A studio school established in Tallinn in 1903 by Ants Laikmaa (1866–1942) served as a major center for art education in Estonia. Laikmaa was an important authority in Estonian art and mainly worked in a "national-romantic" style. He also employed art-nouveau stylization, impressionism, and expressionism, and he gathered around himself many remarkable young talents. He was a notable publicist and theoretician who defined ideological tendencies in Estonian art at the beginning of the twentieth century. As a refugee, after the Russian revolutionary events of 1905–6, Laikmaa

lived in Italy, Sicily, and Tunisia. He returned to Estonia in 1913 when the cultural environment and the possibilities for art education and the organizing of artists had improved.

In 1913, the Tallinn State School of Applied Arts was established to provide students with a solid comprehensive educational background. Baron Stieglitz's School for Technical Drawing in St. Petersburg can be considered the model for this educational institution, where many Estonian artists of the older generation studied at the beginning of the twentieth century.

Nikolai Triik (1884–1940), one of the most important Estonian artists in the early twentieth century, received his education at the Stieglitz art school, Brasz's and Roerich's studios, and other free studios, and he continued his studies at the École des Beaux Arts in Paris. His trips to Norway in 1907 and 1908 brought elements of art-nouveau stylization into his work, while his exposure to German expressionism when he lived in Berlin during 1911–13 evoked interest in social themes. Triik was also influenced by the fauves, which is evident in his use of vivid colors.

Konrad Mägi (1878–1925), a landscape painter and portraitist, organized his own education, a phenomenon common at the time. His early works combine art-nouveau elements with neo-impressionist painting technique into an idiosyncratic symbiosis. Later in his career, he turned to expressionism, Cézanne-like faceting of planes, and cognizant contemplation in his landscapes. Mägi was an important figure mainly on the Tartu art scene after World War I when Estonia achieved its independence. He was one of the founders of the Pallas art association and the first director of the Pallas art school until his early death in 1925.

The sculptor Jaan Koort (1883–1935) started his education at the Stieglitz art school together with Triik and Mägi and in 1905 began to study sculpture and painting at the Paris École des Beaux Arts. Koort became a talented sculptor and developed his characteristic artistic language early in his career. The synthesis of influences of ancient Egyptian and Greek sculpture, combined with those of the French school of the sculptor Émile-Antoine Bourdelle (1861–1929), formed the basis for his work. Koort's expressive way of modeling with an accent on the silhouette marked the coming of the modernist epoch in Estonian sculpture.

Among new art movements of the early twentieth century, expressionism played a particularly important role in Estonia. Kristjan Raud (1865–1943), whose name became an inseparable part of Estonian art life, deserves a special mention. He was involved in preserving Estonian national heritage and in museum work and pedagogical activities for more than half a century. His works combine diligent adherence to ancient themes with the modernist conception of art. His oeuvre, publications, and social activities enriched and developed Estonian culture and significantly influenced it at the time when the national professional art life was beginning and during the following interwar period of independence in the 1920s and 1930s. The "national-romantic" awakening in fine arts, which in Scandinavian countries found its expression in the flourishing of symbolism, academic realism, and art nouveau, was experienced in Estonia mostly during the last decades of the nineteenth century. This phase, essential to the cultural consciousness of such a small nation, affected the works of Raud in a belated and restrained way from the beginning of the twentieth century until the end of the interwar period.

Raud's modernist language and Christian pantheistic conception of the world that continued throughout his artistic career form a peculiar symbiosis resulting in *Lebenfilosophie*, which draws on Estonian pre-Christian ancient imagery and imparts an eternal spirituality to every small drawing. This philosophy and practice of art was almost fully developed during his studies in Munich, where the atmosphere was open to the irrational and saturated with symbolism. Munich at that time was a European center of the national-romantic art tradition exemplified by the work of such artists as Gerhard Munthe (1849–1929), Axeli Gallen-Kallela (1865–1931), and Hugo Simberg (1873–1917).

Raud's return home from Munich can perhaps be explained in part by the success of Scandinavian art at the Paris World Exhibition in 1900. Of greater importance, however, was Raud's compelling desire to create an Estonian national art and to invigorate Estonian cultural life with elements of his own experience and education as well as the romantic tendency of his circle of Estonian intellectuals. The same sincere belief determined Raud's creative activities in the late 1930s, when nationalism was politically accepted. His interpretations of folklore made visible what the contemporary public found verbally inexpressive and embodied it in the dimensions of universal archetypes. Raud's works emerge out of the Estonian folk heritage. For the first time in Estonian culture, strange ancient crea-

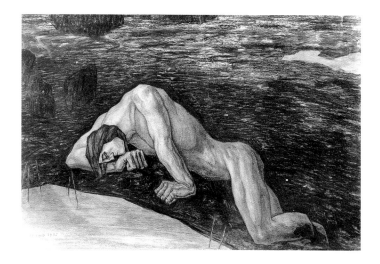

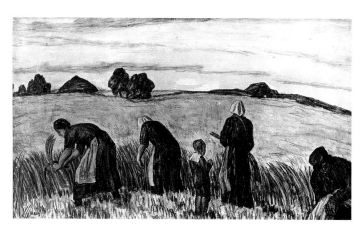

FIG. 1. [TOP] Kristjan Raud, *Death of Kalevipoeg*, 1935. Charcoal on paper, 69.6 × 105.8 cm. Collection of The Art Museum of Estonia.

FIG. 2. [BOTTOM] Kristjan Raud, *Rye-Harvest*, 1940. Charcoal on paper, 61 × 100 cm. Collection of The Art Museum of Estonia.

tures, ghosts, and devils as well as personified elements of nature found a visual shape in his drawings.

In 1935, many Estonian households acquired the national epic *Kalevipoeg* (Kalev's son) with illustrations by Raud (fig. 1), thus making his name widely known. Raud's illustrations are among the most powerful works dealing with epic themes. Most of his images are based on contrast: silhouettes of figures and spare sketches of nature were placed against pale backgrounds. The tension embodied in the figures is emphasized by the lowered horizon and the flat vastness of the landscape (fig. 2).

The coming of the avant-garde to Estonia at the beginning of the twentieth century began with a notable event in national art life: Ado Vabbe's (1892–1961) exhibition of 1914 at the Vanemuine theater in the university town of Tartu, the center of Estonian artistic life at that time. The press unanimously labeled Vabbe a futurist artist[2] (fig. 3). Actually, this young, internationally oriented artist was influenced by a number of contemporary art movements. From 1911 to 1913, he had studied at Anton Ažbe's school in Munich when Wassily Kandinsky (1866–1944) and Franz Marc (1880–1916) organized there the German expressionist group Der Blaue Reiter.[3] Vabbe's first contacts with Kandinsky's art go back even earlier, to the years when, during his studies in Narva, he visited the family of Sergei Lavretsov, a collector of Estonian art, whose foster son was Vabbe's schoolmate. As a draftsman, Vabbe used the nearly abstract forms characteristic of Kandinsky, who combined Indian ink and watercolor with oil painting to give an impression of colored drawing. In 1914, Vabbe went to Italy, the birthplace of futurism, for a short stay. Then, when World War I broke out, he went to Moscow, where he came into contact with the Russian avant-garde. Upon returning to Estonia, he stood out as an artist with his novel cubo-futurist vignettes, book illustrations, and paintings that synthesized modernist art trends. Vabbe's unabashedly improvised works with erotic overtones opened doors to a new conception of art in Estonia. However, in the 1930s, Vabbe's work shifted to the late impressionist style dominating the art scene in Estonia at that time.

In 1923, Eesti Kunstnikkude Ryhm (Estonian Artists' Group) was formed, the first Estonian formalist art group that persistently pursued cubist and constructivist experimentations. Its rational intellectual conception of art was new to Estonia, and the group func-

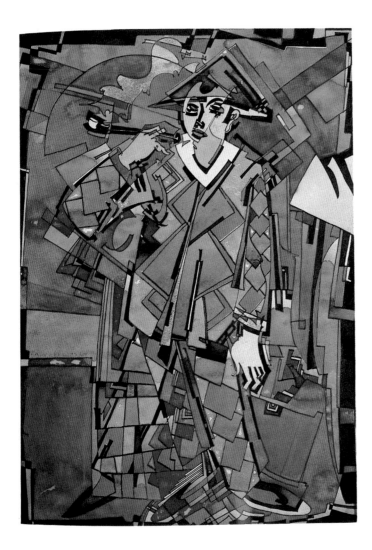

FIG. 3. Ado Vabbe, *Arlecino*, 1924.
Watercolor on paper, 38.5 × 27.3 cm.
Collection of the Tartu Art Museum,
Tartu, Estonia. Courtesy: The Art
Museum of Estonia Archive.

tioned actively until the 1930s. Vabbe's interest in the modernist art movements set an example for the members of the group, and contacts with the Latvian constructivists played an important role in promoting the constructivist movement in Estonia. The dissemination of art magazines such as *L'Esprit nouveau*[4] and *Vesch-Gegenstand-Objet*[5] played an important role as well. The former publication contained essays by the architect Le Corbusier (1887–1965) and contemporary intellectuals like Ilya Ehrenburg (1891–1967), who postulated the principles of art in the new machine age that was supposed to restructure the human environment. Estonian cubists declared the pessimism of German expressionism no longer suitable for a state that was embarked upon a rigorously planned reconstruc-

tion. Most of the members of the movement had received their art education in Russia or in Rīga. For instance, Jaan Vahtra (1882–1947), the first leader of the group, studied at the Rīga Art School and at the School of the Society for the Encouragement of the Arts in St. Petersburg as well as at the Academy of Fine Arts. Artists such as Eduard Ole (1898–1995), Felix Randel (1901–1977), and the sculptor Juhan Raudsepp (1896–1984) studied at the Pensa Art School during World War I. Edmond-Arnold Blumenfeldt (1903–1946; fig. 4) studied at the school of applied art and theater decoration of Moritz Reiman in Berlin and joined the Novembergruppe[6] there.

Märt Laarman (1896–1979; fig. 5) and Arnold Akberg (1894–1994; fig. 6), who were largely self-taught

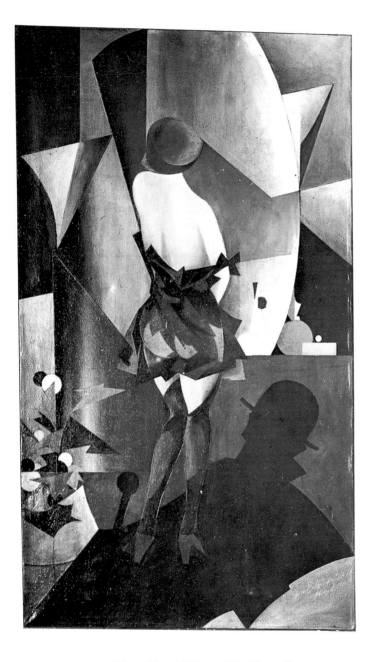

FIG. 4. Edmond-Arnold Blumenfeldt, *Woman Figure*, 1920s. Oil on canvas. Whereabouts unknown. Courtesy: The Art Museum of Estonia Archive.

artists, also belonged to the core of the Tallinn group. Laarman edited and published *The Book of New Art* (1928), the group's programmatic almanac, which helped the public develop a better understanding of the avant-garde.

The cubist-constructivist period of Jaan Vahtra, Ole, Randel (fig. 7), and Raudsepp (fig. 8) was rather short. Already in the first half of the 1920s, the decorative array of colors in their paintings pointed to the influences of art deco, which was to rule Estonian art during the following decade. Ole, on his trip to Paris in 1927, was greatly impressed by Japanese artist Tsuguharu Fujita's (1886–1968) delicately modeled figurative paintings with warm coloring and highly stylized representation.

The large number of art commissions points to another transformation of the Estonian art scene. Raudsepp, who at the beginning of the 1920s created cubist sculptures, became one of the most favored portraitists and creators of monumental sculpture in Estonia, preserving nevertheless in his mostly realist works a certain geometric generalization of form.

Laarman and Akberg became the most persistent followers of the constructivist movement and recently served as examples to the young nonconformist artists of the 1960s and 1970s. Art deco, the decorative style that flourished in Europe in the 1920s, became dominant on a national scale in Lithuania but influenced Estonian visual arts only slightly, by adding stylized elegance to the local art forms affected by the cubist and neo-realist movements.

Painters Kuno Veeber (1898–1920) and Aleksander Krims (1895–1947) produced works that were strongly influenced by the constructivist manifesto of the Group of Estonian Painters. Veeber's and Krim's paintings from the 1920s, as well as those by Arkadio Laigo (1901–1944) and Johannes Greenberg (1887–1951) from the second half of the 1920s and the beginning of the 1930s, are characterized by a refined coloring typical of art deco. Greenberg's and Ole's mundane compositions were marked by erotic overtones that were rare in Estonian art at that time.

Anton Starkopf (1889–1966), who studied in both Munich and Paris, was one of the most notable personalities among Estonian sculptors in the 1920s. The art deco stylization and eroticism that appeared in his figurative works represented a debt to German expressionism. Beginning in 1919, Starkopf worked as a

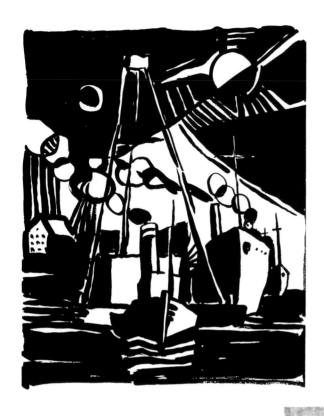

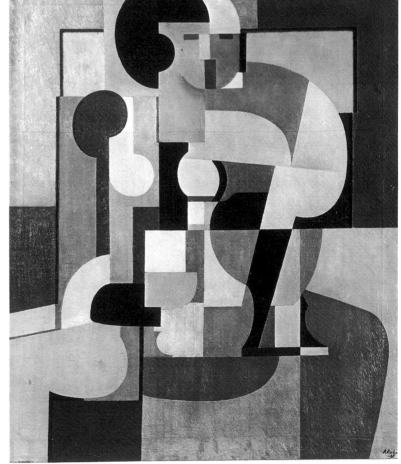

FIG. 5. [TOP] Märt Laarman,
Port, 1923. India ink on paper.
Private collection. Courtesy:
The Art Museum of Estonia Archive.

FIG. 6. [RIGHT] Arnold Akberg,
Composition, 1925. Oil on canvas,
92.5 × 81.3 cm. Collection of
The Art Museum of Estonia.

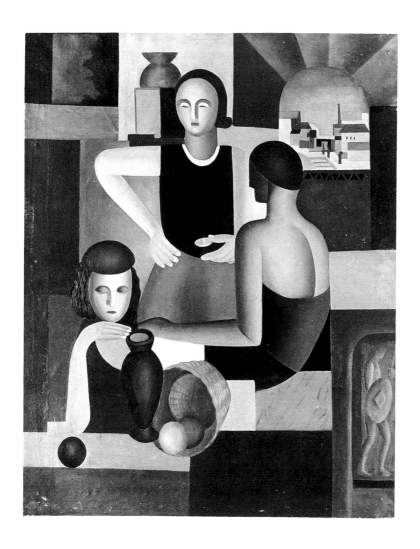

FIG. 7. [TOP] Felix Randel, *Sunday*, 1924. Oil on canvas, 123 × 99.8 cm. Collection of The Art Museum of Estonia.

FIG. 8. [LEFT] Juhan Raudsepp, *Composition*, 1924. Charcoal on paper, 37.8 × 27.2 cm. Collection of The Art Museum of Estonia.

teacher of sculpture at the Pallas Art School and shaped the aesthetic tastes of many sculptors who began their creative work in the 1930s.

The drawings and prints of Eduard Wiiralt (1898–1954), an important figure in Estonian graphic arts, were influenced by German expressionism (fig. 9). Visions full of sensuality, decrying the vices of life in big cities, that were characteristic of his works from the 1920s and the beginning of the 1930s were replaced by realist themes by the late 1930s. Psychological portraits, scenes of nature, and images of exotic animals seen in the Paris Zoo and on his trips to Northern Africa marked his move toward the universal language of symbolism.

In the 1930s, Estonian art began a return to realism, use of intimate genres, and painting in an impressionist mode. Many leading Estonian painters of the 1930s, including Adamson-Eric (1902–1968; fig. 10), Aleksander Vardi (1901–1983), and Greenberg, developed their skill in Paris, incorporating in their works the sensuality of light and color as well as tender scenes from nature characteristic of the School of Paris. The painters from Tartu favored small-scale townscapes, landscapes, interior views, and nudes and ignored social problems in their art (fig. 11).

Fauvist influences that defined the artistic tendencies at the Pallas Art School were reflected in the vivid colors of Karl Pärsimäe (1902–1942) as well as in Endel Kõks's (1912–1982) sensual café and boudoir scenes. Karin Luts (1904–1993) employed fauvist colors in combination with naïve-grotesque forms.

To answer the question of why Estonian art in the 1930s almost entirely rejected the avant-garde ideas of previous decades, one must examine the realities of the Estonian state in the context of the global political situation. Since there were many similarities between the official Estonian art policy of the 1930s and art politics in other European countries, it would be incorrect to say that totalitarianism in the common meaning of the word defined Estonian policy in the arts in the second half of the 1930s. Estonia witnessed no serious acts of violence by the government. However, the art scene was seriously affected during the so-called "silent age," when presidential powers were transferred to Konstantin Päts and conservatism in all cultural spheres prevailed. Fear of the Soviet Union's aggressive ambitions was, in the light of later developments, fully understandable. Nevertheless, at that time, these dan-

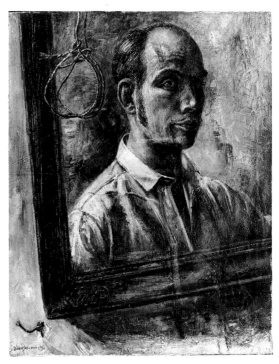

FIG. 9. [TOP] Eduard Wiiralt, *Women with Top Hats*, 1927. Etching, 39.3 × 37.8 cm. Collection of The Art Museum of Estonia.

FIG. 10. [BOTTOM] Adamson-Eric, *Self-Portrait*, 1929. Oil on canvas, 64.8 × 53.7 cm. Collection of The Art Museum of Estonia.

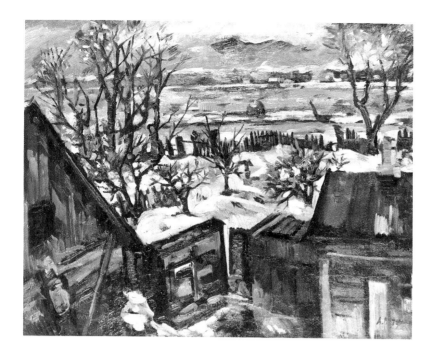

FIG. 11. [LEFT] Aleksander Vardi, *The Water-Meadow of Emajõgi River*, 1933. Oil on canvas, 65.5 × 81 cm. Collection of the Tartu Art Museum, Tartu, Estonia.

gers may not have been apparent to many contemporaries.

Caught in the chaos during the Soviet occupation that began in 1940, some Estonian artists were involved in the process of Sovietization. Their involvement was an attempt by the Soviet authorities to transform the characteristic nature of the creative intelligentsia from protest to collaboration.

The resettlement of the Baltic Germans (*Umsiedlung*) just before the outbreak of World War II (an event that became known to the government of Estonia in the most humiliating manner only on its very eve), the agreements between the Great Powers about the resettlement, and the potential division of territories following it could not go unnoticed by any reasoning citizen. Russian army bases were constructed, and the rule of the authorized representatives of the Soviet Union in Estonia became stricter every day. Thus began the Soviet takeover of Estonian culture.

NOTES

1. Gustav Suits, "Noorte Püüded" (The aspirations of the young generation), in *Noor-Eesti* 1 (1905): 3–19. (*Noor-Eesti* was a literary and art album of the Noor-Eesti group.)

2. Karl August Hindrey, "Kunstinäitus Vanemuises" (An art exhibition in Vanemuine theater), *Postimees*, February 22, 1914; Friedrich Thorsten von Stryck, "Meie kunsti-elu" (Our art-life), *Vaba Sõna* no. 3 (1914): 104–106.

3. Founded in 1911 as a splinter group from the Neue Künstlervereinigung (NKV), Der Blaue Reiter held only two exhibitions and was broken up by World War I, but its brief life is considered to mark a high point of German expressionism.

4. *L'Esprit nouveau*, edited by Le Corbusier and Ozenfant, was a periodical published in Paris from October 1920 to January 1925. It was the main channel for promoting the ideas of purism, but it also provided a platform for other views on contemporary art.

5. *Vesch-Gegenstand-Objet* was a trilingual (Russian, German, French) periodical founded in Berlin in 1922 by El Lissitzky and Ilya Ehrenburg with the object of publicizing Russian constructivism in the rest of Europe.

6. Novembergruppe was a group of radical left-wing artists formed in Berlin in December 1918; it was named after the revolution that had broken out in Germany the previous month, at the end of World War I. The professed aim of the Novembergruppe was to help national renewal by means of a closer relation between progressive artists and the public.

Eda Sepp

ESTONIAN NONCONFORMIST ART FROM THE SOVIET OCCUPATION IN 1944 TO PERESTROIKA

BETWEEN THE YEARS 1940 and 1956, Estonia suffered from genocide, terror, and emotional upheaval, resulting in psychological scars that have left their mark on the population to this day. The country was occupied three times, once by Germany under Hitler and twice by the Soviet Union under Stalin. Over 350,000 people, or more than one third of the Estonian prewar population, were adversely affected during Stalin's and Hitler's reigns of terror between 1940 and 1953.[1] The Soviets deported many Estonians to Siberia or imprisoned them in labor camps, the Germans imprisoned others, thousands were murdered, and many more starved to death or perished in the war. The rest remained in a state of shock and grief.

In 1941, during one night of terror between June 13 and 14, some 10,200 families—persons of all ages, from infants to the very old—were dragged from their beds without warning and deported in cattle trains to the Siberian hinterlands, with the men separated from their wives and children. In addition, about 13,000 people, mainly the intellectual elite and the prewar political leaders, were imprisoned. The majority of them were killed, tortured, or left to die by starvation. Estonian art historian Villem Raam, who was the director of the Estonian Art Museum in 1939, spent fifteen years in prison camps in Siberia. Of the 2,000 people who were arrested with him in 1940, only seven survived.[2] Before the second Soviet occupation, about 80,000 citizens fled without their possessions to Sweden, Germany, and Finland. Almost 7,000 of these people perished during their flight.[3]

Postwar Estonian nonconformist art developed against this background. The whole country was in a state of shock and fear after the end of the war. The art world was paralyzed except for a few artists who tried to

comply with the required Socialist Realist style, which called for heroic Soviet subjects like happy workers building the Communist state, glorious deeds of the Soviet army, factories "overfulfilling the plan," and flattering portraits of the Communist leaders. At best, artists could get away with nonpolitical landscapes, still lifes, or portraits, but any modernist trend was considered "formalist" and hence subversive. No innovative styles were possible between 1944 and 1953 during Stalin's reign of terror, when punishment for dissident or unofficial art was extreme. Even vague suspicions were a cause for arrest, as in the case of two students at the Tartu Art Institute, Varmo Pirk and Herman Aunapuu, who were arrested and sent directly to the gulag camps in Russia in 1945. Their fate was a grim warning for both their teachers and the other students at the institute.

Pirk and Aunapuu had studied at the institute with a group of talented, active art students influenced by the charismatic artist Ülo Sooster (1924–1970), who was their fellow student. Besides Sooster, the group consisted of Lembit Saarts (b. 1924), Heldur Viires (b. 1927), Valdur Ohakas (1925–1998), Henn Roode (1924–1974), Silvia Jõgever (b. 1924), Esther (Potissepp) Roode (b. 1923), Valve (Moss) Janov (b. 1921), Kaja Kärner (1920–1998), Lüüdia Vallimäe-Mark (b. 1925), and, to an extent, Heljulaine Zauram (b. 1922). They had begun their studies in the early 1940s during the German occupation, when the prewar school, which had been named Pallas, was renamed the Higher Courses for Visual Arts and continued after 1944 when the Soviets renamed it the Tartu Art Institute.

After the second Soviet occupation when studies at the institute resumed late in 1944, there were no marked changes in the teaching methods, although Soviet political subjects were added and a Socialist Realist content in art was demanded. Nevertheless, the roster of teachers remained the same, notably Ado Vabbe (1892–1961), who did the first Estonian abstractions in 1914;[4] Johannes Võerhansu (1902–1980), whose teachings stressed impressionist and post-impressionist color theory and the tradition of the School of Paris; Aleksander Vardi (1901–1983), also a follower of the impressionists; and the modernist Elmar Kits (1913–1972).[5] Although Kits did many commissioned official works and received the Prize of Soviet Estonia in 1970 for the paintings *V. I. Lenin* and *The Builders*, he also did a cubist-inspired collage, *Composition with*

a Fox, as early as 1949, during the grimmest year of the second Soviet occupation,[6] and privately painted abstractions during the sixties, many of which were eventually exhibited in 1968. His handling of space, however, remained cubist, and by this time, many of his former students had already created works that were more interesting and avant-garde by Western standards. Vabbe also painted abstract works shortly before his death in 1961 but did not show them even to his closest students, and Vardi also painted abstractly in the 1960s.

Twentieth-century art movements were quite well known in Estonia before the war, despite the prevailing taste for the School of Paris and realism during the 1930s. The main source of modernist art in Estonia before the 1960s was a translation of the noted British art historian Herbert Read's *Art Now*, published in Estonian in 1939, which many art students and young artists knew almost by heart. Silvia Jõgever, whose husband had been a student at the art institute, recalls long discussions about Read's book and twentieth-century art. A few articles on surrealism and Salvador Dalí by Ilmar Laaban (1920–2000), the first Estonian surrealist poet who had fled to Sweden in 1944, also circulated among the artists and intellectuals. Other artists found access to materials on modern art that had been collected before the war. For example, the painter Endel Kõks, who left Estonia in 1944 and later became a major exiled artist in Sweden, had collected books and magazines on modern art, which Valve Janov recalls borrowing from the artist's mother and sister.[7] According to Lüüdia Vallimäe-Mark, teachers, older students, and artists who had been studying abroad were well aware of contemporary art movements and shared their knowledge with younger artists. Vallimäe-Mark's teacher, Vabbe, had met Wassily Kandinsky in Munich and had seen the futurist exhibitions in Italy.[8] Jõgever believes the time was ripe for abstraction in Estonia during the 1940s, if only Estonia had remained free.[9] Nevertheless, many students at the art school after the end of the war complied with the requested Socialist Realist norms that were detested by the group of students around Sooster.

Estonia was relatively calm with only a few scattered arrests until 1948, when new hard-line Communists from Russia were appointed to lead the art institute. They made every effort to smear the reputation of longtime teachers like Vabbe and Vardi as "bourgeois

nationalists" and "formalists" who had misled the students. Heldur Viires remembers that up to this time, things were still quite open, the spirit of the prewar Pallas prevailed, and there was still faint hope that the Soviet occupation might not last. By 1948, however, it became clear that the occupation had begun in earnest. An influx of new students from remote areas of the Soviet Union created a stark break from the old Pallas atmosphere. Also, members of the KGB and the Soviet army circulated among the students and reported on the Estonians. Many Estonian students, including Jõgever, Janov, Valdur Ohakas, and Lembit Saarts, were expelled. By this time the majority of students were Russian-speaking and were from other republics of the Soviet Union.[10]

In the early spring of 1949, again during one night of terror, 20,702 farmers were deported to Siberia as *kulaks*.[11] Altogether 30,000 Estonians were deported between 1945 and 1952; in addition, about 75,000 were arrested and sent to labor camps.[12] In December 1949, Sooster, Saarts, Viires, Ohakas, Esther Potissepp Roode, and Henn Roode were arrested, imprisoned, and sent to various camps in Siberia, paralyzing the rest of the group, many of whom had to turn to other occupations to support themselves. Kaja Kärner, who had begun to teach at the art institute in 1948 after her graduation, was fired in 1950, was thrown out of the Artists' Union, and worked as a sign painter in a local department store for many decades. Janov worked in a veterinary laboratory for twenty years, while Jõgever taught art in high schools and Vallimäe-Mark illustrated children's books and painted portraits.

In 1956, after Khrushchev's denunciation of Stalin, the prisoners were released. Ohakas and the Roodes settled in Tallinn. Viires commuted between Tallinn and Tartu. The Roodes and Viires enrolled at the new Estonian State Art Institute in Tallinn that had been created by merging the Tartu Art Institute with the Applied Arts School in Tallinn. Sooster had married Lidia Serh from Moscow in the prison camp in Karaganda and returned with her to Estonia in the summer of 1956 to see his family and explore whether he could find work in Tallinn. According to Vallimäe-Mark, Sooster painted a series of works with the hope of being accepted into the Artists' Union or finding some means of earning money.[13] Since his official reception was hostile, he decided to settle in Moscow, where his wife had lived before she was sentenced to hard labor.

Nevertheless, this first visit by Sooster and the return of Viires, Saarts, Ohakas, and the Roodes from the camps mark the beginning of the new avant-garde in Estonian art. The artist Peeter Ulas (b. 1934) remembers a new excitement at the art institute when the former prisoners returned, bringing with them the technical skills of prewar Pallas, a new, bold sense of resistance, and a drive toward renewal and innovation.

Sooster's visits to Tallinn from Moscow were a catalyst for his former friends' development. In addition to reporting on the various artistic events in Moscow, he urged his friends to begin to paint again, to pick up where they had left off before the ill-fated year of 1949. All of his former friends credit Sooster for their renewal and their new enthusiasm.

The year 1957 marks a new beginning for abstraction and surrealism in Estonian art, which was different from anything that had taken place before. Nobody remembers exactly how this abstract art originated. In Tartu, it began with the group of Sooster's friends, the "first Tartu group," which worked closely together until Sooster's death in 1970. Although it was the first unofficial, dissident group in Estonia, it was never formally established as a group but was united by old friendships and trust from their student days. The artists shared a nostalgic love for the prewar Pallas tradition with its emphasis on modeling with color rather than line, as in the Soviet tradition. They also had similar artistic aims and looked toward Paris and Western art for inspiration. They shared a dislike of Russian and Soviet art and enjoyed the energetic patronage of Sooster. Furthermore, their style—painterly abstraction and collage—formed a radical break with the rigid demands of the Stalinist period.[14] These artists were not accepted into the Artists' Union before the 1970s, when the Tartu group had already dispersed. Their abstract works were shown only in their apartments and exchanged with friends and admirers. They also shared a stubborn resistance to succumbing to the prevailing Soviet ideology. Instead of doing a few commissions every year to survive, as did former members of the group in Tallinn, like Roode and Ohakas, members of the Tartu group abhorred accepting official commissions of a political nature. Instead, they earned their main income from other sources discussed above.

In Tartu the instigators of abstraction were two women artists, Janov and Kärner, who also were prob-

FIG. 12. [TOP] Valve Janov, *Ice Melting on Ema River*, 1958. Mixed media (painted plaster or gesso) on board, 44.5 × 59.5 cm. Dodge Collection, ZAM, 16810.

FIG. 13. [BOTTOM] Lembit Saarts, *Marriage*, 1958. Oil on paper, 26 × 39.3 cm. Dodge Collection, ZAM, 18614.

ably the first Estonian artists to experiment with collage and mixed-media techniques. Janov created her first abstract collages in 1957. In Janov's mixed-media painting *Ice Melting on Ema River*, done in 1958 (fig. 12), the composition and the flat handling of the picture plane is closer to American abstract expressionism than any other work in Estonian art at the time. Although most of Kärner's work is undated, we can be certain that the two artists began their experiments in abstraction at the same time because they shared an apartment in the Janov family's house. Varmo Pirk (1913–1980), who lived in Tartu until 1958, was introduced into this circle through his friendship with Saarts and Janov. He created abstract paintings after 1957. Both Jõgever and Saarts began experimenting with abstraction after 1958. Saarts's first small abstract oil paintings date from 1958 (fig. 13). Viires began experimenting with abstractions while visiting Sooster in Moscow in 1961.[15]

The relationship of the Tartu group to unofficial art in Moscow has not been fully researched.[16] However, we know that Estonians were aware of events leading to the thaw in politics following Stalin's death in 1953 and the attack on the "cult of personality" by Khrushchev in his secret speech to the Party leadership in 1956, which was followed by the gradual relaxation of museum policies about showing European "formalist" art.[17] In 1956, for example, a large Picasso exhibition was organized in Moscow, which later traveled to Leningrad and other centers.[18] Even more important for Estonians was the Sixth World Festival of Youth and Students held in Moscow in 1957, which was visited by a group of artists from Tallinn and Lola Makarova (b. 1928) from Tartu.[19] Two years later the *Exhibition of American Painting and Sculpture* was held in Moscow, where works by Jackson Pollock, Willem de Kooning, Arshile Gorky, and Mark Rothko, among others, were shown. These events were thoroughly discussed by Estonian artists, and Sooster described them to his friends in Tartu who did not see the exhibitions.[20] The Tartu group also knew of the path-breaking activities of the Studio School of Eli Beliutin in Moscow, which had been attended by Vladimir Yankilevsky and Ernst Neizvestny, close friends of Sooster.[21] In addition, at about this time many artists in Estonia and Moscow began subscribing to Polish and Czech art magazines. According to Tõnis Vint (b. 1942), Sooster had personal contacts with many Czech artists and scholars. Essentially, all progressive artists in

the Soviet Union were influenced by what was going on in Czechoslovakia and Poland.[22] Equally important were visits to the Library of Foreign Literature in Moscow to see books and journals on Western art as well as visits to Sooster and his friends to see Western literature on art that they had received from foreign visitors.[23] It appears that there was little direct stylistic influence from Russian artists, since the group considered their own Pallas training far superior to what was being taught in Soviet art schools.[24] Nevertheless, we should not underestimate the importance of discussing events that signified artistic freedom, new possibilities and artistic strategies, and the nature of surrealism and abstraction.[25]

Sooster entered the Moscow nonconformist artistic scene through Yuri Sobolev, who introduced him to the cafés, the basement studios, and the crowded apartments where writers, musicians, artists, and composers gathered. Like the Moscow artists, Sooster earned his living as a book illustrator. Russian artist Leonid Lamm, a schoolmate of Sobolev, also introduced Sooster to Moscow publishing houses, where he worked until the end of his life.[26] Neizvestny became a friend within this circle of artists in 1958, and Yankilevsky, Ilya Kabakov, and Victor Pivovarov joined in 1960. Sobolev first visited Estonia with Sooster in 1957, and he claims that until the middle of the 1970s Tallinn was "our principal guide to the context of real culture and art."[27] Sobolev writes:

> Now in order to "mend" the gaps in his time, Sooster invented a somewhat naive ontogenic literal method. He suggested (or, to be more correct, demanded) that we should restore, in a compressed way, the whole chain of development of art of the last thirty years: the principles of deformation of cubism and expressionism, the spatial inventions of Picasso, Braque, De Chirico, and Morandi, the abstractions of Mondrian and Pollock, the surrealism of Max Ernst and René Magritte, the poetics of Klee and Miro . . . it was like a sophisticated theater performance. We wore holes in our trousers sitting in libraries, studying monographs and journals about the drama of art and the great masters of the twentieth century.[28]

Sobolev has described Sooster as "the main guide and mediator" between Estonia and Moscow, serving as "the bridge connecting the two cities."[29] Sooster and Sobolev became central members of the café Artisticheskoe, which opened in 1959, and helped trans-

form it into a true café-club where the majority of the alternative intellectuals of the time began to meet. "The Moscow elite met in the Artisticheskoe, Molodezhnoe, and in Siniaia ptitsa cafés where Ülo, Eric Bulatov, Kabakov, and others exhibited their works," Lamm stated. "These exhibitions stirred our [the nonconformist artists'] imagination [and our desire to establish] new trends in art." In 1962, Beliutin organized an exhibition of his students on Bolshaia Kommunisticheskaia Street in Moscow and invited Sooster, Sobolev, and Neizvestny to participate. Several days later, all participants of the Bolshaia Kommunisticheskaia Street exhibition were invited to participate in the infamous Manege exhibition where Sooster had a personal dispute with Nikita Khrushchev about modern art.[30]

Sooster's apartment became the regular Tuesday meeting place for Moscow's liberal thinkers.[31] Moscow artist Kabakov shared studio space with Sooster after 1960. Kabakov remembers that Sooster brought thousands of drawings made while in prison camps and reflects about Sooster's art: "[His] aspirations always represented in a decisive way the entire Universe and all of the conversations in Ülo's studio easily moved from the techniques for preparing an etching to the problems of mathematics, geography, politics, history, philosophy. . . . Ülo as an artist was interested in absolutely everything. . . . He asked the 'ultimate questions'—remaining all the while a craftsman who stands at the easel and works."[32]

Wallach notes that after Kabakov moved to the studio with Sooster, Kabakov's drawings "appear to be in the manner of an aesthetic and intellectual argument with Sooster; a comical response to the cosmic seriousness of Sooster's art."[33] Estonian artists in both Tartu and Tallinn were also doing drawings partly under Sooster's influence and partly under the influence of the Pallas Art School. During the 1960s, the style of Sooster's drawings encompassed pure abstraction, surrealism, cubism, expressionism, and realism. He wrote Vallimäe-Mark from the prison camp in 1955 that he was attracted to abstract art, and in another letter from Moscow in August 1959 he noted that he had lately been preoccupied with totally abstract pictures, which he found a pleasure to make.[34]

According to Kabakov, Sooster's art still remains vividly and lastingly in the memory of his friends. Kabakov has attempted to give his own reasons for this lasting presence, claiming that "all of Ülo's art is pri-

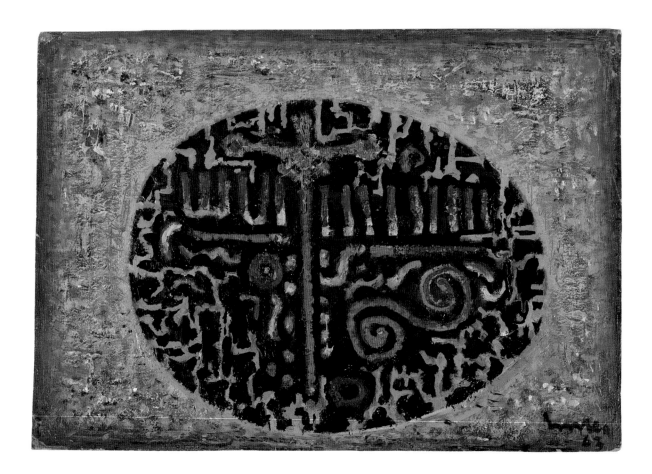

FIG. 14. Ülo Sooster, (Untitled), 1963. Oil on illustration board, 35 × 50.1 cm. Dodge Collection, ZAM, 02716.

mordially mythological, it contains in it myth" that is "of the cosmos, of the universe, a myth about its entire state, of the minimal and maximal, of the micro-world and the macro-world and their interaction."[35] It seems that not only Sooster's art but his entire personality has become an integral part of this powerful mythology, which still remains so vividly in the minds of the people who were touched by his presence.[36] The Russian filmmaker Andrei Hrzanovsky has also claimed that the legend of Sooster reached him much earlier than their actual meeting.[37]

Sooster always considered himself a surrealist even though he was able to appreciate abstraction and conceptualism in the works of other artists. While his drawings ranged from surreal realism to pure abstraction, he often explored the limited subjects of the egg, the fish, and the juniper in his paintings. Kabakov calls

these his "three main metaphors, the proto-elements of life and the drama of being with which he was able to express the universal and mythical of the whole cosmos"[38] (fig. 14). This cosmic egg is often of enormous proportions and hovers above the landscape. His juniper is both a tree of life and a link with his childhood landscape on the island of Hiiumaa in Estonia. Sooster thus unites the personal and the cosmic general to his primordial roots.

Kabakov has also described Sooster's method of creating "relief with a sculptor's knife from colored paste," and then "while it is still 'raw' putting into it little spheres, pieces of red glass, fragments of ceramics."[39] His method of pouring, molding, and adding is not unlike the action painting of many American postwar artists. Yet, like many other artists in the Soviet Union at that time, Sooster painted in several different styles.

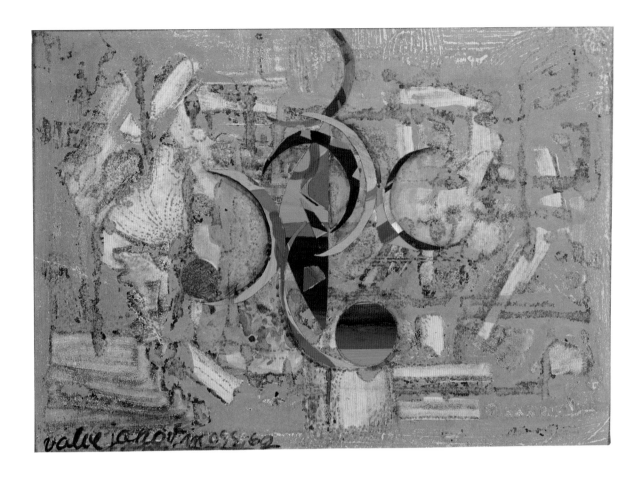

FIG. 15. Valve Janov, (Untitled), 1962. Gouache and
paper collage on monoprint on paper, 18.2 × 25.5 cm.
Dodge Collection, ZAM, 17073.

He also did animated films for adults with Andrei Hrzanovsky in Moscow, which have thus far not been analyzed. The films, of which the *Glass Harmonium* is the best known, have only been shown twice in Estonia, once during the 1970s (after his death in 1970), and again in the spring of 2000. According to Vallimäe-Mark, due to their subversive satirical character, the films were not widely accessible, even in Moscow.[40]

Janov was under the spell of Sooster and visited him often in Moscow, where he introduced her to the studios of unofficial artists.[41] Though she did not speak Russian, she spent long days at the Library of Foreign Literature in Moscow studying Western art magazines and books, and with the help of Sooster visited many underground apartment exhibitions. After 1957, she completed many "fish" paintings, crediting Sooster's influence. She has also said that she often argued with Sooster, who preferred surrealism, which she never liked, favoring instead the abstracted, more lyrical style of Paul Klee and others.[42]

Still, from Sooster she inherited the preoccupation with texture. She builds up her artwork into thick relief patterns, as in *Ice Melting on Ema River* of 1958 (fig. 12, p. 46), which is one of her strongest early works. The flat, textured surface and overall expressive covering of the picture plane relates it to American abstract expressionism and French Art Informel. She began doing many abstract collages in 1957, which she continues to do today (fig. 15). Janov's nonobjective paintings, often in mixed media, also date from around 1958. Her abstractions are a total break from anything that had been done in Estonia previously and do not seem to have any relation to the Moscow underground, even though she visited Moscow many times.

FIG. 16. [TOP] Kaja Kärner, (Untitled), 1964–66. Gouache and paper collage on paper, 65.5 × 55 cm. Dodge Collection, ZAM, 18627.

FIG. 17. [BOTTOM] Lüüdia Vallimäe-Mark, *Women*, 1960. Oil on fiberboard, 49.8 × 70.2 cm. Dodge Collection, ZAM, 16917.

Instead, her work is related more to that of the Estonian exile artist Endel Kõks, who was able to send small works from Sweden to his mother and sister in Tartu. She has said that she liked doing her "fish painting" because she could use patterns and textures and nobody could say that such fish never existed. With the fish she felt she could cheat the Soviet system and do what she wanted.[43] However, such work was studio art, shown only to Janov's friends in the Tartu group, Sooster, and other close friends.[44]

If Janov liked detail, structure, and texture, Kaja Kärner was a born colorist. In her early collages, Kärner combined cut objects and texts from magazines with fluid tempera paint. In one collage, she used cutouts with Polish texts, perhaps inspired by art magazines from Poland (fig. 100, p. 145). She never went to Moscow and did not speak Russian. However, Sooster sent her letters with elaborate discussions about exhibitions and artistic events in Moscow and brought books on contemporary art when he visited.[45] During the 1960s, Kärner began creating large tempera and gouache abstractions with rhythmically balanced color planes that cover the entire shallow picture surface (fig. 16).[46] Olav Maran has called Kärner the most convincing and consistent abstractionist among the Tartu group.[47] Tragically, she could seldom exhibit her abstractions at the time, and the scope and importance of her work during the late fifties and sixties has almost been forgotten. During her final years, she became more reclusive, and few people had access to her works.

After returning from the prison camps in the region of Karakanda in Kazakhstan in 1956, Saarts began doing abstract drawings and created small, powerful abstractions in oil on paper in 1958 (fig. 13, p. 46). Sooster's influence can be seen in Saarts's drawings. Saarts was able to become a member of the Artists' Union in 1959 by doing theatrical stage designs and realistic commissions. His larger abstract paintings, which younger Tallinn artists admired, were done during the 1960s.

Vallimäe-Mark claims that, for her, there was no Tartu group as such, only artists united by common experience.[48] Nevertheless, other artists in the group considered her a member. She graduated from the Tartu Art Institute with Sooster in 1949, and they remained friends until his death in 1970.

Vallimäe-Mark illustrated children's books and did

some haunting visionary paintings with surreal undertones based on fairy tales. She was best at psychological portraits, of which *Women* (fig. 17) is an expressive example, depicting with tragic undertones the alienation and loneliness of each subject in the group portrait. She has done some abstractions but claims she preferred doing portraits and imaginary subjects. Yet one recognizes the influence of the "Sooster tradition" in her nonobjective painting *Confession* of 1978. Painted in somber reds, black, and gray, with heavy texture, the painting symbolizes, in her own words, "the end of the Soviet stuff."

Heldur Viires (b. 1927) is the youngest member of the Tartu group. After spending seven years in the Vorkuta coal mine prison camps, he returned to Estonia in 1956 and was admitted to the art institute in Tallinn with a prisoner's shaved head. He commuted back and forth between Tallinn and Tartu to visit his partner, Kärner, and was the link between artists in the two cities. Sooster, a good friend of Viires, also had close connections with all progressive Tallinn artists. Viires is the only artist in the Tartu group who admits to being influenced by the underground art in Moscow, perhaps because he could speak Russian after six years in the forced labor camps. During the winter of 1961–62, he spent three months in Moscow and lived in Sooster's studio. Viires arrived there when the sculptor Ernst Neizvestny was organizing an exhibition of his drawings at the Institute of Physics and was asked to help select the works. According to Viires, the night of making the selections was his best art school. He was happy when Neizvestny approved his choices the next morning.[49] Sooster encouraged Viires to experiment with nonobjective forms and considered him a natural-born abstractionist. While in Moscow, Viires discovered the monotype technique that he employs to this day (fig. 18) and created many collages, which unfortunately have not been preserved. Viires feels that his three months in Sooster's studio were like a university graduate semester and a major confidence builder after his years in prison.[50]

The drawings and now-lost collages Viires did in Moscow and brought back to Estonia provided important inspiration for younger artists in Tallinn. Many still remember his discussions of the Moscow experience in Maran's studio in 1962 and the novelty of the drawings and collages (fig. 19). These small drawings were very important for the development of Estonian

FIG. 18. [TOP] Heldur Viires, *Bubbles*, 1963. Monotype, 31 × 43 cm. Dodge Collection, ZAM, 18621.

FIG. 19. [BOTTOM] Heldur Viires, (Untitled), 1961. Ink and paper collage on paper, 19 × 15.6 cm. Dodge Collection, ZAM, 18971.

art during the early sixties, helping to lead younger artists to experiment. Viires became the activist in the Tartu group, mediating information between Sooster, Tallinn, and Tartu and organizing artwork by his friends for exhibitions. Through him, younger artists at the institute received information about prewar Estonian art as well as Sooster's group in Moscow.

In 1960, Silvia Jõgever organized the first unofficial art exhibition at a secondary school in Tartu, where she was a teacher. This exhibition caused a major scandal in the official art circles all over Estonia. Jõgever credits Sooster with the idea of such a group exhibition, which he had urged during his return to Tartu in 1956. She already had Sooster's works at home and added works by Janov, Kärner, Viires, Saarts, Vallimäe-Mark, and Ohakas from Tallinn, as well as one of her own works. According to the artist, no abstract or surrealist works were exhibited. Jõgever's statement that accompanied the exhibition expressed the artistic aims of the group—reliance on color and light in expressing form and emphasis on individuality and subjectivity. The statement was handwritten in blue ink with a black title on white paper, the colors of the prewar Estonian flag. Mati Unt, one of Jõgever's gifted senior students who became a leading novelist and playwright during the 1960s, wrote another text similar to Jõgever's for the students' wall bulletin, also in blue, black, and white. These texts were quietly removed by worried teachers after accusations from official circles began.

This unofficial exhibition in Tartu was the first artist-organized show in Estonia, produced without the consent of the Artists' Union or the Party officials. It was also the first exhibition with aims that did not conform to the official ideas of Socialist Realism. At this time in the Soviet Union, only the Artists' Union and the Ministry of Culture had the authority to organize exhibitions; no grassroot groups were allowed to do so. As the very first artist-organized exhibition, preceding the ANK group exhibition by four years, Jõgever's show suffered most. When news spread, a scandal was created, followed by many tribunals with interrogations and accusations at the local Artists' Union and the Communist Party headquarters. Jõgever was accused of organizing an anti-Soviet group, and efforts were made to find out who else was responsible. Officials tried to find reasons to accuse the former prisoners whose works were included in the exhibition. However, Jõgever took full responsibility for organizing the exhibition and received all the blame.[51] Eventually several people in the Artists' Union began to defend her by pointing out that in Moscow there had been similar exhibitions without such harsh consequences. The scandal attracted large crowds to the exhibition. One of the visitors was a young art student named Enno Ootsing, who was to become a leading member of the ANK group in Tallinn in 1964.

Jõgever was later asked to take all the works to Tallinn and present them to the Executive Committee of the Artists' Union, where the initial reception was also negative. However, Villem Raam, an art historian who had spent fifteen years in forced labor camps, defended her. Eventually many members of the Artists' Union expressed their admiration for Jõgever's efforts, and she was sent to Moscow to familiarize herself with proper Socialist Realist art. However, she spent most of her time in Sooster's studio, visiting dissident artists and looking at art books in the Library of Foreign Literature.[52]

Although no abstract works were shown at the exhibition, many paintings had formal distortions and expressive color use. The works were not different from others exhibited at earlier exhibitions of young artists in Tallinn. The main problem seemed to be the exhibition's unofficial nature and the lack of permission from the Artists' Union, a permission that would never have been granted.[53]

Jõgever eventually joined the Artists' Union in 1977, while Janov joined in 1969 and Kärner in 1984. Like many artists at the time, Jõgever worked in several styles concurrently and did many abstract paintings and collages during the 1960s (fig. 20). In the collages, she often cut out parts of her previous works and pasted them together in different ways. Her *Caged Animals* of 1965 (fig. 21), which she painted to symbolize Estonia, Latvia, Lithuania, and Moldavia—the four countries whose fate was decided in the Hitler-Stalin pact in 1939—is perhaps closest to a number of works by Sooster. It is an example of subtle subversion, which especially angered authorities. Jõgever's expressionistic *Songs of the Setus* of 1960 may be more like some of the works shown in the notorious exhibition.

These events influenced the younger artists in Tallinn. Viires had graduated from the art institute in Tallinn in 1959 with Maran, Ulas, and Herald Eelma (b. 1934). Enn Põldroos and Evi Tihemets (b. 1932) had

FIG. 20. [TOP] Silvia Jõgever, *Picture with an Oval*,
1967. Gouache on paper, 44.2 × 62 cm. Dodge Collection,
ZAM, 16953.

FIG. 21. [BOTTOM] Silvia Jõgever, *Caged Animals—Estonia,
Latvia, Lithuania and Moldavia*, 1965. Oil and tempera on
paperboard, 49.8 × 69.8 cm. Dodge Collection, ZAM, 16915.

graduated in 1958, and Lembit Sarapuu (b. 1930) was still a student. It has often been claimed in Estonia that the Tartu group restored old Pallas traditions. However, while the former Pallas students had a nostalgic attachment for their school and often painted landscapes and figurative compositions in the Pallas style, their abstractions and collages from the late fifties and sixties formed a total break from previous Estonian art and transcended the retroactive spirit of the Pallas school of the 1930s. The Tartu group's work was, hence, not a restoration of the old, but a totally new beginning. The artists were the first in postwar Estonia to choose a path radically different from the ideology of Socialist Realism. Particularly, the women in Tartu steadfastly refused any official commissions until the 1970s, after the group had already dispersed. Unfortunately, they never had a chance to make themselves known or to exhibit their work at a time when abstractions were considered innovative and influential. (Janov's and Kärner's abstractions were first exhibited officially in Tartu in 1971. The joint exhibition was reviewed by Eha Ratnik in the local newspaper *Edasi* [March 21, 1971].) During the seventies, after Sooster's death, their enthusiasm for abstraction waned, but by this time younger artists in Tallinn and Tartu were already carrying the avant-garde banner.

Henn Roode (1924–1974), also a member of the group during the prewar Pallas times, returned from the prison camps in Karaganda in 1956 and enrolled in the art institute in Tallinn with his wife, Esther. Jõgever has described him as intellectually inclined and independent. He did not belong to the later postwar Tartu group, and his works were not included at the 1960 Tartu exhibition. He was a talented artist and experimented with many styles after his return to Estonia, including surrealism, cubism, expressionism, and abstraction. He began doing abstract paintings (fig. 111, p. 155) after being prodded by Maran, who in 1963 suggested that Roode should paint some abstract work: "and soon (Roode) showed me his first experiments done with thick paint on paper. He quickly became adept with abstraction."[54] Younger artists admired his work for its pure painterly qualities. Lapin has referred to him as one of the three major individuals in the revival of the avant-garde in Estonia.[55] However, he was more compromising than the Tartu group and painted official commissions, even though reluctantly. His painting *Peace*, which he did privately after an official

commission in 1962 or 1963, expresses the anger he felt against such commissions and the Soviet system. It also illustrated his credo that "truth is a caricature, the caricature of absolute truth."[56] Some of his more surrealist works, such as *Undefined with an Eye and Hand* (1964–66), expressed the helplessness, tragedy, and undefinable doom of an evil eye. Roode finally was admitted into the Artists' Union in 1964 but was never totally accepted by the authorities, and his work was often rejected for exhibition.

While still a student at the art institute in Tartu, Varmo Pirk was arrested in 1945 for a cartoon illustration done in 1943 for the newspaper *Postimees* during the German occupation (fig. 22). He was sentenced to prison camps in the Kirov district for twenty-five years but was released in 1954 because of bad health. He lived in Tartu and worked with Saarts on theater design before moving to Tallinn in 1958. Pirk began doing abstractions in 1957 and continued during the 1960s. His style at the time alternated between abstraction and stylized decorative imagery. Pirk was one of the few Estonian artists who saw the renowned George Costakis collection of Russian avant-garde and nonconformist art during the 1960s, with the help of Russian friends of his wife, who had also spent many years in prison camps.[57]

The 1960s saw the opening up and optimistic testing of barriers all over the Soviet Union. In Moscow, among the intellectual circles, there was a growing religious revival and a new interest in philosophy and esoteric knowledges of Tantrism, Sophism, and Zen Buddhism.[58] This period is often referred to in Estonia as the "Golden Sixties," when the composers Arvo Pärt (b. 1935), Veljo Tormis (b. 1930), and Kuldar Sink (1942–1995) were beginning their careers. During those years, Paul-Eerik Rummo (b. 1942), Jaan Kaplinski (b. 1941), Hando Runnel (b. 1938), Andres Ehin (b. 1940), and Viivi Luik (b. 1946) published their first poetry collections. The plays and novels of Mati Unt (b. 1944) and Arvo Valton (b. 1935) were published, and the first novels of Jaan Kross (b. 1920) also appeared in print.[59]

Interaction among artists, writers, composers, and other intellectuals has always been close in Estonia, where ethnic Estonians number barely a million. Thus, unlike the situation in larger countries, the segregation of different creative and intellectual individuals into isolated groups is inconceivable. Estonia also

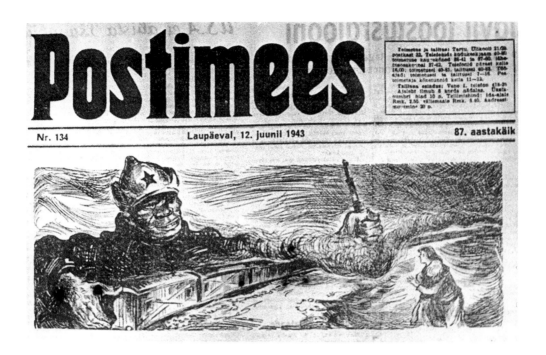

Postimees

Nr. 134 Laupäeval, 12. juunil 1943 87. aastakäik

FIG. 22. Varmo Pirk's cartoon illustration done in 1943 for the newspaper *Postimees*. Collection of Eda Sepp.

differs from the other Baltic states in its proximity to Finland and the similarity of its language to Finnish. During the sixties, most Estonians in Tallinn and along the northern shore of Estonia could view Finnish television, and the ships operating between Helsinki and Tallinn brought a steady stream of tourists, including many intellectuals and artists who formed lasting friendships with their Estonian counterparts.[60] After the Czechoslovakian uprising, contacts with Finnish intellectuals intensified, especially after the opening of the Viru Hotel in Tallinn in the early seventies.

The literary critic Rein Veidemann (b. 1946) recalls that during the second half of the 1960s many contemporary philosophical texts that had been forbidden during the Stalin era spread among the young intellectuals in Estonia. Works of Jean-Paul Sartre, Albert Camus, Martin Heidegger, Theodor Adorno, Jürgen Habermas, Herbert Marcuse, and Roger Garaudy were passed from hand to hand, copied, studied, and deliberated over. For the generation of the sixties, the world had again become multidimensional, with information from hitherto-forbidden disciplines like ge-

netics, cybernetics, cosmology, psychology, and semiotics opening new perspectives.[61] The artist and architect Lapin has recalled inspiring discussions on Freudian psychoanalytic theories, Jungian archetypal psychology, and Russian modernism.[62] According to Veidemann, the quest for new, previously forbidden knowledge became an almost cult-like activity among Estonian intellectuals. During the 1960s, Russian writer Aleksandr Solzhenitsyn wrote his manuscript for the *Gulag Archipelago* while "hiding" incognito in an Estonian friend's farmhouse near Tartu after the KGB had confiscated some of the material for it in Moscow in September 1965.[63]

Although the West remained a closed world to younger people and to those without Communist Party affiliations, many intellectuals were able to travel to Poland, Hungary, and, until 1968, Czechoslovakia. Books and periodicals on Western art were scarce, but magazines from Poland, Czechoslovakia, and Hungary could be subscribed to and paid for in rubles until the 1968 uprising in Prague, after which external contacts were curtailed, even with the Eastern bloc. Contacts with Sooster and the Moscow artists who par-

ticipated at the notorious Manege exhibition of 1962 remained frequent, and artists visited back and forth until the 1980s.

In an authoritarian society, where art was supposed to obey an alien political ideology, the formal language of surrealism with its fragmented and distorted images, jarring viewpoints, and hidden symbolism offered a vocabulary with which the artist could elude the demands of the censors. The surrealist movement in Eastern Europe and the Soviet Union differed from the original European surrealism in that it related more to social and political issues and was often in subversive dialogue with the monolithic ruling authorities. This Eastern European surrealism occurred at the time when artists in North America and Western Europe were preoccupied with abstraction and pop art. In the Soviet Union and Eastern Europe, surrealism was often combined with abstraction, pop art, and later with conceptual art, depending on what the artists were interested in and had access to. Surrealism also appealed to many Estonian artists, especially to those born before 1943.

In the 1960s, Tallinn, where the art institute and artists' organizations were located and where the major exhibitions were held, also gradually became the art capital of Estonia. Maran was an important activist in Tallinn at that time, especially influential for the ANK group. In many ways, he was a link between the older Tartu group and the younger artists.[64] He had studied printmaking at the Estonian Art Institute, graduating in 1959, the same year as Roode, Viires, Ulas, and Eelma. According to Maran, an important event for his generation was the 1957 Sixth World Festival of Youth and Students in Moscow, where abstract works were exhibited for the first time and Jackson Pollock's drip technique was demonstrated. Maran did not go to Moscow, but he heard detailed descriptions from Ulas, Põldroos, Eelma, and Heldur Laretei.[65] According to Maran, all of the younger artists in his circle of friends began to use distorted imagery in their works after this exhibition. Around the same time, Viires showed him an article by the exiled poet Ilmar Laaban (1920–2000) on Salvador Dalí (1904–1989). The article, which had appeared in the *Estonian Youth* magazine before the war, raised his interest. Surrealism and abstraction thus reached Estonia almost simultaneously, and Maran claims he shared the aim of synthesizing these two movements with Sooster and the artists in Mos-

cow.[66] He experimented first with abstraction in 1957, probably inspired by what he heard about the International Youth exhibition in Moscow, and did his first surrealist work in 1959.[67] Throughout the 1960s his art vacillated between surrealism and abstraction, the collages often being more surrealistic (fig. 23; fig. 107, p. 152) and the paintings more abstract (fig. 101, p. 146). Young artists in Tallinn gathered regularly in the studios of Põldroos and Maran to discuss these new ideas. Põldroos, who later became the chairman of the Artists' Union and joined the Communist Party, also painted abstract and surrealist works during the 1960s.

Somewhat freer exhibitions of young artists' work were held in the Tallinn Art Hall in 1959, 1960, and 1962. The Art Hall was the place for younger artists to show their work, even if the exhibition of abstract and surrealist works was not possible. After the scandal at the Manege exhibition in Moscow in 1962 and the articles in *Pravda* attacking formalism and nihilism in art, similar repressive writings appeared in Estonia and, as a result, the young artists' exhibitions were forbidden for several years.

Maran had his first unofficial exhibition in 1963 in the apartment of the Estonian surrealist poet Andres Ehin, where he exhibited abstract and surrealist works. Although only a select invited group was able to see this exhibition, it caused a sensation. In 1966, Maran also exhibited a few abstract works in the lobby of the Academy of Sciences.

As a theorist and intellectual activist, Maran had much in common with Sooster. He shared Sooster's optimism and hope that modern art would eventually culminate in a new Renaissance.[68] He often theorized and discussed art with Sooster and then passed on his conclusions to other artists. Both Sooster and Maran had contacts in Latvia.[69] However, Maran's closest ties were with Tartu artists such as Saarts, Kärner, Janov, Jõgever, and Vallimäe-Mark.[70] He first met them in 1963, after which one can detect a change and maturation in his abstractions.

The official breakthrough for Estonian avant-garde came in 1966 with a youth exhibition in the Tallinn Art Hall. Maran played a key role because he was a member of the jury as the representative of young artists. Prior to the exhibition, he went to all younger artists who had experimented with abstraction and asked them to submit as many nonrepresentational works as possible. He argued to Soviet Estonian officials that if

FIG. 23. Olav Maran, *Damsky*, 1965. Paper collage on paper, 40.5 × 27 cm. Dodge Collection, ZAM, 17068.

Soviet Estonia wanted to show it had young talents, the jury should choose from what was submitted, since there were no other artists to choose from. As the majority of works were either abstract or surrealist, Maran argued that if everything was rejected, Estonia would be left in the embarrassing position of having no young artists. The officials in the jury found the situation extremely objectionable, but Maran succeeded in persisting and pushing many works through. His strategy worked, since appearance counted in the Soviet Union, and this time it was the appearance of having a substantial number of young artists.[71] Maran himself exhibited three abstract paintings. Concordia Klar (b. 1938), Ulas, Eelma, and Jüri Palm (b. 1937) had interesting surrealist or abstract works. Tihemets and Viive

Tolli (b. 1928) showed prints. The Tartu artists and Roode did not exhibit because they no longer qualified for youth exhibitions. The ANK group exhibited officially for the first time and was well represented. Vint, Jüri Arrak, Malle Leis, Kristiina Kaasik, and Enno Ootsing showed abstractions or semi-abstractions.[72]

The exhibition created the usual paranoia in the official circles, but it also launched the younger Tallinn artists, notably the ANK group members, who would have important roles during the next decade. Lapin, who had recently arrived in Tallinn and begun his studies at the institute, recalled that he can still remember the exhibition clearly because it gave him many new ideas.[73] Lapin singled out Lembit Sarapuu's (b. 1930) 1963 surrealist *Composition*, a haunting work

with symbolic connotations that shows a mysterious hand coming from an outside space and a large key on a red tablecloth.[74] Lapin also remembers Jüri Arrak's expressive and powerful *Lava* (1966) and Malle Leis's abstract mixed-media painting *The Song of Sand* (1966),[75] which he considers major works in contemporary Estonian art. According to Lapin, this exhibition encouraged his generation to continue in an even more radical direction. Although the exhibition sent shock waves throughout the art establishment and exhibitions of young artists were again forbidden for a few years, it was, nevertheless, an important precedent. It broke the ground for other abstract and surrealist works to gain somewhat freer acceptance at official exhibitions, which created for Estonia a reputation of being more permissive in exhibiting works incompatible with the official Communist Party dogma in Moscow, although abstractions and surrealist deformations were never totally acceptable. An additional reason for the acceptance of nonconformist works was that more young artists and their protégés managed to sneak onto juries, as Sooster had suggested. With the Tallinn Art Hall exhibition, abstraction emerged from the underground, and the precedent was established.

After the scandal, several younger artists published articles to explain the exhibition and to defend nonrepresentational art. Maran's article in the magazine *Noorus* (Youth) was especially interesting and groundbreaking.[76] He was one of the first Estonian theorists of abstraction to draw on science and mathematics to substantiate his views. This point was important for the ANK group and even more so for Raul Meel during the seventies. Maran was also the first to openly base his theories on the ideas that Juri Lotman expressed in his book *Lectures of Structural Poetry*. Lotman (1922–1993), who taught at Tartu University, was the "grand old man" of semiotics and founder of the world-famous Tartu School of Semiotics.[77]

In 1968, however, Maran became a "born-again" Christian and stopped doing abstract works altogether. He began painting the serene landscapes and detailed still lifes in the Renaissance and Baroque tradition for which he is known today. He also withdrew from his activist role and showed only his new paintings at exhibitions.

Lola Liivat Makarova (b. 1928) is another painter from Tartu whom scholars have neglected. She did not belong to any group and was not an insider in Tallinn.

Makarova began studying art in Tartu in 1948 and graduated from the art institute in Tallinn in 1954 after the school had been moved there. She thus studied during the darkest years of Stalin and the Soviet occupation. She had no contact with Western art before attending the World Festival of Youth and Students, where she first saw abstract works of art and met the American artists Harry and Katherine Coleman, who were living in England at the time. This meeting was to have an enormous impact on Makarova's art, which became abstract expressionist in style.[78]

Harry Coleman was asked by the Russian artists to demonstrate Pollock's drip technique, which Makarova described in the following way:

> When Coleman started to paint, it totally transformed my way of understanding art. He worked intensively for about twenty minutes … and after the pause continued to work … sometimes with a brush, sometimes splattering right from the pod. Katherine asked what I thought of it. I answered: "I feel it reached me." This made us friends. It had given me the impulse for receiving abstract art.… I came home from Moscow and went to the studio. I had been changed.… I locked my studio door, had a glass of cognac and started to paint my first abstract picture.[79]

It took Makarova a few years to master the action painting technique and its method of covering a flat picture plane. Nevertheless, there was no looking back. She has claimed that the Colemans were her real teachers and she had no contact with Estonian early abstraction, even though she did read Herbert Read's book. She corresponded with the Colemans after the festival, but the KGB soon ended that by confiscating the letters. Makarova also saw the 1959 exhibition of American contemporary art in Moscow and the later exhibitions of French and British art.[80]

After Makarova began doing abstractions, her studio became a regular gathering place for many Tartu artists, poets, theater directors and actors, writers, composers, and musicians. Sometimes parties were held after theater openings and concerts, and new intellectual ideas were always discussed.

I and My Snake (1961–63) is one of her early abstractions, painted on unprimed cardboard with red, black, and white paint. Her works between 1960 and 1964 show that she has mastered the technique of action painting and learned the lesson from the initial il-

lustration of Jackson Pollock's *Number 5*. During the second half of the 1960s, her style began to change and mature. While she still preferred action painting, she claimed she now wanted to be inside the work and use her hands. She began building up the painting with layers of thick paint, adding objects, mirrors, pieces of wood, and sometimes metal. Her formats also became larger. Unlike the American painters, however, she still kept painting portraits, flower arrangements, and landscapes. Thus, like many other artists in the Soviet Union, she maneuvered between abstraction and representation.

In 1974, Vitalii Shazonovy, a Russian artist living in Tartu, arranged to show the works of Makarova, Ilmar Malin, and Helle-Reet Vahersalu (b. 1939), who studied at the art institute with the ANK group but moved to Tartu after graduation, at underground exhibitions organized by Moscow nonconformists. According to Makarova, the exhibitions were held in the two-bedroom apartments of eight dissident artists scattered all over Moscow—this, after the bulldozers had recently demolished the outdoor exhibition of the Moscow dissidents on the orders of Nikita Khrushchev. Makarova relates:

> Everybody knew that the KGB was watching the apartments but the artists defied the political pressure and the possible repressions. Our works were exhibited in Oskar Rabin's apartment, which had been emptied of the furniture except for the piano.... I saw all the exhibitions and slept on a camp cot in Rabin's apartment. When Rabin and his wife left the apartment at night they warned me, that if the KGB would come and harass me, I should phone the American Embassy. Fortunately I did not need to phone but I was quite nervous. In the morning we drank coffee in the little kitchen with the organizers of the exhibition. The kitchen also served as a press office where the members of diplomatic corps were received. Swedish and Dutch television crews had been invited and a press conference was held at the apartment. Everything seemed as outside reality.[81]

Ilmar Malin (1924–1994), who lived and worked in Tartu, exhibited his works in this exhibition. During the war, he had fled to Finland to avoid being drafted into the German army. When he returned to Estonia, he was drafted anyway and, after a series of escapades, was wounded, imprisoned in Czechoslovakia, and finally sent to Siberia by the Soviets. After being freed in 1949, he enrolled in the art institute, but in 1953 he was arrested again and tortured.[82] He began working in the realist manner, preferring figurative art and portraiture. His art collector brother, who lived in Sweden, began sending him books in 1962 and was able to visit him in Estonia in 1964.[83] He began experimenting with collage in 1965, when this medium was popular in both Tallinn and Tartu. He also created his first surrealist drawings inspired by Marcel Jean's book *Histoire de la Peinture Surrealiste*.[84] While visiting his brother in Sweden in 1967, Malin was introduced to Estonian surrealist exile poet Ilmar Laaban, Swedish pop artist Öyvind Fahlström, and the surrealists in the collection of the Moderna Museet.[85] Under this influence, he began to create surrealist works.[86]

Malin's delicate drawings and watercolors are more closely related to the works of Endre Nemes, who was a friend of Laaban, than to East European surrealism. Malin continued doing surrealist works until his death in 1994, but he also painted portraits and did figurative commissions. In some writings he referred to this split as his "creative schizophrenia." He shared this "schizophrenia," however, with the majority of artists in Soviet Estonia at the time. Only the younger artists turned their backs on such multiplication of styles, where some of an artist's works were acceptable, and others were nonconformist and therefore unacceptable.

The second half of the 1960s was also the beginning of what could be called the heroic period of Estonian printmaking. Artists of Maran's generation—Ulas, Tolli, Eelma, Tihemets, Heldur Laretei (1933–1994), Klar, and Palm—studied printmaking in Tallinn. Artists usually did not work in both painting and print medias in Estonia, and the art institute had sharply differentiated courses for painters and graphic artists. The above-mentioned artists preferred abstracted, surrealist formal devices rather than pure abstraction and had already exhibited interesting works at the 1966 Tallinn Art Hall youth exhibition.

Printmaking was popular in Estonia for a number of reasons at this time. The first Baltic Graphic Triennial was held in Tallinn in 1968 and every three years thereafter. The jurors of the Triennials were predominately younger artists who favored innovation. Consequently, the exhibitions became forums for new art and known all over the Soviet Union. The Triennials had a decisive influence on printmaking in Estonia because they inspired artists to excel and innovate. An-

other important factor was the quality of the printing studio established by Ado Vabbe and continued during the sixties under the master printer Nikolai Kann. A third factor was the publication of the annual catalogues on Estonian graphic art and the catalogues for the Baltic print Triennials by art historian Jüri Hain, who had the courage to include innovative works. Perhaps even more important was the belief, as expressed by artist Raul Meel, that graphic art was experiencing a boom in the international art world similar to that of video art in recent years. People believed that the print medium could be the most mobile and innovative art form, capable of reaching the widest audience because of its relative low cost and unlimited copying possibilities.[87] There was thus a general feeling of optimism about printmaking in Estonia and a conviction that it would be the art medium of the future. This belief was reinforced by the multitude of prestigious international graphic exhibitions to which the Estonian artists began to mail their prints during the early seventies. They won prizes at Krakow, Frechen, Tokyo, Heidelberg, and Rijeka. In 1972, a group of artists sent their works to the Venice Biennial without permission from Moscow. As a result, this work was inadvertently included in the international print exhibition, and the official Soviet exposition was left out.[88] Needless to say, Moscow did not like the Estonians' insubordination and used every possible means to stop the direct shipping of prints to international exhibitions, including putting stricter controls on mail and border customs. They also prohibited local organizations, such as museums and the Art Fund (which was run by the Artists' Union), from buying works of artists who had exhibited abroad. The same artists were banned from official local exhibitions. By the middle of the 1970s it became very difficult, if not impossible, to send prints out of Estonia; smuggling by friends via Finland became the only method.

Of the major printmakers in Estonia, Peeter Ulas (b. 1934) is the undisputed master. He graduated from the institute in 1959 with Maran, Viires, and Roode. His major works date after 1965, but from the beginning he stood out by virtue of his powerful compositions, professional control of the graphic media, and masterful drawing skills. He won the grand prize at the First Baltic Graphic Triennial in 1968 and prizes at the following Triennials until 1983. He was never considered a nonconformist artist because by the time he began to exhibit his surrealist works at graphic exhibitions, they were acceptable, even if not favored. Neither was he totally a *persona grata*, because he refused political commissions and never compromised himself. The art critic Boris Bernstein has appropriately called him "the leading outsider."[89]

In 1968, Ulas exhibited the *Victim*, a powerful early work. It looks like a cross section of the underground, with the forms flattened and close to the picture plane. The large, black, diagonal form, running from lower left to upper right, resembles a decayed body, or the remains after a bombing. The black shape has a compositional affinity to Kristjan Raud's *Death of Kalevipoeg* (fig. 1, p. 36), the nineteenth-century Estonian epic hero. The form, patterned with biomorphic objects in black and gray, makes the work seem monumental despite the finely textured, detailed picture plane. The composition looks abstract, but the method of detailing the picture surface is surrealist. According to the artist, the inspiration for the work was a side panel of an altar at the medieval St. Nicholas Church, which depicted a saint's body covered with wounds. The artist once described the *Victim* to the author as "a cosmic view through the body in the darkness of the night."

Clouds on the Farmyard (1970), *Pompeii* (1971), and *Night* (1971) contain sinister undertones of destruction and doom. In *Clouds on the Farmland*, the heavy, monumental, and seemingly solid clouds have descended on the fragmented remnants of log buildings. The forms are, however, suggestive rather than descriptive, and the overall effect is abstract, with the three-dimensional, fragmented forms crowded close to the picture plane in shallow space.

During the mid-1970s, Ulas became preoccupied with intricate spatial depths and complex, fibroid, surrealistic forms (fig. 24). In the *Building* (1973) and *Look* (1974; fig. 25), the figures and unidentifiable details are crowded into a deep, multidimensional and multilayered space with numerous vanishing points.[90] In the early eighties, Ulas's formats became larger. He often used three or more plates with embossing on each print, as in *Black, Black, Black* and *Air, Air, Air* and *Roar, Roar, Roar*. The shallow space and flat picture plane with intricate details—for instance, with different shades of blacks on black—are still affiliated with surrealist stylistic inventions rather than abstract expressionism. According to the artist, the dark pictures of those years relate to his personal depressions

FIG. 24. [LEFT] Peeter Ulas, *Evening*, 1974. Aquatint and etching with embossing, 90.1 × 63.8 cm. Dodge Collection, ZAM, 05731.

FIG. 25. [BOTTOM] Peeter Ulas, *Look*, 1974. Soft-ground etching, 65 × 89.9 cm. Dodge Collection, ZAM, 02505.

FIG. 26. Viive Tolli, *Pirita II*, 1982. Etching and aquatint,
61.5 × 57.6 cm. Dodge Collection, ZAM, 02685.

resulting from tragic events in his family but may be inspired as well by works he saw during his trip to Canada and the United States in 1978.[91]

Tolli, Tihemets, and Klar are three women among the innovators in printmaking technique during the sixties. Tolli's favorite subjects up to 1965 were fishermen and rural Estonian coast dwellers. Although her subjects conformed to Socialist Realism, her treatment of them did not. Her pieces had nothing in common with the "Severe Style" of the late fifties and sixties but were, instead, intimate, decorative, and dreamy scenes of seaside villages and the people inhabiting them, reflecting the influence of Estonian mythology and poetry and, possibly, printmakers in Lithuania. Tolli graduated from the art institute earlier, in 1953, and came under the influence of modernism during the mid-1960s. She broke away from the realist style with etchings that depicted subjects of nature, like *Closed Garden* of 1966, and folklore, like *The Traveling Lake, Lake above Town*, and *The Grave in the Lake*, all of 1967. *Closed Garden* was exhibited at the Tallinn Art Hall youth exhibition in 1966. Her works have surrealistic distortions and juxtapositions of objects and are patterned with stylized floral motifs that resemble the decorations on Estonian folk costumes. The later works of the seventies and eighties are freer but still lyrical and intimate. Most of her etchings have a distinct ethnic and mythological orientation, where fragmentary images and different viewpoints from medieval architecture in Tallinn and Estonian mythology have been juxtaposed to form an indirect protest against the Soviet demands (figs. 26 and 27). Her drawings have a more minimal quality and a tension that is often absent in the finished prints (fig. 28).

FIG. 27. [TOP] Viive Tolli, *Hari Island*, 1967. Etching and aquatint, 58 × 54 cm. Dodge Collection, ZAM, 19404.

FIG. 28. [LEFT] Viive Tolli, (Untitled), 1977. Ink, crayon, and graphite on paper, 63.6 × 49 cm. Dodge Collection, ZAM, 08734.

FIG. 29. Evi Tihemets, *World of Games IV*, 1978–79.
Lithograph, 62.5 × 46.8 cm. Dodge Collection, ZAM, 05574.

FIG. 30. Concordia Klar, *Outside the Snowstorm*, 1978. Etching and aquatint, 48.8 × 61 cm. Dodge Collection, ZAM, 05628.

Evi Tihemets was the only printmaker in Estonia during the sixties and seventies to experiment with color (fig. 29). During the late sixties she began a series of totally abstract lithographs that were different from anything done in either print media or painting. In the *Poet* (1971), a portrait of Paul-Eerik Rummo (b. 1942), the most acclaimed young poet in Estonia at the time, she has combined the abstract silk-screen technique with a photolithograph. Rummo was repressed because he refused to make changes demanded by the censors in his latest book of poetry. Tihemets represents him with a large, square, abstract form in reds hovering over his head, a pink line running through his head, which he holds with both hands as if protecting himself. The blue line intersecting his heart may symbolize purity, while the pink at the head could stand for political pressure.[92] At the time, Tihemets's portrait made a strong impact in Estonia, showing protest against the repressive system and siding with a dissident poet. Tihemets has produced an interesting self-portrait, *I, Barefoot* (1979), where she has combined photo-etching for the upper part of the body on one plate and soft ground etching on the lower plate

with an elongated, extended dress and bare feet pointing at the spectator. During the eighties she was preoccupied with landscapes of Taburla in northern Estonia, where she spends her summers in a fisherman's small cottage.

Concordia Klar graduated from the art institute in 1963. Her works have always been surrealist inspired. After 1973 she began to depict women as subjects in all her prints. She has given her women the roles of creators and participators in areas where they would customarily not be visible. She poses questions about women's roles as participants in medieval buildings, domestic areas, and nature, and shows how women have been actively intertwined everywhere.

She is married to Peeter Ulas, but her lyrical prints are quite different from his monumental works. Her etchings depict women with elongated bodies, bare breasts, and long dresses, playing on fantastic musical instruments that seem to have been transformed from the kitchen sink, the gas stove, and the laundry basket, or blowing flute-like instruments and creating the large floral motifs used on Estonian folk costumes (fig. 30). One series won the first prize at the Baltic print

FIG. 31. Herald Eelma,
Man with a Fish, 1982.
Lithograph, 78.8 × 60.4 cm.
Dodge Collection, ZAM, 05705.

Triennial in 1977. During the second half of the seventies and into the eighties, she continued to depict women in different roles. Sometimes they are shown outside in nature weaving fantastic creations, and at other times they are integrated into medieval buildings and the old city of Tallinn.

Eelma and Laretei graduated from the art institute in 1959 with Ulas, Viires, and Roode. Both were influenced by the "Severe Style" and combined it with surrealist distortions (fig. 31). Eelma exhibited at the Krakow print Biennial in 1968, but his best work was done during the 1970s. In drawings of that time, he has shown both the present and the future by depicting figures and objects in various stages of completion and leaving some picture space unfinished, suggestive of forms not yet realized.[93] Eelma's work at this period may have also been influenced by the ANK artist Marju Mutsu, to whom he was married.

Palm, another important Estonian artist, graduated from printmaking but turned to painting during the seventies and is now known for his powerful surrealist compositions (fig. 32).

Vello Vinn (b. 1939) graduated from the art institute's glass-making class in 1968 after first studying English at the University of Tartu. He exhibited his prints soon after graduation at the international graphic Triennials and Biennials. His first international exhibition was the graphic Biennial in Krakow in 1970. His *Sandglass* of 1970, a surrealist work, was the first Estonian print to win an international prize in Ljubljana in 1972. His prints were also exhibited at the Venice Biennial in 1972, where the younger artists associated with the ANK group had joined forces with the older printmakers. Vinn was a prolific printmaker, and his unique work reflects boundless imagination (fig. 33).

The 1960s saw intense experimentation in Estonian

FIG. 32. Jüri Palm, *The Mystery of the House*, 1979.
Oil on canvas, 111 × 191 cm. Dodge Collection, ZAM, 05228.

art. During this short period, three distinct artists' groups were formed: the ANK in Tallinn in 1964, the Visarid in Tartu in 1967, and Soup '69 in Tallinn. In Estonia, both abstraction and pop art seem to have been true expressions of individual freedom, and several younger artists who employed these styles totally defied the increasing political pressure of the Brezhnev era and the intimidations and restrictions that followed. Here the charismatic personality and enormous influence of Tõnis Vint, in many ways the spiritual father of the Estonian avant-garde, motivated two generations of artists. Vint himself was the heir of both Sooster and Maran. He inherited from them not an artistic style but an intellectual curiosity and drive toward originality combined with philosophical depth and a refusal to compromise with the authorities in any way whatsoever. As Sooster had been before him, Vint was the undisputed leader and activist within the

artistic community during the later 1960s and 1970s, and he was a bridge between different artists, groups, and nationalities. Like Sooster and Maran, Vint organized regular studio meetings of his students and other creative persons in his apartment.

While still a student at the art institute in Tallinn in 1964, Vint was one of the organizers of the ANK group of young artists. This pioneering artistic group of the 1960s was a heuristic movement whose aims were to hold exhibitions outside the official system, to exchange theoretical ideas, and to organize private seminars on modern art, all of which were neglected by the art institute. ANK, especially Tõnis Vint, also influenced artists not actively involved in the group, including many beginning younger artists.[94]

The original ANK group had ten members, five young women and five men. Besides Tõnis Vint, the group comprised Jüri Arrak (b. 1936), Kristiina Kaasik

FIG. 33. Vello Vinn, *Exchange*, 1977. Etching, 48 × 63.5 cm.
Dodge Collection, ZAM, 03856.

(b. 1943), Tõnis Laanemaa (b. 1937), Malle Leis (b. 1940), Marju Mutsu (1941–1980), Enno Ootsing (b. 1940), Tiiu Pallo-Vaik (b. 1941), Vello Tamm (1940–1991), and Aili Vint (b. 1941).[95] Before participating in the exhibition, these artists had already begun their studies at the art institute. According to Arrak, ANK, rather than the institute, played a major role in his artistic development, and other artists have seconded this opinion.[96] ANK began with a student-organized exhibition in 1964. The group's activities during the next three years were intense. More informal exhibitions were organized in Tallinn, Tartu, and southern Estonia. ANK offered lectures on twentieth-century literature, notably the works of Jean-Paul Sartre, Eugene Ionesco, Albert Camus, and Samuel Beckett, as well as on Freudian psychoanalysis; regular meetings with students of the conservatory included seminars on contemporary music, concerts, performances, and staging of absurd plays. The group held unofficial meetings with young intellectuals and scientists and poetry readings with students at Tartu University. It also organized exhibitions, concerts, and performances in southern Estonia.[97]

In 1965, the group visited Leningrad to collect reference material for seminars on twentieth-century Russian avant-garde art and to visit the studios of Russian underground artists Evgenii Rukhin, Mikhail Chemiakin, and Larin.[98] Later during the same year, artists from Leningrad visited Tallinn. Back home, the group organized a conference with lectures on Kazimir Malevich, Wassily Kandinsky, Marc Chagall, Antoine Pevsner, Naum Gabo, and Natalia Goncharova. Arrak discussed the theories of Kandinsky and Malevich; Tõnis Vint lectured on pop art, op art, and new realism; Enno Ootsing's topic was the art of Marc Chagall. Vint, Arrak, and Ootsing organized most group activities, while Vint was also the main ideologist. Of the young women, Pallo-Vaik and Mutsu wrote articles and gave presentations. ANK operated within the official Üliõpilaste Teaduslik Ühing (ÜTÜ; Students' Academic Association of the Art Institute). The broad-minded professor Leo Soonpää often defended the group against suspicious teachers and supported its avant-garde activities.

Tõnis Vint, who had been in Poland in 1966, organized a tour there in 1968 for the ANK group and other Estonian artists. Enn Põldroos organized another trip in 1970. By this time the works of Vint, Arrak, Vinn, and Alex Kütt (1921–1991) were exhibited at the International Graphic Biennial in Krakow, where Vint and Arrak received purchase prizes.[99] The younger Estonian artists Mare Vint, Marje Üksine, Silvi Liiva, and Kaisa Puustak were then associated with ANK, while Toomas Vint, Meel, and the sculptors Villu Jõgeva, Jaak Soans, and Kaarel Kurismaa were influenced by its activities. Lapin has gone so far as to claim that everything new in the works of younger artists began in ANK and that its activities often transcended the barriers of visual arts and were interrelated with avant-garde music and literature.[100]

ANK also organized a television program about its members' work, but the film was never shown. Nonetheless, in 1966 the young artists managed to slip by the censors and get a full page and a half of articles in the official youth newspaper *Noorte Hääl*. The articles, written by Marju Mutsu, Tõnis Vint, Tiiu Pallo-Vaik, and Enno Ootsing, detailed their activities within the Students' Academic Association without mentioning the name ANK. Marju Mutsu discussed the joint interdisciplinary ventures with students from the conservatory and seminars on literature, theater, and philosophy, while Tõnis Vint wrote about the collaboration with young scientists and astronomers and stressed the importance of science and technology in contemporary art. He wrote that the conceptions of artists reflect the discoveries in science and "when the technical equipment, installations of chemical laboratories, and the charts, tables, and photos of electrons become a natural part of our everyday life, this will also be reflected in the works of artists and eventually result in a change of our understanding of beauty and the meaning of art."[101] Such ideas would become very important during the 1970s, especially for Raul Meel and the kinetic artists Jõgeva and Kurismaa.

In 1967, the ANK group visited Sooster in Moscow for the first time, although Tõnis Vint had been there earlier. They met Kabakov, Sobolev, and Yankilevsky, with whom they formed lasting friendships.

While the mature style of the ANK artists developed in the early 1970s, the sixties were still a period of experimentation. Tõnis Vint's drawings of 1964 and 1965 alternated between surrealist-inspired figurations and abstraction. Between 1964 and 1970, his art underwent several stylistic phases until it reached a geometric minimalism. At the 1964 exhibition, his work was probably the most abstract and minimal. Arrak was

FIG. 34. [TOP] Jüri Arrak, *Composition with Two*, 1964.
Linocut, 49.7 × 58 cm. Dodge Collection, ZAM, 09028.

FIG. 35. [BOTTOM] Enno Ootsing, *Composition
with a Brown Frame*, 1968. Linocut, 48 × 75.5 cm.
Dodge Collection, ZAM, 18624.

interested in surrealism at this time, but also created abstractions and assemblages combining found scrap objects and figurative painting (fig. 34). Ootsing's work vacillated between abstraction and surrealism (fig. 35), while Pallo-Vaik did interesting abstractions during the sixties (fig. 36). Tõnis Laanemaa focused on etching technique, and his works during the sixties often had surreal distortions. Leis (fig. 37) preferred abstraction during the early sixties but also developed an interest in pop art toward the end of the decade. Aili Vint was interested in color theory and did op-inspired abstractions, while Mutsu had already developed the style with surrealistic fragmentation and sensitive use of line for which she was known (fig. 38). Kristiina Kaasik's small abstractions exhibited at the 1966 youth exhibition were inspired by both the surrealist artist André Masson and abstract expressionism. Vint demanded originality and quality from the group as well as an uncompromising political attitude. The artists never were united stylistically; each developed in her or his own direction. Except for Kaasik and Leis, the emphasis on linearity and flat planes was characteristic of the ANK group, as opposed to the painterly abstraction of the earlier Tartu group. Later, under Vint's influence, the artists of the ANK circle gradually developed a tendency toward geometry and reduction that culminated, during the seventies, in a "school" of geometric abstraction.

In 1967, Kaljo Põllu (b. 1934) organized a group of young art students called the Visarid at the art studio of Tartu University, where he was the resident artist. The loosely knit group consisted mainly of students from different departments of the university. The official role of the studio was to give future teachers skills in art so that they could teach in rural areas, but Põllu developed it into an intellectual center where students from different departments mingled and discussed issues. Põllu was for the Visarid, even more than Vint was for ANK, the ideologist and the generator of ideas; he was also the only professional artist in the group. Although the Visarid group was in Tartu and Põllu's aim was to energize and intellectualize local art, it also had a great impact on the art and art theory of all Estonia. Põllu, who came from Tallinn and had graduated from the art institute there, had better connections with artists in that city than in Tartu, where his influence seems to have been greater on literature, language, history, and science students than on the Tartu

FIG. 36. Tiiu Pallo-Vaik, *Composition*, 1967. Tempera on paper, 64 × 64.7 cm. Dodge Collection, ZAM, 18633.

art community. Only one other professional artist, Rein Tammik (b. 1947), developed from the group. Nevertheless, under the leadership of Põllu, the Visarid was extremely important in two areas. First, with its publications and discussions, the group disseminated information on Western art to artists and art students throughout Estonia. Second, it introduced pop and op art to Estonia on a broader scale by organizing exhibitions and seminars.

The group translated and circulated, in typewritten manuscript form, international texts on contemporary art.[102] Even more important was the Visarid's publication of four albums between 1968 and 1970 with articles by internationally established authors. These albums were also typewritten manuscripts in editions of fifty.[103] For many Estonians, these translations were the only sources on the theory of contemporary art. According to Põllu, who was the editor, the group was well aware of all the trends in Western art. He has claimed the difference in the time of appearance between Paris and Tartu was often only a few weeks.[104] The difference between ANK and the Visarid was that

FIG. 37. [TOP] Malle Leis, *Exchange*, 1968.
Oil and watch parts on canvas, 74 × 116.5 cm.
Dodge Collection, ZAM, 16815.

FIG. 38. [BOTTOM] Marju Mutsu, *Early
Morning*, 1970. Etching, 44.4 × 40.9 cm.
Dodge Collection, ZAM, 19408.

FIG. 39. Kaljo Põllu, *Jump*, 1971. Aquatint and photo relief, 49.2 × 37.9 cm. Dodge Collection, ZAM, 18732.

the latter had contacts with the West rather than with Moscow. Information often came via Czech, Polish, Hungarian, and Finnish sources as well as through the local university library, where Põllu had good connections. It should be emphasized that all the publications were "unofficial" but legal in that editions of fewer than fifty copies did not need permissions from the Ministry of Culture and could thus escape censorship. Furthermore, the texts always specified on title pages that the translations were to be used as educational aids for students at the university art studio.

The Visarid and Põllu organized exhibitions of their own works and works of other artists, several in conjunction with young artists in Tallinn (figs. 39 and 40). They introduced op art, pop art, and assemblage to the student exhibitions. ANK had several meetings with the Visarid, and communication between the two groups was close. Tõnis Vint wrote the leading article

for the first Visarid album, where he expounded his own theoretical vision of contemporary art in the West by analyzing the situation in 1968. Vint's article points to many tendencies in Estonian art that were to become relevant during the seventies, and also some tendencies that differed from those of the West and of other areas in the Soviet Union.[105]

Põllu, as the only professional artist of the Visarid, was responsible for creating the stylistic tradition of the group. Around 1965 he became interested in op art (fig. 41). In 1967, in an article in the University of Tartu's newspaper, he described op art as a reflection of the urban and technological world that uses elements based on scientific color theory, games with perspective and depth, and commercial materials to achieve optical effects. He illustrated the article with a work by the Hungarian artist Victor Vasarely (1908–1997), who resided in Paris.[106] Põllu's interest in op art

FIG. 40. Kaljo Põllu, *Fear*, 1967. Etching, aquatint, and photo
relief, 41 × 36 cm. Dodge Collection, ZAM, 18734.

culminated in 1969, when he received by mail a dedi-
cated copy of a recent catalogue from Vasarely in re-
sponse to Põllu's sending Vasarely his article on op
art;[107] somehow the parcel had escaped the notice of
the Soviet censors. This catalogue, of which only loose
pages remain today, became a source of inspiration for
many younger artists during the seventies. By this
time, Põllu was past the op phase of his art and was
instead preoccupied with pop-inspired assemblages.
Still, his op-inspired kinetic objects and metal assem-
blages of the late sixties and early seventies were ex-
ceptional in Estonian art at this time, as were his later
pop paintings, prints, and assemblages (fig. 42). In
1969, Põllu also constructed windmills in the ocean at
a happening during a youth camp at the beach of
Kabli, and a group from the Visarid experimented with
"air art" on the same beach.[108] The ANK artists were
also present at Kabli, and the younger "Soup" art-
ists organized a performance there. The Visarid dis-
persed in 1972, after which Põllu's preoccupation with
ancient Finno-Ugric culture, linguistic theory, and
mythology took precedence and eventually resulted in
a total change in his style.

The Besides Põllu, Rein Tammik was the most talented
younger artist of the Visarid. He joined the group in
1969 while he was a student at the Tartu art school,
where both Lola Makarova and Ilmar Malin were
teaching. His early pop paintings show commonplace
objects in unexpected juxtapositions. Later, during the
1970s, he used slides and painted hyperrealist works
with banal, commonplace, sometimes even anecdotal
subject matter (fig. 43; see p. 115 for further discussion
of this work).

The last artists' group to be formed in Estonia dur-
ing the sixties and the last one before the Estonian in-
dependence in 1991 was Soup '69. The founding mem-
bers were Ando Keskküla (b. 1950), Leonhard Lapin
(b. 1947), and Andres Tolts (b. 1949). Tolts and Kesk-
küla had been students in the design department of
the art institute, while Lapin had studied architecture.
All three artists were to make a major impact on Es-
tonian art during the seventies. The pop-inspired Soup
period was a short interlude and helped free them
from the academic teaching of the institute. The
group began with an exhibition at the Pegasus Café, a
popular gathering place for writers, artists, architects,
musicians, and actors in Tallinn. Students of the art in-
stitute often showed experimental works there. Lapin

FIG. 41. Kaljo Põllu, *Op-Composition No. 7*,
1966. Linocut, 38.2 × 27.2 cm. Dodge Collection,
ZAM, 18730.

claimed that his poster design announcing the exhibi-
tion depicted "Andy Warhol's open soup-can."[109] The
texts on Lapin's can, however, referred to Estonia. It
reads "SOUP 69, ERKI ÜTÜ" (Standing for the Stu-
dents Academic Association of the Art Institute), and
in the middle it lists the names of the participating
artists: Olevi Eljand, Ando Keskküla, Leonhard Lapin,
Gunnar Meyer, Rein Mets, and Andres Tolts. Hence,
while the open soup can pointed to Warhol and Amer-
ican pop as an inspirational source, the texts clearly
show an Estonian content. The artists referred to their
deliberately homespun version as "Union Pop" or "So-
viet Pop." According to Lapin, Soup '69 did not directly
borrow from American pop. While the idea of in-
cluding banal, everyday subject matter and the use
of ready-made objects came from the Americans,
the subject matter itself was always local, incorporat-
ing Soviet furniture and cheap, kitsch objects. Tolts

FIG. 42. Kaljo Põllu, *Horizon Line*, 1968.
Aquatint and photo relief, 38 × 32.7 cm.
Dodge Collection, ZAM, 18733.

painted an old headboard for the exhibition. Ando Keskküla showed *Head in the Basin*, an object assembled from the broken head of a discarded bronze sculpture glued onto an old enamel basin, which formed a halo-like circle around the head, on which he had glued his own hair that had been cut off when members of the group were arrested after a happening-performance in Pirita in a "forbidden zone" on the Baltic Sea.[110]

Lapin exhibited the first version of *The Rabbit's Kiss* (*Jänku suudlus*). According to the artist, it was an enlargement from a popular postcard reflecting Soviet Estonian mass culture. The linear forms and flat color planes resemble comic strips and illustrations in children's books. Pictorially, the picture can be compared to Andy Warhol's early pop works, such as the comic strip *Nancy* of 1961, or even more to John Wesley's copulating *Squirrels* of 1965.[111] With its decorative coloring and simplified, wistful forms, *The Rabbit's Kiss* seems, at first glance, to be an innocent Easter postcard, showing a large rabbit standing and embracing a little girl. But, upon closer scrutiny, Lapin's rabbit no longer seems innocent. The work does not depict an affectionate children's story. The rabbit is big and holds the little girl, who balances on her toes, totally in his power, seemingly licking her as if she were a forbidden piece of candy.

Does this scene have ominous undertones of imminent violence? As is evident in other works by Lapin at the time, violence seems to be very much on his mind.[112] The paradoxical, imminent violence within a totally decorative and seemingly beautiful context

FIG. 43. Rein Tammik, *In the Studio*, 1982–83. Oil on canvas,
199.1 × 257.5 cm. Dodge Collection, ZAM, 10950.

distinguishes the Estonian pop of the Soup group from its American sources. It is quite different from the direct statements of Andy Warhol's car accidents, race riots, and electric chairs. Rabbits, furthermore, carry the connotation of very active sexual and reproductive lives, and when we realize that the French word *lapin*, meaning rabbit, may actually stand for the artist himself, the work takes on a parodic, self-reflective, and autobiographical reference. It could then be suggestive of the split between self-image and the imagined self and the idea of simultaneously being and ironically observing the self, which would relate to the double vision in the postmodern contradiction, quite different from American pop.[113]

The Soup group organized three students' exhibitions at the art institute in 1969, 1970, and 1971 as well as several joint exhibitions with the Visarid in Tallinn and Tartu. Discussions and performances were frequent, and both groups were actively involved with happenings. The Soup members also participated with young musicians and actors in several performances and absurd theatrical events in Tallinn. The ANK group had its final exhibition in 1969. By this time, Mutsu was the only member still at the art institute. Both the Visarid and Soup ceased to function as groups in 1972, which marks the end of pop art in Estonia, although several artists combined certain aspects of pop in their mature works.

Although local art officials did not approve of abstraction, it was never totally prohibited in Estonia. Generally, exhibitions were much freer in Estonia than in other parts of the Soviet Union, although artists such as Vint, Lapin, and Meel often faced persecution. Sooster died in 1970, but relationships with the Moscow artists remained close throughout the seventies. Even though no new movements emerged, Estonian unofficial art was at its peak during these years. Still, the decade is also often referred to as "the period of stagnation" that followed the Czechoslovakian uprising. Party surveillance tightened, and more effort was needed to push through avant-garde ideas. Throughout the Soviet Union, especially during the Brezhnev era, private unofficial gatherings of any sort were viewed with extreme suspicion by the authorities and seen as threats to the authoritarian system. Tõnis Vint, who organized regular gatherings in his apartment to discuss art—and is still doing so to this day—paid a price for his activities. He was kept under constant sur-

veillance, his telephone was tapped, and his works were often left out of publications and exhibitions. Vint, Lapin, Arrak, Meel, and Siim-Tanel Annus were not allowed to travel anywhere outside Soviet borders until 1988, thus suffering from the normal repressive tactics used during the Brezhnev era.

Around 1980, the political climate in Estonia worsened, and the sale of works by unfavored artists was almost totally restricted. However, Norton Dodge was able to acquire major, museum-quality works by Estonian and other Baltic artists, thanks to the assistance of Elena Kornetchuk, owner of the International Images Gallery in Pittsburgh. On the one hand, the Ministry of Culture in the Soviet Union prohibited unofficial exhibitions by its artists abroad and requested that all such exhibitions and sales of art be channeled through it and its censors. On the other hand, another ministry's agency in Moscow happily sold nonconformist art for hard currency. Yet the Ministry of Culture in Soviet Estonia was never able to comprehend how artists were able to send their works to North America for exhibition.

During the 1970s, younger Estonian artists organized two large unofficial exhibitions that escaped the scrutiny of art censors and the Ministry of Culture. Tõnis Vint organized the first exhibition because his father, a professor of agriculture, was able to get permission from Ministry of Agriculture officials to use a newly built building in Saku, outside Tallinn, as an exhibition hall. Though the Artists' Union approved the list of participating artists, the artists themselves chose the exhibited works. The exhibition opened on March 30, 1973, with works by eleven artists: Leis, Mutsu, Liiva, Mare Vint, Aili Vint, Arrak, Lapin, Meel, Vinn, Toomas Vint, and Tõnis Vint. These artists formed the core of younger progressive artists in Estonia. The authorities were suspicious and their official reaction was negative, but the exhibition was widely visited and admired.

The other unofficial exhibition was organized by Lapin late in 1975 in the Institute of Experimental Microbiology in Harku, again outside the city of Tallinn. It was advertised as the "Harku Happening," a joint venture between young artists and scientists, and thus did not need the approval of the Artists' Union. Among the better-known artists participating were Kaarel Kurismaa, Lapin, Meel, Jüri Okas, and Sirje Runge. The band "Mess," led by the composer Sven Grün-

FIG. 44. Kaarel Kurismaa in front of his assemblage *Solstice* (1975) at the "Harku Happening." Photograph by Jaan Klõšeiko. Dodge Collection Archive, ZAM.

berg, played music. Kaarel Kurismaa (b. 1939) exhibited audiokinetic pop sculptures that spurted water, had flickering lights, and made sounds and movements (fig. 44). Younger artists created large-scale installations, and the whole event closed with a symposium for artists and scientists.[114] In the "Harku Happening," Meel first exhibited his series *Gold Chase*, which is now in the Zimmerli Museum collection. Tõnis Vint did not exhibit his works at Harku, but he played an important symbolic role by leading the procession of artists at the opening of the event and cutting through a paper covering the door to the exhibition room.

Besides influencing art theory, Tõnis Vint has been a major force in introducing geometric abstraction and minimal art to Estonia. He began making minimal drawings as early as the middle sixties. His mature minimal abstractions, however, date from after 1972 (figs.

45–47). Vint's drawings are inspired by his interest in the reduction in Japanese art, his studies of universal symbols, the Tarot, Russian constructivism, Estonian cubism of the 1920s, and an intense research of esoteric literature. He has always been preoccupied with the underlying universal messages of lines and symbols and how signs produce meaning in art. His works, which are mostly in black and white, with an occasional addition of red, convey energy and hidden messages by lines and other minimal signs.[115]

Vint's geometric abstractions contain a sensitive and careful organization of lines and patterns on white paper, an elegance of the graphic line, an utter simplicity of transmission of the structure and the idea, a lightness and clarity, which in the end produce energy and tension with minimal lines and dots. His compositions have an evocative power beyond their immediate visible structure.

FIG. 45. [TOP] Tõnis Vint, *Four Dots in Space II*, 1972. Ink on paper, 61.7 × 60 cm. Dodge Collection, ZAM, 02988.

FIG. 46. [LEFT] Tõnis Vint, *House on the Mountain Side*, 1980. Gouache over lithograph, 69.6 × 62.4 cm. Dodge Collection, ZAM, 09549.

Siim-Tanel Annus (b. 1960), a young student of Tõnis Vint who began attending Vint's studio sessions around 1974 and continued for over a decade, has described Vint's activities and teaching in Estonia during the seventies and eighties:

> Tõnis Vint's school was very different from all others in Estonia and it was an exception in the previous Soviet Union.... The geometrical art of the seventies ... goes back to the Estonian constructivist artists of the twenties. However, there is still a great difference between their creation [and Vint's].... Looking at Vint's meditative figures one can think of Jung's theory of the collective unconscious, the ornaments of the Estonians, and the analysis of the Ying-yang energy line. Chinese I Ching helps to interpret the new and old structures that appear in art and culture.[116]

Annus explained, "The method of teaching in Vint's studio is empirical. It is not based on traditional drawing and the (traditional) cognizing of form. The contact with the surrounding is achieved by the penetration into oneself and into one's own inner world.... To make art was not the only aim in his studio. Art was the means to spiritual opening."[117] Over and over we see the spiritual content in otherwise seemingly nonobjective Estonian works.

During the mid-1970s, Vint began combining his geometric abstractions with what Johannes Saar calls "the archetypal female figures," which have been compared to Aubrey Beardsley's art-nouveau illustrations (fig. 48). Vint characteristically gives the female figure the same structural value as geometric forms and uses the female form as an integral part and a sign in his aesthetic programs. He has claimed that the images in his works stand for ideas from the "other side."[118] Sometimes, especially in Vint's works of the 1980s, one wonders to what extent these figures represent the artist's own unconscious Jungian feminine anima aspects. His pictures become like game boards where "a certain mysterious oracle, a timeless field exposes with magic clarity connections that otherwise are invisible to our eye."[119]

Though reflecting politics and outside events in his works is not Vint's primary intent, his architectonic compositions do express the general political tightening of the Brezhnev era. He achieves this by using closed compositional directions or "roads" with "barriers" and hindrances that the viewer encounters before

FIG. 47. Tõnis Vint, stage design and costumes for *Post Station* by Rabindranath Tagore, 1983. Photograph by Ene Kull. Collection of Eda Sepp.

FIG. 48. Tõnis Vint, (Untitled), 1975. Lithograph, diam. 20.4 cm. Dodge Collection, ZAM, 06871.

reaching the central structural emphasis. Round black dots, although compositional devices, may also be reminders of World War II bombings, about which Vint said at one time he had recurring dreams since childhood.[120] In terms of Juri Lotman's theory, the diverse meanings in Vint's drawings do not exist independently but are intimated in such a way as to enable us to become aware that the meaning we perceive now will be followed by other meanings, which do not occur together but flicker so that each meaning becomes a synchronous segment while at the same time retaining the memory of the previous meaning and the consciousness of possible future signification.[121] Vint's preoccupation with Jungian archetypal theories, Eastern symbolism, the semiotic meaning of I Ching, the Tarot, geomancy, and psychogeometry has influenced several younger generations of Estonian artists, and perhaps even some Russian artists who visited him in Tallinn. Preoccupation with hidden meanings is an artist's response to totalitarian pressure, and any evidence of such a response alarmed the Soviet authorities.[122]

Raul Meel (b. 1941) was educated as an engineer and represents the scientific polarity of the Estonian avant-garde. He had no formal training in art and has listed Tõnis Vint as his teacher and early influence.[123] Meel has always worked in series, a system that he claims is related directly to the scientific approach, where abstract concepts are developed in a series of experiments with different variables. Rather than to copy nature, Meel's aim has been to show eternal truths and new relationships to the environment that are not anthropomorphic.[124] After meeting Tõnis Vint at Toomas Vint's birthday celebration in the spring of 1969, Meel acknowledged Tõnis Vint as an authority. The Vints began to instruct Meel on the formal culture in art and many other things.[125] Meel's first artworks were adapted, with the encouragement of Tõnis Vint, from his early experiments with concrete poetry. Between 1969 and 1973, Meel did silk-screen enlargements of typewritten texts and patterns, which he first exhibited in Tartu in 1969. Of this series, the artist has described *Function* as a "barbed-wire fence of battlefields and state borders," *The Drum Beat* as a depiction of military functions, and *Sad*—made up of the typewritten Estonian word *kurb*—as the connecting link in the series.[126] Meel's early works were, like Tõnis Vint's, in black and white and, as he has expressed later, were

"visual expressions based on the structures of language and unifying scientific experiment and literature."[127]

The 1970s were difficult years for Estonian artists who refused to conform with the official Soviet norms. In 1972, Meel exhibited his prints with a group of Estonian artists at the Venice Art Biennial print exhibition. All works had been sent unofficially by mail and, according to Meel, not a single catalogue reached the participants of the exhibition, even though seven of them were to be sent to Estonia. After this exhibition, Soviet authorities made clear to postal officials that accepting any artwork was strictly prohibited. The artists involved were accused of having "disturbed Soviet cultural politics with unorganized art contacts"; many were accused of being instigators of scandal, drunks, egocentrics, or "dilettantes." Those who were members of the Artists' Union were pressured to promise formally never to send their works to international exhibitions independently. The artists' mail was also scrutinized and confiscated, or pages were ripped out of books and magazines. Nevertheless, the international recognition and attention also increased the artists' security at this tense time. Meel, for instance, asked his wife to notify his international connections if the authorities were to imprison him or if he were attacked, as had happened to some artists in Moscow and Leningrad.[128]

In 1994, Meel learned of even grimmer secrets from Vaino Väljas (b. 1931), Secretary of Ideology of the Estonian Communist Party's Central Committee during the 1970s. According to Väljas, the Soviet ideological leaders, with the encouragement of Mikhail Suslov, had planned to organize a witch-hunt in Estonia as a warning to everyone in the Soviet Union. Thus the situation was much more dangerous than Meel or the other artists had realized.[129] According to Meel, in 1972 it was no longer possible to order *Vitvarnij Zhivot*, the Czech cultural newspaper, which had been "an inspirational breath of air" to his generation of artists and intellectuals.[130] Meel has also written how the Russian artist Kabakov and art critic Vitalii Patsiukov took him to see the collection of George Costakis in Moscow; he described the event as an "enriching explosion."[131] Moscow, with a large number of dissident artists and libraries with foreign publications, became an important venue for information. Also at this time, the "window to Finland" opened new personal artistic contacts.[132]

FIGS. 49A–C. [FACING AND ABOVE] Raul Meel, from the series *Under the Sky*, 1973. Screen print, 65 × 62.8 cm, 65 × 63.1 cm, 64.8 × 62.7 cm. Dodge Collection, ZAM, 03666, 07074, 00088.

In 1973, Meel began a large silk-screen series, *Under the Sky*, which was made up of variations on four elemental patterns and their mirror images based on graphs taken from engineering handbooks. The series consisted of 196 different works created by shifting the images and colors. The independent prints were then combined into serial systems of four, six, eight, or more (fig. 49).[133] Meel was preoccupied with variations of these prints and series until 1979. The works were screen printed on white paper with blues and blacks. "The use of blue, black, and white for creating a sense of cosmic consciousness is usually considered obvious," according to Meel, "but these were also the national colors of the former Estonian Republic. Therefore, their use was for many Estonians a natural search for identity as well as a political act."[134] In at least one series, Meel substituted green for the blue, perhaps to confuse censors in the case of an attack.[135] By manipulating the simple images of technical graphs, Meel

FIG. 50. Raul Meel, *Windows and Landscapes I–IV*, 1986. Screen print, 100 × 88 cm (each). Dodge Collection, ZAM, 09488, 09489, 09490, 09491.

achieved a monumental cosmic series that placed him within the Sooster-Vint tradition of Estonian art. His works were seldom shown in official Estonian exhibitions, but he participated in international print shows and received many prizes during the seventies, which understandably angered local party bureaucrats.

The first screen prints of Meel's monumental series, *Windows and Landscapes*, were submitted to the Baltic graphic Triennial in 1986 and were intended to be exhibited as a single work composed of four prints, with the spherical compositions on the top and the square compositions on the bottom (fig. 50). The black silhouette of the map of Estonia assumed a vital role in the prints' composition and is the single element that recurs throughout the series. In the lower two images, the repeated map contours form square frames around the central windows with grid-like muntins; in the upper spherical compositions, the maps appear to revolve around the central circular axis. The maps are used as both compositional devices and signs with multiple meanings. As a sign, a map relates to a real place, as a word relates to an object, but we *know* a cor-

respondence between map and landscape exists, even though we can never see it. A map thus has, in Juri Lotman's terms, an iconic quality charged with meaning that a word lacks.[136] By framing his window with Estonian contours, Meel provides a reference for his place, his language, and his condition and illustrates his worldview from which there is no escape—therefore the bar-like windows, which limit his freedom and scope. The work denotes not only a political barrier but also a human condition—the "prisons" or confinements inherent to all humankind.

The upper spherical compositions, on the other hand, stand for the abstraction of "nosphere," the higher and broader cosmic aspect that forms a backdrop as universal knowledge.[137] For Meel, the cosmic ultimately involves, in the words of Pierre Teilhard de Chardin, "the consciousness of being in actual relationship with the spiritual and the transcendental pole of universal convergence."[138]

The four prints are interconnected and should be exhibited together. When viewed together as a "single solution," the work represents differentiated time that

is simultaneous.[139] When seen independently, as parts of the whole, the prints represent sequentiality. In later editions of the *Windows and Landscapes* series, the shapes of the first four screen prints have been combined into different, complex compositions on very large sheets of paper that can be viewed individually as independent works or as a series. The philosophical content, however, remains unchanged. The censors and Soviet art bureaucrats in the jury of the Baltic graphic Triennial in 1986 interpreted the two screen prints with square compositions as prison windows above Estonia and rejected them. Consequently only the prints with spherical compositions were exhibited at the Triennial. The situation caused a minor political scandal, and Raul Meel became persona non grata again. His art was censored and not allowed out of Estonia until about 1988, when the Soviet Union was beginning to fall apart. The *Windows and Landscapes* series was considered a most dangerous form of anti-Soviet propaganda in art.[140]

Meel actually began to experiment with the images of contour maps in about 1976. The best-known series is *Striped Estonia* (1980) with black, red, green, and blue ink stripes on golden serigraphic images of Estonian maps (fig. 51). His acrylic painting *Heartland Estonia* of 1981 has a large black silhouette of the Estonian map with a small silver one in its center on blue background. When I first saw the painting in 1981, Meel called it *Silver Estonia*, probably with the intention to mislead censors from reading the nationalistic flag colors into the work. At that time, he explained that he had to use silver instead of white because white appeared yellow against the black background. The silver in the heart of the painting thus served two purposes: first, to appear white, as in the old flag, and second, to mislead potential critics.[141]

In the series *Caresses* (1986–87), Meel has superimposed his own hands and forearms, freely impressed in red paint, on four gold and four black silk-screened forms in the shape of the maps of Estonia. This series, not exhibited in Estonia before 1988, was perhaps his most overt political statement; the oppressive red arms leave no doubt about the artist's intention (fig. 52).[142] In the silk-screen series *Ideal Landscapes* (1988), four black silhouettes of Estonian maps are superimposed on gold maps with varying degrees of coverage, creating dark shadows above the golden "landscapes." In 1983, in the series *Estonian Islands* and *The Story of*

Arthur and Liidia, Meel used ink cartouche outlines of the islands Saaremaa and Hiiumaa in western Estonia as repetitive forms on which his images were based. In the Soviet Union, maps were considered state secrets, and the islands around the Estonian coast as well as whole border areas were "forbidden territories" that could be entered only with special permits. Meel's map series hence can be interpreted as deliberate defiance to the Soviet regulations, as well as being symbolic representations of his space and his political and social condition. Nevertheless, the artist aims also to give his conceptual stories independent aesthetic energy so they stand on their artistic merit, where the hidden meaning may broaden but never overshadow the total effect.

Around 1975, Meel began to plan his monumental serial systems as paintings. Initially, it was very difficult for him to get the proper paints, since he was not a member of the Artists' Union, and he had to rely on friends from abroad to get them for him.[143] The series *Journey into Greenness* was to be shown at an exhibition of Estonian contemporary art at the Art Gallery of Hamilton in Canada but at the last minute, the show was axed, mainly due to the influence of Estonian bureaucrats.

All of Meel's paintings convey both a cold and seemingly neutral objectivity and a deeply personal, poetic sensibility. Even though the images on which Meel bases his large serial structures are simple, he has achieved a monumentality and dynamism that is unique in Estonian art. His work has thus been of central importance, which has been heightened by his recent large conceptual installations and fire performances.

Leonhard Lapin (b. 1947) has been called the "universal man in the Estonian art world" (fig. 53).[144] He is an architect, sculptor, poet, and theoretician who organized happenings, theater performances, and exhibitions and wrote an interesting, well-documented book on Estonian avant-garde art during the Soviet occupation—the only one on the subject—based on his personal experiences.[145] Lapin is also a professor at the Art Academy in Tallinn and editor of *Ehituskunst* (The art of architecture), a publication of the Association of Estonian Architects. Lapin, who graduated from the art institute as an architect in 1971, has published numerous scholarly articles on Estonian architecture and art and edited many exhibition catalogues.[146] He has

FIG. 51. Raul Meel, *No. 15*, from the series *This Beautiful Land Is My Home*, 1980. Screen print, 59.7 × 49.1 cm. Dodge Collection, ZAM, 07065.

listed Tõnis Vint among his early influences. By the early seventies, he was a forceful and energetic leader of the young avant-garde in Estonia. In 1969, he was a founding member of the Soup group and afterwards went through a brief period of pop art and organized several happenings with other students. His early black-and-white prints of 1972–74 have a distinct constructivist, architectonic quality. As did Vint and Meel, Lapin often worked in series.

Lapin's art has always possessed a self-reflective, self-conscious, and ironically self-criticizing quality bordering on parody, with a tendency to politicize the personal, which is characteristic of the postmodern condition (fig. 54). He comments and represents without judging. In Linda Hutcheon's terms, his art manages to reinforce as much as undermine and subvert, being "inside and outside" at the same time and combining complicity and criticism.[147] Much of Lapin's art also possesses a postmodern autobiographical reference that Hutcheon sees as another way of problematizing the centered self which challenges the notion of self-representation by both being and seeing the self at the same time with an ironical double vision.[148]

Between 1973 and 1979, Lapin was preoccupied with a monumental series of prints entitled *Machine*, in which black and white (and later silver-gray and red) forms that look like deconstructed or not-yet-constructed machines pound, penetrate like phallic clubs, and create circular energy spheres. The series evolved from abstract, minimal, geometric forms to include human figures in the *Woman-Machine* and *Man-Machine* series and culminated in depicting fauna, flora, stars, and other cosmic forms. The work is usually considered one of the first erotic series in Estonian art.

The narrow vertical shape within white space of the series' first piece, *Machine I* (1973), evolves into a cross in *Machine II* and then into more complex geometric forms. In *Machine X* (1973), Lapin uses his own name, LEO, thereby situating himself as a sign within the work and confronting the viewer directly with "I am here." The series thus becomes personal and autobiographical.

In 1974, Lapin added *Woman-Machine* to the series, and *Man-Machine* was begun shortly afterwards. In recent interviews, Lapin has pointed out that man as a bureaucrat is represented in the quadripartite

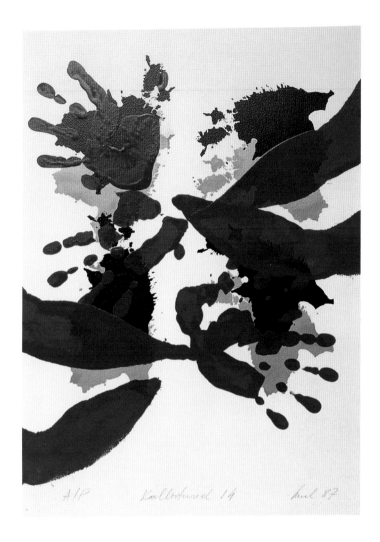

FIG. 52. Raul Meel, from the series *Caresses*, 1986–87. Screen print with artist's handprints, 62.2 × 45 cm. Dodge Collection, ZAM, 08746.

FIG. 53. [TOP] Leonhard Lapin at his studio, 1975. Photograph by Jaan Klõšeiko. Dodge Collection Archive, ZAM.

FIG. 54. [BOTTOM] Leonhard Lapin, from the series *Faces: Flowing in the Head* and *Holes in the Head*, 1972. Gouache on paper, 40 × 40 cm (each). Dodge Collection, ZAM, 15214, 15215.

Man-Machine I (1976), in which busts of men have a black circle, square, or triangle for heads, to suggest man's role as a creator of bureaucracy as well as of civilization.

When first exhibited, Lapin's *Phallus* series (beginning in 1974) was also sometimes referred to as *Man-Machine* and *Vertical*. It seems he initially conceived the phallus as a symbol for man. Furthermore, since the artist has situated himself in the series by using his name, we may assume that the phallus also belongs to him. Lapin has on occasion referred to the French meaning of his name, which extends the sense of the work to be a parody on the relationship between the word, the thing, and the name.[149] The phalluses, composed of geometric forms, some of them suggesting orgasmic experience, are shown large and erect. The exaggerated enlargement suggests a phallocentric idea of sexual energy, which in the patriarchal society has been equated with a positive creative energy possessed only by men as sole creators—hence, the idea often expressed in feminist critique that the possessors of phalluses were also those who possessed the energy to create and the power to rule a bureaucracy.

Although acknowledging the phallus as a source for pleasure, feminist critique also sees it as a source of power that may be, and often is, a cause of violence.[150] Lapin's *Woman-Machine* series has deconstructed parts of machine-like objects penetrating the puppet-like women (fig. 55). The women, generally shown in passive and receptive poses, are represented from the point of view of the man (in this case, the artist himself) in the sexual encounter as the "other" to be acted on. There is no direct emotional contact, only machine-like energy and force. The human beings have become machines and slaves of the machines of their own creation.

Though the preoccupation with the machine ideology comes from both futurist and Russian constructivist sources, Lapin's attitude is different. It no longer glorifies the machine. The machine that was initially created by man is now acquiring a life of its own, to the point where it may eventually destroy both nature and man himself. For Lapin, the new aesthetic system is one whereby man adapts and creates an "art that resonates with the needs of the industrialized machine environment."[151] The preoccupation with the man-made and the objective, everyday world is also reflected in Lapin's early interest in pop art.

In 1975, Lapin met Leningrad artist Pavel Kondratjev (1902–1985), who had been a student of Kazimir Malevich and Pavel Filonov and had known several Russian avant-garde artists of the 1920s. Kondratjev spent the summers in Tallinn with his wife, who lived there, and moved back to Leningrad during the winters to teach. For the young Estonian artists in Lapin's circle, he represented a "follower of Malevich's charismatic Suprematism and a living Classic." According to Lapin, he was a strict critic who explained to the Estonian artists theories behind the stylistic phenomena of the Russian avant-garde that were often not accessible through published sources.[152] Kondratjev had many students among the Leningrad underground artists and became a mentor, teacher, and friend to Lapin.[153] Another important event in 1975 was Lapin's visit, with his first wife, Sirje Runge, to Moscow that autumn. There they saw the Costakis collection, which made a strong impression on both artists and had a lasting effect on Lapin's art.

Lapin's oil paintings noticeably changed after 1976. He began a series of pictures dedicated to Malevich and sign paintings and prints in which he increased the semiotic potential of the written language and commonly used signs. Whereas Western pop artists were primarily interested in depicting common signs found in everyday culture and commercial art, Lapin's "signs," inspired by the geometry of Malevich's *Black Square*, have an aesthetic quality of the latter's pure forms, as well as a depth of meaning that is foreign to American pop. They relate much more to conceptualism and, in their political, contradictory content, to postmodern art.

An important autobiographical work of this period is *Signed Space* (1978; fig. 56), in which Lapin has depicted himself not as a portrait image in the traditional sense but by his printed name, as he did once before in the *Machine* series. The painting consists of seemingly empty grayish space, dark on the top and almost white below. The dense, fog-like space is counterbalanced in the composition by the large, black, block printed signature—LAPIN—in the lower right corner. The space, which the artist says relates to the Zen idea of emptiness, is painted with visible brushstrokes, the artist's personal marks, and contrasts with the impersonal "signature." We read the space in which the name appears as three-dimensional, shallow, because we associate it with other works depicting fog, smoke,

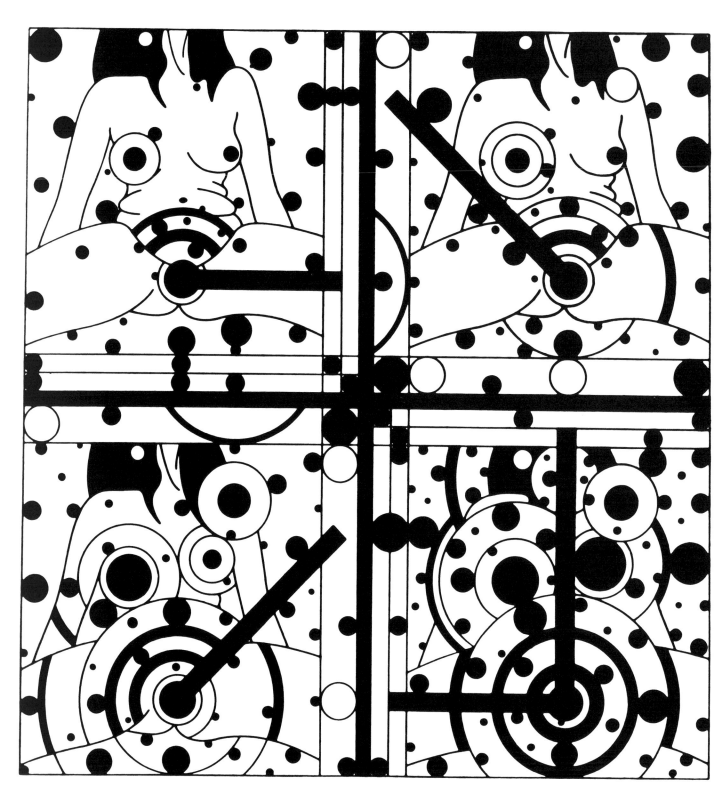

FIG. 55. Leonhard Lapin, *Woman-Machine X*, 1975,
from the series *Woman-Machine*. Screen print,
54 × 52 cm (each). Dodge Collection, ZAM, 05563.

FIG. 56. Leonhard Lapin, *Signed Space*, 1978; *Self-Portrait*, 1979; *Red Square*, 1978; *The Corner Problem*, 1980; *The Black Triangle III*, 1978. Oil on canvas, 100.5 × 90.5 cm (each). Dodge Collection, ZAM, 05311, 05314, 05313, 05365, 05312.

and dense space. But it is a deceptive appearance of space—a sign of space—juxtaposed against the sign of the artist. Lapin is playing semiotic games with a twist of irony with the process-like nature of visual perception and the resulting game-like status of art. His works require the viewer's active participation. The investigation of what constitutes a representation of an artist —an artist's signature, his brushstrokes, or his printed name—and how the art image (depiction) and the depicted nature relate to the cognitive process, the label, and the picture is central to this work and many others in Lapin's oeuvre. The painting can also be interpreted as autobiographical in the ultimate Buddhist sense and represents the culmination of almost a decade of interest in dharma. From the Buddhist point of view, the painting depicts the experience of space-like meditative equipoise of a person—the artist, in this case—when he realizes that he is no more than a sign, a name, or a label and is empty of inherent existence. According to Buddhism, what one perceives is not how things actually are; conventional reality is only a deceptive appearance of ultimate nature.

In the second panel of the series of paintings, *Self-Portrait* (1979; fig. 56), Lapin again threads the thin line between the object and the mental world. The red silhouette of the artist against a white background alludes to the official Lenin portraits decorating festivals and public gatherings in the Soviet Union. It is a banal, pop-like portrait, a political satire with a mocking, prank-like quality. In semiotic terms, the pompous Lenin portraits become a negation of Lapin's *Self-Por-*

trait, which then drives their meaning to the point of the absurd. It challenges both the notion of Lapin's self—a parodic, self-reflective view—and the notion of Lenin, which is loaded with ideology and preexisting meaning. The viewer is thus forced to reevaluate aesthetic forms and political content. Unfortunately, this work was never shown in Estonia while Lenin had political relevance.

Another panel in the same series is Lapin's *Black Triangle III* (1978; fig. 56), which consists of a large sign of a black triangle on white ground with the Russian word "end" in Cyrillic letters underneath. Only when we realize that this sign commonly appears at the end of Soviet films do we understand the image's meaning and implications. The end is not in Estonian but in Russian; hence, for the artist, it signifies a statement of the end of the Soviet Russian narrative. While originally it was perceived as a statement of dissidence, this work can now be interpreted as prophetic and visionary. The idea that the perception of the world is the perception of signs is central to Lapin's art, as is the semiotic relation between thought and the world, the relationship between art and extra-artistic reality where memory, cognition, and language have central importance.

In 1980, Lapin produced his boldest autobiographical statement: *Self-Portrait as Venus* (fig. 57), a staged photograph based on Giorgione's reclining *Venus*. The Renaissance Venus is a young maiden, facing the viewer, asleep on silk sheets and red velvet blankets in a beautiful landscape. Venus has for centuries rep-

FIG. 57. Leonhard Lapin, *Self-Portrait as Venus*, 1982. Screen print, 43 × 26.5 cm. Dodge Collection, ZAM, 15217.

resented the ultimate in female erotic beauty: naked, young, passive, an expectant receptacle for man's admiration. Her image is thus loaded with preexisting androcentric meaning.

In the photograph, taken by the architect and conceptual artist Jüri Okas (b. 1950) and duplicated into a photo etching in 1982, Lapin has placed himself in a similar pose, but his eyes are open. Instead of the landscape, a floral wallpaper (a cheap, pop-like reproduction) serves as background. Behind the bearded, naked, reclining artist and poly-foam sheets, which extend up the wall, is a black square that, according to the artist, represents Malevich's *Black Square*.[154] Lapin has exploited the power of a familiar female "beauty" image by placing it in a new and ironic context (which is, according to Hutcheon, typical of postmodern photography). By doing so, he has de-naturalized the image and made visible the concealed mechanisms that work to make them transparent and bring to the fore their politics.[155] Such parodic appropriation of the Venus image and gender reversal have also been used

by feminist artists to reveal the politics of gender, which Hutcheon calls "de-naturalizing the iconographic tradition of the female erotic nude intended for the male viewer."[156] Certainly Lapin intended to shake up gender stereotypes with his parodic and ironic manipulation of details. When exhibited in 1984, the work caused a scandal, and the exhibition was forced to close.

Lapin's self-portrait, however, is more than a parody on stereotypes of beauty and gender. Inspired by the *Black Square* and Malevich's theories, it points toward new systems of art that come from the parodic contradiction of banal, everyday surroundings (as represented by the couch, the poly-foam sheets, and the wallpaper) and the artist himself, who is now his own muse and inspiration for an intellectual and objective art. The picture can thus be perceived as the artist's credo or statement for his new art.

In 1979, Lapin began the series *Processes*, in which he experimented with minimal lines and fragmentary shapes on white paper to suggest the Buddhist ideas of

clear mind and emptiness, concepts that preoccupied him at the time. He expressed these ideas best in *Tühjus ja ruum — Void and Space*, which he published as a teaching aid in 1998.[157] The *Process* series shows the spiritual and transcendental polarity in Lapin's art, which began about 1976 with his interest in Buddhism and culminated during the eighties and nineties.[158]

While the *Process* series reflects the spiritual aspect of Lapin's art, the series *Geometrical Narratives*, begun around 1985, is again ironic and humorous. Liivak has called it "a post-modern narrative."[159] The works in the series are on white paper with black, geometric images and stylized cubist figures and objects. The subject matter is parodic, with deliberate allusions to kitsch.

Lapin's most interesting political statements during the final years of the Soviet occupation are the silk-screen sign series in which some works commemorate the infamous Molotov-Ribbentrop Pact in 1939 and others symbolize the artist's reaction against the occupation. The tension in these works lies between the decorative, calm, balanced, geometric compositions of the pictures and the grim reality of their content. For example, the silk-screen print *Freedom in Russian Style* (1989) is seemingly simple and decorative, with a Cyrillic text on four blue rectangles superimposed on top of each other. But the content becomes more sinister when one realizes that the Estonian word *vabadus*, which means "freedom," is written in Russian letters. The piece thus shows how, during the occupation, only a Soviet-imposed definition of "freedom" was possible. These works were Lapin's final statements on Soviet politics before the end of the occupation.

Jüri Arrak (b. 1936) stands outside the mainstream of Estonian art. Though an active and leading participant in ANK during the 1960s, he developed, from surrealist imagery of the early seventies, an almost representational style with which he depicted strange creatures—some half human or half animal—with distorted, generalized features. He drew his subject matter from myth, fantasy, and the dream world.

Arrak's visits with Sooster and other artists in Moscow influenced his early development. Sooster inspired Arrak to produce drawings.[160] Arrak has also claimed that Sooster's *Old Tallinn* (1964), now in the Tartu Art Museum, inspired him to use the window motif with the view into a different space.[161] In Sooster's work, a small church tower is seen through a little window in the middle of the canvas; the rest is covered with textured, stucco-like paint. The influence of this painting is evident in Arrak's linocut *Looking Inside* and in other later works. Arrak has also singled out Russian artist Vladimir Yankilevsky, whose large-scale relief paintings and erotic compositions with tragic undertones greatly impressed him.[162] Even today, one of Yankilevsky's surrealist compositions (a small, framed etching) hangs in Arrak's apartment in Tallinn. The ANK meetings and periodicals from Poland and Czechoslovakia were important also for Arrak's artistic development.

Arrak had a close relationship with many Estonian poets and writers. The surrealist poet Andres Ehin, in whose apartment Maran had his first unofficial exhibition, was a good friend. Arrak has illustrated many of Ehin's poetry books. Vaino Vahing, the psychiatrist and writer who introduced the ideas of Jung and Freud to young Estonian intellectuals during the sixties, was another good friend. In 1975 Arrak designed the scenery for Vahing's psychological one-man drama *The Man Who Did Not Fit on the Stone*. Jungian and Freudian concepts as well as the theater of the absurd undoubtedly influenced Arrak at this time. His art has a distinct literary emphasis, which is different from the mature works of the other artists in the ANK group. Arrak has said that if the visual arts were a line between music and literature, his pictures would lean toward literature.[163]

Arrak often paraphrases religious and mythological subjects. His lithograph *Fragment of Life II* (1980) echoes the Last Judgment prototypes of medieval church tympanums, manuscript illustrations, and paintings. The godlike figure, whom Arrak has depicted as an old, bearded man seated on a throne on the left side, will decide the destiny of the dead man's soul by manipulating magical objects on a table in front of him.

In addition to references to medieval Last Judgment subjects, there may be allusions to other sources in which people float out of their bodies and move into a tunnel toward light during a death experience. Arrak, however, does not give the viewer ready solutions or answers, which is what lifts the work above the commonplace. One puzzling element is the hook on the left side to which the judge-like figure appears to be attached by his coat, implying that even he is not totally free.

The world of Jüri Arrak's paintings, charcoal draw-

ings, and prints is filled with seemingly real inhabitants and objects in realistically perceived spaces. Yet it is not our world as we know it. Rather, it is peopled with strange, ageless, troll-like creatures with generalized features and distorted bodies who perform incomprehensible acts with an almost sacred seriousness. In this surreal world of dreams and fantasy, everything can happen and the unexpected becomes accepted—humans and elephants can fly, and animals have human eyes (fig. 58).

The emphasis on visionary, imaginary, even hallucinatory dream images as subject matter, as well as the formal distortions and mutilations in Arrak's art, share a common denominator with both East and West European surrealism. The surrealist preoccupation with eroticism and myth is also an important element in Arrak's world.

Masks often occur as motifs in Arrak's art, and a real face can be masking something mysterious underneath (figs. 58 and 59). His pictures combine tragic seriousness with humor. Birds, elephants, or strange humanoid figures balancing on ropes may indicate the absurd and difficult everyday life in Estonia during the Soviet occupation. Arrak has claimed that, even though his works have a surreal quality, he was depicting contemporary Soviet reality, and the subject of his art is the real life in the Soviet Union. Surrealism and the tragic absurd were thus the most appropriate expressions of the two-faced Soviet society, where real life had no relationship to official description and where the whole society was forced to live a lie. With surrealist distortions, the artist could covertly express alienation and the existential angst against the false Soviet optimism (fig. 60).

The paintings *Medieval Legend* (1980) and *Medieval Plague* (1981; fig. 61) relate to an animated film Arrak was working on at the time. Suur Tõll, a mythological giant from Estonian folklore, battles hordes of masked invaders to protect the villagers on the islands where he lives. The film, as well as other works by Arrak, refer to contemporary invaders from the Soviet Union. Officials considered his works suspicious, but since he made no overt political reference, little could be done to him except to reject his art. Nevertheless, he was watched by the KGB and never allowed to travel outside Soviet borders.

If the 1960s were a period of experimentation in Estonian art, then by the early seventies most artists had reached their mature style. Of the ANK group, besides Tõnis Vint and Arrak, Malle Leis, Aili Vint, Marju Mutsu, and Kristiina Kaasik also created important work and exhibited at the Triennials. Enno Ootsing became secretary of the Artists' Union in 1972 and kept the position until 1977. Although his work during the seventies was more within the Estonian official mainstream, he remained an important ally within the establishment for his former friends. Tiiu Pallo-Vaik painted many portraits and semi-realistic landscapes and excelled especially in watercolor. Kaasik, although she had forsaken her colorful abstractions of the ANK period, painted powerful expressionistic works with surrealist undertones. By the early seventies, all the ANK artists except Lapin and Meel were members of the Artists' Union. Lapin was accepted into the Union in 1977, but Meel remained an outsider until 1990. Of the remaining ANK group, Leis, Mutsu, and Aili Vint had important roles in the Estonian avant-garde during this decade.

Malle Leis (b. 1940) began her studies at the art school in Tartu between 1958 and 1961 and was one of the links between the artists in Tartu and the ANK group. She graduated from the stage design department at the art institute in Tallinn in 1967 and was one of the original members of ANK.[164]

During the sixties, Leis experimented with both painterly and geometric abstraction, but pop art had the most lasting impact on her mature work (fig. 62). An example of her early style is *Exchange* of 1968 (fig. 37, p. 72), in which she combined a background of essentially abstract geometric forms with pop elements, like the objects pasted into the middle area of the picture and the double profile of a man's head on either side. Geometric patterns juxtaposed with pop subject matter also appear in the works of Western pop artists at the time. The linear, deliberately archaic, emotionless face of the man's head with the back cut off by the right picture edge reflects the influence of pop art. It is a portrait of Leis's husband, Villu Jõgeva (b. 1940), and is actually a painting with a wide frame within the painting.

Another early pop-inspired work by Leis was painted in 1969, the year of the Czechoslovakian uprising, the aftermath of which shocked Estonian intellectuals. Leis's work aptly expresses the sentiments in Estonia after Soviet tanks crushed the "Prague spring." Profile heads of three emotionless bald figures with

FIG. 58. Jüri Arrak, *Masked Bird*, 1983. Lithograph,
62.4 × 46.8 cm. Dodge Collection, ZAM, 05602.

FIG. 59. [TOP] Jüri Arrak, *The Ten*, 1981. Pastel on paper, 69 × 99 cm. Dodge Collection, ZAM, 07116.

FIG. 60. [BOTTOM] Jüri Arrak, *The Jump*, 1975. Lithograph and linocut, 52.8 × 47.6 cm. Dodge Collection, ZAM, 02256.

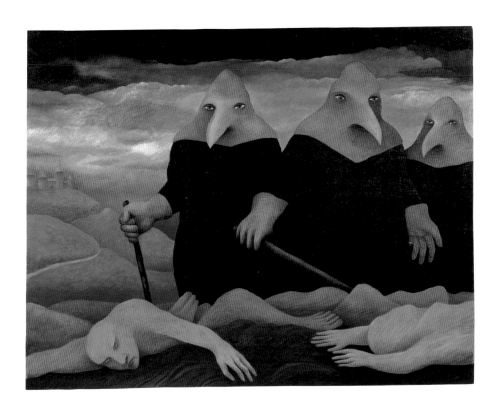

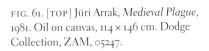

FIG. 61. [TOP] Jüri Arrak, *Medieval Plague*,
1981. Oil on canvas, 114 × 146 cm. Dodge
Collection, ZAM, 05247.

FIG. 62. [RIGHT] Malle Leis, *Greenhouse*, 1968.
Oil and tempera on canvas, 116.5 × 73.5 cm.
Dodge Collection, ZAM, 06540.

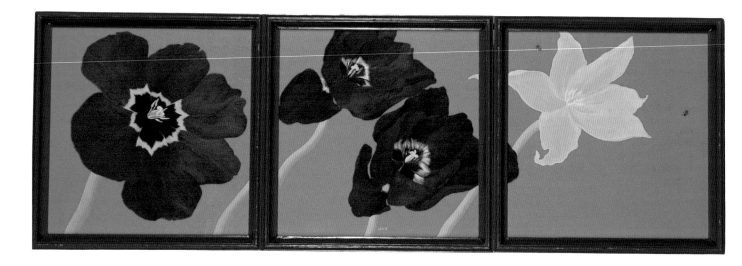

FIG. 63. Malle Leis, *Sunlight Triptych*, 1972. Oil on canvas, 68 × 202.5 × 8 cm. Dodge Collection, ZAM, 06057.

open mouths stare into the space ahead of them, each in front of a dark arch that looks like a tombstone.

During the seventies, large, bright-colored flowers and vegetables became Leis's main subject matter. She often combined the flowers with human figures, horses, or, during the eighties, rural farmhouse motifs into serial compositions of triptychs and diptychs. An early example is *Sunlight Triptych* (1972; fig. 63), in which brilliant, large red poppies and yellow daffodils spread against a flat blue background. This work relates to Andy Warhol's large *Flowers* series, which were first exhibited in the United States in 1964 and were widely reproduced and known to the Estonian artists. Undoubtedly, Warhol and the international pop art inspired Leis, but her mature flowers of the seventies are quite different and individual, and she cannot be labeled a pop artist in Estonia.

Three paintings in the Zimmerli collection, although not intended as a series, could well be exhibited as one. In all three paintings, the large plant motifs against a relatively flat, dark background form the dominating elements of the pictures and seem to be suspended in the shallow space close to the picture surface. In *The Longest Day* (1977; fig. 64), a woman's face appears in the left foreground, very close to the picture plane and with the lower part of the face cut off by the edge of the painting. Behind her, and partly beside her, as if growing out of the back of her head and suspended in space, large leaves of tulips extend diagonally from the lower left to the right, culminating in three large red blooms with black and yellow centers. Larger than the human head, the flowers seem to emerge from the dark space. Removed from their usual context, they form the dominant element of the painting. Like Warhol, Leis appropriated a subject with a long history in traditional art and displaced it from the known historical content. She has enlarged the flowers and floated them freely in space. Yet her flowers lack the banality and impersonality of Warhol's flowers; they are, instead, vibrant and suggestive of life and happiness. This is no longer pop art. Leis has raised the flowers and the plants to an iconic, life-giv-

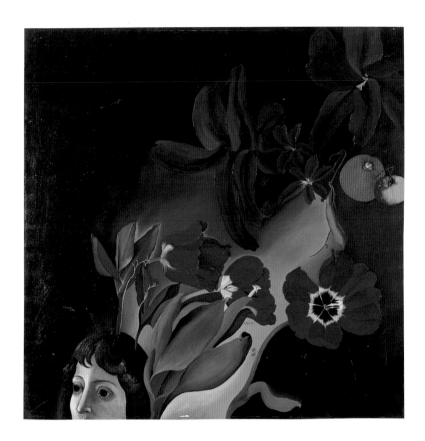

FIG. 64. Malle Leis, *The Longest Day*, 1977. Oil on canvas, 100 × 100 cm. Dodge Collection, ZAM, 06248.

ing level. Their energy starkly contrasts with the emotionless stare of the woman, who has been reduced to an object. Lapin noted that Leis's figures look frozen, animal-like. He considered them a parody of officially commissioned works, which were always supposed to represent happy workers. According to Lapin, Leis's figures also reflect the general attitude of hopelessness during the period of stagnation in the seventies.[165]

Such works are typical for Leis from around 1973 to 1985. Similar subjects also appeared in her watercolors, and she produced large series of flower and vegetable prints in silk screen, which she executed with the help of Villu Jõgeva. Leis's silk screens, with flat backgrounds and large, decorative flowers close to the picture plane, reflect an oriental inspiration, perhaps from Japanese artist Ogata Kōrin (1658–1716), whose flat, simplified floral designs were also suspended in space. Leis would often use ten to twenty different colors in one single print and then print a whole series of the same impression, each in different colors.

Aili Vint (b. 1941) studied printmaking at the art in-

stitute and married Tõnis Vint's brother Toomas. In the sixties and early seventies, she did gouache works in op-art style that reflect her preoccupation with color theory. According to art historian Heie Treier, all Aili Vint's later works illustrate her early interest in Vasarely, whom she admired immensely during the ANK period. Her early gouache series depict nature with erotic allusions—flower clusters with stamens and pistils, the forms of the female body, and abstract biological images.[166]

After 1972, Aili Vint painted mostly seascapes and became one of Estonia's most consistent photorealist painters.[167] Her seascapes, however, lacked the cold objectivity of American photorealism. She was interested in catching the mood and light of a specific moment and eternalizing it, as in *The Black Sea* (1978; fig. 65). According to Treier, the phenomenon of the sea fascinated Aili Vint because of its "ungraspable nature." Her aim was to capture on canvas the kinetics of the sea.[168]

During the early seventies and the eighties, Aili

FIG. 65. Aili Vint, *The Black Sea*, 1978. Oil on canvas, 100 × 173 cm. Dodge Collection, ZAM, 06205.

Vint was preoccupied with a series of etchings depicting female body parts. She combined photographic images with the help of mirrors into a series of erotic artworks. Treier states that Vint saw the female body as a part of nature, elemental as the sea.[169] Soviet Estonian art bureaucrats had an ambivalent attitude toward Aili Vint. On the one hand, her seascapes were accepted and admired; on the other hand, the etching series was a threat to the two-faced Soviet morality. Furthermore, she belonged to the dangerous Vint "dynasty."

Toomas Vint (b. 1944) was not an original ANK member. Initially, he studied biology at the University of Tartu until 1966, when he was drafted into the Soviet army. There he met Raul Meel. While he was serving in Severomorsk, his older brother Tõnis sent him Czechoslovakian and Polish art magazines along with other reading material, and his interest in art arose. Tõnis recalled that Toomas began to send him letters that included op-art-inspired illustrations. In 1967, back in Tallinn, Toomas married Aili Sarv (Vint) and joined the group of artists gathered around his brother Tõnis.

He has never studied art formally but received his training from his brother and his wife. After his return from the army, he associated with the ANK group and exhibited with them. Tõnis Vint has described his brother's first works as compositions in color done on paper toilet covers and hung in the family backyard, which was a gathering place for the ANK artists.[170] Meel recalled Toomas Vint's early surrealist-related gouache paintings exhibited at the artists' Pegasus Café. Toomas Vint has credited the influence of his wife and her studies of color theory for his early abstract works of the late sixties.[171] After 1970 he mainly painted landscapes, sometimes with unexpected or unusual features. Art historian Maria Shashkina refers to the pieces as half-photographic, half-primitive, half-romantic realism—which add up to more than one and is an apt characterization of Vint's art. Besides being a painter, Toomas Vint is also a writer who has published novels and several collections of short stories and written poetry.

Vint's early landscapes were happy, playful, and bright. In the landscape with a squinting girl (fig. 66),

the bright yellow sunlight dominates the painting, caressing the juniper shrubs in the background, which form a low horizon line, and the field in front of them.[172] See also *Forgotten Doll Carriage* (fig. 67).

In Toomas Vint's later paintings, as in *Rainy City* (1980), the mood is much more somber and foreboding.[173] The city contains no humans, no cars. It is like a dream landscape of a closed world—inhuman, empty, and uninviting. The mood created is as forbidding as the repressive political climate was in Estonia in 1980, when forty Estonian intellectuals wrote a protest letter to the Soviet authorities against the Russification policies of the time.

Marju Mutsu (1941–1980) was an original member of the ANK group. Enno Ootsing recalls her as a generator of ideas who wrote articles for the group.[174] She graduated from the art institute in 1969. Even early works show evidence of an original surrealist fragmentation and a sensitive, seemingly spontaneous use of line (fig. 38, p. 72). The freely flowing lines and suspended fragments in her early pieces seem to have influenced many artists, both painters and printmakers, during the seventies. Characteristic of her prints are large areas left empty, seemingly unfinished forms, and scratched, fragmentary lines seemingly floating in space on the picture plane. She was probably the first to place cut-off faces and fragments of objects on the edges of her prints and the first to use forms and lines that seem to float into the pictures, extending to the picture plane and seemingly out from the edges, giving an impression of openness. Scratches and blotches on the plate produced an impression of spontaneity, chance, and movement. She was the master of energizing large areas of empty space. Most of these features appear in the works of other artists in Estonia during the next decade. Even the passive, idle women with bare breasts combined with abstract geometric forms so characteristic of Tõnis Vint's art after 1973 appear in Mutsu's prints in 1972.[175] Mutsu seems to have generated form-ideas and in a quiet way left her imprint on other artists' works. She died of cancer in 1980 at the age of thirty-nine.[176] Her prints are lyrical expressions of anticipation, memories, change, fragrances, and sounds during a fixed and ever-changing moment between the past and the future.

Although not originally members of the ANK group, several women printmakers—Mare Vint (b. 1942), Silvi Liiva (b. 1941), Kaisa Puustak (b. 1945),

FIG. 66. Toomas Vint, *A Child on the Seaside Meadow*, 1974. Oil on canvas, 115 × 92.5 cm. Dodge Collection, ZAM, 06541.

and Marje Üksine (b. 1945)—were associated with the ANK artists, exhibited with them, and took part in their activities. Liiva, Mutsu, and Puustak graduated from the art institute in 1969. They all exhibited internationally during the early seventies when prints could still be freely mailed abroad. Liiva was a close friend of Mutsu, and their styles were similar, although Liiva's forms and objects, especially after the middle seventies, are generally more concrete (fig. 68). Liiva's early interest in surrealism is evident in all her work. Liiva and Mutsu both exhibited their works at the notorious exhibition for young artists in 1966. Liiva's work is generally more symbolic than Mutsu's and contains mystical or mythical subjects, often dream-like female figures in ritual-like activities, as exemplified by her etching *Encounter* (1976). In 1973 *The Fish* was singled out as the best print in Estonia for that year.[177]

Kaisa Puustak's art differs from Liiva's and Mutsu's in that she strives for permanence, stability, and symmetry rather than chance and impermanence. She is

FIG. 67. Toomas Vint, *Forgotten Doll Carriage*, 1979.
Oil on canvas, 92 × 70.2 cm. Dodge Collection, ZAM, 05342.

FIG. 68. Silvia Liiva, *Game I*, 1978. Etching,
49.4 × 43.8 cm. Dodge Collection, ZAM, 08363.

FIG. 69. Kaisa Puustak, *Morning Roads*, 1975. Etching and aquatint, 50.3 × 48.3 cm. Dodge Collection, ZAM, 03843.

the master of still lifes; her starting points are everyday objects, the city environment of pop art, and the exact representation of new realism and photorealism.[178] One of her favorite subjects during the seventies was the railway, for which she received international acclaim. *Morning Roads* (1975; fig. 69) represents a railway station in which the viewer is positioned directly above the tracks, which run from the foreground up to the horizon in the back. Although the railway is man-made and industrial—an object created by civilization—in Puustak's work, it has been removed from its realistic environment, purified and raised to a higher level by its symmetrical composition and its vertical parallel tracks that seem to run into emptiness and eternity.[179]

Although Puustak chooses her objects from simple, everyday surroundings, her arrangements are often arbitrary and construed, which helps lift the subjects out of their known context. *Basket with Potatoes* (1981; fig. 70) depicts a strange combination, an old, hand-plaited basket filled with potatoes and placed on an open book on a bare table. The combination of the open book and basket of potatoes with the long eyes

running upward brings to mind a poem with political allusions by one of Estonia's greatest postwar poets, Paul-Eerik Rummo (b. 1942), who was persecuted during the 1970s for not allowing censorship of his poetry.[180] Rummo was one of the forty intellectuals whose name appeared on the "letter of forty," a document sent to *Pravda* and the Soviet ministries in Moscow in 1980 protesting the repressive means of Russification of Estonian schools. The letter led to a political witch-hunt against the prominent scholars, writers, and creative people who had dared to sign it and put careers at stake. The year 1981 was very difficult for intellectuals and free-minded artists in Estonia, and Kaisa Puustak's *Basket of Potatoes* was one way of alluding to these difficulties.

Marje Üksine also represented everyday objects and events in her work. Her early interest in surrealism is evident in the *Bathers* (1973), which alludes to works of André Delvaux. Forms with parallel lines, common in her prints, give an impression of movement or passing time. She also combines abstract geometric elements with realistic imagery, and the use of photography is evident in her work.[181] The etching *On the*

FIG. 70. Kaisa Puustak, *Basket with Potatoes*, 1981. Aquatint and etching, 40.4 × 56.4 cm. Dodge Collection, ZAM, 02401.

Narva Road (1977) represents a girl skipping a rope, her body rendered with horizontal parallel lines. Lines in the sky and the buildings in the background create the appearance of movement, as if the wind is blowing. As a contrast, square and rectangular black forms close to the picture plane cast shadows behind them and destroy the otherwise realistic impression of the scene. The juxtaposition of abstract forms against an otherwise realistic background is characteristic of much of Estonian art during the seventies. During the early eighties, the abstract forms in Üksine's compositions become freer and more expressionistic, as in her self-portrait *One Awaiting* (1983; fig. 71). Üksine then began doing color lithographs in which the juxtaposition of the objective landscape background and the abstract forms is more marked. The colorful, expressionistic structures become central to the composition of the prints and dominate the background landscapes.

Mare Vint (b. 1942) did not belong to the original ANK group, but she was in a special position as wife of Tõnis Vint, whom she married in 1967, when she graduated from the art institute. She had studied glassmaking while at the institute but took a different direction under the influence of her husband, who inspired and educated her and argued with her when she didn't want to do the constructivist works for which he felt she had a special predilection.[182] For two years, she taught at a secondary art school, but after 1969 she devoted her time entirely to her art. Another early influence was Maran, of whom she has said, "Maran was the guru and half-god for ANK. I remember how happy I was when Tõnis Vint said we are going to visit Maran and promised to take me along and Maran talked about art and we listened."[183] Although Mare Vint did some constructivist abstract drawings during the sixties, her mature art was based on nature. Her early preoccupation with constructivism and her interest in Josef Albers (1888–1976), as well as her close in-

FIG. 71. Marje Üksine, *One Awaiting*, 1983. Etching, 56.3 × 58.4 cm. Dodge Collection, ZAM, 03578.

teraction with Tõnis Vint, would, however, remain a basis for all her later landscapes. During the seventies, she began doing lithographs and won prizes at internationally established drawing and print biennials. Her work seems deceptively minimalistic. The mature works are landscapes drawn with pen and ink or colored pencil and, after 1973, on the lithographic stone. In the lithographs and pen-and-ink drawings, she does not shade the forms but instead uses small dots or intricate repetitive linear patterns for the darker areas, which have an effect of flat planes (fig. 72).

A characteristic work is *Garden III* (1975), for which she received a prize at the print biennial in Ljubljana.[184] The print is made with schematic lines and dots that create flat shapes close to the picture plane. She has constructed a purified and ideal park landscape with a high wall and stairs in the center of the picture, which lead up to a gate framed by pillars topped with empty flower pots on either side. The wall

and stairs have been rendered mechanically with a draftsman's precision. On first sight, the image appears to be straightforward—a park with stairs leading up to a higher level surrounded by a wall. On a closer look, however, it becomes evident that the two bushes in the foreground may actually be treetops and the space between them another sky, since it is dotted in the same way as the sky above. The wall, thus interpreted, would be suspended in air. Likewise, on closer scrutiny, the steps on the stairs cannot be walked on. What happens on the other side of the stairs is also unclear; there may be a platform one can walk on, or the trees on the other side may be lower down and the steps and the gate lead to nowhere. The longer we look at Mare Vint's ideal landscape constructions, the less certain we are about them and the more questions we have. In the end, the clarity of the composition and the tension between the deliberate flatness and linearity of the forms and the recognizable but simplified landscape create a dy-

FIG. 72. [TOP] Mare Vint, *Underground Passage*, 1978. Lithograph, 64.9 × 60.3 cm. Dodge Collection, ZAM, 03079.

FIG. 73. [BOTTOM] Mare Vint, *Greenhouse in the Snow*, 1979. Lithograph, 65 × 62.2 cm. Dodge Collection, ZAM, 03974.

namism in the deceptively simple, minimalistic works. Mare Vint has pointed out that

> I have always been interested in the concept of many horizons because the horizon as one line actually does not exist. Therefore I often use several, it does not matter how many I use. It is the same with the sky. It does not matter if it is the sky or land. I like borderline situations where something almost is, but not quite. Stairs that may not lead to where one expects, bridges on which one may not be able to walk, contours of bushes that are like maps. Fences, barriers, borders and boundaries fascinate me. Boundaries between what exists and what does not, what seems and what is real.[185]

Mare Vint's combination of the real and ideal, her scrupulous sense of design and clear composition, and the images of perfect harmony with classical architecture, columns, and arched bridges make one think of such French artists as Claude Lorrain (1600–1682) and Nicolas Poussin (1594–1665), whom she admired. Some drawings allude to the work of the German Romantic painter Caspar David Friedrich (1774–1840). Her style and format have not changed markedly during the past twenty years. Her drawings rendered with colored pencils have the same simplified, serene quality of the pen-and-ink works and prints (fig. 73), though they lack their linearity. They represent landscapes of the mind, where peace and harmony reign. Nevertheless, most of Mare Vint's landscapes are uninhabitable paradises where human beings have no place. In the mid-1980s, Mare Vint married Andres Tolts; his influence may have brought new elements to her subject matter. Many works have abstract, antenna-like structures sticking out from the otherwise serene landscapes, thereby bringing a new energy and lesser reference to the objective world.

Andres Tolts (b. 1949) was one of the founding members of the Soup '69 group. Although his pop-art period was relatively brief, lasting until the early seventies, its impact is evident in most of his later work. Tolts studied design at the art institute from 1968 to 1973, but as important for his development was his prior attendance at a secondary school specializing in art in Tallinn, where his teacher during his final year was ANK member Marju Mutsu. Mare Vint, who also taught at the school, introduced the young students to Tõnis Vint and other ANK members.[186] By the time

FIG. 74. Andres Tolts, *Two Paintings*, 1978. Oil on canvas, 136.5 × 151.5 cm. Dodge Collection, ZAM, 07562.

the artists met Lapin, who was a few years older, they were already well versed in the language of contemporary Western art. Lapin has conceded that students' interest in pop art rose after Ando Keskküla and Tolts came to study at the institute in 1968; their activities influenced many young artists.[187]

Tolts's early pop works were paintings, collages, and objects constructed with cheap Soviet textiles and wallpaper. According to Liivak, his collages and gouaches from 1967 to 1969 contained ironical references to the stereotypes of Socialist popular culture, the press, and the cinema, highlighting the absurdity of Soviet life. In his collages in particular, Tolts took a critical stand against the dominant ideology and the hollow Soviet propaganda.[188] In 1970, he began doing large-scale oil paintings in which he combined common, cheap objects—like plastic toys, paper flowers, and stuffed animals—with abstract, painterly elements. Art historian Evi Pihlak states that Tolts's originality lies in the way he combines abstraction and concrete objects.[189] Tolts also often used decorative constructions and painted fragments flying around in

the picture space or on the picture surface. These may both symbolize the presence of the artist creating the work and help to break the illusive power of the otherwise realistic work. Similar abstract, floating lines and shapes first appeared in the prints of Mutsu and later recurred in the works of Liiva, Puustak, Üksine, Keskküla, and many younger Estonian painters during the seventies.

Tolts's *Two Paintings* (1978; fig. 74) depicts a corner of a room with yellow walls, against which lean two awkwardly angled paintings, one on either side of the picture. Only a portion of each painting within the painting is shown; the center of focus is the bare yellow wall. Tolts's work often contains paintings within a painting, which relates to his interest in achieving several, often complex, spatial effects in one picture. Of all Tolts's work of the 1970s, *Two Paintings* perhaps comes closest to pop aspirations.[190]

In *The Apple Year* (fig. 75), Tolts has depicted a typical north Estonian flat landscape with a very low horizon line. Black cords hanging vertically down the sides, each with an apple on the end, create an

FIG. 75. Andres Tolts, *The Apple Year*, 1983. Oil on canvas, 127.5 × 148.5 cm. Dodge Collection, ZAM, 06200.

interesting Magritte-like element. The cords seem suspended in the sky at the corners by black square dots floating in space. The frontal and symmetrical arrangement produces a ritualistic and altar-like serenity. Like Magritte, Tolts likes to play games with reality, space, and the meaning of objects and signs. Balance and harmony give a deceptive appearance of simplicity. Under closer scrutiny, his works do not make logical sense; real objects are combined into impossible arrangements, and the artist plays tricks with spatial perceptions. Man-made moons, suns, and stars hover in a seemingly real sky, tile walls seem to stand unsupported, apples hang from the sky, and landscapes open up on drawn blinds. There is a constant semiotic testing of relationships, meanings, and possibilities, which charges the works with energy. But all this is masked by the seemingly general harmony of the works.

Ando Keskküla (b. 1950) developed as an artist in much the same way as Tolts. During the school years, they were referred to as "the creative twins" because they were always together, and their early art and interests had many similarities. They were leaders among the art students in generating ideas and organizing pop evenings, many of which were held at the dilapidated house in the Nõmme suburb of Tallinn where Keskküla lived and which he immortalized in several paintings. The first pop exhibition was organized in 1968 in Keskküla's apartment on Kuiv Street. There the artists arranged an installation, which Lapin has described as "old, worn-out boots and shoes stuffed between window panes and made into an assemblage."[191] In another work, Keskküla had placed inside an old mattress a radio tuned to programs like the "Voice of America" that were jammed by the Soviet authorities. The effect was a constant, muddled sound arising from the mattress, which was easily recognized by the visitors as a social and political pun. According to Keskküla, the early pop events and installations always had a political undertone. In this sense, the artists consciously differed from the ANK artists, whose aspirations were more aesthetic.[192]

The pop evenings and happenings in Keskküla's apartment were forerunners of the Soup '69 exhibition in the Pegasus Café the following year. In addition, theoretical and stylistic innovations of Western pop masters were discussed and analyzed. Keskküla mentioned the influence of Mare Vint, Marju Mutsu, Ludmilla Siim (b. 1938), and Tõnis Vint as well as trips to

Leningrad and Moscow. Czech, Polish, and Hungarian magazines also had a stimulating effect on the young artists. He recalled the collections of articles that Põllu and the Visarid had translated into Estonian as important influences on the students during the late sixties.

In the summer of 1969, the Soup artists organized a happening at a youth camp in Kabli, where Põllu constructed his windmill in water and the Visarid demonstrated "air art." During an evening at a campfire, Lapin, Keskküla, and Tolts performed a ritualistic grave digging to unearth a headless, armless display mannequin that had been buried earlier in the day. According to Lapin, there was a deliberate allusion to the Venus de Milo. The mannequin was then chopped to pieces, some of which were burned in the campfire and some "drowned" in a nearby river. The spectators subsequently filled the grave.[193]

That September Tolts, Keskküla, Lapin, and Vilen Künnapuu (b. 1948), a student of architecture, organized "Papers in the Wind," another happening on Pirita beach near Tallinn, which ended with the participants being arrested by the Soviet militia on charges of causing a public disturbance. Keskküla, Tolts, and Künnapuu were imprisoned for ten days and their heads shaven, according to rules of Soviet prison. They were released after the intervention of Künnapuu's aunt, Olga Lauristin (b. 1903), an important political figure in Estonia. She also saved them from being expelled from school.[194] Keskküla later used the hair that had been cut off by the militia for his *Head in the Basin*, a work he showed at the Soup exhibition. The piece (now lost) consisted of a found enamel basin into which Keskküla glued a broken head of a bronze statue retrieved from the local garbage dump. He glued his cut-off hair as a wig around the statue's head. A shirt collar, a tie, and some enamel paint were also added.[195] *Head in the Basin* was unfortunately removed from the exhibition after a few days because people visiting the café complained about its obnoxious look. Keskküla's other assemblage shown at the Soup exhibition was a large landscape painting on which he had attached a real jacket smeared with red paint to suggest blood. In the "sky" area of the painting were three real clothes pegs on which people could hang their garments. According to the artist, his concern was environmental and social, and he alluded to people littering with garbage and

FIG. 76. Ando Keskküla, *The Beach*, 1976. Oil on canvas, 71 × 90 cm. Dodge Collection, ZAM, 08862.

hanging objects anywhere in nature. The Soup artists' social comments were often political but without an emotional value judgment.[196] Unlike the ANK group, whose members had studied printmaking, metalwork, and glassmaking, the Soup artists had studied design and architecture.

During the 1970s, Keskküla became known as one of the first hyperrealist painters in Estonia and was the first to use an airbrush.[197] The works executed between 1971 and 1973, such as *Still Life with Vegetables* and *Late Summer*, were set outside. Lapin believes the exuberant colors and "baroque vitality" of these works influenced Rein Tammik and other Soviet artists. In the autumn of 1973, Keskküla was drafted into the army, and early in 1974 he painted *North Estonian Landscape*.

Keskküla painted the work from memory and in a depressed state, which was reflected in the painting: "The landscape is severe and laconic; there is a feeling of depth and tension."[198] The artist has created what at first glance seems like a realistic landscape, but is actually, in the words of Sirje Helme, an "intellectual ma-nipulation."[199] The lines of perspective don't end at the same vanishing point, which increases the tension and the feeling of unreality. A glass door on the picture plane forms a barrier between the viewer's space and the picture space. Immediately on the other side in the foreground are bleak objects of the artist's life in the army: a lightbulb, a Russian electrical shaver, an envelope, and a cigarette package with a map of the Soviet Union on it. Behind, in the distance, is a cold and uninviting landscape.[200] Estonia remains distant and unavailable, a memory and dream. Lapin has written that, beginning with *North Estonian Landscape*, "Keskküla's paintings convey a sense of metaphysical space and the intertwining of different realities, different moments and scales ... where light dominates color."[201] The painting is generally considered a landmark in Estonian art of the seventies. Some of its characteristics emerged again in Keskküla's mature art. It was a turning point in Keskküla's work and influenced many younger artists.[202]

In the painting *The Beach* (1976; fig. 76) Keskküla used the airbrush for the first time. The scale of the

picture, which represents a close-up of a beach, is given by recognizable objects, like razor blades, hair-pins, matches, and a cigarette. We see the objects obliquely from above, as if through a photographic lens pointed directly down. The camera, however, is a "mind's camera"—the artist's mind and the lens his eyes—that is able to adjust the sharpness and relay different levels of meaning, as in magic realism. The landscape is not real. The artist has said such an image comes from gazing at an object for a long time and relaxing the eyes so that the image blurs. This effect is achieved by the use of the airbrush. According to Keskküla, the work is hyperrealistic in the sense that it does not represent a specific beach but rather a photographic image as an abstraction. The painting is in an unreal, monochromatic blue. The red, seemingly seeping from the inside of a wrapped object, and the red imprints made by a razor blade in the foreground have sinister undertones, evoking associations with blood. The general mood is ominous and mysterious. Although Keskküla has painted relatively few works, several are, according to art historian Evi Pihlak, masterpieces of Estonian art.

The architect Jüri Okas (b. 1950) was one of the foremost installation and land artists in Estonia during the seventies and eighties. At the "Harku Happening" in 1975, he exhibited his photo etchings of run-down sites and buildings called *Reconstructions* and *Projections*, in which he had added constructivist designs and writings on photographs that had been achieved by altering film negatives and etching plates (figs. 77 and 78). During the first half of the seventies, he organized many happenings and land-art events that he photographed and filmed and later used as sources for photo etchings (fig. 79). An interesting example is the humorous land-art project for a monument for Leonhard Lapin, *The Object in Räpina* (1978). The photograph site was supposedly near Lapin's birthplace, in Räpina in southern Estonia, and on it were written instructions and designs for a final project. A pile of loosened soil with instructions to pound it flat and sow grass on it is in the foreground, and in the middle ground are directions to scratch the artist's family name into the soil. Behind these stands a large rectangle of anodized steel plates adorned with chromed steel poles on which are marked various specifications of sizes and materials and the scratched names of Lapin, Pille, Malle, and Räpina.[203] During the 1990s,

FIG. 77. Jüri Okas, *Reconstruction Mol I*, 1977. Offset lithograph, 50.5 × 49 cm. Dodge Collection, ZAM, 19389.

FIG. 78. Jüri Okas, *Reclining*, 1975. Offset lithograph, 44.5 × 60 cm. Dodge Collection, ZAM, 19391.

FIG. 79. Jüri Okas, *Land Art*, 1979. Photographs by Jüri Okas. Collection of Eda Sepp.

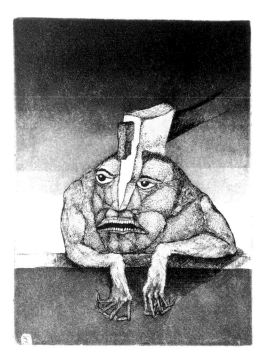

Okas turned to architecture; he designed several large commercial buildings in Tallinn and Pärnu and published the *Concise Dictionary of Modern Architecture* (1995), which included photographs of strange buildings and ugly sites. Sirje Helme has called the book "a kind of philosophical credo" of his work depicted with "a sense of the absurd."

Many talented independent artists in Estonia during the seventies and eighties produced interesting work and were inspired by the energy and activities of the various art groups. The abstract expressionist artist Ado Lill (b. 1932) was initially influenced by Tõnis Vint, Lapin, and Meel.[204] In 1951 and 1952, he attended preparatory courses at the Estonian Art Institute, which provided students with basic art skills. He then decided to pursue law at Tartu University and worked as a lawyer until 1988. He began painting again during the sixties, and some of his abstractions dating from the second half of the decade are reminiscent of Hans Hofmann's work. During the seventies, he passed through several phases of painting large abstractions, shifting from the expressionist style to the geometric hard edge and grid style (fig. 80) and then to the drip style of action painting. He was influenced by American abstract artists, notably Mark Rothko, Franz Kline, and Jackson Pollock, as well as the color theory of Josef Albers and the Swedish artist Olle Baertling.[205] His first semi-official exhibition was in 1977.[206]

Lill has also done satirical etchings, which have been described as expressing the insignificance and alienation of man,[207] that are rendered with a sensitive line and skilled draftsmanship (fig. 81). He tries to depict, in ways sometimes approaching caricature, people in different absurd situations that are seldom openly acknowledged in human relationships and social processes.[208]

Tiit Pääsuke (b. 1941) belongs to the generation of the ANK artists, but since he studied painting at the art institute and graduated in 1971, he never belonged to the group. His works were always more painterly and fluid, perhaps because he had attended art school in Tartu before enrolling at the institute. His works attracted general attention even when he was a student at the institute, and immediately after graduation he was offered a teaching position there.[209] Thus, his career differed from that of the ANK and Soup artists, who often experienced problems with the authorities. It is therefore curious that, although Pääsuke was

FIG. 80. [TOP] Ado Lill, (Untitled), 1985. Acrylic and oil on canvas, 170 × 160 cm. Dodge Collection, ZAM, 05130.

FIG. 81. [BOTTOM] Ado Lill, *The Axe*, 1984. Aquatint, 24.9 × 19.9 cm. Dodge Collection, ZAM, 04598.

widely admired both in Estonia and elsewhere in the Soviet Union, his art is by no means typically conformist. His ghost-like, expressionless women of the seventies who seem to be moving like puppets within an abstract and expressively painted environment are not typical Socialist Realist subject matter. As the eighties advanced, his work became more simplified. Pääsuke used photography as a basis for his pictures, such as the *Landscape Spread Before the Eye* (1987), which depicts an expressionistic winter landscape on an easel. But photography was merely a means to his painterly ends, never an end in itself.

Rein Tammik (b. 1947) was the only other professional artist besides Kaljo Põllu in the Visarid group. He studied at the art school in Tartu while working as a stage designer and artistic director in the small town of Rakvere and graduated in 1974. Initially he was inspired by pop art, as were all the artists associated with the Visarid. Elements of Keskküla's and Tolts's works can be detected in his art. Whereas Tolts juxtaposed abstract blotches in otherwise realist spaces and Keskküla used design elements on the picture plane to suggest the presence of several realities, Tammik's trademark is the addition of surreal elements, such as table settings floating beyond the perimeter of the table in his early works or scribbles and coils of paint on a picture plane different from the photorealistic background. The scribbles result in not only two different realities but also different intentions—the one inside the painting is objective, while the scribble on the picture plane apparently on the outside is destructive. Tammik based his works on photographic sources and also often used images directly silk-screened on the canvas.[210]

During the seventies, he worked as a painter and also as art director for Tallinnfilm. According to Ants Juske, Tammik was one of the first postmodernist painters in Estonia to introduce art historical citations in his works, as early as the seventies.[211] One such work is *In the Studio* (1982–83; fig. 43, p. 77), in which Tammik has transposed the figure of an artist sitting on a stool from Jan Vermeer's *The Art of Painting* (1662–65). Although the image of the artist has been taken directly from the Baroque work, everything else is different. Tammik's painter does not use a model but instead has a large book and a photograph in front of him. In Vermeer's picture, on the background wall, a large tapestry shows the map of the Netherlands as it

was before 1581, when the entire country was part of the Hapsburg Empire, which alludes to the fame and importance of Netherlandish painting and culture.[212] Tammik's artist has on the easel in front of him a large white canvas with square grid lines that takes up roughly the compositional position of Vermeer's map and easel. On the back wall, visible behind the right side of the canvas, is a poster of an Aeroflot airplane TU 134 taking flight. Instead of Vermeer's ordered interior, Tammik's studio has a sharply foreshortened floor with worn wooden boards in the foreground and paint jars and magazines with texts in Russian scattered all around the room, some of them even flying in the air, insinuating the chaotic life in the Soviet Union. On the right side in the foreground, a globe showing North America faces the viewer, an allusion to flying away to the West to escape from a shabby Soviet interior.

In 1988 Tammik emigrated to France, where he is presently living. His art was never fully appreciated in Estonia, and his success was much greater in Moscow and the rest of the Soviet Union.[213] Recently he has had two exhibitions in Estonia and now, as postmodernism is better understood, his work is receiving critical attention.

During the 1970s, many younger artists in Estonia were inspired by superrealism.[214] In the former Soviet Union, this style was frequently referred to as "hyper." Such realism did not provoke the authorities unless it depicted something on the list of forbidden subjects or conveyed a negative message. Keskküla and Tammik were popular with the Soviet public at the time, and Keskküla's airbrush technique was especially influential. Lemming Nagel (b. 1948) graduated from the art institute in 1976. He worked in the figurative style and leaned toward surrealist deformation and superrealism. His huge, three-dimensional *Seljanka* (1975–79; fig. 82) is an enlarged, gravity-defying, hyperrealist version of a real bowl of this popular soup. On the edge of the plate is the word "restaurant" in Estonian, which indicates that this soup—which is as common for Estonians as a hamburger is for North Americans—is being served in a restaurant. The work can be compared to Claes Oldenburg's pop-art hamburgers and other huge, common objects, although they were not exact copies of real things, while Nagel's *Seljanka* is a depiction of an actual bowl of soup. His earlier figurative, hyperrealist paintings often had too much clutter in

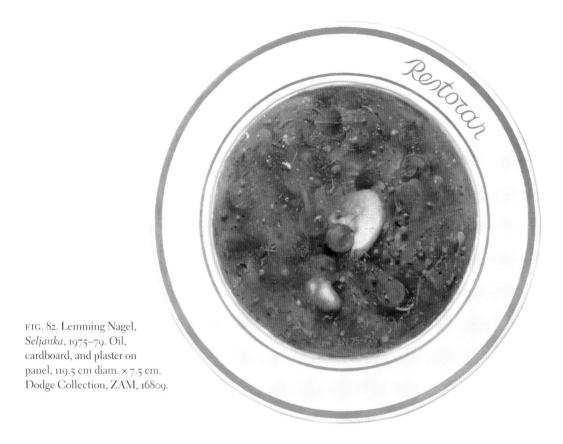

FIG. 82. Lemming Nagel, *Seljanka*, 1975–79. Oil, cardboard, and plaster on panel, 119.5 cm diam. × 7.5 cm. Dodge Collection, ZAM, 16809.

them, but recently he has found a new, more interesting style.

Jaan Elken (b. 1954) was trained as an architect but soon turned to painting. Evi Pihlak saw Elken's style as the continuation of the tradition begun by Tolts and Keskküla.[215] Like many superrealist artists in the West, Elken preferred contemporary city scapes, especially construction sites, industrial districts, new concrete-block buildings, and such commercial interior scenes as *In a Laboratory* (fig. 83). His depictions are straightforward, as presented by a camera's lens, with no added effects. In some works, the final effect, however, is more painterly and abstracted, as in the painting with a street sign (fig. 84), where he has added graffiti-like scribbles on the lower edge. Like Keskküla, Elken also used the airbrush, which has created an effect of the street sign not being quite in focus. The works of Ilmar Kruusamäe (b. 1957; fig. 85), Heitti Polli (b. 1951), and Miljard Kilk (b. 1957) also fall within the superrealist category.

After 1973, Kaljo Põllu abandoned his earlier pop style and began to search for a different, more ethnic originality. He became interested in Finno-Ugric language, folklore, and ethnography and was influenced by the scholar Paul Ariste (1905–1990) at Tartu University.[216] Ariste had encouraged Põllu to look for a broader picture in Finno-Ugric studies, claiming that the discipline should not be limited to language, folklore, history, and ethnography but should also include the arts.[217] Põllu first studied the material objects and folklore of the Finno-Ugric groups in museums and archives in Estonia and then began to make field trips with his Estonian students to various sites throughout the Soviet Union, making drawings, gathering photographs, and compiling other information. His first series of prints, *Kodalased* (Ancient Dwellers), was produced between 1973 and 1976 (fig. 86). The word *koda*, an ancient Finno-Ugric term, refers to the primitive, cone-shaped dwellings of the Finno-Ugric tribes. It is believed to be their original home, a round tent, like

FIG. 83. [LEFT] Jaan Elken, *In a Laboratory*, n.d. Oil on canvas, 73.3 × 75.3 cm. Dodge Collection, ZAM, 06032.

FIG. 84. [BOTTOM] Jaan Elken, (Untitled), 1978. Oil and collage on canvas, 130 × 97.4 cm. Dodge Collection, ZAM, 05002.

FIG. 85. [TOP] Ilmar Kruusamäe,
Contact, 1980. Oil on canvas,
85 × 75 cm. Dodge Collection,
ZAM, 17235.

FIG. 86. [LEFT] Kaljo Põllu,
Sun Boat—Ancient Dwellers,
1974. Mezzotint, 48.8 × 58.7 cm.
Dodge Collection, ZAM, 18616.

that of many North American Indians, with an opening at the top for the smoke to escape and through which one could always see the North Star (which the main supporting pole pointed to). On the one hand, Põllu's pictures represent idealized and spiritual visions of the ancient Finno-Ugric world, but, on the other hand, they are based on well-documented, scholarly research of mythology, cultural anthropology, and linguistic theory.[218] According to art historian Ene Asu-Õunas, Põllu unites the past and the present, the primitive life of the Finno-Ugric tribes and our modern way of thinking, by taking us through the habitations of these ancient dwellers.[219]

During the seventies, a whole movement of geometric and minimal abstraction developed in Estonia with Tõnis Vint, Lapin, and Meel as the nucleus. The movement culminated on August 3, 1977, with the opening of a large exhibition of prints and drawings in the Tallinn Art Hall. Apparently the term "geometric" was not as threatening as "abstraction," and therefore the exhibition received official permission under the name *Geomeetriline graafika* (Geometric prints). Lapin opened the show by citing the Estonian cubists of the twenties and Kazimir Malevich as spiritual forefathers and defining the goals of geometric art in Estonia.[220]

His emphasis on the technical and urban environment and the consequent geometrical process relate to Western minimalism, in which the processes of industrial design and methods based on modules and simple geometric formal elements are important, but the desire to analyze meaning beyond the purely visual configuration is absent. Lapin, however, emphasized a combination of "human energy" and "cosmic power," which is different from Western geometric and minimalist art.

Tõnis Vint, Meel, Lapin, Runge, Annus, Ene, Kull, Mari Kurismaa, and Avo Keerend were among the artists represented at the exhibition. Tõnis Vint had, by this time, a large following of students who practiced geometric abstraction. The Russian artist Pavel Kondratjev, whom Lapin has referred to as his mentor, was at the opening, which turned out to be a landmark in Estonian art—an exhibition of pure abstraction in the Tallinn Art Hall. Seventeen artists participated in the exhibition.

Sirje Runge (b. 1950) studied design at the art institute and graduated in 1975. She married Lapin in 1969 and first exhibited with the Soup artists in 1971. Her preoccupation from the beginning has been with geometric abstraction, and her mature works date from 1974. In 1975 she visited Moscow with Lapin and saw the Costakis collection, which was a powerful inspiration for works like *Geometry VI* (1976). In 1975 she exhibited freestanding geometric triptychs at the Harku exhibition. During the seventies, her drawings were shown at many international shows. At that time, she was preoccupied with geometric forms—the square, the triangle, the circle, the grid, and the cross—varying them by multiplying them and shifting the colors to create dynamic compositions, as in *Geometry VIII* (1976; fig. 87).[221]

In 1979 and throughout the eighties, her work became simpler, more minimal. This development coincided with her second marriage, to the photographer Evgeni Klimov. She painted works in series under the titles *Light*, *Landscape* (fig. 88), and *Objects*. As the titles indicate, the content was related to the real world, not pure abstraction. Nevertheless, even if her paintings referred to landscapes or objects, the real subject matter was light and air. Runge always used the brush and achieved layers of transparent nuances in pastel blues, grays, light pinks, oranges, and pale greens—tones that are like the colors of the sky in different light. She has said that her inspiration comes from the view from the studio window in her top-floor high-rise apartment in the suburb of Õismäe, where she can see the sunset and sunrise on the Gulf of Finland.[222] The key words for Runge's art are silence, eternity, and security.

Siim-Tanel Annus (b. 1960) studied anthropology and history at Tartu University and attended Vint's private studio sessions from a very early age, which greatly influenced his work. He never attended art school.[223]

Annus started exhibiting in 1976 at the age of sixteen. His untitled drawings in ink on paper from the series *Black and White Cities* belong to this early period (fig. 89). Allusions to visionary church buildings with large cross-like forms rising up from the black structures characterize this series. All his geometric drawings have a deep symbolic and spiritual content, an inheritance from Tõnis Vint. Sirje Helme has compared Annus's art with Tõnis Vint's and found the former more intuitive, less programmatic, and with a greater emotional content. She has described Annus's *Towers to the Heavens* (fig. 90) as a work where real

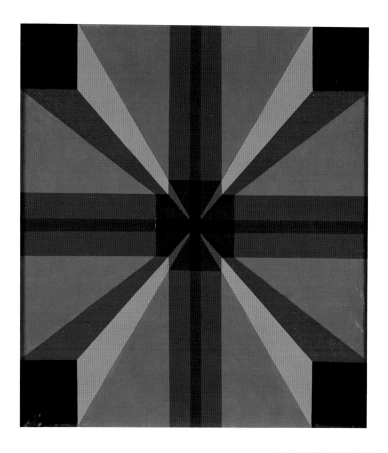

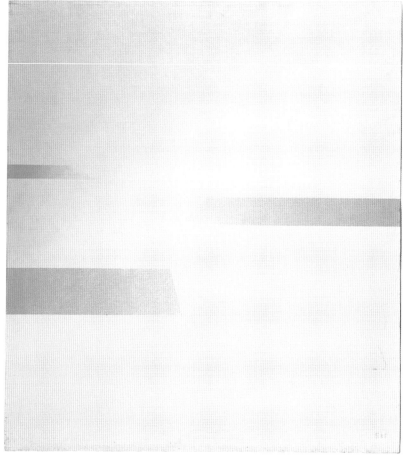

FIG. 87. [TOP] Sirje Runge,
Geometry VIII, 1976. Oil on
canvas, 100 × 89.8 cm. Dodge
Collection, ZAM, 06741.

FIG. 88. [RIGHT] Sirje Runge,
Landscape XXIII, 1982. Oil on
canvas, 99.2 × 90.1 cm. Dodge
Collection, ZAM, 06305.

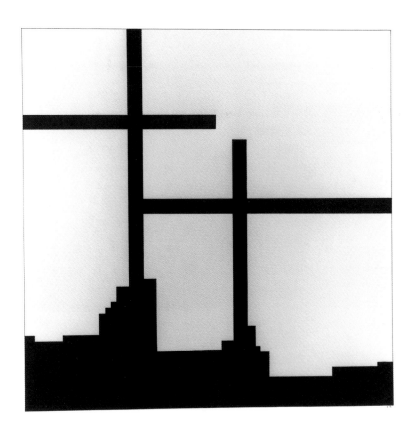

FIG. 89. [TOP] Siim-Tanel Annus, (Untitled), 1976. Gouache on paper, 61.5 × 60.2 cm. Dodge Collection, ZAM, 09555.

FIG. 90. [LEFT] Siim-Tanel Annus, from the series *Towers to the Heavens*, 1982. High print, 44.6 × 39.1 cm. Dodge Collection, ZAM, 02495.

FIG. 91. Siim-Tanel Annus, in performance, 1979. Collection of Eda Sepp.

objects lack concrete meanings as such but instead have allusions to inner spiritual states.[224] Art historian Vappu Vabar has written, "The ideal forms of the pyramids can be interpreted in many ways in the series *Towers to the Heavens* where the central idea is to rise higher from the mundane worldly aspects to a spiritual sphere."[225] Annus's drawings are based on fine, mechanically drawn lines with which he builds up forms and structures; the delicate lines give an airiness to the pyramid-like buildings.[226] Although visionary and symbolic architecture was a central motif in Annus's art during the seventies and early eighties, he also created many fine abstract and nonobjective drawings and prints.

In 1979, Annus began organizing unofficial performances in the backyard of his family home (fig. 91), for which he sent invitations by mail or by word of mouth. The news about them spread fast. The first performance was organized concurrently with an unofficial exhibition in his home on November 1, 1980. The audience, consisting of friends and fellow artists, was led into the dark backyard. Suddenly the artist, dressed entirely in black, jumped up from a pile of dry leaves and blew a trumpet. He then ran from one group to the next and threw blue leaves around. The second performance followed the opening of his exhibition in the hall of the library of the Academy of Sciences in Tallinn on October 17, 1981. This time Annus had built a more elaborate setting in the backyard, with a ladder

leading to the second floor of the house and lumpy paper constructions that looked like wrapped figurines all around the yard. The performance was accompanied by loud music. The artist, dressed as a black "death angel" with wings and a scythe, descended from the second-floor window, threw around white pieces of paper, and finally set fire to the paper constructions. After an intermission, a film of the previous year's performance was projected on a large screen, thus emphasizing, according to Evi Pihlak, the conceptual continuation of the two events.[227] Annus organized almost yearly one-man performances, with the settings becoming more and more complex. Towers were built, and musical and light effects were included.

These events created suspicion, and Annus was summoned to the KGB and asked to become an informant. He was offered, as a reward, freedom to organize performances and to travel abroad. The following day, Annus went around town and told everyone of the proposition. That was the end of the KGB offer, and constant harassment and surveillance of Annus began. The militia even approached his father, a respected literary scholar, and asked him to confirm the insanity of his son. At this time, Annus was financing his art activities by growing chrysanthemums and tomatoes in the backyard and selling them on street corners.[228]

Events finally culminated on the evening of December 5, 1989, when Annus planned his biggest performance, which a Finnish television crew had come to record with the intention of doing a film about the artist. This time Annus was wise enough to get permission from the authorities in Moscow and Tallinn. The novelist Mihkel Mutt described the event in the weekly cultural paper under the title "Performance in Two 'Parts.'"[229] This time the artist wore a crown and a white toga. The setting was elaborate, with white tower-like columns and a platform on railway tracks leading to a white structure. Ariel Lagle had composed music for the event. Torches and fires created a mysterious setting for the ritualistic movements of the artist. Lighting effects and a loud explosion accompanied the final scene, when the protagonist was swallowed up by smoke. During the performance, Mutt saw the militia moving around among the spectators. He was not sure whether this was a planned part of the performance. The camera crews were busy recording, and photo lights were flashing. However, at the end of the show,

FIG. 92. Ene Kull, (Untitled), 1979. India ink and gouache on paper, 43 × 43 cm. Dodge Collection, ZAM, 18981.

when people started to move out, a fire engine and three militia cars were waiting outside the house. Annus and the Finnish TV crew were interrogated, arrested, and whisked to the militia headquarters for questioning, which lasted several hours. Thus, according to Mutt, the performance turned into a "happening," and the authorities had their final show of power. Pihlak believes that Annus's *Tower* series and his performances belong to the same spiritual and cosmic narrative.

Ene Kull (b. 1953) was Tõnis Vint's second wife and partner after 1976. She never attended art school and considers Vint her only teacher. Her geometric abstractions had a spiritual and mystical message characteristic of his closer students. Her first mature works date from 1975. She had three personal exhibitions in Estonia, but her work has been shown internationally. Since the mid-1980s she has been a member of the Studio 22, a group of Vint's students who are involved with hermetic visual systems.[230] According to Tõnis Vint, Kull's earlier works contain certain architectonic allusions behind which the symbolic contents are hid-

den, thus intertwining aesthetic and symbolic levels (fig. 92). The main characteristic of her work is, however, a negation of three-dimensional space, which enables her to interact with symbols as absolutes. We can, says Vint, relate the symbols to our world, but they lack scale. During the eighties, there was (again, according to Vint) a deliberate denial in Kull's work of any allusions to the real world. Her emphasis was on alchemical symbols and constructions of signs, which convey a direct psychic activity.[231] Kull usually works in black india ink and gouache on paper, but she also produces prints of her drawings. Her works are predominately black and white, sometimes with lines or dots in red or other colors. Symmetry and clarity characterized her works of the seventies, while those of the eighties were more abstract and structurally more complex without forfeiting the symmetry.

Mari Kurismaa (b. 1956), known as Mari Nõges until 1981 (figs. 93–95), studied interior design at the art institute and graduated in 1979. She attended Tõnis Vint's classes during the late seventies but never really belonged to the group's core. Nevertheless, she partic-

FIG. 93. Mari Kurismaa, *Bottles*, 1975. Oil on paper,
49.7 × 49.7 cm. Dodge Collection, ZAM, 17061.

FIG. 94. Mari Kurismaa, *Numbers*, 1975. Oil on paper,
50 × 50 cm. Dodge Collection, ZAM, 17062.

FIG. 95. Mari Kurismaa, *Cloude I*, 1978–79; *Cloude II*, 1978–79; *Pyramid and Snail*, 1978–79; *Mushrooms*, 1978–79; *SA*, 1978–79. Ink and gouache on paper, 30.5 × 86 cm (each). Dodge Collection, ZAM, 17077, 17078, 17075, 17076, 17079.

ipated in the exhibition of geometric prints in 1977 and did geometric abstractions during the first part of the eighties, including a series of conceptual drawings entitled *Words in Tallinn*, in which she combined the written word and the abstract image.[232] She has achieved with scribbles and rubbings an effect of impermanence and passing time, as in the work *Shores*, of which she has two versions. The words scribbled on the picture convey an image in the viewer's mind of changing, fleeting moments when the water meets the shore, but the images, in contrast, are nonobjective scrawls, blotches, and scratches. The words and letters are dynamic because they refer to a reality that exists but cannot be grasped visually. The work *Dream* is more abstract because the words are difficult to decipher; the effect is that of a vague dream, where images shift and fuse. An interesting work is *Mushrooms and Berries Incline Toward the Dream*, in which the signs suggesting the dream, mushrooms, and berries are conveyed by slanting, scribbled, abstract lines, and the text also slants downward, from upper left to lower right. The images are like somnambulist scrawls.

Mari Kurismaa's paintings convey a great feeling of reality and concreteness. In *The Still Life on the Terrace* (1985), geometric forms fill the space, and the light from the left side acts as a spotlight. The painting's theatricality, stillness, and silence are reminiscent of the metaphysical paintings of Giorgio de Chirico (1888–1978). The stage-like construction and lighting, characteristic of all her paintings, reflect Kurismaa's background as an interior designer. A mysterious radiance creates the effect that, in the literary scholar Hasso Krull's words, "what we see is neither our everyday world nor a geometric abstraction, but a strange other world … in front of us are visual puzzles."[233]

Avo Keerend (b. 1920), the oldest artist showing his works at the geometric print exhibition in 1977, has been a prolific printmaker since the sixties. His style has gone through many changes, from severe realism and surrealism to abstraction. His geometric abstractions of the second half of the seventies and eighties are his best work (fig. 96), but during the sixties he did interesting still lifes that are reminiscent of the works of Ben Nicholson (1894–1981). At that time he also did large political, figural compositions in the print medium and thus was never considered an unofficial artist.

During the middle eighties, a style emerged in Es-

FIG. 96. Avo Keerend, (Untitled), 1977. Linocut, 64 × 38 cm. Dodge Collection, ZAM, 05990.

tonia that reflected neo-expressionist trends in Germany. Talvi Johani (b. 1948), initially a textile artist, began doing powerful expressionistic paintings in oil, acrylic, and gouache that were sometimes nonrepresentational but more often contained vague figural images emerging from the abstractions. Many works had erotic allusions, as in *Birth of the Demon*, a depiction of oral sex in which the woman is represented as the subject instead of an object of a male "gaze." In Johani's painting, the man's head is a shadowy form in the lower foreground, while the emphasis is on the explosive colors around the woman, whose body takes up most of the painting. In *Somnambuul*, a self-portrait, the anguished face emerges from the powerful abstracted forms. Art critic Harry Liivrand has written about Johani's first personal exhibition in 1988: "The artist's spontaneous self-expression has found its best vehicle in abstract expressionism as a means of direct

FIG. 97. Jüri Kask, *Patch On Patch*, 1973. Gouache and collage on paper, 21 × 29.7 cm (each). Dodge Collection, ZAM, 17053.01–04.

representation of moods and visions.... [She] has created some confusion among our women painters. No colleague of hers has represented her temperament so directly and in this lies the greatest appeal of her works."[234]

Jüri Kask (b. 1949; fig. 97) graduated from the department of painting at the art institute in 1974 after first attending the art school in Tartu. He began his studies in 1969, when the first Soup exhibition was organized, but he never belonged to the group, probably because he did not study design or architecture.[235] He nevertheless expressed interest in surrealism, especially Joan Miró, and tried to combine urban technology and geometric forms in early works, which were figurative with cubist distortions (fig. 98), like the *Soldier* (1975). After about 1979, he turned to pure abstraction. His mature compositions have elements of

graffiti art, geometric pattern painting, and abstract expressionism. Art critic Ninel Ziterova has described his works as an art "where geometry, order, and symmetry collide with arhythmic anarchism," where, despite the geometric construction of the formal structure, the color is reminiscent of action painting.[236]

Jaak Soans (b. 1943), Villu Jõgeva (b. 1940), and Kaarel Kurismaa (b. 1939) each represent different trends in Estonian sculpture during the 1970s. Two women sculptors, Mare Mikof (b. 1941) and Aili Vahtrapuu (b. 1950), also did interesting unofficial works, and Lapin has created three-dimensional objects since the 1970s. Since sculpture requires a large studio space and takes up more storage space than works on paper and canvas, few three-dimensional unofficial works existed in Estonia.

Jaak Soans studied sculpture at the art institute and

FIG. 98. Jüri Kask, *Apocalypse*, 1974. India ink on paper, 30.8 × 43.2 cm. Dodge Collection, ZAM, 17059.

graduated in 1966, at the same time as the ANK artists Jüri Arrak, Malle Leis, and Enno Ootsing. Although he did not belong to the group, he nevertheless attended many of their events and still fondly remembers Jüri Arrak's lecture on Kandinsky.[237] Soans began teaching at the institute immediately after graduation and did many official commissions for monumental sculpture during the seventies. These pieces were not, however, of a political nature. His best-known monumental work is the over-life-size bronze portrait of novelist Anton Hansen Tammsaare (1878–1940), which is centrally located in the park between Hotel Viru and Estonia Theater in Tallinn. Soans's most intriguing works were his smaller exhibition pieces, which could be labeled unofficial by Soviet standards but were shown freely in Estonia during the seventies and eighties. The pop-inspired *2178* of 1976 is an empty, free-standing man's shirt dipped in plaster, with the prisoner number 2178 hanging from the collar. While Western pop artists would have elevated the shirt itself to the status of art, Soans was more interested in its deeper social and political meaning. The empty shirt with a number rather than a name reflects what a person will be reduced to in a prison or a war, or in a society where an individual no longer counts. Soans's *Rape of Europe* is a relatively small clay model for a bronze statue. Instead of the allegorical female figure from classical literature or Renaissance prototypes suggested by the title, the piece represents a bull with metal objects attached to its body that insinuate war machinery—a twentieth-century rape of Europe, where the bull itself may eventually become as ravished as its victims. Jaak Soans's sculpture has rightly been described as intellectual, with its emphasis on

the human condition in an alienating social environment.[238]

Villu Jõgeva was trained as an electrical engineer, but as the husband of Malle Leis, he befriended the ANK circle. Through Yankilevsky, he met Russian dissident composer Alfred Schnittke (1934–1999), whose music profoundly affected him.[239] Avant-garde music has an important place in Jõgeva's life. He created unofficial and interesting electronic art during the late sixties and the seventies, which could only be seen privately as "apartment" art and was first shown officially at the 1976 exhibition of experimental architecture organized by Lapin. *Two Triangles* (1976–78) consists of two equilateral triangles with parallel bases placed on a wooden block. Each triangle is composed of thirty-six small, different-colored lightbulbs that light up rhythmically and produce small peeps. The electronic work is based on the rhythm of the bulbs lighting up in constantly repeating and overlapping polyrhythmic patterns with different starting points. The structure resembles the method of American composer Steve Reich, whose minimalist music was produced by the repetitive layering of rhythmic patterns with different downbeats.[240] The percussive, repetitive minimalist music that Reich created around 1970 seems as mechanical as Jõgeva's electronic visual words, but Reich's music was, with a few exceptions, produced by live performers. In contrast, Jõgeva's work reflects his training as an electrical engineer and unfolds in an objective, mechanical, and impersonal manner, producing an almost trance-inducing, mantric effect. When Jõgeva heard Reich's compositions much later, on Finnish radio, he immediately recognized a kindred spirit.[241]

Kaarel Kurismaa is best known for his audiovisual kinetic sculpture and three-dimensional relief works constructed with found objects and enamel paint (fig. 99). Anu Liivak has called him one of the most original and uncompromising personalities in the circle of Estonian avant-garde artists of the seventies.[242] Kurismaa attended the art institute between 1966 and 1971 and graduated in painting. As a student, he was interested in pop art and worked part-time as a window display decorator for the only department store in Tallinn. The job, according to critic Ants Juske, was to be very important for his later development because it gave him experience in arranging mass-produced goods and Soviet utility objects.[243] Kurismaa's first pop ob-

jects date from the early seventies. In 1973 he had his first semi-official exhibition in the back room on the third floor of the Tallinn Art Hall. His *Amour Column*, shown at this exhibition, consisted of a large, round column with a wider round capital-like structure on top. Around it, he had arranged cheap dolls acquired from the department store; they had wings attached to their backs and were holding trumpets that appeared to make sounds when the structure moved around. The column and objects on top were all painted with shiny enamels, which further emphasized the nonsensical, pop-like nature of the work. (Kurismaa always used ready-made objects of wood and plastic for his kinetic objects and painted them with bright enamels.) The sound, movement, and lighting were arranged by electrical engineer Härmo Härm. As explained by Anu Liivak, "An element of staging is essential in [Kurismaa's] moving, resounding objects. This in turn is connected to his work as a director of puppet and cartoon animation films at Tallinnfilm studio and as designer of the backdrops for the concerts of composer Sven Grünberg's progressive rock band *Mess*."[244] Sven Grünberg's band opened the 1975 Harku exhibition, where Kurismaa displayed eight works. According to Ants Juske, the most effective object in Harku was Kurismaa's large *Sounding, Dripping Object*. There, it was exhibited with the large kinetic self-portrait of the artist. In 1977, I viewed a private exhibition in Kurismaa's apartment. Entering the dimly lit room, accompanied by weird sounds and flickering light effects, I saw objects moving around me, spurting water and acting in otherwise strange and unexpected ways—a world of useless objects living their own absurd and humorous life.

The beginning of glasnost and perestroika in 1985 did not abruptly change the Estonian art world. Initially, things actually became more difficult due to a repressive local counteraction. In 1986 Meel's work was almost totally banned, and the KGB intensified its watch on artists and their activities. Not until 1988, after the Plenary Session of the Creative Unions and the "Singing Revolution," did the grip of the Communist Party loosen. These political events influenced other areas of Eastern Europe and led to the final dissolution of the Soviet Union, which culminated in the official recognition of the Baltic states' independence in 1991. Artists in Estonia responded by expressing their assessment of the occupation. As discussed earlier, Meel

FIG. 99. Kaarel Kurismaa, *White Relief*, 1980. Assemblage, 55 × 80 × 72 cm. Dodge Collection, ZAM, 17081.

produced his series *Caresses* between 1986 and 1987; the blood-red arm-prints on the map contours of Estonia are like the embraces of wild bears. His *Windows and Landscapes* series with grid prison windows on Estonian maps are also political statements. Evi Tihemets did a *Memento* series of large prints, in which the dominating motifs were prison windows with bars and crosses. Perhaps the most overt statements were in Lapin's series commemorating the fiftieth anniversary of the signing of the Molotov-Ribbentrop Pact in August 1939.

Despite the Soviet occupation, Estonian noncon-

formist art after World War II had a distinct Western orientation. Although the art movements and artists discussed here were not always labeled unofficial, they had social, political, and formal intents that were not sanctioned by the autocratic state. Moreover, the Soviet authorities considered every idea that was compatible with Western thought, if not downright nonconformist, at least suspect. In this sense, the artists' tenacious efforts to achieve creative independence in their work contributed in a major way to Baltic political independence.

NOTES

1. The demographical information is from Ene Tiit, "Eesti Rahvastik ja selle probleemid," parts 1 and 2, *Akadeemia* no. 8 (1993): 1654–1679; no. 9 (1993): 1847–1866. I am indebted to Sirje Kivimäe for drawing my attention to this article. Also see Evald Laasi, "Mõnede lünkade täiteks," *Sirp ja Vasar*, November 27, 1987, p. 3.

2. Villem Raam, private conversation with author, 1976.

3. Tiit, "Eesti Rahvastik ja selle probleemid," 1848–1849.

4. On Vabbe, see Evi Pihlak and Reet Varblane, *Ado Vabbe* (Tallinn: Kunst, 1993). Also see Reet Varblane, "Avangardism ja traditsionaalsus Ado Vabbe Loomingus," *Looming* 10 (1994).

5. Mare Joonsalu, Reet Mark, and Tiiu Talvistu, *Elmar Kitse Fenomen/Phenomenon of Elmar Kits, 1913–1972* (Tartu: Tartu Art Museum, 1994).

6. Ibid., 86.

7. Valve Janov, conversation with author, July 24, 1998.

8. Helmi Üprus, *Päikeswmängud* (Tallinn: Kirjastus Kunst, 1976), 61; "Ado Vabbo about Himself," *Tartu kunstimuuseumi Almanahh* 2 (1967): 65; Lüüdia Vallimäe-Mark, letter to author, December 10, 1998.

9. Silvia Jõgever, conversation with author, July 22 and July 26, 1998; letter to author, December 4, 1998.

10. Heldur Viires, conversation with author, July 25, 1998; Silvia Jõgever, conversation with author, July 22 and July 26, 1998.

11. Aigi Rahi, "1949. Aasta sõda Balti riikide elanike vastu ja selle tagajärjed," *Vaba Eestlane*, July 8, 1999, p. 10.

12. Tiit, "Eesti Rahvastik ja selle probleemid," 1849–1851.

13. Vallimäe-Mark, letter to author, December 10, 1998.

14. It should be stressed here that abstraction and surrealism were not the only styles the artists worked in, although Kärner, Janov, Jõgever, Saarts, and Viires all did series of abstract and semi-abstract works during the late 1950s and the 1960s. They also did figurative works in the traditional "Pallas style." Vallimäe-Mark does not consider herself an abstract painter, although she experimented with nonobjective art.

15. This information comes from various discussions with the artists and from assessing works in their collection and at the Tartu Museum.

16. The Tallinn-Moscow catalogue deals only with Tallinn, not Tartu; *Tallinn-Moskva/Moskva-Tallinn, 1956–1985*, ed. Anu Liivak (Tallinn: Tallinn Art Hall, 1996).

17. See Amei Wallach, *Ilya Kabakov: The Man Who Never Threw Anything Away* (New York: Harry N. Abrams, 1996), 29.

18. Ibid., 35.

19. According to Margarita Tupitsyn, the appearance of Soviet alternative art became possible in the late 1950s precisely because Khrushchev's thaw brought a number of Western art exhibitions to Moscow; Margarita Tupitsyn, "On Some Sources of Soviet Conceptualism," in *From Gulag to Glasnost: Nonconformist Art from the Soviet Union*, eds. Alla Rosenfeld and Norton Dodge (New York: Thames and Hudson, 1995), 331.

20. Sooster mentions a whole room of Picassos at the Hermitage in Leningrad in a letter dated January 16, 1959, to Lüüdia Vallimäe-Mark. In another letter dated August 18, he writes about fifty works exhibited at the American exhibition in Moscow (letters in the collection of the artist). He also corresponded with Kaja Kärner, Silvia Jõgever, Heldur Viires, and others.

21. Victor Tupitsyn, "Nonidentity within Identity: Moscow Communal Modernism, 1950s–1980s," in *From Gulag to Glasnost*, 82. Reet Varblane mentions the third exhibition in Eli Beliutin's studio held in 1957; in Ilya Kabakov, *On Ülo Sooster's Paintings: Subjective Notes* (Tallinn: Kirjastus Kunst, 1996), 207.

22. Taped interview with Tõnis Vint.

23. According to Vallimäe-Mark, when Sooster came to Estonia from Moscow, "he always had a pile of works with him, which he showed us and wanted to know our opinion. He always discussed new and interesting problems which he explained and talked about. He told us what he had found in the Moscow libraries and what he had seen that was new"; manuscript, Archives of Tartu Art Museum (TKM TA F3nim SÜ246A).

24. The Estonian artists considered Sooster's circle Jewish, not Russian, and therefore more acceptable and more informed about Western art trends; the group members were also viewed as being bolder in their approach. Katrin Kivimaa, "Interview with Olav Maran," *Kunst* 2 (1994): 38; also personal discussions with Maran and the Tartu artists.

25. There was a language gap between the Estonians and Russians, and Sooster was the main mediator of information. Only the men with Soviet prison experience could speak or read Russian. Janov has related how Sooster made appointments for her with artists and collectors in Moscow and drew maps with instructions of how to reach them because she spoke no Russian.

26. Leonid Lamm, "Ülo Sooster—An Artist, a Friend, and His Time," unpublished manuscript translated from Russian by Natalia Kariaeva; Leonid Lamm file, Zimmerli Museum Archive of Nonconformist Art.

27. Yuri Sobolev, "Virtual Estonia," in *Tallinn-Moskva*, 25.

28. Ibid., 12.

29. Ibid., 38 and 43.

30. Lamm, "Ülo Sooster—An Artist, a Friend, and His Time."

31. Wallach, *Ilya Kabakov*, 38.

32. Ibid., 37–38. According to Kabakov, "it is impossible to speak of one or a few of [Sooster's] works, since each of them is organically connected with the whole and can be understood only with the revelation and exposure of the idea of that whole", Kabakov, *Ülo Sooster*, 182.

33. Wallach, *Ilya Kabakov*, 38.

34. Letters in the collection of Vallimäe-Mark. Sooster added, however, that pure abstraction seems to lack emotionality. Nevertheless, apart from the drawings, I have not been able to find abstract works in any other media by Sooster. It seems Sooster was often preoccupied with his work as an illustrator and may not have had time to realize many of his drawings into paintings. The artist's son, Tenno, who now resides in Israel, has confirmed this, saying that Sooster was not able to fulfill many of his projects because he could not earn a living from painting and had to work as an illustrator. Many of his works were also bought by foreigners visiting Russia. Quoted by Mihkel Kärmas, "Soosteri lese mälestused toovad lagedale uusi episoode," *Eesti Ekspress—Areen*, October 14, 1999, p. B3. The memoirs of Sooster's wife, Lidia, have been published in Russian and in Estonian translation. According to Lidia, Sooster "began to hate books. He suffered because he was known mainly as a graphic artist and not as a painter. He considered painting as the main part of his art"; see Lidia Sooster, *Minu Sooster/Мой Соостер* (Tallinn: Kirjastus Avenarius, 2000).

35. Kabakov, *Ülo Sooster*, 207.

36. About Sooster, see also Reet Varblane, "Ülo Sooster," in *Personal Time: Art of Estonia, Latvia and Lithuania, 1945–1996*, Estonian volume, eds. Anda Rottenberg et al. (Warsaw: The Zacheta Gallery of Contemporary Art, 1996), 38–41.

37. Manuscript, Archives of Tartu Art Museum (TKM TA F3 nim1 SÜ Z47A).

38. Kabakov, *Ülo Sooster*, 202–205.

39. Ibid., 188.

40. Vallimäe-Mark, letter to author.

41. On Valve Janov, see also Reet Varblane, "Valve Janov," in *Eesti kunstnikud—Artists of Estonia*, ed. Johannes Saar (Tallinn: Soros Center for Contemporary Arts, Estonia, 1998), 29–35.

42. Valve Janov, conversation with author.

43. Ibid.

44. Janov was almost totally forgotten in Estonia until 1993, when Eha Komissarov organized an exhibition of collage in Estonian art of the 1960s at the National Art Museum in Estonia and published reproductions of Janov's works in *Eesti kunstnikud—Artists of Estonia*.

45. Sooster to Vallimäe-Mark, March 11, 1957. Here, Sooster mentions a longer letter to Kärner about the exhibitions in Moscow. Heldur Viires showed me a small book by Frederick Gore, *Abstract Art* (Series Movements in Modern Art; Methuen & Co., Ltd., 1957), that Sooster had brought from Moscow. It was worn and had underlinings and translations for the English terms. Most of the works illustrated were abstractions from the 1950s by European artists.

46. According to Heldur Viires, Sooster always told the Moscow artists, "If you want to see color, go and look at Kaja Kärner's work." Viires worked in Moscow in Sooster's studio for several months in late 1961 and early 1962, where Sobolev recalls having met him.

47. Katrin Kivimaa, "Interview with Olav Maran," 38.

48. Vallimäe-Mark, letter to author.

49. Ernst Neizvestny was one of the major unofficial sculptors in the Soviet Union and belonged to Sooster's inner circle of friends. He also did many official commissions because he was a wounded veteran and had been a star student in the sculpture faculty of the Surikov Institute, which Kabakov also attended. Because of his veteran status, Neizvestny was able to get special access into the forbidden areas of the Tretyakov Gallery where the works of the Russian avant-garde were hidden from the general public. See Wallach, *Ilya Kabakov*, 35. Wallach has aptly described Neizvestny's style as "cubo-surrealist," where he shrouded the Soviet optimism in a tragic vision of surrealism.

50. Heldur Viires, taped discussion with author, July 25, 1998.

51. Jõgever's manuscript with reminiscences about the events leading to and following the exhibition is deposited in the archives of the Tartu Art Museum. My information is from taped discussions with the artist in July 1998. She has also provided another handwritten text for me outlining the events.

52. Jõgever's friends in Tartu were proud of her, and Sooster wrote encouraging letters from Moscow when the battle was raging. For example: "The exhibition is a historical event and it turns out that you are now a hero! Right now the whole thing is quite difficult and dangerous but the risk is not serious. It is damaging to your nerves but eventually the bad will be forgotten and you will be satisfied that you have been able to accomplish something very big. You found friends and learned who your enemies were. And in the end it became evident that it was interesting for people to see things which the artists had originally made for only themselves"; Ülo Sooster to Silvia Jõgever, October 20, 1960, collection of the artist.

53. Sooster to Jõgever, Moscow, December 21, 1960: "It seems the notorious exhibition has begun to have positive results. Kaja wrote that you and Lüüdia had sold some pictures. Excellent! It seems that after all this noise they are forced to take this group seriously.... I congratulate you, powerful woman! Now you should all enter the [Artists'] Union because there you may be able to exert influence on things. In a jury, for instance, one could paralyze the influence of some spook and sneak some good works into exhibitions. It is good if one can struggle for a good cause.... Those people are, after all, no Gods . . . and to express one's opinions honestly will not be futile."

54. Kivimaa, "Interview with Olav Maran," 36.

55. Leonhard Lapin, "Eesti Kunstiavangard ja punane okupatsioon," unpublished Estonian manuscript for the Finnish book (with English summary) *Pimeydestä valoon: Viron taiteen avantgarde neuvostomiehityksen aikana* (Helsinki: Otava, 1996).

56. Henn Roode, "Mõttekilde joonistustest," *Kunst* 73, no. 1 (1989): 27.

57. Elvi Pirk, conversation with author, March 1999.

58. Wallach, *Ilya Kabakov*, 44.

59. Two of Jaan Kross's novels have been published in English: *The Czar's Madman* (1993) and *Professor Martens' Departure* (1994). His books have been translated into almost all European languages, and he has been a front-runner for the Nobel Prize in literature for several years but thus far not the winner. Jaan Kaplinski has also been a candidate for the Nobel Prize. His collections of poetry *The Same Sea in Us All* (Mission, British Columbia, Canada: Barbarian Press, 1985; Portland, Ore.: Breitenbush Books, 1985) and *The Wandering Border* (Port Townsend, Wash.: Copper Canyon Press, 1987) have been published in English in Sam Hamill's translations.

60. Finnish artists Jorma Hautala and Carolus Enckell formed lasting ties in Estonia. The latter is also the editor of the art magazine *Taide*, where the best surveys about the Estonian avant-garde have been published. See especially Jorma Hautala, "Paikallisen ja modernin syntessejä," *Taide* 4/82: 42–45; "Rakennettu ajatus rakennettu kuva," *Taide* 4/84: 34–41; "Müüdid ja utoopia," *Kunst* 75, no. 1 (1990): 10–14 (translation into Estonian from the Finnish catalogue *Struktuuri/Metafyysika* [Pori, Finland: Pori Art Museum, 1989]); Carolus Enckell, "Tallinnalaisia Impressioita," *Taide* 4/84: 18–21; and Sirje Helme, "Viron taide valinauhassa," *Taide* 3/87: 38–44.

61. Rein Veidemann, "Kuuekümnendate põlvkond eesti kultuuris ja ühiskonnas," *Sirp* 16, no. 33 (August 1991): 2–3.

62. Leonhard Lapin, "Startinud kuuekümnendatel, mälestusi ja mõtteid," *Kunst* 68, no. 1 (1986): 17. Sooster also quoted Freud in a letter to Lüüdia Vallimäe-Mark on August 18, 1959, saying that "the reading of Freud's books convinced me that he has many interesting ideas. Every picture-maker should read him because his ideas about the unconscious and creativity are especially instructive."

63. Juhani Püttsepp, "'Gulagi arhipelaag' sündis tänu eestlaste vaikimisele: Kirjanik Aleksandr Solzhenitsõn küsib, miks taasiseseisvunud eestlased vihkavad Venemaad, mitte kommuniste," *Postimees*, October 12, 1999, p. 22. Solzhenitsyn stayed in the village of Vasula for two winters, 1965–66 and 1966–67, where he was disguised as a scientist from Moscow writing his dissertation. According to Heli Susi, he typed extremely fast with three fingers—about forty pages every day. Solzhenitsyn had shared a cell in Lubjanka Prison with Heli's father, Arnold Susi, a lawyer and former minister of education in prewar Estonia. The handwritten manuscript was kept in Estonia until 1998. His *One Day in the Life of Ivan Denisovich* was first published in the Soviet Union in 1962 and in the following year was translated into Estonian by Lennart Meri, the current president of Estonia.

64. On Maran, see Anu Liivak, "Olav Maran," in *Eesti kunstnikud—Artists of Estonia*, 120–129; and Liivak, *Olav Maran* (Tallinn: Tallinn Art Hall, 1993).

65. See Kivimaa, "Interview with Olav Maran," 34.

66. Ibid., 38.

67. Olav Maran, discussion with author.

68. Kivimaa, "Interview with Olav Maran," 37.

69. Mark Svede has discussed Uldis Zemzaris's contacts with Maran in Tallinn. See Mark Allen Svede, "Nonconformist Art in Latvia: Smaller Measures to Equal Effect," in *From Gulag to Glasnost*, 196. The Estonian and Latvian artists also met regularly at seminars for young painters in Latvia.

70. See Kivimaa, "Interview with Olav Maran," 38.

71. Olav Maran, discussion with author.

72. Tolli's *Garden* (1966) and two compositions by Kaasik in the Zimmerli collection were among the works exhibited.

73. Lapin, "Eesti Kunstiavangard."

74. Illustrated in *Noorus* 11 (1966), fig 11.

75. Lapin, *Pimeydestä valoon*, color plates 26 and 27.

76. Olav Maran, "Kujutamisest kujutavas kunstis," *Noorus* 11 (1966): 66–68. The same magazine also contained illustrations of works by Ulas, Laretei, Korstnik, Eelma, Arrak, Maran, Klar, Leis, Põldroos, Tõnis Vint, Palm, and Sarapuu. *Noorus* was one of the most progressive magazines in Estonia during the second half of the sixties and the seventies.

77. Lotman came to Estonia from Leningrad, where he could not find work because of anti-Semitic restraints. He was not in official favor even in Estonia and suffered from restrictions on publishing and travel. Maran based his justification of abstraction on Lotman's theories of creativity and scientific definitions of matter.

78. She has discussed the meeting many times: "When we arrived at the art barrack, there was a lecture going on. Harry Coleman spoke about American abstract art. This was my first contact with contemporary Western art. He had art books and magazines with him. When the lecture ended, I went and asked questions. The Colemans were happy that I showed such enthusiasm and gave me a recent issue of *Art News* which contained an article about Pollock, who had died recently in a car accident, an illustration of one of his works, and also an illustration of a recent painting by de Kooning. . . . We spent the whole of the following week together"; *Lola Liivat: abstraktsionist* (Tartu: Tartu Art Museum, 1998). My text is based on the Estonian version, which differs slightly from the English one in the catalogue. The *Art News* in question was the issue of September 1956, with an illustration of Willem de Kooning's *Gotham News* and Jackson Pollock's *Number 5* (1950). Lola Liivat was Lola Makarova until 1968; between 1968 and 1992 she was Lola Liivat-Makarova and thereafter Lola Liivat.

79. Ibid.

80. Lola Liivat, "Kollaažh kahe näituse teemal," *Sirp*, January 29, 1997.

81. Ibid.

82. This information comes from Ilmar Malin's widow, Inge Malin.

83. The earliest inscriptions in books date from 1962 and are still in the family collection.

84. Fragments of autobiography; I am grateful to the artist's son and wife for this information.

85. Tamara Luuk and Ain Kalep, *Ilmar Malin: inimesed, sümbolid, olevused* (Tallinn: Kunst, 1988). See also Evi Pih-

lak, *Ilmar Malin* (Tallinn: Estonian Art Museum, Tallinn, 1981); and Ants Juske, "Ilmar Malin," in *Eesti kunstnikud— Artists of Estonia*, 110–119.

86. The artist discussed this in an interview with Erik Linnumägi: "In Sweden, in 1966, I visited the Museum of Modern Art in Stockholm and became acquainted with its collection. There I found Max Ernst and Öyvind Fahlström especially congenial. This changed all my previous convictions about art. I recalled my childhood drawings and automatic scribbles and I realized they had an inner meaning, which had to be organized systematically. I have also been influenced by Endre Nemes, an artist of Hungarian descent living in Stockholm, and the French-Spanish artist Francis Picabia"; "Siis kui valmib Rüütli galerii 'Jutuajamine maalikunstnik Ilmar Maliniga,'" *Postimees*, March 30, 1993, p. 7.

87. Raul Meel, "Coordinates That Matter to Me," in *Rujaline roostevaba maailm/Rocking Rustfree World in Estonian Art of the '70s* (Tartu: Tartu Kunstumuuseum, 1998), 85.

88. The French art critic Raul-Jean Moulin singled out the Estonians in his review of the international print exhibition in the cultural issue of *Les Lettres Françaises*, and he emphasized that the works of Tihemets, Meel, Klar, Marju Mutsu, Vint, Vinn, and Eelma could not by any means be classified as official Soviet art. Less than two months later, another French critic, Pierre Descargues, wrote about the Rijeka international drawing biennial in the same magazine, analyzing the works of Lapin, Meel, Mutsu, Sirje Runge, Vint, and Mare Vint; Jüri Hain, "The Rise of Estonian Graphic Arts in the 1970s," in *Rujaline roostevaba maailm*, 74–75.

89. Boris Bernstein, *Peeter Ulas* (Tallinn: Kunst, 1984), 28.

90. The picture, no longer a single space for the objects, has become a complex setting for mental images where memories and associations meet with the cosmic "other side." See Bernstein, *Peeter Ulas*, 32–35.

91. In 1978, Peeter Ulas made his first trip to the West, visiting New York and Toronto. He saw many exhibitions, among them one by Toronto artist Ron Martin, who painted all-black canvases with heavy textural patterning.

92. The original photograph was taken by Jaan Klõsheiko in quite different circumstances.

93. Sirje Helme, "Aeg Herald Eelma joonistustes: emotsioon 1975. aasta personaalnäituseslt," *Kunst* 50, no. 1 (1977): 30.

94. Enno Ootsing, one of the original members of ANK, has discussed the formation of the group and the first ANK exhibition by students of the art institute: "The idea came about to give an exhibition which became a reality in October, 1964 in a small room in the Estonia Theatre ... and so, in this way an exhibition was presented there which established the foundation for ANK-64. We rotated guard duty at the exhibition. Friends and friends of friends came to look at the exhibition. Recalling from memory, basically art students, young artists, and musicians. Repercussions of course resulted and soon the KGB appeared to investigate. Even so,

it never led to outright repression"; Enno Ootsing, "The Art Group ANK-64," in *ANK '64*, eds. Anu Liivak and Sigrid Saarep, English text in the end (Tallinn: Tallinn Art Hall, 1995).

95. Ibid.

96. ANK was responsible for resurrecting the Estonian cubists of the twenties, especially the three surviving members of the original constructivist-oriented "Estonian Artists' Group": Märt Laarman (1896–1979), Arnold Akberg (1894–1984), and Juhan Raudsepp (1896–1984).

97. See the "Chronology" in Liivak and Saarep, *ANK '64*.

98. Several ANK artists were at Rukhin's funeral in 1976. Both Vint and the photographer Jaan Klõsheiko have described the KGB surveillance during the ceremony.

99. See Jüri Hain, "Üks kollektiivne kogemus kuuekümnendatest," *Kunst* 71, no. 1 (1988): 28–30.

100. Leonhard Lapin, "Startinud kuuekümnendatel," 17.

101. *Noorte Hääl*, June 7, 1966, pp. 1–2. In the November 1966 issue of the youth magazine *Noorus*, Olav Maran drew parallels between science, mathematics, and abstraction in even greater detail.

102. Between 1968 and 1970, translations of ten books on contemporary Western art were produced. This exposure was enormously important for younger artists in both Tallinn and Tartu. All texts were translated by the students and circulated in typewritten manuscripts of under fifty editions. The choice of topics reflected the interests of all Estonian younger artists at the time. As early as 1964, Põllu had organized the translation of Michel Seuphor's *Fifty Years of Abstract Art*. Carola Gideon Welcker's *Paul Klee* was translated from German; Kandinsky's *Stupeni* (Steps), a 1918 version of *Rückblicke* (1913), was translated from Russian (see *Kandinsky, Complete Writings on Art*, eds. K.C. Lindsay and P. Vergo [New York: Da Capo Press, 1994], 913); and Herbert Read's *Concise History of Modern Painting* and Aldo Pellegrini's *New Tendencies in Art* were translated from English. Monographs on Klee, Kandinsky, and Picasso, as well as books on color theory and Japanese prints, also were translated and copied.

103. Each represented a different Western country: France (1968), Finland (1968), the United States (1969), and Sweden (1970). The Finnish album contained a translation of a Finnish article on the recent Venice Biennial in 1968. The Swedish album had one article by the eminent international art historian Pontus Hultén and another by the surrealist poet André Breton. The American album contained articles by Sam Hunter and Douglas M. Davies, an article by the Czech critic Jindrich Chalupecky on avant-garde art, a translation of a Finnish article on Andy Warhol, and several articles from 1967–68 editions of *Art in America* and *Studio International*. For a list of publications, see *Kunstirühmitus Visarid—The Visarid Artists' Group, Tartu, 1967–1972* (Tallinn: Tallinn Art Hall, 1997), 80–81.

104. Kaljo Põllu, "Punane joon," interview by Toomas Raudam, *Kunst* 1 (1995): 44.

105. According to Vint, abstract expressionism had exhausted its potentialities while "pop art, op art, kinetic art, new realism and new sculpture of England seem to provide answers for future developments of new universal systems." Vint noted the need for the spiritual in art as expounded by Wassily Kandinsky, where colors are identified with great cosmic themes. He cited Kandinsky's inner sound and claimed that the question of the spiritual had arisen again in art during the mid-1960s. Kandinsky was very important for Estonian artists during the 1960s. Jüri Arrak's lecture on Kandinsky at an ANK seminar in 1965 made a powerful impact on many young artists; both Leonhard Lapin and Jaak Soans have mentioned it as one of the most interesting experiences at the ANK seminars. Vint felt that from pop art's new pictorial constructions could emerge an art similar in spirit to that of the early Renaissance and Kandinsky, with the same emotional and social content. According to Vint, "the beginning of these new aspects in art can already be detected in many works, although it is not certain yet whether the initial manifestations will become all-embracing"; Tõnis Vint, "Olukord," *Visarid I* (1968): unnumbered pp. This emphasis on the universal and the spiritual is quite different from the pop art and other contemporary expressions in Western art as we know them. Nevertheless, it was important to Estonian artists during the 1970s, especially to Tõnis Vint and his circle. Other articles in the four albums also emphasized that abstract expressionism had lost its relevance. Consequently, most younger artists in Estonia began to look elsewhere for inspiration.

106. Kaljo Põllu, "Op-kunstist," *Tartu Riiklik Ülikool,* March 17, 1967, pp. 3–4.

107. According to Põllu, Visarid group members wrote artists from around the world and asked for contemporary literature on art for the art studio. Artists' addresses were printed in the catalogues of the Krakow print biennial. Many requests were answered, and soon the studio had a considerable collection of books and catalogues from around the world. See "Manifesto of the Visarid Artists' Group," in *Kunstirühmitus Visarid,* 88.

108. Ibid., 55, fig. 43. Air art was discussed in an article by Willoughby Sharp translated from *Studio International* 5 (1968) that appeared in *Visarid III* (1969). Sharp described the 1,001 balloons hovering in the air during Yves Klein's exhibition and other examples of helium-filled objects by Piero Manzoni, the T-Group in Milan, the Zero Group in Düsseldorf, and the blown-up figure by Takis in Paris in 1968.

109. See Leonhard Lapin, "Soup '69," in *Pimeydestä valoon.* The English summary "Estonian Avant-Garde Art" is on pp. 146–152. My quotes are from the Estonian manuscript. About Soup '69, see also Leonhard Lapin, "Startinud kuuekümnendatel," 17–23; and Eha Komissarov, "Soup '69 — 20 aastat hiljem," *Kunst* 76, no. 1 (1991): 17–19.

110. Soviet custom was to shave the prisoners' heads at the time of arrest.

111. John Wesley's *Squirrels* is illustrated in Lucy Lippard's *Pop Art.* According to Lapin, he bought the German edition of the book while in Hungary in 1969; as related to Heie Treier in "Leonhard Lapin vestleb: Pilgud kuldsete kuuekümnendate fassaadi taha," *Kunst* 1 (1993): 34–36.

112. Eda Sepp, "Leonhard Lapin: Autobiography as Paradox and Parody," in *Leonhard Lapin: maal, graafika, skulptuur, arhitektoon/Painting, Graphic, Sculpture, Architectonic* (Tallinn: Estonian Art Museum, 1997), 17–25.

113. For postmodern contradiction, see Linda Hutcheon, *The Politics of Postmodernism* (London and New York: Routledge, 1993), 1–23; and Sepp, "Leonhard Lapin."

114. Martti Preem, "Sündmus Harkus," *Tartu Riiklik Ülikool* (TRÜ). TRÜ was the Tartu University student paper; it contained the only review of the event at the time. See also *Harku, 1975–1995* (Tallinn: Tallinn City Gallery, 1995); and Leonhard Lapin, *Pimeydestä valoon,* 74–89.

115. What Vint wrote about Japanese family crests in 1976 applies also to his drawings of the period and his work in general: "We are inspired by the elegance of their graphic line and the utter simplicity of their transmission of the underlying concepts.... [It] is not only ... [a] distinctive mark or decoration. Hidden in the sign are philosophical concepts and religious beliefs. It can be used as an aid in meditation. The sign contains generalizations about universal laws as well as aesthetic programs. It is both a talisman and an aid in magic rituals"; Tõnis Vint, "Jaapani peremärgid," *Kunst ja Kodu* 2 (1976): 25. For writings containing Vint's theories, see also Tõnis Vint, "Hermetria ja rühm 22," *Sirp ja Vasar,* February 3, 1989, p. 8; and "Kalevan kirjat ja I Ching," *Taide* 4/84: 22–29.

116. As Annus has explained, "The aspirations of Studio 22 differ greatly from our ordinary art knowledge. It was there in the seventies already. At that time they called their art psycho geometry. If we try to find a kind of parallel from history then perhaps the Medieval Geomantia may fit. Geomantia explains the structures in nature, the visual aspects and the numerical rhythms of sprouting and perishing.... Tõnis Vint thinks that Estonian folk art, the belt ornaments, carpets and Japanese family crests are connected with the rules of geomantia. 'Studio 22' was formed in the middle of the eighties. The interest in mystical, esoteric knowledge can be seen from the group's name 'Studio 22.' It comes from the Tarot cards where the last card is called the Fool. It is marked by the magic number zero or 22. It is the reality outside the reality, the absolute and nothing, the will to understand without taking part in the game"; Siim-Tanel Annus, "From Cosmic Rhythms to Rituals: Tõnis Vint — Siim-Tanel Annus," unpublished lecture in English, 1992.

117. Annus prepared the text for a lecture in Toronto in connection with an exhibition of Baltic art from the Zimmerli collection in 1992. Vint himself has rarely commented on his teaching methods, and few students have been with him as long as Annus. Very little on Vint's methods has thus far been published in Estonian.

118. Johannes Saar, "Tõnis Vint," in *Eesti kunstnikud — Artists of Estonia,* 240–241; and "Võluri sisekaemused," *Postimees,* May 31, 1996, p. 17.

119. Quoted from Tõnis Vint, "Reval. Tallinn. Üks linn, kaks saatust/Reval. Tallinn. One city, two fates," *Ehituskunst. Estonian Architectural Review*, no. 22/23 (1998): 77–79.

120. Tõnis Vint, discussion with author, 1975.

121. Juri Lotman, *Kultuurisemiootika: tekst—kirjandus—kultuur* (Tallinn: Olion, 1990), 25–31.

122. The section on Vint has been adapted from my text "Estonia: Art as a Metaphor of Its Time," in *Baltic Art during the Brezhnev Era: Nonconformist Art in Estonia, Latvia and Lithuania*, ed. Norton T. Dodge (Mechanicsville, Md.: Cremona Foundation), 12–14.

123. Raul Meel to Juhani Rautio, Finland, 1975. Meel served in the Soviet army with Toomas Vint, Tõnis's brother. Tõnis sent magazines and articles to Toomas, which were probably Meel's introduction to contemporary art.

124. Unpublished text in the author's collection, dated April 1974.

125. Meel to Juhani Rautio, Finland, 1975.

126. Meel, "Coordinates That Matter to Me," 88.

127. Raul Meel, "Minevikukonspekt," Estonian text of 1998 unpublished memoir, p. 29.

128. Raul Meel, "Conspectus of the Past," unpublished August 17, 1999, version, p. 21.

129. Ibid., 24.

130. Ibid. Kaljo Põllu has related that when Czech and Polish connections were cut in about 1972, the Finnish ones intensified, and many Estonian artists began to receive their information from Finland; Kaljo Põllu, discussion with author, Tallinn, March 11, 1999.

131. Meel, "Conspectus," 25 and 34. The Costakis Collection, consisting of Russian avant-garde art from the first part of the twentieth century, is now also well known in the West.

132. The "window" initially referred to viewing Finnish television and extended to other areas of Estonian culture as well as personal contacts.

133. Meel, "Minevikukonspekt," 21 and 28.

134. Ibid., 21.

135. In 1975 Meel wrote to Juhani Rautio, an art history student in Finland who was writing his master's thesis on Meel, "As an artist, I would like to be a window into another dimension, another worldview … the cosmos which is ever-changing when it flows through us yet always eternal. This other world can be a window into the third world and eventually into the spiritual and the cosmic consciousness"; unpublished letter, March–April 1975.

136. See Juri Lotman, *Kultuurisemiootika: tekst—kirjandus—kultuur.*

137. In the words of Pierre Teilhard de Chardin, who invented the term, "nosphere" is where "the personal reaches its triumph at the summit of the mind … the All and the beyond in the evolution, and the ascent of consciousness." Meel uses the term "nosphere" in his article on serial art, "Seeriaprintsüp kunsks," *Kunst* 61, no. 1 (1983): 41.

138. Pierre Teilhard de Chardin, *The Phenomenon of Man* (New York: Harper & Row, 1965), 297–298. According to Rein Ruutsoo (in a private discussion with the author), this book was published in Russian during the 1960s and was discussed in Estonian periodicals.

139. Meel discussed differentiated and simultaneous time in serial art in "Seeriaprintsüp," 41.

140. The four works have only been exhibited together as initially intended by the artist in the exhibition at the John B. Aird Gallery in Toronto in 1992.

141. Meel has explained in detail how he painted the work in "Conspectus," 47–48.

142. Two pictures of the series were on the covers of the September 1988 issue of the cultural magazine *Vikerkaar*. *Vikerkaar*, established in 1987, promoted pro-independence democratic scholarship and fine arts in Estonia. See also the article by Sirje Helme, "Raul Meel Arkaadia teel," in the same issue (pp. 36–38), which is one of the best analyses of Raul Meel's art to that date.

143. When I visited Meel in 1977, he had few finished works to show. Instead, he had hundreds of detailed drawings on little pieces of paper (each about 5 cm square), which he planned to combine for large serial structures. Each was marked with specific color names and numbers he had found on commercial acrylic color samples. He left nothing to chance. The first version of Meel's *Journey into Greenness* was done in gouache on paper in 1975, although the acrylic series in the Zimmerli collection is from 1979.

144. Anu Liivak, "Leonhard Lapin," in *Leonhard Lapin: Architecture, Graphics* (Helsinki: Aalvar Aalto Museum, 1991). See also other articles in the catalogue by Jorma Hautala and Juhani Pallasmaa.

145. Lapin, *Pimeydestä valoon.* See also the exhibition catalogue *Leonhard Lapin: maal, graafika, skulptuur, arhitektoon*, with articles by Eda Sepp, Harry Liivrand, Jorma Hautala, and Ott Arder (in Estonian and English).

146. The articles were published as a collection, *Kaks Kunsti: valimik ettekandeid ja artikleid kunstist ning ehituskunstist, 1971–1995* (Tallinn: Kunst, 1997).

147. See Linda Hutcheon, *The Politics of Postmodernism* (London and New York: Routledge, 1993), 1–23.

148. Ibid., 41. Much of the present article is based on my text "Leonhard Lapin: Autobiography as Paradox and Parody," in *Leonhard Lapin*, 17–25.

149. Leonhard Lapin, "Leonhard Lapin: oleksin võinud olla ka Adolf Mõttus," interview by Annika Koppel, *Postimees: Ekstra*, November 9, 1996, p. 3. Here Lapin states that in French his name means rabbit and *la pin* means phallus.

150. Stephen Feinstein was the first to point out violence within Lapin's erotic female figures and interpret the elements as symbolic devices of sexual abuse. Feinstein notes that it is difficult to discern whether the female torso with legs spread apart in Lapin's *Woman-Machine X* is experiencing orgasmic pleasure or abuse from the penis-like sexual object. Feinstein also believes the first three quadrants may represent the initial physical aspects of lovemaking, while the fourth is the consummation of the act; Stephen C. Feinstein,

"The Avant-Garde in Soviet Estonia," in *New Art from the Soviet Union*, eds. Norton Dodge and Alison Hilton (Washington, D.C.: Acropolis Books, Ltd., 1977), 31–34.

151. Leonhard Lapin, "Objektiivne kunst," reprint of Lapin's presentation at the Harku 1975 exhibition in *Harku, 1975–1995*, 23–25.

152. See Lapin, *Pimeydestä valoon*, 95–96.

153. About Pavel Kondratjev, see also Alla Rosenfeld, "A Great City with a Provincial Fate: Nonconformist Art in Leningrad from Khrushchev's Thaw to Gorbachev's *Perestroika*," in *From Gulag to Glasnost*, 101–102.

154. The identification of the black square was given by Lapin in an April 1997 taped interview with the author.

155. See Hutcheon, *The Politics of Postmodernism*, 44.

156. Ibid., 100.

157. Leonhard Lapin, *Tühjus ja ruum—Void and Space* (Tallinn: Estonian Art Academy, 1998). See also Leonhard Lapin, *Kontseptsioonid ja Protsessid, 1979–1980, 1980–1995* (Tallinn: L. Lapin, 1997).

158. Lapin has stated, "Here a white sheet of paper is for us primarily a symbol of the void, a part of the universe we have selected, not simply a sheet upon which pictures are drawn. Here we are working above all in a symbolic void and space and only secondarily on paper. Our main objective is the achievement of a clear mind which is indeed spiritual freedom.... Form and the void are not opposites, they are two aspects of the same reality which always function together.... One line in the void. This is an exercise in the origin of material from the void. A white or black background symbolizing the void and one line as the first thing in it. Here the line is the trace of motion, the connecting link between that which exists and the non-existent, both space and time simultaneously.... We seek a pure line—the expression of our clear mind! ... While lines suspended in the void suggested endless space, then here a concrete, material surface is added, in turn adding depth—a manifestation of our inner space.... This is a space existing in our mind—thus it is our inner space.... [Now] we create a new abstract space on the surface, which is the creation of our clear mind and thus our inner space. This inner space gives the illusion of a multidimensional space on the surface of the picture.... The inner space is a view into the mirror of the mind.... A multidimensional space is like an architectural project for a home for the clear mind"; Lapin, *Tühjus ja ruum—Void and Space*, 15, 21, 30, 45, and 51.

159. Anu Liivak, "Leonhard Lapin," in *Eesti kunstnikud—Artists of Estonia*, 86.

160. Jüri Arrak, discussion with author, April 13, 1996. See Arrak's reminiscences in *ANK '64* about studying the writings of Malevich and Kandinsky.

161. Statement in the archives of the Tartu Art Museum; also printed in Mari Pill, "Ülo Sooster, novaator ja traditsioonide kandja," *Kunst* 68, no. 1 (1986): 25–27.

162. Jüri Arrak, interview with author, April 13, 1996. See also Arrak's reminiscences in *ANK '64*.

163. Jüri Arrak to author, April 12, 1992.

164. About Malle Leis, see Evi Pihlak, *Maal, seigraafia, akvarell* (Painting, Serigraph, Watercolor) (Tallinn: Kirjastus Kunst, 1988). My analysis owes a lot to this book. Leis's painting *Light* (1973–83) is illustrated as plate 11.

165. Lapin, unpublished manuscript, "Estonian Avant-Garde and the Soviet Occupation," chap. 3.

166. See Heie Treier, "Aili Vint," in *Eesti kunstnikud—Artists of Estonia*, 231.

167. Ibid., 228–237; and Heie Treier, "Naine ja Meri," *Kunst* 74, no. 2 (1989): 40–44.

168. Treier, "Aili Vint," 231.

169. Heie Treier has written, "What makes her prints so intriguing is probably their 'truthfulness.' Aili Vint bases her prints upon photos, she works at the photo with mirrors and looks for an aesthetically satisfying solution. From one and the same image she may present positive as well as negative versions, often of different sizes, which together form a numbered series (*Variations*, i.e., variations in form, color and size). In the interest of truth, so to say, her prints are soft pink in color, flesh colored. In 1974, at the time the prints were first exhibited, they constituted a real challenge to the Soviet taboos"; Treier, "Aili Vint," 232.

170. Tõnis Vint, conversation with author, March 21, 1999.

171. See Maria Shashkina, *Toomas Vint* (in Russian), trans. Daila Aas (Tallinn: Kunst, 1993), color plates 1 and 2, dated 1968 and 1970.

172. According to Maria Shashkina, Toomas Vint almost always used photographs as a starting point for his works. The use of a snapshot is especially evident in this work, with the lower part of the girl cut off in the front.

173. Toomas Vint's intentions are summed up in the following statement, which he wrote for the Karlsruhe catalogue: "Toomas Vint's landscapes are the determination of the artist's relation to the surrounding world. Beauty is a deceptive surface, which is actually a mystical lost (closed) paradise, full of the premonition of the tragic. A wandering between the real and the dreamlike, a labyrinth where pretty scenery hides a catastrophe. The things depicted are not made very understandable, the spectator is not directly initiated. Toomas Vint's landscape is not the paraphrase of the romantics, instead it is a transromantic game, secret, joke, mystification. Motives acquire the meaning of everlasting stability and absolute perfection. An unreal world is created according to the rules of reality. Stake is made on man's indifference toward nature. The existentialist method in interpreting reality creates an illusion of the extension of the human soul, helping to make the existence more bearable"; artist's statement, *Mythos und Abstraktion: Aktuelle Kunst aus Estland/Myth and Abstraction: Actual Art from Estonia/Müütos ja abstraktsioon: Tänapäeva Kunst Eeslis* (Karlsruhe: Badischer Kunstverein, 1992), 111.

174. Enno Ootsing, discussion with author, February 26, 1999.

175. See Jüri Hain, "ANK 64," *Kunst* 50, no. 1 (1977): 44, illus. 73. About Marju Mutsu, see Mai Levin, "Marju Mutsu," *Sirp ja Vasar*, January 29, 1982, p. 8; and Ants Hein, "Marju Mutsu loomingust," in *Kunstikteadus, Kunstikriitika*

4, eds. M. Levin, M. Lumiste, and L. Viiroja (Tallinn: Kirjastus Kunst, 1981), 43–54.

176. Mutsu wrote about her art: "Movement—the fixation of a moment during its change and its eternal effect on us ... each person is like a two-way door, one opens to the future, the other to the past. And this duality is the present moment, from this will begin our reception and development"; unpublished manuscript in the possession of Herald Eelma, quoted in Hein, "Marju Mutsu loomingust," 44.

177. Mai Levin, "Silvi Liiva Graafika," *Kunst* 49, no. 2 (1976): 53–57; Martti Soosaar, *Ateljee-etüüde* 2 (Tallinn: Kunst, 1990), 14–21; and Silvi Liiva and Vappu Vabar, *Silvi Liiva* (Tallinn: Silvi Liiva, 1997).

178. On Kaisa Puustak, see Jüri Hain, "Vaikelu igavikuline mõõde," *Kunst* 67, no. 2 (1985): 42–47; and Vappu Vabar, "Kaisa Puustak," in *Uued põlvkonnad* 2 (Collection of articles) (Tallinn: ENSV TA Ajaloo Instituut, Kunstiajaloo Sektor, 1988), 65–69.

179. Vappu Vabar, "Kaisa Puustak," 66.

180. A free rendering of the poem runs thus: "Dear, I would like to know what the potato eyes in our basement intend to do. I believe soon they will rise through the floors, demolishing the ceilings, destroying the floors, furniture into pieces, cutting through the market-nets (freedom for the vegetables!) ... and then ... potato eyes will become antennas, flags, the potato eyes who had hereto been forced underground." See "Väikese linna kohvikumuusikat II" in Paul-Eerik Rummo, *Lumevalgus-Lumepimedus* (Tallinn: Loomingu Raamatukogu, 1996), 29–30.

181. On Marje Üksine, see Jüri Hain, "Marje Üksine," in *Uued põlvkonnad* 2, 54–64.

182. Jüri Hain, "Mare Vint," in *Usutlusi kunstnikega* (Tallinn: Arlekiin, 1995), 155.

183. Mare Vint to author, July 31, 1998.

184. Martti Soosaar, "Mare Vint," in *Ateljee-etüüde* 2, 101. On Mare Vint, see also Eha Komissarov, *Mare Vint* (Tallinn: Kirjastus Kunst, 1991); Evi Pihlak, "Mare Vint," in *Uued põlvkonnad* 2, and "Puhtavormiline loodus," *Kodumaa*, April 13, 1983, pp. 1 and 7; and Peeter Urbla, "Tundelise inimese otsingul," *Sirp ja Vasar*, April 7, 1978, p. 8.

185. Mare Vint, discussion with author, July 31, 1998.

186. Ibid. Mare Vint also introduced the students to Czechoslovakian, Hungarian, and Polish magazines.

187. Leonhard Lapin, *Ando Keskküla* (Tallinn: Estonian National Art Museum, 1986), and "Startinud kuuekümnendate," 17–23. According to Tolts, he received his first information about pop from Czechoslovakian and Hungarian magazines; Tolts, discussion with author, July 31, 1998.

188. Anu Liivak, "Andres Tolts," in *Eesti kunstnikud—Artists of Estonia*, 211. See also *Andres Tolts* (Tallinn: Eesti Kunstimuuseum, 1999).

189. Evi Pihlak, "Andres Tolts: meie maailma avardajana," *Sirp ja Vasar*, September 19, 1986, p. 8.

190. Andres Tolts, discussion with author, July 31, 1998.

191. Lapin, *Ando Keskküla*. Also see Sirje Helme, "Ando Keskküla," in *Eesti kunstnikud—Artists in Estonia*, 56.

192. Ando Keskküla, discussion with author, July 30, 1998.

193. Lapin, *Ando Keskküla*.

194. Helme, "Ando Keskküla," 57.

195. Ando Keskküla, discussion with author, July 30, 1998.

196. Ibid.

197. I am quite aware of the problems of terminology of superrealism, hyperrealism, new realism, photographic realism, imagist realism, and so on. My concern here, however, is to discuss and analyze Keskküla's art as he saw it himself and to use his terms as much as possible. Even in Estonia, there is no agreement about the terminology. Lapin thinks Keskküla is neither a hyperrealist nor a photorealist. Keskküla himself, however, has identified many of his works as hyperrealist, though with some reservations; Ando Keskküla, discussion with author, July 30, 1998.

198. Ando Keskküla, discussion with author, July 30, 1998.

199. Helme, "Ando Keskküla," 57.

200. This picture has been analyzed by Ants Juske in "Ruum ja pilt Ando Keskküla maali-piltides," *Kunst* 71 (1988): 10.

201. Lapin, *Ando Keskküla*.

202. Helme, "Ando Keskküla," 57.

203. About Jüri Okas, see Sirje Helme, "Jüri Okas," in *Eesti kunstnikud—Artists of Estonia*, 162–171.

204. Ado Lill, discussion with author, May 2000.

205. Harry Liivrand, "Ado Lill, maalija" (Ado Lill, the painter), in *Ado Lill* (Tallinn: Estonian Art Museum, 1994). See also Harry Liivrand, "Vestlus Ado Lillega" (Conversation with Ado Lill), *Kunst* 70, no. 2 (1987): 34–35.

206. Art historian Heie Treier has written, "Now, in retrospect, it is difficult to understand what was so dangerous about Ado Lill's abstract paintings in 1976 [*sic*], when his exhibition had to be hidden in the room behind the office of the Chairman of the Artists' Union rather than shown in the official exhibition space at the Art Hall. Ado Lill's canvases are painted with abstract color splashes that seem not to mean anything. Arabesques, intertwined patterns, seemingly random scribbles and scrawls. The background for such art is in the the Buddhist and Taoist theories, the experience of Jackson Pollock, surrealism and the artist's own explorations in the science of color.... Lill uses cold colors befitting his Estonian nature. Even the reds and yellows are cool in his paintings"; Heie Treier, "Ado Lill. Abstraktsionismi metamorfoosid ajas," *Eesti Ekspress*, no. 23 (June 17, 1994): B5.

207. Piret Kukk, "Pilte väikesest inimesest," *Noorte Hääl*, February 28, 1982, p. 2.

208. Liivrand, "Vestlus Ado Lillega."

209. Mai Levin, "Maalija Tiit Pääsuke," *Sirp ja Vasar*, June 27, 1975, p. 8. Also see Evi Pihlak, "Inimesed, esemed, värvid," *Kodumaa*, December 1, 1982, pp. 1 and 4.

210. Jaak Olep, "Barokne Tammik," *Areen*, January 15, 1999.

211. Ants Juske, "Tammiku teine tulek," *Eesti Päevaleht*, December 17, 1998.

212. See Albert Blankert, *Vermeer of Delft, Complete Edition of Paintings* (Oxford: Phaidon Press, 1978), 48, plate 19.

213. According to Jaak Olep, Tammik produced large

wall paintings in Soviet cities, the best of which is in Kirizh. Olep believes Tammik's art was not appreciated because he graduated from the art school in Tartu and never attended the art institute in Tallinn. See Olep, "Barokne Tammik."

214. Ants Juske has analyzed Estonian hyperrealism in "Hüperrealismi kajastusi Eesti kunstis," *Sirp ja Vasar*, July 7, 1987, p. 8.

215. Evi Pihlak, "Jaan Elken," in *Uued põlvkonnad 1*, 62–64.

216. The Estonian language belongs to the Finno-Ugric linguistic group, which is different from the Indo-European languages. Besides Hungarian, Finnish, and Estonian, smaller, related Finno-Ugric groups are scattered throughout the Soviet Union.

217. Kaljo Põllu, *Ten Expeditions to the Finno-Ugrians* (Tallinn: Olion, 1990), 27.

218. Kaljo Põllu has tried to find a visionary synthesis between the ancient cosmology and cultural anthropology of the Finno-Ugric peoples by tracing their common images of the circular tent and waterfowl. The historian Lennart Meri (presently the president of Estonia) did the same in his books and films of the seventies. The composer Veljo Tormis has created choral music inspired by Finno-Ugric folk songs but based on contemporary vocal theory. Meri's films are available in English, and Tormis's music can be acquired from music stores in North America.

219. Ene Asu-Õunas, "Foreword," in Kaljo Põllu, *Kodalased: Thirteen Reproductions* (Tallinn: Kunst, 1978).

220. "Geometric Art: Opening speech at the exhibition *Geometric Prints* in Tallinn on August 3, 1977, on the second floor of the Art Hall," in Leonhard Lapin, *Kaks kunsti: valimik ettekandeid ja artikleid kunstist ning ehituskunstist, 1971–1995* (Tallinn: Kunst, 1997), 61.

221. For an analysis of Runge's early style, see Eha Komissarov, "Sirje Runge," in *Sirje Runge* (Tallinn: Soviet Estonian State Museum, 1986). Also see Evi Pihlak, "Objektid helendavas ruumis," *Kodumaa*, June 13, 1984, pp. 1 and 7.

222. Sirje Runge, discussion with author, January 1982.

223. Annus has described his debt to Tõnis Vint as follows: "I first met Tõnis Vint when I was thirteen and very soon became kind of a family member. In my memories the two homes get mixed up—my own and Tõnis Vint's studio. Sometimes it's difficult to distinguish what happened in my home or in that other. It was like living in two places at the same time. I stress it to show Tõnis Vint's intensive personality. It can also be seen now when there are about thirty young people around him in his studio. Tõnis Vint's phenomenon influenced the whole art situation of that time in Estonia (I mean the seventies) and partly even now. Many Estonian artists work in the same size of paper—60 cm × 62 cm—once suggested by Tõnis Vint. Also black and white combinations are still much used in modern Estonian graphics.... Tõnis Vint not only shows and speaks of art. He also encourages every student to do something himself. At that time the symbols, their similarities and constructional logic, no matter in what culture in the world, were at the center of his attention. He explained the different influences of the symbols on hu-

man psychology and the unconscious. This influence may be destructive or stimulating"; Siim-Tanel Annus, "From Cosmic Rhythms to Rituals."

224. Sirje Helme, "Siim Annuse loomingust," *Sirp ja Vasar*, November 6, 1981, pp. 8–9.

225. Quoted in Johannes Saar, "Hegel, Annus, Subbi, Priimägi," *Postimees*, February 14, 1997, p. 14.

226. Evi Pihlak, "Siim-Tanel Annus," in *Uued põlvkonnad 2*, 85–87.

227. The descriptions are from Evi Pihlak, "Taevas, tornid ja maa," *Vikerkaar* 7 (July 1987): 65–75.

228. Siim-Tanel Annus, discussion with author, June 1992.

229. Mihkel Mutt, "Etendus kahes 'osas,'" *Sirp ja Vasar*, December 18, 1987, p. 9.

230. Tõnis Vint, "Ene Kulli märkidest maailm," *Vikerkaar* 12 (1989): 36–37. See also *Mythos und Abstraktion*, 156–157, 163–167.

231. See Tõnis Vint, "Ene Kulli märkidest maailm." Ene Kull has described her own aspirations thus: "That means to make visible what is hidden and invisible, and to subtilize that which is known and visible. This is the creation of the reality in its highest order. Simultaneously perfect stillness and perfect motion. The discovery of the secrets of eternity and infinity. To achieve a reflection of cosmic completeness, to transform the reflection into reality and to dissolve in it. Perpetual and repeated renewal at ever higher levels. To connect with another timeless dimension. To find light in darkness. It is the flight of Ikaros toward the sun"; Ene Kull, in *Mythos und Abstraktion*, 163. My translation of Kull's Estonian statement differs slightly from the English text in the catalogue.

232. Piret Pukk, "Universaalne geomeetria," *Ehituskunst* 2/3 (1982–83): 75.

233. Hasso Krull, "Mari Kurismaa piltidest," *Vikerkaar* 1 (1995): 51.

234. Harry Liivrand, "Näitused," *Sirp ja Vasar*, March 25, 1988.

235. Ants Juske, "Jüri Kask," in *Eesti kunstnikud—Artists of Estonia*, 46.

236. Ninel Ziterova, "Uue maailma loomine: Jüri Kask," *Kunst* 72, no. 2 (1988): 26–31, and "Jüri Kase näitus Kadriorus," *Sirp ja Vasar*, June 26, 1987.

237. Lecture given in Toronto in 1978 when Soans participated in the Tenth International Sculpture Conference.

238. Tiina Pikamäe, "Eesti skulptuur 1970. Aastatel," in *Uued põlvkonnad 1*, 88.

239. Villu Jõgeva, discussion with author, 1998.

240. For Steve Reich's method, see K. Robert Schwarz, *Minimalists* (London: Phaidon Press, 1996), 68–76.

241. Jõgeva, discussion with author, 1998.

242. Anu Liivak, "Kaarel Kurismaa," in *Eesti kunstnikud—Artists of Estonia*, 66–67.

243. Ants Juske, "Peatükk Eesti moodsa kunsti ajaloost—Kaarel Kurismaa," *Vikerkaar* 9 (1993): 41.

244. Liivak, "Kaarel Kurismaa," 66.

Eha Komissarov

ART IN TARTU DURING THE SOVIET OCCUPATION

SOVIETIZATION, which occurred from 1945 to 1953, was the transformation of the way of life in occupied Baltic countries so that it would accord with the laws and norms of the Soviet Union. The Estonian writer Emil Tode has described the situation metaphorically, asserting that the poor, blind, postwar Eastern European states mourn their stillborn history.[1] More particularly, the reorganization of the former democratic state of Estonia according to Stalinist principles resulted in a cataclysm, turning all the former values upside down. The Estonian population of a little over one million people did not actively attempt to resist the flood of Soviet troops that began to take over their country in the early 1940s. These iron-willed Communist Party soldiers from Russia effectively reduced the differences in the way of life to a struggle between classes. The Russian occupants of Estonia presented themselves as liberators as well as

representatives of a higher sociopolitical system, leaving the local population on the lower steps of the power hierarchy. Thus, democratic socialism, which every Soviet schoolchild was taught was the most progressive political system in the world, was transformed by the Soviet system into a system that suppressed any opposition. Sovietization forced Estonians to admit guilt for their former way of life. As punishment, the Soviet occupants brainwashed the local population, coercing them to adopt socialist policies. Thus, Soviet socialism equaled colonialism in the minds of the Baltic people.[2] Such a loss of independence has always had far-reaching consequences.

At first, the Estonians could not understand the rules of Stalinist polity. This misunderstanding led to enormous personal sacrifices by many Estonians. For example, at the beginning of the twentieth century, a large part of the Estonian population owned rural

land. After the Soviet occupation, this rural population refused to join *kolkhozes* (collective farms). They could not imagine that their refusal to give up their ancestors' land and their means of production would be treated as a crime against the state. However, the Soviet government forced them to join *kolkhozes* through mass repression and deportation. On March 25, 1949, over twenty thousand people, or two and a half percent of the Estonian population, who resisted collectivization were loaded into cattle wagons and transported to Siberia without notice.

While the Soviet state could essentially steal land for itself with just one primitive act of violence, the campaign of brainwashing that uprooted the relics of "bourgeois nationalism" turned out to be an uncontrollable process that lasted longer than anyone expected. Immediately after the occupation, the Soviet propaganda machine started to produce a socialist vision which suggested that equality existed between the "liberated" and the "liberators." For the Estonians, such propaganda provided evidence that they had little control over their national image that the Soviet government was presenting to the outside world.

The ideological campaign that started in Estonia in 1948 had several common features with the events in Leningrad and Moscow after the decision of the Central Committee of the Communist Party to censure Vano Muradeli's opera *The Great Friendship*.[3] However, in Estonia the attacks against "formalist" artists and writers[4] turned into a revision of national culture on an unprecedented scale. What seemed to be a campaign for Socialist Realism was in reality the cleansing of the entire history and cultural heritage of Estonia. Once that past was eradicated, a new cultural policy based on Marxist-Stalinist ideology seemed possible.

Russians introduced Socialist Realism to Estonia on chauvinist terms. The campaign argued that discussions of Estonian cultural heritage must include the influences of Russian culture, which eliminated any distinguishing features of other ethnic groups, and the subordination and limitation of the unique Estonian culture. Everything that did not fit the parameters of Socialist Realism was eliminated. In Tartu, forbidden literature was burned in the vacated rooms of an abandoned factory, modernist artworks were hidden in museums' cellars, and newspapers carried out gruesome witch-hunts against writers and artists. Artists were forced to publish penitent letters and publicly denounce their former ideas, and had to display proof of their commitment to Socialist Realism and pledge an oath to the Soviet state.

In the Soviet attempt to indoctrinate Estonians with the ideology of Socialist Realism, important Socialist Realist novels were translated into Estonian and professors from Russian art schools were sent to teach in Estonia. Many Russian students who had never encountered any art but Socialist Realism were enrolled in Estonian schools.

On November 20, 1949, a so-called "bourgeois-nationalist" student group at the Tartu Art Institute was eliminated. During the investigation, the recent graduate Ülo Sooster (1924–1970) and the students Henn Roode, Valdur Ohakas, Heldur Viires, Lembit Saarts, and Esther Potissepp were arrested. Several professors who advocated "formalism" were interrogated, although some of them were the most outstanding figures of Estonian intelligentsia. The arrested artists were charged with a long list of presumed anti-Soviet activities: spreading leaflets with caricatures of the heads of state; secretly exhibiting modernist works in closed storage rooms of the Tartu Art Museum; possessing "forbidden literature" (Roode was accused of translating a forbidden book, *Twentieth Century French Painting* by Raymond Escholier, which he found in the Tartu Art Museum on the bookshelf of "forbidden" literature); comparing Socialist Realism adversely with Western modernism; discussing the international situation and the possibility of war between the Soviet Union and the United States; preparing to escape from the Soviet Union to Paris via China; discussing the possibility of hijacking a plane; and commuting between Tallinn and the islands of Estonia as a way to escape the country. This list shows the fears of the Soviet state.[5]

In 1950, the arrested students were sentenced to ten years of hard labor and sent to different labor camps in Siberia. This event led to the reorganization of artistic life in Estonia. The art school in Tartu, which was judged to be too nationalist, was moved to Tallinn. Old professors lost their jobs. Several outstanding artists were arrested and sent out of the country, and the Artists' Union was cleansed of unloyal members.

Open discussions, which in Estonia were traditionally associated with cafés, ceased to exist. People accepted the situation, without asking many questions,

and tried to escape into their own private worlds where they painstakingly preserved their traditional way of living. Those who could not adapt themselves to the norms of the new Soviet society faced hardships. A number of postwar artists performed manual jobs in order to survive, and many turned to alcohol. Some people, of course, tried to rise within the Soviet system, although the authorities could rely only on a few artists to paint in their prescribed style. Estonian artists' participation in official exhibitions dropped dramatically. The first Estonian Socialist Realist works were shown in 1950 at several exhibitions in Tallinn and Tartu, and works not corresponding with the pattern of Socialist Realism were expelled from exhibitions.

Both groups, the Estonians and the Russians, were aware of the gap between them. The Estonians identified themselves with the West and the Russians with Asia, distancing themselves as far as possible from the Russians. From their conflicts and the frustrations of Sovietization emerged all of the stereotypes of Russians and Soviet power, stereotypes that only started to disappear from the Estonian language in the 1990s.

The period of Khrushchev's thaw that began in 1956 brought about some positive changes in the totalitarian regime and slightly broadened the regulations over artistic life. At the same time, it offered examples of new aspirations. However, the ease of tension in international relations and the modernization of the Soviet economy did not exclude the prohibition of Boris Pasternak's *Doctor Zhivago*, or prevent Khrushchev's scandalous behavior at the Moscow Manege exhibition in December 1962.[6] His actions destroyed hopes connected with the thaw and raised strong doubts about the trustworthiness of the Kremlin empire.

In Estonia, the thaw helped to encourage some cultural autonomy. In 1956, Khrushchev started to support the independence of national communist parties and the development of local authorities. This allowed some Estonian activities to influence decisions made in Moscow. The focus of the activities of art authorities in the 1960s turned away from restrictions based on Marxism toward increased tolerance and a softening of censorship. The collaboration of the Estonians with the government resulted in several compromises. Therefore, the cultural life of the period saw very few drastic conflicts between spirit and power. However, the idea of independence was limited. For example, the KGB watched over Sooster, who had settled in

Moscow and had identified himself as a nonconformist artist. In 1955, for example, he had declared his rejection of Socialist Realism, stating, "My ideas of art were formed in bourgeois Estonia, thus being formalist. It was impossible for me and for many others to accept the principles of Socialist Realism. I could not pretend to be the supporter of the ideas of Socialist Realism, since in art perfection is achieved only by a sincere approach. Therefore, in our private talks we discussed ideas that were in opposition to official trend. Our discussions were not political but just conversations about art."[7]

In Estonia, unlike the situation in Moscow, the division line was not always between a nonconformist minority and an official majority of artists. Around 1960, one may point to a strong sense of nationalism, including attempts to revive an Estonian culture and an emergence of a national Estonian style within the realm of Soviet art. This Estonian art was based on being entirely different from Socialist Realism. In their struggle against the Soviet power, Estonian artists often used the discourse of modernism, but they were also open to ideas based on conservative traditionalism. The Estonian art scene at the end of the 1950s offered different interpretations of prewar art trends, exhibiting evidence of the existence of strong traditions. Already some artists were using the national heritage to create a feeling of continuity. For several others, nostalgia for the past made possible a living link with the Estonian heritage; therefore, these artists became the caretakers of traditions.

One of the most difficult tasks that faced Estonian art was the renewal of an artistic language. In reality, it turned out to be impossible. The attempts to avoid Soviet-style art did not eliminate it. Most artists began to consider the possibility of working within the frames of Soviet art, yet filling it with new meaning. They saw restoring and creating a formal painting style as their mission, and the early 1960s witnessed the development of several ideas.

Also during this period, nonconformist art appeared in Estonia. This radical minority of artists presented the symbolic idea that they were fighting for justice, and art was their means of resistance. These artists created art expressing their oppressed circumstances and traumatic experiences. Therefore, in order to make their radical statements more prominent, they used stylistic references to European modernism.

These nonconformist artists found some examples of modernism in officially sanctioned art. Several official artists also invested in new possibilities, getting into conflicts with the artistic bureaucracy or keeping their experiments secret. For example, the painter Elmar Kits (1913–1972), who was not in contact with dissidents, was a "politically correct" artist, yet his permission to exhibit was not guaranteed. Kits, an abstractionist, appeared on the art scene sporadically, as the exhibition juries did not always accept his work.

During the war, Kits became the leading painter in the impressionist style in Estonia. In the first Soviet years, he was a professor at the Tartu State Art Institute, where he was the favorite teacher of Sooster. In 1949, he lost his job because of the trial of the students. Accused of formalism and waiting for arrest, Kits knew what choices he had to face. After a routine petition for pardon, he was granted the right to work as a Socialist Realist artist. His interpretation of Socialist Realism became realism with the hint of impressionism. In Kits's paintings, the world became beautiful, pleasant, and desirable again. He bought from the authorities his right to paint in the style he liked by creating compositions on the subject of the revolutionary movement.

Kits was one of the first artists at the end of the 1950s who felt that prewar traditions had exhausted themselves. As the most famous artist from Tartu, he knew his hometown's provincial distrust of everything that differed from the prewar traditions. Although Kits did not deny his root in traditions, he was an extravagant creator and a temperamental experimenter. At the end of the 1950s, Kits changed his style completely, abandoning his impressionistic manner and returning to a style influenced by Picasso. Fascinated by Picasso's grotesque compositions, he often painted centaurs and bizarre groups around tables, and used faceted planes and multiple viewpoints. Kits moved from figurative to abstract art and became the first artist in postwar Estonia to cross the psychological border that the Soviet power had built around abstraction.

His paintings were a tangle of discontinuous lines, thrown on the canvas with quick, fine strokes of his brush. His richness of color and refinement of broken half tones remained an example of modern coloring in the Estonian painting school.

In the 1960s, Kits, who was experimenting with new, even more radical elements in his work, became a symbol of the revival of Estonian art. His works were extremely important to other Estonian artists. Several artists of the next generation, active in Tartu around 1960, were former students of Kits. However, they saw things in a completely different light, starting a new trend that opposed official Soviet art as well as abstract art. The initial goal of the group, formed in 1956 by a group of artists who had been classmates at the art institute, was to provide support to their friends who were returning from Siberia. However, the discussions quickly turned to art and their role as artists in the rapidly changing situation of Khrushchev's thaw.

Sooster, who at that time quite often visited his homeland from Moscow, became the leader of the group. The circle of friends in Tartu, now known as the Sooster group, became similar to the informal artist groups of Moscow. However, the Sooster group professed anti-Soviet attitudes and a sense of Estonian nationalism that prohibited their comparison with Russian artists. The art of the Sooster group emerged as a way of freeing oneself from the constraints of the Soviet system. Sooster introduced his artist friends to the new trends of postwar Western art.

One of the significant features of Sooster's group of friends was the dominance of strong women artists who shaped the image of the group with their interest in the interpretation of personal spheres and their creation of strange, dreamlike compositions, which were influenced by the oppressive atmosphere of the postwar period. For example, Silvia Jõgever (b. 1924) and Lüüdia Vallimäe-Mark (b. 1925) created grotesque, dramatically tense self-portraits and figural groups in bizarrely playful situations (fig. 17, p. 50). They based their narratives on symbols of ecstasy and sexuality, thus transcending worldly morality.

Another woman artist, Kaja Kärner (1920–1998; fig. 100), chose the most convenient and, at the same time, the most effective way of expression by representing specific events, often in the form of allegories. In one work, a clumsy and repulsive military truck stands in a disturbingly empty street with only soldiers walking around. By depicting the depressing contrast between life and lifelessness, the artist reminds the viewer of the atmosphere of mass deportations.

Kärner's most famous picture, *Mourning Ceremony* (1961) represents a funeral where people are sitting behind an endless table and a long line of glasses filled with red wine, which is reminiscent of the sacrifice

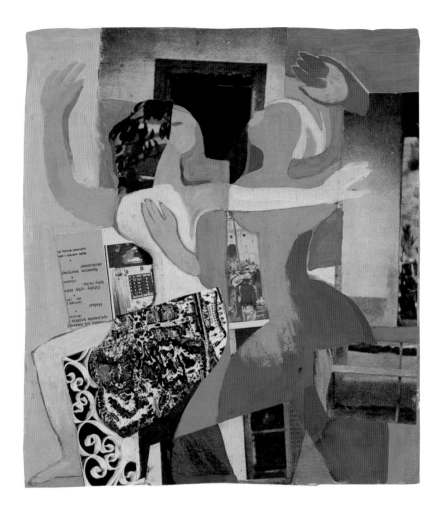

FIG. 100. Kaja Kärner, (Untitled), 1958–61. Gouache and paper collage on paper, 40 × 35 cm. Dodge Collection, ZAM, 18609.

of innocent blood. In paintings such as this, Kärner turned away from the iconographical program of urban transformation, the theme that hundreds of thousands of artists, including Estonians, glorified in Soviet art. Soviet landscape and cityscapes had to reflect progress and expansion in order to present the idea of development and a bright future. In contrast, Kärner was interested in the process of replacing old towns, which represented Estonian national identity, with images of Soviet oppression. In her interpretation, the deserted and depressing city becomes a metaphor for the past. Safe suburbs, which in prewar painting were the embodiments of urbanism, have become symbols of loss.

The critics, who were aggressively Stalinist at the end of the 1950s, dedicated several long, negative articles to the women artists working in Tartu, claim-

ing that their image of life and the world was sickly, distorted, and hopeless. These artists were asked to change their style to reflect Soviet ideology, in which the artist was expected to bring out spiritual beauty and dignity even when depicting tragedy.

In 1960, Jõgever organized an exhibition of the group in a spacious hall of a school in Tartu. Although the exhibit was small and carefully selected, the authorities took it down, considering it an unsuitable glorification of political prisoners. However, people were used to the changing moods of Soviet authorities, whose words and deeds often differed greatly. Therefore, the members of the Sooster group continued their artistic experiments underground.

These experiments reflected Estonian artists' contact with postwar European modernism, which was facilitated by Sooster, who sought to restore the conti-

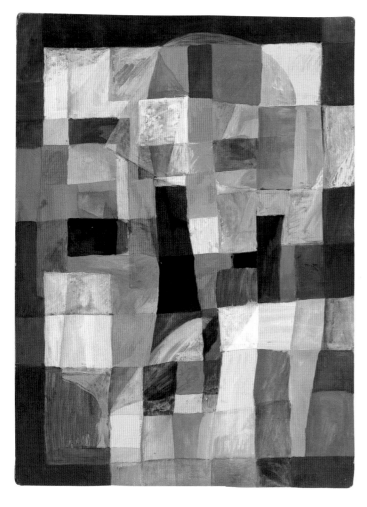

FIG. 101. Olav Maran, *Tamla*, 1964. Watercolor and tempera on paperboard, 69.5 × 51.7 cm. Dodge Collection, ZAM, 16962.

nuity of Estonian art with European traditions. He ardently supported the Estonian painting school by providing the artists with access to examples of European art that in the Soviet Union could be seen only in Moscow. One of the few public libraries in the Soviet Union that acquired literature about contemporary art was in Moscow. Influential exhibitions of Western art took place mostly in Moscow and Leningrad. However, in spite of this spotty information, Estonian artists did not feel close to Moscow and until the mid-1960s had little contact with the nonconformists of Moscow. However, the Estonian seaside was a favorite vacation destination for many Russians. A number of Russian intellectuals spent the summer months there, where they looked for a non-Russian way of life and empathized with the Estonians' struggle for independence. Little by little the attitudes toward Moscow changed, and a relationship between Estonian and Russian artists was eventually established.

The international art events that first took place on a large scale in Moscow at the end of the 1950s influenced Estonian art tremendously. Here, many young artists, including Estonians, saw contemporary Western art for the first time. Biographies of modern Estonian artists often mention the influence of the Sixth World Festival of Youth and Students (where artists also made personal contacts with Western artists) held in Moscow in July and August 1957, the exhibition *Fourteenth to Twentieth Century French Art* held at the Pushkin Museum in Moscow in November 1955, or the 1959 Sokolniki Park exhibition of American art, also at the Pushkin Museum, which was organized in connection with Khrushchev's visit to the United States and included works by such artists as Jackson Pollock, Arshile Gorky, and Mark Rothko. The influence of these events varied, but they brought everyone faith in the possibility of increasing freedom. For some, the new art experience created a desire to identify themselves with Western artists and to appropriate their artistic language. For others, it allowed them to try to determine their positions more realistically.

The Estonian artist Olav Maran (b. 1933) has described his first encounters with Western contemporary art as a shock that revealed the true extent of the backwardness of his generation. Nevertheless, Maran saw that what depressed this generation was the impossibility of identifying directly with Western art. In the 1950s and the 1960s, many artists associated artistic re-

newal with abstraction, which the thaw period had imported and against which the authorities started to fight at once (fig. 101). The first attempts to introduce some abstracted forms to the Estonian public were a failure. The first young artists' exhibition, held in 1959, was seen as too radical; the jury removed several works. Thus, the organization of exhibitions of young artists stopped for several years. Articles revealing the anti-Soviet content of abstraction appeared on the front pages of newspapers, as officials using brutal methods continued to repress theoretical discussions. The combination of these repressive measures helped to prevent the artists from turning to forbidden forms of art. However, after several years, the subject had lost its threatening character, and artists continued to experiment with abstraction.[8]

Nonfigurative art of the 1950s and 1960s was part of a learning process. These works often seem like sketches, and their experimental character is evident. The artists later described the difficulties they faced when starting to work in an entirely unknown style. Abstract art that would represent a forceful visual language and would bring into reality the passion of the creative process was rare in Estonia. Lola Liivat Makarova (b. 1928), from Tartu, was the only artist who worked consistently in an expressive abstract style. While visiting the Sixth World Festival of Youth and Students in Moscow in 1957, she took part in a workshop run by American artists Harry and Katherine Coleman, who demonstrated Pollock's "poured painting method" and therefore referred to her American influences.

Maran combined abstract art with symbolic ideas, starting a prolific dialogue with the Swiss-born artist Paul Klee (1879–1940). The mid-1960s witnessed a circle of artists influenced by Klee in Estonia. In their works, abstraction acquired geometrical forms, and paintings had very fine nuances. The ideology of minimalist painting, which became typical of Estonian modernism, developed from that period. It could be described as a dialogue between opposing notions of hedonism and asceticism.

In addition to affecting his style, Western ideas also influenced themes in Maran's work. He adapted the urban themes used by Kärner, combining the city as a symbol of loss with a Nordic sense of nature. This combination reflects outside influences that were affecting Estonian national identity as the post-Stalinist identity

crisis ended. By the mid-1960s, Estonians began to identify themselves with Nordic culture, just as they had under Tsarist rule. In 1965, regular passenger ships started to operate between Tallinn and Helsinki, Finland. It also became possible to watch Finnish television broadcasts in Estonia. These developments made Estonia the most open area in the Soviet Union. From 1963 to 1965, representatives of art and cultural life had turned forcefully to the authorities, demanding greater freedom of creation. Enn Põldroos (b. 1933), a progressive young board member of the Artists' Union, wrote an article in which he claimed it bizarre that the freedom to experiment was permitted in science but not in art. Surprisingly, such opinions were published in official press. In Tallinn, following the example of Moscow, several apartment exhibitions took place in 1965–66, mostly to display Maran's work.

In 1965 and 1966, surrealism was also exhibited publicly in Estonia. Several major works were created in this style, and several students of the art institute turned to surrealism. Sooster was undoubtedly the most important artist to work in this style. Some people believed that Sooster's activities as a member of the unofficial art world of Moscow at the end of the 1950s and the 1960s were more important than his achievements in painting. Sooster is the only Estonian artist who influenced Russian art. However, Sooster has only recently become recognized as an influence on some nonconformist Russian artists.

After returning from Siberia, Sooster (fig. 102) settled in Moscow, which had been the home of his wife, Lidia.[9] Lidia, a stage designer, had been sentenced to Siberia, where she met Sooster. In Moscow, Sooster surrounded himself with people who had been active nonconformist artists for many years. Most fortunate for Sooster was his meeting with Yuri Sobolev (fig. 103), the artistic director of the publishing house Znamia. Sobolev commissioned him to illustrate books, providing Sooster with his lifelong major source of income.

In 1957, Sooster rented a studio with Leonid Lamm, where they painted nudes. Sooster began reading literature about René Magritte (1898–1967) and Max Ernst (1891–1976), and in 1959, he created his first surrealist compositions, including the image of an egg and several nudes of women at the seaside. In 1960, Sooster began to use a labyrinth motif to build up the space of his compositions.

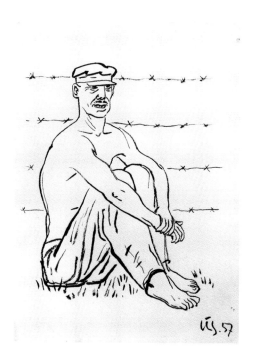

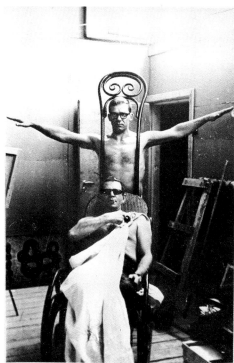

FIG. 102. [TOP] Ülo Sooster, *Prisoner*, 1957. Ink on paper, 28.3 × 20.4 cm. Dodge Collection, ZAM, 17092.

FIG. 103. [BOTTOM] Ülo Sooster and Yuri Sobolev, in performance, 1967. Photograph by Jaan Klõšeiko. Dodge Collection Archive, ZAM.

By 1960 Sooster had become an integral part of Eli Beliutin's studio, Oskar Rabin's circle, and the café Artisticheskoe. Sooster's own artistic identity was based on surrealism, which attracted young artists. In the 1960s, Sooster's apartment on Krasin Street was opened on Tuesday evenings as a meeting place for nonconformist artists, above all for young friends of Sooster like Sobolev, Vladimir Yankilevsky, Boris Zhutovsky (b. 1932), and Eduard Shteinberg (b. 1937).

On December 1, 1962, Sooster took part in the scandalous Manege exhibition where he, Sobolev, and Yankilevsky, along with Ernst Neizvestny and a group of Beliutin's students, shared special exhibition space to display their modernist works, including the first version of Sooster's famous *Eye in Egg*. These artists hoped to gain acceptance of modernist works by Communist Party authorities so that such works could be exhibited in future official exhibitions. This effort backfired when Khrushchev personally delivered a scathing, brutal denunciation of the artists and their works and threatened to send them to prison camps. Sooster even prepared for exile, which never happened. In 1963, Pankratov, the head of the Second Department of the Moscow KGB, demanded Sooster's file from the Estonian KGB and let his Estonian colleagues know that Sooster was actively being investigated as a person who had contacts with suspicious people. We still do not know who these suspicious people were.

Sooster had many contacts with scientists, including physicists, who were a separate, privileged group in the intellectual world of the Soviet Union. Scientists felt independent of ideological restrictions and were not influenced by conventional taste. Instead, they were concerned with abstract discussions about time, space, the meaning of life, and the nature of man. Under the influence of these discussions and the physicists' ideas, Sooster started working on illustrations for the book *Physics—Distant and Familiar*.

Visiting Estonia frequently, he saw the change of generations there. On the initiative of Maran in 1964, a group of students from the Estonian Art Institute visited Sooster in Moscow.

Beginning in 1965, Sooster's work was included in international exhibitions that introduced the avant-garde of Moscow to Czechoslovakia, Poland, and Italy. Later it was exhibited in the prestigious Gmurzynska Gallery in Cologne. In 1967, the Estonian public also

came to know Sooster's work. Together with Sobolev, Yankilevsky, and Ilya Kabakov, he exhibited his work with Estonian art students at the first Tallinn Jazz Festival, one of several interesting international events that occurred during that period. Such events were possible because of the development of a more liberal atmosphere in Estonia.

In 1960, Sooster began to share a studio with Kabakov and later acquired his own studio in the neighborhood of Stretenskii Boulevard. The nonconformist artists who had studios in this area included Kabakov, Lamm, Neizvestny, Eric Bulatov, and Victor Pivovarov. In 1967, Sooster, Sobolev, and director Andrei Hrzhanovsky worked on the animation *Glass Harmonium*, which was forbidden for twenty years because of its vague atmosphere and anti-Soviet allusions.

On October 25, 1970, at the age of forty-six, after years of alcohol and drug abuse, Sooster was found dead in his studio, having suffered a stroke. He was buried in Tallinn at the Woodland Cemetery, where other major Estonian artists were interred, although he never belonged to the official Artists' Union (fig. 104). Alfred Schnittke (1934–1998) composed a concerto for oboe and harp in memory of Sooster. Lidia Sooster gave most of his remaining work to the Tartu Art Museum where, in 1971, the first major retrospective of Sooster's work took place. Eventually the political tension around Sooster's work dissolved, leaving only myths surrounding his work and his relationships with artists in Moscow.

In 1993, the exhibition *Illustration as a Way to Survive* took place in Belgium on the initiative of the IKON Gallery. Book illustrations were in the 1960s the only means of subsistence of Moscow dissident artists, and both Sooster and Kabakov were very engaged in this field. The exhibition was the first joint showing of Sooster's and Kabakov's works. In 1996, a monograph on Sooster, written by Kabakov in the 1980s, was published. This book remains the best analysis of Sooster's work.[10] In constructing an analysis of the creative process of his friend and mentor, Kabakov undertook an enormous task, interpreting hundreds of drawings and sketches.[11] However, Kabakov never suggested ways in which younger artists might have built on Sooster's work. Instead, he looked at Sooster's heritage from the viewpoint of conceptualism, concentrating on the birth and development of ideas and images.

FIG. 104. Tombstone on Ülo Sooster's grave. Photograph by Jaan Klõšeiko. Dodge Collection Archive, ZAM.

From this, one can recognize that several of Sooster's close friends became the founders of the Moscow conceptual art movement.

However, Sooster's most important role was his promotion of surrealism in Tallinn and Moscow (fig. 105). The sudden appearance of surrealism in Soviet art around 1960 manifested itself in artists' experimentation with the possibilities of deconstructing reality in the Soviet Union. For example, Sooster added his own allusions and symbols to the traditional subjects of Magritte. He has taken Magritte's egg motifs and placed them within his paintings, where they seem to hover in space over the landscape below. For Sooster, this image was inseparable from his ideas about the process of evolution. Infinity, evolution, and the experience of timelessness are expressed in Sooster's system of signs, including his use of the egg.

The art of Sooster also has a lighter, more playful side found in his sketches (fig. 106). Here, Sooster returns to his childhood, a pre-political environment on the island of Hiiumaa. In his work of the early 1960s, junipers—the symbol of his native country—are the basis for the abundance of forms of the organic world, expressed and symbolized by the endless possibilities of abstraction. Pictures of junipers express Sooster's interest in the organic world of surrealism. Later the form becomes minimal and geometric, and he represents the juniper more as a sign.

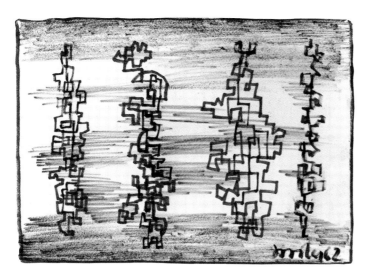

FIG. 105. [TOP] Ülo Sooster's exhibition in Moscow,
August 31, 1979. Photograph by Jaan Klõšeiko.
Dodge Collection Archive, ZAM.

FIG. 106. [BOTTOM] Ülo Sooster, (Untitled),
1962. Black marker on paper, 19.3 × 27.4 cm.
Dodge Collection, ZAM, 00113.

Inseparable from the subject of nature is the animalism of Sooster's drawings. He liked to depict the animalistic character of human beings—more exactly, of women—as well their association with plants. According to Kabakov, there is nothing strange about allegorically referring to the transformation of body parts of an animal to the human figure, where they become symbols of utopia.

Sooster also plays games with the ideas of familiarity and distance, comparing the personal and universal. In doing so, Sooster continues Magritte's motif of the window and uses the possibilities of the idea of an image within an image. Sooster depicts space in two ways. In the first one, rooms seem endless and figures always appear to be lost. In the second, Sooster uses a labyrinth, which provokes a more dynamic viewpoint and produces fragmentary narratives, as small openings in the labyrinth often reveal a new image on the other side. In Sooster's pictures, the labyrinth can be constructed with geometric forms, but more often organic forms such as lips shape the maze.

Ilmar Malin (1924–1994), a Tartu artist, began experimenting with surrealist art independently from Sooster during the 1960s and further developed the "psycho-paranoic" method of Salvador Dalí's work. Malin later combined his surrealist drawings into a series, *Nolens Volens*. Malin's works at the end of the 1960s often featured biological forms and presented ideas on destruction, genetics, and cosmology. He continued to work with psychedelic images until his death in 1994.

Olav Maran also worked in a surrealist mode as a means of raising existentialist problems. In the 1950s and early 1960s, Maran was very socially active, trying to organize exhibitions of nonconformist works by young artists. During the 1960s, Maran began to introduce surrealist ideas, thus persuading other artists to experiment with new styles.[12] He expressed his worries by interpreting oppression, unclear yearning, and anxiety. Maran dealt with many genres, including the psychological portrait, the landscape, and the still life, which was strongly influenced by the Italian artist Giorgio Morandi (1890–1964), as well as surrealist collage, where psychological observations were replaced by the grotesque.

Maran's collages were based on photos from newspapers combined with drawings. He was interested in creating absurd, satirical situations that did not openly

reveal Soviet reality but worked as critical opinions and indicated the lack of reason in the world (figs. 107 and 108). Maran openly disputed materialist ideas, expressing his intolerance and anger. Some of the collages produced in this period combine different tendencies within the surrealist movement, indicating the wide influence of surrealism in Estonia during the 1960s (fig. 109). Use of collage was characteristic of unofficial art throughout other parts of the Soviet Union. The components of collage were found in Soviet mass culture, in leaflets, in slogans and posters, all of them full of political quotations. The later use of collage in postwar Soviet art owes much to the experiments of artists working in a surrealist mode in the 1950s and 1960s.

Surrealism was not the only influence on Estonian collage in the 1960s. Estonian artists also started creating collages that show the influence of Art Informel, a European movement that paralleled the action painting of American abstract expressionism.[13] They used these techniques to combine realistic imagery with abstraction. The collages by Valve Janov (b. 1921), who was the most successful artist working in this manner, and Lembit Saarts (b. 1924) are often like small paintings. Yet only in the "paradise of freedom" found in collage could Janov be expressionistic and paint over the paper cutouts in the way she liked (fig. 110).

These various influences on collage prove that the medium was independent and unlimited. It showed that the artist could use all kinds of objects to create a work of art. Thus, collage could express things that painted images could not. In collage, every detail could start a new narrative, and the juxtaposition of fragments indicated several meanings, thus interrupting linear and logical reasoning. This method signified the Estonians' fragmentary memory and their marginal position in Soviet culture.

In the 1960s, the Tallinn artists were more interested in creating logical oppositions, being more influenced by surrealism. Maran, Valdur Ohakas, Tõnis Vint, Jüri Arrak, and some members of ANK created unusual situations and demonstrated paradoxical ways of reading an image. As early as 1966, Vint was interested in the idea of an image as a sign, a concept that he developed from pop art. Visualizing the analysis of spatial relations between small, geometrical forms, the artist proved that meaning had become a dynamic principle that could not be described by a static image.

Like many young Western idealists in the 1960s, Vint studied Oriental mysticism.

While Vint represented the sovereignty of art ideas of the young generation in Estonia, Sooster and Roode remained role models of independent thinking by the older generation. It is interesting to compare Sooster and Roode because of their radically different interpretations of modernism. They were of the same age and had similar experiences, but they created entirely different works. In one aspect, however, they are very close: they strove to create a national art that would break through the limits of official Soviet Socialist Realism. This search relates to the notion of the well-guarded border, a symbol of limits and confinement that was part of the Soviet reality.[14]

Roode graduated from high school in Tallinn in 1943, and the following year he entered the painting department of the Tartu Art Institute. In 1947, the KGB tried to force him to work as their informer, but to avoid these duties, he left Tartu for a year. In 1948, however, he returned to his studies and was arrested for his activities in an underground anti-Soviet group. In addition to being falsely accused of attempting to hijack a plane, he was accused of translating and spreading forbidden Western art literature.

Like Sooster, Roode was sentenced to ten years of hard labor. He was sent to Lugovoilag, a prison camp in Karaganda. After returning from Siberia, he graduated from the art institute in 1959. In 1961, he submitted a work, *Market*, a large painting (100 × 252 cm) composed of abstract, geometric forms, which had all the features of "formalist art" opposed by the Soviet art establishment. The authorities did not understand this abstract work and Roode's intended statement about modern technology and progress, and thus the work was not allowed to be displayed. Estonians now view this work as an important contribution to Estonian modernism.

For Roode, the modernization of society was synonymous with modern art. At that time, Roode was interested in Picasso's work and began to employ Picasso's means of deforming the figure. He depicted large groups of people at the market, in the streets, and in various processions. These figures appear fragmented, divided, and deformed, as if they were geometrical masses without faces or names. He often left whole areas of canvas unpainted.

On an ideological level, his conception of

FIG. 107. Olav Maran, *This Day*, 1965. Paper collage on paper, 27.8 × 20.8 cm. Dodge Collection, ZAM, 17057.

FIG. 108. Olav Maran, *Quest*, 1963. Graphite,
gouache, and paper collage on paper, 37.4 × 27 cm.
Dodge Collection, ZAM, 17067.

FIG. 109. [LEFT] Olav Maran, *Aromnia*, 1964. Ink, marker, and collage on paper, 20.3 × 20.5 cm. Dodge Collection, ZAM, 17056.

FIG. 110. [BOTTOM] Valve Janov, *Green Fish*, 1961. Oil on paperboard, 33.5 × 48.5 cm. Dodge Collection, ZAM, 17060.

modernism was like that at the beginning of the century when European artists associated progress with creating abstract forms. Instead of seeming outdated, Roode's passion is understandable in the Estonian context, since progress seemed evident in the Soviet Union during the thaw after Stalin's death in 1953. New functionalist architecture with its rationalist interior design began to appear in Estonia. The signs of Stalinist society were being pushed into the background. Life became easier—much food was no longer rationed, Sputniks appeared in the sky, and everyone was thinking about "progress."

In the mid-1960s, Roode secretly practiced abstraction in his studio (fig. 111). He left behind hundreds of studies and thousands of sketches. Roode's studies are more abstract than the works of any other artist in Estonia. He systematically worked in different forms of abstraction, and he often combined amorphous and structural forms, creating dialogues between soft paint and geometrical surfaces that surround it. This combination reflected the principle of dualism, which at that time was on everybody's mind, since everything could be divided into opposing pairs: East-West, public-private, official-nonofficial, and so on.

The influences on Roode's work are still unclear. He never created abstract paintings that would have summed up his experience; and when modernism lost its importance in Estonian art and society during the second half of the 1960s, Roode somehow froze. His paintings became cold as he turned to religious contemplation for comfort.

The late 1960s and the early 1970s were remarkable for their liberalism and tolerance, which allowed an intensive and open development in art; dissidence as a hidden way of resistance began to disappear. In 1970, however, Leonid Brezhnev started to demolish all the systems of regional independence that Khrushchev had once allowed. Authorities who held strong Marxist positions appeared again in Estonia, marking the beginning of another Russification period in Estonian history.

Translated by Kersti Kuldna

FIG. 111. Henn Roode, *Temper*, 1965. Oil on illustration board, 73.8 × 52 cm. Dodge Collection, ZAM, 11449.

NOTES

1. Emil Tode, *Piiririik* (Tallinn: Tuum Publishers, 1993).

2. Therefore, in the most recent stage of Estonian cultural life, Estonian intellectuals lack any kind of leftist sympathies.

3. In 1948, the Central Committee of the Communist Party denounced Muradeli's opera and published a resolution entitled "On the Opera *The Great Friendship* by V. Muradeli," which levied unjustified attacks on many Russian composers and heralded a new order in Soviet music. For more information, see Boris Schwarz, *Music and Musical Life in Soviet Russia* (Bloomington: Indiana University Press, 1983), 213–214.

4. "Formalism" was defined in the *Kratkii slovar' terminov izobrazitel'nogo iskusstva* (Dictionary of art terms), published in Moscow in 1965, as "reactionary trends in art and aesthetics, connected with the ideology of decaying capitalism." According to this dictionary, "reactionary formalist art includes such styles and movements as Cubism, Futurism, Constructivism, Surrealism, and Dadaism.... All these different formalistic trends are based on the separation of form from content and on the superiority of form over content." In the same dictionary appears the statement that the "fight against formalist art is the primary goal of Soviet art"; *Kratkii slovar' terminov izobrazitel'nogo iskusstva* (Moscow: Sovetskii Khudozhnik, 1965), 177–178.

5. In 1956, after Khrushchev's secret speech to the Party leadership that denounced Stalin's excesses, an officer of the Tartu KGB had to report to the authorities which of these accusations were true and which were made up by the KGB. He argued that the arrested definitely expressed anti-Soviet ideas, but he did not believe that they were preparing for terrorist acts.

6. In anticipation of a possible end to censorship, members of the Moscow Section of the Artists' Union organized a large exhibition of their works at the Manege. The exhibition included not only works in the Socialist Realist style but also innovative works that broke from the standard. When Khrushchev visited the exhibition, he became outraged at the work of the experimental artists, claiming that it was "anti-Soviet" and "amoral." He asserted that "art should ennoble the individual and arouse him to action." Following his visit, the Moscow Section of the Artists' Union was censured for exhibiting "formalism." For a more complete discussion, see *From Gulag to Glasnost: Nonconformist Art from the Soviet Union*, eds. Alla Rosenfeld and Norton T. Dodge (New York: Thames and Hudson, 1995), 50–51.

7. BRAF, f. 129, s. 23352, pp. 337–339.

8. The policy prohibiting abstraction remained in force until the end of the Soviet era, since it was never officially rescinded.

9. The biographical data of Ülo Sooster are from the Tartu Art Museum, which has reconstructed the curriculum vitae of Sooster.

10. Ilya Kabakov, *Ülo Soosteri piltidest: Subjektiivseid markmeid* (On Ülo Sooster's paintings: subjective notes) (Tallinn: Kirjastus Kunst, 1996).

11. Kabakov divided Sooster's work into three parts: sketches and drawings, book illustrations, and paintings. He first discussed Sooster's sketches and drawings, which offer endless developments of his favorite images and interpretations of abstract forms. He then turned to Sooster's paintings, where he identified the process of evolution in which the artist becomes the tool of a progression from the pulsation of abstract forms to their growth into systems. Last, Kabakov described the transformation of substance into creatures, ending with a majestic description of the final phase of evolution—the dissolution of bodies into frozen, petrified shreds, forms, and reliefs. Kabakov has successfully interpreted the complex symbolic character of Sooster's work, which many writers find difficult to decipher. He has discovered that the paradox of Sooster's artistic language belongs to his surrealist subject matter.

12. Ironically, his surrealist collages were not displayed in public until 1993.

13. The term "L'Art Informel" was devised by French critic Michel Tapié to broadly describe the expressive painting that developed in Europe during the 1940s and 1950s. This movement broke from the dominance of the cubist tradition and turned toward a painting style that was based on personal, spontaneous expression.

14. In Estonia, for example, several beaches were for decades closed to the local population, and Estonian islands and seashores were full of broken ships and boats that had been destroyed to prevent their owners from fleeing Estonia by sea.

Sirje Helme

ESTONIAN ART FROM 1987 TO THE PRESENT

STRUCTURE AND METAPHYSICS

In the early spring of 1989, the exhibition *Structure and Metaphysics* opened at the Pori Art Museum, at that time Finland's most important venue for showing contemporary art. Finnish art critics led by Marketta Seppälä organized the exhibition to show free Estonian art that had been produced despite the restraints of official state ideology. Although perestroika had already started in the Soviet Union, the principles of the state's administration of intellectual and cultural property had not changed. In addition to helping Estonian artists escape a hopeless situation (that of not being able to organize an exhibition of their art outside of the Soviet Union on their own), the organizers of the exhibition had a great interest in the developmental mechanisms driving Estonian art as well as in the peculiar aesthetic phenomenon of the Estonian avant-garde,

Written in Tallinn, 1998

which seemed conservative in the international context. The exhibition (which later traveled to the Helsinki Taidehalli, Kiel City Gallery, and Stockholm Kulturhuset) may have had a political agenda, but for the majority of Estonian participants, it served as a gate to the international art world they had been dreaming of for so long. For most of the artists invited to the exhibition's opening, the trip was their first visit to Helsinki, situated only eighty kilometers across the Finnish Gulf from Tallinn, and the very first time abroad for many. *Structure and Metaphysics*, presenting mostly Estonian art from the 1980s that still possessed the innovative spirit of the 1970s, served as the summary of a lengthy and bizarre period rather than the inauguration of a new one.

In 1991, the Republic of Estonia was reestablished and independence proclaimed. The Estonian art world, which had developed for many years in a rather

stable manner, unaffected by political events, was caught in a whirlwind of change. No rupture between generations could be more conclusive than the one born of the radical political changes of the past decade. The last ten years have been fruitful for Estonian culture and have teemed with rapid changes. In the midst of this upheaval, tensions have developed. This essay describes these years in Estonian art, focusing on the new themes, and the difficulties they have caused. It will examine the changes in organization of exhibitions, exhibitions' shifting focus, and the various groups of artists that have emerged. The decade of the 1990s appears to be as significant as the period of dramatic change at the end of the 1960s and the beginning of the 1970s. This introduction is far from an exhaustive review. Nor is it objective, as we are still too close to the complicated time and events.

THE BACKGROUND: VIRTUAL WEST

News of international art reached Estonia only through the print media; I call this phenomenon "repro-avant-garde."[1] Information about international art was inadequate; international art was not accessible to Estonian artists; it was not experienced directly but was instead constructed and virtual. Estonian artists did not know what the Western artist's lifestyle was like. Nor did they understand the administration of art in the West, or the advantages of the structure of Western art institutions as compared to that of the Soviet art scene. Ando Keskküla, summarizing the shock experienced by Estonian art upon its entry into the "free world," wrote, "The political reality of former Socialist countries has changed. The virtual continent known as the 'free world' has disappeared, transforming into a physical reality whose unexpected ambivalence and fragmentation rapidly deconstructed existing identity mechanisms."[2] It soon became clear that in the West, no one is willing to guarantee an artist's welfare, fame, or galleries for exhibition and sales. The loss of the "virtual land of joy" could be why reproach and anger emerged. After the reestablishment of Estonian independence, Estonian artists expected to finally gain their share of recognition and success but found instead that they had to start from the very beginning again.

Much has been written about the economic and

ideological hardships of the transition period. Yet the collapse of the Socialist system and its repercussions in Estonia cannot be directly compared to that in Poland or any other former Socialist country. The cultural life of a country within the Soviet Union cannot be treated as identical to the cultural life of a country that belonged to the Soviet bloc. The difference lies in the degree of political repression. The nature of present-day art in the post-Soviet countries was determined in the Soviet times.

Changes occurred most rapidly and were felt most directly in the administration and financing of art. First, the financing of art by the state via the Ministry of Culture and Artists' Unions ceased. The so-called state purchases that provided income for the majority of artists no longer existed. Since Estonia had failed to develop a system of independent, private galleries, the economic situation of many artists became extremely difficult. Older artists, as well as those of middle age, found it difficult to understand why the art scene could not continue to function in the old way, even though the economic organization and the role of the state were changing. However, the old structure did dissolve before a new one had started to function. In a few places, nostalgia for the system of state purchases persists despite the development of the free art market in Estonia.

Dependence on private foundation support received much criticism. The policies upon which various foundations based their allocation of funds were unfamiliar to most artists; some artists expected the money to be more or less equally distributed to everyone, as it was in Soviet times. New foundations, such as the Soros Center for Contemporary Arts in Estonia (SCCA), emphasized support of the emerging art culture but left traditional art with little support. It seemed as if the aesthetic and ethical values that defined art had collapsed.

Let us chart the changes in a simplified form.

A) State support of art that provided relative economic security was not adequately replaced by private foundations or other private sources, and the lack of a fully developed art market resulted in economic insecurity for artists and the art establishment.

B) Traditional structures such as the Ministry of Culture and the Artists' Union that had supported artists were replaced by the SCCA, the Open Estonia Foundation (and, later on, the Estonian Cultural En-

dowment), the National Cultural Fund, and other organizations that finance art projects.

C) The traditional hierarchy of art genres and artists contrasted with an unclear understanding of freedom in art.

In other words, everything that developed was insecure, provided no guarantees, and gave no sense of continuity. Within this boiling cauldron, many new strains bubbled. For instance, in 1991, no one had the slightest idea of what exhibitions would be like in 1995, yet the various interests, opinions, and principles and the resulting conflict had already taken on a form different from that of Soviet time. Ants Juske (b. 1956) has written of the collective incarnation of the enemy—Soviet ideology forced its rules onto art, and artists collectively rose up against it in reaction.[3] The resistance, in spite of the great variety of opinions concerning art, had created a certain feeling of unity in the Estonian art world. Now, without that simple idea and goal of resistance to the enemy, the feeling of unity fell apart. Opposition to the enemy that had held artists together for so long left behind an ideological mess and a wide variety of incompatible ideas. Artists dispersed and formed small, unstable associations in accordance with their aesthetic preferences and understanding of art. There were no answers to the questions regarding what had happened and how, what positions an artist might take, and what Estonian art might be like when Estonia became an independent state, shed of Soviet controls.

MEMORY: THE ARTIST'S PLACE IN HISTORY

After the first difficult economic years, artists began to reassert themselves as artists. They combined a rapid appropriation of new methods of expression with a restored image of their postwar art. A similar situation had occurred thirty years earlier while trying to revive the idol of Pallas, although different aesthetic issues were dealt with in the 1950s and 1960s.[4]

Beginning in the late 1980s, a number of retrospective exhibitions were organized, including *Avant-Garde and Trans-Avant-Garde* at the Art Museum of Estonia (1988); *SOUP 69–89* at the Tallinn Art Hall (1990); *Classics of Estonian Avant-Garde* at the Luum Gallery (1993); *ANK 64* at the Tallinn Art Hall (1995); *Kinetic Art Mobil I* at the Tallinn Art Hall (1995); *Harku 75* at the Linnagalerii (City Gallery) (1995);

Tallinn-Moscow/Moscow-Tallinn, 1956–1985 at the Tallinn Art Hall (1996); and *The Art of the 1970s* at the Tartu Art Museum (1997). A comprehensive exhibition of the art of the Baltic countries entitled *Personal Time* took place in Warsaw and St. Petersburg in 1996.

These large retrospective exhibitions were popular among art critics and scholars not only in Estonia but also in the West. However, many younger art critics who had little contact with Estonian art of the 1960s and 1970s—museums did not collect the more radical artworks from that period, so critics had no chance to see them—expressed negative attitudes. In 1996, Holger Rajave wrote about the *Harku 75* exhibition, "The so-called 'old avant-garde' is securing its positions—as avant-garde, so as not to remain in the gray rearguard."[5] Johannes Saar (b. 1965) added, "Those grand retrospectives can be seen as seeking revenge on the past and they do not pay any kind of tribute to the present.... The exhibitions with an introspective look at the past must be suffered through, their value assessed and put away into a museum."[6] Saar was right on two points—Estonia lacks a contemporary art museum, and many generations have not been able to see postwar art. Yet these exhibitions still must be valued as a temporary replacement for more formal museums, and as the first exhibitions trying to analyze the avant-garde in Estonian postwar art.

At the same time, Peeter Linnap (b. 1960) approached the issues of memory and history in a much more ambitious fashion by organizing on the island of Saaremaa a large international exhibition called *Fabrique d'Histoire*, which dealt with questions of the role of history making. The event was labeled the Saaremaa Biennial, thus beginning a new tradition.

CONTROVERSIES WITHIN THE ART SCENE

In the early 1990s, a rapid restructuring of the art scene began in spite of the unstable material base for the undertaking. Obviously, the desire to forget the past as quickly as possible and to work according to a Western model was so strong that it outweighed the problems created by change. Serious discussions began in the mid-1990s, when the art scene was becoming pluralist. The art life of the early days of the independent Estonian Republic was characterized by a belief in a mythic Western artistic lifestyle in which, once the system was in place, artists would be guaran-

teed galleries, exhibitions, money, and fame. Most artists, however, were unaware of the latest developments in Western art, since subscriptions to Western art periodicals and publications were not accessible in Estonia on a regular basis before 1992–93. For this reason, the 1991 exhibition of young Finnish artists entitled *Blue Shore* at the Tallinn Art Hall shocked its Estonian audience. Marketta Seppälä, the curator of the exhibition, stated in the catalogue's foreword that the young artists whose works make up the exhibition "are in many ways proof of the inevitability of and need for innovating art."[7] Two other ideas presented in the catalogue gained importance for Estonian art in the next few years: "Above all, the exhibition presents an analysis of the process of the loss of values that developed in parallel with this century's victorious parade of aesthetics"[8] and "The world is constantly changing—even without art—however, the essential question is whether art is able to survive in the whirlwind of changes and make itself important for life."[9] In 1991, Estonian artists were unfortunately dealing with pragmatic problems instead, and the issue of art's radical changes was extremely delicate and complex. "What will become of art in a changing society if its tradition for so long has been a-sociality? How should we react in a situation where interacting with society through art was essentially unpleasant?" were the questions I posed in an article published in conjunction with the exhibition.[10] At that time, these questions had no answer and, as was mentioned earlier, the true controversy began later.

The first signs of conflicting ideas were already visible in the issue of organizing annual exhibitions. The Estonian Artists' Union traditionally organized a comprehensive exhibition each year in which artists from all over Estonia wished to take part. The difficulty of making it to the final round was proof of the high level of the competition. Within a few years, however, it became clear that the exhibition no longer had a leader or a point. The Estonian Artists' Union, formerly an ideological organization, now served purely economic and administrative functions. Galleries, such as the Vaal, Luum (later renamed Linnagalerii), and Draakon, and the Gallery of the History Institute (now closed), started to appear, and their exhibitions seemed more interesting and cutting-edge than those of the Artists' Union. Private galleries also opened in Tartu, of which the Rüütli Gallery was the most prominent. The emergence of private galleries was a decisive

step in the development of Estonian art, though the process had its share of problems.

At the same time, groups such as Group T and the Kursi School as well as private foundations organized independent exhibitions.[11] The Tallinn Art Hall's attempts to continue the tradition of exhibitions were met with much criticism. Suddenly the issue of organizing such exhibitions became a litmus test for differentiating those who dared to take risks from those who preferred the old system. The final stage of this debate occurred in 1996, when the *Figure and Abstraction* exhibition replaced the Artists' Union's annual spring exhibition. Juske called the exhibition "purely formalist," a relic of abstract art of the 1950s.[12] But at the end of the twentieth century, the Artists' Association has again begun to organize big "annual" exhibitions, collaborating with different curators in order to avoid giving preference to any particular trend. Such exhibitions were the wish of many members of the association.

A more serious controversy arose around the fate of painting. In the early 1990s, installation and video art advanced quickly because numerous funds supported such pursuits. Installation and video art was also the main focus of art critics, thus creating an impression that the traditional art of painting was no longer appreciated. Kreg A. Kristring (b. 1962) boldly called the situation "the war of installation against painting."[13] Although no one had spoken badly of painting (speaking against it would in fact be downright impossible in Estonia), on the occasion of the 1995 retrospective exhibition of painting, the press was full of headlines such as "Rumors of the death of painting are premature."[14] Of course, the question of painting's place in the hierarchy of art forms is not unique to Estonia. Furthermore, in Estonia the problem was not with painting as such but with its becoming purely decorative, marginal, and void of meaning—so-called "corporate" or "commercial" art, which many painters were accused of producing. Such complaints were the reason for so much talk about abstract art, and the distancing of art from real life. "Timelessly festive," commented Mari Sobolev about painting in 1995.[15]

The most serious, if not to say hostile, controversy developed after the opening of *Biotoopia*, the SCCA's third annual exhibition in 1995. It was picked up with renewed fervor in 1996, and serves as an example of Estonia's painful coming to terms with pluralism. Even journalists intervened—unfortunately, as opponents to the new trends in art. No matter how theoretically

elegant the debate, its basic substance remained simple: when contemporary art lacks aesthetics, deeply rooted in modernism, can one still speak of ethics in terms of its social message? By 1996 it became clear that art which grew from subcultures, MTV-, E-, and X-generations had managed to secure considerable attention both in exhibition halls and in the mass media and had begun to examine issues not connected to traditional aesthetics.

GROUPS AND DIRECTIONS

Group T and "Intronomadism"

The late 1980s and early 1990s was a period of transition, largely but not exclusively due to political events that influenced the art scene. Estonian art of this time is characterized by a tendency to avoid social or political criticism—in contrast, for instance, to German art, especially that of German expressionist artists such as Otto Dix (1891–1969) and Käthe Kollwitz (1867–1945). This same tendency was evident in Estonian art during World War II, when, in spite of the turbulence, the preferred genres were landscapes or still lifes. Estonian artists apparently chose to ignore political reality, or at least not to portray it in their work. Political changes in Estonian art can be evaluated only in terms of its historical perspective or its local context. Some changes began to occur at the end of the 1980s—for example, with the exhibition *I've Never Been in New York*—when the goal was to give new meaning to the art of the younger generation. In 1993, the SCCA's first annual exhibition, *Substance-Unsubstance*, created an atmosphere of growth for young artists with a new mentality and orientation, who subsequently rose to the forefront of the art world in the mid-1990s.

This interim period could be called the era of performances, a time strongly tied to the activities of Group T. The ideas of architects Raoul Kurvitz (b. 1961) and Urmas Muru (b. 1961) formed the ideological core of this group of young intellectuals, who included the essayist and philosopher Hasso Krull (b. 1964), photographer Tarvo Hanno Varres, and musician Raul Saaremets. Later, architect Peeter Pere (b. 1957) and stage designer Ene-Liis Semper (b. 1969) also joined the group. An entirely different spectrum of experiences—death, erotica, violence, and power—

was the focus of this group. In 1986, Group T showed paintings in a neo-expressionist style, drawing immediate attention and creating an upheaval on the otherwise quietly and obediently unfolding art scene in Estonia. The manifesto of the exhibition spoke of ambivalence, nonstandard behavior, and the attempt not to be affiliated with any artistic ideology. After the exhibition, only Kurvitz continued to pursue painting. The group's path is marked by a series of performances, many of which united play with true danger, such as burning or swimming in rushing water released from a dam, thus touching the sphere of death and violence sometimes mixed with erotica. Juske has called Group T's performances "the aesthetisizing of coarseness into decadence."[16] Their performances in February and March 1991 culminated at the Tallinn Art Hall, where performances were put on almost daily for two weeks alongside installations and video art. The group defined and presented its project as "A Guide to Intronomadism." In 1994, Kurvitz's contribution to the exhibition *Unexistent Art* was a large video installation, and from there on, he developed a preference for video, computers, and projects involving mass media. But he continued to paint and has recently submitted mostly large-scale paintings to exhibitions.

Group T, which never set rigid parameters concerning its membership, served as a crucial link between the cultivated aestheticism of the 1980s and the rise of youth as "kinky sophistication" in the second half of the 1990s. The group tried to juggle many roles at once—preaching and praising the esoteric and decadent, and attempting to define French philosopher Gilles Deleuze in practice, as was demonstrated at the exhibition *Unexistent Art* curated by Urmas Muru. Group T stretched the definition of art beyond art's physical forms and helped instill a belief in art as a mystery.

Destudio

The Destudio team, which included Peeter Laurits (b. 1962), Herkki-Erich Merila (b. 1964), and Tarvo Hanno Varres, contributed to the acceptance of photography into Estonia's closed art scene (fig. 112). Destudio's 1993 Luum Gallery exhibition—which highlighted communication, technology, and information—was perhaps the first of its kind in contemporary Estonia. The artists presented large, mixed, and

FIG. 112. Destudio (Peeter Laurits and Herkki-Erich Merila),
Self-Portrait (from the series *Diseases and Metamorphoses*),
1993. Photo collage, 130 × 100 cm. Collection of the artist.
Courtesy: Center for Contemporary Art, Tallinn, Estonia.

chopped-up photographic images in various styles, synthesizing bits from different eras, religions, and forms. Peeter Laurits was chosen to represent Estonia at the ARS Baltic photo exhibitions *The Memory of Images* and *Return of the Past* and was the only Estonian artist chosen to participate in the *Europa, Europa* exhibition in Bonn.[17]

Besides being included in art exhibitions, Destudio's photography influenced advertising and fashion photography. When Destudio was formed in the early 1990s, advertising was not yet well developed in Estonia, and Destudio had opportunities to introduce and direct its development. Destudio members considered advertising as an opportunity for art to communicate with society, since art's main function was to communicate. But Destudio disbanded. The new world of advertising quickly established rules that were too narrow for Destudio's philosophical way of thinking about art. Laurits has instead chosen to work on an international project to strengthen the development of the arts in southern Estonia.

The Kursi School

The Kursi School (named after a small village in the middle of Estonia) was formed in Tartu in 1988 and still exists. At various times, group members worked in the Tartu University Art Cabinet. The group includes Ilmar Kruusamäe (b. 1957), Peeter Allik (b. 1966), Albert Gulk (b. 1969), Priit Pangsepp (b. 1965), and Marko Mäetamm (b. 1965). The Kursi School has always sought to do everything differently from the artists of Tallinn and Tartu; their creative program is best characterized as an opposite way of doing things, spiced with the right amount of humor. The group's creative roots can be found in neo-pop, which characteristically parodies fashion and style of the 1960s. Periodically, the Kursi School prints and distributes its own magazine, a melding of collage and text that mixes all forms of the absurd and provides notices about upcoming Tartu art events. The school itself claims Fluxus as its official inspiration, and Kruusamäe is one of the few Estonian artists who has been actively engaged in mail art.

Tartu's aura as the second and more traditional art center has not disappeared, even in the late 1990s. Young artists generally start by studying the style of the Pallas school. It seems that part of the mission of the

FIG. 113. Peter Allik, *Kunst Kunst*, 1997. Oil on canvas, application of printed paper, 115 × 210 cm. Private collection. Courtesy: Center for Contemporary Art, Tallinn, Estonia.

Kursi School is to counter that academic atmosphere, opening up and adding character to the town's stiff environment.

Faculty of Taste

"Faculty of Taste" was the name given to the Center of Photography that was founded within the Estonian Academy of Arts. Peeter Linnap (b. 1960) became its spiritual leader, and the center developed a reputation for producing ambitious projects. Photography as an art form was a relatively new notion in the Estonian art scene of the late 1980s and early 1990s, and Linnap helped it gain acceptance. The importance of photography was demonstrated by such exhibitions as the 1988 Baltic Photo Triennial in Tallinn and, in the same year, *I've Never Been in New York*. Linnap envisioned the center as a place to showcase contemporary art rather than as an exhibition space exclusively for photography. A group of young art students, including Martin Pedanik (b. 1974), Margot Kask (b. 1974),

Marko Laimre (b. 1968), Piia Ruber (b. 1972), Kadri Kangilaski (b. 1973), and Piret Räni (b. 1974), congregated around Eve and Peeter Linnap and founded Mobilgalerii in 1995. Using mostly photo techniques, the artists attempted to document all facets of society, even the most disturbing ones. Estonian society in all its diverse manifestations generated material for them. At the same time, their works were deliberate simulations made to comment on the principles and structure of society. Although the unity of the Mobil group has weakened, members are still active on the art scene.

Neo-Pop

In the early 1990s, artists whose style was christened "neo-pop" began showing their works at exhibitions. Mall Nukke (b. 1964), Peeter Allik (b. 1966; fig. 113), Marko Mäetamm, Rait Pärg (b. 1966), Reiu Tüür (b. 1974), Hannes Starkopf (b. 1965), and the tandem of Toomas Tonissoo (b. 1972) and Lauri Sillak (b. 1969)—known as "Tommy and Laurentius"—established the

FIG. 114. Marko Mäetamm, from the series *Seasons*, 1997. Lithograph, 33 × 33 cm (each). Collection of the artist. Courtesy: Center for Contemporary Art, Tallinn, Estonia.

movement. Later, artists Jasper Zoova (b. 1965), Kaspar Toomet (b. 1965), and Kadri Kangilaski were also considered members of the movement.

Neo-pop has no group manifesto. The movement's members are united by their use of elements of pop art and their references to mass culture. Nukke's playful works are based on the mass media, and she hides criticism behind her Hollywood glamour, as in *Sweet Home*, shown at the 1996 *Art Genda* exhibition indebted to camp aesthetic.[18] In writing about Nukke, Johannes Saar has spoken of reviewing large ideas and idols whose fate is to remain circulating in all possible texts.[19] Parts of that text constantly form new and unexpected constellations that constitute Nukke's object of analysis and source of imagery.

In imagery and style, Mäetamm is more pragmatic and focused than Nukke. He has developed a precise language of forms analogous to the system of public signs such as traffic signs, warning signs, and so on (fig. 114). He has said that he translates everyday signs into the language of the end of the twentieth century—the language of the generation that reads icons which have

only a surface meaning, expresses its opinions with clichés, socializes via the internet, and seeks nourishment in fast food.[20]

The works of Tommy and Laurentius seem to derive from the MTV generation's ability to read deconstructed forms. The large pieces contain various shapes combined and glued together without the slightest internal hierarchy, creating a jumpy, chaotic environment that mirrors our own.

Estonian neo-pop is not overly critical of society and the environment from which the artists derive material. Moreover, society is enjoying the new cult of advertising and consumer goods, reflected in the exhibition entitled *Everything at Once, a Lot and Immediately*. Mari Sobolev, around whom artists of the young generation have gathered, curated the show. Sobolev, while earning a living as a critic and a curator, started a gallery using the rooms of the Brotherhood of the Blackheads' House; this bohemian-style gallery was the only place where one could catch a glimpse of the up-and-coming generation. Unfortunately, the gallery no longer exists, but Sobolev is involved in many other projects that support young talents from all over Estonia. She is tirelessly persistent and democratic, being very much against Tallinn-centric art, and constantly emphasizes art's social role and function in the public sphere. She curated Estonia's first highway project, in which artists painted huge posters that were put along the highway from Tallinn to Tartu. To fully appreciate such exhibitions, one must understand Estonian mass-media involvement with ideology and local subcultures. Innate to every generation is the desire for protest, the desire for social confrontation.

IMPORTANT EVENTS

Exhibitions of the Soros Center for Contemporary Arts

The annual exhibitions at the Soros Center for Contemporary Arts (SCCA) have greatly affected and accelerated changes on Estonia's art scene at the end of the twentieth century. Estonia's SCCA was a part of the network of Central and East European Open Society Foundations financed by renowned philanthropist George Soros. SCCA opened in Estonia in 1992 and continues to develop its three basic programs, of which the largest is its information center. The center's so-

called ideological core is the SCCA annual exhibition, which later expanded into a set of annual events. The center's first exhibition in 1993, *Substance-Unsubstance*, was curated by Ando Keskküla. It helped to mold the new principle of exhibition of focusing on one contemporary theme rather than on displaying works chronologically or monographically. These exhibitions not only paved the way for young artists and their ideas within the art mainstream but also acted as a "laboratory" for exploring new technologies in art, such as video and computer art. In 1993, when other institutions lacked sufficient funds and space to organize and hold large exhibitions, the SCCA exhibition became an educational experience, opening up entryways into the art world's hottest themes. Urmas Muru, Sirje Helme, Eha Komissarov, and Ants Juske curated four such exhibitions. Artists such as Jüri Ojaver (b. 1955), Kai Kaljo (b. 1959), and Mart Viljus (b. 1965), who received the main prize on two occasions, entered the art scene at SCCA exhibitions.

Gradually, the exhibition became a biennial event. At the same time, other organizations were established that were prepared to mount similar thematic exhibitions at the Tallinn Art Hall and the Art Museum of Estonia. SCCA's function was to organize art events such as conferences and symposia rather than exhibitions. They were dedicated to particularly important clusters of themes on the rapidly developing art scene at the close of the century and created a base for the development of local media art. In 1995, SCCA organized *Interstanding*, a media conference that has become SCCA's signature exhibition. The goal of the first *Interstanding* (subtitled *Understanding Interactivity*) was to discuss how society's rapid digitalization affects culture. The theme had not been addressed in Estonia before, and the organizers (Keskküla from Estonia and Eric Kluitenberg from Holland) managed to gather an international group. *Interstanding* determined SCCA's thematic priorities for its annual event —the study of culture and art in media, various behavioral strategies of individuals and cultures encoded in media, and the effect of digital technology on art. The exhibition gained international status—a fact significant for the Estonian art scene and for developing connections with local art communities. *Interstanding 2: Freedom*, held in 1997, focused on the relationship between freedom and the internet; *Interstanding 3: Beyond the Edges*, held in 1999, dealt with so-called

fringe cultures and their relation to mass-media culture.

At approximately the same time, multimedia became an area of exploration at the Estonian Academy of Arts, where the E-Media Center was founded, the goal of which was to give students instruction on the use of today's technological tools in art. The center's founder was the academy's chancellor, Ando Keskküla, who has worked with video and interactive video installations in recent years. He represented Estonia at the São Paulo Biennial in 1996 with an interactive video installation that depicted a typical interior of the Saaremaa (island) house with a man whose movements were dictated by the viewer placed in the interior—a multilayered work about manipulation, and the potential of new media to analyze this process. Keskküla also represented Estonia in the 1999 Venice Biennale with his interactive sound installation *The Breath*. Largely due to Keskküla's work and personal contacts, Tallinn has become a center for art that deals with the problems of a digital society.

Also working at the E-Media Center are Raivo Kelomees (b. 1960) and Tiia Johanson (b. 1965), two of the few artists working exclusively with digital technology. They both have participated in numerous international exhibitions and are the coordinators for the international *French-Baltic Video Festival*. They have also organized the new media festival *Offline@Online*.

Saaremaa Biennials

Peeter and Eve Linnap began organizing the Saaremaa Biennial, the goal of which was to establish connections between Estonian art and its international counterparts. The first, held in 1995, was entitled *Fabrique d'Histoire*. The event consisted of an exhibition with the participation of such internationally renowned artists as Christian Boltanski, Wojciech Prazmowski, and Vibeke Tandberg and a conference that addressed the issues of memory, history, and power. In his introduction, Peeter Linnap wrote, "We live in an era in which a non-stop argument between world views, instruments of understanding and ways of seeing is occurring. In order to support one view or the other, we search for support from history which has become a warehouse of arguments for everyone and everything."[21]

The exhibition *History's Artel* that took place at the

FIG. 115. Jaan Toomik, *Way to São Paulo*, 1994.
Video installation. Courtesy: Center for Contemporary
Art, Tallinn, Estonia.

same time presented works of the young followers of
Linnap's school—Marko Laimre, Andrus Kõresaar,
Piia Ruber, Mari Laanemets (b. 1975), and others. Ac-
cording to Linnap's ideology, art documents the day-
to-day mythology of the environment.

In the 1997 biennial entitled *Invasion*, Estonian
artists showed their works alongside foreign guests. At
the conference accompanying the exhibition, speakers
approached the idea of invasion from various angles,
such as national identity and history, and the relation-
ship of identity to the image of an inner and outer en-
emy or territory.

The biennials raised an important issue—how to
present nationalities and individuals in a spatial con-
text. The Saaremaa Biennials succeeded in getting
the international art public to come to Estonia and or-
ganizing local exhibitions of noteworthy caliber. Such
work is surely an essential step on the road toward the
end of isolation.

The success of the Eleventh Tallinn Print Triennial
in 1998 serves as proof of the importance of reviving
and bringing to the level of international standards
such major events of the 1970s. The Triennial's goal
was to keep alive the printmaking tradition and to ex-
plore print's possibilities and developments in today's
art context. Alongside the official competition at the
Triennial, an exhibition curated by Keskküla featured

fringe phenomena of the print world, which went be-
yond the borders of traditional printmaking. This
unique addition to the Triennial constituted one of the
reasons for its success.

International Exhibitions

For years, the international press has criticized the
format of the Venice Biennial, Documenta, and other
similar international exhibitions. Yet similar new exhi-
bitions are being developed—for instance, Manifesta.
Regardless of criticism, Estonia must be a part of this
international merry-go-round in order to remind the
art world of its existence.

The 1994 São Paulo Biennial was the first inter-
national large-scale exhibition in which Estonia was
represented by Jaan Toomik (b. 1961) and Leonhard
Lapin. The fame of Estonia's most internationally
renowned video artist, Toomik, began at this biennial.
Toomik presented the work *Way to São Paulo* (fig. 115),
in which a video screen showed a mirror cube swim-
ming peacefully through the rivers of three cities.
Toomik's video installations render a poignant sense of
loneliness, timeless mythology, and, at the same time,
a strong sense of the here and now. Toomik also repre-
sented Estonia at the 1996 Manifesta, the 1997 Venice
Biennial, and many other international exhibitions in
Europe and the United States.

Estonia took part in the Venice Biennial for the first
time in 1997. Since Estonia did not have its own pavil-
ion, outdoor performances were held, thereby turning
the street into a pavilion. Siim-Tanel Annus was one of
the artists performing in Venice. In 1988–91, he was the
key performance artist in Estonia, and Lapin described
him as "a kind of aesthetic concentration of what was
occurring on our streets and parks during the Singing
Revolution."[22] Raoul Kurvitz and Jaan Toomik also
presented work in Venice. Toomik's installation of bot-
tomless wooden coffins was set up along the shore of
the Grand Canal, halfway to the Giardino.

IDENTITY AND OPENNESS

At the core of the stormy development of art in re-
cent years lies the issue of national identity. Estonians
have emerged from domination by the Soviet Union, a
large, closed system that used its power to attempt to
destroy Estonia's identity. As a reaction against oppres-

FIG. 116. Liina Siib, *Presumed Innocence II*, 1997. Digital print, 79 × 104.5 cm. Collection of the artist. Courtesy: Center for Contemporary Art, Tallinn, Estonia.

sion, people feverishly sought to preserve national identity during Soviet occupation. The sudden jump into the free world after establishing independence has raised serious questions concerning Estonia's ability to preserve its identity and original culture. For a long time, Estonians lacked the experience of open communication with the world, and now they must overcome many difficulties at once. Rapid computerization and integration into a communication network without geographic landmarks raises serious questions of survival for small cultures that base their national identity on their language and cultural traditions. What does the open media mean for such nations? Where does a small culture go in the global media space? On the one hand, Estonia as a state wishes to become integrated into international political structures; on the other hand, the previously established rules of those structures require that Estonia modify and transform its identity to fit these structures. The same applies in the cultural sphere. Estonians are doing all they can to speak up in the international arena without losing the originality of their voices.

In the 1990s, all the problems that the Western artist attempts to deal with—violence, sexuality, drugs, and death—have slowly made their way into Estonian art, where the local club culture and MTV-, X-, and E-generations have emerged. Critics write of "trendy art," yet are not overly critical of it. An attitude of permission has prevailed: let artists try everything, as long as they develop.

The growth of feminism in Estonia can be seen as one of these new, intentionally cultivated developments. Although we have always had many strong female artists (Estonian women printmakers during the 1960s and 1970s, for instance), they did not foster a feminist mentality in art. An exhibition of feminist art, entitled *Kood-eks*, was co-organized by Estonian and Swedish artists in 1994, yet only the Swedish participants took a knowledgeable feminist stance. In 1995, *Est.fem*, the first feminist exhibition of young Estonian artists, was organized by Eha Komissarov (currently curator at the Rottermann Salt Storage), Reet Varblane (b. 1952), and Mare Tralla. Komissarov and Varblane are renowned critics, and Tralla was one of the first artists to try her hand at net-art, recent work built on digital technology. She gained notoriety and fame as the so-called "Disgusting Woman," a provocative image meant to challenge the restrained image of the petty bourgeois female that dominates advertising. Experienced artists such as Anu Kalm (b. 1960), Tiina Tammetalu (b. 1961), Kadri Mälk (b. 1958), and Lilian Mosolainen (b. 1961) participated in the exhibition; so did young women just entering the art scene, such as Piia Ruber (b. 1972), Kamille Saabre (b. 1970), Margot Kask (b. 1974), and Kaire Rannik (b. 1971). Barbi Pilvre, who has studied various facets of feminist theory, wrote on the occasion of the exhibition that "feminist art reached Estonia both too early and extremely late —early because a theoretically founded and objective feminist view of society does not yet exist in Estonia,

and late due to the fact that in the rest of the developed world the entire feminist discourse has already become an institution that devours its young."[23] Of course, Estonian artists relate differently to feminism—one has to acknowledge the many decades of foreign feminist art and at the same time work within local conditions. One can easily be accused of having imported trends. The many feminist exhibitions (which have included male artists as well) have been relatively meek, often regressive (with such unspoken themes as "life through the eyes of a young girl"), and focused on everyday life. Liina Siib (b. 1963; fig. 116), who works mainly in photography and who has extensively studied women's stories, does not associate herself directly with feminism but deals with its issues.

Estonian art at the beginning of the twenty-first century faces the same problems that art in the rest of Europe faces. During the Soviet era, artists could avoid unpleasant issues and remain apart from the rest of the world. In this age of globalization, such isolation is almost impossible. Also, Estonians have lately become aware that a "neutral aesthetic object" of fine art no longer exists. This realization may open up unique prospects. Art in Estonia has not been guilty of attempting to change either itself or society. Estonian artists now have the opportunity to start with a clean canvas.

Translated by Riina Kindlam

NOTES

1. I have used the term "repro-avant-garde" to stress that Estonian artists received information about international art only through printed material such as art magazines, not through lived experience. The two-dimensional reproductions and theoretical articles certainly influenced the understanding of contemporary art in their own way.

2. Ando Keskküla, "Tangents for Touch," in *The Eleventh Tallinn Print Triennial Catalogue* (Tallinn: The Association of the Print Triennial, 1998).

3. Ants Juske, "Postcommunist Art in a Postmodernist Condition," in *Substance-Unsubstance* (Tallinn: Soros Center for Contemporary Arts, 1994).

4. Pallas, situated in the university city of Tartu, was the art school in Estonia before World War II and during Soviet times was considered the keeper of traditions in art and of Estonian and European spirit in culture. The Pallas artists preferred the late impressionist style in painting and admired works of the School of Paris.

5. Holger Rajavee, "Harku 75," *Postimees*, March 4, 1996.

6. Johannes Saar, "Repliik. Harku 75," *Postimees*, March 4, 1996.

7. Marketta Seppälä, "Foreword," in *"Sinirand" Uus Soome kunst* (New Finnish art) (Tallinn: Pori Art Museum, 1991).

8. Ibid.

9. Ibid.

10. Sirje Helme, "Sinirand polegi sinine" (The blue beach is not blue), *Kunst* 1 (1992): 44–45.

11. For example, the Kursi School's 1993 exhibition in the Luum Gallery.

12. Ants Juske, "Eesti kunst aastal 1996" (Estonian art in the year 1996), *Kultuurimaa*, September 4, 1996.

13. Ants Juske, "Esimese Eesti kunsti ülevaade" (An overview to the first-level Estonian art), *Eesti Päevaleht*, April 2, 1996.

14. Mari Sobolev, "Kuuldused maalikunsti surmast on enneaegsed" (Rumors of the death of painting are premature), *Eesti Sõnumid*, March 10, 1995.

15. Mari Sobolev, "Abstraktne ilu ajaloo küüsis" (Abstract beauty in the hands of history), *Eesti Sõnumid*, March 21, 1995.

16. Ants Juske, "Eesti performance" (Estonian performance), *Favoriit* (November 1993).

17. *The Memory of Images*, Stadtgalerie im Sophienhof, Kiel, March 17, 1993–April 25, 1993, and in Kunsthalle Rostock, June 27, 1993–September 5, 1993; *Europa, Europa*, Das Jahrhundert der Avantgarde in Mittel-und OstEuropa. Kunst -und Austellungshalle der Bundesrepublik Deutschland in Bonn, May 27, 1994–November 16, 1994.

18. *Art Genda* is the title of the annual art exhibition held in the cultural capitals of Europe. Each year, one European city is chosen to be the cultural capital.

19. Johannes Saar, "Iidolid, iidolid, hellad velled …" (Idols, idols, good fellows …), *Postimees*, December 29, 1995.

20. Marko Mäetammest, "Autodest ja subjektiivsest formalismist" (About Marko Mäetamm, cars, and subjective idealism, an interview by Piret Räni), *Eesti Aeg*, March 8, 1995.

21. Peeter Linnap, "Fabrique d'Histoire," in exhibition catalogue for the 1995 Saaremaa Biennial (Tallinn: Center for Contemporary Photography, 1995).

22. Leonhard Lapin, "Space and Ritual," in *Catalogue of Forty-Seventh Biennial in Venice* (Tallinn: Estonian Cultural Endowment, 1997).

23. Barbi Pilvre, "Märtrid, amatsoonid, meesteõgijad" (Martyrs, amazons, man-eaters), *Eesti ekspress*, August 25, 1995.

3
ART of
LATVIA

Mark Allen Svede

MODERNISM, BALLISM, PLAGIARISM

Latvia's Avant-Garde under Fire

N THE SUMMER OF 1910, the young Latvian painter Voldemārs Matvejs (1877–1914) scandalized newspaper readers in Rīga by assaulting the city's art establishment with a manifesto titled "Russian Secession." On behalf of his colleagues in the progressive St. Petersburg Union of Youth, Matvejs proclaimed, "We do not paint nature, but only our attitude toward nature, the power to be quite different from nature. We take the essential from nature and strip her of materialism. We rape nature because great beauty is found in violation and anomaly." This was the first and perhaps only occasion such an anti-social metaphor was invoked as culturally affirmative in the history of Latvian art, but it was not the first time in Latvia that modern artistic endeavor had been likened to a criminal offense.

The initial lodging of charges, so to speak, had occurred six years earlier when a modest attempt at mod-

ernizing the Latvian folk costume had been publicly condemned by a conservative artist as "vandalism." The alleged vandal, a designer named Jūlijs Madernieks (1870–1955), had adapted venerated peasant ceremonial attire on the occasion of the Fifth Song Festival, the latest in a series of celebrations that heightened sensitivities among native preservationists. This festival also became a crucible of nationalist sentiment within the disintegrating Russian empire, so the *Jugendstil* liberties Madernieks took with folk ornament were regarded as not only debasement of traditional motifs but also capitulation to foreign fashion. This was treacherous because *Jugendstil* was unavoidably identified with the Baltic German petty aristocracy in Rīga, most of whom believed Latvian culture to be inferior. Such airs of superiority would become increasingly difficult to maintain as Latvian national romanticist architects availed themselves of *Jugendstil-*

171

FIG. 117. [TOP] Jānis Rozentāls, *Leda & Swan*, 1909. Pastel on paper, 30 × 40 cm. Collection of State Museum of Art, Rīga, Latvia.

FIG. 118. [BOTTOM] Voldemārs Matvejs, *7 Princesses*, ca. 1909. Oil on canvas, 66 × 71 cm. Collection of State Museum of Art, Rīga, Latvia.

inflected abstraction, ornamentation, and composition, and the new generation of Latvian painters, particularly Jānis Rozentāls (1866–1917; fig. 117), demonstrated complete fluency in styles prevalent among German artists (or at least the Sezession contingent).

Whatever the effect of Madernieks's vandalism, it was inconsequential compared to modernism's impact. The manner in which the newest art debuted in Rīga practically ensured an adversarial reception for native avant-gardists, appearing as it did with little warning and even less local representation in two substantial exhibitions during the summer of 1910. *Salon of the International Exposition*, organized by the Russian sculptor Vladimir Izdebsky, was first to open, with nearly 800 works by 150 artists, some of whom were discovering cubism, futurism, or neo-primitivism, others who were founding Der Blaue Reiter and Neue Künstlervereinigung, and still others who had launched the cubo-futurist and rayist movements. This lesson in radical aesthetics was promptly followed by Matvejs's declaration and the Union of Youth show, remembered later by Latvian modernist Niklāvs Strunke (1894–1966) as "an exploding bomb in quiet, provincial Rīga. It was the first manifestation of our new art, first breath of the new age in the history of our gray metropolis." Naturally, when Madernieks published an appreciation of one exhibited work, Natalia Goncharova's *Planting Potatoes* (1908–9), traditionalists in Rīga unleashed further invective.

As if to underscore and formalize the polarity of nationalism and internationalism within Latvia's incipient art world, the first significant group exhibition of exclusively ethnic Latvian artists also occurred that summer. A number of the exhibitors had affiliated during their student days at the imperial Academy of Art in the late 1890s as the group *Rukis* (Gnome), dedicated to formulating a uniquely Latvian visual culture. Yet back in their homeland, the vast majority of *Rukis* artists were prevented from exhibiting in Rīga's art museum because of their ethnicity and suffered other discrimination at the hands of the Baltic German ruling class, especially after Latvian peasants and workers supported the 1905 Revolution. Also problematic was that the *Rukis* goal of fostering an indigenous art often and unwittingly took the form of impressionist rural landscapes and genre scenes done in *Peredvizhniki* ([Russian] Wanderers) fashion. Despite the effectiveness of these non-indigenous styles in sympathetically

rendering Latvian topics, the overall project was un-appreciated by certain Latvians—namely, the peasants who physically abused *Ruķis* members who had moved to the countryside to commune with their beloved subjects.

By 1910, however, the veterans of *Ruķis* were not so easily deterred from their mission of establishing a national school of art. In fact, they were confident enough to include their younger, heretical colleague Voldemārs Matvejs in the *First Latvian Exhibition*. His work poised between effete symbolism and brute avant-gardism (fig. 118), Matvejs's inclusion demonstrated that the issues of modern art were no longer reducible to a matter of Us versus Them—meaning, Latvians versus outrageous foreign innovators—a dichotomy suggested by the earlier exhibitions. Here was a Latvian artist who valued intuition, mysticism, the element of chance, so-called primitive cultures (including his own), and "painting with the thickest brush available," interests so incompatible with those of his instructors in St. Petersburg that Matvejs is better known today by his pseudonym, Vladimir Markov, under which he felt compelled to publish his theoretical works, such as the seminal essay "Faktura," and the name he assumed when exhibiting alongside Mikhail Larionov, Kazimir Malevich, and the like.

Although Matvejs's prolific writings inspired the Russian constructivists and suprematists, they were unavailable in his own birthplace, a situation ironically reminiscent of his reluctance as a secondary student to speak Latvian, doing so only when forced, and then in a whisper. But by the early 1910s, coincident with his belated appreciation for Latvian folkcraft, Matvejs would lecture before an informal circle of Latvian émigré intellectuals in Paris whenever ethnographic research took him to the West. One member of this audience, a younger and profoundly francophilic painter named Jāzeps Grosvalds (1891–1920; fig. 119), was particularly attracted to Matvejs's philosophy and, moreover, his personal example as a champion of Latvian identity within an increasingly cosmopolitan artistic culture.

When Matvejs died unexpectedly in 1914, Grosvalds succeeded him as the leading personality among Latvia's modernists. Grosvalds returned to Rīga with the onset of World War I, and within his group of friends, he began proselytizing for new artistic principles. This circle included Aleksandrs Drēviņš (1889–

FIG. 119. Jāzeps Grosvalds, *The Outskirts of Paris*, 1914. Oil on canvas, 56.5 × 60 cm. Collection of State Museum of Art, Rīga, Latvia.

FIG. 120. Jēkabs Kazaks, *Refugees*, 1917. Oil on canvas, 210.5 × 107 cm. Collection of State Museum of Art, Rīga, Latvia.

1938) and Kārlis Johansons (1892–1929), both later renowned for their contributions to Soviet avant-garde art. Contrary to Grosvalds's description of their informal gatherings as conspiratorial soirées, his effect on colleagues was less radicalizing than mollifying. Whereas Drēviņš had once been given to futurist antics on the streets of Rīga, his association with Grosvalds reinforced an appreciation of Cézanne and Poussin. Grosvalds's sober palette, simplified form, chiaroscuro, and straightforward compositional instinct would be adopted by most younger Latvian artists during the war years.

By 1916, as the front overtook Rīga, the artists were evacuated to the Russian interior, where their refugee experiences inspired what could be considered the first truly Latvian art, at least of the modern age. In contrast to the *Rukis* project, this work was Latvian not just in subject but in a singular stylistic reticence that corroborates most written and oral accounts of the peasants' wartime existence. Initiated by Grosvalds, the "Refugee" genre was explored by virtually every modernist, receiving its most poetic treatment by the student painter Jēkabs Kazaks (1895–1920; fig. 120). Whereas Grosvalds's works devoted to the theme are unrelievedly stolid, Kazaks managed to communicate both the gravity of the circumstances and the momentary relief that an aesthetic sensibility might provide: Witness the extraordinarily witty detail of the suit jacket vent barely visible between the central figure's legs.

Paradoxically, exile from Latvia physically brought together the future Latvian modernists, many of whom had spent their prewar years abroad and unaware of each other's existence. Conscription united most of the young male artists in exclusively Latvian regiments, where Grosvalds founded the second great historical genre of Latvian painting with his "Rifleman" cycle, which was immediately emulated by his comrades-in-arms. Still other instances of artistic unity were occasioned by the war. Group exhibitions in Moscow and Petersburg presented Latvian modernists and traditionalists to the Russian public as a cultural continuum. This unusually congenial coexistence was reinforced in Petersburg every Thursday, when the two camps would meet at a café and discuss the future of Latvian art. Among things they could not have predicted was that the three Latvian artists best known to the West today would earn their reputations apart from

FIG. 121. Vilhelms Purvītis, *Moon Night*, 1909. Oil on cardboard, 39 × 57 cm. Collection of State Museum of Art, Rīga, Latvia.

their native culture. Drēviņš, Johansons, and Gustav Klucis (1895–1944) began their tenure in the Soviet avant-garde with nonobjective work, a direction virtually unexplored in their homeland. And although café discussions might have included predictions of Latvia's independence, it seems unlikely that any of the artists could have foreseen the bizarre cultural factionalism that followed.

The prewar antagonism between modernists and traditionalists revived at the end of 1918, with a debate on the social role of art, which appropriately took place in a provincial Latvian town where the future democratic government was organizing. The modernist position was articulated by Romans Suta (1896–1944), an argumentative young painter distinguished in art school more for his wrestling skills than for artistic ability. Suta had recently learned the revolutionary precepts of *Proletkult* while in the company of Mayakovskii in Petrograd, and no doubt his speech advocating a national art was as polemical as his subsequent writings would be. A few months later Suta displayed complete intolerance of the old order when he was com-

missioned, along with most of his peers, to decorate Soviet-occupied Rīga for May Day, 1919.

The city was transformed by monumental propaganda: plaster busts of Socialist heroes, wooden triumphal arches and obelisks, a dais called the Temple of Reason, and numerous *panneaux*. Of special interest was a battle scene painted by Suta in an angular, expressionistic style. Instead of showing the Red Army and White Guard, the ostensible subjects of this civil war–themed *panneau*, Suta painted himself vanquishing his professional adversaries. Suta the wrestler was well cast as the attacker of a conservative sculptor, shown running away. Vilhelms Purvītis (1872–1945), the dean of Baltic impressionism (fig. 121), former instructor of many avant-gardists, and—to his enormous credit—their discreet advocate in future confrontations, was depicted digging a grave for a fallen member of the older generation of artists.

Before long, the modernist cause was advanced even more aggressively. When the head of Rīga's school commission denied the young modernists studio space in the former beaux arts school, a structure

FIG. 122. [TOP] Oto Skulme, *Composition*, 1920. Oil on canvas, 81.5 × 75 cm. Collection of State Museum of Art, Rīga, Latvia.

FIG. 123. [BOTTOM] Jānis Roberts Tillbergs, Untitled modernism parody: Ballism (from Kasparsons Exhibition), 1920. Oil on canvas, 67.5 × 82 cm. Collection Tillbergs family.

known as the Jēkabs Barracks, the modernists summoned their talents as riflemen and confiscated the building. With a barricade erected at the entrance, a machine gun and artillery cannon installed in the yard, and guard duty assigned, ten members of Rīga's newly returned avant-garde resided in the extorted building, resuming their art-making in earnest. These months became known as *jefiŋu laikmets*, the time of irresponsibility, or, more charitably translated, mischief.

At the end of 1919, in a reversal of its prewar exclusionary policies against Latvian artists, and reflecting the profound shift in political fortunes, the Rīga city art museum hosted the so-called "Retrospective Exhibition," which showcased the short history of Latvian art. But given the volatility of local military conditions—Rīga was still threatened by a rogue German regiment—history was being dramatically rewritten daily. Nine years after Niklāvs Strunke compared the Union of Youth exhibition to "an exploding bomb," an enemy artillery shell crashed through the museum skylight into a gallery containing the aesthetic bombshells of the native avant-garde. In those intervening nine years, the modernists had attained a status that would have seemed premature, disproportionate, and even unearned anywhere else. But at the retrospective, they presented the most distinctive group identity, if mostly in name. They called themselves the Expressionists, belying the diversity of formal influences felt by its six members and four candidates. This sudden stylistic breadth was not kindly received by traditionalists still smarting from May Day, and they promptly formed an antipodal group dedicated to realism and sometimes giving the modernists a dose of their reality.

The discord between younger artists, eager to establish a national tradition, and their elders, never fully in possession of one, might have been ameliorated had Jāzeps Grosvalds returned to Rīga after the war. But it was precisely his moderation and gift of diplomacy that won him a post in Latvia's embassy in Paris, where he died during the influenza epidemic of 1920. The mantle now passed from Grosvalds to Kazaks, the intimist of the refugee genre and now leader of the Expressionists. However, untimely death was to become a leitmotif in Latvian modernism, with Kazaks dying later that same year. It is said, in fact, that his death was hastened by the next altercation with

conservatives, who were incensed by the increasingly positive reception of the avant-garde.

Capaciously renamed the Rīga Artists Group (later, the Rīga Group), the expanding number of modernists had mounted an ambitious show in March that immediately caused a sensation, particularly with its cubist sculptures and paintings, such as *Composition* (fig. 122) by Oto Skulme (1889–1967). Besides having impressive attendance figures, the exhibition showed works that were purchased by museums and collectors at prices higher than those commanded by most older, established artists. Even more exasperating, modernists and their sympathizers were offered important cultural posts in the newly formed government. Konrads Ubāns (1893–1981) was named assistant to the museum director, while Madernieks, erstwhile vandal of the folk costume, was invited to head the painting section of the Education Ministry.

Conservative artists responded with an imaginative, elaborate subterfuge. In October 1920, led by the reactionary academic Richard Zariņš (1869–1939), five realist painters created parodies of modernism—62 paintings, 38 drawings, and one sculpture—that were exhibited collectively under the pseudonym "R. Kasparsons" and promoted as the new style, *bumbisms* (ballism). The name plays off of cubism, of course, but can also be translated as "bomb-ism." Ballism's one extant painting (fig. 123), saved because its reverse side was used for a treacley family portrait, is a quasi-Orphist composition, certainly not the worst exercise in abstraction and liberated color, insincerity notwithstanding. When art critics were underwhelmed and the state museum failed to purchase these works offered under false pretext, the hoax's perpetrators went public with a caustic declaration, but only after they lured the unsuspecting modernists—publicly enthusiastic about ballism—into a humiliating debate at Rīga's Latvian Society about how easy it was to create modern art. As one might expect, the modernists were ridiculed for inattention to time-honored technique and inordinate attention to foreign trends. The modernists responded with countercharges and even fisticuffs. Kazaks reportedly exited the mêlée while sweaty, entered the chilly night air, succumbed to a cold, and died shortly thereafter.

His departure was poorly timed. Latvia's avant-garde entered a spectacularly productive period last-

ing through the 1920s, first working through the lessons of cubism, as seen in the *Section d'Or*–like painting by Uga Skulme (1895–1963; fig. 124) and the urban-scape by Aleksandra Belcova (1892–1981; fig. 125), soon supplemented by the lessons of constructivism, a style that the Berlin-based sculptor Kārlis Zāle (1888–1942; fig. 126) helped popularize. The synthesis of the cubist and constructivist approaches could be seen in work by Emīls Melderis (1889–1979; fig. 127), although he, like all of his colleagues in Rīga, maintained figural elements even within works that, upon initial viewing, seem nonobjective. These syntheses—of cubism and constructivism, of figuralism and nonobjectivity—became hallmarks of Latvian modernism, as seen in paintings such as Niklāvs Strunke's *Man Entering Room* (fig. 128), art-and-industry hybrids such as the extraordinary ceramics from Belcova and Suta's *Baltars* enterprise (figs. 129 and 130), and even the café environment frequented by the Rīga Group. Throughout the decade, Suta's mother owned a club named Sukubs, a telling amalgam of the Latvian words "suprematisms" and "kubisms," and its interior was filled with furniture, murals, and artists—all assiduously modernist, of course.

The vitality of the local scene was directly attributable to the modernists' ability to get away from it. When government travel restrictions were rescinded in 1922, the avant-garde took immediate advantage of travel stipends and departed for Berlin and Paris. There, encountering the advanced work of compatriots Drēviņš, Johansons, and Klucis, they were confirmed in their belief that Latvians had more to offer international culture than ethnographic peculiarities. His perspective enhanced by distance, Suta wrote two articles for *L'Esprit nouveau* and published, in German, the first survey of Latvian art, which trenchantly noted the foreign stylistic influences in the work of his principal detractors. In the mid-1920s, the Rīga Group exhibited jointly with the Novembergruppe, the Polish artist group Blok, and Estonian cubo-constructivists, as well as exhibiting independently throughout East and Central Europe and Scandinavia. Complementing this exchange of ideas, the Latvian-language journal *Laikmets* presented art and essays by numerous Western and Soviet modernists to its Latvian readership.

This reciprocity and the art that resulted from it were, of course, attacked at home by Zariņš and

FIG. 124. [ABOVE] Uga Skulme, *Portrait: Man at Table*, 1923. Oil on canvas, 65.5 × 54.5 cm. Private collection.

FIG. 125. [RIGHT] Aleksandra Beļcova, *Berlin*, 1923. Oil on canvas, 65 × 48.2 cm. Private collection.

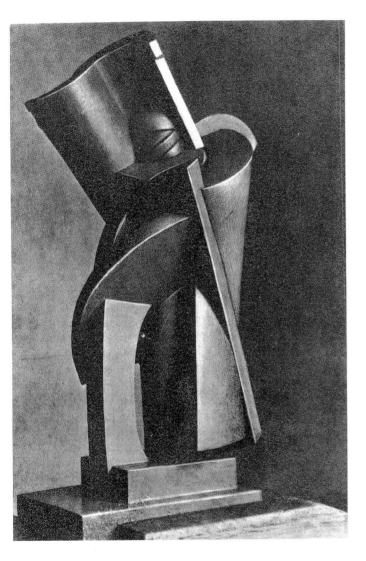

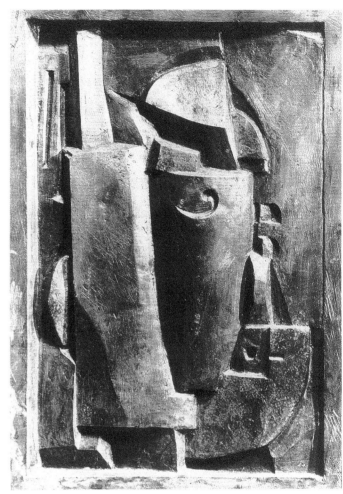

FIG. 126. [LEFT] Kārlis Zāle, *Movements of Mass*, 1922. Plaster (destroyed).

FIG. 127. [ABOVE] Emīls Melderis, *Constructive Relief (Bee-Keeper's Tools)*, 1920s. Plaster (aluminum casting made in 1967), 86 × 58 cm. Collection Melderis family.

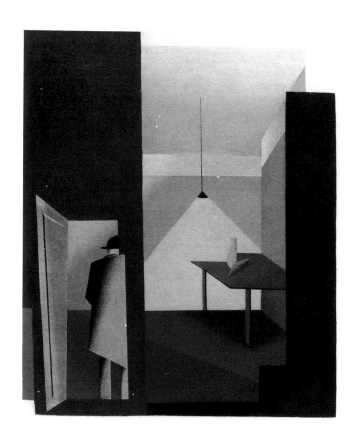

FIG. 128. [LEFT] Niklāvs Strunke, *Man Entering Room*, 1926. Oil on canvas, 92 × 86 cm. Collection of State Museum of Art, Rīga, Latvia.

FIG. 129. [BELOW] Aleksandra Beļcova, *Organ-Grinder*, 1925. Porcelain, diam. 33.5 cm. Baltars Workshop, Collection of Decorative Applied Art Museum, Rīga, Latvia.

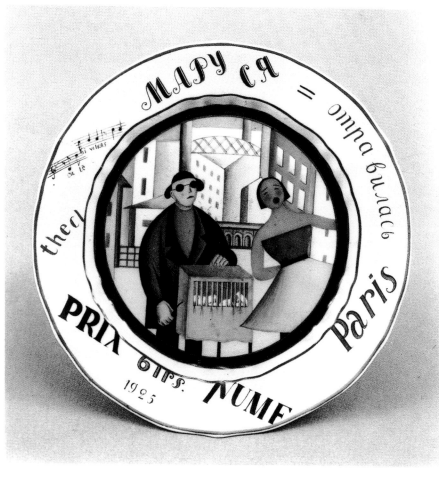

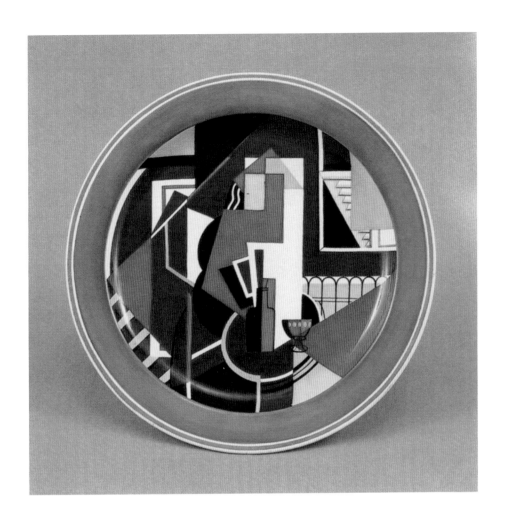

FIG. 130. Romans Suta, *Composition with Interior*, 1927. Faience, diam. 33.5 cm. Baltars Workshop.

friends, who imagined the national image disgraced by modernists squandering public funds, "to stroll on the streets of Berlin and Paris, and talk over cups of coffee or glasses of wine about the new directions in art." Perhaps their most deflating reproach of all was that Rīga Group works were derivative of already outmoded artistic fashions, a criticism that ignored essential differences between cubism and purism, the latter being more inspirational to the Latvians at mid-decade, as well as the stylistic moderation taking place in the re-classicizing oeuvres of Picasso, Gris, and others. (This also introduces an interesting conjectural paradox: Would Zariņš have been more supportive if the Rīga Group *had* synchronized their praxis with the most radical models available, say, the productionists?) One reactionary journal editor detected more than foreign inspiration in Suta's work, however, and printed repro-

ductions of a Suta canvas alongside a similar work done previously by Amadée Ozenfant, Suta's liaison at *L'Esprit nouveau*. Maligned as a plagiarist, Suta filed suit against the editor, and the Rīga Group en masse protested the journalistic ethics of this editor who had asked Suta for the very reproduction used to defame him. Eventually the suit was dismissed.

Challenges to the modernist position continued in Latvia for the remainder of the 1920s. Trivializing reviews, protests against design jury awards, contested job appointments, and conflicts within the Rīga Group itself all exacted a toll on avant-gardism. The degenerative effects were amplified by the intimate scale of Latvia's modernist community, an intimacy defined by a small membership and enforced by the commonly professed goal of establishing a national art. The degeneration was accelerated as well by the

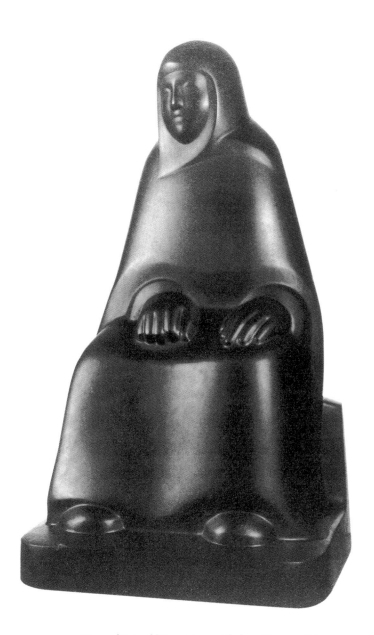

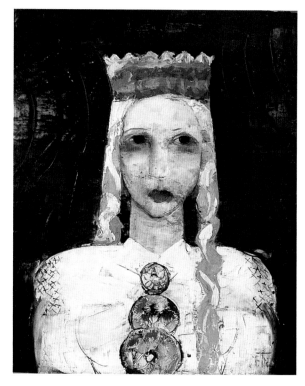

FIG. 131. [ABOVE] Marta Liepiņa-Skulme, *Woman of Vidzeme*, 1933. Granite, 75 × 43 × 53 cm. Collection of State Museum of Art, Rīga, Latvia.

FIG. 132. [RIGHT] Jānis Tīdemanis, *A Young Girl in Traditional Latvian Costume*. Oil on wood, 55 × 48 cm. Collection of State Museum of Art, Rīga, Latvia.

eroding spirit of internationalism in Europe and the global depression, which dealt a fatal blow to Baltars, Sukubs, and art sales in general. One by one, members of the Rīga Group abandoned the tenets of cubism, constructivism, and purism, and then their places within the group. Their work became increasingly romantic in subject and conservative in style, although this trend was sometimes countered by a sublime sobriety of mood and economy of means, as seen in the 1933 work *Woman of Vidzeme* (fig. 131) by Marta Liepiņa-Skulme (1890–1962).

True avant-gardist activity during the 1930s was relatively rare and usually found in the work of two younger artists, Kārlis Padegs (1911–1940) and Jānis Tīdemanis (1897–1964). Their work, and indeed their personalities, illustrated not only the maturation of modernism but also the compound sense of citizenship with which Latvian artists have always grappled. Born in the port city of Ventspils, Tīdemanis became a shipmate and found himself in Cleveland, where he learned to paint. He returned home, sailed off again to study art in Antwerp, and then returned in time to offer his perspective on the newly installed dictatorship's subtle encouragement of Latvian artists to depict ethnic purity and civic stability (fig. 132). Meanwhile, Kārlis Padegs became the dandy of 1930s Rīga, his art canvassing the social terrain—cabaret to city morgue, the demi-monde to the downtrodden, Mother of God (fig. 133) to mothers of invalids—and his chameleon-like persona even seemed to change nationality. Occasionally signing his edgy, exquisite works "Charles" or "Carl," Padegs was the perfect chronicler of a society that thought it had seen it all in a very short time, but, alas, was just entering its most dramatic, traumatic transformations.

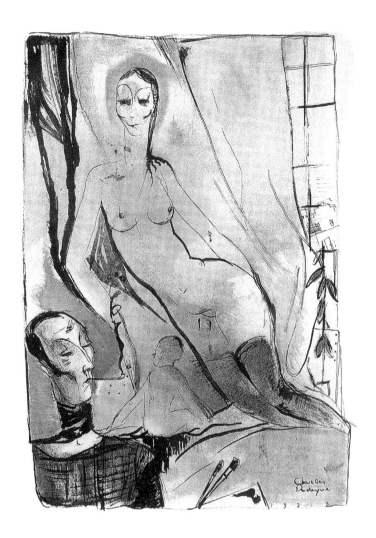

FIG. 133. Kārlis Padegs, *Self-Portrait with the Madonna*, 1933. Ink and watercolor on paper, 33 × 24 cm. Private collection.

SOURCES

A historical overview of this range is obviously indebted to previous scholarship by many others, though to cite every source of information would result in multiple endnotes for a majority of its sentences. For those desiring such numbing thoroughness on this subject, please consult my thesis, "Epigones of Themselves: Origins of Latvia's Conservative Avant-Garde" (The Ohio State University, 1990). Lest I, too, be suspected of plagiarism, I will gratefully point out my ongoing dependence on a number of key sources. General works of note include:

Bilzens, Indulis, et al., eds. *Unerwartete Begegnung: Lettische Avantgarde, 1910–1935. Der Beitrag Lettlands zur Kunst der Europäischen Moderne, 1910–1935.* Exhibition catalogue. Cologne: Wienand, for Neue Gesellschaft für Bildende Kunst, 1990.

Blūma, Dz[idra], et al. *Latviešu tēlotāja māksla, 1860–1940.* Edited by R[omis] Bēms et al. Rīga: Zinātne, 1986.

Cielava, S[kaidrīte]. *Latviešu glezniecība buržuāziski demokrātisko revolūciju posmā, 1900–1917.* Rīga: Zinātne, 1974.

Dombrovskis, Jānis. *Latvju māksla. Glezniecības, grafikas, tēlniecības un lietišķās mākslas attīstības vēsturisks apskats. ar 165 reprodukcijām un 6 krāsainiem pielikumiem.* Rīga: Valters un Rapa, 1925.

Fogelström, Lollo, Elisabeth Haitto, and Folke Lalander, eds. *Oväntat möte. Estnisk och lettisk modernism från mellankrigstiden.* Exhibition catalogue. Stockholm: Liljevalchs Konsthall, 1993.

Siliņš, Jānis. *Latvijas māksla, 1800–1914.* Stockholm: Daugava, 1979, 1980.

———. *Latvijas māksla, 1915–1940.* Stockholm: Daugava, 1988, 1990, 1993.

Suta, Romans. *60 Jahre Lettischer Kunst.* Leipzig: Pandora, 1923.

Key essays in the contemporaneous journals *Illustrets žurnals*, *Laikmets*, and *Senatne un māksla* were invaluable as well. Notable monographic and autobiographical works in this area include:

Apsītis, Vaidelotis. *Kārlis Zāle.* Rīga: Liesma, 1988.

Brancis, Māris. *Jānis Roberts Tillbergs.* Rīga: Zinātne, 1996.

Bužinska, Irēna, ed. *Cheniya Matveya.* Rīga: Irēna Bužinska, 1991.

Čaupova, Ruta. *Marta Skulme: Tēlniecība.* Rīga: Liesma, 1994.

Kalnačs, Jānis. *. . . arī sapņu zīmētājs. Kārlis Padegs.* Rīga: Liesma, 1993.

———. *čāks. padegs. rīga. 30. gadi.* Rīga: Liesma, 1985.

Konstants, Zigurds. *Baltars* (ser. Virzieni un stili. Mazā mākslas enciklopēdija, 14). Rīga: Latvijas enciklopēdija, 1996.

Lamberga, Dace. *Jēkabs Kazaks* (ser. Mākslinieki un darbi. Mazā mākslas enciklopēdija, 8). Rīga: Latvijas enciklopēdija, 1995.

Markovs, Vladimir (pseud. V. Matvejs). *Faktūra.* Translated by T[aira] Haļāpina. Rīga: LPSR Kultūras ministrija, 1984.

Novadniece, I[nāra]. *Jūlijs Madernieks.* Rīga: Zinātne, 1982.

Strunke, Niklāvs. *Svētā birze. Esejas.* Stockholm: Daugava, 1964.

Suta, Tatjana. *Romans Suta.* Rīga: Liesma, 1975.

Vipers, B[oriss]. *Jāzeps Grosvalds* (ser. Latviešu Māksla monografijas). Rīga: Valters un Rapa, 1938.

Also, collegial conversations and correspondence over the past ten years with scholars and descendents of Rīga Group members have proved invaluable in gaining a sense of the complexity of Latvian modernist activity. My deepest thanks extend to Māris Brancis (particularly for the pilgrimage to photograph the infamous ballism canvas), Ingrīda Burāne, Irēna Bužinska, Ruta Čaupova, Jānis Kalnačs, Eduards Kļaviņš, Džemma Skulme, Tatjana Suta, Edvarda Šmite, and Genoveva Tidomane.

Finally, in terms of sources, it should be mentioned that the core of this essay originated as a presentation at the 1990 College Art Association annual meeting, Washington, D.C.

Mark Allen Svede

MANY EASELS, SOME ABANDONED

Latvian Art after Socialist Realism

PERHAPS THE LATEST IRONY of Latvian cultural
history is that such a compact and in-
tensely self-reflective nation—2.5 million
people living on territory the size of New Jersey, with
indigenous academic (and anti-academic) art tradi-
tions traversing barely two centuries, a concentration
of professional art historians rumored to be the highest
per capita in the world, and the publication of materi-
als devoted to local visual culture almost as dispropor-
tionately high—lacks even a remotely comprehensive
account of its artistic life as it developed in the second
half of the twentieth century. This deficiency might be
explained by the recent, distracting necessity of rewrit-
ing Soviet-era surveys and monographs concerning
the art of earlier periods and personalities, publica-
tions that had been skewed or circumscribed by Com-
munist ideology. Still, in the decade since Latvia's po-
litical independence was reestablished, it seems likely

that at least one of its many historians would have at-
tempted a more comprehensive study of Latvian art
from the last fifty years.

Of course, these days few historians of any nation-
ality would presume to write a totalizing narrative of
their country's artistic culture, for such ambitions have
been soundly discredited or at least muscled to the
sideline by competing critical methodologies that,
when their analyses are considered together, do a more
credible job of accounting for a broader range of cul-
tural expression. But even in this polyphonic moment,
Latvia is bereft of extensive art historical accounts
thoroughly informed by semiotics, psychoanalysis,
feminism, cultural anthropology, queer theory, or
even Marxism (that is, in its most rigorous intellectual
sense).[1] Therefore, no possibility exists of collating a
variety of such surveys and interpolating them with
some standard, detailed chronology of key works, cre-

ators, and stylistic derivations in order to gain a balanced, exhaustive understanding of Latvian art since 1945.

Indeed, perhaps the biggest problem, historiographically speaking, is that one can quickly become mentally exhausted when pondering the multiplicity of artistic styles, aesthetic philosophies, and working strategies that were simultaneously practiced by artists in Soviet-occupied Latvia. Posing an even greater challenge to forming an accurate account, the professional practice known as "working at two easels" arose during the highly repressive years following World War II and the nation's absorption into the Soviet Union. In a published speech of March 11, 1951, cultural bureaucrat Artūrs Lapiņš railed against

> an unwelcome phenomenon . . . that is, work at "two easels." This can also be observed in the youth. They paint one state commission, ostensibly fulfilling the demands of socialist realism but another work follows the direction of formalism with its different methods—old methods which artists were using twenty years ago.[2]

Thus, thorough-minded researchers not only need to trace the irregular, diachronic development of purportedly antithetical styles—on one hand, Socialist Realism in its many guises and, on the other, whatever offending stylistic qualities and/or content Lapiņš lumped together under that ever-useful denunciation, "formalism"—but must also reconcile disparate tendencies that existed within the oeuvres of individual artists.

Fortunately, this two-easel phenomenon had almost disappeared by 1970, the date after which most of this study of art-making in Latvia concentrates attention. However, around 1970 the vexing dual easel was supplanted by a plethora of easels, so to speak, a plurality of artistic approaches, some of which dispensed altogether with the easel (or, for that matter, the sculptor's pedestal). Admittedly, this essay will be an incomplete attempt to chronicle this stylistic heterogeny, for I devote little effort to tracing the most doctrinaire and *retardataire* tendencies as they persisted into the 1970s and 1980s. Nonetheless, I shall examine some of the complexities and contradictions within Latvian art of the late Soviet era, which entails including personalities dismissed elsewhere as irrelevant, retrograde, and even pernicious presences within the cultural milieu.

At the same time, I consciously underplay certain prominent artists who remained active during this period—pedagogically, even influential—mainly because they already suffer from overexposure, their reputations bloated by honorific, uncritical treatment by other historians.

Another acknowledged limitation of this essay, a limitation born of an embarrassment of riches, is that it is designed to accompany an exhibition of Baltic work drawn from the Dodge Collection and is therefore accountable to the strengths of that curatorial selection. Namely, particular attention must be paid to singular nonconformist articulations, nonconformist in terms of political content, aesthetic realization, or, more troublesome, the ineluctable intermingling of the two, made possible by a social context wherein even examples of resolutely nonobjective artworks (meaning, both nonfigural and without overt political objective) took on ideological significance unintended by their creators. Therefore, not only will this essay occasionally foreground the political trenchancy of specific works at the expense of their aesthetic accomplishment, but also in instances of nonconformism of a wholly stylistic nature, it may do so contrary to the artists' original intentions. Although post-structuralism licensed this liberated manner of interpretation, it becomes a delicate issue (and, some might say, a hypocritical practice) in light of the blatantly fraudulent Soviet historiographic tendency to endow art, often retroactively, with revolutionary meanings that were, in many cases, antithetical to the authors' political convictions.

Alas, this essay deliberately steps into already muddied waters, with hopes of stirring still more sedimentary matter to the surface. At the risk of overextending this metaphor—one whose imagery of submerged, murky regions already perpetuates romanticized notions of unofficial art activity in the Soviet Union—I find it apt because the full depth of Latvian art is yet to be charted, especially as lost worlds continue to surface, an erstwhile visible world is in the process of sinking from view, and relations between the appearing and the disappearing remain fluid. For the sake of such fluidity (if not a reassuringly linear lucidity), the structure of my argument is meant to evince the multivalency of cultural philosopher Mikhail Epshtein's online *Book of Books* and the coalescence of historical minutiae and commentary into so-called "convolutes"

in Walter Benjamin's *The Arcades Project*,[3] though any direct comparison with either model is doomed to be unflattering. The episodic form of this essay is also an engagement with Olesya Turkina and Viktor Mazin's assertion that "the place of the former opposition between official and unofficial art is occupied by personal narratives,"[4] which suggests that the overarching, Manichean historical account once useful for making prognoses about mid- to late-Soviet art is inadequate for elucidating present-day developments in East European art. I'm not sure that this schema of good-versus-evil ever made full sense of the Soviet situation, especially in the peripheral regions of the empire, though it certainly made more than a few artistic reputations. The "small stories" that follow seek to expand this reputable company.

READING AGAINST THE GRIN

On June 17, 1940, Red Army troops overran Latvia, collecting the spoils of the Nazi-Soviet Non-Aggression Pact penned by Molotov and Ribbentrop the year before. Meeting negligible physical resistance, the occupiers were immediately able to shift their priorities from tactical to psychological dominance of the local populace. However, to judge from the arsenal of weaponry deployed, this shift occurred a bit too swiftly for the Soviets to achieve immediate, commensurate success in conquering native hearts and minds. For example, given so little notice, propagandists often took posters previously used elsewhere in the empire, applied Latvian-language captions to the original illustrations glorifying collectivized society, and hastily pressed them into service on the streets of Rīga.

In some cases, the synthesis was not particularly persuasive; in others, it was downright counterproductive. One poster on display showed a proud Central Asian mother and infant, standing before a gleaming new community center on the steppe, its façade sporting a monumental portrait of Stalin (fig. 134). The text below proclaimed, "For the socialist homeland, for a happy life, vote enjoying-full-rights Soviet woman!" The stuttering syntax was foreign, the physiognomies and arid mountainous landscape were even more so, and the building next to Stalin's dour face is labeled *bērnu siles*, a phrase that translates as "children's trough." Not only were prevailing nationalistic notions of homeland challenged, but also apparently the kids

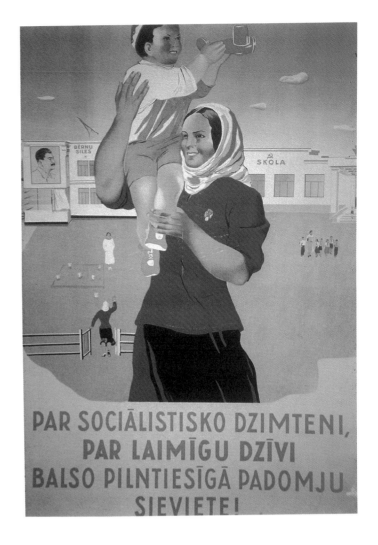

FIG. 134. Anonymous, *Vote, Enjoying-Full-Rights Soviet Woman!* 1940. Screen print on cardboard, 100 × 68 cm. Collection of Mark Allen Svede.

would no longer be attending *bērnudārzs*, the straight-forward, Latvian translation of kindergarten commonly used by urbanites of the time. The fuller message was not unlike that of the flashing "Welcome" sign at compulsory-attendance political rallies in the Soviet Union;[5] such posters merely underscored the compulsory nature of Latvia's attendance in the Soviet Union, an attendance first enforced by army regiments that just so happened to be composed of troops from Central Asian republics. For an audience already inclined toward racist attitudes about the repressive "Mongol invaders," this poster could not have been a worse miscalculation. Nor could it have been more prescient, as thousands of Latvians would be deported to the Soviet interior in the years ahead.

As a privileged proselytizer of official Communist ideology, painting had its own problems during the first years of postwar annexation. Although Latvian artists took full advantage of the new regime's ambitious exhibition policy, most were slow, even loath, to adjust their individually developed styles and personal content to the imported requirements of Socialist Realism. In a show of 260 paintings by 92 artists held at the newly renamed State Latvian and Russian Art Museum in May 1945, only five painters tailored work to reflect the reinstated Socialist reality (or, more to the point, Socialist ideality). Four of their six retooled canvases were conventional portraits of newly arrived military personnel, and we can only imagine their limited crowd appeal.[6] The other artists chose to exhibit essentially the same sort of painting that Latvia's Nazi occupiers during the previous four years had found inoffensive, which had been the same sort of painting shown during the prewar independence period: landscapes that fathomed a peasant people's connection to the earth, portraiture that variously celebrated that agrarian heritage and indicated the rise of an indigenous cosmopolitan society, and still lifes that inventoried bourgeois domesticity, mostly rendered in a picturesque, painterly realism or flaccid impressionist manner.

To judge from published rosters of subsequent painting exhibitions of the late 1940s, the effort to conform to official expectations was underwhelming, especially among participants with identifiably Latvian surnames. One early exception was Aleksandrs Zviedris (1905–1993), whose painting titled *Red Armymen Crossing the Daugava* (1945) was apparently excep-

tional enough, in ideological ambition if not in artistic execution, to appear in both state-sponsored exhibitions of 1945. Two years later, for the bombastically named *Art Exhibition Dedicated to the Restoration and Construction of Rīga's Seaport and Industry Units*, Zviedris contributed almost a third of the sixty-three works shown, a truly Stakhanovite effort given that there were twenty-six other exhibitors, most of whom were represented by a single work apiece. Equally notable, a majority of the other paintings depicting heavy industry were authored by artists born outside of Latvia, while native artists, if they deigned to show something like a cement factory, did so within a composition dominated by beloved features of the local landscape, such as the river Daugava. Moreover, the frequency with which particular titles reappear within this exhibition roster—for example, *First Navigation* or *Superphosphate Factory*—indicates that organizers felt the need to assign topics for representation, given the certain lack of initiative on the part of artists.

Cultural apparatchiki were quick to recognize this inertial state within the larger artistic community, and an extended public debate ensued in which a growing number of Latvian artists zealously enumerated their colleagues' violations of Socialist Realist praxis.[7] A morbidly fascinating subject in itself, this process of cross-incrimination is relevant to Latvian nonconformist art, not only because artists like the fledgling Communist Ojārs Ābols (1922–1983) are revealed to have served as grand inquisitors in this sadistic episode, but also because it reveals that the knack for producing politically correct art could elude even those who had the requisite political intentions. Ābols himself was ridiculed when he depicted peasants battling tsarist soldiers in the 1802 Kauguri peasant rebellion, because, according to his critic Artūrs Lapiņš, "from these very same soldiers later grew the soldiers of the October Revolution."[8] Lapiņš seemed to discount the likelihood that these very same soldiers, if they were still half as protective of tsarist interests, would have stood on the wrong side of the barricades—presumably a forgivable spell of disorientation for what would have been, by then, a regiment composed of 140-year-olds. Actually at stake, of course, was the perception of the Russian military as an adversarial force.

If an ardent supporter of the new regime had difficulties anticipating absurd technicalities, a habitual "formalist" like Rudolfs Pinnis was bound to encoun-

ter trouble. In his same diatribe, Lapiņš pointed out historical flaws inherent in an attempt by Pinnis to showcase consumer plenitude after five years of Soviet economic policy. His painting of a well-stocked meat merchant in a market pavilion was judged reactionary because the availability of meat was only possible at that moment of Latvian agriculture's intense collectivization thanks to " 'private kulaks' striving to slaughter and sell beef in the market" in defiance of efforts to build animal herds in the new *kolkhozi*.[9]

However, complete accuracy in representing Soviet Latvian reality would have complicated the painting of other works that passed muster with critics and, indeed, were lauded as paragons of Socialist Realism: for example, the dynamic, colorful composition *Latvian Fishermen*, painted in 1951 by Jānis Osis (1926–1991). The subject was a safe choice. Six years earlier, Eduards Kalniņš (1904–1988) had produced an allegorical work, *New Sails* (1945), in which three men seated in a skiff prepare a new source of power for their vessel. Not coincidentally, the outfits of the three figures contained, respectively and not too blatantly, the colors of the Baltic states' pre-Soviet flags. *New Sails* was instantly acclaimed, widely reproduced, and promoted as a model to be emulated by other artists (and even by Kalniņš when his subsequent paintings were deemed less ideologically effective).[10] And so, just as the annexation of Latvia provided the Soviet Union with strategic water frontage, acquiescent local artists now assured authorities of a steady supply of seascapes, and Osis provided one of the best. Duly recognized for its technical achievement, *Latvian Fishermen* also enjoyed widespread publication and display, including an appearance at the 1956 Venice Biennale, one of only two Latvian works featured in the Soviet pavilion. But what Biennale visitors could not have known was that this exemplary Socialist Realist work was patently unrealistic. At that very moment, Soviet paranoia regarding naval reconnaissance or even outright invasion from Sweden was causing catastrophic disruption within the Latvian fishing industry. Fishermen whose ancestors had worked the coast for centuries suddenly found their activities severely restricted, if not forbidden. Given these circumstances, which cost many families their livelihood when Latvians were replaced by more "dependable" Soviet colonists, *New Sails* would have been more aptly titled *New Sailors*; *Latvian Fishermen*, simply *Fishermen*. This irony could

not have gone unnoticed, though discussion of it in the art press of the day was certainly impossible.

Instead, critics had plenty of other things to disparage, even works that initially found favor with officialdom. For example, a painting by Arvīds Egle (1905–1977) depicting the reconstruction of Rīga's Iron Bridge might appear unobjectionable in terms of Socialist Realist standards. The strong diagonal perspective that recedes across the building site and punchy *répoussoir* effect of the foreground vignette intervene with the stable panoramic view of Rīga in much the way Soviet engineering was aggrandized as an improvement on the existing infrastructure. Here workers and managers interact equitably. And so on. But when this painting was exhibited in Moscow as part of a Latvian art festival in 1955, it was quickly pointed out that one could not see the faces of these heroes of Soviet labor. Trifling as this observation might seem, the fact remains that an inordinate percentage of Latvian Socialist Realist works avoided showing facial expression, either through compositional ruses that positioned human figures with their backs to the picture plane or, if figures were turned toward the viewer, through stoical countenances. It could be argued that twentieth-century figural painting in Latvia from the time of Jāzeps Grosvalds (1891–1920), Jēkabs Kazaks (1895–1920), and other chroniclers of the World War I experience tended to depict the native physiognomy as stalwart, forebearing, and betraying little, if any, emotion. But this tradition of laconicism is all the more conspicuous when seen in contradistinction to the typical euphoric faces populating Socialist Realist works from elsewhere or, for that matter, in paintings of that ilk authored by Russian artists freshly imported to Rīga. Yet, as often as these other works might be termed more emotionally empathic, their passionate facial expressions read as caricatures to native audiences.

Even when Latvian artists set out to paint explicitly Socialist subjects, chances were good that the affective human element would be eclipsed by other representational concerns. Another widely known work dating from the introductory phase of Latvian Socialist Realism, *Grain for the State*, by Ārijs Skride (1906–1987), shows rural collectivization at its most halcyon: Peasants in horse-drawn carts gather in a sunny autumnal landscape where even bare soil exhibits a chromatic richness to rival the harvest. Once again, considered

as a social document, this 1948 painting fortuitously records the calm before the storm—that is, the mass deportations of the following year that radically transformed rural society precisely in the interest of collectivization. Heedless of their probable fate in a future gathering, farmers converge on a communal collection point, indicated here in shorthand by a small pair of red banners festooning the entrance to the structure in the distance. However, one needs to look closely to perceive this revolutionary décor, just as the viewer is challenged to discern faces of the compliant peasants. This diminution of the human form in Skride's work can be diametrically contrasted with a paradigmatic Socialist Realist *panneau* done the following year by Ukrainian artist Tatyana Yablonskaya, in which a team of ebullient women on a *kolkhoz* fill grain sacks during a record-setting corn harvest. The proximity and positioning of Yablonskaya's subjects leave no doubt as to their attitude toward the pictured proceedings.[11]

Obviously, more suitable role models needed to be found elsewhere, and throughout the 1950s officially engaged artists in Latvia steadily conformed to Union-wide standards or, in the case of Edgārs Iltners (1925–1983), set new standards with the so-called Severe Style, whose pictorial austerity and emotional sobriety found increasing currency outside of Latvia proper. Foremost among those artists of the next generation who bolstered their careers by sustaining and consolidating the more traditional school of Socialist Realism, Indulis Zariņš (1929–1997) painted renowned works such as *What a Height!* (1958) and *We Are Already Roofing Our House* (1960). Well after Stalin and the urgency of following his stylistic directives to the letter had passed, the workers' life-affirming disposition was finally foregrounded. But even if Zariņš seems to have "gotten it right"—presenting uplifting, socially relevant subject matter in a clear, expository manner— there was no assurance that his painting, once released to the viewing and interpreting public, would behave as ideologues (or Zariņš) intended. Although historians and critics are quick to grant a measure of autonomous meaning to artworks belonging to dominant Western traditions—which is to say, we permit ourselves interpretive latitude under Barthes's "death of the author" hypothesis—it seems almost foolhardy to propose that the pedantic, programmatic work produced under the rubric of Socialist Realism is equally eligible for multiple readings. Yet, one can revisit

such seemingly unambiguous paintings like *What a Height!* and find indications that all is not necessarily utopian.

According to Latvian folk tradition, having a stork nest atop one's structure is an auspicious event, conferring luck on the inhabitants. However, over the shoulder of Zariņš's blissful ironworker, two storks fly overhead, apparently heedless—or is it scornful?—of the nesting opportunity below. Is this a sign of ill-fortune or disapproval of the stylistically incongruous architecture, or is Zariņš simply recording that storks are unlikely to nest in the midst of riveters and welders? My point here is that just as we enjoy a certain interpretive license at this historical remove, contemporary viewers of this work had equal, though not equally expressible, possibilities to read subversive content into Socialist Realist works—and far greater motivation to do so. Likewise, *We Are Already Roofing Our House*, despite its salutary element of the wreath hung on the ridge beam (denoting the successful "topping out" of the structure), opened a space for multiple readings, especially if the viewer's personal experience of residential space in Rīga would more accurately be titled "We Are Already Fighting in the Communal Kitchen." When this painting was made, most Latvians were enduring severely compromised urban living arrangements because their homes had been expropriated or subdivided and redistributed to non-Balts imported to staff Soviet industry. Zariņš's vision of commodious, well-built housing in a bucolic setting did not have the motivational effect that a home-builder's illustrated sales brochure would have had in the prospering, acquisitive West. The word "already" in the title is itself a dissonant inflection on the topic of homesteading, intimating surprise at the very possibility of having one's own roof.

Again, such an interpretation may not reflect the average contemporaneous viewer's reception, but subversive receptions should not be foreclosed merely because we commonly consider Socialist Realism to be painfully obvious (if even more painfully and obviously dishonest). Cultural authorities from Lenin onward operated on the patronizing premise that they were indoctrinating a herd of dullards, but this does not preclude the existence of so-called "deep" readers, especially among a Baltic audience less bludgeoned by the ideological assault that began decades earlier elsewhere in the Soviet Union. Conversely, yet by the

same token, the possibility that a museum visitor might stand before Skride's *Grain for the State* and choose to see a glorious afternoon in the countryside, nothing more and nothing less, should give us pause when we roll our eyes at the title and, in doing so, overlook qualities that have nothing to do with the politics plaguing painters in that difficult time.

CARRYING ON

The reassuring fact that viewers could read whatever they wanted into artworks included in the newly Sovietized exhibitions did not mean, however, that the public was able to see whatever artwork it wanted. Collections on display at the state museum were censored, and works found objectionable were banished to the storerooms, replaced by either Socialist Realist exemplars or the traditional realist works freshly confiscated from private collections of Rīga's bourgeoisie. The amount of Russian art on display multiplied and was posited as formative to Latvian cultural development, though, paradoxically, the works that would have made the most persuasive case for a stylistic debt were among the art found most objectionable. Latvia's modernists had assimilated much of Russian and Soviet avant-garde praxis—that is, when Latvian modernists themselves weren't formulating it. Nevertheless, neo-primitivist paintings by Voldemārs Matvejs (1877–1914), constructivist photomontages by Gustav Klucis (1895–1944), productionist spatial constructions by Kārlis Johansons (1892–1929), and the late figural expressionistic paintings by Aleksandrs Drēviņš (1889–1938) were as unwelcome in local exhibitions as they had become in Stalinist Russia's museums.

Fortunately, these very works were welcomed by curators remaining from the prewar staff for whom artistic value outweighed the political liability of preserving modernist art from destruction. And so, quietly transferred from Russian institutions by sympathetic colleagues, the disallowed artworks were secreted in Latvia's museum storerooms until a changed political climate could permit reexposure. This curatorial impulse also preserved avant-garde work created within interbellum Latvia. Overall, this persistent proof of another, more independent, era served a talismanic purpose for subsequent independently minded artists, such as Boriss Bērziņš (b. 1930), though access to such "special collections" was highly regulated. Also im-

portant, but much more accessible, were the majority of Latvia's former modernists who remained in Rīga during the annexation. Though conciliatory toward changed political circumstances to varying degrees, they all preserved the evidence of their earlier, radical production—even Oto Skulme (1889–1967), newly appointed rector of the academy. His cubist paintings remained safely at home, even though the home where they had been created alongside the cubist sculptures of wife Marta Liepiņa-Skulme (1890–1962) was now expropriated, forcing the couple to house their modernist legacy in lesser surroundings. Likewise, Aleksandra Beļcova (1892–1981) sheltered her modernist canvases dating from the 1920s, along with those of husband Romans Suta (1896–1944), who'd fallen victim to the Soviets. Such protectiveness, although exceptionally brave, was not an exceptional reaction.

An even greater risk than that of concealing progressive art of the past was assumed by artists who continued to make it anew and submit it for exhibition. Though younger than the modernist generation, Kurts Fridrihsons (1911–1991), Jānis Pauļuks (1906–1984), and Rudolfs Pinnis (1902–1992) were old enough to have experienced full artistic freedom in prewar European art centers, and they continued to operate with the conviction that independent behavior was worth whatever professional toll it might take. The price soon became apparent. On the advice of Latvia's ambassador in Paris, where Pinnis studied and painted for much of the 1930s, he returned to Rīga on the eve of World War II. During the first Soviet occupation in 1940–41, he agreed to administer the painting section of the government's art directorate, a post for which his absence from Rīga's art scene was believed to afford impartiality.[12] His responsibilities were as short-lived as the initial Soviet presence, and when the Nazi successors retreated three years later, Pinnis was neither back in favor nor long for Latvian soil. After brief incarceration in the gulag, he returned and resumed painting, predominantly landscapes in a patently École de Paris manner. Within months, speakers at the 1948 Latvian Soviet Socialist Republic Artists Creative Work Conference denounced Pinnis for his formalist tendencies.

Jānis Pauļuks was similarly faulted. That year, he painted *Nude* (fig. 135), a portrait of Felicita Jānke (b. 1925), a Jewish artist who had been expelled from the academy mere days after the Nazis occupied Rīga (fol-

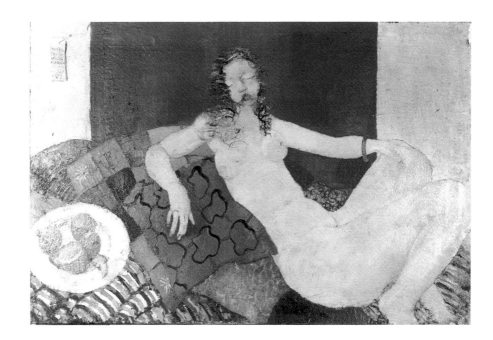

FIG. 135. Jānis Pauļuks, *Nude*, 1948. Oil on canvas, 80.3 × 120.5 cm. Dodge Collection, ZAM, 01211.

lowed within the week by Pauļuks's expulsion for associating with her) and whom Pauļuks had married at the height of the occupation, defying acute risk. Felicita Pauļuka would eventually secure her own reputation with portraits of lesbian lovers that were every bit as sensuous as this depiction and, confounding feminist assumptions about the gaze, even more objectifying and centerfold-like than her former husband's many female nudes. The spatial compression, anatomical distortion, and overtly decorative patterning that nearly eclipses the passages of painted skin: all these qualities of Jānis Pauļuks's work provoked the conference critics' ire. They had found Pinnis's unabashedly Parisian decorativism offensive—anything so overtly Parisian was condemnable as "cosmopolitanism"—but Pauļuks compounded the offense of a moderately decorative impulse with the bleak hermeticism pervading his work of the 1940s. Faces in his portraits of that time (especially many self-portraits) are often contorted and shadowed. Overall, human forms are estranged from their environments by the addition of incongruous elements, funereal backgrounds, or ludicrous contexts (for example, a bare-chested woman and man stand in a queue of clothed

people in his provocatively titled work, *The Long Servitude* [1942–54]).

When the Artists' Union began its punitive "re-registration" process in December 1949, Pauļuks came under scrutiny for his unrepentant "symbolism and formalism," and shortly thereafter was demoted from member to candidate status, a penalty given to twenty other noncompliant artists.[13] Rudolfs Pinnis and Kurts Fridrihsons were among fifty members who were expelled outright during the re-registration winnowing. Before long, Fridrihsons's luck worsened. His dedication to maintaining a global cultural outlook—which resulted in personal interactions with André Derain, André Gide, and Edvard Munch—languished when the Soviet government curtailed individuals' ability to communicate with the West. To compensate, Fridrihsons and eleven other intellectuals began meeting privately in 1947 to discuss world literature and philosophy, though their concentration on the writings of Camus, Gide, and Sartre caused this informal circle to become known as the French Group.[14] In January 1951, Fridrihsons and his colleagues were arrested, tortured, and eventually deported to Kazakhstan, a fate shared at that xenophobic moment by many Latvians

who evinced internationalist interests, even members of philately and Esperanto clubs.[15]

Returning to Latvia after Khrushchev's general amnesty in 1956, Fridrihsons began a painting career that influenced artists more by its audacity than by its aesthetic particulars. The overall effect of his harsh palette, stained and striated surfaces, attenuated forms, and tectery compositions had no Latvian precedent, so instead, more tradition-bound admirers learned from his willingness to allow media to dictate form, his idiosyncratic interpretations of classical myth (ultimately serving his own), and his determination to investigate artistic problems heedless of career impact. During the 1960s, he was instrumental in the widespread popularity of watercolor as a medium for serious investigation of painterly problems. Watercolor's inferior material status—an age-old reputation ensured by its provisional use in preparatory studies—made it suitable for experimentation in the midst of a generally unexperimental artistic culture, and its inherent contingencies—the ability to blur, bleed, pool, and so on—facilitated a degree of abstraction and dematerialization of form likely to have vexed censors had such effects been explored in other media. Fridrihsons, in particular, was aggressive about completing the teleological drive toward pure abstraction left unfinished by Latvia's modernists, yet within his abstract work itself this aggression is ameliorated. His large, untitled drawing of 1962 (fig. 136) reconciles rigid Mondrian-like geometry with lyrical biomorphism, resulting in some sort of a second-generation modernist rapprochement. With a work such as *Composition X* (1967; fig. 137), or especially his 1968 painting *In the Distance*, one senses that Fridrihsons found a compromise between the hard-edged post-painterly abstraction and amorphous color field tendencies coexisting in the West. The frailest state of coexistence, however, was that between abstraction and figuration within his numerous drawings of human faces, surprisingly kindred to Viennese expressionist portraiture: The figural passages' edgy, fragile linearity appears vulnerable to the color washes that saturate the background, threatening to obliterate the visual field. Somehow, the elements remain in check. Perhaps it was this inclination to resolve differences without capitulation of the most vulnerable party that put Fridrihsons on the anti-Soviet barricades in 1991 during the final weeks of his life,

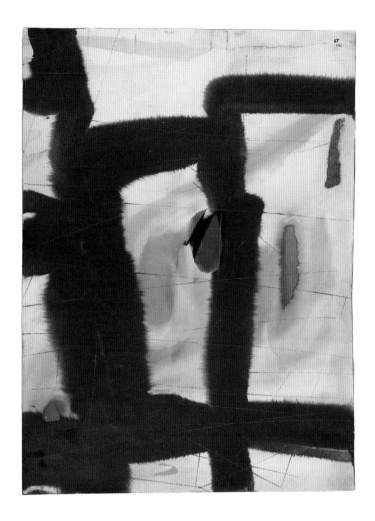

FIG. 136. Kurts Fridrihsons, (Untitled), 1962. Watercolor on paper, 66.6 × 49.3 cm. Dodge Collection, ZAM, 01129.

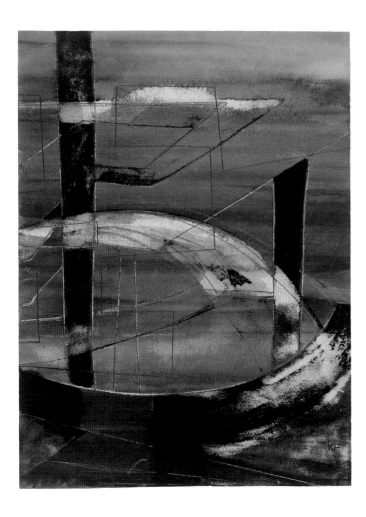

FIG. 137. Kurts Fridrihsons, *Composition X*, 1967. Ink on paper, 64.1 × 48.5 cm. Dodge Collection, ZAM, 01130.

drawing and painting in his inimitable manner until the very end.[16]

Like Fridrihsons, Pauļuks and Pinnis were august, charismatic presences in Rīga's intelligentsia throughout the 1970s and 1980s. The aesthetic values they represented, however, did not age as gracefully, and the pure decorative impulse that was so renegade during the 1950s and 1960s merely proceeded to reaffirm the bourgeois sense of art as an appurtenance to a genteel private life. Their paintings were not, by any stretch of the imagination, catalysts for revolutionary (or counterrevolutionary) consciousness, or even acute self-analysis. They simply recovered a pre-Soviet sense of domestic beauty, and so found their way onto the living room walls of many Rīga apartments.

OFFICIAL NONCONFORMISTS

In a recent essay, David Elliott credits Norton Dodge with popularizing the term *nonconformist art*—or, rather, Elliott discredits Dodge, because to Elliott's mind this word choice, relative to the term *unofficial art*, "gives a more 'dissident,' rebellious, moral spin to the work," apparently an undesirable association because, nowadays, when Elliott toys with labeling a seminal work by Moscow painter Oskar Rabin "Non-Conformist," the designation "looks considerably past its sell-by date."[17] What spoils it for Elliott is that the Rabin still life of a dead fish on pages torn from *Pravda* looks "incredibly conventional and 'conformist'" compared with contemporaneous work by Donald Judd, Robert Ryman, and others. What seems to escape attention, however, is just how closely such artists active in New York in the 1960s conformed to Soviet avant-garde artistic concepts decades beyond *their* sell-by dates: in Judd's and Ryman's cases, productionist and suprematist notions, respectively. If, as Elliott believes, the term *nonconformist* does promote connotations of oblique, coded artistic expression within a hostile, unreceptive cultural environment, he might consider how, in 1966 and a half mile outside of the SoHo gallery where it carpeted the floor, an esteemed Carl Andre metal-slab work would have played to the proletariat, despite Andre's pretension that his work was "communistic because the form is accessible to all men."[18] Alas, validation of artistic worth is no less time- and place-dependent than its vilification; nonconformity is predicated thus even more so.

FIG. 138. Ojārs Ābols, *Populated Area*, 1974. Oil on canvas, 71.5 × 100 cm. Dodge Collection, ZAM, 06185.

Unfortunately, the alternate duality—*official/unofficial*—is not without its own semantic problems. In the case of Latvian art, the painting careers of Džemma Skulme (b. 1925) and Ojārs Ābols demonstrate just how unsatisfactory Elliott's preferred terminology can be. As already mentioned, Ābols vociferously critiqued fellow artists in Latvia's initial days of reckoning with Kremlin standards, while Skulme benefited vocationally from family connections: Her father, Oto Skulme, once an adamant modernist, ameliorated his style under the Soviets to such an extent that he was among the few artists secretly summoned to Stalin's deathbed to render final portraits.[19] Eligible for the finest Socialist Realist training available, these two artists of the next generation forged solid careers for themselves within the artistic establishment with capably painted works that toed ideological lines: Ābols gravitating toward historical revolutionary subjects; Skulme couching her communal spirit in innocuous folk festival scenes that, if their author went unidentified, would warm the hearts of nationalists who, to this day, have not forgiven her for collusion with central authorities. Such incrimination rarely takes into account, however, that high-level access within the Soviet art bureaucracy also put this inquisitive wife-and-husband team in contact with progressive foreign artistic trends and even the occasional celebrity dissident.

In the course of the late 1960s, they took advantage of a certain tacit immunity conferred by their privileged professional status and began formal experimentations that effectively rendered the term *official* meaningless. (To be fair, the greater risks entailed by their enhanced visibility as public figures must also be acknowledged.) Skulme's long-preferred subject of women in ceremonial roles occasioned explorations of painterly technique. Her female forms were variously carved, washed, abraded, and molded into being, and depending on whether the form was that of, say, a classical caryatid or a long-vanished peasant matriarch, the final effect was appropriately one of excavation or evocation. Parallel to his wife's stylistic evolution, Ābols's brushwork loosened to the extent that the pigmentation on his canvases began to suggest figuration beyond the abstracted shapes it was designed to describe. Scumbled, etched paint took on cartographic and geological properties, and the titles of these compositions reflected this new indexical dimension: for instance, *Populated Area* (fig. 138). Although the degree of abstraction increased to a point at which one might mis-

FIG. 139. [TOP] Aleksandrs Zviedris, *Seagull*, 1972. Oil on paper on canvas, 75 × 100 cm. Dodge Collection, ZAM, 11347.

FIG. 140. [BOTTOM] Uldis Zemzaris, *Laughter of the Sun*, 1972. Sanguine over watercolor, gouache, and graphite on paper, 55 × 76 cm. Dodge Collection, ZAM, 11486.

take nonobjectivity as Ābols's achievement, the truly remarkable aspect of his critical exercises in mapping the processes (and tolls) of civilization is that they were made in a paranoid society where accurate maps were classified information. Indeed, the paranoia was such that one beginning artist who enjoyed the professional encouragement of Skulme and Ābols recalls an early job retouching Rīga street maps for book reproduction so that "strategic" railyards, in existence since the 1860s, would disappear before supposedly prying Western eyes.[20]

As it happened, Ābols's and Skulme's greatest contribution to Latvian art, official or otherwise, was their willingness to defend and even encourage nonconformity among other artists. In the late 1960s, Ābols began publishing some of Latvia's first criticism that revealed a fluency with the theoretical stakes in contemporary art. Although this initially served to explicate his recent stylistic conversion, artists who read Ābols's writings against the grain understood them to be a signal that experimentation might well be officially tolerated.[21] Džemma Skulme, for her part, is known to have personally intervened on behalf of certain nonconformist artists. Painter Leonīds Mauriņš (b. 1943) believes that his mother, Lidija Auza (1914–1989), was able to publicly display her extraordinary assemblages and abstract paintings because Skulme, as president of the Artists' Union, defended her radical, tectonic-oriented work before exhibition censors.[22]

Ordinarily, by virtue of her union membership and regular appearance in state-sponsored exhibitions, Auza would have qualified within the general Soviet context as a so-called official artist, but such categorizing characteristics meant relatively little in the Baltics. Auza's work confirms her fully nonconformist status, whether it takes the form of an assisted ready-made in which a child's chalkboard preprinted with the image of a cottage is first raked with local color and then violently consumed by a flame-like swirl of yellow paint troweled onto its roof, or what may be her masterwork, *With the Sun*, a mixed-media tour de force completed in 1971. Starting with an oil painting as a matrix, Auza embedded and encrusted the work with all matter of … matter, resulting in a work of almost impossible heft and optical depth. Like the American artist Jay De-Feo's epic mixed-media work *The Rose (Deathrose)* (1958–64), the sheer muscularity of Auza's *With the Sun* forces reevaluation of any assumptions one might

still entertain about fragility and delicacy as being endemic to women's art. Similarly, Auza's assemblage *Décor* (1969), whose repeat pattern of roses formed by industrial metal shavings embedded in oily impasto was an unsentimental tribute to the flower paintings of Warhol done only five years earlier. Befitting the work's place of origin, the grid bordering Auza's blooms has all the tactile charm of concertina wire, and her muddy palette tempers any pop inclination toward giddiness. Whatever challenge Auza's work posed conventional expectations of floral imagery (or décor, for that matter), Skulme was commensurately challenged justifying *Décor*'s existence to a state censor.

Most older artists exhibiting alongside Auza in the 1960s and 1970s were not so fearlessly experimental, and if they did explore unorthodox ideas, they were typically less willing to expose their results to the public. Aleksandrs Zviedris may have begun his Soviet career with that Stakhanovite-like profusion of industrial landscapes and consolidated his reputation with seascapes, but in a classic, latter-day example of the two-easel phenomenon, he discreetly produced abstract compositions—for example, the 1972 painting *Seagull* (fig. 139)—in which the select private viewer needed to exert considerable imagination to recuperate the figuration intimated by his titles. Figural abstraction wasn't the only liberty taken in the privacy of one's studio. That same year, Uldis Zemzaris (b. 1928), an establishment portraitist renowned more for his meticulous draftsmanship than for his powers of psychological illumination, created a compelling series of surrealist works, including *Laughter of the Sun* (fig. 140), in which his solar subject displayed more emotion than a majority of his officially commissioned sitters. Here the imprint of Estonian surrealist sensibilities is obvious, transmitted to Zemzaris by his longtime friend, Olav Maran.

Notably, Zviedris's abstraction and Zemzaris's surrealism came to the Dodge Collection and, in essence, to light only because the power of conformity kept these atypical works hidden from the public eye throughout the Soviet era. A network of discreet contacts—a historian knew an archivist who knew the artist's family, and so on—brought the potentially troublesome work out of, quite literally, its hiding place. On the other hand, certain nonconformist works, like Skulme's *Night* and Ābols's fully nonobjective *Composition* (figs. 141–43), took up residence in the West

FIG. 141. [TOP] Džemma Skulme, *Night*, 1974. Oil on canvas, 73.5 × 102.5 cm. Dodge Collection, ZAM, 06155.

FIG. 142. [BOTTOM] Ojārs Ābols, *Composition*, 1968. Oil on canvas, 75.5 × 53.5 cm. Dodge Collection, ZAM, 18010.

FIG. 143. Ojārs Ābols, *Processes on the Earth*, 1978.
Oil and collage on canvas, 100.5 × 100 cm.
Dodge Collection, ZAM, 05315.

because their authors cultivated strategic connections with the Soviet government's art export agency and its American representative. Eventually Skulme and Ābols were able to cross political borders in person, accompanying their paintings to exhibitions in the West during the 1980s. Still, these borders were an assiduously Soviet construct, and even someone as well placed as Ojārs Ābols was subjected to harassment from the KGB upon his return from the Venice Biennale in 1982. Intimates of the artist believe that the stress of repeated interrogation exacerbated a cardiac ailment, hastening Ābols's death. Given to gallows humor, one might be tempted to say that the official cause of death was officialdom.

TREASURES OF THE HERMITAGE

Personal strategies of resisting official dictates of artistic style and subject matter varied widely in Soviet-era Latvia. The distance from the Moscow dictators to the Baltic littoral enabled a diversification of tactics, ranging from semantic sophistry when summoned before censorship boards to outright defiance of guidelines, that simply wasn't possible in more proximate art milieux. Unfortunately, this tactical latitude encourages occasional valorizations of Moscow's "underground" scene as somehow more authentically nonconformist than aboveboard developments elsewhere. Yet, depending on the political circumstances in Latvia proper, the visibility of progressive art-making fluctuated year by year, and a few extraordinary talents and intellects deemed it safer to conduct their experimentation in complete obscurity.

Musical conductor Pēteris Ērglis recalls spending a significant portion of his adolescence riding his bicycle to a communal flat in a once-grand *Jugendstil* building on Rīga's Blaumaņa Street, where he would deliver medication and sundries to two elderly sisters, former colleagues of his mother.[23] Already labyrinthine, the flat grew even more congested within the three rooms shared by the pair, who avoided all contact with their flatmates, managing with a makeshift kitchen nestled among heaps of books and artwork. In addition to providing courier service, Ērglis was enlisted to help the women hoist large, weighty homemade tapestries into place on the single exposed expanse of wall. This display rotated as the younger sister,

Elize Atāre (1915–1993), executed the designs of sibling Zenta Logina (1908–1983), both of whom underwrote this enterprise by working as handbag and textile designers. Their latest creation in place, Atāre and Logina would retreat down a narrow passageway cleared through their ceiling-high stacks of chattels and view the tapestry from the opposing wall of the adjacent room, using inverted opera glasses to amplify the distance (which, in reality, was all of six meters). Concerned that their vertiginously abstract compositions based on cosmological motifs would not be exhibited in official venues with enough perspectival vantage to show the tapestries to their intended effect, the women learned to make art by using an optical artifact from the world of high culture in a manner diametrically contrary to its intended use. Indeed, one might say that their own professional recognition receded far into the distance.

Despite appearances, the reclusive sisters were not exactly hermitic, nor were their phenomenally congested environs a symptom of eccentricity or siege mentality. Logina and Atāre inhabited the world more than most of their fellow Latvians—indeed, more than fellow humans the world over—devouring books and newspapers, preferably foreign, and even learning sixteen languages between them in order to follow reportage of key current events in the local languages in which such events transpired. For instance, Ērglis recalls how the Prague Spring occasioned their acquisition of Czech reading skills. The appetite for knowledge was not purely lingual, however, and the sisters compiled a vast collection of clippings bearing visual imagery, morphologically organized into folders titled, for example, "portals" or "trees." Paradoxically, Logina's mature-style paintings, drawings, and sculptures (and Atāre's weavings made to Logina's specifications) were not worldly in concern, except in the astronomical sense (fig. 144). Among the geometric abstractions, planetary motifs are often discernible; less frequently, a disembodied eye or some other incongruous element appears. One is reminded variously of characteristic works by Lithuanian symbolist Mikalojus Čiurlionis (1875–1911) or the Estonian nonconformist Ülo Sooster (1924–1970), between whom Logina fell in both age and artistic mien. Like Čiurlionis, Logina plumbed an allegorical universe available to anyone willing to raise their horizon to celestial heights; like Sooster, the horizon was constantly foreshortened by

FIG. 144. Zenta Logina, (Untitled), n.d. Gouache and oil on paper, 57.3 × 39.5 cm. Dodge Collection, ZAM, 16322.

sociopolitical circumstances, but one's vigilance and self-reliance could breach newly imposed limits.

Logina hadn't always been unwilling to represent mundane surroundings. She began her painting career—more precisely, she had a painting career—in the final days of pre-Soviet Latvia with winsome, classically composed still lifes and landscapes, which were recognized initially by Soviet curators for their technical accomplishment. The honeymoon was over, literally and tragically, when Logina's husband of eight years was arrested by Soviet authorities in 1941, never to return. After her expulsion from the Artists' Union in 1950, ostensibly for "insufficient creative activity that has caused a decline in artistic level,"[24] Logina herself was subject to KGB interrogation for years to come, even after she was readmitted to the Union's less-esteemed, less-privileged decorative arts section. In direct contrast to the defensive behavior of others widowed and harassed by Stalinist oppression, Logina's response was to *begin* producing stylistically forbidden art, rather than destroying art already made that might incur further persecution. In the relative privacy of their three rooms, she and her sister sustained an exercise in abstraction on a magnitude unseen in Latvia before or since. With time, Logina's inventiveness escalated, in both compositional terms and the facture of her pieces. The precise material composition of her "dimensional objects"[25] (a euphemism for sculptural work that recalls Judd's term "specific objects") remains known only to Logina, but the disparate effects are that of epoxy casting, lapidary work, electroplating, and more Arte Povera–style aggregative happenstance.

Whereas Logina's obscurity has been modestly rectified since her death—in 1987, a posthumous exhibition of the cosmos-themed tapestries was attended in twenty-six days by forty thousand visitors, including actual cosmonauts, who expressed amazement at Logina's comprehension of their realm—widespread recognition continues to elude other artists who also worked in seclusion and produced art that has proven to be historically notable. The graphic artist Pēteris Smagiņš (1901–1970) produced hundreds of images detailing the travails of a Latvian Everyman across the volatile, violent landscape of the twentieth century, creating this chronicle even as the threat of state violence against dissenters remained acute. Here one often sees the no-longer-seen: architectural landmarks destroyed by wartime bombing, Siberian deportees,

prewar capitalist advertising erased by Soviet central planners, and even incorporeal entities, such as a ghostly figure of a conscience that hovers in a flamboyant mandala above an issue of *Pravda*, admonishing the reader to listen to a higher truth. Clearly Smagiņš followed his conscience, because he not only addressed taboo political topics in his work before any other visual artist in Soviet Latvia (fig. 145) but also had the temerity to air his discontent. His small exhibitions were routinely closed by the KGB shortly after they opened, but he circumvented the possibility of being totally silenced in 1966 when he presented hundreds of drawings and prints to the American embassy in Moscow, stipulating that they be donated to the inchoate Kennedy presidential library. What scant reputation does exist for Smagiņš is largely the result of advocacy by the historian Jānis Kalnačs,[26] who has championed the neglected work of other "difficult" artists, primarily Kārlis Padegs (1911–1940).

While discretion was increasingly necessary in Smagiņš's later years because his engagement with political topics reached a culmination as the repressive pall of the Brezhnev era settled in, those exploring more formalist concerns in the mid-1960s were able to judge which sorts of work could risk exposure and which still required concealment. Oļģerts Jaunarājs (b. 1907; fig. 146) is paradigmatic in this regard, because overall he was able to create fully abstract compositions on the premise that he was studying natural phenomena such as ice crystals, leaf veining, and the cracquelure of dried mud, but his ability to have such compositions published at the time seemed dependent on their media: Watercolor versions, by virtue of the freer behavior of the pigment, seemed to be argument enough for such abstraction to be included in official surveys of that renascent medium, while such compositions in, say, oil paint were not reproduced, perhaps because oil continued to shoulder the pedagogical onus it bore under Socialist Realism. This dichotomy posed an interesting epistemological dilemma for painters, which may explain why a number of progressive Latvian artists—Fridrihsons immediately comes to mind—did their most challenging work of the 1960s in watercolor, a medium typically deprecated for its association with dilettantes. So while Jaunarājs published watercolor "nature studies," his abstract compositions done in other media remain hidden from public view, and these are precisely his

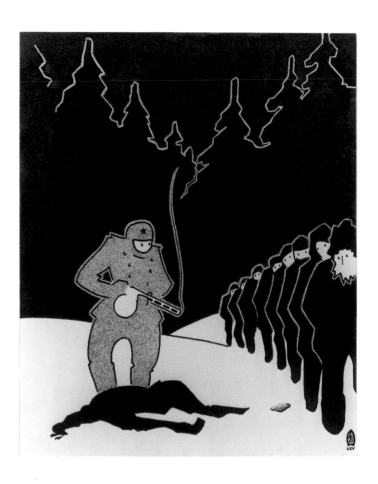

FIG. 145. Pēteris Smagiņš, *Bloody Handed No. 491 (for Solzhenitsyn)*, 1965. Ink on paper, 30.8 × 25.2 cm. Dodge Collection, ZAM, 01321.

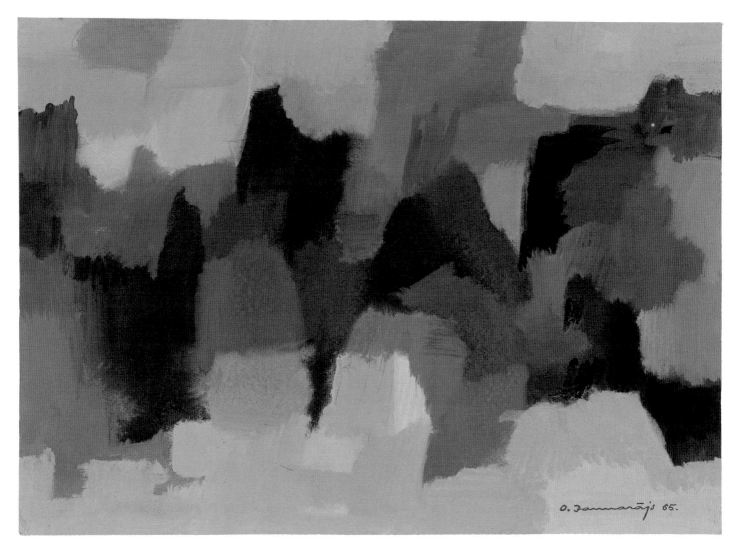

FIG. 146. Oļģerts Jaunarājs, *Silence*, 1965. Tempera on paper,
38.5 × 58.3 cm. Dodge Collection, ZAM, 04760.

most ambitious works. The title alone of his 1964 work *Sorrow* (fig. 147) proves that the painter dispensed with any pretense of depicting the stuff of botany or geology, and instead we are confronted with another material reality: the evocative power of color, the affective force of nonobjective form. The phenomenological exercise supersedes the materialist bracketing, as it were, of officially acceptable subjects, so, understandably, *Sorrow* and similar abstract paintings remained in Jaunarājs's studio, unseen, until the Dodge Collection acquired them twenty-some years later.

The role of private collectors in sustaining or resurrecting the careers of nonconformist artists in the Soviet Union cannot be underestimated, and Latvia's prime example of this symbiotic relationship was the one between painter Georgs Šenbergs (1915–1989) and his dedicated collector Valdemārs Helmanis.[27] Like Jaunarājs and Logina, Šenbergs was not a completely unknown figure in local art circles; also like them, he withheld his finest work from an ill-comprehending public and an even more philistine cultural bureaucracy. His withdrawal from standard art world commerce was foreshadowed in 1937 when he abandoned his training at the academy and, in contradistinction to his fellow students and the modernist generation that taught them, stopped painting in a realist fashion and embraced cubism. This style was transitory, however, and already in the 1940s, after Šenbergs was allowed to return to Rīga from exile in the Arctic, his distinctive manner of figural painting was established. Cursory inspection of a typical Šenbergs work reveals that its seemingly integral forms are, in fact, coaxed into an appearance of solidity through the accretion of minute details, though details not necessarily specific to the aggregative subject. Yet, as with the cubist technique he had abandoned, Šenbergs fused fragmentary elements perceived through time and space to summarize the beheld object, although the temporal aspect was often as attenuated as the twenty years he took to complete individual paintings, and the spatial continuum was something more akin to the composite image one might get if viewing a compressed stack of renderings and alphanumeric texts executed on the sheerest sheets of vellum. He repeatedly expressed admiration for the work of Leonardo da Vinci, and one readily sees the impact in the Latvian's work: It is as if Šenbergs regarded a natural subject from a variety of scholarly disciplines, meticulously recorded his data, weighed it

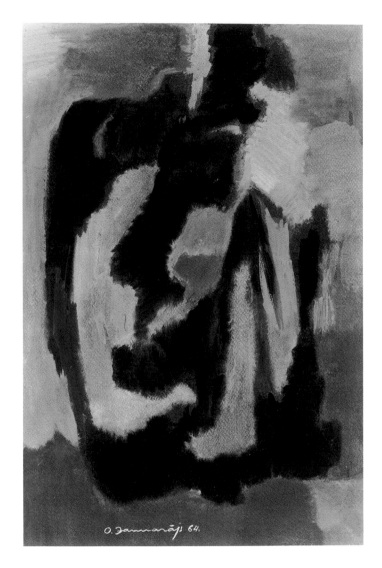

FIG. 147. Oļǵerts Jaunarājs, *Sorrow*, 1964. Tempera on paper, 53.5 × 37 cm. Dodge Collection, ZAM, 01146.

against the findings attained with other methodologies (still visible through the adjacent, translucent pages of a voluminous notebook), and, only after thorough investigation, released the physical proof of his conceptual synthesis. Therefore, one can look at a Šenbergs image of, say, a nude and discover glimpses of other human bodies, vestiges of inanimate objects, arabesques meandering into automatic writing or stuttering into silence, and, once committed to form, this summary mass of description reconfigured by erasure and reiteration. The cumulative effect of a Šenbergs work can be destabilizing and decentering, a portrait of intersubjectivity in extremis (think of Arcimboldo as a schizophrenic), or it can attain all the gravity and substance of a Renaissance composition, though one wonders if his blurred contours are an homage to Leonardo's sfumato or simply the erosion endemic to any palimpsest.

Financially supported by his wife, Beata, Šenbergs could live as an artist without state subsidies and the attendant accommodations (in both the positive and the pejorative sense). Conversely, Beata broached this isolation when she submitted one of her husband's watercolors to an exhibition in 1966, which became his first public exposure.[28] Even so, Šenbergs's public presence was limited thereafter, partly due to a minuscule output curtailed by his intensive, decades-long process of reworking pieces, but mostly attributable to his shyness, which prevented him from attending his only solo exhibition, held in 1987, when public association with his fantastical imagery was not only safe but historically vindicating. Until that retrospective, Šenbergs's celebrity (as it were) derived from works purchased during the 1970s and 1980s by enlightened acquisitions specialists working for Latvian state collections. As gloriously representative as these paintings were of particular portions of Šenbergs's oeuvre (for example, floral still lifes), they did not disclose the full force of his pictorial powers or the breadth of his philosophical outlook. For that perspective, credit goes to Valdemārs Helmanis, who began assiduously collecting the work of Šenbergs before the artist had a following and, for that matter, before Helmanis, because of his youth and unaccountability to cultural authorities, was taken seriously as a collector. By the time of Šenbergs's death in 1989, an extraordinary survey of the artist's career had been assembled, and Helmanis enshrined his holdings in a garret of minimalistic design

in the heart of Rīga. Apropos of paintings that never really seemed to be concluded, the space indicates ongoing interaction with the art it showcases: Flowers, vessels, candles, and incense are arranged before particular paintings with the sensitivity of a *feng shui* master, as dialogically engaged with the canvases as Šenbergs's canvases were engaged with their real-world referents. An adjacent meditation chamber has been ornamented by an artist of the next generation who claims Šenbergs as inspiration in her work. And Helmanis maintains the magnanimity and encyclopedic wisdom to admit just one more critical element to the overall composition—any and all newfound viewers.

SCAPEGOATS

Entertaining hopes of writing a seamless, detailed, chronological narrative of Latvian art-making in the 1970s? Even the initial task of assessing the artistic climate in Rīga, circa 1970, would need to correlate such climatological facts as these: Three sculptors—Aivars Gulbis (b. 1933), Jānis Karlovs (b. 1939), and Juris Mauriņš (1928–1993)—had recently been chastened by authorities for works that were deemed too nationalistic, too expressionistic, and too kinetic, a disjunctive litany of attributes straight out of a Borges novel. Their 1969 group exhibition was summarily closed by officials.[29] In the meantime, a "brigade" of industrial designers headed by Ojārs Ābols[30] was gearing up to outfit the city's Intourist hotel with kinetic sculptures and installations that served well as bearers of both ethno-nationalistic pride and progressive stylistics. In the exhibition hall to be located behind this hotel, Ābols and his wife, paragons of the cultural establishment, would soon be exhibiting expressionistic abstraction. Still elsewhere, one city block away, an out-of-favor middle-aged artist was sequestered in two rooms of her communal flat, painting and sculpting some of the most nuanced, committed investigations of nonobjective art ever to be made in Latvia, works that would not become known until after her death a decade later. Meanwhile, at a nearby gallery, a contemporary of this recluse, a woman with no conspicuous ties to officialdom, would routinely exhibit abstract assemblages that combined paint and industrial detritus. If all these contradictory impulses and reactions became too dizzying to assimilate, the observer could repair to a café a short walk from the hotel, in which

its longtime beatnik regulars snubbed the hippie performance artist and his entourage walking through the door, suspecting that the younger contingent was actually a KGB provocation designed to close the coffeehouse, which had become Rīga's countercultural home base.[31]

From the early 1960s, café *Kaza* (Goat) had been frequented by many of the city's promising young artists and intellectuals. Among the core group of *kazisti* by the end of the decade was painter Biruta Delle (b. 1944), whose only professional promise, so to speak, was a strict one made to herself. In 1967, while a student at the Latvian Academy of Art, Delle stood before classmates at an end-of-semester exhibition as professor Indulis Zariņš critiqued her project, an expressionistic streetscape, with words to the effect, "Your painting is interesting, but a simple *kolkhoznik* [collective farmer] would never understand it." Delle flatly replied, "You're able to say so because you're a *kolkhoznik*." Of course, she was expelled, her works banned from exhibition.[32] A few months later, academician Zariņš would go on to win the Latvian Soviet Socialist Republic State Prize for his painting *Speak*, a panel of the overtly propagandistic triptych *Soldiers of the Revolution*,[33] while Delle would continue to speak her mind as she began organizing a modest alternative to the academy.

Among her students, Delle's studio became known as *Zemūdene*, or Submarine, in honor of the Beatles' ode to a yellow one, which she and her friends heard courtesy of illegal BBC and Radio Luxembourg broadcasts. According to a former student, the most important lesson Delle imparted during their daily painting sessions was to resist the Soviet regime by ignoring its quotidian pressures (for example, proscription of Western radio programs).[34] A formidable task under normal circumstances, this required heroic effort on the part of the *zemūdenieki* because Delle's own husband at the time, Pēteris Kampars, was a KGB informant. But in a situation that would recur throughout Latvian art life of the 1970s and 1980s, this state of surveillance was not exactly an unmitigated evil, for it is believed that Kampars reported relatively minor infractions in order to deflect attention from the studio's graver violations of cultural norms.

Once one sees a painting by Biruta Delle, there is no mistaking her will to work independently of official aesthetic standards. *The King* of 1971, in its use of the grotesque to depict a diminutive head of state, can be read as a deprecation of power, but its primary purpose was to interrogate the despotic power of painting itself. At the time, she was virtually alone among Latvian artists in her embrace of the grotesque, though grotesquerie's effective disturbance of local complacency had clear precedent. During the 1930s, painters Kārlis Padegs and Jānis Tīdemanis (1897–1964) employed ugliness to extravagant, notorious effect. They opposed the vast majority of artists who gravitated toward a *belle peinture* aesthetic, which in subsequent decades became somewhat easy to pass before Soviet censors.

By the 1970s, Latvian art audiences had viewed for years the cruder linearity, harsher palette, and coarsened brushwork of the so-called Severe Style that countered the saccharine qualities typically equated with Socialist Realism.[35] But even this optical severity did not prepare viewers for Delle's work. She and her students recall private exhibitions of *Zemūdene* paintings at which some spectators should more accurately be termed expectorators: The displayed canvases were actually spat upon. Nevertheless, shows continued to be organized, and visitors were determined enough to attend that they even consented to registering their names with state security agents who monitored entrances to Delle's makeshift galleries.[36]

She also painted works that were more conventionally beautiful, but their subjects compensated for this conventionality, provocative in either their topicality (as in *Joan Baez Sings for Peace* [1977]) or their reference to "disreputable" literary sources (whether Decadent, as in *Composition on a Baudelairian Theme* [1967], or divine, as in *Who's Unwanted in the Olive Garden?* [1981]). Toward the end of the 1970s, Delle's works were reproduced in Soviet publications with increasing frequency. But even so, her studio remained ineligible for state-subsidized art materials, which for her were obtainable only through a network of friends who worked as restorers in the Baroque palace of Rundāle near the Latvian-Lithuanian border, another locus of nonconformist activity at that moment.

Part-time restorer at Rundāle and chief conduit of these pilfered supplies, Eižens Valpēteris (b. 1943) was also a *Kaza* regular and, apparently, a cause for official concern. Rather than being caught and denounced for smuggling paints to Delle, however, Valpēteris and his long-haired friends were filmed by a television crew as they left the café; they were later alluded to on the

FIG. 148. Eižens Valpēteris,
(After Saul Steinberg), 1969.
Ink on paper, 18 × 21.3 cm.
Dodge Collection, ZAM, 18389.

evening newscast as drug peddlers.[37] His criminality falsely alleged, Valpēteris felt no compunction about using personal connections to gain illegal access to the restricted holdings of the Academy of Science's Fundamental Library, which included issues of *Studio* and *Vogue* magazines. *Studio*, read in combination with art publications from the more liberalized Eastern bloc countries, inspired Valpēteris's own illustrations and collages, which variously recall modernist, conceptualist, surrealist, pop, and psychedelic sources, together paralleling the hybrid quality of visuals published in the West's alternative press. His homage to American illustrator Saul Steinberg (fig. 148), executed in that American consumer commonplace of ballpoint pen on cheap newsprint, deliberately eschewed the precious qualities of mainstream Soviet-era Latvian graphic work—namely, its exactitude and high finish—as well as its typically stultifying lack of ambiguity.

For its part, *Vogue* taught Latvian beatniks and hippies how to dress fashionably, of course, and even to dance, despite the improbable hermeneutical feat of extrapolating movement from still photographic images. But perhaps most important, *Vogue* communicated to Valpēteris and his peers something of the

nexus of fashion, painting, film, and performance epitomized by Warhol's Factory in New York. Motivated by this phenomenon and galvanized by more proximate events, like the 1971 jazz festival in Tallinn and Rīga's nascent rock music scene (credited as the first in the Soviet Union[38]), a small group of Latvia's hippies began organizing a range of unprecedented subcultural activities: Happenings, jazz jam sessions, private photography exhibits, and underground filmmaking. This circuit was increasingly dominated by Valpēteris's friend, aspiring clothing designer Andris Grinbergs (b. 1946), whose flamboyant public persona served to attract like-minded—which is to say, iconoclastically minded—individuals. Grinbergs was not, by any means, Rīga's only attention-getter. From the previous generation, avuncular painter Jānis Pauļuks crowned himself "*Hipiju karalis*," or king of the hippies, though his association with true hippies was episodic and more or less café- or studio-specific. Also, within the city's cafe society—such as it was, migrating between *Kaza* and the nearby open-air café *Putnu dārzs* (Bird garden)—the young painter Maija Tabaka (b. 1939) held court in eccentric dress and an animated personal affect that were remarkable for the drab, collectivized culture. But Grinbergs remained singular among this

dynamic crowd in his determination to promote new artistic genres, particularly performance-based ones.

Beginning in 1969 with a surreptitious, offbeat staging of *Romeo and Juliet* amid the art moderne sculptural ensembles of Latvia's pre-Soviet national war memorial, Grinbergs and associates progressed from interpretations of classical drama to performance works that sought the fullest integration of life and art. To wit, on August 24, 1972, Grinbergs married Inta Jaunzeme (b. 1955) during Latvia's first Happening, a two-day event titled *The Wedding of Jesus Christ*.[39] Held by the seaside with the participation of a dozen or so poets, artists, and musicians, *The Wedding* made explicit the messianic role that Grinbergs envisioned for himself within a philistine artistic wilderness, while at the same time reveling in conditions of a natural wilderness as only someone appreciative of Latvia's indigenous pagan heritage could. In the following years, Andris and Inta Grinbergi, with a changing cast of collaborators, organized Happenings and Actions that took, as points of departure, subjects as diverse as Līv tribal music, the Baader-Meinhof terrorist gang, medieval sacral mysteries, and Bo Widerberg's contemporaneous film *Elvira Madigan* (fig. 149), all the while integrating such arcana with the stuff of daily living, like the birth of the Grinbergi's son.[40]

The hippies' familiarity with this Swedish film was not as extraordinary as it might sound. At this time, the director of Goskino Latvija, Oleg Rudnev, and the Latvian Cinematographers Union pursued liberal screening and production policies (liberal relative to Moscow-issued guidelines),[41] and Rīga's cinema cognoscenti were able to see current Western features from major studios and independent auteurs alike. The latter, in particular, inspired Grinbergs and several acquaintances to direct their own short experimental films. In a flurry of activity from 1972 to 1973, a half-dozen works were created, the two surviving examples of which are remarkable for their affinity to canonical avant-garde films that were assuredly not screened in the Soviet Union. For example, in *Twilight Plays with Mirror* (1972) by Ivars Skanstiņš (b. 1945), the modernist montage sequences that combine neo-Dadaist newspaper collages by Eižens Valpēteris with highly enigmatic, impeccably composed vignettes of banal human activity recall passages in Man Ray's *Étoile de mer* (1928) and René Clair and Francis Picabia's *Entr'acte* (1924). In opposition to the genteel

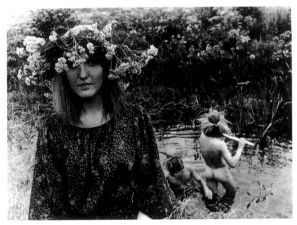

FIG. 149. Andris and Inta Grinbergi, *The Green Wedding*, 1973. Photo documentation by Jānis Kreicbergs. Dodge Collection, ZAM, 20267.

modernism of Skanstiņš's film, and in keeping with his dandiacal persona, Grinbergs made his audacious *Self-Portrait* (1972), recently lauded by experimental film authority Jonas Mekas as "one of the five most sexually transgressive films ever made."[42] This evaluation puts *Self-Portrait* in the superlative company of Jean Gênet's *Un Chant d'amour* (1950) and Kenneth Anger's *Fireworks* (1947), with which it shares a pioneering stake in visibility of the homosexual self and its consequences; Andy Warhol's *Blowjob* (1964), which is equally reticent in recording actual sex; and, most important, Jack Smith's *Flaming Creatures* (1962), an anarchical, carnivalesque film that *Self-Portrait* most closely resembles in style.

As formidable as its sexual provocations are, Grinbergs's film stands as an unrivaled document of unofficial art-making in Soviet Latvia, paradigmatic in both form and history. For example, the film's soundtrack, which commences with a close-up of Grinbergs's face during orgasm, contains a melancholic love poem read by its author, Ināra Eglīte. Seconds in, she flubs her recitation, and we hear Grinbergs stop the tape recorder. In the instant it required for Eglīte to begin again, the tape has slipped past the recording head, leaving a remarkable trace of Cold War cultural history: a tiny, unmistakable fragment of the Jackson Five song "I'll Be There," surreptitiously recorded from a Voice of America radio broadcast in the spirit of *magnetizdat*, the reel-to-reel duplication and dissemination of jazz and rock albums smuggled from the West. As it happened, less than two weeks after completion of the film, KGB agents raided a private photography exhibition held in the Grinbergi apartment, during which the single print of *Self-Portrait* somehow escaped discovery, so Grinbergs cut his work into thirty-some pieces, easier and safer to conceal. Already fragmentary in its sound- and image-editing style, *Self-Portrait* existed for twenty-three years in physical fragments hidden throughout Rīga. Restored in 1996 with the financial support of the U.S. State Department, Norton Dodge, and others, *Self-Portrait* regained an audience precisely at the moment when general audiences began forgetting the magnitude of risk taken by nonconformist artists. For Latvia's other hippie-directors, who either destroyed their works for fear of discovery or had films confiscated and destroyed, there was to be no equivalent expiation.

Overall, however, recent years have seen a heartening recovery of the art created by café *Kaza* alumni, even within an exhibition that reconstructed *Kaza*'s interior, filling it with artwork that never decorated the original's walls for fear of drawing official attention and reprisal.[43] Among the artists reappearing after decades of obscurity are photographer Zenta Dzividzinska (b. 1944) and her husband, the autodidact painter Juris Tīfentāls (b. 1943). Like their contemporary Delle, they made no concessions to conventional notions of beauty in their work. In Tīfentāls's paintings from the 1970s, the forms of still-life objects, portrait heads, and landscape features emerge from dark, primordial backgrounds, awkwardly scumbled into being. Reminiscent of Georges Roualt (or, closer to home, Jānis Tīdemanis), these works underscore Tīfentāls's belief that painting is a "sacral act of creating from nothing…. Not a thing from my paintings has ever existed, and any resemblance [to] real objects is coincidental."[44] That self-portraits feature prominently among his limited and little-known output renders this statement both self-effacing and illustrative of the alterity conferred upon him. A similar modesty permeates the photography of Dzividzinska, in which overweight, undercoiffed women circulate through daily routines, oblivious to codified feminine glamour and, even more satisfying, to any sense that their plainness should somehow compromise their happiness, gratification, and self-worth. Dzividzinska's compositions are as cheerfully disheveled as her breast-feeding, sunbathing subjects. A notable exception to this casual assembly is her image *Stone Woman II* (fig. 150), in which an ancient sculpture of a female figure bisects the background so that an armored tank is seen to oppose small, damaged figures of kindred sculptures. Taken in the aftermath of the Prague Spring, whose suppression severely demoralized *Kaza*'s habitués, Dzividzinska's image of a fertility figure amid sprouting weeds bespeaks a faith that even brutal scapegoating can be overcome with time. Publicly displayed only last year, *Stone Woman II* argues that choices an artist makes under adversity might hasten that process of overcoming.

SKIRTING THE ISSUE

To speak only of underground activity is to misrepresent the ways in which a majority of Latvian artists resisted conforming to official expectations during the

1970s. Indeed, in terms of conformity, official levels of expectation per se in Latvia would have disappointed officials almost anywhere else in the empire. Even during periods of heightened cultural repression in the previous two decades, a significant number of scholars and artists who had received training and formed their philosophical outlook during Latvia's first period of independence discreetly pursued goals that predated and countered Kremlin policy. When these mid-career professionals attained positions of responsibility within the academy and museums during Brezhnev's tenure, these goals became more or less institutionalized—though always on an informal, tacit basis. A text might bear an epigraph from a Stalin Prize winner, only to illustrate abstract art a chapter later;[45] a professor might quote Leninist maxims about culture and, in the next breath, explain Cézanniste painting techniques or approve a thesis devoted to Klee; and an acquisitions committee might purchase a modernistic sculpture to sit in the storeroom next to its wealth of Leniniana, awaiting the day when it might be exhibited without interference.[46]

There also were unflappable, unassailable artists like Boriss Bērziņš (b. 1930), who evolved irrespective of regime, whether a totalitarian political one or the style-driven market one that followed. Bērziņš worked openly without accepting public commissions that palliated social reality, and his personal integrity, along with that of his art, exerted tremendous effect on younger artists. With Bērziņš, one can observe from early on a drive to essentialize the means and content of painting, though his own process of purification did not follow the sort of teleological progression Latvia-born American critic Clement Greenberg had, years before, divined in the work of the New York School and envisioned for everyone else. Instead, Bērziņš's process was more dialectical: Compositional interest was continually reformulated as economies of stylistic means and figural content shrank and grew in direct, sometimes inverse, relation to each other.

For example, his 1965 still life *Skirt* (fig. 151) seems to be simply that: a stilled skirt—or perhaps less: the shadow of a skirt. Its palette is reduced to the degree that color's capacity to model form is as collapsed as the empty skirt itself. Here one witnesses the modernist affirmation of the flat picture plane and materiality of the medium, both at the expense of illusion and allegory. Yet in this reduced form, the *object's* interest

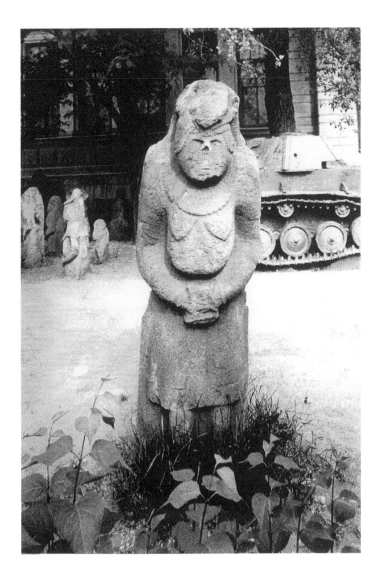

FIG. 150. Zenta Dzividzinska, *Stone Woman II*, 1968. Black-and-white photograph, 29.8 × 24 cm. Dodge Collection, ZAM, 20984.

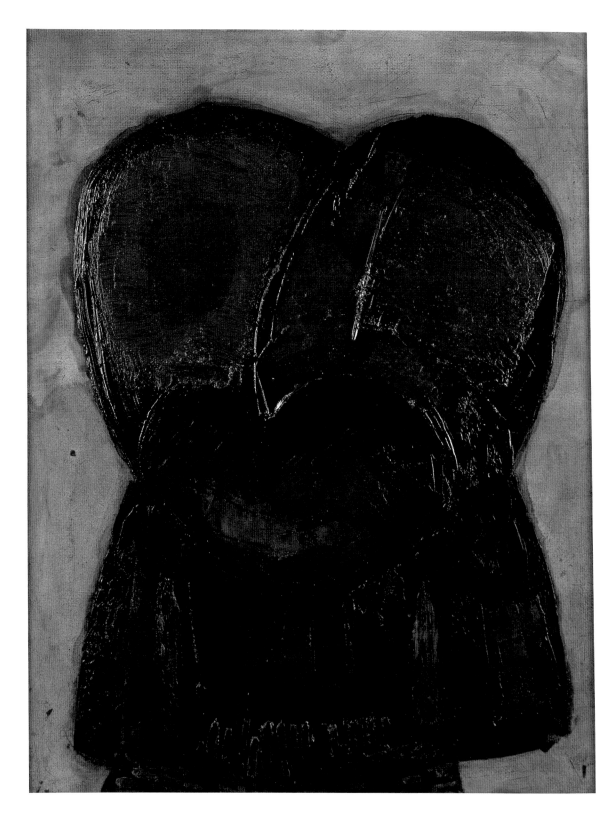

FIG. 151. Boriss Bērziņš, *Skirt*, 1965. Oil on panel,
70 × 54.5 cm. Dodge Collection, ZAM, 18014.

rebounds. Though the garment is conspicuously isolated within the small composition, its meaning expands beyond metaphorical, beyond metaphysical, to meta-textual proportions. One only needs to recall the sequential generations of meaning that accrued out of van Gogh's similarly provident still life, *A Pair of Shoes*, (1887), to understand how this is possible. Originally a synecdoche for the harsh peasant life directly observed by van Gogh, his painting then served as a paradigm of modernism in Heidegger's *Der Ursprung des Kunstwerkes*, wherein the shoes, by virtue of being "equipment," were shown to function in a way analogous to the functioning of paint and canvas (that is, their contingency within history and the social realm conferred meaning well beyond their base materiality). Derrida then checked in with a Freudian gloss on Heidegger's reading, which determined the shoes to be a "heterosexual" pair, "which allows neither for perversion nor for fetishization." Finally, Fredric Jameson, who retraced this interpretive line, brought a much later painting, Warhol's wholly fetishistic *Diamond Dust Shoes* (1980), to bear on the matter, and just as the meaning of the Warhol work is conditioned by its Dutch precedent, van Gogh's work is retroactively informed by the glittery pop confection.[47]

Similarly, *Skirt* participates in a universe of signification wholly autonomous from the Soviet context in which it was created. Most immediately, the image bears iconographic meaning within Bērziņš's own oeuvre, which includes a number of still lifes of doffed skirts, counterparts to another favored motif of the time: backsides of corpulent women (fig. 152), often seated on what appears to be the same ladderback chair used to hang some of these skirts. Perhaps the skirt painting's refusal to participate in the genre of the female nude—a genre which occasioned the skirt to be abandoned on the studio chair in the first place?—causes this work to signify differently than most still lifes made in the Soviet Union (which derived certain meaning from their refusal to participate in the ideological work of history *panneaux*, portraits of Heroes of Labor, and so forth). On the other hand, the skirt could be said to function synecdochically for the nude, so perhaps it isn't really a still life after all. In yet another reversal, the argument can be made that Bērziņš's peculiarly inert, tumescent backside images cleave to the still-life genre, *not* that of the nude. Having established this rich state of ambivalence, the artist

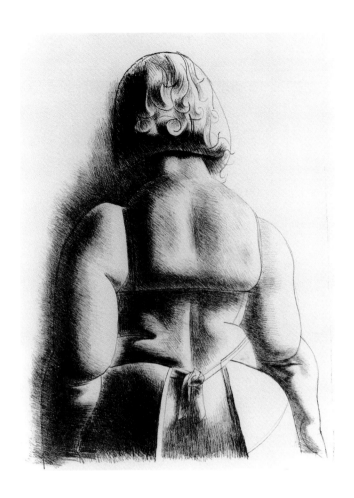

FIG. 152. Boriss Bērziņš, (Untitled), 1978. Lithograph, 69.5 × 53.9 cm. Dodge Collection, ZAM, 00116.

so clearly sets other problems for himself to solve that one senses that circumvention of Soviet aesthetic strictures was hardly central to his painting experience.

While *Skirt* serves as a belated, dislocated paradigm of modernist painting—surrendering to the flatness of the picture plane, exalting the medium, and so on, but years and miles away from Greenberg's epitome—it also nudges painting toward a state of postmodernity by reasserting figuration, but figuration expressed in the vocabulary of pure abstraction. In many other works from the late 1960s and 1970s, Bērziņš affected the compressed space and visual data of Synthetic Cubism with monochromatic compositions filled with flattened yet mostly integral forms of various objects: bathers in a sauna, butchered pigs, farm women, cooking implements, and so on. As much as these works evoke the waning phase of Latvian avant-garde activity in the late 1920s and early 1930s, the most severe examples of his compressive operation also resonate with contemporaneous Western artwork: say, Richard Chamberlain's crushed automobile sculptures or, in a similarly sartorial vein (but from a different vision of female subjectivity), the folded and framed leather jacket in Mary Kelly's psychoanalytic excursus, *Menacé*, from the 1984–85 series *Interim, Part I: Corpus*. The resemblance between Kelly's flattened jacket and the flattened skirts of Bērziņš is more than morphological, however. For each artist, the process of flattening transforms the object-in-the-world into a matrix for bearing text, critical for Kelly given the Lacanian underpinnings of her work; for Bērziņš, it was an opportunity to supply his works with resolutely nontheoretical (though thoroughly conceptualist) exegeses. Bērziņš often writes upon the flattened forms within his still lifes: inventories, identifications, and instructions that function sometimes as wordplay and sometimes as purely visual elements. (Interesting in light of wordplay, the Latvian word for skirt, *svārki*, is also the word for a man's jacket; if one was unaware that Bērziņš returns frequently to the skirt motif, in this particular painting, titled *Svārki* in the original, the garment's identity—and the gender of its wearer—would remain nicely ambiguous.)

As often as Bērziņš grounds his works with tectonic material concerns, haptic spatial investigations, and textual tetherings to a physical world beyond the frame, other paintings appear evanescent, threatening to dematerialize before our very eyes. In a Heideggerian sense, the visibility of these sublime geometric compositions of golds, yellows, grays, greens, and browns is wholly contingent on the history of painting, and not just the Latvian landscape tradition invariably invoked in parochial literature about Bērziņš. Whether the transcendental backgrounds of Orthodox icons, the ethereal foregrounds of color field painting, or the shifting ground of a cubist monochrome, it is, figuratively speaking, all about groundedness. His earthy colors often inspire panegyrics from local historians, who see their native landscape in microcosm and then sanctify the mineral pigments as something akin to holy soil. But insofar as even his most minimalistic compositions remain expositions on figure and ground, or image and frame, Bērziņš shows no inclination to be a priest performing sacraments, but only a painter—and a painter whose wit never succumbs to the self-seriousness of Painting, as evident in the title of his seriously beautiful, seriously clever *Still Life with a Low-Quality Rabbit Skin* of 1983.[48]

Bērziņš is commonly considered the *ne plus ultra* of contemporary Latvian easel painting, but Henrihs Vorkals (b. 1946) is his worthiest successor in terms of refined humor, incisive draftsmanship, meticulous color sense, and, most important, an implacable heuristic impulse that generates suites of paintings that tend to answer formal questions with further, harder questions. The fact that Vorkals began conducting these interrogations in the early 1970s in watercolor indicates the high degree to which the medium had developed in Latvia during the previous ten years, and Vorkals expanded this evolution in a distinctly conceptualist vein. Watercolor had been an instrument of abstraction for others, whereas in Vorkals's hands it became a vehicle for figural illustration of abstract thought. His 1974 work *Morning*, for example, is less a description of a time of day than an expression of incipience. Instead of producing foggy atmospheric effect, the milky passages of white define absence waiting to be filled, and the faint geometric notations on this obscured field indicate paths for future elaboration. Minimalist aesthetics inform this work to an extent rarely seen in Soviet-era Latvia (only Ilmārs Blumbergs provided company at this juncture, but his investigations were three-dimensional), and this is evident both in the austere appearance of Vorkals's paint-

ings and in the procedural clarity that regulates the presence of compositional elements and subordinates them to an almost mathematical or grammatical logic.

Another work from the 1970s, *The Golden Mean* (fig. 153), takes as its central motif a well-known photograph of Lenin's childhood family. The young Vladimir Ilich is extracted from the group of sitters within the sepia lozenge in almost the same way figures disappeared from retouched photographic group portraits during the Purges, except that the iconological dislocation performed on the unimpeachable Lenin is that of a Transfiguration: To the side of what had been the Son, the grown Father of the Revolution assumes the immediately recognizable form of a propaganda medallion. The Holy Spirit, one might say, is manifested in the superimposed algebraic notation for the Golden Mean, which emphasizes some supposed natural, harmonic order in extrapolating Lenin from the personal realm to the ceremonial. At the same time, Vorkals exposes the formulaic nature of Soviet political representation, as well as the process of reification that ideologists jump-started when they modeled commissioned representations of Soviet leaders on religious icons. As deliberate as this critique may appear, Vorkals would object to any consideration of this work as *Gedenkenmalerie*, or even a conscious deconstruction of *Gedenkenmalerie*'s programmatic political task.[49] Instead, he would maintain that the specific imagery in *The Golden Mean* is incidental to the pictorial operations, which methodically trace a multiplicity of optical effects and their associated meanings. The proportional relation of AB to BC begets BC's relation to AC; the aureate appearance of a family photo begets an iconic image; visual identification of personages begets a literary history; and so on. While all of this should, in accordance with the Golden Mean, conspire toward some higher principle, Vorkals grounds it all within the sensible confines of a sensuously painted object, all the more striking for its laconic attitude toward the subject. Like Bērziņš, he is too serious a painter to be bothered with the vicissitudes of cultural politics.

FRESH PROVINCIAL

As often as Baltic critics and scholars like to underscore the problems and opportunities of existing on the periphery of empires, we ignore the fact that within Latvia proper, the dynamic of center (Rīga) versus periphery (the outlying provinces) determined the visibility and working conditions of certain artists, not always equitably.[50] This has been true in Estonia and Lithuania as well, though both countries possess a pair of urban cultural centers, complicating this intradynamic still further. Granted, societies in which most city dwellers traditionally have had easy recourse to the countryside—usually the farmstead whence their families migrated a generation or two earlier—tend not to be overly dismissive of cultural phenomena occurring outside the city limits. Still, artists living beyond the concrete monoliths of the suburban *mikrorajons* of Rīga and the other major Baltic urban centers experienced benefits and disadvantages specifically due to location.

Among the benefits was diminished surveillance by republican authorities, which enabled a painter like Leonīds Āriņš (1907–1991), living in the small town of Tukums, to delve into various modernist paradigms and test their aesthetic propositions within his own work. Āriņš is notable among Latvian artists for his egalitarian consideration of styles, freely applying techniques of fauvism, cubism, expressionism, and so on to his paintings, often switching his chosen influence from one canvas to the next. Before the war, his eager, appropriative behavior drew the wrath of professors at the academy, several of whom, it must be admitted, had passed through an identical phase only ten years earlier. For Āriņš, however, it wasn't phasic. That these various stylistic models appealed equally to Āriņš throughout his life may be explained by the fact that, already in the 1930s, he had amassed a broad-based art collection that formed the basis of the first Latvian provincial art museum, founded in Tukums in 1936. His prewar enterprise raises two points: First, and most obvious, any museum that can boast the quality and range of modernist work existing in the Tukums collection can be called "provincial" only in terms of setting. Second, the need for alternative, decentralized exhibition venues existed well before Soviet ideology hindered the showing of advanced art, although during the Brezhnev era it was often the rural workers' clubs and cultural centers—usually no more cultured than a room furnished with a piano, some chairs, and the requisite revolutionary leader's portrait—whose

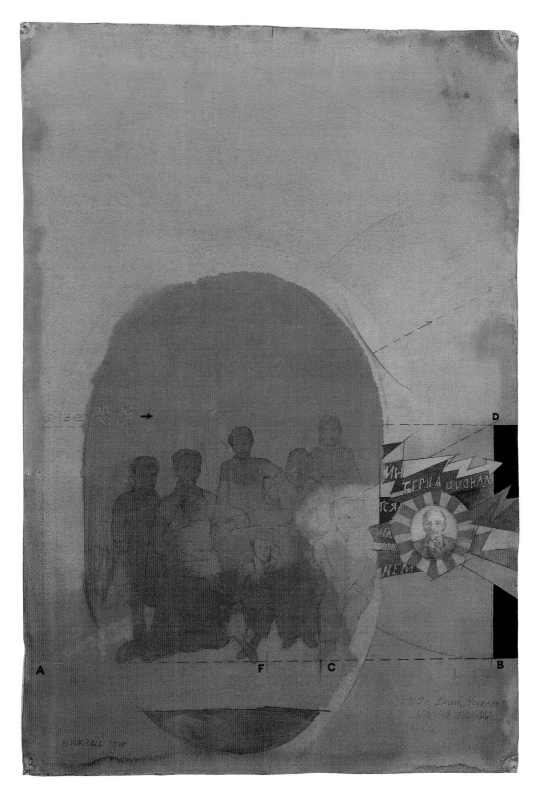

FIG. 153. Henrihs Vorkals, *The Golden Mean*, 1978.
Watercolor, ink, and graphite on paper, 64.8 × 44.6 cm.
Dodge Collection, ZAM, 11479.

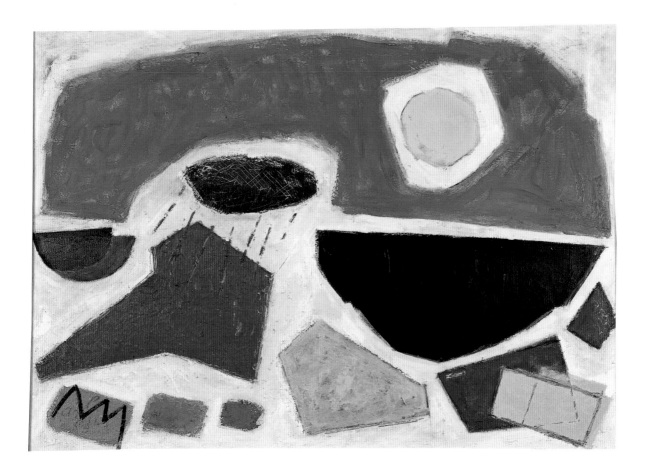

FIG. 154. Leonīds Āriņš, *Still Life*, 1983. Oil on canvas, 69.5 × 99 cm. Dodge Collection, ZAM, 16873.

sympathetic (or oblivious) administrators gave experimental artists use of their premises for brief, unadvertised exhibitions that proved crucial to a sense of solidarity among the nonconformists.

As were many of the personalities already mentioned, Āriņš was ousted from the Artists' Union during the 1950s witch-hunt, ostensibly for "passivity."[51] This alleged passivity had no impact whatsoever on his experimentation. By the 1960s, he had established cycles of recurring subjects: intimate studio interiors, sky and field formations, and townscapes in which buildings fused with the natural world, à la Braque's protocubist L'Estaque images. In his 1964 painting *Furrows*, the title is our sole indication that the vibrant orange hatching superimposed on a multihued patchwork pattern is representational. Even so, color is virtually liberated from any descriptive obligation in the natu-

ralistic sense, and the athletic brushwork almost leads us to believe that Āriņš titled the work after his painting technique, not the agricultural subject. Perhaps because from the start his production was heterogeneous at any given moment, there is a certain constancy throughout his oeuvre: simple geometric shapes, an exuberant palette, and a preference for flat local color, all of which tend to belie the works' subtle compositional structures. These characteristics remain very much evident in the 1983 painting, *Still Life* (fig. 154). The playful color assignment and seemingly random patterning might insinuate that Āriņš treats his subject casually, but the pictorial restraint he exercises here makes most contemporaneous examples of this genre appear almost desultory. Unlike other Latvian artists his age, Āriņš displayed no symptoms of *horror vacuii*, opting instead for the essentializing abstraction of late

FIG. 155. Miķelis Golts,
Sea Rhythms, 1979.
Mixed media on canvas,
111.3 × 120.5 cm. Dodge
Collection, ZAM, 06236.

Picasso or, particularly in *Still Life*'s lower register, the transcendent simplicity of suprematism.

Working at an even further remove from Rīga, Liepaja-based painter Miķelis Golts (b. 1922) matured into Latvia's exclusive action painter. Tachiste dripping and spattering had debuted much earlier in the work of Jānis Pauļuks and Rita Valnere (b. 1929), but after this technique was incorporated within daring, innovative canvases of the late 1950s—where it existed in exquisite tension with figural brushwork, almost as a witty analogy to the officials' struggle against abstractionism in the larger cultural sphere—continued use of the spatter technique throughout the 1960s, particularly by Pauļuks, appeared increasingly gratuitous (constituting, one might say, enfeebled gesture painting). A full decade later, Miķelis Golts managed to recover the radical impetus of Jackson Pollock's action-painting method in works like *Sea Rhythms* of 1979

(fig. 155). The poured, puddled pigment fills the entire visual field, though in Golts's case, the field is a fraction of the size typically marshalled by Pollock, and the physiological (ergo, phenomenological) impact is proportionately smaller. Golts's palette as well is severely restricted in comparison to Pollock's, and one wonders whether this reduction of color and scale is the result of studying abstract expressionism through poor-quality reproductions—a distinct downside to provincial life—or a deliberate constriction, akin to Lidija Auza's sober pop art homage to Warhol's high-chroma originals, which she had the opportunity to see while visiting the United States. If Golts consciously curtailed his coloristic effects, then *Sea Rhythm*'s similarity to Unistic works of the 1920s by the Polish avant-gardist Władysław Strzemiński should be noted, if only to suggest that the venerable East European fascination with painting's facture (*faktura*) may be the most salient fea-

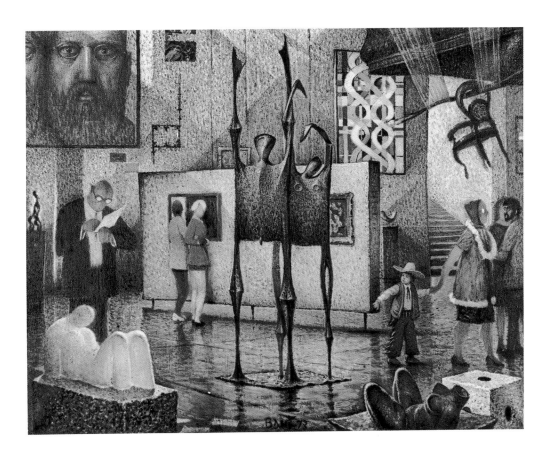

FIG. 156. Auseklis Bauškenieks, *Memories of Some Exhibition*, 1973. Oil on canvas, 73 × 92.5 cm. Dodge Collection, ZAM, 16868.

ture of Golts's paintings.[52] In either case, one can argue that his fully abstract composition is nevertheless representational of a marine subject, as with the Pollock exemplar *Full Fathom Five* (1947). Media mix and accumulate on the canvas like flotsam and jetsam, with analogous force, accident, and gravity. Still, in this and other works of the time (such as *The Forest in Winter* [1979], also in the Dodge Collection), Golts retreats to the semantic refuge of a representational title, a strategy altogether common for that less than liberal cultural environment.

MIRROR STAGE

In 1973, Auseklis Bauškenieks (b. 1910) painted *Memories of Some Exhibition* (fig. 156), and despite its oblique titling, the work is a detailed recollection of a specific gallery experience that had figured recently

and significantly in the artist's life. Permitted by authorities to travel to the United States in order to visit his elderly sister, Bauškenieks spent several weeks in the Minneapolis area, where he was able to attend exhibitions at the Walker Art Center.[53] Though the venue's interior is recognizable, the painting is less a record of the installation of a particular show in a particular institution than an amalgam of a retired drawing teacher's inexact impressions: of contemporary artworks, naturally, but also of contemporary gallery-goers and even of a certain contemporaneity existing between the American and Baltic art worlds. A good deal of the work's interest lies in this refractory dynamic, particularly the tension between what seems to be factually remembered and what naïveté or bias has supplied in place of fact. For example, although the Walker displays minimalistic objects like Tony Smith's *Die* (1962) or oversized pop objects by Claes Olden-

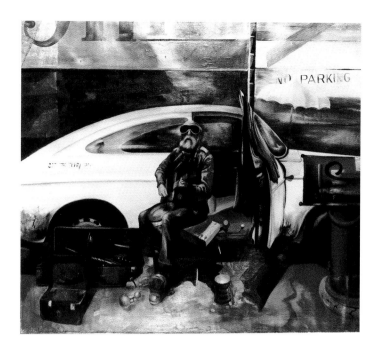

FIG. 157. Juris Zvirbulis, *Street Musician*, 1978. Oil on canvas, 105 × 119.5 cm. Dodge Collection, ZAM, 01183.

burg, it's hard to imagine that Bauškenieks actually saw the oversized die he depicts in the lower right-hand corner. Or, when Chuck Close's monumental portraits have been exhibited, they certainly weren't hung, like Orthodox icons, in the uppermost corner of the gallery space. While a degree of whimsical invention is characteristic of Bauškenieks's work in general—here most obvious in the child dressed in ur–American cowboy clothing—the whimsy of transcultural apprehension (or misapprehension) becomes his most serious and interesting content.[54]

Writing in the early 1990s in reference to Western fascination with the political upheavals then erupting in Eastern Europe, Slovene philosopher Slavoj Žižek posited a psychoanalytic basis for this interest: It was fundamentally narcissistic insofar as emergent democratic processes in the East reaffirmed what was quintessential about the West's self-identity, even if —or rather, because—the realization of democracy at home was flawed, incomplete, fragmentary. In effect, this East European theatrical performance was cheered on because, framed and estranged as it was as a media spectacle, it nonetheless appeared more real than what the West was experiencing for itself.[55] Of course, Žižek is implying a similarity between the West's desire for philosophical integrity and the Lacanian theory of an infant's so-called "mirror-stage" of subject development: the reassuring identification with her image reflected in a mirror, appearing as it does more integrated and whole than the distracting, conflicting sensations she actually experiences within her uncontrollable, uncoordinated body. Something of this reassurance is present in our reception of the Bauškenieks work. The pleasure of seeing a composite image of modern American culture projected back at us is undeniable, even if it doesn't exactly correspond to what we have experienced. Perhaps most validating is the realization that we've been scrutinized by sympathetic, even desirous, observers.[56]

The recurrence of Western mass-cultural imagery in Latvian painting during a period when things Western were actively maligned by Soviet authorities is significant, even if not necessarily symptomatic of subject formation on the national scale. Its interpretation can be equally significant. Just as scholars of East European art must police inflections of orientalism in the historical literature published in the West—to be fair, some of the Slavophilic culture it interprets, such as

Russian neo-primitivist painting, encouraged notions of exotic Otherness—the occidentalism that appears in East European art also deserves nuanced analysis. Of course, Latvian artists' motivation for representing Western culture during the Cold War era varied from individual to individual, and from individual work to individual work. Even case-specific analysis becomes difficult when considering representations like the 1974 painting *Cry* by Jānis Andris Osis (b. 1943), a lurid pastiche of Vietnam-era Americana produced unexpectedly by an artist who hadn't previously addressed popular culture. A tondo portrait of a bra-less Jane Fonda, wearing a mini-dress and pontificating before a microphone, is set against a background of urban disorder: An African-American riot cop in jackboots and full body armor stands on a trash-strewn sidewalk before a shop window featuring mannequins in hot pants, bikini tops, and green and purple Afro wigs. Is this work an indictment of America's civil unrest and the foreign policy that created "Hanoi Jane"? Or is it a lovingly detailed editorial spread on Western street fashion? Can it perform both functions simultaneously?

The likelihood that equivocal social messages reside in Latvian representations of Western culture is greater when these representations include more contextualizing detail, as in *Cry* or in Juris Zvirbulis's *Street Musician* (fig. 157) from his cycle "America—78," painted after a visit to San Francisco. The potential for equivocation is evident in the title alone, which editors of one painting survey of the time "clarified" as *War Veteran's Song*, perhaps to counter any romanticized interpretations of the American busker's sidewalk performance from the doorway of his VW.[57] The imagery itself, however, refrains from editorializing, and this is usually the case in such representations from this era. This holds true for even Latvian painting's most sensational and dramatic—in reverberative effect: most sensual and traumatic—juxtaposition of worlds, Aleksandrs Stankēvičs's 1971 diptych titled *Door*. The left-hand panel features a dapper black male, standing atop a sidewalk grate, playing a saxophone whose mechanical parts have morphed and multiplied into a veritable atomic reactor's control panel. Below this erect life-sized image with its riveted steel background, starred-and-striped and sealed with eagle medallions, is a predella vignette of tangled, battered forms: most conspicuously, a transistor radio, a

soldier's helmet, and the number 13. The right-hand panel positions a fair-skinned woman, in contrapposto supporting a child, against an amorphous background that sports a faint poster of Che Guevara; its predella features orderly stacked books, a pristine sheet of paper, and a glass of water. As dichotomous as the respective groupings of objects are, as binary as the principal figures seem (male/female, black/white, solitary/family, rigid/relaxed), and as divergent as the two panels are treated stylistically (pop-influenced versus naturalistic), the overall composition effects something of a rapprochement. The title, after all, is *Door*. Yet when *Door* was shown in Moscow as part of a pan-Baltic exhibition in 1973, it polarized critical reactions more than any other work,[58] suggesting that ambiguously presented imagery of the West was so atypical in Soviet visual culture of the Brezhnev era that viewers were unprepared for expressions of cultural relativism. (Accordingly, an early work by Stankēvičs, *Two* [fig. 158], most likely became available to the Dodge Collection because its image of mirror opposites in a process of mediation, the outcome equivocal, had little application or resonance in its native environment.)

No less laconic in presentation, but also less likely to engender unsympathetic reactions among viewers accustomed to official painting's moralistic commentary, still lifes began appearing in the late 1960s that prominently featured Western consumer goods: for instance, a pair of Converse high-top basketball shoes, a splayed soft-porn magazine, or a stack of canned goods that Soviet shoppers had little chance of actually seeing together on store shelves, much less in their kitchens.[59] Susceptible as this phenomenon might be to charges of commodity fetishism, there's also the possibility that the painters of these images were critically addressing more complicated material-culture issues. Because the well-worn athletic sneakers are dropped on a copy of *Harper's Bazaar*, whose cover text promises fashion news from Paris, Italy, Spain, and the United States, one could posit a confrontation between regimes of taste, neither of which was readily available to the typical Soviet consumer, unless supplied by visiting émigré relatives (who understood these very items to be highly convertible gifts). The painting's surface is conspicuously crazed, and if intentional, the cracquelure would seem to underscore fashion's evanescence. The still life composed of canned goods may also address transitory states, and

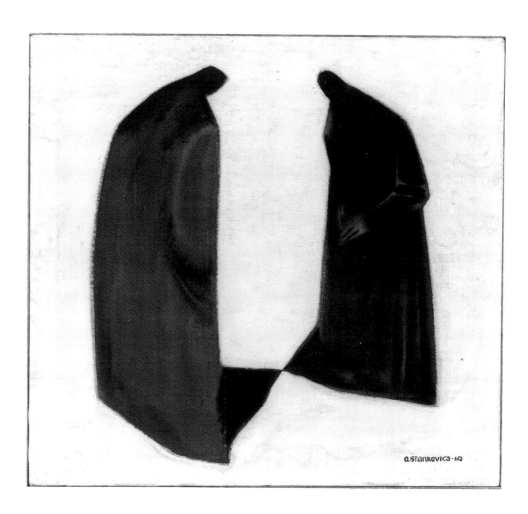

FIG. 158. Aleksandrs Stankēvičs, *Two*, 1960. Oil on linen, 51.8 × 56 cm. Dodge Collection, ZAM, 10799.

not only those deferred by pasteurization or chemical preservatives: Similar to seventeenth-century Dutch floral still lifes that combined, within a single vase, botanical specimens that never naturally coexisted in site or season, one work by Imants Lancmanis (b. 1941) pictures the coexistence of lemon, mango, orange, and tamarind juices (all sporting Western labels) alongside onions and a flour sifter in a Latvian pantry. Is this a vision of culinary utopia, documentation of treasures from a recent trip abroad, or a portrait of material privilege among the Soviet *nomenklatura*?

Even without understanding exactly why Second World artists included particular items of First World ephemera in these still lifes—whether it was a claim on material status, a display of exoticism (not so unlike *japonisme* in nineteenth-century French painting), or a show of resistance to local privation and/or taste—we can safely say that their decision to picture Otherness

in an era when the Other was officially disparaged constitutes yet another form of unofficial art-making.

A KODAK MOMENT

Sometimes visual recollection of an event sharpens with the aid of even the most out-of-focus, underexposed, poorly framed photograph, just as a candid shot, with its accidental cropping and blurring, can supply a more accurate representation of a subject than a carefully composed image of the same. Although such antilogies are so common within modern visual cultures as to be banal, the deeper implications of "snapshot aesthetics" for a society weaned on omnipresent, all-too-obvious realist imagery, whether on murals, banners, paintings, or magazine spreads, were understood by certain Baltic artists who came of age in the early 1970s. Critic Ekaterina Dyogot put it another way in

her explanation of how Russian photorealist painter Semyon Faibisovich, with his metro-riding, sunbathing, sidewalk-standing anonymous subjects, secured "genuine" reality against the false "totalitarian 'viewpoint of the majority' " (that is, the clichéd realist imagery of propaganda):

> The paradox … is that under the Soviet system this personal point of view can only be achieved by technical means: an individual sees the world not through an ideological film but through the lens of a photographic camera. Thus, he or she is left facing the world alone.… [T]herefore, the 'objective nature' of a picture is not only an aesthetic criterion, but a moral one as well.[60]

Perhaps it was not coincidental, then, that hyperrealism emerged within Baltic art (whence it rapidly spread throughout the Soviet Union) at roughly the moment realist painting was retired as the privileged idiom of Soviet visual propaganda and Brezhnev's regime began masking its domestic entropy with superficially dynamic posterized images of cosmonauts, athletes, and the like, abstracted into angular, overlapping shapes of flat color.[61] As stylization and abstraction were co-opted by officialdom (however predictably), younger artists felt it incumbent upon themselves to reclaim realism from the system, and the "objectivity" of meticulously replicated photographic effects appeared in pieces by nonconformist painters.

In Latvia, this work was initially undertaken by Imants Lancmanis and Bruno Vasiļevskis (1939–1990), key personalities in a small gathering of independent-minded student painters who became known, first within the academy and then in the broader cultural community, as the "French Group."[62] Mentor-figure of this now-legendary circle, Lancmanis displayed the earliest interest in hyperrealism and was the first to effect its unblinking gaze. In *Rīga: Suvarov Street* of 1971 (fig. 159), he records a random instant on a downtown avenue, and though the vantage is obviously one determined by an adult human eye, details of human countenances are weighted no more favorably, no more anthropocentrically, than those of the surrounding architecture. The optical qualities Lancmanis emphasizes are those attainable only with a camera: Depth of field is fixed, captured motion is blurred, and light erases detail almost as often as illuminating it. Never before had a Latvian painting been so seem-

ingly dispassionate about its contents, so guileless about presentation. However, the exquisitely balanced composition betrays this apparent lack of engagement, just as the pedestrians' palpable lack of engagement serves to underscore the artist's acute intellectual investment in the nature of optical experience.[63]

If *Suvarov Street* cleaves to the terse urban-scape variant of photorealism epitomized by Richard Estes (though wholly devoid of its capitalist sheen), the work of Bruno Vasiļevskis tends to recall the symbolic still lifes of Audrey Flack. Again, there is a profoundly local shading to Vasiļevskis's paintings—as localized as the small tabletop upon which his still lifes are arranged and as singularly local as the sallow midwinter sunlight that filters onto the wall behind. Although the simple objects populating his spare compositions change, the horizon of the table edge, infinitesimally off-level, remains constant throughout his oeuvre, an imprecision that orients the viewer as reliably as magnetic north leads to true north.[64] Household objects occupy, yet hardly crowd, the tabletop. A water glass and tankard might be the only articles in sight, but their precisionist rendering pervades the composition and sates the viewer's attention. Vasiļevskis's selectivity regarding the elements composing each still life confers a gravitas upheld by a hyperrealistic style that mines the full optical wealth of even the simplest surfaces.

Indeed, simplicity was paramount for Vasiļevskis, in not only painting but also philosophical matters. Adhering to the "simple man" worldview of the Russian writer and film actor Vasilii Shukshin, he conducted his life in a manner unlike most of his contemporaries and even most Baltic nonconformist artists, rejecting their rather uncritical embrace of Western values and material culture. One close associate recalls,

> Vasiļevskis' 'Slavophilism' served as a definite counterpoint to the pro-Western mythology which prevailed among the intellectuals and youth of the time. He went the full distance in the opposite direction declaring, for example, his faith in the pure Soviet [sic] ideals as understood in their human and Christian aspect, but at the same time recognising that Soviet reality was far from them.[65]

This estrangement between communistic ideals and their Soviet bastardization is subtly imparted in the 1979 work *My Passport*, of which the Dodge Collec-

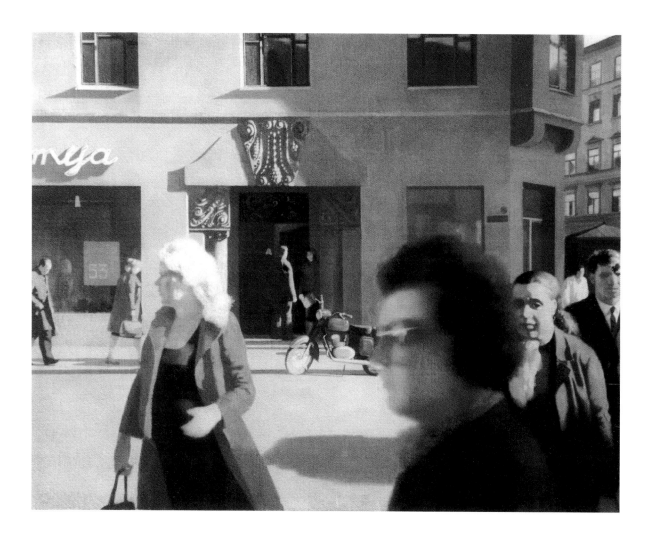

FIG. 159. Imants Lancmanis, *Rīga: Suvarov Street*, 1971.
Oil on canvas. Collection of the artist.

tion has the preliminary drawing Vasiļevskis used to transfer his austere composition to canvas. Verisimilitude of the isolated, foreshortened passport aside, this drawing reveals the artist's covenant with exactitude: Even his signature was transferred to the final work, a telling instance of mechanical reproduction in what is essentially a bureaucratic self-portrait. In fact, this particular "BV 79" originated on an even earlier preparatory sketch, from which it was fastidiously traced onto the study of *My Passport*, making this customarily unique, personal, identifying mark a veritable multiple (a seriality which, given the definition of a signature, flirts with forgery). The third-generation signature claims, as it were, a landscape of alienation. The very notion of expressing self-identity, as though it were reducible to initials or official documents, be-

comes intriguing in light of Vasiļevskis's tragic biography, for a number of his friends believe that his unsolved murder in 1990 was the result of a private life at variance with his public persona.

In the hands of Miervaldis Polis (b. 1948), hyperrealism became the vehicle for a protracted exercise in manipulated self-identity—not to mention an exercise in manipulating imagery to the extent that one is often challenged to distinguish original from copy, one medium from another, and even the artist from his creations. More than Lancmanis and Vasiļevskis, Polis can be called a true photorealist, a distinction he shared for much of the 1970s with Līga Purmale (b. 1948), to whom he was married at the time. Both Polis and Purmale graduated from the monumental painting program at the academy in 1975, though they es-

tablished their reputations the year before by mounting Latvia's first photorealist exhibition at Rīga's Poligraphers' Club, an event as notable for its having been organized without authorization of cultural or academic apparatchiki as for the virtuosity and variety of the work shown. Their formal training in monumental painting compounds the interesting nature of their photorealism: To wit, the hypertrophied scale of their subjects, whether Polis's sixteen-inch knuckles in the painting *Fingers* or Purmale's grapefruit-sized red currants in *Summer* (fig. 160), could almost be regarded as mere fragments of compositions having the overall dimensions of some propagandistic billboard. Insomuch as the hypothetical "source" compositions would have been Red Square–scaled personality cult portraiture or marketplace murals exaggerating the yields of collectivized agriculture, the provocation these mute images represented within the Soviet context was commensurately amplified. Of course, these works are emphatic refusals of any such aggrandizement, and considering the artists' subsequent output, *Fingers* and *Summer* are more legitimately construed as anti-sentimental benchmarks within the Latvian self-portrait and landscape traditions (even as those traditions necessarily include Soviet-era distortions and debasements).

Indeed, considered as a reaction against the ideologically heated atmosphere of the late 1960s and 1970s, the photorealist paintings of Polis and Purmale possess a moral weight equivalent to that of the early hyperrealist work of Gerhard Richter, a product of East Germany's similar pedagogical machinery. Whereas Richter balanced his photo-based paintings with a parallel series of abstract compositions, Polis and Purmale often countered the seeming impassivity of reproducing straight photo imagery by replicating images that indulged in photographic high artifice, such as solarization or soft focus. The pictorial liberations of unnatural color (an ersatz fauvism born of lens filters), distorted shape (ersatz expressionism born of eroding glare), and disintegrated form (ersatz cubism born of extreme cropping of the image) were actually indexical notations of the natural world and its optical caprices, and thus, like Richter's nonobjective works, can almost be considered analog abstraction. Altogether different from modernist abstraction painted by the previous generation of noncomformists, the collateral abstraction of photorealism was equally forceful as a site of semiotic and stylistic resistance (though, like

the earlier manifestation, it was unimpeachably pacific). By the same token, their photorealist paintings were hardly devoid of humor, as seen in Purmale's *Reflection* (1975), an extreme close-up view of a horse's cornea, or Polis's *Car and House* (1973), a faithful transcription of a double-exposure photograph. Polis takes as much delight in the malfunction of an ordinarily dependable camera—the fallibility of photographic representation in general?—as in the resulting morphological pun of a boxy automobile superimposed onto a nondescript apartment block, two inelegant mainstays of Soviet consumerism.

By the late 1970s, Polis's and Purmale's artistic exactitude served more complicated, even narrative ends. Purmale painted scenes of domesticity and domestication: evocative interiors with lighting reminiscent of Vermeer and foggy pastures inhabited by grazing animals. Oddly, homey and bucolic moods arise within compositions painted just as rigorously and unsentimentally as her photorealist close-ups of a few years prior. Still later, Purmale's progression to haze-obliterated landscapes done in an acidic palette and framed with the narrow black trompe l'oeil frame of a Sony Trinitron monitor seems a logical culmination of her work's long-standing engagement with other media. Also acutely aware of painting's renegotiated status within modern visual culture, Polis devoted his energies to a wildly inventive, highly elaborate simulationism, years before it became fashionable in Western art circles. Even as a student, Polis created an appropriative series in which he painted his unprepossessing likeness onto actual book illustrations, placing himself alongside Venetian canals and other foreign landmarks he was unable to visit in person. This vague sense of disembodiment was soon literalized when Polis transposed the monumental knuckles seen in *Fingers* into various geographical settings, whether a glossy magazine photo of the Dallas skyline or a bucolic miniature from a sixteenth-century Mughal illuminated manuscript. His knuckles occupy these landscapes as comic colossi, not unlike César's enormous metal sculpture of his thumb that hitchhiked its way through European and American sculpture gardens at this same time. Soon, the painted likeness of Polis was vicariously inhabiting reproductions of masterpieces, tipping his hat to the viewer from beneath the Virgin in Raphael's *Sistine Madonna* (fig. 161), gesticulating along with the mourners in Caravaggio's *Deposition from the Cross*, and recoiling from *Judith Beheading*

FIG. 160. Līga Purmale, *Summer*, 1975. Oil on fiberboard, 90.8 × 70 cm. Dodge Collection, ZAM, 16876.

FIG. 161. Miervaldis Polis, *Raphael and Polis*, n.d.
Photolithograph, 29.3 × 21.6 cm. Dodge Collection,
ZAM, 04525.

FIG. 162A. [TOP] Valdis Celms, *Prague*, 1967–68. Gouache over collaged gelatin silver print, 21.8 × 42.1 cm. Dodge Collection, ZAM, 01124.01.

FIG. 162B. [BOTTOM] Valdis Celms, *Prague*, 1967–68. Gouache over gelatin silver print, 20.3 × 39.5 cm. Dodge Collection, ZAM, 01124.02.

Holofernes. As witty and cavalier as the specific interventions with the existing texts seem, this series can be read as an earnest reckoning with artistic genealogy.[66] Polis's performance career (discussed below) furthered this process of self-mythologization, and this assertion of the individual subject within a collectivized society was initially made tangible by the specificity—the visual "proof"—of photorealism.

Perhaps because photographic evidence had long been fabricated by Soviet authorities to suit their policies and personnel changes, the physical manipulation of photography to artistic ends was relatively rare in Latvia. Significant, then, was the decision by artist-designer Valdis Celms (b. 1943) to alter photographic imagery for the purpose of exposing criminal effects of Soviet foreign policy. His 1968 diptych titled *Prague* (fig. 162) shows details of church façades from that city in black-and-white photographs, which Celms col-

laged, polarized, reversed in value, and flipped in orientation before masking with vertical bars of tempera, symbolically imprisoning what had been, until that year's Warsaw Pact invasion, a spiritually renascent culture. Naturally, sympathy with the Czech liberals was widespread among Latvian artists, but Celms was singular in how much of his work sought to effect equivalent social improvement at home. One immediate objective was to raise the visual sophistication of mass audiences—he understood the Soviet avant-garde's mission to engender class consciousness via new visual languages—and his use of manipulated photography, especially photograms, in his poster designs from the late 1960s onward battled local visual complacency, just as it fought prevailing hierarchical attitudes that relegated photography to a lesser status.[67] Ironic in light of this bias, a progressive image of contemporary Latvian culture was concurrently being

projected abroad with a three-by-twelve-meter solarized photo mural installation by Valters Ezeriņš and Genādijs Varlamovs in the republic's pavilion at the 1968 Soviet industrial exposition in London.

Photographer Atis Ieviņš (b. 1946) met the same challenge in a different manner. As one of Latvia's innovators of photo-based serigraphy, Ieviņš interposed photography's aesthetics into the realms of other media, most obviously printmaking but also painting and performance. Beginning in the early 1970s, he documented Happenings organized by Andris Grinbergs, and though these representations had complete integrity as art when simply, directly printed as photographs, Ieviņš subsequently made silk screens of these images and proceeded to colorize, crop, and superimpose them, reducing their straightforward documentary value in inverse proportion to a new synthetic, expressive force. Although the interpretive liberties belonged solely to Ieviņš, the serigraphs recovered a dynamism original to the Happenings and fulfilled Grinbergs's collaborative spirit as well. (For example, Grinbergs reciprocated by organizing exhibitions of work by Ieviņš, Polis, Purmale, and other nonconformists at *Loja* [Boat], a cultural center he administered for youth of the indigenous Līv people in Mazirbe, a remote fishing enclave, also the site of experimental poetry readings and performance art events in the mid-1970s.[68]) In other work, Ieviņš established an equivalent symbiotic relationship with painting. For example, a photographic portrait of painter Jānis Pauļuks was converted into a silk screen in mildly polarized format, and then screened atop an offset reproduction of a well-known Pauļuks composition—appropriately, a composition in which Pauļuks himself engaged in aggressive layering of paint. By 1977 Ieviņš, along with his colleague Aldonis Klucis (b. 1935), had created enough examples of this new graphic hybrid to mount a large photo-silk-screen exhibition that toured the three provincial towns of Tukums, Talsi, and Ventspils.

A work by Ieviņš from the early 1970s, simply titled *Head* (fig. 163), reveals one likely source of inspiration for these artists: The head-shot of a woman, enlarged to emphasize the benday dot pattern of its print origin, is overlaid with washes of color across the facial features where one would expect to find eye shadow, lipstick, and blusher on this fashion model/movie star, its overall effect recalling Richard Bernstein's celebrated covers for Andy Warhol's *Interview* magazine. The almost

FIG. 163. Atis Ieviņš, *Head*, 1978. Photo silk screen on fiberboard, 42.5 × 50 cm. Dodge Collection, ZAM, 19038.

FIG. 164A. [LEFT] Eižens Valpēteris, (Untitled), n.d. Graphite on paper, 20.5 × 14 cm. Dodge Collection, ZAM, 18397.

FIG. 164B. [MIDDLE] Eižens Valpēteris, (Untitled) n.d. Graphite on paper, 19 × 13 cm. Dodge Collection, ZAM, 18398.

FIG. 164C. [RIGHT] Eižens Valpēteris, (Untitled), 1966. Graphite on paper, 21 × 12.8 cm. Dodge Collection, ZAM, 18401.

instantaneous transmission of this jet-set look to a location barely served by Aeroflot was quite remarkable. Even more so was the fact that Ieviņš did not passively ape the glamorous commercial aesthetic but altered the source photography in such a way that the latent grotesquerie of high fashion is teased out, much like an overwrought coiffure. In the Soviet context—where, among other visually based miracles, Stalin's pockmarked face had regularly benefited from dermabrasion, courtesy of photo retouchers and official portraitists—this honest distortion, as it were, could truly be called beautiful.

"ASSOCIATIVE PICTORIALISM"

If photorealism's unforthcoming narrativity perplexed Soviet ideologues, surrealism's love of non sequiturs was thoroughly vexing when it debuted in Latvian art during the 1970s. To be fair, its strangeness had little to do with Soviet cultural constraints. Even Latvia's prewar avant-garde, which had been quick to assimilate expressionism, cubism, purism, constructivism, and so on, displayed no interest whatsoever in the ascendant international surrealist movement during the 1930s. Unlike those other modernisms, surrealism had no native adherents to facilitate—or, for that matter, obviate—a revival.[69] Instead, it entered local artistic practice via revivals elsewhere: for instance, within contemporary Polish poster design, to which Rīgans had firsthand exposure in a significant 1970 exhibition, and, even closer at hand, in work by Estonian nonconformists Ülo Sooster and Olav Maran.

On the other hand, this dearth of local precedents may explain why surrealism eventually assumed such diverse forms in Latvia. As already mentioned, surrealistic work was produced by artists as politically, aesthetically, and temperamentally incompatible as Eižens Valpēteris and Uldis Zemzaris (figs. 164 and 140,

p. 196, respectively), the former informed by Polish journals and the latter through friendship with Tallinn-based Maran. Not surprising, their renditions are nothing alike, though not nearly as different from each other as they are from surrealist-inflected work by, say, Valdis Celms and Lolita Zikmane. Perhaps because its manifestations were so disparate, the label "surrealism" was rarely used, even in private discussion about such artwork. Historically, of course, "surrealism" had been wielded in Soviet art criticism as an epithet, so avoidance of the term within sympathetic public dialogue parried the undesirable attention of censors. For instance, in its stead, Laima Reihmane used the euphemism "associative pictorialism" (*asociatīvā tēlainība*) in a 1982 monograph about graphic art, and her accompanying definition is illuminating:

> It appealed to the artists with its unlimited possibilities to reveal the idea expressed in a variety of aspects thus contributing to a broad and variegated perception of the image. The then young artists Aleksandrs Dembo, Artur Nikitin, Lolita Zikmane, Inārs Helmuts, Māra Rikmane, Malda Muižule and a number of others strove for introducing into print the relationship of conceptions which are widely used in psychology where one conception may create others in people's minds on the basis of analogy or contrast.

> They set themselves the task of avoiding a direct reflection of really existing phenomena, tried to master aspects of life and events that had been little studied before, and endeavored to estimate more rationally and to reveal more sensitively the surrounding world and the people.[70]

This noncommittal language, written more than a decade after surrealistic work began widely appearing in the Baltic print and painting triennials, reflected the ongoing need for discretion, though the second paragraph's double-entendre account of not just artwork per se but also local historiography is remarkably concise. Equally interesting, Reihmane's choice of the word "psychology" to describe what had been, elsewhere, a full-tilt psychoanalytical project intimates an ingrained Latvian skepticism regarding psychoanalysis, particularly its radical Lacanian recovery that may have been thought to undermine those traditional conceptions of individuality which offered self-reliant Latvians considerable psychic refuge during their Soviet colonial predicament.

In artistic practice, this bias translated into surreal-ist work that often seemed perfunctory about juxtaposing incongruous elements, a response more to the pictorial peculiarities of first-round surrealism than to its structural underlayment—namely, the human subconscious, but also any theoretical slant on why this might provide eligible material (much less a method) for art-making. Despite the fundamental indifference, we find revelatory bodies of work by such artists as Juris Dimiters (b. 1947) and Maija Tabaka, whose technical refinement heightened the vividness of their irrational imagery to the point of believability, much like a delirious dream. Of course, one could have claimed similar achievement for the most affective Socialist Realism, and certain nonconformist artists—Daina Riņķe (b. 1941) foremost among them—found these *folies à deux* between official painter and state patron inspiring enough to conjure their own latter-day absurdities, like a traffic jam on a cloverleaf interchange or an obscenely bounteous harvest, neither of which bore the faintest resemblance to local reality.

Despite their factual preposterousness, Riņķe's paintings remain fully tethered to the natural world in terms of spatiality, color, and other sensory cues. This groundedness wasn't necessarily the case with works by Malda Muižule (b. 1937), Artur Nikitin (b. 1936), Māra Rikmane (b. 1939), and Lolita Zikmane (b. 1941), a generation of graduates from the academy's graphic art program who benefited greatly from the precocious example of Aleksandrs Dembo (b. 1931), only a few years their senior. Dembo effected a revolutionary shift in pictorial sensibility by introducing overtly non-diegetic and symbolic elements into montage-like figural compositions, an innovation excused by authorities otherwise impressed by his technical prowess and cultural erudition.[71] As with any montage, the syntactical gaps between figural passages expanded the possibility of multiple readings of an image, and as Dembo became a dynamic teaching presence within the academy even before his graduation in 1963, other students observed how his representational ambiguities and ellipses licensed broadly divergent interpretations from viewer to viewer. By the early 1970s, artists such as Muižule and Nikitin began producing imagery for which even the single viewer was likely to have competing explications, not unlikely when amorphous form congeals into a figural detail that, in turn, dissipates into pure color or pattern. Obtuse titles like Nikitin's *Cosmic Sprout* provided scant hermeneutical

orientation (unless, of course, it prescribed the most expansive interpretative horizon possible). Other graphic artists—Rikmane and Zikmane, in particular—devised almost spurious combinations of objects within a unified landscape scheme. For instance, in Zikmane's *Spring: White Locomotive* (1977), a ghostly train hurtles past a flock of wild turkeys in a forest glade while a nude looks onward. Though works of this nature were increasingly exhibited and published, even the most rudimentary Freudian decoding of them was out of the question.

This held true even for Maija Tabaka (b. 1939), whose psychosexually charged portraits and "merry company scenes" peopled by friends and relatives became phenomenally popular in the late 1970s. Early in the decade, Tabaka was a highly visible member of Rīga's bohemia, a *flâneuse* often seen in the *Putnu dārzs* café with poet-musician Imants Kalniņš and other young nonconformists,[72] but officials ensured that her work was not so easily observable. The situation changed in 1973, when she was included in *20 Künstler aus Sowjetlettland* at Düsseldorf's IKI-Messe, the first exhibition of contemporary art from Latvia to be shown outside of the Eastern bloc in nearly forty years. Her participation was justified by her talent, but quite possibly secured by her father's high government position. As it happened, the exhibition was organized by Latvian émigré Valdis Āboliņš (1939–1984), who, as a key member of the Fluxus community, found a kindred anarchical spirit in Tabaka and, as executive secretary of West Berlin's Neue Gesellschaft für bildende Kunst, had the institutional authority to offer her a year-long residency in the West. One informed source insists that permission was granted for this unprecedented opportunity because it was believed Tabaka would prove useful to the KGB as a source of information about the émigré community. As a matter of fact, she did become an unparalleled conduit—but to the Latvian public at large, and about progressive émigré art in particular.[73] Emboldened by record attendance at her critically acclaimed first solo exhibition, which was mounted upon her return from Berlin, Tabaka worked to popularize the art of Āboliņš and other émigrés who might have otherwise remained unknown to broader Rīga audiences.

Indeed, Tabaka raised the visibility of certain aspects of contemporary culture that officials would have gladly ignored. Gallery director Inese Riņķe credits Tabaka with introducing images of "men from the street"[74] to a portrait tradition theretofore dedicated to either idealized representations of the common folk or obeisant depictions of the intelligentsia. She painted rock musicians in a coarsened, energized manner analogous to the music itself; surrounded the likeness of her seven-year-old son with enough capricious elements (for example, a parachuting elephant) to evoke childish pique; cast Latvian artists and architects as self-absorbed, melodramatic actors in some absurdist mise-en-scène; and played tripmaster-monkey to a group of Berlin drug addicts. Whether lurid, flamboyant, histrionic, or indecorous, unprepossessing subjects were for Tabaka as eligible for depiction as the salutary ones that also frequent her work. Moreover, both categories were treated disinterestedly. Her nonjudgmental attitude stunned puritanical audiences, even as they were titillated by the sight of the forbidden and disenfranchised, though it's debatable to what extent Tabaka's hallmark inclusions of bizarre, seemingly extraneous elements, foppish costuming, and spatial dislocations actually comforted conservative audiences by buttressing their sense of alienation. By comparison, her 1983 work *Summer* (fig. 165) might seem only mildly provocative. Yet the modicum of concealment and the lack of conspicuous artifice, both of which would tend to ameliorate the provocation of the dancing, self-exposing younger woman, actually heighten the shock effect of the roseate light emanating from her pudendum, giving us Gustav Courbet's *Origin of the World* (1866) without ob/gyn specificities, the sexual without the clinical.

Deeply ironic in light of its countless salon nudes, Latvian painting during the Soviet era was so enervated sexually that it comes as little surprise that the most eroticized imagery offered scarcely a glimpse of human skin. Instead, like the best striptease, it relied on showmanship and imagination, qualities endemic to anything worthy of the name "associative pictorialism." In 1979, in the midst of a multifaceted career as theater and graphic designer, Juris Dimiters (b. 1947; figs. 166 and 167) painted an extensive series of small-scale compositions in which disconsonant objects, or fragments thereof, were fused to form what might be considered, if realized in three dimensions, assisted ready-mades. These hybrid objects, part biomorphic and part inanimate, were rendered in what was essentially, appropriately, a hybridized painting genre,

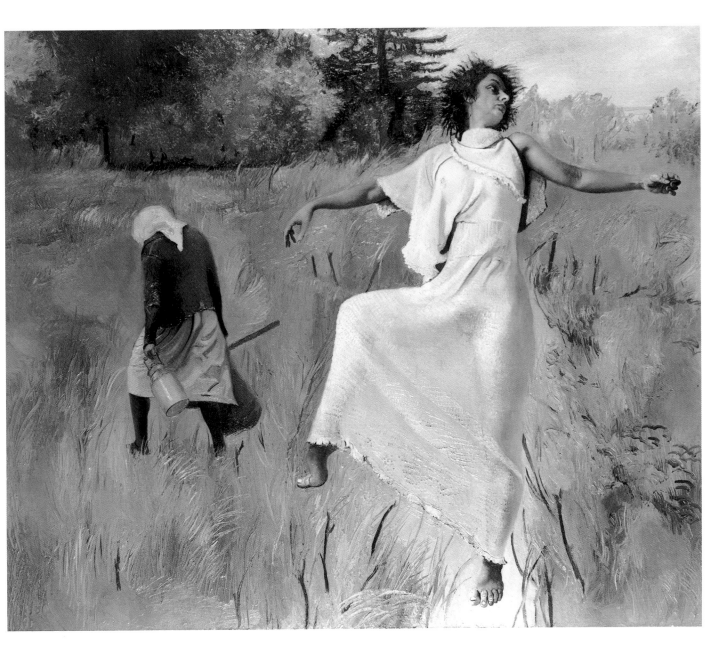

FIG. 165. Maija Tabaka, *Summer*, 1983. Acrylic and oil on canvas, 145 × 176.5 cm. Dodge Collection, ZAM, 05118.

FIG. 166. [ABOVE] Juris Dimiters, *Women's Unlib*, 1985–86. Screen print, 90 × 47.5 cm. Dodge Collection, ZAM, 09706.

FIG. 167. [RIGHT] Juris Dimiters, from the series *Barbed Wire*, n.d. Gouache on paperboard, 10 × 15 cm (each). Dodge Collection, ZAM, 12930, 12931.

combining the discursive, dispersive nature of still life with the centripetal presence of portraiture. One characteristic composition, *Music Machine* (fig. 168), initially strikes the viewer as whimsical: Not only does the protruding beak-like form seem to belong to a bird comically oversized for the cabinet, but also the title itself recalls Paul Klee's good-natured *Twittering Machine* (1922), which portrays birds perched on a wire as benignly mechanized. However, the paintings' respective dispositions are incomparable. The birds' reduced sense of agency in Klee's work, offset by their playful forms, is fully compromised in Dimiters's version, where cheerful colors only exacerbate the tension. The beak is silenced and, moreover, fetishized, separated from its body of origin as well as its very utility. Other paintings in his series, with their cage and container motifs, sustain the theme of constriction, confinement, and obstruction, and may ultimately suggest a sociopolitical critique.[75] But the fact that other Dimiters compositions contain, for example, a human buttock-like form sodomized with a pole hoisting a white surrender flag, or self-contradictory erotic imagery à la Magritte, urges a generalized psychoanalytic reading of his work, one in which freedom (or its lack) is defined by libidinal forces rather than liberal principles.

Dimiters's success might be considered symptomatic of the greater artistic culture in which liberalism and libido were equally lacking, guaranteeing that some of the most assured surrealist work in Latvia issued from designers rather than "fine" artists (guaranteeing, also, that such professional distinctions became quite meaningless in the local context). Already adept at couching abstraction within "compositional studies" and producing kinetic art as industrial prototypes (see section below), designers now probed the psyche's interface with the material world under the rubric of surrealism. For instance, certain manipulated photographs by Valdis Celms are deeply compelling for their fetishistic regard of materials and strategically repressed detail. His 1969 photogram *Head* shows a segmented profile of indeterminate gender, but because the brutal, vestigial form consists of openwork lace, it suggests a pictogram of femininity, though a disturbingly ambivalent one. Gender uneasily parsed, *Head* implicates the reticulating force of traditional social identities and the vital role base materials play in this. The choice of lace is redolent not only of femininity, countered here by its indelicate handling, but also of

FIG. 168. Juris Dimiters, *Music Machine*, 1979. Oil on fiberboard, 44 × 31.9 cm. Dodge Collection, ZAM, 06668.

the petit-bourgeois material decadence once derided by Russian Communist activists as *poshlost'*.[76] Just as activists decreed utilitarian design to be the antidote to "counterrevolutionary" taste, Celms remedies whatever maudlin association these lace fragments might bear to Grandmother's antimacassars with his ascetic photographic treatment. Consequently, *Head* does the same for egocentric portraiture.

At the same time, surrealistic design offered humorous relief from the technocratic dysfunction of Soviet central planning. Exemplary in this regard were Māris Ārgalis (b. 1954) and the activities he termed "*polūcionisms*" ("emissionism"), a neologism derived from the Latvian physiological loan word *polūcija*, meaning emission or ejaculation. As critic and fellow designer Jānis Borgs has pointed out, "By this semi-sexual term he meant the free flow of free ideas or 'emission.' He called his fellow travelers 'emissionaries.' "[77] The punning nomenclature recalls the Lacanian concept of *jouissance*—*jouir* is French slang for "to come"—when a subject finds enjoyment or pleasure in the Real at the point where knowledge (not to mention language) fails. Like *jouissance*, *polūcionisms* had its communal aspect, which, also like *jouissance*, was in ambiguous relation to the private realm: Though Borgs would simply describe the *polūcionisti* as "a like-minded group of artists, designers, architects and young philosophers gathered around [Ārgalis],"[78] one of the artist's closest associates recalls how his name and those of others found their way onto artworks authored solely by Ārgalis. In particular, components of the 1980 serigraph series titled *Graphism* are signed "a[nda] & m[āris] Ārgaļi, [Dimitrijs] Lūkins, [Kirils] Šmeļkovs, [and Aldonis] Klucis," but Šmeļkovs recalls that neither Anda nor he (nor probably Lūkins) had any hand in it—except for perhaps a hand in the budgetary pocket of the Artists' Union, which would allocate production monies to each of the listed *polūcionisti*.[79] This happily promiscuous authorship befits the imagery of the *Graphism* series: an aggregation of machinery, zoology, and typography, all of it conspiring toward a common goal—presumably locomotion— and pointedly against rational assembly, whether mechanical or grammatical. Its imagery already readable as a nonsensical rebus, the winged steam locomotive in the series' second serigraph (fig. 169) is paced within the composition by the sibilant text "3§ [trīs sekcijas/trešajā sekcija] SkursteniS SignālS SpārnS" (three

sections/third section smokestack signal wing), positioned synaesthetically where we would expect to find smoke and steam. This hissing, puffing conflation of linguistic and visual elements mimics dreamwork schemata as they might be plotted by a structuralist-minded psychoanalyst.

But the particular genius of Ārgalis and his emissionaries was to maintain apoliticality in a project largely inspired by the ideals of constructivist Gustav Klucis, the Bolshevik firebrand who eventually paid for his ideological purity (and Latvian ethnicity) during the Purges. According to Borgs, *polūcionisms* was "distinctly intellectual and creative, anti-bourgeois and as alien to consumer society as possible, but it never degenerated into political intrigue."[80] Indeed, as encrypted as the phantasmagorical imagery of Ārgalis can be, it conspires only toward pleasure, mostly that afforded by wordplay and visual puns. On the other hand, pleasure and play can pose the greatest subversive threat to order, and just as a technocrat would find the wacky inventiveness of a Rube Goldberg device unamusing, Soviet authorities regarded *polūcionisms* with increasing hostility until, in 1979, they accused Ārgalis of seeking to establish an alternative artists' union, susceptibility to "traps set by Western imperialist special services," and other fabricated offenses.[81] After extended interrogation and harassment, Ārgalis ceased all artistic activity. The emission had dried up.

ULTERIOR DESIGN, ULTERIOR MOTIFS

In a mid-1990s interview, Džemma Skulme reminisced,

> We began to organize exhibitions that took place three and four times a year. This could never have happened in the Soviet Union [*sic*], and we were reprimanded, but we were shrewd and crafty. Our Latvian artists' union was subordinate to the USSR Union of Artists, but as leader of the Latvian union, I managed to hold our exhibitions anyway. So we really did not have any dissident artists because they could exhibit officially. If, for instance, an artist painted in an abstract or even in an unacceptable realistic style, we would exhibit those works with the design department, as if they were designs rather than paintings.[82]

Skulme's description of one particular Soviet-era exhibition strategy is interesting, not least for how it would be received by KGB-harassed artists who nevertheless

FIG. 169. Māris Ārgalis, *Graphism #2*, 1980. Screen print, 20 × 30 cm. Collection of Mark Allen Svede.

fail to qualify as dissidents in the opinion of their most officially decorated co-national. While her quote is truthful, it falls slightly short (or, as it were, to the Left) of the full truth. Beginning in the 1960s, some Latvian artists indeed resorted to the semantic ruse of designating their formalistic experiments "artistic constructions," which enabled a considerable amount of otherwise objectionable art to be exhibited and sometimes published. But even to the degree that this strategy succeeded, certain works did not pass muster, some exhibitions didn't run their scheduled duration, and, as demonstrated by Māris Ārgalis, at least one designer was persuaded by the KGB to leave the profession altogether.

Or, considered another way, Skulme's version errs slightly to the Right. Some artists sought exhibition exposure specifically *as* designers after having educated themselves about Latvians active within the Soviet avant-garde of the 1920s, particularly those engaged with extreme leftist, anti-fine-art factions such as the productionists.[83] Yet this revival was readied less by the dazzling examples of Johansons and Klucis fifty years earlier, now suddenly rehabilitated, than by a gradual process begun in 1963 when examples of progressive product design first appeared within the context of a Latvian applied arts exhibition. Previously relegated to exhibits vaunting the economic achievements of central planning, this aesthetically determined display represented an apotheosis of sorts for design, and it wasn't long before design, in turn, represented a transformative opportunity for artists. Not surprisingly, students in the academy's interior and industrial design departments, especially those under the tutelage of sculptor Tālivaldis Gaumigs (b. 1930), were soon generating "studies" of texture, composition, and structure that were unexhibitable as art, yet bore striking resemblance to contemporaneous nonfigural sculpture in the West, particularly the work of Latin American op artists.[84]

Recognition of these "artist-constructors" came

from colleagues elsewhere in the Socialist world almost as quickly as it did domestically, when in 1963 a feature article appeared in the Czech journal *Tvar*.[85] Five years later, at the time of the First Republican Design Exhibition—itself a triumph over cultural bureaucracy and aesthetic parochialism—the French trade journal *Design industrie* devoted two editorial pages to exhibition highlights, validation from the West compounded by accompanying text that more or less treated Latvia as an autonomous nation.[86] But if, from the French perspective, reference to the republic's Soviet status risked eliciting a reputation for shabby production quality and antiquated styling, from the other direction the status of Baltic designers was enhanced by their peripheral position in the Soviet Union, especially when their audience was Russian. Editor of the preeminent journal *Dekorativnoe iskusstvo SSSR* during this liminal period, Iurii Gerchuk recalls that the "Baltic Republics … actively contributed to the transformation of the aesthetic milieu of Soviet everyday life and to the formation of a new style. … For us, the products of the Baltic bore the unmistakable stamp of the European culture we so desired."[87]

Befitting their intermediary location and compound job title, Latvia's artist-constructors bridged the artistic and the technical by creating works that also spanned disciplinary boundaries. For example, in the late 1960s engineer-designer Egons Spuris (b. 1931) created a site-specific "photo-panneau" for the interior of Rīga's café *Joma* (Inlet) by conjoining photography and architecture. Given the idiomatic expression "*būt sava jomā*" (to be in one's element), it was manifestly apparent that Spuris had found his, and within the next fifteen years he would go on to win most top international photography honors. Superimposed on the gridded, solarized background of the photographic mural, major details are fixed as photogram imagery, and the multiple reversals of tonality and polarization of value prepare the viewer for what is arguably a statement about radical reorientation. A globe, sextant, compass (with German-language cardinal points), and other navigational tools maintain position on a minutely patterned field that appears to have been revealed by either an electron microscope or a surveillance satellite but, in fact, derives from a map. This ambiguity of scale and the indeterminate, even shifting, position of an implied viewer, especially when

regarded within the haptic unity of the architectural context, unsettles and defamiliarizes the subject. The same effect, but with ideological consequences, was performed on documentary images of the famed Red Riflemen within a photo-panneau designed in 1970 by Valters Ezeriņš for the Latvian pavilion at a Soviet trade show in Paris. The severe abstraction of the young revolutionaries' faces, achieved through the twin photographic operations of extreme enlargement and posterization—that is, the elimination of gray tones and, one might metaphorically propose, gray *areas*—managed to be both visually hip and spiritually alienating in that post–May 1968 environment.

The market for architectural decoration licensed experimental painting and sculpture, too. Leo Mauriņš (b. 1943) was a new graduate of the academy in 1969 when he was commissioned to paint murals in the jazz club *Allégro*, a case of purest serendipity because his inclination to compose paintings around highly patterned expanses and intricately worked surfaces had gone unappreciated by his professors—professors who also didn't share his keen interest in op artist Victor Vasarely's color theory. Responding to the absence of a confining frame, Mauriņš bridged the ceiling and wall planes with vertiginous forms, stylized shapes of musical instruments that transmogrified into the shape of music itself: undulating, enveloping, doubling back on itself in reprise, and layered throughout with textural passages and punctuated with angular, percussive motifs. In contrast to the composer-painter Čiurlionis, who concretized symphonic music with tightly structured compositions, Mauriņš created form analogous to jazz's improvisational nature. Moreover, he consummated the recovery of modern Latvian painting's ornamental impulse, a process revived in the Soviet era by Pinnis. Although most local critics and curators would continue to disregard Mauriņš, artists understood immediately what transpired in this synaesthetic environment.[88] His influence continued through further interior commissions and many vividly chromatic easel paintings of the 1970s and 1980s that mirrored the stylistic concerns and visual impact of the Pattern & Decoration movement in America (though he predated that phenomenon by almost five years). Like P&D artists who found inspiration in traditional quilt designs and Navajo blankets, Mauriņš often acknowledged native ethnographic sources for his imagery, as in the 1974 painting *Folk Motif: Mummery*,

a Dodge Collection work. Appropriate to such arti-sanal inspiration, he sometimes built his paintings with interwoven skeins of pigment, the warp and woof of paint lifting clear of the canvas, as in the monumental composition *Silvery Fishing* from 1972.

In terms of actual weaving, certain fiber artists also freed their work from the wall surface and, hence, from limiting preconceptions of the genre. In 1971, a decade after the establishment of the academy's tapestry department forced the reexamination of orthodoxies concerning ethnographic patterning and color,[89] Aija Baumane (b. 1943) became the first Latvian textile artist to push the woven object's plasticity into full three-dimensionality. And so, just as folklorists were forced to recognize that even the most "authentic" peasant costume could depart from rigid traditional norms, artists understood that tapestry could now be free-standing or -hanging sculpture, and rectilinearity became irrelevant. A key example is the 1974 work *Pulse of the City* by Edīte Vīgnere (b. 1939), a suspended, perforated, flared cylinder formed of taupe wool and linen, enclosing an amorphous red-orange core. Saturated hues of the interior component transfer suggestively to the perforations' edges. In formalistic terms, Vīgnere's work meets the criteria for high-modernist sculpture famously advanced by Michael Fried in his essay "Art and Objecthood": The gestalt of the abstract structure is instantly, fully perceivable, and color obeys the form's logic. This would argue a formal similarity to Anthony Caro's work, exalted by Fried as paradigmatic modernist sculpture, yet Vīgnere's piece also compares well to certain fiber works by Eva Hesse, and a feminist, anti-formalist interpretation could equally pertain. In the 1970s, another textile artist, Vera Viduka (b. 1916), produced monumental tapestries of which some resemble Josef Albers's *Homage to the Square* and others, the shaped canvases of Frank Stella's post-painterly abstractions. However, while a Möbius-like work like Viduka's *Bārta* allows pure geometry to generate its own elaborated form, the title also signals an ethnographic source for the colors used (namely, the peasant costume from the Bārta region). Once again, humanistic, anti-formalist implications of art-making arise and assumptions regarding craft as a genteel, gendered activity are challenged. Most certainly, the notion that artisans trailed fine artists in pushing modernism to its limits had no validity in Latvia.

Likewise, architecture and urban planning readily offered opportunities for experimentation, although non-architects often proposed the most experimental projects utilizing the vocabulary of these disciplines. Because architecture had been, during the thaw, the one visual art actively encouraged to return to modernist praxis, it was perhaps natural that these projects spoke the language of constructivism, the dominant style when modernism had been interrupted. Initially, the return was faithful to historical antecedents: *Dynamic City* (fig. 170), a 1976 proposal for a kinetic sculpture by designer Jānis Borgs (b. 1946), is a veracious adaptation of Gustav Klucis's 1919 photomontage of the same title. But whereas Klucis incorporated photographic fragments of the metropolis, as well as architectural materials like sand, within a work on paper for the purpose of energizing graphic space, Borgs transposed collage-like elements into the urban space, contrasting their geometric purity with the messy polymorphism of a medieval-*Jugendstil*-Soviet metropolis, and their fluid, mechanical movement with the erratic motion of street traffic, all with the aim of increasing the dynamism of a city that hardly fulfilled the promise it once held for Klucis. Another resuscitation of the Klucis legacy and ethic was proposed by Māris Ārgalis, his architect wife Anda Ārgale (née Bērziņa, b. 1943), and Valdis Celms with their 1978 concept for a communications center that took, as its primary inspiration, the numerous *Radio-Orator* designs of the 1920s in which Klucis combined rostra, loudspeakers, projection screens, and other early mass-media devices in order to proselytize the Revolution. In addition to updating the technology, such as rotating LED screens and satellite broadcast capabilities, the latter-day orator took into account contemporary political reality and deconstructed its symbolic form accordingly, reducing the hammer-and-sickle motif into a light marketing spectacle—in all senses of the phrase.

As the 1970s progressed, Valdis Celms was instrumental in focusing attention on design's theoretical issues, and his success can be gauged by the substantial emphasis on conceptual-based work at the May 1977 Fifth Republican Design Exhibition and conference, *Environment—Design—Quality*. That same year, Celms was commissioned to create a complex kinetic object for the central plaza of an industrial facility in Ivano-Frankovsk, Ukraine, a project known as *Positron*.[90] Its original presentation boards and kinetic

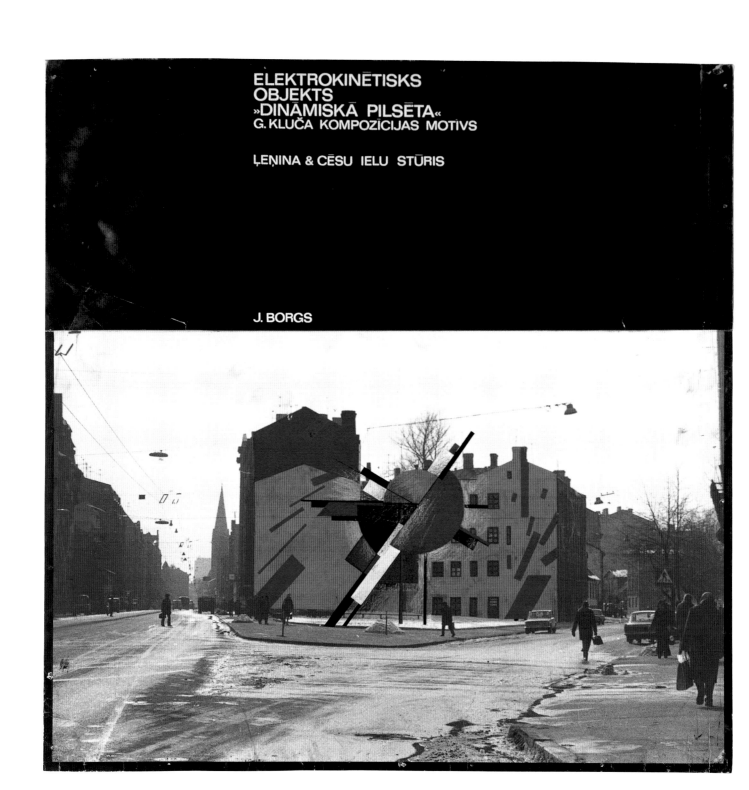

FIG. 170. Jānis Borgs, *Dynamic City*, 1976. Gouache
and oil pastel on photograph on plywood, 79.5 × 79.5 cm.
Dodge Collection, ZAM, 16987.

maquette (fig. 171) are part of the Dodge Collection. Reaching a height of 335 feet, a white polyhedron was encased within a rotating metal geodesic cage, onto which colored light patterns were internally projected according to a program determined by various calendars: astronomical, seasonal, cultural. The motions of the projected light, the subtly faceted polyhedron, and the prismatically reflective metallic enclosure combined to scintillating effect (in turn, amplified by a reflecting pool), articulating a techno-utopianism that was, alas, unwarranted. Like Tatlin's *Monument to the Third International* and other such expressions of faith in Soviet technological capability, *Positron* was never built, though its maquette remains, an impressively complicated kinetic sculpture.

Fortunately, there were no problems realizing the decorative program proposed for Rīga's principal Intourist facility. Opened in 1978, Hotel Latvija became a prime venue for artistic innovation, from the prominent kinetic object on its façade—*Sakta*, a minimalistic abstraction of a peasant brooch by Artūrs Riņķis (b. 1942)—to the discotheque's illuminated wall that flashed ornamental folk motifs, to even the audacious subterfuge of outfitting every guest room with a white lace curtain flanked by maroon drapery that, when drawn, formed the outlawed flag of pre-Soviet Latvia.[91] In a way, the hotel was a tour-de-force work of installation and process art, although, overall, its architectural effect remained boorishly Eastern bloc and the finest technology on the premises was, of course, reserved for the KGB's guest-surveillance needs. Also in classically Soviet style, the hotel interiors were off-limits to the average local resident.

But Rīgans were able to experience the same caliber of art later that year in December when Celms, Riņķis, and Andulis Krūmiņš (b. 1943) mounted the watershed exhibition, *Form—Color—Dynamic*, in the deconsecrated Peter's Church, Sovietized into a museum space. The significance of restoring a celebratory atmosphere to one of Latvia's most revered yet profaned ecclesiastical structures during the course of the Christmas season was not lost on visitors, but religious sentiment aside, the impeccable execution of the enterprise, extending to the design of its catalogue and invitation card, left no doubt as to the aesthetic integrity and philosophical rigor of the individual works within. In addition to introducing physical motion as a determinant of modern sculptural mass, *Form—*

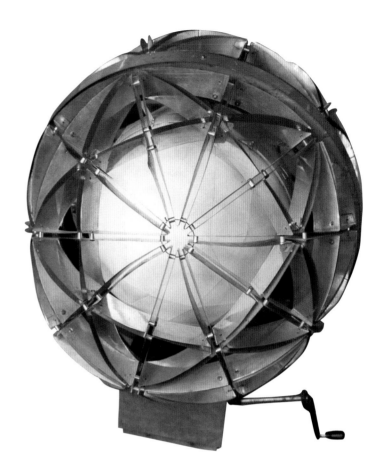

FIG. 171. Valdis Celms, *Positron*, 1977. Kinetic maquette of steel, paper, and wood, 50 × 40 × 40 cm. Dodge Collection, ZAM, 19068.

Color—Dynamic was a definitive moment in Latvian art regarding an alternate hierarchy of materials. Eminently unsuitable for the art object's inevitable dematerialization under conceptualism, long-favored granite and bronze no longer automatically dominated local sculptural practice. (The compensatory effect of this iconoclasm was that subsequent sculptors, such as Ojārs Feldbergs, could recuperate the mythic material associations of granite with great affectivity.) Perhaps most emblematic of the exhibited works, *Points of Intersection*, a six-foot-tall whirling column of polychromatic light by Krūmiņš, marked the beginning of a new cinematic tendency in Latvian installation art—indeed, it introduced installation art within a gallery setting.[92] *Points of Intersection* was cinematic insofar as it exacted many of the same physiological responses from its audience that viewers in the West were experiencing from structuralist films (for example, those of Paul Sharits). In addition to interrogating the motility and shape of vision, Krūmiņš also articulated what film phenomenologists call the "lived-body" of cinema or the embodied visible object,[93] and what certain structuralist filmmakers explored in the 1970s by, say, nominating the cone of projected light as a sculptural form or eliminating the projector altogether by positing the yellowing of a white outdoor billboard as an incipient screen with an unfolding narrative.

Advanced as the designers' ideas might have been, Soviet material conditions almost always played a retarding role in their execution. However, this delay sometimes benefited artists, heightening inventiveness in mediums that might have otherwise been disregarded as worthy of experimentation. Starting in the late 1960s, Pēteris Martinsons (b. 1931), who began professional life as an industrial engineer, found such reasons to contemplate clay's technological potential and thus elevated what others treated as the stuff of pinch pots into some of Latvia's most formally sophisticated sculpture. Tectonically engaged, yet at the same time mindful of clay's intrinsic qualities, Martinsons succeeded in counterbalancing the geometric rigor of minimalism with the organicism endemic to handicraft and, appropriately, earth art. Elsewhere, privation forced inventive material substitutions and technical compensations. For photographers, the scarcity of color film and the means to process it resulted in elaborate recipes for vegetable dyes, used to hand-tint black-and-white aviation film.[94] Similarly, the absence

of computers in the early 1980s forced graphic artist Laimons Šēnbergs (b. 1947) to hand-draw a seemingly pixellated tripartite poster commemorating the sesquicentennial of the birth of Krišjānis Barons, the seminal intellectual force behind Latvia's nineteenth-century National Awakening. The brilliance of this triptych—beyond its virtuoso draftsmanship—was that digitalization was only slightly more unfamiliar to Barons than it was to Šēnbergs's design colleagues.

Versed in such bricolage and accustomed to functioning in a state of professional hybridity, some Latvian artists responded specifically to the epistemological peculiarities posed by their situation (see the discussion below of the collective, the Workshop for the Restoration of Nonexistent Sensations). But of anyone, Māris Ārgalis could be counted on to broach the issue. Shortly before *Form—Color—Dynamic* began spinning and strobing against philistinism, Ārgalis staged a solo graphic exhibition titled *Models*, a use par excellence of the diversionary tactic that Skulme described. Eleven small drawings central to the exhibition—"speculative architectural models"[95]—follow the conceit of a typical design process, progressing from a simple diagram to various elevations to axonometric views of a ziggurat-shaped object. In his accompanying catalogue text, Ārgalis compares this evolution of the first six images to the unfolding structure of classical tragedy. One senses that he believes inexorable closure is truly tragic, because as soon as the object evolves into three-dimensionality in image six, subtle graphic suggestions of alternate realities arise: Wispy clouds gather in the distance, intermixed with faint handwriting. From there onward, the images hybridize schematic and illusionistic views of each model, with the abrupt introduction of a fingertip in the final image. Ārgalis characterizes images seven through ten as "simultaneously including spatial reality and optical absurdity," but hints at a purely existential dialectic, "ambivalently combining the BURNING—of life / and / the CHILLING—of decomposition." Image eleven tempers this solemnity: The finger is toying with a phallic model, and the artist quips that this "kinetic energy represents—[me] SELF-REPRODUCING, consequently REPEATING MYSELF, CONTINUING" … emissionism, indeed. The exhibition's climax was a larger drawing titled *Confrontation*, an interpellation of Johann Carl Loth's seventeenth-century painting *Philemon and*

Baucis with the vaguely industrial environs from the *Models* series. *Confrontation* would be Latvia's first postmodernist pictorial composition. Choosing as its narrative basis Ovid's tale of the redemption of an impoverished but inventive elderly couple living in an inhospitable country, Ārgalis was essentially recounting the story of the artist-constructors. And given Latvian folklore's reverence for oak and linden trees, the metamorphosis of Philemon and Baucis into these intertwined species would hardly count as tragedy.

SKIRTS: NOT AN ISSUE

Difficult as it is to argue convincingly that any nation's female artists have achieved full professional equality with their male peers, one risks accusations of sophistry to propose that gender parity existed in a society in which washing machines were luxury items and food shopping required standing in queues, yet women were expected to perform these domestic chores even after working all day as a gallery director, all-Union legislator, or Artist Laureate of the Union of Soviet Socialist Republics. At best, a pyrrhic victory might be claimed. But perhaps preliminary to determining the extent to which gender shaped Latvian art—or sexism, its history—the question might be asked whether discussing women artists separately from their male colleagues raises other issues, such as intellectual ghettoization. To this there is no easy answer. Near the end of the Soviet era, in a high-profile publication, two eminent young critics discussed whether a specifically "women's" art existed in Latvia, concurring that it didn't. They felt, furthermore, that there were no significant gender-based issues within local art life.[96] But within six years' time, the Frauen Museum in Bonn opened the exhibition *Karyatiden: Sech Malerinnen aus Rīga*; the National Gallery in Ottawa, *Reconstructing Identity: Latvian Women Artists*; and Mimi Ferzt Gallery in New York City, *Women Painting Women* (featuring four painters who hailed from Rīga).[97] Each exhibition confirmed the notion that a gender-specific focus could illuminate something particular about the work and perhaps even about Latvian culture.

Naturally, the professional experiences and aesthetic particularities of Latvia's female artists cannot be neatly summarized as a demographic phenomenon. But the success of curatorial efforts in this cate-gorical vein indicate one remarkable thing about women's art-making: A cogent and substantive exhibition, representative of any period of modern Latvian art, could be made using only female artists. This is true even of early modernism, for which painters Aleksandra Beļcova and Hilda Vika (1897–1963) and sculptor Marta Liepiņa-Skulme (1890–1962) would more or less comprise the exhibitor roster (with a work or two by Lūcija Kuršinska). For the next generation, Soviet ideology complicates potential curatorial groupings. Lidija Auza, Zenta Logina, Džemma Skulme, Rita Valnere, and Vera Viduka would be essential participants, but combining their works within a single gallery space, even if stylistically compatible, would perpetrate a grave anachronism, morally speaking. Their successor generation (artistic, not strictly chronological)—including Anda Ārgale, Biruta Delle, Zenta Dzividzinska, Līga Purmale, Daina Riņķe, Maija Tabaka, and Edīte Vīgnere—coheres in terms of personal attitudes held toward the political system, and the individual works of these artists could coexist in exhibition as symbiotically as the artists did in historical reality.

While the number of women who played critical roles in Latvian art's historical development is impressive (indeed exceptional, relative to other national cultures), the early work of one painter virtually unrecognized to this day is probably more emblematic of the average woman's experiences in Soviet Latvian society. Whether eclipsed by her husband's professional stature, pigeonholed by her training as a decorative artist, hindered by her own modesty, or a combination of these factors, Ilze Zemzare (b. 1940) remains an unknown quantity. Although the situation is unjust, it has a certain tragic aptness, for her strongest works plumb fear and sadness of unknowable quantity. *The Path of Life* (fig. 172), from 1966, is a diminutive triptych in which, on the left, a woman stands alone in a posture of vulnerability, the fragility exacerbated by her figure's mannerist attenuation. The central panel contains a strand of barbed wire—no exegesis needed there, certainly, but it bears noting that the wire's sinewy, undulating vertical form mimics the woman's, unexpected beauty that augments the work's latent horror. To the right, a floating silhouette or void mirrors the woman's figure, though its identity, and that of the similarly human-like white shape within, is lost, even occult. Another Zemzare painting, *A Woman's*

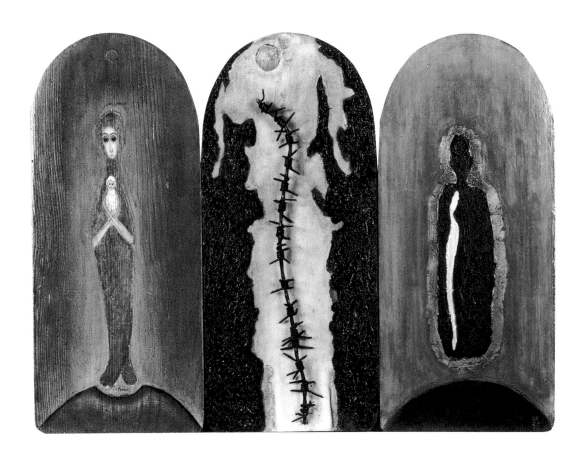

FIG. 172. Ilze Zemzare, *The Path of Life*, 1966. Oil and barbed wire on panel, 45 × 61 × 5 cm. Dodge Collection, ZAM, 00102.

Life (fig. 173), from 1969, indicates that the artist was interested in generating a proto-feminist body of work, not simply political commentary (although the toll, particularly on women in Soviet Latvia widowed by political repression against their mates, cannot be ignored in interpreting a work like *The Path of Life*). In this second painting, an odalisque, executed with a pictorial ingenuousness that critiques the odalisque tradition itself, is suspended above blackness teeming with monstrous forms, eyes glowing, jaws agape, and necks craning toward the woman. But the nightmarish lower register is almost as comical as the woman's massive spherical breasts, indicating perhaps that giving rein to one's phobias (sexual or otherwise) is as indulgent and infantile as the convention of splaying a nude for viewer delectation. After all, Zemzare was an artist snubbed by a cultural elite that had no qualms whatso-

ever during the 1970s and early 1980s about the quarterly appearance of soft-core porn in the inside back cover of Latvia's principal art journal, purporting to be art photography.

By and large, however, women were not particularly disadvantaged in the institutional art world of this time. It was the Soviet Union, after all, where, in addition to the privileged social status of artists and the lip service paid to feminist principles, nepotism flourished. Therefore, children of cultural bureaucrats and academy professors—daughters and sons alike—received preferential admissions treatment, found favor when official commissions and permissions were dispensed, and so on. But because many of the beneficiaries were genuinely talented, strong female career models rose to public prominence. Furthermore, with Džemma Skulme's crossover into professional politics,

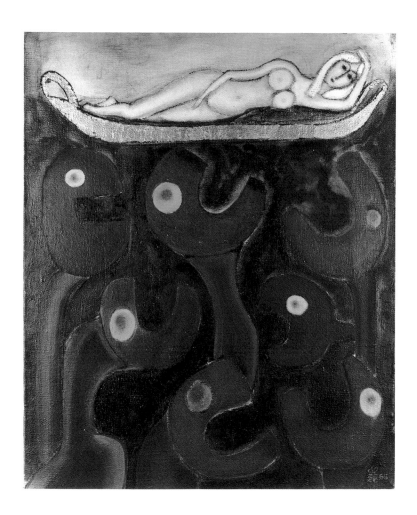

FIG. 173. Ilze Zemzare, *A Woman's Life*, 1969. Oil on canvas, 65.1 × 54.3 cm. Dodge Collection, ZAM, 00098.

gender imbalances within institutional structures began to be rectified.[98] Curatorial and editorial exposure of women artists was equitable. More often than not, female curators and editors set the tone of that critical dialogue. On occasion, they even set the pace for recovery of sensitive historical material, as seen in Tatjana Suta's 1975 monographic book about her father, a modernist stalwart who had been executed by the Soviets in 1944. Despite rehabilitation in 1959, Romans Suta had never been given his due, and this monograph was the fullest accounting to date of not only his achievements but also those of all the Latvian modernists. Suta insisted that her book include reproductions of cubist and constructivist work, full bibliographic sources, and other factual disclosures that one could hardly take for granted in that moment and place, and she prevailed.[99]

In any event, painters and sculptors who came of professional age in 1970s Latvia faced progressively lessening discrimination, rendering the contemporaneous Western project of an autonomous women's art movement somewhat less than imperative. Also, the fullest enfranchisement of painters like Skulme and Tabaka, combined with Latvians' high regard for handicraft (which rendered it less oppositional in nature), undermined the key Western feminist art premises that painting was irredeemably patriarchal and craft-based work was to become its antidote. These environmental conditions offer the best chance of explaining both the origin and character of a Latvian "women's art" phenomenon: painting-oriented, figural, coloristic, nondidactic, and rarely (if ever) self-described as "women's art."

Painters such as Inta Celmiņa (b. 1946), Helēna

FIG. 174. Inta Celmiņa, *Quartet*, 1969–70. Oil on canvas, 110 × 130.5 cm. Dodge Collection, ZAM, 01222.

Heinrihsone (b. 1948), and Vija Maldupe (1947–1997) initially made color the overriding concern in their work, as evident in Celmiņa's painting *Quartet* (fig. 174), an uncharacteristically abstract work from 1969–70. As time advanced, images of maternity became Celmiņa's signature, woman as the divided sex became a recurrent subject for Heinrihsone,[100] and Maldupe chronicled the everyday joys of a life not unlike her own, but color remained the primary means for them to express, respectively, the solemnity of motherhood, the anxiety of split-subjecthood, and the vibrancy of womanhood.

While sophisticated colorism remains apparent in work of women painters who came to prominence the following decade, color was secondary to exploration of representational strategies, and much of the credit for this shift of emphasis is due Aija Zariņa (b. 1954). Introducing a deceptively simple figural style possessing the savage energy of Art Brut, Zariņa recast images of femininity as pictograms, reexposing the forces of

desire—libidinal to maternal, physical to spiritual—that underwrite such sanitized cultural mainstays as ballerinas, "Europa and the Bull," and even matrimony. Zariņa's 1986 work *Husband* (fig. 175) is a portrait of art critic Ivars Runkovskis, her partner at the time, and all the affection, humor, and honesty that one expects in a primary relationship are manifested in this painting.

The controversy surrounding Zariņa's debut in the 1980s is only partly explainable by the graphic boldness of her art. Even her candid representations of woman as an empowered sexual creature, while unusual for Latvian art theretofore, can't fully account for the negative critical reaction at the start of her career. (In different ways, Inta Grinberga, Felicita Pauļuka, and Tabaka had previously and adequately broached that topic.) Zariņa's offense, it seems, was that for the first time, a Latvian woman artist was speaking with the kind of irreverent wit that local audiences had only tentatively accepted in the work of a select fraternity of

FIG. 175. Aija Zariņa, *Husband*, 1986. Oil on fiberboard, 170 × 170.5 cm. Dodge Collection, ZAM, 13414.

male artists. Before long, wit became the province of a newly ascendant circle of female painters, including Ieva Iltnere (b. 1957), Frančeska Kirke (b. 1955), and Dace Lielā (b. 1957). Kirke's 1985 work *Dance of the Militarists* (fig. 176) is a comic indictment of testosterone-fueled aggression—on a global scale most obviously, though her inclusion of S&M sex-play within the Boschian maelstrom of bodies links the personal with the political, as feminists have contended all along. Kirke's wit burgeoned with her subsequent series of appropriationist paintings, many of them dealing specifically with sexual identity and gender representation. Meanwhile, Lielā's work evolved from tongue-in-cheek expressionism to an extremely wry, self-referential attitude that eventually emboldened her to pair her juvenalia (and even a drawing done by her non-artist father) with icy photorealist renditions of the very same subjects she'd drawn as a schoolgirl. As for Iltnere, some of her earliest paintings were done in a deliberately schoolgirlish manner; one wonders

if this was a reaction to being seen as the privileged daughter of Edgārs Iltners, pioneer of Severe Style painting, head of the Artists' Union, and rector of the academy. The daughter's wit was purely her own, however, and it continues to inspire a body of work that somehow retains elements of that girlish style while addressing topics as diverse as paternal debt (Iltnere recreated her father's 1959 masterwork *Amber Seekers*, using the sort of aluminum mesh one might use to pan for minerals) and, indeed, the stakes of being a painter in a digital future.

Discussion of these last three artists has ranged beyond the Soviet era—deliberately, because the topic of women's art overlaps unevenly with that of nonconformism. Among the artists occluded from this preliminary attempt at such a match are photographers Māra Brašmane and Inta Ruka; painters Biruta Baumane, Līvija Endzelīna, Māra Kažociņa, Anita Kreituse, Antonija Lutere, and Anita Meldere; sculptors Ruta Bogustova and Arta Dumpe; and filmmakers Mudīte

FIG. 176. Frančeska Kirke, *Dance of the Militarists*, 1986. Oil on canvas, 147.5 × 167 cm. Dodge Collection, ZAM, 00181.

Gaiševska, Maruta Jurjāne, and Laima Žurgina. To varying degrees, each pursued a nonconformist tack in her art. Moreover, Brašmane organized an extraordinary international exhibition of women photographers in Rīga, providing an unprecedented professional network for Soviet women.[101] It is a woefully left-handed compliment to admit that so many accomplished Latvian women artists were active that it becomes impossible to discuss every one in the context of this essay, and therefore, they face the predicament of those worthy male artists who also go nameless in any historical survey.

SALON DES REFUSÉS

The hazard inherent in enumerating personalities who comprised Latvia's various nonconformist communities, the diversity of their work, and the broad range of their activities is that even an attentive reader may be lulled into thinking that conditions could not have been so adverse if unofficial art proliferated to that extent. Indeed, this seems to be the argument of erstwhile nonconformists from other parts of the So-

viet Union who now specialize in comparative maryrology. ("You call that suffering? We Muscovites *suffered!*" or the Estonian penchant for reverse chic: "Your republic still had *censors* in 1980? Pity.") Therefore, it is useful to recount several incidents that illuminate the true nature of the Soviet cultural system, focusing on artwork in the Dodge Collection that provoked these incidents.

Understandably, many examples of Latvian art that incited the government's ire early in the annexation period have not survived. For example, in 1951 when Indriķis Zeberiņš mocked the hyperbolic promises of collectivized agriculture by drawing *Kolkhoz Cow*—outfitting comrade cow with two udders—the caricature was seized by the KGB and used as state evidence in his court trial, after which it was presumably destroyed.[102] Other works did survive, such as one untitled, unattributed Latvian curiosity dating from the 1950s (now in the Dodge Collection), an oil painting of polished professional quality depicting Stalin as the face of the Great Sphinx. Too unlawful for their authors to risk being identified, such paintings and graphic works entered the world anonymously, belat-

edly, and wholly without our understanding what circumstances might have caused an artist to court disastrous consequences for the sake of protest.

Despite that, well into the 1980s, officials continued to close exhibitions, confiscate catalogues containing offending images or text, and deny art-making materials to anyone unaffiliated with the Union, many artists intuited already in the 1960s that enforcement was becoming erratic and arbitrary enough to justify the risks incurred with free expression. Conversely, sometimes bureaucratic arbitrariness—or a censor's overactive imagination—beleaguered artists who intended no offense whatsoever in terms of the style or content of a particular work. For example, Māra Brašmane (b. 1944) believed she was working in the genteel tradition of urban photographers like Brassaï when she created the work *Cabbages* in the mid-1960s. A well-stocked shop window, picturesquely unkempt but precisely framed, an understated sense of the surrounding context: this is a benign depiction of city life—comfortable, peaceful, abundant, and so on. But *Cabbages* was barred from exhibition because the censor suspected that, within the image, the presence of a hat that had fallen behind the produce indicated that Brašmane was making a subliminal linkage between heads of cabbage and "cabbageheads," or simpletons.[103] That a nonpatriotic viewer might extrapolate a political message from all of this was wholly insupportable.

Ten years later, when Miervaldis Polis attempted to exhibit his photorealist painting *Brass Band* (fig. 177), he considered the possibility that censors might become agitated by the visual trope of an abrupt palette shift between the overall composition, done in the washed-out hues of cheap color film, and the central detail of a trombonist, rendered in grisaille (or, more specifically, the gray scale of even cheaper black-and-white film). He hardly expected the rationale the censor gave him for denying public display of *Brass Band*: To his eye, the trombonist looked like Lenin. And as if enlisting the Father of the Revolution in a marching band wasn't disrespectful enough, Polis had compounded the insult by rendering him colorless.[104] If anything, this incident makes official sensitivity about cabbageheads fathomable.

Admittedly, such paranoia was both infrequent and entertaining enough that artists with a sense of sport began deliberately passing works of questionable content before exhibition and publication expurgators. Polis, who was always up for delivering abstruse art-theoretical apologia to a screening panel, submitted a painting titled *Still Life with Orphan* for exhibition in the early 1980s. Though the scene was very peculiar—a towheaded boy in a suit stands next to a funeral bier heaped with flowers and flanked by Douanier Rousseau–like profusions of foliage—censors found no reason to reject it. Evidently they had been too distracted by an awkward child amid botanical onslaught to notice that Polis had filled a large central portion of the composition with the outlawed pre-Soviet national flag, reconstituted with maroon and white roses. Of course, he was not so petulant as to supply the painting's full title, *Still Life with Orphan in Memory of the First Latvian Republic*, by which it is properly known today.

But the guardians of public morale were not always so easily duped. The following year, designer Ivars Mailītis (b. 1956) submitted an oil sketch for a poster commission, *C'est la Vie* (fig. 178), in which a sinking lifeboat filled with smug, overfed, well-dressed, inert people is being abandoned by giant rats who possess far better instincts in the face of disaster. This work was soundly rejected for its depiction of Soviet social apathy. Considering the potential alert that *C'est la Vie* might have sounded if produced and distributed as a poster, the rejection betrayed a certain fatalistic cynicism on the part of the censors themselves. Mailītis obviously did not accept this verdict as a defeat, for he devoted much of the remainder of the decade to public acts of political-cultural critique. In addition to organizing extraordinary performances, he defended others' rights to perform: When the rock band "Jumprava" was prohibited from staging a concert in 1987, Mailītis rallied fans with a poster (fig. 179), which instructed them to gather en masse and toss paper airplanes against the brick walls of the government ministry issuing the crippling paperwork.

Unquestionably, the steadiest commitment to the role of gadfly was assumed by painter and graphic artist Ivars Poikāns (b. 1952), who became the most dependable scourge of the censorship boards. As a consequence, he was also the most qualified to render an unauthorized portrait of a typical hack surveillant, *Portrait with Ears and Necktie* (fig. 180) of 1983. As caustic as this image is, Poikāns understood that its effectiveness was dependent on humor, and this indelicate

FIG. 177. Miervaldis Polis, *Brass Band*, 1974. Oil on fiberboard,
110.5 × 139 cm. Dodge Collection, ZAM, 11139.

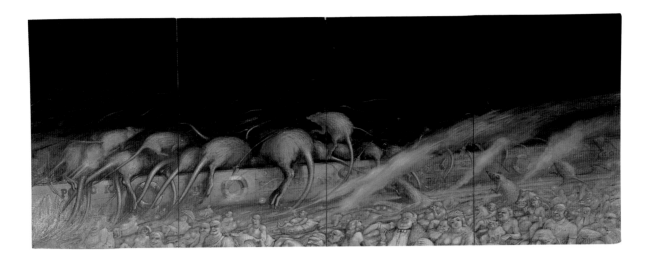

FIG. 178. [TOP] Ivars Mailītis, *C'est la Vie*, 1982.
Oil on fiberboard, 90.5 × 240 cm. Dodge Collection,
ZAM, 01386.01–04.

FIG. 179. [BOTTOM] Ivars Mailītis, *Jumprava*,
"*Poster Action*," 1987. Gouache and tape on gold-coated
paper, 60 × 90 cm. Dodge Collection, ZAM, 16983.

FIG. 180. Ivars Poikāns, *Portrait with Ears and Necktie*, 1983. Lithograph, 57.3 × 43.4 cm. Dodge Collection, ZAM, 11481.

balance is maintained throughout his oeuvre. Furthermore, as obvious as the enemy might have been, Poikāns did not hesitate to implicate himself in the whole rotten mess, and his lack of self-righteousness was refreshing for that environment. He lampooned professional celebrity in a self-portrait that shows his distended abdomen encrusted with undeserved medals à la Leonid Brezhnev, and he even dismissed the notion of art as the loftiest of callings in the 1984 lithograph *Glory to Labor!*, showing the artist analogous to a May Day Spectacle and executed in a mock-heroic sots-art style.[105]

Poikāns submitted works like *Portrait with Ears and Necktie* for exhibition, usually without success. Because of his undeniable technical skills, he attained visibility nonetheless, appearing in numerous graphics exhibitions beginning in the late 1970s after an abortive one-year stint at the academy. If some Party apparatchik would reject a caricature of a spook like him- or herself, then there were plenty of other works to accept—though Poikāns's more widely shown still-life etchings were no less acerbic, no less challenging to established tastes. Lurid color, frenetic line quality, the inclusion of vulgar elements (for example, wilted roses, an anatomically correct male marionette): there was something to offend everyone. And there were exhibition catalogues in which the entry devoted to Poikāns would be the only page lacking a reproduction, having been censored moments before the catalogue went to press.[106]

The irony central to Poikāns's art, however, is that societal ugliness is inventoried with a most beautiful, sumptuous painting technique. The effect is disarming. Cheerful nihilism pervades a work like *Landscape with Bathers* (fig. 181), which has as its twin targets Soviet Latvia's near-catastrophic pollution levels and similarly calamitous levels of anemic nymphets in local salon art. With closer inspection of the grotesque bathers—requiring movement contrary to one's inclination to recoil from the scene—one finds colors juxtaposed and brushwork propelled with such bravado that the viewer must concede that Poikāns upholds higher standards of beauty than the *belle peintre*. Of course, Poikāns has it both ways. Instead of deriving the juvenile thrill of rubbing the audience's nose in something repulsive, he discovered that, given the right incentive, contemporary audiences are more than willing to lean closer and do the rubbing them-

FIG. 181. Ivars Poikāns, *Landscape with Bathers*, 1983. Oil on fiberboard, 80 × 102 cm. Dodge Collection, ZAM, 19064.

selves. Similar to the bloodlust he witnessed among bathers brawling in a public sauna until the militia arrived to quell a growing riot—the subject of a spectacular pair of paintings now in the Dodge Collection —the appetite of Soviet authorities (and art world audiences) for scandal and disruption was seemingly insatiable, but Poikāns was there to satisfy.

As for scandal and disruption, the heavy hand of censorship was felt even after glasnost ostensibly curtailed such things. On the eve of Mikhail Gorbachev's new official policy of openness, the Cultural Ministry ordered the closure of an exhibition of works by Andris Breže (b. 1958), Ivars Mailītis, Ojārs Pētersons (b. 1956), and Juris Putrāms (b. 1956). Its curator, Irēna Bužinska, was dismissed from her post in the Young Artists' Union, an organization responsible for considerable liberalization of local visual culture during the early 1980s.[107] Another promising young curator, Inese

Baranovska, found her inclusion of Aija Zariņa on a mid-1980s exhibition roster challenged by authorities, and Zariņa's participation was permitted after a prolonged stalemate, broken only when the other, "acceptable" artists united and threatened withdrawal.[108]

Stories of artist solidarity in the face of mistreatment can be heartening, but the reductive scheme of an Us/Them dichotomy, perpetuated by such legendary confrontations, obscures the fact that the exclusionary dynamic in Latvia was more complex and multivalent. As disadvantageous as one's Baltic ethnicity was in the notoriously Russocentric, all-Union context, being an ethnic Latvian within the precincts of Latvian Soviet Socialist Republic cultural administration was decidedly an asset. An understandable response to the forces of Russification affecting Latvian culture, this protective, tribalist mechanism was bound to have an adverse effect on Slavic artists resid-

FIG. 182. Kirils Šmeļkovs, *Table I*, 1980. Etching, 74.9 × 56.7 cm. Dodge Collection, ZAM, 11476.

ing in Latvia. Paradoxically, non-Balt artists *unrelated* to those non-Balt bureaucrats responsible for the underlying cultural crisis tended to pay the price. One Latvian curator, whose marriage to an ethnic Russian afforded acute insight on the matter, has spoken extensively, though off-record, about patterns of discrimination against ethnic Russian painters active in Rīga during the 1970s and early 1980s. The fact that a majority of them worked in a surrealistic manner proved convenient for Latvian art administrators who pursued an informal "non-Latvian non grata" policy and needed a rationale for denying them exhibition space, publication exposure, or membership privileges.

Even Kirils Šmeļkovs (b. 1954), whose family was based in Rīga decades before the annexation and had assimilated culturally during the interwar period and, moreover, suffered Siberian exile after World War II, could recall situations in which he, as an ethnic Russian, was subjected to stricter criteria than his Latvian colleagues.[109] But for a variety of reasons, his career was relatively unaffected by this. First of all, Šmeļkovs entered professional life at the moment when local artists were assuming greater control of their own opportunities. He also was a demographic rarity, a multilingual ethnic-Russian resident of Rīga, and his perfect command of the Latvian language—not to mention his dim view of Soviet imperialism—made "cultural integration" a redundancy. Finally, and most crucially, Šmeļkovs was fluent in the lingua franca of postmodern graphic style, as one would expect of a member of the Ārgalis *polūcionisti*. And so works like *Table I* (fig. 182) not only had a pedigree beyond reproach, but also their *raison d'être* was clarity of expression within the de-ideologized space of the grid, delivered with the expediency of the marquee and the seductiveness of the billboard, two communication sites particularly aimed at blurring social distinctions through common desire. By the end of the 1980s, Šmeļkovs was producing work quite literally the size of billboards, an interesting scale for that historical juncture, given its recent disreputable association with monumental propaganda and its imminent disreputable association with corporate advertising, the visual blight of Rīga today.

Other ethnic Russian artists professionally active in Latvia are not so often incorporated within general discussions of local art historical development. Typically, a painter like Albert Goltiakov (b. 1924), an assistant professor at the academy whose work of the late 1960s

correlates to the revived realist impulse of Lancmanis, Vasiļevskis, and others, would go unnamed as an influence. (Consider, for example, Goltiakov's striking nude/still life from 1968, *Tension*.[110]) Other impressive artworks, like Yuri Nikiforov's untitled minimalistic painting of 1984 (fig. 183) or Gennadi Sukhanov's 1980 lithograph *Darkroom* (fig. 184), a work done in the tradition of paper architecture, demonstrate the vital presence of ethnic-Russian artists in Latvia, although critical and historiographic attention to this population is underwhelming. For instance, neither of these artists has been included in a major contemporary artist database under compilation in Rīga, a resource that is exhaustive with regard to ethnic Latvian artists.

In the interest of maintaining some sense of moral scale, it should be emphasized that there were mechanisms of discrimination far larger and more debilitating than the noninstitutionalized bias encountered by Russian artists in Latvia. In the case of anti-Semitism, the problem was not uniquely Soviet, yet the Kremlin's so-called nationalities policy fiercely abetted its workings. And so, while his decision might have nothing specifically to do with local aesthetic policy, a Jewish artist such as Semyon Segelman (b. 1933) could readily conclude in the 1970s that Rīga was inhospitable—the thriving, exemplary careers of Jewish artists Aleksandrs Dembo and Felicita Pauļuka and critic Herberts Dubiņš notwithstanding. Segelman emigrated to the West, as did many Jewish artists throughout the Soviet Union during the 1970s and 1980s. For fear that this merely reads like a litany of victimhood, the final point should be made that the greatest price in episodes of artistic intolerance is ultimately sustained by the dominant culture. Segelman was producing some of Latvia's most expressive, playful graphic works before his emigration to the West in 1975.[111] His large silk screen *Allez!* (ca. 1968–75)—in which a Picasso-like pair of circus acrobats cavort, the figure/ground and void/solid relationships do likewise, and the pubic hair of the female acrobat spells out the suddenly racy title—evidenced some of the reasons a nonconformist printmaker might be better off leaving, but also what the Latvian art community would be losing as a result.

STAGING RESISTANCE

One truism about the Latvian art community of recent decades is that some of the nation's most sig-

FIG. 183. Yuri Nikiforov, (Untitled), 1984. Mixed media on fiberboard, 80.2 × 52 cm. Dodge Collection, ZAM, 00733.

FIG. 184. Gennadi Sukhanov,
Darkroom, 1980. Hand-colored
lithograph, 47 × 46.3 cm. Dodge
Collection, ZAM, 09030.

nificant artists, critics, and historians were, before tak-
ing those positions, some of Latvia's lesser-known
boiler-room attendants, night guards, philologists, and
chemists. Prevented from enrolling in an art-related
course of study or denied work in an artistic setting (or
simply having chosen another vocational path ini-
tially), these artists and intellectuals found themselves
trained in methods and approaches different from ones
prescribed by the academy or the Cultural Ministry —
ultimately to their benefit. As the 1970s art-as-design
phenomenon proved, creative work informed by the
criteria of a different discipline could enjoy a distinct
advantage within the convention-bound system, and
the same held true for its creators.

To claim that Ilmārs Blumbergs (b. 1943) did not
train or begin working professionally as an artist would
be inaccurate, but in a sense his meteoric rise within
Latvian art was boosted by his cross-disciplinary atti-
tude toward visual culture. From the start, his work in
one discipline behaved as if it belonged to another.
Moreover, he had the foresight to introduce his inno-

vations backstage. Latvian theater productions had, for
some time, given artists some indication that set design
offered conceptual possibilities not yet available in
fine arts institutions. For instance, a set by Dailis Rož-
lapa (b. 1932) for the Youth Theater's 1964 staging of
Gundārs Priede's comedy, *The Reading Beaver*, com-
bined twin spiraling ramps with billboard-sized photo-
graphic details of snowdrifts, tree branches, and Rīga's
International Style bus terminal to form a minimalistic
photo installation that, frankly, authorities would not
have tolerated in a gallery, even if fancifully associated
with a bibliophilic beaver.[112] So, benefiting from such
precedents, and as a process artist in the guise of a
scenography student, Blumbergs gained immediate
public recognition with his set design for the Rīga Rus-
sian Drama Theater's 1972 production of Andrejs
Upītis's *Joan of Arc* (fig. 185). As the tragedy unfolded
on stage, what started as a barren, cube-like space grew
progressively cluttered with lowly objects, some func-
tional, some trashed beyond function. Actors soiled
the pristine walls with their "bloodied" hands and lac-

erated the surface with spears, giving audiences a lesson about corporeal engagement with the art object, be it in the manner of Burden, Fontana, Klein, or Pollock. In the production's final scene, a conflagration of ladders, barrels, lances, and a massive tangle of black wire occupied the cavity like an Arte Povera installation, chaos obliterating the virginal.[113]

Also analogous to the historical legend, but on the scale of his own life, Blumbergs catalyzed an aesthetic crusade, one that appealed to material simplicity, directness of means, and the vigor of heritage—indigenous heritage mindful of its contemporary responsibilities within a universal ethical context. This dualism was apparent in his 1978 project for *Latvian Mandala* (fig. 186), which again demonstrated the artist's tendency to blur boundaries separating genres. Essentially another process work, *Mandala* has, as its compositional foundation, a gray lithographed field with eight openings arranged around a central diamond, like cardinal points on a compass. Onto this schema, Blumbergs hand-drew elements of various symbolic systems—sequences of primary geometric shapes, lunar phases, and *tautas zīmes*, ancient Latvian motifs representing cosmological entities—sometimes segregated, sometimes interspersed, and thus mapped onto each other in a sort of symbolical ecumenism. The final, composite image finds these marks arranged within a concentric, lotus-like layering of squares and schemata. Being Latvian, the preliminary images have a hand-drawn quality that submits to rectilinear geometry as would any *raksti*, those native ornamental motifs. Being a mandala, the final work was intended to induce a meditative state, which is why Blumbergs intended the work to be displayed as a kinetic artwork, in perpetual rotation.[114]

Throughout the 1980s, he himself seemed perpetually kinetic, shuttling from project to project, whether scenography, costume design, easel painting, editorial illustration, ceramic work, or printmaking. Impressive simply in terms of his number of undertakings, Blumbergs also tended to conceive each work project as a series, perhaps a result of learning to conceptualize episodically for the theater. Consequently, his oeuvre possesses a depth as well as a breadth that makes critical encapsulation nearly impossible. How fitting, then, that as the printwork of Latvia's most prodigious artist enjoyed increasing international circulation, his untitled lithograph with a central image of an expo-

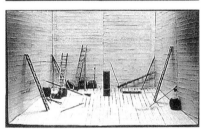
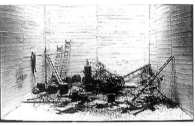
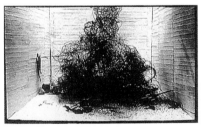

FIG. 185. Ilmārs Blumbergs, model for stage design of *Joan of Arc* by Andrejs Upītis, Russian Drama Theater, 1972.

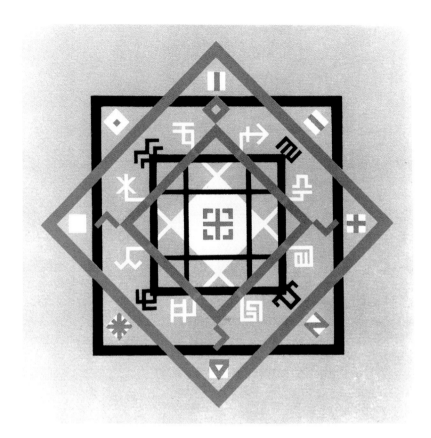

FIG. 186. Ilmārs Blumbergs,
Latvian Mandala, 1978.
Lithograph, 17 × 17.3 cm.
Dodge Collection, ZAM, 11487.

nentially self-reproducing priapic form was the one work repeatedly chosen for reproduction in the West, probably without the editors' awareness that they were printing a fertility idol.[115] Some of the strongest talents of the subsequent artistic generation, such as Andris Breže, Kristaps Ģelzis (b. 1961), and Oļegs Tillbergs (b. 1956), clearly have internalized Blumbergs's example in their installation work, just as his highly expressive draftsmanship can be seen to have profoundly influenced the graphic work of many younger Latvian artists. In the theater, his impact was immediate, as seen in the process-art décor Andris Freibergs (b. 1938) designed for the Leningrad Youth Theater's 1974 production of *Boris Godunov*.[116]

The staging of progressive art went well beyond the proscenium during the 1980s. The annual springtime festival Art Days (*Mākslas dienas*), initiated in 1959 and expanded to a week's duration in 1961, evolved over the years into such a large, complicated enterprise that artists and curators began to regard it as an opportunity to present nonconformist work. Not only

was government monitoring at its most diffuse during the week-long, republic-wide programming, but also funding was more likely to underwrite spectacle. Accordingly, kinetic environmental art was introduced in 1983 when Valdis Celms and Eduards Milašs (b. 1948) hoisted above Rīga's Dome Square a monumental, minimalistic interpretation of a Lithuanian decorative mobile (traditionally made of straw and a fraction of the interpretation's fifteen-foot height). *Puzurs* had social commentary as its basis, though this went unmentioned to festival organizers in need of décor.[117] Other Art Days events did not pass muster with authorities—the Breže/Mailītis/Pētersons/Putrāms group show was closed during the 1985 festival—but as artists moved their work into pedestrian tunnels and other locations of increasingly unrestricted public access, the risk of direct intervention was lessened. Still, state security escorted Oļegs Tillbergs from an installation/performance he staged in collaboration with Sergejs Davidovs (b. 1959) and Sarmīte Māliņa (b. 1960) in Philharmonic Square during Art Days 1987. During their

FIG. 187. Juris Boiko and Hardijs Lediņš, *Walk to Bolderāja*, 1982. Photographs by Juris Boiko. Collection of Mark Allen Svede.

performance, titled *Accident*, metal cages contained the artists' prone bodies, but authorities could hardly contain the anti-Soviet message transmitted to crowds assembling in the square, provoking a disturbance in which teenagers ran amok through Rīga, shouting liberationist slogans.

However, this audience reaction was highly uncharacteristic, mostly because *Accident* was uncharacteristically tendentious. More representative of the late-twentieth-century Baltic temperament, *Walk to Bolderāja* (fig. 187) became the central, even defining, work for an artists' collective known as the "Workshop for the Restoration of Nonexistent Sensations." The Workshop was formed in September 1982 by Juris Boiko (b. 1955) and Hardijs Lediņš (b. 1955), its name expressing not only an existential quandary but also, less succinctly, the avocational attitude that the two founders brought to art-making: Boiko was an autodidact painter; Lediņš, an architect. Predating the collective by two years, *Walk to Bolderāja* became an annual occurrence—"event" would connote greater

deliberation than it was given—and, in keeping with the Workshop's open-ended, exploratory name, these *Walks* happened in various seasons, at various times of day, with various participants. The single constant was its route: along train tracks that ran from near the center of Rīga to Bolderāja, the site of a Soviet submarine base. Their access blocked, the walkers would return, having seen not the sea but only a suburban, industrial netherworld. During the carnivalesque hike, nothing and yet everything happens, as can be seen in the three-hour video documentation of the last *Walk* in 1987 (a copy of which is in the Dodge Collection). In a conceptual sense, *Walk to Bolderāja* was conducted as if scripted by Marcel Duchamp's *Three Standard Stoppages*: The forces of chance were allowed to act repeatedly upon one rather inconsequential given, and cumulatively a pattern is revealed that somehow tallies as an artwork of profundity-qua-banality.

Despite being such a provisional, offhanded enterprise, the *Walks* served as a touchstone for the Workshop's full range of structured activities: "project-po-

ems," recordings, performances, "telephone-concerts," video work, and exhibitions. For these, Boiko and Lediņš were joined by Inguna Černova (b. 1962), designer Dace Šenberga (b. 1967), and architects Aigars Sparāns (1955–1996) and Imants Žodžiks (b. 1955) as core members, but the cross-disciplinary, interactive, and often improvisational nature of Workshop activities meant the frequent involvement of a larger cast: musicians, singers, and other artists, as well as audience participants. In their years of peak public activity, 1985 to 1989, the Workshop for the Restoration of Nonexistent Sensations went beyond the earnest, initial Actions and staged fashion-conscious, multimedia events—for example, the 1985 performance-installation, *An Opening: The Past and Postmodern Nightlife* —somewhat akin to those happening concurrently in New York's East Village. The truly postmodern aspect of all this was the artists' acute sense of irony. It was understood that Rīga had a paucity of modern nightlife to postmodernize, and prospects were even direr with regard to postmodern art-making in a technological backwater. If the Workshop's ultimate goal was to divine a "contemplative life-approach" mediating between "Zen-Buddhism and California hi-tech philosophy,"[118] it was apparent which of these paths was readily available and which would require some sort of simulation or approximation. Consequently, in what Baudrillard proclaimed the age of simulacra in the West, the Latvian collective began practicing what they called "Approximate Art," in which the artist's role as bricoleur continually challenged and reformulated the spectator's relationship to the real.

Adjunct to the Approximate Artists, hyperrealist-turned-appropriationist painter Miervaldis Polis promptly, gamely heightened the stakes. The challenge of determining what was real had long been an entertaining aspect of his paintings, but Polis's facility with trompe l'oeil technique was put to larger and more complex surfaces in 1986, when he created a mannequin perfectly resembling himself—or resembling Polis even more than Polis had of late. Corollary to this sculptural project, Polis began appearing in Rīga as *The Bronze Man,* a gilded but ambulatory monument, sometimes accompanied by the mannequin, which made surprisingly congenial company for something known as "Alter Ego." So began a complicated exercise in doubling, complicated further by the

fact that Polis vaguely modeled his nonperformance appearance after Joseph Beuys.[119] Like Workshop members (and, of course, Beuys), Polis posed extra-aesthetic questions in an extended interrogation called *Egocenter.* In particular, he was interested in isolating the point at which the egocentrism that authorizes the creative (artistic) process could escalate into aggression, the sort responsible for human disaster—which, in turn, inspires so much "great" art. Complicated enough in the entropic Soviet context, his assignment became even harder in light of Russian performance artist Oleg Kulik's Actions in the mid-1990s, suggesting that whatever answers *Egocenter* might find are fully contingent on the episteme of cultural expression within which an artist works (for example, Polis's Western humanist versus Kulik's aggrieved auto-orientalist).

Polis embarked on a sequence of dizzying replications, subjecting his multiple likenesses to a variety of exaltations and indignities. For instance, he painted a series of self-portraits within the center ring of paper practice targets, which he then took to a shooting range and trained a rifle on. The quality (and presumably price) of these works depended upon his marksmanship, an appropriate criterion for an artist celebrated for his precision. Elsewhere, Polis peeled the metallic coating off his body and either displayed it as a saintly relic or painted a hyperrealistic image of it, creating an icon (though one entirely of *uklad*).[120] This simultaneous self-effacement and -aggrandizement relates directly to the Bolshevik practice of coating inexpensive plaster statues with bronze powder to simulate a precious, permanent monument. As Polis dryly observed, this "led to the devaluation of bronze and made the advance of pseudo-heroes easier."[121] The Bolsheviks' monumental propaganda program had segued into a full-scale industry producing Leniniana for every home, office, school, and club; likewise, *Egocenter* was soon corporatized, with Polis acting as chairman of the board, overseeing corporate identity, awarding franchises (or at least an *Egocenter*™ cloisonné lapel pin) to like-minded thinkers, and planning a global strategy. For an artist who first insinuated his likeness into a Venice guidebook in 1973, continued finding new markets—for instance, *Self-Portrait in Dallas,* of 1986 (fig. 188)—and even convened an official "summit" in Helsinki with Finnish premier Harri

FIG. 188. Miervaldis Polis, *Self-Portrait in Dallas*, 1986.
Oil and collage on fiberboard, 46 × 36.5 cm.
Dodge Collection, ZAM, 16945.

Holkeri one year before Latvian diplomats could formally do the same, eventual establishment of a global presence did not seem unrealistic.

But there were unsolved problems closer to home. When photographer Atis Ieviņš conceived of a performance factographically titled *Unprecedented Event, First Time in the World, Boxing Match Between Women in Folk Mittens!* Polis was a natural to assume the stage role of boxing impresario. Ieviņš commissioned textile artist Inguna Zariņa (b. 1964) to knit anachronistic boxing-glove-shaped *cimdi* (mittens) bearing the *raksti* indigenous to two districts separated by the river Daugava. This symbolized a major undercurrent of political antagonism between Latvians in Latvia and those abroad, each imagining the other to be the Other, somehow complicitous in the Soviet tragedy: "If *you* hadn't fled …" versus "If *you* had resisted …" The performance debunked nationalists' cherished illusion of the Latvian people as a potentially homogeneous nation—geographically, psychically, or culturally—by pressing trifling ethnographic difference into service as a litmus-test-*cum*-loyalty oath. Staged on September 15, 1986, *Unprecedented Event* was actually one of two: That morning the divided Latvian people, those in the Soviet Union and the diaspora, were convening their first officially sanctioned rapprochement in over forty years at the "Chautauqua Conference on USSR-USA Relations" held in Jūrmala, Latvia. As history would have it, the boxing match (that is, Ieviņš's) was refereed by Māris Gailis, valuable practice for his post as premier of post-Soviet Latvia's contentious Fifth Saiema (parliament), in which he presided over a legislative agenda in which issues of national identity and citizenship came to the fore.

Another artist grappling with performative notions of nationality, Ojārs Feldbergs (b. 1947) was the sculptor mainly responsible for the post-1970s recovery of granite's empathic force as a "Latvian" material. In the early 1980s, Feldbergs directed his extraordinary abstractive powers—already evident in his 1976 undulating, curtain-like form that ripples across the façade of Rīga's Daile Theater—to features of an archetypal Latvian farmstead: a thatched house, hayracks, birch groves, even cattle blanketed in fog. These simple, elegantly rounded, volumetric sculptures recall the paintings of Grant Wood, that other resolute regionalist. For the sculptural group *My Homeland* of 1982 (fig. 189),

Feldbergs emphasized his vision of Latvia as an autonomous entity by surrounding a three-dimensional map of the republic with four vignettes representing the stages of human life: childhood, adolescence, adulthood, and seniority, each inseparable from (and symbolized by) a quintessential feature of the Latvian landscape: meadow (primordial), garden (endeavor), seaside (self-reflection), and forest edge (transition).[122] The symbolism is even more integral to a Latvian's experience: By orienting the vignettes with the cardinal points of the map, beginning with childhood in the east, the life stages correspond to the sun's ascent and decline, and the landscapes correspond with geographic characteristics typifying the four Latvian provinces, which lie in these four general directions.

A similar intricacy informs Feldbergs's 1989 performance-sculpture *Simple Stone*, in which he subjected ten granite boulders, each the approximate weight of an adult human, to tortures familiar to any KGB interrogator, including burning, drowning, shooting, and solitary confinement. On the fiftieth anniversary of the mass deportations, the assailed rocks were exhibited on crude wooden sledges, evoking Siberian exile, and eulogized in poems by Uldis Bērziņš.[123] Returning to both his renowned abstractive style and subtle philosophical tenor, Feldbergs created a monument honoring those who maintained the January 1991 vigil alongside the state television center, menaced by Soviet Interior troops. The sculptor had, in fact, dragged massive slabs of granite from his studio to the site, helping anchor the barricades. After the threat had passed, Feldbergs, in a sublime act of historical-material cathexis, transformed one of these slabs into an abstraction of the bonfire that had warmed those courageous separatists.

Of course, before the 1988 founding congress of the Latvian Popular Front and open debate regarding de-annexation, the chilling directness of *Simple Stone* would have been impossible. Recognizing this, and also understanding humor's equally subversive force, Ivars Mailītis took full advantage of his commission to decorate the Komsomol's 1987 Great Socialist Revolution anniversary youth dance. He choreographed an Action, privately titled *Aurora and the Worm*, in which a pasteboard battleship (somewhat less daunting than the original Aurora, launching pad of revolutionary events in St. Petersburg) skirmished on the dance floor with a giant black worm, while the band, in the guise

FIG. 189. Ojārs Feldbergs, *My Homeland*, 1982. Plaster, 15 × 20 × 20 cm, 12.4 × 10.5 cm diam., 7.5 × 10.5 cm diam., 11 × 10.5 cm diam., 8.4 × 10.5 cm diam. Dodge Collection, ZAM, 00419.01–05.

of Tsar Nicholas II and entourage, played on. Meanwhile, the familiar cartoon character *Iskra* ("Spark"— of the Revolution), actually a woman in costume, fanned the flames, hormonally speaking.[124] Just one year later, as the masses' mood grew markedly un-Party-like, Mailītis and his fiber artist partner, Inese Mailīte, helped return to public dialogue the mass graves in Siberia with huge totemic, dark, anthropomorphic wrapped-textile forms evoking the winding of shrouds, the metamorphic power of cocoons, and the weight of exile. The forms then served as props for the performance *People as Flags*, a ritual commemoration of ethnic displacement, and were finally hoisted over Rīga's rooftops at the moment the pre–Soviet Republic's flag was rehabilitated and flown for the first time in half a century.[125]

Suddenly, textile-based protest art looked to be a trend. In 1990, for the third annual "Arsenāls" film festival, Sergejs Davidovs and Krišjānis Šics (b. 1961) were tapped to decorate the main screening venue, which happened to be the deconsecrated Orthodox cathedral. Their proposal was to intertwine a vertical repeat-patterned fabric among the building's domes, forming an Oldenburg-like soft-sculpture analogue of unspooling film. However, officials were dismayed to discover that the closest celluloid equivalent of the fabric pattern was a porn movie's depersonalized shot of a woman's torso, a discovery made only after the fabric had been installed among the admittedly breast-like domes and, moreover, inflated to appear like a snake. In the same moment that Rīga's most prominent architectural vestige of Mother Russia was crudely femi-

FIG. 190. Ivars Poikāns, *Pup in the Summer (Perestroika)*, 1986.
Colored pencil on paper, 75 × 95 cm. Dodge Collection,
ZAM, 20770.

nized, the Church, like Eve, was depicted as colluding
with the Serpent. The vagaries of glasnost meant that
Davidovs and Šics would go unpunished, while the
manager of the factory that had printed the custom
fabric was not so protected and lost his job.[126]

DIE LETTISCHE SEZESSION

Latvian contemporary art, as a phenomenon, is
often dated to April 20, 1984, when the group exhibi-
tion *Nature—Environment—Man* opened in Peter's
Church. Of course, contemporary art had thrived lo-
cally for years. For proof, one needed to look no further
than this same venue, where, roughly a decade earlier,
installation and interdisciplinary work debuted before
a general public with the show *Form—Color—Dy-
namic*. Nevertheless, the 1984 exhibition was a pivotal
event in Latvian art, presenting work by over one hun-
dred artists to near-capacity audiences who, for the
most part, responded favorably, as well as to authori-
ties, who did not. Thus the exhibition was closed pre-
maturely in early May. This reaction was not entirely
unexpected, given that the church's former sanctuary
had been, in effect, reconsecrated by a life-size sculp-
tural interpretation of Leonardo's *Last Supper*, minus
the figure of Judas. Not coincidentally, the apostle's
position would be occupied by anyone wanting to view
the work, unflattering to even a presumably atheistic
censor.

Certain exhibited paintings, such as Ojārs Ābols's
Anti-Biedermeier, Leo Mauriņš's *Spring*, and Maija
Tabaka's *Summer* were progressive for the Soviet
Union as a whole—maybe even for liberal Hungary,
where an article about the exhibition contained an in-
verted reproduction of *Spring*[127]—but the far bigger
challenge to late Soviet convention was delivered by
a new generation of talent working in relatively new
media. This challenge took the form of assisted ready-
mades, as in a turf-filled Volkswagen by Andris Brēže,
Anda Neiburga, and V. Ošiņš; crypto-design models
such as neon chairs by Hardijs Lediņš, Imants Žodžiks,
and Leonards Laganovskis (b. 1955); hybrid forms such
as the painted *objet trouvé* called *Cucumber and Potato
Season*, by an artist noted for neither sculpture nor
painting at that time, Vitolds Kucins (b. 1955); small
installations, as in Mikelis [?] Bikše, Zaiga Putrāma (b.
1956), and Juris Putrāms's deStijl-like loom that pro-
duced mossy vegetation; or the enigmatic *Action* by

Indulis Gailāns (b. 1962), who erected a wooden fence, wheat-pasted handbills upon it, and then proceeded to dismantle it. The metaphor may have been muddled, but for an audience accustomed to numbing overstatement, Gailāns's anti-message was both stimulating and liberative.

The exhibition coincided with the rise of sympathetic art reportage and criticism within an increasingly diversified local press, and this proved far more important to the widespread sense that a contemporary art phenomenon was afoot. New voices like those of Pēteris Bankovskis and Ivars Runkovskis not only were conversant in issues shaping contemporaneous Western art, but they also understood that adopting foreign critical standards without regard to local discursive peculiarities would be detrimental to everyone. Correspondingly, the emergence of the Latvian artist-theoretician, such as Polis and Lediņš, ensured an interplay of global awareness and local praxis. This critical and artistic dynamic was reinforced by an expanding network with Latvians abroad, such as longtime émigré Valdis Āboliņš and relatively recent émigré Māris Bišofs. Most fortunately, this balance had already been struck when the West came calling with the advent of perestroika, so the seductions of the capitalist art market, curator-as-superstar, and ethnos-as-calling-card did not affect every Rīgan's ambitions and attentions. Indeed, an artist like Ivārs Poikāns, who had ample reason to doubt the promises of reform, would change nothing at all about his life and, in fact, subtitled his mutant *Pup in the Summer* (fig. 190) "*perestroika*." Here was a *Kolkhoz Cow* for the 1980s.

Despite some ominous eleventh-hour bureaucratic retrenchment and the lingering possibility of reprisals, glasnost did animate Latvia's art communities. Painting and printwork entered something of a renaissance in the mid-1980s. Increased exposure to art in broad international circulation had almost instantaneous reverberations in Latvia, as can be seen in *Old City Nude* (fig. 191A) by Kristaps Ģelzis, who transliterated Keith Haring's urbanism for a profoundly different architectural culture. Concomitantly, art that had been suppressed was now resurfacing, the ultimate example being Zenta Logina's abstract paintings and sculptures. Other marginalized artists who had maintained some measure of public presence, such as Auseklis Baušķenieks and Biruta Delle, suddenly found themselves the subject of solo exhibitions. And, as could be

FIG. 191A. [TOP] Kristaps Ģelzis, *Old City Nude*, 1983. Etching, 42.8 × 57.8 cm. Dodge Collection, ZAM, 11265.

FIG. 191B. [BOTTOM] Kristaps Ģelzis, *Mechanical Nude*, 1984. Etching, 58.5 × 44.3 cm. Dodge Collection, ZAM, 11266.

expected, artists who had long dominated the Latvian institutional art world either brushed off hidden caches of old work that might have compromised their privileged status during more repressive times or, in new work, suddenly discovered the pictorial liberations of abstraction, collage, faux-naivism, and ironic quotation, though this usually had pathetic, *arriviste* results. As Komar & Melamid have recently shown, elephants can be credible abstract painters, but the same does not hold true for dinosaurs.

Clearly, momentum had shifted to the young, also meaning that Latvia had shifted to the Western art world model that valorizes youth. In addition to doing complex and elegiac installation work, artists like Andris Breže, Ojārs Pētersons, and Juris Putrāms established their reputations with extraordinary series of monumental silk screens—average size, five by seven feet—whose imagery was commensurately overwhelming. Here the expressionistic influence of Ilmārs Blumbergs (fig. 192) is clear: bold linearity, mythopoeic imagery, and virtuoso craft. Their collective printmaking skill was all the more impressive given that they were maneuvering silk screens the size of walls in a typical Soviet flat, as seen in Putrāms's six-by-eight-foot diptych image of chameleons. Despite close collaboration on these so-called "super graphics," the artists maintained extremely distinctive styles. For example, Pētersons favored the emblematic image, rendered with the directness of Germany's *die Neue Wilden*, while Breže, always accounting for deep material associations, seems to have sensed that within Soviet culture, paper of this scale connotes mass propaganda, and so he incorporated photo collage–like elements one might find in Socialist Realist photo murals. But this referent is altogether sublimated, the impression complicated by postmodern ambiguity and wit that could only fail at mass manipulation.

In contrast to Estonian artists, whose comparatively advanced state of artistic dissent now risked devolving into visual pedantry when final restrictions on political self-expression lifted—bloody handprints on a national map silhouette would be stultifying imagery even for a secessionist rally leaflet, much less a fine-print edition—Latvian artists for the most part responded with a reinvigorated command of metaphor and allusion, apparently understanding that the shortest path between the two points of grievance and redress might well be the curve of an elliptical thought that doesn't foreclose further discussion by polarizing opinion or eliminating nuances of the situation. Even a work like *Who Is To Blame? II* (fig. 193) by Jānis Knakis (b. 1957), with its unflinching photo-vérité representation of a once-invisible segment of the Soviet population—people institutionalized with mental and physical disabilities—poses its accusation as a question. This strategy was honed by internationally acclaimed documentary filmmaker Juris Podnieks (1952–1992), who interrogated Soviet reality with paradigmatic glasnost films like *Is It Easy To Be Young?* proving that it was often more difficult, but vastly more productive, to refrain from narrative conclusiveness.

The most intellectually engaging artwork of the mid-1980s onward in pre-re-independent Latvia often seemed to balance between the mnemonic and a sort of willed amnesia regarding the nation's fifty-year Soviet experience. The content of this art might fully engage with historical trauma, while the means chosen to express the interpretation of historical events remain alien to that history. Therefore, a work like Andris Breže's *Bread Box No. 3* (fig. 194) from 1989 can distill multicultural anxiety within an ostensibly neutral late-modern assemblage. To the right, the torn cardboard scrap and enameled medallion evoke the Soviet colonial presence, by virtue of the Cyrillic lettering on what appears to have been a parcel sent to Latvia from the empire's interior, as well as the fact that such enameled portraits are typically found on non-Latvians' gravestones in Rīga's cemeteries. In contrast to this tattered, morbid vignette, another lozenge shape is carefully constructed—though of equally impoverished materials—and adorned with an abstract decorative element. This ornament is, by no means, traditionally Latvian, but it stands in elegant contradistinction all the same. Breže literally frames his works in this series with the ubiquitous bread box, which delivered the one dependable foodstuff to the Soviet citizenry, regardless of geographic origin or destiny.

Another archaeologist of the Soviet experience at this juncture, Oļegs Tillbergs let material circumstances speak for themselves. His 1987 assemblage, *Lotus Leaf* (fig. 195), consists of a plastic doll torso stuffed into a bakelite shell of a long-abandoned household appliance and fastened to an unexceptional piece of plywood. Given the components, we might expect to find something of a Hans Bellmer edginess here, but

FIG. 192. Ilmārs Blumbergs, *The Iron Age*, 1988.
Screen print, 70 × 101 cm. Dodge Collection, ZAM, 07980.

FIG. 193. [LEFT] Jānis Knakis, *Who Is To Blame? II*, 1986. Gelatin silver print, 36.7 × 28 cm. Dodge Collection, ZAM, 00896.

FIG. 194. [BOTTOM] Andris Breže, *Bread Box No. 3*, 1989. Mixed media, 64 × 74 × 7.5 cm. Dodge Collection, ZAM, 01506.

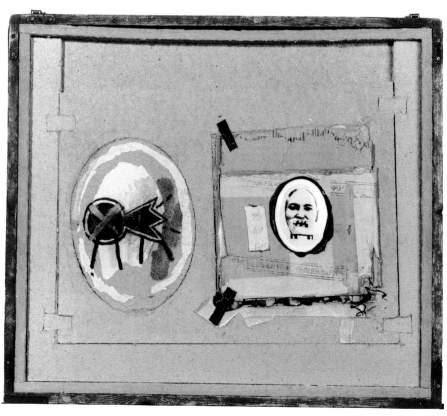

the materials are too fatigued and the assembly too slapdash to muster sexual dysfunction, much less perversion. In his installation work of the time, Tillbergs became the maestro of industrial decay, constructing ramshackle systems of scrapped machinery, stockpiling base elements (whether coal or army boots), and often adding the necrophiliac touch of his own inert, abject body. Ironically, these works proved more powerful—vital, even—than his more rational, serial installations, whether a dozen crane buckets poised between the presidential palace and a monument to a native Bolshevik, or the imposition of cool geometry on massive, wheeled slabs of basalt (a maquette for which is in the Dodge Collection).

Even Leonards Laganovskis, long considered Latvia's solitary sots artist, responded to the Soviet cultural malaise with a pictorial sensibility that clearly operates beyond it. *Tablitsa Laganovskogo dlya proverki ostroti zreniya*, a work from 1989, takes, as its form, the bulletin board common to the stairwells of Soviet housing blocks. The board is crudely made and sloppily painted, repeatedly, by some overzealous building super who is nonetheless incapable of keeping its lighting operational, given the widespread practice of switching burned-out lightbulbs from one's flat with working bulbs in the building stairwells. Instead of smudged, dog-eared bulletins from the housing authority, a pristine eye chart fills the space, its test pattern formed by acronyms for Soviet institutions: Communist Party of the Soviet Union, KGB, news agency TASS, German Democratic Republic, and entities progressively more obscure, in both reputation and typographic point size.[128] In essence, Laganovskis's announcement to fellow residents is about ideological acuity and what that means, metaphorically, in relation to clear vision. To perform well in this test, one also needs to know the Russian language, an adaptive (indeed, survival) behavior that most ethnic Latvians had no choice but to adopt. But the rote memorization of "All-Russian Special Committee for the Suppression of Counter-Revolution, Sabotage, and Black Marketeering" and its acronym was a sign of ideological dedication—which is to say, a certain moral degradation.

Of course, there were countless works from Latvia's perestroika era that, contrary to the passions of their artists, remained wholly disengaged from the political predicament or took a fully proactive approach. With a

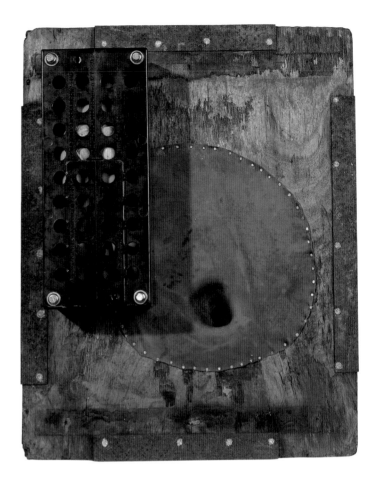

FIG. 195. Oļegs Tillbergs, *Lotus Leaf*, 1987.
Wood, leather, metal, and doll parts on wood,
50 × 40.5 × 22 cm. Dodge Collection, ZAM, 10938.

FIG. 196A. [TOP] Ojārs Pētersons, *Bridge Across the Sea*, 1990. Wood, Pētersons trademark orange pigment (destroyed).

FIG. 196B. [BOTTOM] Ojārs Pētersons, *Bridge* maquette, n.d. Painted wood, 14.8 × 40 × 20.4 cm. Dodge Collection, ZAM, 00594.

burgeoning exhibition exchange developing between Latvia and Germany, Scandinavia, and, to a lesser extent, the United States, Rīga's artists in the late 1980s found their work topical enough by virtue of geopolitical circumstances that there was little need to indulge Western orientalist tastes with ersatz Soviet culture from which they had long distanced themselves within the Soviet Union proper. Therefore, a work like Ojārs Pētersons's *Bridge*, for which the Dodge Collection has a maquette (fig. 196), was an optimistic gesture that Rīga, site of one terminus, would imminently find its cultural life linked with those where the opposing *Bridge* terminus was sited, first in Finland and then later in Germany. That Rīga's ice fishermen found *Bridge* to be a convenient source of firewood the winter after its erection was only a temporary setback to Pētersons's utopian program.

The role of painting within this politically electrifying situation was illustrated by an art event scheduled during the twilight of the Soviet empire. In November 1990, an exhibition titled *Gentle Fluctuations* involved six painters: Ieva Iltnere, Sandra Krastiņa (b. 1957), Jānis Mitrēvics (b. 1957), Ģirts Muižnieks (b. 1956), Edgārs Verpe (b. 1958), and Aija Zariņa. Many of their careers enhanced by rapturous critical reception in Berlin two years before, they were able to reserve Rīga's chief exhibition space for one month, where they resided and worked, and the public was invited to observe and interact with them. Documentation included weekly publication of a tabloid containing photographs and a chronicle of their progress. It included, as well, a calendar of exhibitions in New York, Paris, and Berlin, and also public reassurances to George Bush and Margaret Thatcher that Latvians were persevering in spite of terrorist attacks by Soviet Interior Ministry (OMON Black Beret special forces) troops while the Western powers took care of evidently more pressing business in the Persian Gulf.[129] Reaction to all of this was mixed, with detractors equating the project to a handful of musicians laying siege to the nation's best symphony hall at the height of the concert season, simply for the purpose of tuning their instruments for a month. They somehow missed the point—or deplored it—that contemporary art was less about a particular performance than it was process, personality, and the process of becoming a personality.

NOTES

1. To imply that no historical work of merit is currently being done with regard to late-twentieth-century Latvian art would be absurd and grossly unfair. For example, the Soros Center of Contemporary Arts/Rīga (now the Latvian Contemporary Arts Center) has compiled an extraordinary database pertaining to predominantly younger, more stylistically progressive artists. Yet this information is neither all-inclusive nor particularly analytical. Another qualified example: For the substantive 1996 Warsaw exhibition *Personal Time: Art of Estonia, Latvia and Lithuania, 1945–1996*, a more catholic curatorial selection for such a small number of Latvian artists (sixteen) may scarcely have been possible, yet the time parameter suggested by the title had little bearing on the exhibited works—painter Georgs Šenbergs was the only representative of the 1940s and 1950s, and the earliest completion date of the works of his shown was ca. 1960—while the accompanying catalogue essays were essentially belle-lettristic. Keep in mind that this paucity of broad critical accounts may have nothing to do with historians' efforts but everything to do with the vagaries of publishing, especially as the industry struggles to adapt to capitalist reality. Trotting out yet another compendium of much-beloved folk costumes is far more profitable than any serious analysis of contemporary art.

2. Lapiņš's speech, published in *Literatūra un māksla* (Literature and art) no. 10 (Rīga, March 11, 1951), is quoted by Helēna Demakova in "The Apple Harvest or Art in Latvia, 1945–1995: Between Personal and Ideologized Time," *Personal Time: Art of Estonia, Latvia and Lithuania, 1945–1996*, eds. Anda Rottenberg et al. (Warsaw: The Zacheta Gallery of Contemporary Art, 1996), Latvian volume, 11.

3. Epshtein's website has changed coordinates repeatedly, but for a sense of his *Book of Books*, see Evgeny Shklovsky, "From Internet to InteLnet: Electronic Media and Intellectual Creativity: An Interview with Mikhail Epshtein," at www.artmargins.com. For a more linear account of art-making in Soviet Latvia, see my "Latvian Nonconformist Art: Smaller Measures, To Equal Effect," in *From Gulag to Glasnost: Nonconformist Art from the Soviet Union*, eds. Alla Rosenfeld and Norton T. Dodge (New York: Thames and Hudson, 1995).

4. Olesya Turkina and Viktor Mazin, "In the Time when the Great Stories Collapse," in *After the Wall: Art and Culture in Post-Communist Europe*, eds. Bojana Pejić and David Elliott (Stockholm: Moderna Museet, 1999), 77.

5. Natalia Tamruchi, *Moscow Conceptualism, 1970–1990* (Roseville East, New South Wales: Craftsman House, 1995), 38.

6. Information on this and other exhibitions of the immediate postwar era comes from "Padomju Latvijas republikāniskas mākslas izstādes un to dalībnieki stājgleznotāji," in *Latviešu Padomju glezniecība*, ed. Skaidrīte Cielava (Rīga: Latvijas Valsts izdevniecība, 1961), 253–283.

7. See Aija Nodieva, "Staļinisma mākslas politika Latvijā un mākslinieku likteņl," and Māra Markēviča, "Latvijas Padomju mākslinieku savienības darbības daži aspekti (1944–1951)," both in *Doma* 1 (Rīga, 1991).

8. Recorded in the Latvian Artists' Union's Painter Section's protocol of January 31, 1949, preserved in Latvijas Centrālais Valsts Oktobra revolūcijas un sociālistiskās celtniecības arhīvs, 230 f., 1 apr., 127 l., p. 9.

9. Ibid.

10. Ojārs Ābols, in fact, helpfully pointed out Kalniņš's "degeneration" in an August 31, 1948, exhibition critique at the state art museum, as recorded in Latvijas Centrālais Valsts Oktobra revolūcijas un sociālistiskās celtniecības arhīvs, 230 f., 1 apr., 112 l., pp. 1–3.

11. Perhaps part of the reason one does not encounter such human presence in early Latvian Socialist Realism is that one rarely encounters a significant human presence in the local landscape tradition that so obviously informed works like *Grain for the State*. The keen attention Skride paid to the description of the rutted roadway alone bespeaks a heavy debt to the titan of Baltic landscape painting, Vilhelms Purvītis. Despite the efforts of the Soviet cultural elite to revise local art historiography to show Purvītis as a natural precursor to the new official style, the severe limitations of the master's method for achieving propagandistic results are evident here.

12. Juris Soikans, *Rudolfs Pinnis, gleznotājs. No Aiviekstes līdz Sēnai* (Rīga: Puse, 1993), 94–95.

13. Minutes of the Union meeting held January 5–6, 1950, quoted by Zigurds Konstants, *Jānis Pauļuks* (Rīga: Liesma, 1992), 19. Three years later, Pauļuks was expelled from the Latvian Artists' Union, but his expulsion was not upheld by the central governing body in Moscow. Within days of Pauļuks's participation in a Moscow exhibition organized by the all-Union Union, his Latvian membership was reinstated, which of course proves local subservience to Moscow, but also the odd fact that republican administrations were sometimes less forgiving than their repressive overseers.

14. For discussion of the French Group and an incisive yet sympathetic biography of Fridrihsons, see Gundega Repše, *Pieskārieni. Kurts Fridrihsons* (Rīga: Jumava, 1998), 33–36.

15. Andrejs Plakāns, *The Latvians: A Short History*, Studies of Nationalities Series (Stanford, Calif.: The Hoover Press, 1995), 147.

16. Conversation with relatives Jānis and Ieva Spalviņi, Rīga, June 14, 1993.

17. David Elliott, "Looking Things in the Face," in *After the Wall: Art and Culture in Post-Communist Europe*, 29–30, 34 n.7.

18. Quoted by Daniel Wheeler, *Art since Mid-Century, 1945 to the Present* (New York: Vendome Press, 1991), 223.

19. A small pencil drawing of Stalin's corpse made during

this covert trip to Moscow is in the private Skulme family archives.

20. Conversation with Jānis Borgs, July 3, 1994.

21. Already in 1962, Ābols was making timid remarks about modernist painter Aleksandra Beļcova's "constructive synthesis" ("Līdzsvars un formu harmonija," *Māksla* 4 [1962]: 37). By the late 1970s, his critical writings were a regular occurrence. To appreciate the full significance of this liberalism on the part of an official artist, see Imants Lešinkis's investigative journalism piece, "Kalpības gadi," *Laiks* (Brooklyn) (July 11, 1979–September 24, 1980), excerpted in *Latvija Šodien* (1986), 106–108. Lešinskis alleges the KGB recruited Ābols, along with Gunārs Krollis, Laimdots Mūrnieks, Ināra Ņefedova, Pēteris Postažs, Džemma Skulme, Indulis Zariņš, and Uldis Zemzaris to staff the KGB art supervisory section.

22. Interview with Leonīds Mauriņš, September 17, 1996. Skulme's personal intervention in matters of exhibition censorship was previously corroborated, off record, by a distinguished academic (now Latvian state official) who is widely believed to have collaborated with the KGB in his own nonart discipline and, thus, would have an insider's perspective on the involvement of other prominent individuals.

23. This information was shared by Ērglis, now executor of Zenta Logina's estate, in a series of conversations and private correspondence with the author, 1997–99.

24. Quoted by Ksenija Rudzīte in the catalogue *Zenta Logina: Kosmiskie loki. Glezniecība, meti gobelēniem, telpiskie objektie* (Rīga: Zentas Loginas fonds, 1999), 6.

25. Ibid. Several of these dimensional objects bear a striking tectonic resemblance to the epic mixed-media work *The Rose (Deathrose)* (1958–64) by Jay DeFeo (1929–1989), another artist whose belated, mostly posthumous, critical attention can be attributed to her gender and residence outside the major art centers.

26. Biographical information from Jānis Kalnačs, "Nomaļš latviešu grafiķis," typescript in author's archive.

27. Biographical information about Šenbergs is taken from author correspondence and conversations with Helmanis, dated 1991 to the present.

28. Noted by Gundega Cēbere in the Šenbergs catalogue entry in *Personal Time*, Latvian volume, 200.

29. Interview with historian Ruta Čaupova, June 10, 1993. Catalogues to this exhibition, containing an essay by Čaupova, were confiscated and destroyed.

30. Jānis Krastiņš, et al., *Latvijas arhitektūra no senatnes līdz mūsdienām* (Rīga: Baltika, 1998), 212.

31. For an extended discussion of this café milieu, see my essay "All You Need is Lovebeads: Latvia's Hippies Undress for Success," in *Style and Socialism: Modernity and Material Culture in Post-War Eastern Europe*, eds. David Crowley and Susan Reid (London: Berg, 2000).

32. Interview with Biruta Delle, February 15, 1998. Unless otherwise noted, all information about Delle's studio was obtained in this interview with the artist and two of her students.

33. A. Belmane and I[nāra] Ņefedova, eds., *Latviešu tēlotāja māksla* (Rīga: Liesma, 1970), 224.

34. Interview with former Delle student and poet Liāna Bokša (pseud., Langa), February 15, 1998.

35. As it happened, the Severe Style was pioneered by members of the immediately preceding generation of Latvian artists, such as Edgars Iltners (1925–1983).

36. Like many nonconformist exhibitions, *Zemūdene* shows were mounted in spaces not designated for art, yet they remained susceptible to surveillance and closure. For example, Delle's 1979 solo show opened in the western provincial town of Kuldiga, was closed after one week, and then reopened in the seaside resort of Bulduri—the first nonjuried exhibition in this outlying area of Rīga.

37. Interview with Eižens Valpēteris, February 17, 1998.

38. Regarding Latvia's introductory role in Soviet rock music, see Artemy Troitsky, *Back in the USSR: The True Story of Rock in Russia* (London & Boston: Faber & Faber, 1988), 21.

39. For an extended discussion of Grinbergs's identification with Christ, see my essay "Twiggy & Trotsky: Or, What the Soviet Dandy Will Be Wearing This Five-Year-Plan," in *Dandies: Fashion and Finesse in Art and Culture*, ed. Susan Fillin-Yeh (New York: NYU Press, 2001).

40. These performances were, respectively, *The Last Lībiete* (1974), *Terrorists* (1974), *Creation* (1973), *The Green Wedding* (1973), and *Birth* (1976). The Livs (or *lībieši*), an indigenous Latvian people, were already nearing extinction before Kremlin policy thwarted their seafaring folkways and livelihoods, hastening the group's assimilation into Soviet urban or collectivized rural social structures.

41. For an overview of the liberalized Latvian film industry, see Val S. Golovsky, *Behind the Soviet Screen: The Motion Picture Industry in the USSR, 1972–82* (Ann Arbor, Mich.: Ardis, 1986), 44–45.

42. Summary comments by Mekas to the audience at the première of the newly restored *Self-Portrait*, Anthology Film Archives, New York City, February 15, 1997.

43. The 1993 exhibition *Kaza kāpa debesīs* took place in the J. Raiņa Literatūras un mākslas vēsture muzejs, Rīga.

44. Quoted in a 1999 promotional publication produced by daughter Alise Tīfentāle.

45. For example, Yuri Pimenov's doctrinaire quote served as an epigraph to the chapter "No kurienes mēs nākam" in Aija Nodieva's otherwise open-minded survey, *Latvieši jaunākā glezniecība* (Rīga: Liesma, 1981), 9.

46. In fact, the Dodge Collection has faced a unique challenge in its acquisition of representative Latvian nonconformist works, relative to its overall project of collecting from former Soviet republics: from the mid-1970s onward, acquisition policies of the state museum association, Cultural Fund, and Artists' Union were so uncharacteristically universal and extensive as to make it nearly impossible today to locate available examples by artists of limited output (for example, painter Bruno Vasiļevskis). Moreover, the very fact that official cultural organizations patronized artists who

were nonconformist by stylistic definition tends to call into question their status as nonconformist, particularly in the minds of critics who regard this issue as strictly dichotomous.

47. Fredric Jameson, *Postmodernism, Or, the Cultural Logic of Late Capitalism* (Durham, N.C.: Duke University Press, 1991), 6–10.

48. Reproduced in Ināra Ņefedova, *Latviešu glezniecības meisterdarbi* (Rīga: Liesma, 1988), n.p. (fig. 59).

49. Conversation with Vorkals, June 30, 1994.

50. See Leonhard Lapin, "Perifērija un centrs," *Literatūra un māksla*, no. 8/2455 (March 6, 1992): 10. Christian Mailand-Hansen also discusses Baltic attention to center/periphery issues in "Kunst fra Baltikum," *Siksi* 2 (1990): 20. Intranational manifestations were addressed in 1999 when the Soros Center for Contemporary Arts/Rīga temporarily relocated its major annual exhibition to the port city of Ventspils. Revealingly, aspects were patronizing—art celebrities were brought (bestowed) from Rīga on a veritable *agit*-train and whisked back before nightfall—and, at the same time, designed to seduce patrons. It was hoped that this momentary deflection of the spotlight would convince Ventspils's lucrative transit-business titans to underwrite culture at a moment when George Soros was withdrawing his support.

51. Gundega Cēbere, "Leonīds Āriņš," in *Personal Time*, Latvian volume, 28.

52. Actually, even so simple a suggestion cannot be made without questioning Pollock's debt to his predecessor, a topic somewhat elided by Yve-Alain Bois in "Strzemiński and [Katarzyna] Kobro: In Search of Motivation," in *Painting as Model* (Cambridge, Mass.: MIT Press, 1990), 123ff. At the very least, one should point out, for comparison's sake, the 1934 Strzemiński work *Sea Landscape*, reproduced on p. 132.

53. Author interview with Auseklis Bauškenieks, Rīga, February 10, 1998.

54. As with his many other paintings that address specific aspects of art-making and -display, Bauškenieks skewers cultural pretensions, but he succeeds in confounding whether the trend-following contemporary artist or the philistine who dismisses contemporary art out of hand is more arrogant.

55. Slavoj Žižek, "Enjoy Your Nation as Yourself!" in *Tarrying with the Negative: Kant, Hegel, and the Critique of Ideology* (Durham, N.C.: Duke University Press, 1993), 200.

56. There is also the sense that, like the mother in Lacan's infant-before-the-mirror scenario, the Western critic/curator/historian can be the agent naming names, identifying identities. Therein lies the greatest danger in regarding East European art in a retrospective sense from abroad.

57. See Nodieva, 123. Official apprehension over the possibility that local audiences would empathize with American predicaments was evidently high during the 1970s. For example, Kurts Fridrihsons was denied permission to exhibit his series of Amerindian portraits because officials feared that Latvians would identify with the native Americans' brutalization by colonizers; conversation with relatives Jānis and Ieva Spalviņi, Rīga, June 14, 1993.

58. Reported by Vladimir Kostin in "Baltijas republiku mākslas skate Maskavā," *Māksla* 1 (1974): 9.

59. These consumer rarities feature in *Still Life with Keds* [*sic*] (1967) by Guntis Strupulis, reproduced in *Klusā daba*, ed. Dace Lamberga (Rīga: Liesma, 1986), pl. 138; *Still Life* (1979) by Juris Zvirbulis, in the Dodge Collection; and *Still Life* (1969) by Imants Lancmanis, reproduced in Nodieva, p. 191.

60. Ekaterina Dyogot, *Contemporary Painting in Russia* (Roseville East, New South Wales: Craftsman House, 1995), 46.

61. Such graphic stylization debuted during the thaw, when it conveyed the newfound spirit of contemporaneity, but was subject to the same empty repetition that voided most visual manifestations of Soviet mass culture during the 1970s. This explains why it was so ripe for parody by Komar & Melamid, Aleksandr Kosolapov, and others. In Latvia, Leonards Laganovskis modeled certain early works on this style of propaganda imagery.

62. Named in reference to the group's attraction to foreign style, this "French Group" is not to be confused with the intellectual associates of Kurts Fridrihsons who ran afoul of Stalinist authorities in the early 1950s (see above). However, as the art students maintained their artistic integrity despite an increasingly hostile cultural climate, their collective name surely resonated in the minds of those familiar with the first French Group.

63. Historian Eduards Kļaviņš would argue that the young Lancmanis had no awareness of photorealism as a strategy of representation and that his work was not a " 'return to realism,' but rather, an intuitive discovery of the sensual reality that had become lost in the Post-Impressionist platitudes and the virtuoso decorativism of the local authorities on art today"; "Imants Lancmanis," in *Personal Time*, Latvian volume, 48. This may explain his early realist still lifes, but it cannot account for a work like *Suvarov Street*.

64. This flawed, fixed horizon was pointed out to me by his friend and peer Miervaldis Polis during a visit to Vasiļevskis's Mežaparks flat (February 22, 1998), where the artist's widow, Daina Vasiļevska, keeps the table in the exact position it occupied when it served as painting model/backdrop.

65. Jānis Borgs, "Bruno Vasiļevskis," in *Personal Time*, Latvian volume, 44.

66. For a detailed discussion of the artist's self-portraiture and how it insinuates itself within the Western painting canon, see my essay "Twiggy & Trotsky," in *Dandies*, 259–261.

67. Such experiments with photo manipulation and adaptation were already briefly recognized by Laimonis Stīpnieks in one of the journal *Māksla*'s annual chronologies (1973, no. 3, p. 54), with specific mention of Atis Ievиņš and Aldonis Klucis (see below). Therefore, critic-curator Helēna Demakova's recent assertion, "It would be wrong to overestimate ['art with photography']'s role, for before the mid '80s, with the exception of the experimental artists' group 'Work-

shop for the Restoration of Never Experienced Feelings' . . . no artists had considered the use of photography in their work," is downright mystifying; "Photography and Life—Photography as Life: Extended Horizons in Latvian Photo Art since the 80s," in *Das Gedächtnis der Bilder. Baltische Photokunst heute*, ed. Barbara Straka (Kiel: Nieswand, 1993), 61.

68. Indulis Bilzens, Maruta Schmidt, et al., eds., *RIGA: Lettische Avantgarde/Latviešu avangards* (Berlin: Elephanten Press, for Neue Gesellschaft für bildende Kunst, 1988), 42.

69. Despite his association with Dalí, Rīga-born émigré photographer Philippe Halsmann was hardly august enough to engender hometown emulation in the way New York–based George [Jurģis] Mačiunas begot a Fluxus following in Lithuania.

70. Introductory essay to Reihmane's *Latviešu padomju stājgraffika* (Rīga: Liesma, 1982), n.p.

71. Svetlana Hajenko, "Aleksandrs Dembo," in *Sava krāsa varavīksnē*, ed. Karmella Skorika (Rīga: AGB, 1997), 71–72.

72. See Tabaka's serialized memoir, "Laiks, mans lielais ienaidnieks," *Diena* (*Sestdiena* supplement), April 17 and 24, 1993, p. 11. The Kalniņš milieu is also well described by his former partner, American poet Kelly Cherry, who attempted to reside in Soviet Latvia in the early 1970s. See Cherry, *The Exiled Heart: A Meditative Autobiography* (Baton Rouge: Louisiana State University Press, 1991).

73. An explanation of KGB "art section" involvement with the Tabaka case is offered in Lešinkis, "Kalpības gadi," in *Latvija Šodien*, 106–107. Conversely—and after one might expect Soviet parochialism to have disappeared—Tabaka assiduously lobbied for Andris Grinbergs's inclusion in the 1987 Berlin exhibition *RIGA: Lettische Avant-Garde*, prevailing over the objections of consulting Latvian museum directors who saw no value in performance art, much less anything of an overtly sexual nature; conversation with Tabaka, Jūrmala, June 2, 1994, subsequently confirmed in correspondence with Grinbergs.

74. See Riņķe's introductory essay for the catalogue *Contemporary Soviet Painters from Riga* (New York: Eduard Nakhamkin Fine Arts, 1987), n.p.

75. In a catalogue statement, Dimiters indicates that these still lifes seek to express a "beautiful, indescribable, universal language . . . language without race or national barriers," which argues against divining a political message in the work—unless, of course, the message is that archetypal imagery from the collective unconscious supersedes political regulation. He is less convincing when he describes these enigmatic paintings as "linear, without insinuations," but he readily admits, "If it happens that I include metaphor, humor, [or] grotesque elements, it is only to prevent my thoughts from becoming dry, scientific, academic or crushingly didactic"; translated from "Juris Dimitris [*sic*]," *Sowjetkunst heute. Malerei, Graphik und Skulptur aus der Neuen Galerie-Sammlung Ludwig, Aachen, und aus der Ludwig-*

Stiftung für Kunst und Internationale Verständigung, Aachen (Köln: Museum Ludwig, 1988), 66.

76. The concept of *poshlost'*—a vulgar sort of luxuriousness, the attraction to which was derided by Soviet ideologues as symptomatic of petit-bourgeois attitudes—and its translation into Soviet artistic debate are discussed in Svetlana Boym, *Commonplaces: Mythologies of Everyday Life in Russia* (Cambridge, Mass.: Harvard University Press, 1994), 41ff.

77. Jānis Borgs, "Māris Ārgalis," in *Personal Time*, Latvian volume, 60.

78. Ibid.

79. Aldonis Klucis was Ārgalis's longtime serigraphy collaborator, so his hand may well have produced the *Graphism* series. (In any event, the attribution of the image to Gustav Klucis in *Personal Time* [Latvian volume, 61] is certainly incorrect, although Ārgalis & Co. no doubt enjoyed the serendipitous affiliation with the earlier constructivist master.) Correspondence with Šmeļkovs, November 5, 2000.

80. Borgs, "Ārgalis," *Personal Time*, Latvian volume, 60.

81. Ibid.

82. Renee and Matthew Baigell, eds., *Soviet Dissident Artists: Interviews after Perestroika* (New Brunswick, N.J.: Rutgers University Press, 1995), 67.

83. Regarding the Latvian contribution to the productionist movement (in an essay that is nonetheless oblivious to anything Latvian-inflected about this contribution), see Maria Gough, "In the Laboratory of Constructivism: Karl Ioganson's [Kārlis Johansons's] Cold Structures," *October* 84 (Spring 1998): 90–117.

84. Such studies—in reality, modernist bas-reliefs and sculpture—are reproduced in Rasma Lace and Tatjana Kačalova, eds., *Latvijas PSR Valsts mākslas akadēmija* (Rīga: Liesma, 1969), 99, 104–106. Western artists with comparable works include Sergio de Camargo, Jesús Rafael Soto, and Luigi Tomasello.

85. I. Svabs, "Vytvarnici na pomoc konstrukterum," *Tvar* (Prague) 14, no. 5/6. The earliest recognition of the Latvian design phenomenon in the Soviet press was the 1961 article by L. Aleksandrev, "Rabota nad sozdaniem promyshlennykh obraztsov (Rizhskoe spets. khudozhest.-konstruktorskoe byuro)," *Vosprosy izobretatel'stva*, no. 9. The artists themselves were highly aware of their press presence, compiling an impressive bibliography for the catalogue of the Fifth Republican Design Exhibition, *Vide—Dizains—Kvalitāte* (Rīga: Latvijas PSR Mākslas fonds, 1977), 44–45.

86. "Actualités: Lettonie," *Design industrie. Esthétique industrielle* 92 (September–October 1968): 51–52. To regard this modest journalistic feature from a Western vantage is to understand how the slightest foreign recognition could hearten Rīga's isolated design community.

87. Iurii Gerchuk, "The Aesthetics of Everyday Life in the Khrushchev Thaw in the USSR (1954–64)," *Style and Socialism*, 82.

88. For instance, two of the following generation's most significant artists, Andris Breže and Ojārs Pētersons, recall

the formative influence of the *Allégro* murals on their own development, a powerful tribute considering that neither one's work bears overt resemblance to that of Mauriņš—nor are they painters; credited in the exhibition catalogue *Henrihs Vorkals, Andris Brēže, Ojārs Pētersons, Juris Putrāms* (Rīga: Latvijas PSR Mākslas fonds, 1987), n.p. The murals, now part of the Casino Latvija complex on Kaļķu Street, are reproduced in Ilze Konstante, *Leo Mauriņš. Gleznas, interjeri*, ser. Mūsu mākslinieki (Rīga: Liesma, 1992), pl. 3–6.

89. Sandra Kalniete alludes to this process of reversing anachronistic codifications dating from the 1920s in *Latvju tekstilmāksla* (Rīga: Liesma, 1989), 8–9, 18–21.

90. Images of *Positron* are reproduced as part of a succinct statement of Celms's theories in "The Dialectic of Motion and Stasis in Kinetic Art," *Leonardo: International journal of contemporary visual artists* (Oxford) 27, no. 5 (1994): 387–390.

91. For an extended discussion of covert nationalist expression in Latvian architectural design, see my essay "Curtains: Décor for the End of Empire," forthcoming in *Socialist Spaces in Eastern Europe and the Soviet Union, 1947–1991*, eds. David Crowley and Susan Reid (London: Berg, 2002).

92. The 1984 exhibition *Daba, Vide, Cilvēks* is commonly cited as the debut of installation art in Latvia, which is a mistake. For Andris Grinbergs's 1977 Action titled *The Old Home*, rooms of a house slated for demolition were inhabited by various artists, some of whom created total environments for the select audience. (For instance, Eižens Valpēteris cross-dressed as a vamp—a moustachioed one, no less—and sat enthroned before a wall sporting Maoisms written in Chinese script.) Strictly speaking, *Forma—Krāsa—Dinamika* represented the debut of installation art before the Latvian public.

93. See chapter three of Vivian Sobchack, *The Address of the Eye: A Phenomenology of Film Experience* (Princeton: Princeton University Press, 1992).

94. Information on photographic technique is from Boris Mangolds, *Stepping Out of Line: Contemporary Photography from Latvia* (Millersville, Pa.: Millersville University, 1992), n.p.

95. Māris Ārgalis, *Modeļi* (Rīga: Latvijas PSR Mākslas fonds, 1978), text from folio sleeve.

96. Pēteris Bankovskis and Gundega Repše, "Die Frauenfrage," in *RIGA: Lettische Avantgarde*, 19–22.

97. For three varied perspectives on issues raised by women artists' activities, see the main catalogue essays for these exhibitions: M[aija]S Bišmanis, "Reconstructing Identity," in *Reconstructing Identity: Latvian Women Artists* (Regina, Saskatchewan: Mackenzie Art Gallery, 1996); Antra Klaviņa, "Sechs," in *Karyatiden: Sech Malerinnen aus Rīga* (Bonn: Frauen Museum, 1992); and my "Women Painting," in *Women Painting Women* (New York: Mimi Ferzt Gallery, 1996).

98. Admittedly, this account oversimplifies what was a complex triangulation of nationalist, feminist, and careerist political impulses. Alas, even the exacting Bulgarian-born critic Julia Kristeva glossed aspects of Eastern bloc *Realpolitik* as female empowerment and self-symbolization in her landmark essay, "Le Temps des femmes," republished as "Women's Time," in *Signs: Journal of Women in Culture and Society*, trans. Alice Jadine and Harry Blake, vol. 7, no. 1 (1981): 13–35. Nonetheless, Kristeva's comments about changes in concepts of the nation and identity, and how these relate to feminist issues of self-representation, are fascinating in light of renewed East European nationalism.

99. Proof of the magnitude of the daughter's historiographic accomplishment is found within the book itself: Officials stipulated removal of the face of a fellow artist (a vocal critic of Soviet policy then living in Sweden) from a 1919 group photograph of Rīga modernists, thus demonstrating the persistent threat of censorship; Tatjana Suta, *Romans Suta* (Rīga: Liesma, 1975), 23. The anti-Communist pariah Niklāvs Strunke is fully visible in reproductions of the photo published years later; see, for example, Dace Lamberga, *Jēkabs Kazaks*, ser. Mākslinieki un darbi, no. 8 (Rīga: Latvijas enciklopēdija, 1995), 21. Tatjana Suta pointed out the censorship to me in a conversation of July 20, 1995. In addition to this official act of distortion, the circumstances of Suta's arrest and murder were still unmentionable in the 1975 publication.

100. Heinrihsone explained this growing preoccupation in an informal gallery talk in connection with *Women Painting Women*, Mimi Ferzt Gallery, New York, May 23, 1996.

101. This was *Fotografē sievieti/Fotografiruet zhenshchina/Woman with Camera* of 1977, with seventy-six exhibitors representing seventeen nations.

102. This is recounted in the Zeberiņš memoir, *Kas vēlas ar mani krampjos vilkties?* (Rīga: Māksla, 1992), 75–76, 81.

103. Conversation with Brašmane, February 19, 1998.

104. Conversation with Polis, June 20, 1994.

105. This image was, in turn, used to promote Poikāns's solo exhibition, *Darbam slava!* held in the Young Artists' Club, Rīga, August 2–27, 1988.

106. See, for example, the 1980 Latvijas SSR Art Fund catalogue, in which the work *Rosy Flesh* appeared in title only. Poikāns notes the relative inconsistencies in the visibility of his work. For example, his two small lithographs of an actual brawl in a local sauna (also the subject of a pair of paintings in the Dodge Collection) were prominently hung in the *Third Miniature Graphics Exhibition*, held March 1979 in Rīga's Republikas Zinību nams; personal correspondence, January 20, 2001. One wonders if the comical nudity was palatable because it was represented on the scale of a comic strip.

107. Conversation with Brēže, June 30, 1991.

108. Conversation with Baranovska, June 11, 1999.

109. Conversation with Šmeļkovs, July 2, 1994. However, demonstrating the extent of his family's Latvian acculturation, he accepted the predicament as an inevitable consequence of larger historical processes.

110. *Tension* is reproduced in Ingrīda Burāne, ed., *Lat-*

vian Painting/Lettische Malerei. 70 Years of the Latvian Academy of Arts (Cologne: Unicord, n.d.), 56.

111. For examples of Segelman's art and a brief biographical sketch, see Svetlana Hajenko, "Semjons Šegelmans," in Sava krāsa varavīksnē, 79–83.

112. Rožlapa's set is reproduced in Yelena Rakitina's "Šodienīgi par laikmetīgo," Māksla 1 (1965): 25. The vitality of mid-1960s Latvian scenography with respect to Western contemporary art deserves further investigation. For instance, Valdis Treijs's maquette for the Youth Theater's 1967 production of Anna Brigadere's Maija un Paija (reproduced in Ģirts Vilks and Emīlija Jaunzeme, eds., Latviešu padomju scenogrāfija [Rīga: Liesma, 1981], n.p.) is strongly reminiscent of Alberto Burri's sutured canvases.

113. Although the complexity of the process is fully evident in the series of sketches and maquettes made for the production—wholly realized artworks in themselves—the dramaturgical dimension of Blumbergs's accomplishment is discussed by Viktor Beryozkin in Ilmārs Blumbergs, ser. Mūsu mākslinieki (Rīga: Liesma, 1983), n.p. At the time, editors went so far as to reproduce Blumbergs's sketch showing a crucifix stage-center; Māksla 4 (1972): 52.

114. Conversation with Blumbergs, July 2, 1994.

115. See Edward Lucie-Smith, Art in the Seventies (Oxford: Phaidon, 1980), 121; and Dodge and Rosenfeld, From Gulag to Glasnost, 107. In conversation (June 4, 1993), Blumbergs disclosed that the phallic resemblance was, of course, intentional. Once again, we find a nation with one of the lowest birthrates in the world, generally attributed to a staggering incidence of male infertility, represented by "emissionism."

116. Freibergs's maquettes are reproduced in Latviešu padomju scenogrāfija, n.p.

117. Some years later, Celms went on record stating that Puzurs "represents the structure of the social world with its stagnant classes, which in real creative motion is crushed at the bottom"; from his presentation for the conference "The Way of Life and Living Conditions in Socialism," at Moscow's Soviet Technical Research Institute (BNUUT), October 4–6, 1988.

118. Boiko characterized it thus in the interview "Unge-

fähre Kunst in Riga. Gespräch zwischen der <Werkstatt zur Restauration nie Verspürter empfindungen> und Eckhardt Gillen," Niemandsland. Zeitschrift zwischen den Kulturen [Fahrgang?] 2, notebook 5 (Berlin, 1988), 34.

119. Polis acknowledges his Beuysian debt in "The Bronze Man of Riga: Everyone Can Be a Monument," interview with Kimmo Sarje in Siksi 2 (1990): 10–11. For a richer expression of his self-reflexivity, see "Miervaldis intervē Poli [interviews Polis]," Māksla 1 (1988): 16–20.

120. Uklad is the tooled metallic element surrounding the exposed faces and hands of holy personages depicted in Orthodox icons.

121. Polis, "The Bronze Man of Riga," 11.

122. Conversation with Feldbergs, June 10, 1993.

123. Images of the sculptures and Feldbergs's physical interactions with them are reproduced, with the Bērziņš poems, in Parasts akmens (Rīga: Ojārs Feldbergs, 1992).

124. Conversation with Mailītis, June 11, 1993.

125. An image of the Mailīši hoisting the "people-flag" is reproduced in Niels Peter Juel Larsen, "Im Schatten des Gulag," Zeit Magazin, March 27, 1992, pp. 20–21.

126. Conversation with Davidovs, July 7, 1992. Odd as it might sound after so much evidence to the contrary, art rarely has as much immediate, direct impact on quotidian life as this punitive job termination. Keeping this in perspective is helpful, however, because it is often on the level of ordinary, everyday sights and routines that contemporary Latvian artists have been able to penetrate complacency.

127. Csajka Gábor Cyprian, "Természet—környezet—ember," Mozgó Világ (1984): 29. Curiously, Spring was also given the title Berendezés, meaning "equipment" or "apparatus."

128. In another instance of approximate art-making, the eye-chart portion of this work may appear to twenty-first-century Western eyes to have required an effortless Photoshop procedure to produce, but Laganovskis spent literally days working with press type, manual photographic reduction, and meticulous pasteup to effect what a digital typesetter could accomplish in an hour; conversation with Laganovskis, June 7, 1999.

129. Maigas svarstības (Rīga: Jāņa sēta, 1990), n.p.

Mark Allen Svede

FROM BROOM CLOSET TO BIENNALE
Latvian Contemporary Art Exposes Itself

N 1976, as repayment for the uncommon privilege of attending the Venice Biennale as a Soviet emissary, painter Ojārs Ābols (1922–1983) was required upon return to debrief fifty ranking members of the Latvian Soviet Socialist Republic cultural bureaucracy. An official artist with impeccable credentials and unimpeachable connections, Ābols could be counted on to report not only what he had seen in Venice, but also what he saw happening at home in the unlikely event local artists were granted the same autonomy as their Western peers. Unbeknownst to the assembled apparatchiki, at that very instant three Latvian artists were acting with fullest autonomy—albeit within the confines of a space no larger than a broom closet and well within earshot. Ābols had sequestered Andris Breže (b. 1958), Ivars Mailītis (b. 1956), and Ojārs Pētersons (b. 1956) in a room adjoining the auditorium.[1] The three men, aged eighteen to twenty, had

already demonstrated abundant potential as artists, so Ābols believed this meeting would provide them invaluable insight, not about the Biennale—of which he would talk freely, privately, enthusiastically to them—but about the mandarin nature of the cultural system in which they were about to engage as beginning professionals. He specifically wanted them to overhear the officials' reaction to abominations such as minimalism, installations, and conceptual art. Of course, the fact that eavesdropping was the only possible means of instruction was probably lesson enough.

Twenty-three years, eleven Biennales, and one political system later, another select group assembled at the Cultural Ministry in Rīga to hear the latest dispatch from Venice. Once again, the debriefing's most notable aspect was that three Latvian artists had acted with full autonomy, but this time the official emissary, curator Helēna Demakova, could report that the three

FIG. 197. Artists' collective *New Project–ile* (Ivars Mailītis, Valts Kleins, Hardijs Lediņš, and Valdis Poikāns), promotional flyer for the performance *Empire—Fatal Bomb*, July–September 1992. Computer scan on paper, 21 × 27 cm. Collection of Mark Allen Svede.

comprised Latvia's first national delegation to the Biennale. Of symmetries between the two occasions, the most satisfying was that Ojārs Pētersons, alumnus of the broom-closet episode, was among the 1999 Biennale representatives. For Western observers who regard the Biennale with slight boredom and mild contempt (yet attend nonetheless), the degree to which participation was savored in Rīga that summer should also be lesson enough. Nobody expected that Latvia's pavilion would garner the spotlight in Venice, nor even attract more than a passing mention in the international press (though delegate Inta Ruka's photography certainly merits critical coverage on that level). To obsess about such things would be to acquiesce to values that have cast the Biennale in dubious light. More importantly, the excitement was about articulating a national self-image, an exercise Latvian artists had been perfecting for some time.

Much of Latvian nonconformist art could be read as the articulation of national identity, usually at odds with an imposed pan-Soviet identity, and secured through either a continuation of pre-Soviet Latvian culture or a resynchronization with global aesthetic trends (at least those in the Western liberal democracies). Indeed, a Latvian design for what was originally intended as the Soviet Union's pavilion at Expo '92 in Seville combined these strategies *and* spectacularly bridged the Soviet/post-Soviet divide. In 1988, broom-closet veteran Ivars Mailītis, along with architects Juris Poga (b. 1957) and Aigars Sparāns (1955–1996) anonymously submitted to a Moscow architectural jury their proposed pavilion design, which appeared to be a stark modernist structure adorned with impressive computer-driven visual elements. Unaware that this contemporary form was based on the shape of a traditional Latvian peasant casket and that the Soviet-made computer gadgetry was fully expected to malfunction, jury members awarded the commission to the Latvian team.[2] When it was discovered that the winners were not the Lenin Prize emeriti whom cronies on the jury had supposed them to be—in fact, weren't even ethnic Russian—the architectural Establishment was shocked. And when the renegades began explaining the subversive symbolism of their design, the competition was annulled on the spot.

Months later, having witnessed backroom dealings in his youth (from a back room, no less), Mailītis insisted they resubmit an identical proposal to the sec-

ond competition. With the leverage of glasnost and a key, sympathetic jury member, the Latvians were again declared winners. Their design was built in Seville, though, by 1992, the pavilion represented Russia alone. The artists were unwelcome at its inauguration, the computer-driven façade malfunctioned as hoped, and foreign critics panned the structure as moribund (say, casket-like) and impractical (say, Soviet). Mailītis & Associates were euphoric. To celebrate the victory, Mailītis organized a transcontinental performance titled *Empire—Fatal Bomb*. In a newfound spirit of market capitalism—especially that of the military-industrial cartel—he and three other artists[3] founded the ersatz business firm *New Project–ile*, which sponsored a tour from Red Square to Seville (fig. 197). The men and their turgid *project–ile*, a laughably ramshackle rocket, followed the expected route of the once-feared Warsaw Pact warheads, underscoring Soviet society's bankruptcy through military expenditures bloated by paranoia and greed.

In the wake of de-annexation, artists sought to exorcise the demons of totalitarianism once and for all. Some took a literal swords-into-plowshares approach, acquiring obsolete military hardware and more or less exhibiting it as found art (alas, equally obsolete). In general, such efforts at pathos were outdone by the vainglorious Red Army artifacts abandoned throughout Latvia, from out-of-plumb statues to the silenced Skrunda radar facility.[4] Conversely, wit on a modest scale was often more resonant and cathartic. For his *Fossils* series, Leonards Laganovskis fabricated two dozen small-scale works from amber, the petrified pine resin that washes up onto Baltic beaches and into every souvenir shop in the region. The material has become a cliché of ethnographic art and, moreover, tourist taste. Responding to the Western appetite for Red Army memorabilia in addition to traditional amber necklaces, Laganovskis "fossilized" traces of communism: enameled flag pins, Lenin medallions, and so on (fig. 198). The work transcends mere cleverness through an economic conundrum: The labor-intensive process of embedding the intricate forms hikes their market value well above that of souvenirs, just as the artistic concept is worth more today than the ideology responsible for the kitschy contents. Other *Fossils* contain a bullet or bugging microphone and are thus less susceptible to Cold Warrior nostalgia. With the microphone, however, black humor escalates, for,

FIG. 198. Leonards Laganovskis, from the series *Fossils*, 1988–89. Amber, carved and backed with resin, and military pin, 1.2 × 6 × 4.2 cm. Dodge Collection, ZAM, 01389.

FIG. 199. Ēriks Božis, *Breakthrough*, n.d. Gouache and metallic paint over gelatin silver print, 39.4 × 30 cm. Dodge Collection, ZAM, 00979.

as connoisseurs know, amber containing an insect is particularly valuable. The paradox posed by *Fossils* is that such puns fail when speech must be guarded, that wordplay becomes nonthreatening only if the "bug" has been isolated, captured in hand. Yet even in post-KGB Latvia, retaining this small amber object in one's palm is no assurance of safety, for these pieces suggest a more recent physical peril: Reports began circulating about chemical burns sustained by children who, in the process of collecting amber on the beaches of southwest Latvia, mistakenly pick up residue from phosphorus bombs that the Red Army had dumped offshore, residue that now washes ashore, visually indistinguishable from the stuff of necklaces—or neoconceptual art.

Sadly, this news was not exceptional for a society positioned downwind of the Chernobyl disaster. Just as Latvians' constitutive relationship to nature had been degraded, their urban environment had its toxic elements. For that, however, Rīga's residents had honed coping mechanisms that compromised monuments to Soviet power long before statues physically tumbled in 1991. For example, crosses atop the deconsecrated Orthodox cathedral could be visually aligned with the outstretched hand of Lenin's main monument in such a way that the Father of the Revolution appeared to be a Christian missionary. Until officials removed the crosses, one merely needed to find the right vantage point on Elizabetes Street, which one did by looking for a convergence of amateur photographers and giggling children. But for an audience inured to both Communist and post-Communist iconoclasm, artists needed to find new displacements and disruptions. Ēriks Božis (b. 1969), whose training as a photographer in peripheral Liepaja may well have offered him fresh perspective on the capital city's fixtures, designed a triple phone booth, eighteen feet high and positioned near a trio of huge, granite Red Riflemen stranded in a Rīga plaza. Fitting for this sculptural symbol of by-gone patriotism, Božis used Soviet-era pay-phone cubicles boasting all the outmoded elegance of a Moskvich sedan.[5] (A much earlier photographic work, *Breakthrough* [fig. 199], augurs his high-profile phone booth–themed commissions in Rīga and Stockholm.) Elsewhere on the streets, the Bronze Man, Rīga's favorite mutable monument, appeared outside a recently privatized gallery in May 1992, to be painted gypsum-white by Vilnis Zābers (1963–1994), a young

artist who seemed likely to inherit Miervaldis Polis's reputation as cultural provocateur. The removal of Polis's epidermal splendor recalled the flaking of bronze paint from plaster statues hastily erected by the cash-strapped, propaganda-rich Bolsheviks, but this was less a matter of historical whitewashing than creating a tabula rasa as the former art infrastructure crumbled.

Zābers was one of several artists whose work critiqued post-Soviet cultural intrusions into Latvian society. Amid the proliferation of pornography and prostitution, even an ex–Culture Minister, pianist-politico Raimonds Pauls, could release a recording of schmaltzy original compositions inspired by Rīga's red-light district without raising eyebrows.[6] Naturally, the presence of hard-core erotica in Zābers's mixed-media works proved to be more controversial, but even so, he never experienced the overt censorship that booted Miķelis Fišers's (b. 1970) silly cartoon renderings of intergalactic sex from a Soros-sponsored exhibition in Vilnius a few years later.[7] Alas, greater obscenities existed: Legalized gambling inundated impoverished Rīga, occasioning Ojārs Pētersons's casino-like environment *Orange Player*. The local mafia's mania for status cars coincided with Normunds Lācis (b. 1961) branding himself with the BMW logo.[8] And global Disneyfication provided the tape loop for the audio-sculpture "Mickey Mouse is over here he- . . . Mickey Mouse is over here he- . . ." by Kristaps Ģelzis (b. 1962), which swiftly goes from singsong to strangulation. These works were not unequivocally negative, however, acknowledging in the same bated breath capitalism's seductions and opportunities. For one thing, private art patronage began to look promising when, in 1994, Inese and Ivars Mailīši won a concourse for an art project sponsored by Banka Baltija, Latvia's largest bank. Passionate beekeepers in daily life, the Mailīši relocated their hives to a sculptural abstraction of a hollow tree trunk placed within the bank's lobby, creating egress for the bees through a glazed channel to the outdoors. Metaphors accrued immediately and brilliantly: industry, thrift, conscientiousness, community, and, of course, the buzz of good publicity.[9] Banka Baltija collapsed in scandal a year later, stealing every fifth Latvian's life savings and triggering profound economic crises, while the Mailīši's beeswax encaustic paintings made from the installation's hives remain bankable to this day. *Ars (et apiaria) longa.*

The bank crisis demonstrated Latvia's vulnerability to larger forces, and naturally, the artist renowned for his ability to envision the grander drama, Ilmārs Blumbergs (b. 1943), had already produced the emblematic image of his nation's predicament. In his 1992 series, tersely titled *Drawings*, graphite lines meander across the page like surrealist automatic writing, when a human figure emerges from this haze of prelingual narration. The motif coalesces with repetition of line—a stooped silhouette solidifies—and meaning coalesces with repetition of motif—the thickened line that emerges from its mouth like an utterance eventually doubles back, mirroring the figure's profile. This profile describes everything: the supplicant figure, whom Blumbergs has explained is a representation of Latvianness, acquiescent to outside forces . . . *but also* the embodiment of those greater forces, visible when one rotates the image ninety degrees counterclockwise (fig. 200). Suddenly apparent, another profile is inscribed within the negative space: a head with a broad cranium, its nose formed by the Latvian supplicant's throat, and tightly drawn lips where the Latvian's nose is.[10] Blumbergs's figure/anti-figure is quite possibly the most succinct visual expression of the Lacanian concepts of subjecthood (in which the self is defined by its lack) and *nom-de-Père* (wherein the individual matures when it submits to the Law). That the negative image resembles Freud is purely fortuitous.

Self-definition, contingent on the Father, could also be seen in the 1994 exhibition *Jānis Mitrēvics Exhibits Vilhelms Purvītis . . .* , in which Purvītis, titan of landscape painting in pre-Soviet Latvia, became the subject of a museum installation by Mitrēvics, whose recent paintings had approached the aesthetic matter of the native countryside from a diametrical position. Whereas the elder had painted birch groves sublimating into light and shadow, Mitrēvics harvested limbs from these groves and lashed crude burlap paintings onto them. More than anyone, he furthered the conceptualist project of "de-skilling" that Aija Zariņa had introduced to Latvian contemporary art in the 1970s, a gesture twice as provocative here as in the West because local artistic training—epitomized, in fact, by the academy Purvītis founded—produces high-schoolers with painting skills of greater versatility than those of the typical American art-school professor. And so, for his new project, Mitrēvics selected certain landscapes by Purvītis, hung them, and responded intertextually by filling the State Art Museum gallery space

FIG. 200. Ilmārs Blumbergs, from the series *Drawings*, 1982.
Paper, graphite, oil pencil on paper, with typographic paints,
90 × 70 cm. Collection of the artist.

FIG. 201. Jānis Mitrēvics, installation view of *"Jānis Mitrēvics Exhibits Vilhelms Purvītis" ... Ivars Runkovskis' Sponsored by Banka Baltija*, 1994. Collection of State Museum of Art, Rīga, Latvia.

with mounds of grain, layers of animal pelts, stands of birch trunks, and other raw material bearing tonal, textural, or poetical resemblance to the sublime source paintings (fig. 201)—paintings that have become the standard by which Latvians judge the appearance of their actual landscape.[11] The deconstructive impulse was sustained in the exhibition title itself, which continued beyond the Old Master's name to credit the curator Ivars Runkovskis and sponsor Banka Baltija. Indeed, perhaps the strongest tonal or poetic resemblance lay in this sponsorship: an unsellable installation underwritten by an unbankable corporation.

Corporate arts patronage was hardly exclusive to Banka Baltija. For example, the newspaper *Labrīt!* sponsored *ep!*, a 23-artist Action staged at 5:30 P.M., September 30, 1993, in 33 venues across Latvia, each of which hosted a print exhibition identical to the 32 oth-

ers, a self-ironic commentary on mass media and the unique art object. Ideally, organizers wanted 333 venues, but arts administration and corporate sponsorship had their limits.[12] Indeed, before long, *Labrīt!* itself no longer existed. But new businesses rose to assume patronage responsibilities, as did foreign-based institutions like the Stockholm School of Economics. The reality of the new market economy greatly affected private art collecting, too. Whereas the most impressive collections in Soviet-era Latvia had been amassed by intellectuals and artists who held a profound personal stake in the cultural production of their colleagues, the new collectors were predominantly businessmen who understood the investment potential of art—or the notorious *biznesmeni*, who saw it as a way to legitimize ill-gotten wealth, much as America's robber barons became conspicuously cultured after their dirty

work was done. Not surprisingly, the aesthetic tastes of Latvia's nouveau riche, whether mafioso or conscientious capitalist, usually did not lean toward experimental work.

Regular bankrolling of large-scale experimental projects became the mandate of the newly instituted Soros Center for Contemporary Arts/Rīga (SCCA), which more or less assumed the role of state patron for artists willing to subscribe to the new aesthetic orthodoxy of neo-conceptualism. The SCCA represented a boon for advanced visual culture. With shifting conceptual parameters like "Monument," "State," "Geo-Geo" ("-metric," "-logic," "-graphic," and so on), "Opera," "Ventspils Transit Terminal" (Latvia's oil-exporting city and cash cow), and "Contemporary Utopia," the center's annual exhibitions marked the decreasing urgency of identity politics within local art-making (or at least in local curatorial preoccupations). The growing thematic latitude of these exhibitions meant the inclusion of ever more artists, ever younger and ever less inhibited by traditional aesthetic criteria. In addition, the center has served to promote contemporary work abroad, most often and effectively within Nordic group exhibitions, where enhanced resources have enabled Latvian artists to realize projects, particularly installations, on a scale unfeasible at home. The network of Soros-funded art centers has also helped sustain the tradition of Estonian-Latvian-Lithuanian exhibitions, though the sense of shared purpose is no longer as salient in these meetings, a predictable enough development given the increasingly divergent sociopolitical processes in the respective nations, compounded by the atomization of stylistic trends among artists everywhere.

As elsewhere in the institutional art world, creative prerogative was increasingly arrogated by Latvia's curators during the 1990s, and the finite curatorial pool (or perhaps the finite power-sharing and Svengali-ism alleged therein) has caused resentment among many artists. Feeling beholden for whatever opportunities are dispensed them, even some of Latvia's most successful artists have vouchsafed that open criticism of the system can be as risky now as when the Latvian Soviet Socialist Republic Artists' Union monopolized material support. On a positive note, the once-prevalent mentality of bellying up to the trough for yet another free meal has mostly subsided, and the average artist's sense of entitlement is no more offended by the

state budget than the average pensioner's (and with far less justification). Nonetheless, the two underfunded contingents can still be brought into direct opposition, as when Jānis Mitrēvics created his installation *Bacon for All the State* in 1994, displaying/wasting copious amounts of meat while the state was telling hungry pensioners that a benefit increase was not forthcoming.

In any case, the value of grassroots initiatives in offsetting official (now quasi-official) art policy, evident in Soviet times and always a guarantee of pluralism, is higher than ever in Latvia. This was apparent in the 1996 rave "Empire of Tenderness" organized by Kaspars Vanags (b. 1970) and continues with the site-specific projects created on an ongoing basis for Ojārs Feldbergs's Open-Air Art Museum and Park at Pedvāle in the forested hills of western Latvia,[13] an undertaking so impressive that Pedvāle has received UNESCO world cultural site status. The LN Women's League Project, a five-artist collective that describes its mission as less a confrontation of male chauvinism than an interrogation of "aggressive and sexist trends in Feminism," has recently gained international exposure in Stockholm and London.[14] WorldWideWeb-based art projects are proliferating—indeed, are the preferred medium of the newest generation of artists.[15] In yet another variant of grassroots activity, when Latvia's contemporary artists have found long-term gallery representation abroad, it has often been the result of helpful émigré artists. For example, after establishing a solid presence in the New York gallery system, former Rīga residents Zoya Frolova (b. 1953; fig. 202) and Jānis Jakobsons (b. 1959; fig. 203) strongly, successfully lobbied their SoHo gallery to represent other Latvian talent. So while Helēna Heinrihsone (b. 1948), Ieva Iltnere (b. 1957), and Frančeska Kirke (b. 1953) build a new audience for their paintings in North America, Frolova has moved on to yet another continent, commissioned to create two monumental paintings for a Hong Kong skyscraper. This is, loosely speaking, post-Soviet expansionism at its most benign.

The most incontestable, positive thing that can be said for Latvian art nowadays is that it copes with anything, and often does so with humor. When customs officials on the Soviet border were threatening to prevent Kristaps Ģelzis from transporting his silk-screen-on-aluminum paintings to an exhibition in Finland in the late 1980s, the artist simply went home, bolted

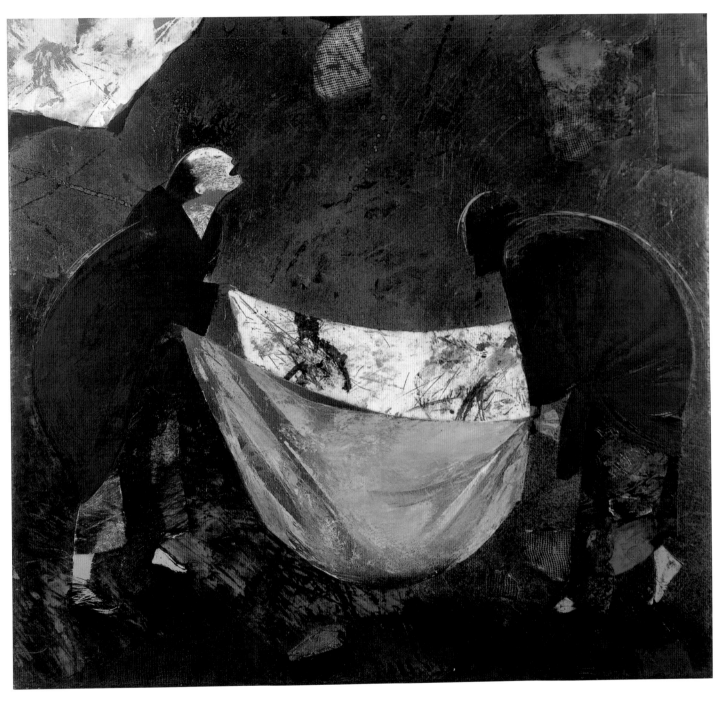

FIG. 202. Zoya Frolova, *Afterwards*, 1987. Oil on canvas,
130 × 140 cm. Dodge Collection, ZAM, 11940.

them to the inside ceiling of his subcompact automobile, and restretched the headcloth over the contraband, much like a conventional artist would restretch a canvas. The ruse succeeded. A few years later, when his mixed-media work *Dialogue* (fig. 204)—made with some of the same silk screens—was being transported to the Dodge Collection, a customs official of the newly independent Latvian Republic regarded the assemblage as if it *were* the vehicle smuggling illicit goods. Granted, copper was disappearing at an alarming rate (commuter trains were disabled when overhead wiring was stolen during rush hour), and the Mother of God image on Orthodox icons was an equally hot commodity for smugglers. Leave it to Ģelzis to push all the right buttons, to expose a nerve. He is, after all, a contemporary artist.

NOTES

1. Conversation with Mailītis (June 11, 1993), confirmed subsequently by Breže and Pētersons.

2. For a fuller account of the episode, see my essay "Curtains: Décor for the End of Empire," forthcoming in *Socialist Spaces in Eastern Europe and the Soviet Union, 1947–1991*, eds. David Crowley and Susan Reid (London: Berg, 2002).

3. The other participants were Valts Kleins (b. 1960), Hardijs Lediņš (b. 1955), and Valdis Poikāns (b. 1952).

4. In the same way that Robert Barry's *Inert Gas Series* inadvertently showed American conceptualism's "scientific" approach to be supercilious at times, wheeling a TU-134 aircraft landing gear into a gallery makes less of a statement than concurrent news reports that Aeroflot personnel were performing emergency, in-flight infusions of lemonade to the leaking brake lines of their plane.

5. Despite its straightforward humor, Božis's work is more epistemologically complicated than a visual joke. See Robert Fleck, "A Dialogue Between Consideration and Thought," in *Ēriks Božis*, ser. Moderna Museet projekt, catalogue no. 276 (Stockholm: Modern Museet, 1998), 12–15.

6. Raimonds Pauls, "Čāka ielas dziesmas" (Latvijas Radio, 1999).

7. Fišers's series *Sex 'n' Spaceships* was removed from the aptly titled exhibition *Misfits*, Sixth Triennial of Young Baltic Art, 1995. See Inga Šteimane, "Dažreiz viņu saprot jeb Miķeļa Fišera message-art," *Studija* 6 (1999): 26–35.

8. Lācis's gesture was part of a larger exhibition named *BMW* organized by the collective LPSR–Z in May 1991, reprised in the 1993 group show/Action *ep!* Equivocation was the forte of LPSR–Z, its name gleaned from the initials of its members' surnames—Lācis, Vilnis Putrāms, Māris Subačs

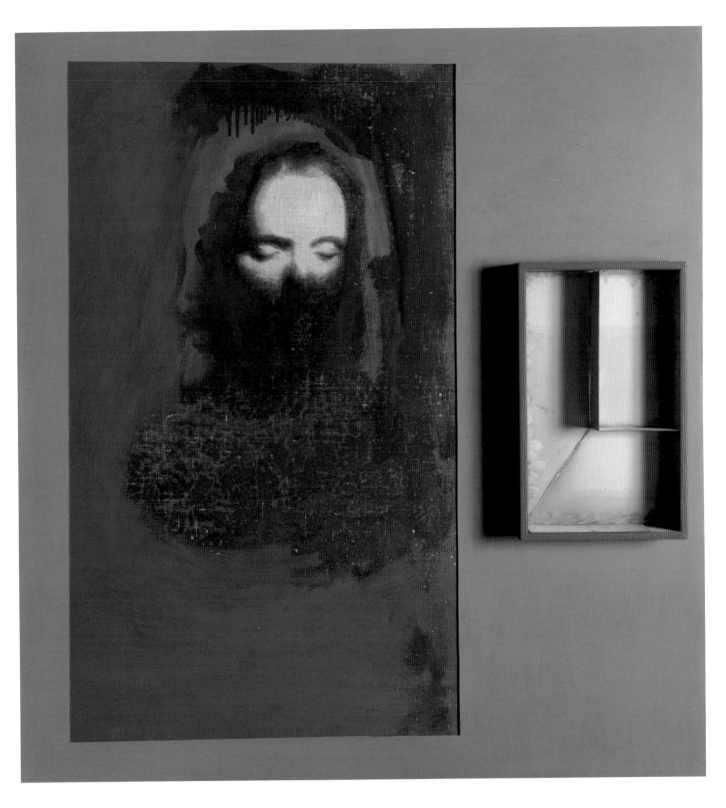

FIG. 204. Kristaps Ģelzis, *Dialogue*, 1986. Silk-screened oil on canvas, plywood, and copper, 116 × 105.5 × 12 cm. Dodge Collection, ZAM, 01524.

(b. 1963), Artis Rutks (b. 1960), and Zābers—*not* the Latvian acronym for "Latvian SSR," which it calculatedly echoes. Similarly, in their hands, "BMW" stood not for "Bayrischer Motor Werks" but "Bewegnung Macht Welt," which variously sounds like personal empowerment or fascistic determinism. See Juris Boiko, "Ne tas, ko tu redzi, ne tas, ko tu gribi," *Diena*, May 30, 1991.

9. Conversation with the Mailīši, September 17, 1996. For an overview of their own hive-like activities, see Ieva Raiskuma, "Mailīši, Bites & Co," *Liesma* 10 (1994): 5ff.

10. Conversation with Blumbergs, July 2, 1994.

11. " 'Look! That snow and birch grove there are exactly like a Purvītis painting!' " Helēna Demakova, "Ainava = ainava," in *Jānis Mitrēvics* (Rīga: SCCA, 1994), n.p.

12. As explained by Ivars Runkovskis in his overview statement in the tabloid-style *ep! 33 izstāžu apvienotais katalogs* (Rīga: Labrīt!, 1993), 1.

13. The project *Firkspedvāle Conversations '94* did receive SCCA support, but Feldbergs had already initiated work on the site in 1992 and independently secured Cultural Ministry funds for the restoration of existing structures (as noted in the artist-produced prospectus, "Open-Air Art Museum at Pedvāle" [1993], n.p.). When speaking of the impact of public art funding, it is necessary to mention Latvia's relatively new Culture Capital Fund, as well as the Artists' Union, which truly enhance the possibility of obtaining support if one's art is not conceptually based.

14. Artist's statement by Inga Šteimane in *After the Wall: Art and Culture in Post-Communist Europe*, eds. Bojana Pejić and David Elliott (Stockholm: Moderna Museet, 1999), vol. 2, 117. LN Women's League Project includes Ilze Breidaka (b. 1968), Izolde Cēsniece (b. 1970), Kristīne Keire (b. 1968), Inga Šteimane (b. 1965), and Ingrīda Zābere (b. 1966). American feminists—this one included—are likely to find some of the LN Women's League Project's representations of Western mainstream feminism to be simplistic and reductivist, especially in the group's earliest promotional literature, in which certain characterizations were redolent of Rush Limbaugh's "Feminazi" rhetoric. The collective's actual projects, however, are tremendously subtle—and extremely effective because of that.

15. For an overview of internet art-making, see Māra Traumane, "Words—Worlds. New Media in Latvia," *Mare Articum* 7 (2000): 41–55.

4
ART of
LITHUANIA

Viktoras Liutkus

BROADENING STREAMS OF NATIONAL ART

Lithuanian Art in the Pre-Soviet Period

THE DEVELOPMENT of Lithuanian art in the nineteenth century can be framed by two events in Lithuanian history: the end of the existence of the Lithuanian state with the third partition of the Polish-Lithuanian Commonwealth in 1795 and the struggle of the Lithuanian nation for the restoration of an independent Lithuania, resulting in the Proclamation of Independence on February 16, 1918. These events roughly coincide with two significant events in world history: first, the French Revolution and second, World War I. In the history of Lithuanian art, we can also distinguish certain events that frame this period. The late eighteenth and early nineteenth centuries saw the founding of the Departments of Architecture (1793), Painting (1797), Sculpture (1803), and Graphic Art (1805) at the Lithuanian Principal School, which became the University of Vilnius in 1803. These developments had an important impact on Lithuanian art

and contributed to the formation of a Vilnius school of art. The period under discussion ended with the first exhibitions of Lithuanian art in Vilnius held from 1907 to 1914, which testified to the emergence of Lithuanian professional art and brought Lithuanian artists together for joint organized activity.

UNDER THE TSARIST OPPRESSION

For Lithuania, the nineteenth century was "a period of occupation and annexation, resistance and liberation; and, finally, it represented a history of a stolen nation."[1] Under the tsarist government, several political events directly influenced the development of art and the activity of art institutions, as well as the life of artists. These events included two uprisings against tsarist rule in 1831 and 1863; the closure of the University of Vilnius in 1832; a forty years' ban placed on the

Lithuanian press after the 1863 uprising; the elimination of the Lithuanian language from schools, along with the persecution and destruction of various manifestations of national culture; and two waves of emigration, repression, and deportations in the wake of the uprisings. Many artists found themselves in the epicenter of these events: Vladislovas Neveravičius, Vincentas Dmachauskas, Napoleonas Ylakevičius, and Adomas Šemešys took part in the 1831 uprising, and Vincas Slendzinskis, Antanas Zaleskis, Alfredas Römeris, and Kazimieras Alchimavičius, in the 1863 uprising. Some of these artists were deported to Russia or had to flee the country. For example, Mykolas Elvyras Andriolis (1836–1893), a well-known artist of the second half of the nineteenth century, who had studied in St. Petersburg, Rome, and Paris and won fame in Lithuania for the illustrations of *Pan Tadeusz* and *Conrad Valenrod* by Adam Mickiewicz, was deported to the north of Russia for fifteen years for participating in the 1863 uprising.

After this uprising, the tsarist authorities confiscated many artworks from Lithuania, reorganized the Vilnius Museum of Antiquities (which had been founded in 1855), and removed unwanted artworks from its art department. In 1865, they also dismissed the Vilnius Archaeological Commission, whose collections had contained 3,938 works of sculpture, painting, and graphic art.[2] The Museum of Antiquities accumulated art collections and became the major patron of Lithuanian art and artists. However, the process of establishing institutions that would support art was rather slow. There were only a few museums and galleries, and the general public had little interest in the visual arts. Moreover, art collectors preferred works by foreign rather than Lithuanian artists. In 1820, the first exhibition of works of art students was held at the University of Vilnius. These exhibitions continued to take place every two years until the university was closed down.[3] In the middle of the nineteenth century, the first local art patrons and collectors, such as Liudvikas Petkevičius, began buying Lithuanian art and financing the education of Lithuanian artists at the art academies of St. Petersburg as well as in Western Europe.

Lithuanian art was directly influenced by the existing social structure in the country. The material culture, spiritual interests, and aesthetic ideas from Western Europe only affected the upper stratum of Lithuanian society, although the nineteenth century was the period of gradual modernization and the mak-ing of the Lithuanian nation. The development of culture and art was complicated by the fact that, in the nineteenth century, the Lithuanian nobility was almost totally under Polish influence and thus dissociated itself from the rest of Lithuania. In terms of nationalism, Lithuanian urban culture was far removed from the roots and ideals of Lithuanian ethnic culture. In 1897, as much as 87.3 percent of the Lithuanian population (2.7 million) lived in the countryside and small towns; peasants constituted 73.4 percent of the population. In public life, the Russian and Polish languages dominated, and the majority of the Lithuanian nobility considered Polish their native language.[4] Not surprisingly, this structure of the population largely determined that the vast majority of Lithuanians still lived in the world of archaic village traditions, myths, and fairy tales, even as late as the nineteenth century. The Grand Duchy of Lithuania, which once was a huge territory, within the course of several decades turned into a nearly anonymous entity in terms of nationhood and statehood, the Severo-Zapadnyi Krai (the North-Western Region) of Russia.

In the nineteenth century, teachers and graduates of the Vilnius Art School were the major influence on the development of Lithuanian art. Although the closure of the University of Vilnius in 1832 was a painful blow to the country's culture and educational system, artistic life had already acquired a sufficient basis for further development. Artists such as Kanutas Ruseckas, Karolis Ripinskis, and E. J. Römeris opened art studios. Articles about art started to appear in the press during this period, and society as a whole took a more positive attitude toward the status of artists, while philanthropic activity in the arts began to develop.

Nineteenth-century Lithuanian art underwent several stages of stylistic development, including classicism, romanticism, and academic art, before finally turning to realism in the late nineteenth and early twentieth centuries. Painting, which became the dominant medium, revealed most clearly the new aesthetic ideas as well as the country's social moods and historic events. In the first stage of this development, a representative of classicism was Pranciškus Smuglevičius (1745–1807), the first chair of the painting department of the University of Vilnius. Having studied in Rome for two decades, he employed historical themes that brought to Lithuania classical ideals and views of enlightened classicism. In such paintings as *Lithuanian Peasants* and *Freeing Peasants from Serfdom in Mer-*

kinė (1795), as well as in his drawings of the old architecture of Vilnius, Smuglevičius realistically depicted images of everyday life.

Polish Romantic writers and historians associated with Lithuania, such as Adam Mickiewicz, Joahim Lelewel, and Juliusz Slowacki, as well as Lithuanian historians and language and folklore researchers including Simonas Daukantas, Kajetonas Nezabitauskis-Zabitis, and Simonas Stanevičius, contributed to the consolidation of Romantic ideas in art, which flourished in the middle of the nineteenth century. Among its followers were graduates of the Vilnius Art School, including Kanutas Ruseckas (1800–1860), V. Vankavičius (1800–1842), and Karolis Ripinskis (1809–1892). These artists were pupils of Jonas Rustemas (1762–1835), an important Lithuanian artist of the first half of the nineteenth century. In their works, these Romantic artists depicted views of the Lithuanian countryside and city life and the life of Jews in small towns. Romanticism brought to Lithuanian art the need to convey the country's ethnic characteristics and to replace the heroic landscape with national imagery. An important fact from this period was the appearance of *The Vilnius Album* (published from 1848 to 1860 by J. K. Wilczinski), which contained images of Lithuanian cultural monuments and historical sites and portraits of famous Lithuanians.

Despite the restrictions imposed by the tsarist government, cultural activity was gaining strength in Lithuania. The country's major cultural institutions were located in Vilnius, which therefore served as the center of cultural and artistic activity. A school of drawing existed in Vilnius from 1866 to 1915, headed by the Russian artist Ivan Trutnev (1827–1912), who was a graduate of the St. Petersburg Academy of Fine Arts and was well versed in Western European art. Among the pupils of his school were Poles (B. Balzukiewicz and B. Kubicki), Lithuanians (A. Žmuidzinavičius), and Jews, many of whom later became world-famous artists, including Jacques Lipchitz, Chaim Soutine, Mane-Katz, and Lasar Segall. Artistic life burgeoned in the last decades of the nineteenth century and the early part of the twentieth century. The Russian *peredvizhniki* (the Itinerants) organized exhibitions in Vilnius in 1873 and 1878,[5] which united artists of different nationalities and educational background.

The Russian revolution of 1905 continued to liberalize art and culture. Societies and circles concerned with Lithuanian, Russian, and Polish art, culture, and science were established, and the theatrical and musical life was becoming more active.

Professional Lithuanian art was consolidated by the first exhibitions of Lithuanian art (eight of them were held from 1907 to 1914), and the foundation of the Lithuanian Art Society in 1907. The ideas of national revival and the goal of creating an independent state provided an impulse to hold these exhibitions, which brought together Lithuanian artists who were scattered in foreign centers such as Krakow, Paris, and St. Petersburg. These exhibitions also encouraged the Lithuanian intelligentsia to develop interest in visual and applied art and thus to raise the general prestige of a national art. Alongside professional art, folk art was usually displayed in the exhibitions and also received much attention in art education. This policy had a decisive influence on Lithuanian art of the twentieth century when many professional artists began referring to elements of folk art in their work.

In the first two decades of the twentieth century, the revival of Lithuanian national art and increased professionalism led to the importation of quite varied artistic traditions from various European artistic centers and art schools. Lithuanian artists were influenced by a large variety of art movements, such as impressionism, symbolism, and art nouveau. However, rather than adopting these trends in their pure forms, they often combined them with elements of academic art as well as motifs of folklore.

The most remarkable figure of Lithuanian art of the early twentieth century was Mikalojus Konstantinas Čiurlionis (1875–1911), a painter and composer, whose work embraced a wide range of philosophical teachings, themes, and motifs, including mythology, Lithuanian folklore, nature, Oriental art, theosophy, and neo-romanticism. Čiurlionis's art and style embodied a transition from symbolic allegories to abstract art, thus following one of the major tendencies of twentieth-century art. The compositional principles of music enriched his paintings with original spatial and temporal patterns and many planes of movement. For example, Čiurlionis's "sonatas," such as *The Sun Sonata*, *The Spring Sonata*, *The Summer Sonata*, and *The Sea Sonata*, which were painted between 1907 and 1908, represent distinct parallels of pictorial and musical thinking (figs. 205 and 206).[6] The scope and breadth of Čiurlionis's work far surpassed the boundaries of Lithuania. Russian artists and critics, including Mstislav Dobuzhinsky, Alexandre Benois, Konstantin

FIG. 205. Mikalojus Konstantinas Čiurlionis, *Sonata of Chaos (Allegro)*, 1908. Tempera on paper, 72.2 × 61.4 cm. Collection of M. K. Čiurlionis Art Museum, Kaunas, Lithuania.

FIG. 206. Mikalojus Konstantinas Čiurlionis, *Sonata of Chaos (Andante)*, 1908. Tempera on paper, 73.5 × 62.5 cm. Collection of M. K. Čiurlionis Art Museum, Kaunas, Lithuania.

Somov, V. Chudovski, and Viacheslav Ivanov, all took a keen interest in Čiurlionis's work, which was displayed at the exhibitions of *Mir iskusstvo* (The world of art) group in St. Petersburg (1911–12) and Moscow (1916) and at the second exhibition of post-impressionists in London (1912–13). Soon after Čiurlionis's death in 1911, an important exhibition of his works was held from October 1913 to November 1914 in Vilnius, and in 1921, the Lithuanian *Seimas* (Parliament) passed a law establishing the Čiurlionis Gallery, which opened in 1925.

THE DEVELOPMENT OF MODERNISM FOLLOWING INDEPENDENCE

In the decades between the restoration of independence on February 16, 1918, and World War II, Lithuanian art underwent major changes. The issues, ideas, and organizational structures that were carried over from the beginning of the twentieth century were further developed in the 1920s. During this period, realism continued to dominate Lithuanian art. Exhibitions of varying qualities in the 1920s included works by the same artists who had been featured in the earlier exhibitions of Lithuanian art held between 1907 and 1914. A number of art societies that engaged in educational and cultural activity were established, and a class of wealthy people was beginning to form. Their aesthetic taste was for salon, pseudo-national, and "patriotic" works, and they had little concern for support of the arts. Besides, the young state was not able to create appropriate administrative structures or to provide adequate support for Lithuanian art. The School of Art established in Kaunas in 1922 became the main art school in Lithuania in the period between the wars. From 1919, the art department was part of the Stephan Bathory University in Vilnius, which was occupied by Poland at the time.

During the 1920s, new developments in Western European art were scarcely known in Lithuania, and the reception of these trends was slow and cautious. Among the most important exhibitions of Western art held in Kaunas, the second-largest city of Lithuania, were those of Marc Chagall (1887–1985) in 1922 and modern German graphic art in 1928. In contrast, artists in Vilnius at that time were more active in developing radical new art.[7] In 1923, the local movie theater, Corso, housed *The New Art Exhibition*, which fea-

tured works by Lithuanian and Polish constructivists Vytautas Kairiūkštis (1890–1961), Henrik Stażewski (1894–1988), Władysław Strzemiński (1893–1952), Karol Kryński (1900–1944), Mieczysław Szczuka (1898–1927), and Teresa Żarnover (1895–1950). This exhibition caused a great commotion among art critics and in society at large, and is considered to be the beginning of Polish constructivism. One of its organizers, Kairiūkštis, is ranked as one of the fathers of the Lithuanian avant-garde (figs. 207 and 208).[8] In paintings of Vladas Drėma (1910–1995), who was a pupil of Kairiūkštis in Vilnius at the time, the constructivist style that prevailed in the 1920s is evident (fig. 209). Zbigniew Pronaszko, another representative of the 1920s Polish avant-garde, designed an imposing wooden monument to Adam Mickiewicz (12 m) at the Neris riverside in Vilnius, which was subsequently pulled down in 1936.

In the 1920s, modern art gradually developed in Kaunas. Paintings by such artists as Vladas Didžiokas (1889–1942), Adomas Galdikas (1893–1969; fig. 210), Justinas Vienožinskis (1886–1960), and Kazys Šimonis (1887–1978; fig. 211) reflected influences of post-impressionism, expressionism, and constructivism, indicating the belated reception of these art movements in Lithuania, even though these trends had already become an integral part of twentieth-century Western art. The inclusion of these avant-garde movements indicates that changes were under way and that art was departing from the traditional style derived from the nineteenth century, as we can see in decorative sculpture works of the 1920s by Petras Rimša (fig. 212). In Kaunas, artists of other nationalities actively working alongside Lithuanians introduced artistic influences from Moscow, St. Petersburg, Berlin, Munich, and Paris.[9]

Modern Lithuanian literature was more vigorous and daring than art. The journal *Keturi vėjai* (Four winds), four issues of which appeared between 1924 and 1928, was the first to introduce modernist movements such as expressionism, futurism, constructivism, dadaism, and surrealism to Lithuania. It stood for changes in Lithuanian art and was in strong opposition to official criticism and the conventional aesthetic taste. Therefore, the 1920s ultimately paved the way for artistic innovations and introduced a modern artistic culture to Lithuania.

More radical changes in the 1930s were brought

about by a new generation of artists who were graduates of the Kaunas Art School and enjoyed the possibility, mainly through state grants, of continuing their studies abroad, most often in Paris. Established in 1930, the Society of Independent Artists was the first to encourage development of modernism in Lithuanian art. On the occasion of the Society's second exhibition in 1932, its chairman, Adolfas Valeška (1905–1994), stated, "We have set an aim before ourselves to free Lithuanian art from the restrictions of academic art, naturalism, and dilettantism. We are searching for original ways in which national creativity could be expressed . . . and hope that we will succeed in creating a national art."[10] The Society's aims included artistic education, which it fulfilled by founding an art club and an art salon, holding exhibitions and discussions that propagated the ideas of modern art, and trying to involve in its activities a wide circle of major Lithuanian artists. However, reality soon showed that the Society's declarations and intentions exceeded its actual potential for implementation, and some important artists left the Society. Its administrative activity grew weaker, exhibitions were no longer organized (only two exhibitions were held), and in 1935 the Society ceased to exist.

The period from 1930 to 1935 brought more changes that marked important transformations and polarization of Lithuanian art. In the summer of 1932, the Lithuanian Artists' Society was established, uniting artists of the older generation in opposition to the increasing dissidence of younger artists. Its membership included painters Vladas Didžiokas, J. Mackevičius, J. Šileika, and P. Kalpokas, and sculptors J. Zikaras, V. Grybas, and others who proclaimed themselves "inheritors and cherishers of traditions." Their exhibition in 1933 was described by Justinas Vienožinskis, a painter and an art critic, as expressing "a world image that has now become past history."[11] In the fall of the same year, several young artists founded the ARS group and held their first exhibition in Kaunas, followed by a second in 1934.

In comparison with the Society of Independent Artists, the ARS group defined its intentions and role in renewing Lithuanian art in a more radical way. The ARS manifesto, edited by Juozas Petrėnas (1896–1980), a member of the Four Winds literary movement, accompanied the catalogue of their first exhibition. It avowed, "The world, and our nation in particular,

FIG. 207. Vytautas Kairiūkštis, *Self-Portrait*, 1923. Carbon on paper, 69 × 48 cm. Collection of Lithuanian Art Museum, Vilnius. Photograph from the archives of Viktoras Liutkus.

FIG. 208. Vytautas Kairiūkštis, *Cubist Composition, Sitting Woman*, 1930. Oil on canvas, 41 × 37.5 cm. Collection of Lithuanian Art Museum, Vilnius.

FIG. 209. [LEFT] Vladas Drėma, *Still Life*, 1928.
29.5 × 22 cm. Collection of Lithuanian Art
Museum, Vilnius.

FIG. 210. [ABOVE] Adomas Galdikas, *St. Joseph*, 1932.
Oil on canvas, 57 × 41.5 cm. Collection of M. K.
Čiurlionis Art Museum, Kaunas, Lithuania.

FIG. 211. [TOP] Kazys Šimonis, *Fantasy (City of Sounds)*, 1920. Cardboard and tempera, 69 × 94 cm. Collection of Lithuanian Art Museum, Vilnius.

FIG. 212. [LEFT] Petras Rimša, *Satire and Owl*, 1921. Bronze, 28 × 20.3 × 12 cm. Collection of M. K. Čiurlionis Art Museum, Kaunas, Lithuania.

entered a new era. After five long centuries we again find ourselves taking part in the great cultural race of the European nations. As we look around, we can clearly see that the absence of a deeper search or the imitation of long-worn-out forms kills our art. We are ready to serve this new era of our reawakening homeland and create a style for this era.... We acknowledge the formal achievements of contemporary art, as they give us more creative freedom. But we do not impose on the members of our group any preestablished dogmas of art."[12]

The group consisted of painters Antanas Gudaitis (1904–1989; fig. 213), Adomas Galdikas (1893–1969), Antanas Samuolis (1899–1942), Viktoras Vizgirda (1904–1993); graphic artists Vytautas Kazimieras Jonynas (1907–1996), Telesforas Kulakauskas (1907–1977), Jonas Steponavičius (1907–1986); and sculptor Juozas Mikėnas (1901–1964). In the first exhibition of the ARS group, graphic works and stage designs by Mstislav Dobuzhinsky (1875–1957), a well-known artist of the older generation, were also exhibited. The inclusion of works by such a respected master protected the younger artists from severe criticism (figs. 214 and 215).

Thus, in the late 1920s and early 1930s, modernism consolidated its position in Lithuania through the formation of avant-garde groups and societies of young artists, the organization of exhibitions, and the publication of articles. It broke the barriers of conservatism in art and changed the negative public opinion. In 1931, Juozas Keliuotis (1902–1983), a graduate of the Sorbonne University, launched the journal *Naujoji Romuva* (New Romuva), which promoted young artists and modern art and was published until the Soviet occupation in 1940. However, *Naujoji Romuva* avoided extreme experimental art. Although the journal published a few articles on dadaism, surrealism, and abstraction, the interest in neo-classicism that developed in Europe in the 1920s and 1930s was one of the major concerns of *Naujoji Romuva*. It was dedicated mainly to representation of works by such established early-twentieth-century masters as Franz Marc, Pablo Picasso, Georges Braque, Natan Altman, Henri Matisse, Paul Gauguin, Fernand Léger, and others.

The views of the ARS group and of the *Naujoji Romuva* journal coincided in several more respects. Both the artists and the editors emphasized creativity as the basis of national culture, a notion that was contrary to the idea of creativity as destruction and nihilism,

FIG. 213. Antanas Gudaitis, *Musicians*, 1930. Oil on canvas, 69.5 × 55.5 cm. Collection of Lithuanian Art Museum, Vilnius.

FIG. 214. [TOP] Artists after the opening of the first exhibition of the ARS group at the entrance of Čiurlionis Gallery, Kaunas, Lithuania, October 30, 1932. *Left to right:* Juozas Mikėnas, Juozas Petrėnas, Paulius Galaunė, Adomas Galdikas, Mstislav Dobuzhinsky, Viktoras Vizgirda, and Antanas Samuolis. Photograph from the archives of Viktoras Liutkus.

FIG. 215. [BOTTOM] Jouzas Mikėnas, poster for the first exhibition of the ARS group, 1932. Collection of M. K. Čiurlionis Art Museum, Kaunas, Lithuania.

which was propagated by the Four Winds group. The journal, and its editor in particular, stressed the idea of "art as an expression of individuality, nationality, and modernity." In their works, artists of the ARS group sought to perpetuate the link between folk art and modern visual expression. Both the members of the ARS group and the *Naujoji Romuva* staff were also devoted to French art and culture. This Francophile aspect can be explained by the improvement in the political relations between France and Lithuania, and also by the fact that many artists of the ARS group such as Gudaitis, Jonynas, Mikėnas, Steponavičius, and Vizgirda had studied in Paris and were familiar with the latest developments in French art. For example, Galdikas, the oldest member of the group and a professor of the Kaunas Art School, was associated with the School of Paris. He made frequent visits to Paris and held a solo exhibition at "Atelier Français" in 1931. In the same year, Waldemar George published a monograph about Galdikas.

Justinas Vienožinskis, the founder of the Kaunas Art School, the first chairman of the Lithuanian Artists' Union (established in 1935), a teacher, a painter, and a radical art critic, was an important figure in the modernization of Lithuanian art in the 1930s. Vienožinskis, who was a consistent advocate of young artists, called for innovations and creativity, measuring Lithuanian art by the criteria of European art and strongly objecting to "patriotic" subservient art. Vienožinskis's nonconformism and individualistic attitude persisted in the period of Soviet occupation as well, and were the reason for his dismissal from the Artists' Union of the Lithuanian Soviet Socialist Republic in 1949.

The work and views of the artists of the ARS group shattered the relatively slow and languid development of Lithuanian art. They used expressive drawing and a restricted range of colors, rejecting details and simplifying forms. The focus of their interest was Lithuanian folk art with its stylized imagery and use of vivid, unmodulated color masses. Works by the members of the ARS group never aimed to please the general public and opposed philistinism and the themes of official art. The artists depicted village landscapes and character types, as in *New Settlers* (1933) or *An Old Master* (1939) by Antanas Gudaitis. They did not avoid satire and the bitter grotesque, and they mocked the manners of the Lithuanian bourgeoisie in works such as *A Lady with a Dog* (1930), *The Crucified Bourgeois*, and *On Summer*

Holiday (both 1934) by Antanas Samuolis. At the same time, we encounter reflections of various states of nature (fig. 216), allegorical symbols, images painted in a spontaneous manner as in the works of Galdikas, and decorative expressions exemplified by the sculpture of Mikėnas, whose works were influenced by the sculpture of Charles Despiau (1874–1946) and Aristide Maillol (1861–1944). The ARS artists moderately distorted form to make it crude and used a darkened range of colors. Their interest in folk art and the roots of national culture can be compared with similar trends in European art in the interwar period.

The modernization of Lithuanian art during the 1930s caused a split between the different generations of artists. Although the Lithuanian Artists' Union aimed to unite all professional artists, this goal remained unrealized, since sections of "realists" and "individualists" established in 1939 mounted separate exhibitions and maintained opposing views. Many young artists who sought to develop their artistic individualities fostered contacts with Western European art and artists. For example, Vladas Eidukevičius (1891–1941), who traveled extensively in many European countries, combined impressionist and classicist influences in his work. In the 1930s, constructivist tendencies were found in the work of Stasys Ušinskas (1905–1974), who was greatly influenced by his studies in Paris in the studios of Fernand Léger (1881–1955) and Alexandra Exter (1882–1949). Later, Ušinskas worked mainly in stage design.

Therefore, by the end of the 1930s, Lithuanian art had reached a fairly high level of development, with a wide stylistic range and a multifaceted and intense artistic life. Organizational structures such as the Artists' Union, art societies, and art departments were active and efficient, and the aesthetic views and the art critics who presented them were polarized. The most important international event was an exhibition of modern French art held in Kaunas in 1939. In addition to shows in Kaunas, the provisional capital of Lithuania at that time, exhibitions were organized in smaller cities such as Alytus, Šiauliai, Klaipėda, and Telšiai. This burgeoning of art was for the most part provoked by the young generation of artists who had introduced contemporary art into Lithuania and established links with European art centers.

These artistic developments parallel the contemporary social and political life of Lithuania. It was still

FIG. 216. Viktoras Vizgirda, *Village*, 1939. Oil on canvas, 73 × 92 cm. Collection of M. K. Čiurlionis Art Museum, Kaunas, Lithuania.

difficult to foretell the course and consequences of political events. The secret protocols of the treaties signed by Ribbentrop and Molotov on August 23, 1939, already prefigured the incorporation of Lithuania and other Baltic countries into the Soviet Union and the subsequent occupation by the Soviets. The demands that the Soviet Union made on Lithuania and the political pressure that followed the signing of the treaties pushed the country into an abyss with the loss of statehood and sovereignty. The Red Army, which occupied Lithuania in June 1940, put an end to the process of modernization of Lithuanian culture.

NOTES

1. E. Aleksandravičius and A. Kulakauskas, *Carų valdžioje: XIX amžiaus Lietuva* (Under the reign of tsars: Lithuania in the nineteenth century) (Vilnius: Baltos lankos, 1996), 13.

2. Ibid., 250.

3. Rimantas Šidlauskas, "Pirmoji dailės paroda Lietuvoje prieš 170 metų" (The first art exhibition in Lithuania 170 years ago), *Kultūros barai* 6 (1990): 23.

4. E. Aleksandravičius and A. Kulakauskas, *Carų valdžioje*, 232–233.

5. In the 1890s, exhibitions were also held by the Warsaw Artistic Salon, and, in the early 1900s, by the Krakow society "Sztuka" and the Vilnius Art Society.

6. Vytautas Landsbergis, *Čiurlionio dailė* (The art of Čiurlionis) (Vilnius: Vaga, 1976), 193.

7. From 1920 until 1939, the Lithuanian capital, Vilnius, was under Polish rule.

8. *The Seventieth Anniversary of the New Art Exhibition. Wilnius, 1923* (Lodz: Muzeum Sztuki Lodz, 1993).

9. Jolita Mulevičiūtė, "Apie arsininkų pažiūras" (About the views of the Ars group) *Menotyra* 2 (1995): 37.

10. J. Keliuotis, "Pasikalbėjimas su Nepriklausomųjų dailininkų draugijos pirmininku A. Valeška" (Conversation with Chairman of the Society of Independent Artists A. Valeška), *Naujoji Romuva* 8 (1932).

11. Justinas Vienožinskis, *Straipsniai. Dokumentai. Laiškai. Amžininkų atsiminimai* (Articles. Documents. Letters. Contemporaries' memoirs) (Vilnius: Vaga, 1970), 127.

12. ARS. *Parodos katalogas* (ARS. Exhibition catalogue) (Kaunas: M. K. Čiurlionis Gallery, 1932), 5–6.

Viktoras Liutkus

BREAKING THE BARRIERS

Art under the Pressure of Soviet Ideology from World War II to Glasnost

THE SOVIET UNION put into effect new methods of management of culture and art. There was no hope of retaining the independent development of Lithuanian national art. All creative work was restricted to the model of Socialist Realism enforced by the Communist Party and widely propagated in the press and at artists' meetings. This model declared the primacy of the Communist ideology and required the glorification of Communist leaders and Party accomplishments. Art and literary publications were closed one after another, and the Artists' Union was restructured several times until it finally became the Artists' Union of the Lithuanian Soviet Socialist Republic in August 1940, and later was made subordinate to the Artists' Union of the Soviet Union.

In 1940–41, artists and creative intelligentsia were negatively influenced by the uncertainty of the future, the sudden change of creative orientation, the inter-ference of authorities in the field of art, and the nature of creative work itself. The painter Antanas Gudaitis, who himself had experienced the situation of ambiguity in creative work, recalled, "Soon illusions were bound to be dispelled. Artists were increasingly oppressed by restrictions placed on their creative work, and specific instructions and directives. Signs of ideological conformism and reconciliation with the official demands appeared. Works were created on commission. Artists found it extremely difficult to work in such conditions."[1]

Horrifying repression, deportation of part of the Lithuanian population to Siberia, physical extermination of the Lithuanian military, and imprisonment soon followed this uncertainty. Many artists became victims of repression, including Adomas Brakas, Vytautas Bičiūnas, Jonas Juozas Burba, Adomas Smetona, and Petras Verbickas, all of whom were deported.

During the first year of the Soviet occupation, Lithuanian artists experienced a drastic change in their existence, which became characterized by conformism and caution, hope and despair, hypocrisy and personal tragedies.

The development of Lithuanian art since the beginning of the second Soviet occupation in 1944 can be metaphorically compared with a slowly moving train: art was put on the tracks of Socialist Realism, the only permissible method in the arts, and had to move in one established direction propelled by a well-equipped propaganda machine and fueled by Communist ideology. The train dispatchers and guides were Party and state authorities who pushed the levers of art censorship, exhibition space, purchase of works, prizes, and privileges. Having found itself in the large crucible of the many Soviet republics, Lithuanian art was subject to all commands from the "center" (Moscow) and had to adjust and compromise its methods of art education and its processes of organizing exhibitions to reflect mandates imposed from above.

Certainly, the metaphor of a train does not cover all political, social, and artistic developments in different spheres of life. Reality was far more contradictory, oppressive, and cruel. Everything was mixed up in the melting pot of Soviet life. It acquired tragicomic forms and became a kingdom of distorting mirrors. On the one hand, there was fear and suspicion brought by Stalinism, because many innocent people were persecuted and deported to Siberia. Many Lithuanians morally dissociated themselves from official life, and Lithuanian partisans led an armed resistance struggle against the invaders and collaborators until 1954 (the longest in the Baltics). On the other hand, there was Soviet rhetoric, which included propaganda of the advantages of Socialist life and happiness for the people, the cult of Stalin, the "leader of nations," and eulogies to the new forms of Socialist existence—collective farms and trade unions. The air was tense with constant talk about "enemies of the people," "agents of capitalism," and "the threat of the United States." This psychological tension directly affected artists and their work conditions. Collective discussions of creative work in artists' organizations were reminiscent of the Inquisition of the Middle Ages. Artists who received public criticism were bound to lose all career and creative opportunities, and their works were banned from exhibitions and museums. For example, in 1946, Justi-

nas Vienožinskis, one of the most outstanding Lithuanian artists and art teachers, was dismissed from the Vilnius Art Institute and later from the Artists' Union. In 1950, professors Liudvikas Strolis (1905–1996), Vytautas Kairiūkštis (1890–1961), and Petras Tarabilda (1905–1977), as well as art historians Klemensas Čerbulénas (1912–1986) and Vladas Dréma (1910–1995), were fired for being "unfit to work as teachers at a Soviet school." Well-known museum experts and art historians were also dismissed. Paulius Galauné (1890–1988), the founder and director of M. K. Čiurlionis Museum, was fired, and Lev Karsavin (1882–1952), a Russian intellectual, philosopher, and cultural historian who had lived in Lithuania since 1928, lost his job as professor at the University of Vilnius and the Art Institute. In 1949, Karsavin was deported from Lithuania and ended his life in gulag camps in the Komi Autonomous Soviet Socialist Republic.

Ideological attacks against artists and the intelligentsia were held on a consistent and deliberate basis and reached their peak in the immediate postwar years. Artists everywhere in the Soviet Union, including Lithuania, were accused of "apolitical attitudes," "formalism," "servitude to the West," and "lack of ideas." In 1948, an attack against the opera *Great Friendship* by Vano Muradeli was launched (see Eha Komissarov's essay in Part Two), and the Central Committee of the Communist Party discussed the activity of the Artists' Union. Artists were blamed for distortions, sketchiness, chaos, schematism, and traces of bourgeois thinking in their work. Stasys Ušinskas, the stage designer for *Great Friendship*, was labeled a "formalist" by Party ideologues and was subjected to particularly severe criticism; he was later deprived of any further possibility to create stage design. The same happened with Liudas Truikys (1904–1987), another gifted Lithuanian stage designer. "Universities" of Marxism-Leninism were established with the aim to "educate," and artists were forced to attend them in order to gain credits for the received "ideological" lessons. Artists' education also included frequent visits of "art experts" from Moscow, during which they usually denounced local art, especially modernist trends. Even moderate hints of impressionism were undesirable. In 1951, these "experts" decided to combine the Kaunas Art Institute with the Vilnius Art Institute on the grounds that it was not expedient to have two art schools in Lithuania.

The peak of the organized ideological attack and a typical expression of artists' attitude and behavior was the 1950 special "case" of discussing Čiurlionis's legacy, a meeting provoked by the article "To Overcome the Influence of Formalism" by Aleksandr Kamensky published in the weekly *Literatūra ir menas* (September 17, 1950). In a two-day discussion, the work by this artist was condemned as formalist, decadent, and cosmopolitan. Only several artists (Vienožinskis and Gudaitis) were not afraid to defend Čiurlionis in public and oppose the vulgar assessment of his work. Attacks on Čiurlionis's work continued later.[2] Opportunities to present Čiurlionis's art to society at large and to publish his literary works became possible only in the second half of the 1950s after the cultural "thaw" following Khrushchev's denunciation of Stalin's crimes.

A wide gap in Lithuanian art was left by the emigration of about eighty artists from Lithuania during the war, especially in 1944. This group included many major Lithuanian artists, art teachers, and historians of the interwar period. In 1946–49, the Lithuanian School of Applied Art in the city of Freiburg, located in the then French occupation zone in Germany, became a place of work and study for many young Lithuanians. Until the mid-1960s, artistic links between Lithuania and Lithuanian artists in exile were hindered by strict Communist Party control, and in this way national art arbitrarily split into two isolated branches.

TIME IMPERSONAL

Resistance and self-preservation, artists' conformism and their ability to maneuver around the official culture characterized life in Soviet-occupied Lithuania. Someone remarked that "despite all the oppression, punishment, and various compromises, a dialogue with the invaders or the suppression of the people's voice, the very existence of a creator became a historically significant bulwark that saved Lithuania from a spiritual void."[3] Survival of a national Lithuanian culture became important evidence of the nation's tenacity.

When one looks at Lithuanian postwar art, one gets an impression that all artistic individuality was eliminated. Ideological taboos, Party control, and the mechanism of oppression suppressed artists' individuality, feelings, moods, interests, and artistic position. Subjective assessment of reality, an original viewpoint, and natural creative instinct, all of which characterize an independent and individual artwork, disappeared altogether.

The whole panorama of art was confined to only one mode—that of Socialist Realism. The heritage of Lithuanian art was also erased from artistic consciousness. Until the early sixties, prewar works of the ARS group were regarded as formalist and "bourgeois" and were banned from museums. As painter Vytautas Mackevičius (1911–1991) noted in 1950, "Artists of the ARS group . . . brought the most reactionary ideas of Western capitalism."[4] However, moderate stylistic variety of art of the prewar and war years existed until around 1948. After the notorious Communist Party decrees of the late forties and the particularly strict control imposed on creative work, the fifties were characterized by total decline, stylistic unification caused by dogmatic aesthetic criteria, and all-powerful administrative supervision.[5] This exerted a detrimental influence on Lithuanian painting and, to a somewhat lesser degree, on graphic art and sculpture. Painting received special attention due to its alleged ideological and educational function. A special category of painting—"thematic composition"—was introduced; it combined the artist's positive, optimistic, and agitational attitude with precise realistic painting. "Thematic composition" became a priority for Socialist Realism, while landscape and still life moved to the lowest position in the hierarchy of genres. Even more unwanted were sketches and plein air compositions in an impressionistic mode. Special emphasis was placed on a meticulously precise and finished look. Paintings of the late-nineteenth-century Russian group of artists known as *peredvizhniki* (the Itinerants), with their didactic moralizing representation of positive and negative characters, were usually used as examples of "thematic composition." Certainly, "thematic compositions" had to depict Socialist reality and reflect ideological topics. The Artists' Union suggested to artists long lists of themes in order to provide boundaries within which painters had to confine themselves: "milkmaids," "mechanic engineers," "young people working on collective farms," "young pioneers in vacation camps," "red units," "Soviet militia keeping watch," "young pioneers in nature," "a victorious Soviet soldier," and similar topics were typical examples

of "urgent issues" of the day. Even landscapes had to reflect ideological themes. Therefore, in many works by Lithuanian artists, landscape is often combined with themes such as "electrification," "parceling out land for peasants," "hay stacked for the state," and "brigade work in collective farms." Such themes are found in paintings by Jonas Vaitys, Vytautas Mackevičius, Rimtas Kalpokas, Zigmas Petravičius, and Antanas Žmuidzinavičius, and in graphic art by Jonas Kuzminskis, Vytautas Jurkūnas, and Antanas Kučas.

The painting *Establishing a Kolkhoz* (1950) by Vincas Dilka (1912–1997) was considered the work that best corresponded to the criteria of Socialist Realism. The manner of creating this work most typically reflects the naturalistic imitation of nature and meticulous precision mandated by the dogmas of Socialist Realism. For this composition, the artist chose more than thirty people who participated in a meeting that established a Lithuanian collective farm. He also depicted an actual location and transformed a visual scene into propaganda for an optimistic future. The content of Socialist Realist art such as this ignored the painful and tragic sides of life in Lithuania, including deportation, "class" struggle between partisans and collaborators, and fear and persecution in Lithuanian villages.

As sculptor Petras Aleksandravičius (1906–1997), an active participant of postwar art and creator of the monument to the writer Žemaitė in Vilnius (1951), once remarked, "Sculpture was more liberal than painting."[6] In the early postwar years, many artists received state commissions and subsidies for monumental memorial sculpture, which was held in high esteem. Victorious soldiers, Party activists, and supporters of the new regime were usually the subjects of these monuments. Lithuanian sculptors were invited to all-Union competitions and received commissions to erect monumental sculptural groups in other republics, such as the sculptural groups of the monument *Victory* in Kaliningrad by J. Mikėnas and B. Pundzius (1946). Soon, monuments representing Party leaders were erected in Lithuania. A monument to Stalin was built in Vilnius in 1949 and a monument to Lenin by Tomsky in 1952; variants of it were also built in other Soviet cities. Such sculpture was the beginning of a long tradition of building monuments to the "classics" of Marxism and Communist Party leaders that continued until perestroika. It was an honor for every large city to have this kind of monument. Monu-

mental sculpture symbolizing important Soviet military and Socialist achievements was also erected. For example, in 1950–52, four sculptural groups in theatrical postures were created in Vilnius on the former General Ivan Cherniakhovsky's Bridge. These groups of industrial and agricultural workers, students, and soldiers presented stereotypical figures, or, in the period's terminology, "a typical hero in typical circumstances," rather than an individualistic interpretation. A more expressive visual language prevailed in small-scale sculpture, bas-reliefs, and portraits, all of which retained some traces of the prewar tradition.

The tendency of naturalism, which was widespread in the Soviet Union in the postwar decade, did not dominate all branches of Lithuanian art. Liberalized artistic expression, the essentials of art instruction, and contacts with European culture and art during the interwar years established a firm basis in Lithuania that prevented art from completely deviating from its course.

A "THAW" OR REAWAKENING: SPECIFYING THE CONCEPTS

In discussing the development of Lithuanian art from the 1940s to the present, we are bound to confront the question of its place in the "melting pot" of Soviet art. The same applies to Latvian and Estonian art. There were certain differences and specific features determined by local conditions in the development of art in Lithuania.

All of the Baltic republics escaped the tragic prewar destruction caused by Socialist policies that befell other parts of the Soviet Union. After the war, Lithuania was subjected to the same censorship and strict administrative supervision from the "center." However, it was not driven to the extremes of Socialist Realism. A large part of visual culture remained within the limits of moderate apolitical realism. Furthermore, Moscow still regarded the occupied Baltic states as a "separate" territory with autonomous local cultural traditions and identities as well as different languages, and a stronger feeling of national roots than found in other Soviet republics. These circumstances gained importance when the "thaw" in the arts naturally turned artists' attention to the recent past and encouraged them to use folk art as a source of inspiration. In Lithuanian culture, the stabilizing factor was the feeling of strong his-

torical and national identity: Lithuanian is one of the oldest Indo-European languages; the Lithuanian state dates back to the thirteenth century; and the country is located (in Lithuanian eyes) at the crossroads of Europe.

Important also were the tactics of artists "to wait until the time is ripe." One of the preconditions of the emergence of a "silent Lithuanian modernism"[7] was the inner disposition of artists to work without seeking publicity, to use metaphors and allusions, and to consolidate their inner freedom. Even before the "thaw," as Jonas Mackonis noted, Lithuanian artists in private conversations discussed with admiration such Russian artists as Valentin Serov, Mikhail Vrubel, and Peter Konchalovsky, as well as French artists Henri Matisse and Auguste Renoir, and their own efforts to renew art were first of all directed to expanding the limits of realism and increasing subjectivity.[8] "Subjectivity" was supposed to return artists' individual attitude to art, to remove from their work traces of "impersonal time." The local Lithuanian Communist Party authorities also maneuvered between strict requirements of the "center" (meaning Moscow) and the needs and interests of local culture and artists. "Tribute" had to be paid to both sides by pander, indulgence, and privileges. The "carrot-and-stick" policy became typical of daily artistic life: On the one hand, censorship of exhibitions and works, and, on the other, honorary titles, awards, prestigious apartments, and privileges for artists who agreed to conform to the requirements of official art.

No less important was Lithuania's geographical proximity to Central and Western Europe, and contacts with the large Lithuanian community in exile, though these were very limited. Most information about Western life reached Lithuania from Poland or through the Polish press, radio, and television. The rather strong influence of the Catholic church on Lithuanian society was also important.

All these factors characterize the period of "thaw" in Lithuanian art. What exactly does this concept mean? As has been accepted in the last decade, it indicates a freer atmosphere in art, liberation from Stalinist dogmas, and a greater variety of forms of expression. The signs of individual artistic style and growing interest in prewar expressionistic traditions of Lithuanian art became an important feature of art processes, especially in painting and graphic art. In the second half of

the fifties, cultural issues were discussed often in the Lithuanian press. The most significant was a debate in the official Communist Party paper *Tiesa* in 1959–60 about innovation in art and the question of tradition versus modernity. The debate embraced a wide scope of artistic issues: innovation, the role of national artistic traditions (including folk art), the impact of modernism on current trends of Soviet art, nineteenth-century art history and the role of *peredvizhniki*, and an evaluation of principles of composition and works of contemporary Lithuanian painters. The painter Augustinas Savickas (b. 1918) noted that "the problem of contemporary style is the most important in the development of our painting," thus expressing the key issue in the features of Lithuanian art at the time.[9] Savickas was one of the investigators of new forms of expression, and his exhibition held in 1959 in Vilnius became an important guidepost for Lithuanian painting of the 1960s. Some articles, however, revealed quite reserved and conservative positions of authors regarding the processes of art.

A strong incentive for the emphasis on innovation was the exhibition of thematic paintings of the Baltic republics and a conference held in Tallinn in December 1959. The exhibition testified to the important changes taking place in Estonian, Latvian, and Lithuanian art by the end of the 1950s. It was obvious that the stylistic scale of painting had started to break through former restrictions of expression. Reports at the conference made by art critics from Vilnius, Rīga, Tallinn, and Moscow stressed the importance of "contemporary style," "monumental style," "variety of individual expression," and "national character of art."[10] The "thaw" affected different fields of the visual arts. More exhibitions of various genres such as landscape, portraiture, and still life were now held. In 1958, the Section of Young Artists was established within the Lithuanian Artists' Union, and beginning in 1959, exhibitions were held on a regular basis. In the early sixties, some artists ventured to show works of modernist styles in public. The Club of the Writers' Union, Vaga Publishers, the State Conservatory, and halls of cinema and drama theaters (for example, in Panevėžys) started to be used as unofficial exhibition spaces. Certainly, these exhibitions did not escape Party control, and many of them were closed. Small exhibitions were also held in artists' private apartments, such as those of Vytautas Šerys and Judita Šerienė. At this point, art

FIG. 217. Silvestras Džiaukštas, *Nude Woman*, 1966.
Oil on canvas, 100 × 130.5 cm. Dodge Collection,
ZAM, 16844.

was divided into "official" and "unofficial." Thus, the "thaw" meant not only liberation but also polarization of art, and a new stage of artistic opposition, as some artists distanced themselves from officially sanctioned art and institutions. However, one must keep in mind that Soviet art critics used various terms to label artists and their works that did not conform to the art establishment: "dissident," "underground," "unofficial," "left-wing," or "nonconformist."[11] Lithuanian art critics are inclined to apply the term "semi-nonconformist" to Lithuanian artists, especially painters, thus indicating the critics' rather ambiguous attitude toward official art.[12]

Lithuania of the 1960s does not boast any representatives of clearly expressed "dissident" or "un-

derground" art, which was found at the time among Moscow artists. Lithuanian artists did not exclude themselves from the Artists' Union or radically confront its administration. Unofficial exhibitions were neither widespread nor "underground." Artworks that were not accepted by official exhibitions were shown in spaces such as theaters, clubs, and apartments, which were adapted by the artists for a display of their work. In the late fifties and early sixties, more experiments in visual arts were permitted, creating a possibility for artists to exhibit their works with the hope of having them bought by the state. Jonas Švažas, Silvestras Džiaukštas, Augustinas Savickas, Vincentas Gečas, Sofija Veiverytė, and Aloyzas Stasiulevičius took up strong positions in the art movement at that

FIG. 218. Jonas Švažas, *Reddish Wool*, 1966. Oil and wood shavings on canvas, 100 × 110 cm. Dodge Collection, ZAM, 14505.

time. Džiaukštas (b. 1928), who appeared on the art scene with the generation of graduates of the Vilnius Art Institute of the mid-fifties, was one of the leaders of Lithuanian figurative painting of the sixties and a representative of "official" art. His subjects were village people and so-called "defenders of people" (collaborators with the Soviet regime), as depicted in the painting *Death of an Activist* (1967), which presents a murdered postwar collective-farm activist. On the other hand, he also painted expressive, emphatically unattractive nudes of distorted shapes (fig. 217). Jonas Švažas (1925–1976) was another mainstream artist who embodied official themes in a modern style. He usually depicted such objects as ferro-concrete bridges, construction cranes, ports, gigantic plants, and elec-

tric power stations, which favorably represented the Soviet regime. His paintings often approached decorative abstraction with barely recognizable subject matter (fig. 218).

Artists often changed the titles of their works into neutral ones or used heroes or episodes from classical literature to camouflage the real meaning of their work, a practice typical of Vincas Kisarauskas and Valentinas Antanavičius in the sixties. Works by many artists were divided into two kinds: works for public shows and museum acquisition, and works for themselves, their friends, and a limited circle of art enthusiasts. "All my best memories are old farmsteads, women digging potatoes—everything that is now dying out. This is all I've ever wanted to paint. Everything that is

FIG. 219. Albina Makūnaitė, *Eglė Sobbing*, 1962.
Woodcut, 73.8 × 51.4 cm. Dodge Collection, ZAM, 09570.

new—houses, farms, equipment—does not suggest to me any ideas for painting. How then am I supposed to reflect contemporary reality? But I know that I should defer to the order of the day," wrote Algimantas Kuras (b. 1940), one of the young innovative painters in the sixties.[13] His early works, noted for a crude, authentic, and ironic manner of representing reality, were first of all works for himself.

Thus, the "nonconformism" of Lithuanian artists was characterized by rather ambiguous phenomena and artists' double standards as they searched for a balance between official art and their own artistic program. During the sixties and seventies, only a few artists were true nonconformists: Kazimiera Zimblytė (1933–1999), Eugenijus Antanas Cukermanas (b. 1935), Vladislovas Žilius (b. 1939), and Linas Leonas Katinas (b. 1941). Their relations with official art politics and the Artists' Union were very complicated and tense, often followed by administrative actions. Until the end of the eighties, works by Zimblytė and Cukermanas were exhibited in remote exhibition venues; Cukermanas, an architect by profession, was not even recognized as a visual artist. Katinas, whose solo exhibition was held in Tallinn, Estonia, "without permission of painters' section and the board of the Artists' Union of the Lithuanian Soviet Socialist Republic," received a severe reprimand and warning. His works were banned from exhibitions for a year, and the artist was deprived of the privilege of going to artists' residence centers.[14] The work and personal attitude of Vladislovas Žilius in the sixties and seventies also contradicted the official policy of the Artists' Union. His compositions entitled *Target Figures* (1968) were unacceptable for exhibitions. The artist eventually immigrated to the United States in 1976.

Cultural dissidence with anti-Soviet contents and in radical opposition to the Soviet regime was expressed in realms other than painting. The publication of *The Chronicle of the Lithuanian Catholic Church*, launched in 1972, informed society about the crimes of the Soviet regime, persecutions, and violations of human rights. A unique example of official resistance to the Soviet regime was the Orvidas homestead in the Plungė district at the end of the seventies. Using fieldstones, wood, found objects, and crosses, its founder, Kazimieras (Vilius) Orvidas (1952–1992), created a work that embodied the free spirit of religious belief

and artistic vision. Several state commissions tried to destroy the monument but did not succeed. Similar actions were taken against the Hill of Crosses near the city of Šiauliai. Dotted with an immense number of crosses and sculptures of various size, the Hill of Crosses later became a motif for visual artists such as the painter Mindaugas Skudutis. The self-sacrifice of Romas Kalanta in Kaunas in 1972, a gesture of protest against Soviet occupation, affected the national psyche and the mood of artists as well as intelligentsia and their consciousness.

The "thaw" of the late fifties and early sixties, regarded as a "reawakening" of Lithuanian art, meant a return to the prewar traditions and folk art that allowed artists to vent what had been repressed, concealed, criticized, and banned in national art. The work of the ARS group became a guide for this renewal, and Gudaitis was an ideological and creative leader at this turning point. The visual expression of the ARS group—vivid form, intense colors, abstract drawing, generalized sculptural masses, and the stress on the line and surface in graphic art—was given a new life. Old Lithuanian folk sculpture (including images of mythical deities) and folk engravings found new expression, as in the art of sculptor Vladas Vildžiūnas and graphic artists Aldona Skirutytė and Albina Makūnaitė (fig. 219). Gudaitis's paintings were also becoming more modern, free, and spontaneous. His exhibition at the Club of the Writers' Union in 1962 aroused much discussion; the artist was criticized and reprimanded by the Scholarly Council of the Art Institute for his *Triptych in Memory of Čiurlionis* (1961–62). Later work by Gudaitis was marked by expressive form and colors as well as abstract structure (fig. 220). His influence led to a substantial part of Lithuanian painting of the sixties and seventies being called "colorist." Some artists, such as Čeponis, used intense colors reminiscent of the fauvist color scheme (fig. 221).

Lithuanian art of the early 1960s was not influenced by the Severe Style, a new movement in Russian official painting of the time. The tradition of colorism and expressionism that originated in the 1930s constituted a fundamental basis for stylistic development of Lithuanian painting in the 1960s and later.

To summarize, the "thaw" in Lithuania gave rise to the developments of art that gained pace in the 1970s and 1980s: abstractions, assemblages, religious and mythological themes, works in the surrealist mode, and photorealism. These phenomena pointed to new directions in artistic thinking and prepared the transition from modern art to postmodernism.

TOWARD ABSTRACTION

There is much debate about who was the first in Lithuania after the war to paint in an abstract manner, though the name of Vytautas Povilaitis (b. 1927) is mentioned most often.[15] He painted his first decorative abstractions at the end of the fifties. A *View of Vilijampolė* (1959) is an expressive work intensified by rhythmic black contours. Later the artist used various geometric and expressive forms in abstract compositions (fig. 222). However, steps toward abstraction in the work of Lithuanian artists in the sixties were cautious. A great number of works were "semi-abstractions," retaining many traces of reality and allusions to nature.

The development of Lithuanian abstract art was influenced by several factors. Inspiration came from different sources, such as exhibitions of modernist art held in Moscow in the second half of the fifties (for example, an exhibition of works by Pablo Picasso in 1956 and the art exhibition of the Sixth World Festival of Youth and Students in 1957, where American abstract expressionist works were exhibited). The political slogan of "peaceful coexistence" also contributed to changes in the art environment, such as a separation of painting from Party ideology. The development of Lithuanian painting's attention to color and a lesser interest in figurative compositions also stimulated the move toward abstraction.

In 1962 (as mentioned earlier), Gudaitis's *Triptych in Memory of Čiurlionis* was exhibited among other works at the Club of the Writers' Union. The triptych was close in spirit to Čiurlionis's work in its abstract form, musicality, and harmony of colors. At that time, however, conditions for showing abstract paintings at official exhibitions were far from favorable. Abstract works by the painter Leonas Katinas (1907–1984; fig. 223), sculptors Antanas Kmieliauskas (b. 1932), Šarūnas Šimulynas (1939–1999), Vytautas Šerys (b. 1931), and stage designer Juzefa Čeičytė (b. 1922) remained hidden in their studios for some time. Therefore, the first solo exhibition of works by Kazimiera Zimblytė in an unofficial exhibition space at the Vaga publishing

FIG. 220. Antanas Gudaitis, *Dramatic Still Life*, 1979. Oil on fiberboard, 60 × 70 cm. Dodge Collection, ZAM, 01410.

FIG. 221. Jonas Čeponis, *Blue Landscape*, 1982. Oil on canvas, 81.3 × 100.6 cm. Dodge Collection, ZAM, 05370.

FIG. 222. [TOP] Vytautas Povilaitis, *Abstraction*, 1964. Oil on paperboard, 50 × 70 cm. Dodge Collection, ZAM, 16878.

FIG. 223. [LEFT] Leonas Katinas, *Composition*, 1980. Acrylic on canvas, 73.6 × 73.6 cm. Dodge Collection, ZAM, 06164.

house in 1969 was provocative. She exhibited abstractions as well as abstract compositions with motifs of folk art; she also made collages with paper and foil strips. Having studied textiles at the art institute, she skillfully used materials of different textures in her later works. With minimal resources, this intuitive painter created expressive colored surfaces (fig. 224), producing a Lithuanian variant of color field painting. Not until 1988 was Zimblytė allowed to show her works at the prestigious Palace of Art Exhibitions in Vilnius (now the Vilnius Contemporary Art Center).

Leonas Katinas was the only early abstract artist who was trained as a painter. However, his son Linas Katinas (b. 1941) and Eugenijus Antanas Cukermanas (b. 1935)—both trained as architects—made a significant contribution to the development of Lithuanian abstract art. From the beginning of his career, Katinas was in conflict with officials of the Artists' Union and the juries selecting works for official exhibitions. The doors of official exhibition spaces were closed to Cukermanas until the end of the eighties. The early works by Katinas in the sixties and seventies were influenced by composition and colors of textile designs. His early paintings and watercolors and later objects and installations are characterized by their wide range of visual expression and association. They shift from quiet and smooth to expressive and rough surfaces, from tranquil illusionary landscapes to analogies of heavenly bodies (fig. 225), from interpretation of cultural phenomena to the parody of this culture's products. In his abstract compositions, Katinas often used a wide variety of brushstrokes, combining in a random manner dots, strokes, underlining, geometrical signs, and splashes of paint. This variation is particularly apparent in his cycle of lithographs. The abundance of associations and techniques makes his compositions rather eclectic. However, the final result is always a well-balanced and precise whole.

In comparison to the works of Katinas, Cukermanas's compositions come closer to pure abstraction. The artist remained faithful to abstract art despite the risks of showing such works to a wider, possibly hostile, audience. Cukermanas's work is far removed from traditional Lithuanian painting, as it is rational, introverted, and minimalist. Although he uses a limited, subtle range of colors, he combines surfaces of different textures, thus addressing the viewer's intellect. At the beginning of his career, his study of architecture

FIG. 224. Kazimiera Zimblytė, (Untitled), n.d. Oil and collage on fiberboard, 106 × 109 cm. Dodge Collection, ZAM, 01424.

FIG. 225. Linas Katinas, *Landscape*, 1972. Tempera on
fiberboard, 74.5 × 60.5 cm. Dodge Collection, ZAM, 11436.

largely determined the visual structure of his works, evident in his fondness for geometric forms and clear-cut constructions (fig. 226). This style was later replaced by a subtle pictorial combination of textural layers and their mobile masses (fig. 227). The color range of Cukermanas's pictures did not conform to the "Lithuanian character" of painting, either, as it was often dull, grayish, and reminiscent of antique objects. His monochromatic textures differed as well from those of typical Lithuanian art. His unadorned abstractions, which looked as if they had been worn out by time, reveal to the viewer an oasis of tranquility, simplicity, and silent contemplation.

Many other artists practiced abstraction, often using intense colors and active forms. The fondness for color abstraction emerged as a feature of the Lithuanian school of art and remained characteristic for various generations. Traditional Lithuanian expressionism and colorism did not reach a "pure" abstract language in all cases. Quite typical in this respect are paintings by Raimundas Martinėnas (b. 1947), which are noted for their powerful, spontaneous, gestural expression and which retain concrete forms, as seen in *One of the Stations of the Cross* (1982; fig. 228). Paintings by Dalia Kasčiūnaitė (b. 1947), an artist who for several decades has demonstrated a wide variety of improvisations of color, are more consistently abstract. Algirdas Petrulis (b. 1912), one of the strongest colorists of Lithuanian painting and a master of the older generation, demonstrates great subtlety of pictorial expression in his lyrical abstractions.

In the seventies and eighties, a painting style that is characterized by even patches of one color emerged in opposition to expressive abstraction of intense colors. This style is exemplified in the works of artists such as Rūta Katiliūtė (b. 1944) and Ričardas Nemeikšis (b. 1959). Geometric abstraction, however, has not been popular, and constructivist ideas, which were propagated by Kairiūkštis in the twenties, are still waiting for their followers. Only a few young artists in recent years have been using geometric abstraction more consistently and quite successfully, namely Audrius Naujokaitis (b. 1961; fig. 229) and graphic artist Kęstutis Grigaliūnas (b. 1957). The works by the graphic artist and painter Vladislovas Žilius done in the sixties and seventies were also close to constructivist abstraction. However, Žilius, who took a stance in opposition to the Soviet regime, was more concerned with Lithua-

FIG. 226. Eugenijus Antanas Cukermanas, A, 1974. Tempera on fiberboard, 74.2 × 62 cm. Dodge Collection, ZAM, 01866.

FIG. 227. Eugenijus Antanas Cukermanas, (Untitled), 1984.
Oil on canvas, 107.3 × 66 cm. Dodge Collection, ZAM, 04782.

nia's occupation and the fate that befell its people than any issues of aesthetics per se (fig. 230). After he emigrated from Lithuania in 1976, Žilius developed an interest in new stylistic features in his works.

Among Lithuanian graphic artists, examples of pure abstraction are even more rare, which is partly due to the strong influence of book illustration. However, general tendencies in the development of art and the tradition of decorative and visually effective images found its expression in the graphic art of the seventies and eighties. Shapes of nature were transformed and reduced to mere signs in drawings by such artists as Dalia Genovaitė Mažeikytė (b. 1943), Bronislovas Rudys (b. 1954), Irena Daukšaitė-Guobienė (b. 1942), and Violeta Gaidamavičiūtė-Kisielienė (b. 1951; fig. 231). Lithuanian artists, who found semi-abstraction a more acceptable form of expression than abstraction, created works that may seem less interesting than abstract works from Estonia. In Lithuania, abstraction certainly was a belated phenomenon compared with developments in Estonia and the West. It did, however, contribute to diversity and create an opposition to the official thematic figurative compositions required by the Soviet regime.

HOW IS IT GOING, MAN?

In 1961, pop artist Claes Oldenburg (b. 1929) jokingly declared, "I am for an art that is political-erotical-mystical, that does something other than sit on its ass in a museum. . . . / I am for an art that imitates the human, that is comic, if necessary, or violent, or whatever is necessary. / I am for an art that takes its form from the lines of life itself, that twists and extends and accumulates and spits and drips, and is heavy and coarse and blunt and sweet and stupid as life itself." Twenty years later, Lithuanian artist Valentinas Antanavičius (b. 1936), in the 1981 catalogue of his solo exhibition (a perfect example of samizdat), announced curtly but not without humor, "My art is a mixture of surrealism, dadaism, and pop art with a dressing of Lithuanian sentimentalism."

This comparison serves as an introduction to the review of the local phenomenon of assemblages, a typical feature of Lithuanian nonconformist art from the sixties through the eighties. The two most significant artists, Vincas Kisarauskas (1934–1988) and Antanavičius, were opponents of Socialist Realism, along with

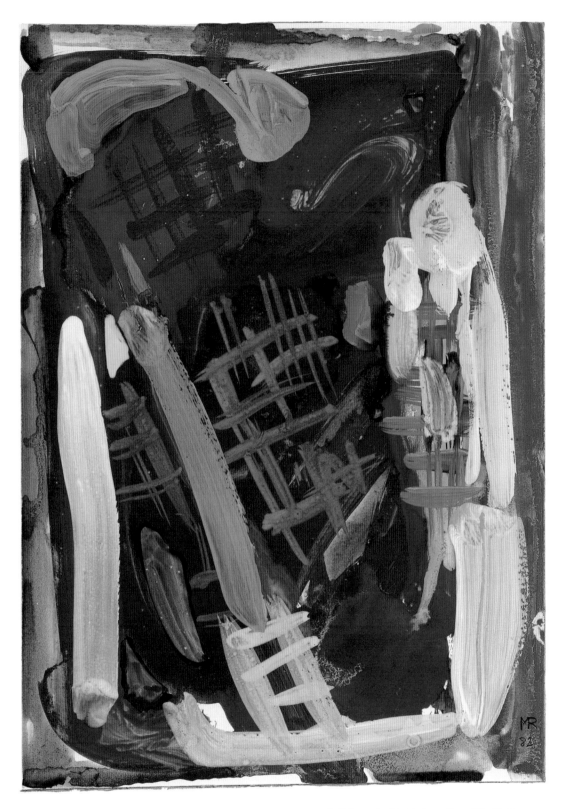

FIG. 228. Raimundas Martinénas, *One of the Stations of the Cross*, 1982. Gouache on paper, 28.8 × 20.4 cm. Dodge Collection, ZAM, 04918.

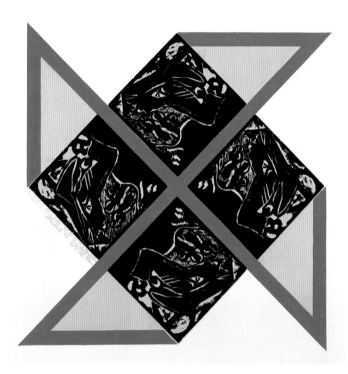

FIG. 229. Audrius Naujokaitis, *Soaring Mill*, 1986. Gouache and monoprint, 61.5 × 61 cm. Dodge Collection, ZAM, 14060.

such artists as Zimblytė, Kmieliauskas, Cukermanas, Žilius, and Šerys.

Both Kisarauskas and Antanavičius began creating assemblages in the sixties and remained the most consistent Lithuanian developers of the art form—the form that blatantly violated the tenets of Socialist Realism. Though, paradoxically, Kisarauskas's diploma work was entitled *Dairymaids*, he never supported Communist Party ideology. Furthermore, paintings by these artists, especially Antanavičius, contradicted the traditional decorative colorism of Lithuanian painting. In addition, Kisarauskas created fragmented figures within crude, structural compositions that had nothing to do with Socialist life. For both artists, the human figure and deformations of the human body became the most important visual motif in painting and assemblages. Both artists also worked in graphic art, including bookplate and stage design, and Kisarauskas created mosaics and conducted studies in art theory. Surprisingly, the artists were not totally excluded from official artistic life, but they had to work out some uneasy compromises to find their way into exhibition halls, museums, and the media. Their interest in the latest developments in world art encouraged them to look for nontraditional (in the context of Lithuanian art) means of expression. Antanavičius recalls,

> I was a close friend of Kisarauskas who had a strong distaste for rules and canons. I was more cautious and thought: "God knows what will happen with this modernism." Together with Kisarauskas we used to make trips to Poland on our own. In Krakow we saw Hasior and Kantor [Polish avant-garde artists of the fifties and sixties]. I found it a great encouragement, and realized that the art game can be a serious thing. Before that, we used to receive information on modernist art from books like *Krizis bezobrazia* [A Crisis of Ugliness]. I was skeptical about making a public show of my assemblages. I realized that if I took them to an exhibition, members of the Artwork Selection Committee would think that I wanted to make fun of them and ridicule them. I was convinced that in the socialist system there was no hope to get away with these kinds of works. So I created for myself and for a very limited circle of people. I dreamed to fill my whole studio with these assemblages and then quit working.[16]

Antanavičius and several other artists were lucky to be able to show their assemblages at a brief, three-day

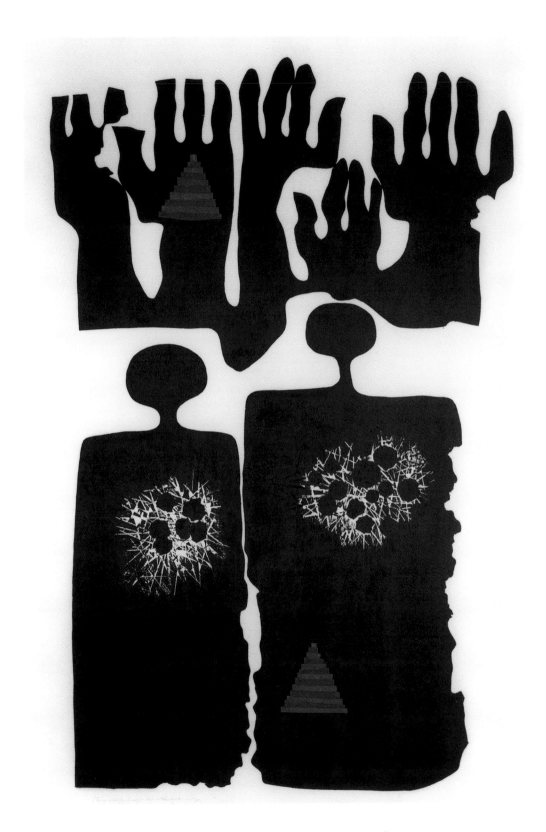

FIG. 230. Vladislovas Žilius, *Target Figures*, 1968. Gouache over linocut, 120 × 80.1 cm. Dodge Collection, ZAM, 05775.

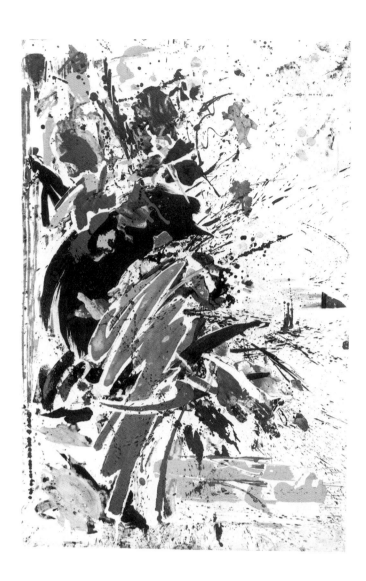

FIG. 231. Violeta Gaidamavičiūtė-Kisielienė, *Summer II*, 1982. Photomechanical reproduction, 94.2 × 63.8 cm. Dodge Collection, ZAM, 02605.

unofficial exhibition in Vilnius's Palace of Artists in 1977. A larger collection of his assemblages was exhibited at the State Conservatory in 1981, and in the late eighties they were accepted for an official exhibition of republican art devoted to the issues of ecology. Although in the first half of the sixties Lithuanian artists were free to show their collages (for example, Aloyzas Stasiulevičius [b. 1925] and Galina Petrova [b. 1927]), assemblage was still terra incognita for many artists. Only after ten more years did this art form finally draw the attention of the artists of the younger generation, including Algimantas Kuras (b. 1940), Galina Petrova, Mindaugas Skudutis (b. 1948), and Raimundas Martinėnas (fig. 232). Some artists, like Marija Teresė Rožanskaitė (b. 1933), created assemblages from ready-made objects.

Antanavičius's work was contrary to the dominant concept of "beauty" in art. His use of irony and the grotesque, strongly deformed human figures, and dark, deliberately muddy colors did not correspond to the established criteria of "good" painting. His pictures are based on opposing concepts: stoicism and vanity, optimism and skepticism, the comic and the tragic.

A more broad-minded and liberal relation with various manifestations of social life and new phenomena of culture and subculture emerged in Lithuanian art in the seventies. Products of mass and pop culture became objects of representation in the works of painters Algimantas Kuras and Kostas Dereškevičius (b. 1937) and graphic artist Mykalojus Povilas Vilutis (b. 1947). Artists also developed a new attitude toward spiritual and emotional aspects in the repressive atmosphere of Soviet life. The confrontations mentioned above created a range of moods in the artwork itself: banality emerged alongside refinement, and witty irony was accompanied by painful destruction. In the words of Antanavičius, "I've always tried to represent something, not just feelings. I want to retain some hints of a human figure, a landscape or a beast. They force a spectator to search for something and make guesses. I seek to encourage thinking, philosophizing, politicizing and tragic moods."[17] His figurative compositions questioned the image of heroic man that was firmly established in Socialist Realist painting. In his works, a figure was reduced to a fragmented, jagged, and coarse semi-abstract construction (figs. 233 and 234), and his portraits were reduced to drawings of grotesque masks.

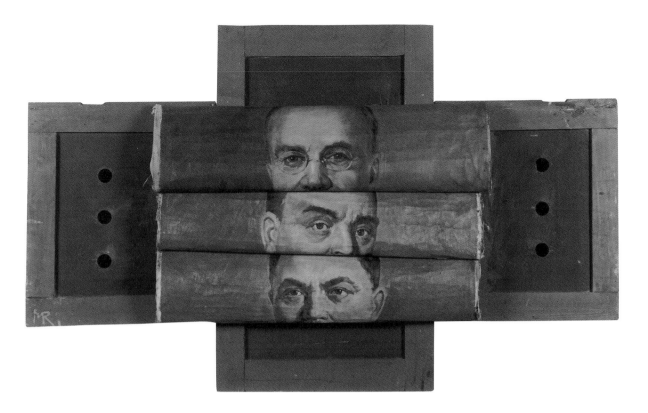

FIG. 232. Raimundas Martinėnas, *Anonymous History*, 1976. Oil over rolled canvas mounted on painted wooden panel, 83 × 134 × 13 cm. Dodge Collection, ZAM, 16812.

In his assemblages, the artist used a wide variety of materials and objects, including folk artifacts, household utensils, plastic items, and objects that he found in dumps (fig. 235). Contrasting combinations of textures and an assortment of objects placed against the construction's background create a field of covert implications and meanings, ranging from ironic representation of political figures (fig. 236) to nostalgic landscapes decorated with relics of folklore objects.

The beginning of Kisarauskas's creative career in the late fifties exemplified artistic resistance, since he could never contain himself within the canons of art. He drew daring sketches, sculpted, and burned wood, on which he glued and attached various materials and objects. Kisarauskas was greatly influenced by art exhibitions at the 1957 Sixth World Festival of Youth and Students in Moscow, which prompted him to create linocuts of expressive broken lines. In 1960, the artist received a severe reprimand from the local authorities for his innovative book illustrations (later his wife,

Saulė Kisarauskienė, was also accused of formalism in her book illustrations). In the first half of the sixties, Kisarauskas created engravings and paintings on the motifs of classical myths, works of world literature such as his interpretations of *The Divine Comedy*, *Hamlet*, and *Los Caprichos* by Goya and themes based on the New Testament. In 1960–65, he made a cycle of cardboard carvings and painted pictures, such as *A Broken Man* and *The Disabled*. These works display the artist's tendency to deform and fragment the human figure and dissect a whole form into separate parts. Remembrances of World War II inspired Kisarauskas to create tragic images of man. He devoted several veneer carvings, such as *The Undefeated* (1960), to the postwar anti-Soviet resistance movement and later painted *After the War* (1965), which represented the maimed figure of a resistance fighter. Of course, none of these works were accepted for exhibition.

Kisarauskas was never attracted to "dissident" art movements such as abstraction, since he needed

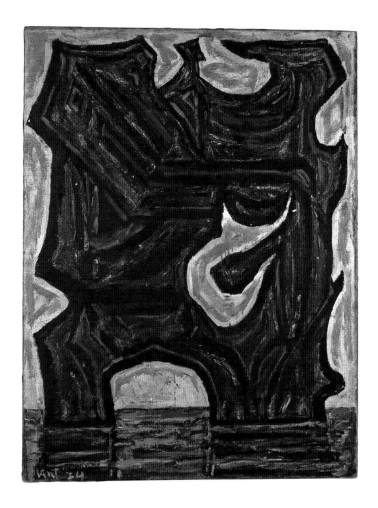

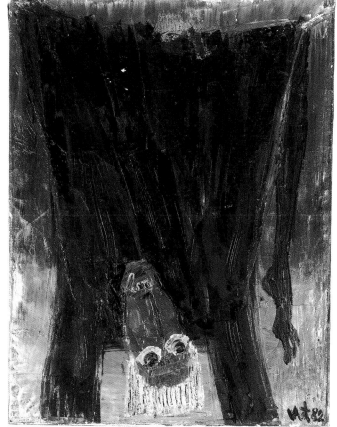

FIG. 233. [ABOVE] Valentinas Antanavičius,
The Figure, 1974. Oil and metallic paint on burlap,
130 × 100 cm. Dodge Collection, ZAM, 11606.

FIG. 234. [RIGHT] Valentinas Antanavičius,
Washed Up II, 1982. Oil on canvas, 80 × 62.5 cm.
Dodge Collection, ZAM, 01582.

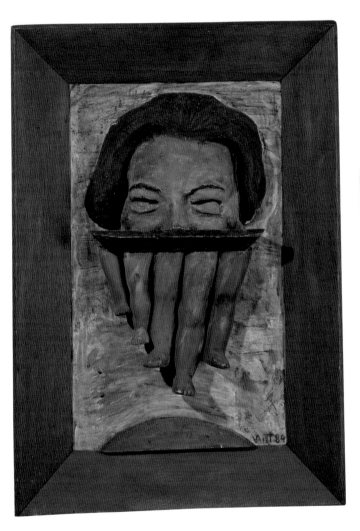

FIG. 235. [ABOVE] Valentinas Antanavičius, *Nostalgia*, 1984. Painted plaster, wood, and doll's legs on fiberboard, 72.8 × 50.2 × 8 cm. Dodge Collection, ZAM, 14035.

FIG. 236. [RIGHT] Valentinas Antanavičius, *The Legacy*, 1968–88. Mixed-media assemblage (plaster casts, leather pouch, sunglasses, doll's arms and legs) on panel, 106 × 69 × 10 cm. Dodge Collection, ZAM, 16944.

objects and figures to express his worldview. "Abstraction is alien to me. I never did abstractions. They seem to be able to express too little. I need a figure. The most I can say is through a figure."[18] However, Kisarauskas treated the figure in a radical way, dissecting it and connecting it with other semi-abstract images (fig. 237). He did not adhere to the established components of a specific genre and combined elements of expressionism with surrealism and pop art. He also studied early Lithuanian folk sculpture, on the basis of which he developed the tension of form and lines in his works. Intricate labyrinths of lines and surfaces and strange combinations of narrow spaces in his paintings are created from geometric and architectural figures as well as constructions of large forms. "I have always wanted and still want to say something bizarre, tragic and bizarre, uneasily, repulsively bizarre," he wrote in the foreword to his *Monograph That Nobody Is Going to Publish* in 1970.[19] In comparison with the works by his colleague Antanavičius, Kisarauskas's human figures look more "civilized," stoic, and peaceful.

Works by Antanavičius and Kisarauskas were ahead of their time in their unconventionality. Although they clashed with ideological regulations, the ideas presented in these works did not disappear and were eventually reflected in works by younger artists.

UGLY IS BEAUTIFUL

Although Kisarauskas and Antanavičius painted in a radical way, the liberalization in Lithuanian art spurred by the thaw that followed Stalin's death did not initially involve profound changes overall in artists' worldview and in their artwork. Other artists seldom addressed prosaic aspects of life. Indications of a change in artists' attitudes eventually appeared in the mid-sixties, when a new generation of artists, including Kuras, Dereškevičius, Algimantas Švėgžda (1941–1996), and later Arvydas Šaltenis (b. 1944), began to exhibit their works upon graduation from the art institute. They initiated a radical conflict with the dominant positive view of reality by painting unattractive and sometimes shocking public scenes (fig. 238) that included downtrodden *homo sovieticus* and mundane aspects of city life such as crowded kiosks, long lines, and packed city buses (fig. 239). They also created compositions that satirized Soviet ideological symbols (fig. 240).

In the late sixties and seventies, these younger painters established an informal group and held joint exhibitions, the two most famous of which took place in 1973 and 1979. Kuras's studio in Vilnius was a gathering point, where they created artworks to oppose official "thematic compositions." Their new style included especially brutal, unaesthetic motifs, unappealing scenes of social life, and ironic or grotesque forms to represent so-called "important themes." Except for Švėgžda, who soon thereafter turned to photorealism, these artists represented not conventional and trite themes but daily life—joyless and monotonous. Kuras described the position of his work, stating, "At first I tried to satirize things, to create different combinations of things and to deliberately impose on the viewer something he or she considered ugly. At that time I was particularly fond of depicting an oily engine that others would find repulsive and not deserving attention. Later I changed this provocative attitude and I came to like the nature of such objects which became for me simply an intimate and cozy world."[20] For this artist, plain and unattractive aspects of nature became a source of beauty, and the central place in his paintings was occupied by some mundane (decaying, discarded, or rusty) thing or by an allusion it aroused (fig. 241).

In the sixties, Lithuanian artists also painted bridges and bridge piers, railroad junctions, poles, transformers and cosmic radars (fig. 242), shop windows, and cars that had been demolished in accidents (Vincentas Gečas [b. 1931]), and they used active and contrasting colors. These works were "metaphors" for the imposing progress in Soviet industry and echoes of Italian neo-realism that persisted in Lithuanian painting. However, Kuras's electric wires painted in the 1970s (such as *Installation*, 1976–78) looked unattractive, dull, and subdued, while his landscapes were immersed in twilight. His painting did not glorify Soviet technical and economic progress in any way. It took a long time for Kuras and his colleagues to convince their senior colleagues and spectators that the world of "unattractive" things was in fact very comfortable. Lithuanian painting of the seventies was quite liberal with regard to its visual form but cautious in accepting more radical concepts.

Many young artists of the seventies began to depict deconstruction of the hero and his surroundings. This phenomenon, which began in painting, eventually

FIG. 237. Vincas Kisarauskas, *Unsolved Situation*, 1974. Oil and collaged painted wood frame on fiberboard, 95 × 65 × 5 cm. Dodge Collection, ZAM, 14526.

FIG. 238. Algimantas Kuras, *In the Railroad Station*, 1972. Oil on fiberboard, 62 × 122 cm. Dodge Collection, ZAM, 10665.

spread to the graphic arts and sculpture. Artists in these fields turned to representing the individual's spiritual state and life circumstances without pathos (fig. 243), while the function of sculpture remained unclear (fig. 244). Exponents of this new approach were the painters Mindaugas Skudutis (b. 1948), Henrikas Natalevičius (b. 1953), Bronius Gražys (b. 1952), Raimundas Sližys (b. 1952), and Romanas Vilkauskas (b. 1949). In the second half of the seventies, these artists formed an informal group and held several exhibitions with the goal of depicting simple things as unadorned reality. Inhabitants of Vilnius slums and ironically rendered urban character types were essential prototypes for their works. Early in their careers, Skudutis and Natalevičius were fascinated by the fantastic and satirical compositions of Hieronymus Bosch and Pieter Brueghel, while Sližys was influenced by the art-nouveau stylistics of Gustav Klimt. The intimacy and vital expressiveness of Skudutis's painting were best revealed in his small-size views of Vilnius old town (*Scenes of the City*, 1982) and variations on the motifs of the Hill of Crosses near Šiauliai. Paintings by Natalevičius were mysterious, contemplative, and noted for their

fantastic representations, often employing a subtle harmony of reddish colors (figs. 245 and 246). He had an amazing ability to create a mystical atmosphere in his paintings of building interiors. Sližys's works are marked by a strange mixture of naïveté and decadence, a combination of painful irony and self-irony (in self-portraits), and the use of the grotesque and kitsch. His paintings, which combine reality and symbolism as well as comedy and drama, are usually turned into synchronic "doubles" of figures stripped of detail, simplified, and depersonalized (fig. 247). Sližys hopes that the individual in his paintings "would become simply a 'somebody' or 'nobody.' The inner state of a character ... is not an aim in itself. I deliberately turn a person, his body and clothes 'inside out.' "[21] In reviews of exhibitions, his paintings were characterized as expressing criticism of "philistinism" and "base morals."

Vilkauskas chose a different approach and several years later became one of the most consistent representatives of Lithuanian photorealism. Photorealism was popular in the Baltics in the 1980s. However, it reached Lithuania belatedly and differed significantly from the style elsewhere. Lithuanians were less radical

FIG. 239. Kostas Dereškevičius, *Posters in the Spring*, 1984.
Oil on canvas, 82 × 60 cm. Dodge Collection, ZAM, 10288.

FIG. 240. [ABOVE] Arvydas Šaltenis,
Lenin's Room, 1972. Oil on cardboard,
100 × 72 cm. Dodge Collection, ZAM, 18109.

FIG. 241. [RIGHT] Algimantas Kuras,
The Grasshopper (P. No. 9), 1981. Oil on canvas,
30 × 33 cm. Dodge Collection, ZAM, 18008.

FIG. 242. [LEFT] Jonas Švažas, *Pipes*, 1975. Oil on fiberboard, 142 × 115 cm. Dodge Collection, ZAM, 10654.

FIG. 243. [BELOW] Edmundas Saladžius, (Untitled), 1986. Lithograph, 44 × 57.7 cm. Dodge Collection, ZAM, 01912.

FIG. 244. Mindaugas Navakas, (Untitled), 1984.
Bronze, 20 × 40 × 18.5 cm. Dodge Collection, ZAM, 04933.

"realists" than American photorealists and did not employ slides in making their paintings. Lithuanian works were also smaller, and the range of themes, particularly those of the urban environment and advertising, was rather limited. In contrast, Estonian photorealism of the 1980s, exhibited at painting triennials in Vilnius, looked very contemporary and precise. The Lithuanian artist Švėgžda painted photorealist still lifes with pumpkins and marrows, green boxes and interiors, jeans and metal cans (fig. 248). The paintings by Igoris Piekuras (b. 1935) remained a compromise with colorism, while those by his wife, Marija Rožanskaitė, reflected her interest in social themes (hospitals, surgery, and scenes of deportation of Lithuanians by the Russians after the occupation). In Vilkauskas's photorealist paintings, small objects were enlarged to fill the whole picture, and depth was almost entirely eliminated. Each of the locked yellow, green, and red garage doors (fig. 249) occupies an entire panel with no surrounding space. Here, the only contextual commentary the artist offered is the colors of the doors, which signified the Lithuanian national colors. These paintings contradicted not only the sentimentality in traditional Lithuanian painting but also the Soviet desire to suppress national feelings.

No less important were the political implications of Vilkauskas's artworks, such as undertones of the Lithuanian resistance movement and the postwar deportations (fig. 250). His views of old interiors with walls covered with yellowed newspapers that contain Stalin's photos were intended to contest the historical fictions that the Soviet Party ideology had manufactured (fig. 251). Vilkauskas's concern for history is illustrated by the motif of targets made of silhouetted figures in one of his works (fig. 252). Only when perestroika progressed further were these works accepted for exhibition.

Lithuanian photorealism, although not fully formed stylistically, seemed dangerous to the authorities because of its strong documentary quality. Lionginas Šepetys, the Secretary of the Central Committee of the Lithuanian Communist Party and "supreme ideologue" of art, wrote in the 1980s, "Superrealist art, also known as 'hyperrealism' or 'photorealism,' has come into fashion lately. Although called by many names, it has only one aim—the elimination, either secretly or openly, of any individuality in the artist's work.... Yet, this super-fashionable 'hyperrealism' is

FIG. 245. [TOP LEFT] Henrikas Natalevičius,
(Untitled), n.d. Matchboxes, painted
with oil, set in wooden case, 31 × 22.8 cm.
Dodge Collection, ZAM, 01973.

FIG. 246. [ABOVE] Henrikas Natalevičius,
The Shadow, 1982. Oil on canvas, 89.5 × 61.5 cm.
Dodge Collection, ZAM, 01542.

FIG. 247. Raimundas Sližys,
*A Group Portrait of Two
Important Persons*, 1987.
Oil on canvas, 82 × 99.7 cm.
Dodge Collection, ZAM, 11297.

dangerous in that it works its way insidiously under-
mining the foundations of realism.... A realistic form,
when very meticulously executed, is by itself devoid of
ideology.... It is only a covering of inanimate details.
A pair of jeans is hanging, some tomatoes are lying
around—and that's all."[22] The ideologue had in mind
the painting entitled *Jeans* by Švėgžda.

FROM FOLKLORIC LYRICISM
TO WILD RAGE

From 1969 on, Baltic Painting Triennials, which
were modeled after Triennials of graphic art in
Tallinn, were held in Vilnius on a regular basis. These
Triennials constituted a forum for artists to officially
present their latest works, including traditional art-
forms as well as new trends, within certain limits. They
were not devoid of conformity, ideological supervi-
sion, and inner conflicts. Some works by daring young
artists were removed from the Lithuanian collection.
Other artists did not even make an effort to exhibit

their works, knowing that modernist nonconformist
works would not be accepted. For example, works by
Cukermanas and Zimblytė could not be exhibited
in the Triennial until 1990. Prizes were generally
awarded according to conformity to Communist Party
doctrines. However, the Triennials opened the way for
new art phenomena, particularly in the seventies.

In 1976, labels that described the works exhibited at
the Triennial were attached to the works of each coun-
try. Estonian painting was called "rational" and "in-
tellectual"; Latvian, "epic" and "monumental"; and
Lithuanian, "expressive" and "colorist." The tendency
of the Estonians to philosophize and to orient them-
selves toward relatively new phenomena, such as pop
art and photorealism, was balanced by the strong pic-
torial quality, expressive gestures, and undisguised
emotionality of Lithuanian art. In many ways, these la-
bels expressed a confrontation between the Protestant
(Estonian) and Catholic (Lithuanian) cultures and
world perceptions; Latvians seemed to be positioned
somewhere in the middle. After the fifth Triennial in

FIG. 248. Algimantas Švėgžda, *Still Life with Paint Cans*, 1971.
Oil and tempera on fiberboard, 112 × 77 cm. Dodge Collection,
ZAM, 11440.

FIG. 249. Romanas Vilkauskas, from the cycle *Motifs of a Courtyard* (1982–83): *Yellow Garage Door*, 1982–83; *Green Garage Door*, 1982; *Red Garage Door*, 1982. Oil on canvas, 120 × 145 cm (each). Dodge Collection, ZAM, 21035, 18006, 01536.

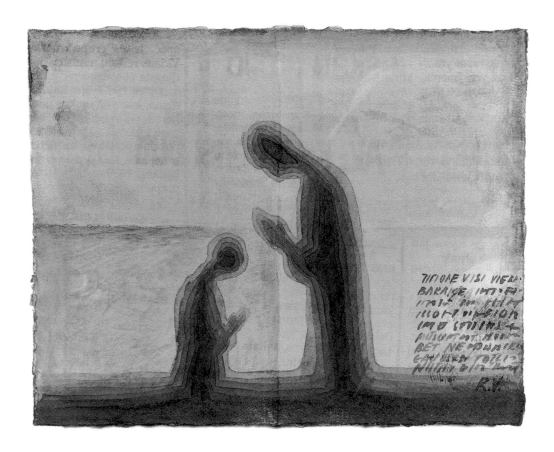

FIG. 250. Romanas Vilkauskas, from *Siberian Miniatures*, n.d. Watercolor, 10.3 × 13 cm. Dodge Collection, ZAM, 02099.

1981, critics stated that "the boom of innovation was a passing stage in the painting of all three republics."[23] The parade of artistic ambitions slowed, and the names of participants repeated year after year. The process of developing art seemed stuck in the same problematic circle, and the art of all three republics exhibited signs of inertia. The Triennials signaled the need for change.

The longing to revive national traditions that had been awakened in the sixties, particularly in graphic art, faded. Artists in the 1980s departed from stylization that was reminiscent of folk engravings; they turned to a more expressive and grotesque style of drawing (fig. 253) and began employing a symbolic language, such as in the work of Viktorija Daniliauskaitė (b. 1951). Graphic artists sought more contemporary visual expressions through the manipulation of space and lines. Diana Radavičiūtė (b. 1958; fig. 254) and Birutė Stančikaitė (b. 1950; fig. 255) expanded the techniques of graphic art and increased the use of association and metaphors. Graphic works by Mykalojus Povilas Vilutis (b. 1947) expressed the most radical change in attitude toward folk art traditions. In his silk-screen works, he used bright colors and symbolic images reminiscent of advertising (fig. 256).

One trend in Lithuanian painting involved the reinterpretation of folk art. The work of Leopoldas Surgailis (b. 1928) reflected influences including early Lithuanian folk sculpture, the New York School of abstract expressionism, and the rage of the "new savages." His grotesque figures represented ritual and carnival motifs (fig. 257). Another trend, associated with naive painting and pictorial metaphors, was evident in the works of Leonardas Gutauskas (b. 1938), Jonas Daniliauskas (b. 1950; fig. 258), and Rimas Bičiūnas (b. 1949). Augustinas Savickas (b. 1919) developed traditional "Lithuanian" colorism and naive figurative compositions. Religious sculpture influenced a third trend;

FIG. 251. Romanas Vilkauskas, *Interior X*, 1981. Oil on canvas,
90.2 × 110.2 cm. Dodge Collection, ZAM, 08739.

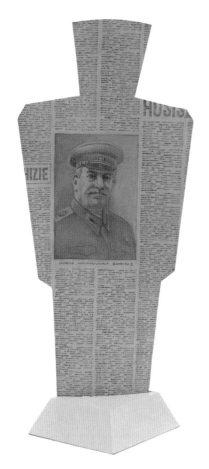

FIG. 252. [LEFT] Romanas Vilkauskas, *Joseph Stalin*, n.d. Plastic and wood, 48 × 20.5 × 19 cm. Dodge Collection, ZAM, 04309.

FIG. 253. [BELOW] Elvyra Kairiūkštytė, *Youth*, 1980. Linocut, 65.6 × 86.3 cm. Dodge Collection, ZAM, 04705.

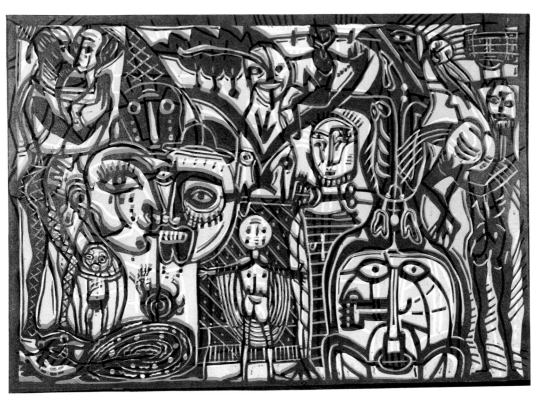

FIG. 254. Diana Radavičiūtė, *Restoration II*, 1984.
Lithograph, 80.5 × 63 cm. Dodge Collection, ZAM, 07584.

enlarged faces and simplified forms were frequently employed (fig. 259). Liberation from traditional iconography in sculpture encouraged artists to develop an interest in classical sculpture, apparent in the work of Petras Mazūras (b. 1949; fig. 260).

"Emotion," "experience," and "mood" nurtured the creative work of several generations of Lithuanian artists and found expression in their works in a variety of ways. Neo-expressionism became the dominant movement, inspired by a mixture of lyrical and dramatic moods and sentiments, and depicting, often grotesquely, the everyday environment.

Povilas Ričardas Vaitekūnas (b. 1940) helped liberate Lithuanian painting from the optimistic themes and Communist Party–approved monumental images. Although Vaitekūnas belongs to the generation of Kuras and his colleagues, his work does not fit into their involvement with "ugly" objects or surroundings. In some of his paintings, he creates a strange world of mysterious forms and fragments, merging the inception and disappearance of things. The limits between living and dead are erased, as inanimate objects are personified and people are turned into signs and outlines (fig. 261). Unlike paintings by his colleagues, the work by Vaitekūnas bears a mark of time flowing in a fragile, transitory world and represents subjects in simplified forms and subdued colors, as in *Still Life with a Stone Looking Like a Skull* (1984). The transformation of natural elements and the mastery of artistic gesture are particularly well revealed in Vaitekūnas's spontaneous paintings on paper that resemble contemporary Zen calligraphy (fig. 262). The views of this artist are very close to those of his friend Antanas Martinaitis (1939–1986; fig. 263).

In the eighties, new features emerged in painting. The younger generation of Jonas Gasiūnas (b. 1954), Henrikas Čerapas (b. 1952), Algimantas Skačkauskas (b. 1955), Vygantas Paukštė (b. 1957), Ričardas Bartkevičius (b. 1959), Kęstutis Lupeikis (b. 1962), Rimvydas Jankauskas-Kampas (1957–1993), and Gintaras Palemonas Janonis (b. 1962) seems to have felt the approaching social and political changes of perestroika. Their paintings feature fantastic and mystical motifs that fascinate the viewer with their great freedom of expression and large size. Unlike the older generation, these artists prefer to combine their feelings and artistic skills with knowledge of art history, the Bible, and ancient cultures.

FIG. 255. Birutė Stančikaitė, No. 3 from the series *Irreparable*,
1985. Lithograph, 64 × 99 cm. Dodge Collection, ZAM, 04029.

FIG. 256. [LEFT] Mykalojus Povilas Vilutis, *Little River*, 1980. Screen print, 59.7 × 46.6 cm. Dodge Collection, ZAM, 09789.

FIG. 257. [BELOW] Leopoldas Surgailis, *Masks*, 1983. Tempera on fiberboard, 87.2 × 116.2 cm. Dodge Collection, ZAM, 01869.

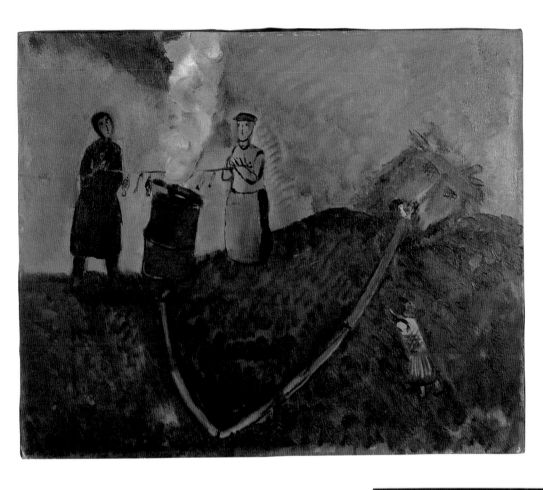

FIG. 258. [ABOVE] Jonas Daniliauskas, *The Last Fish . . .
(Cooking Fish)*, 1982. Oil on canvas, 60 × 73 cm.
Dodge Collection, ZAM, 05418.

FIG. 259. [RIGHT] Vytautas Valius, (Untitled), 1989. Oil on
paper, 85 × 61 cm. Dodge Collection, ZAM, 04254.

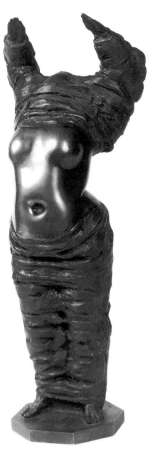

FIG. 260. [LEFT] Petras Mazūras, *Lady Dressing*, 1984.
Bronze, 46.5 × 17.5 × 14 cm. Dodge Collection, ZAM, 04936.

FIG. 261. [BELOW] Povilas Ričardas Vaitekūnas, *Hospital*, 1981.
Oil on canvas, 64 × 91.3 cm. Dodge Collection, ZAM, 01881.

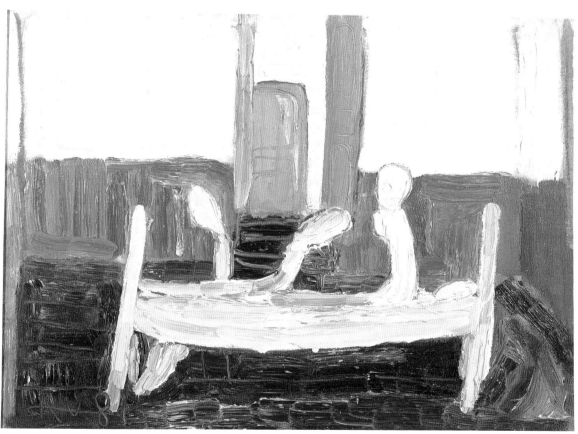

FIG. 262. Povilas Ričardas Vaitekūnas, (Untitled), 1984. Tempera on paper, 49.2 × 63.1 cm. Dodge Collection, ZAM, 04921.

Influenced by Marc Chagall and Chaim Soutine, Skačkauskas's work mixes paradox with tragic mysticism and powerful passions with ritual ceremonies. An excellent draftsman and colorist, the artist turns his vision into a pantheistic spectacle of the world (fig. 264). Paukštė's paintings represent people performing somnambulant actions in adventurous and bizarre circumstances, while ordinary activity is turned into foolish behavior (fig. 265). His scenes are simplified, with bold deformations of figures and the environment reduced to a minimum.

Šarūnas Sauka (b. 1958) creates works noted for a strongly expressed mystical quality. In critical reviews, his paintings were identified with the apocalypse, suffering, destruction, religious expression, and sacrifice. As Sauka has pointed out, "A closer look at those sufferings and rituals enables us to assert that people's chief motivations are basic, fundamental human instincts: to eat, to copulate, and to kill."[24]

Young expressionists in the 1980s took little interest in their daily environment. They focused instead on an imagined, unreal world characterized by bizarre logic and unpredictable behavior. To borrow from the title of one painting by Paukštė, *Bacchus's Hangover* (1989), the younger generation looked tipsy and was preoccupied with joke and play. Renouncing a moderate way of living and the accepted order, it wished to go wild and, in its own way, to decorate and change the established order. For example, in *The Girl and a Head* (fig. 266), Janonis does not paint the background for the very simplified reclining figure but uses a ready-made fabric. The works by this artist, as well as those of Bartkevičius (fig. 267), are reminiscent of the German "new savages." The extreme energy of their brush-strokes and embittered deconstruction of the human figure were signs of postmodernism coming to Lithuanian art.

THE EVE OF ABSOLUTION

"For me, art is a prayer, a catharsis, and an absolution," wrote Vincas Kisarauskas, one of the most

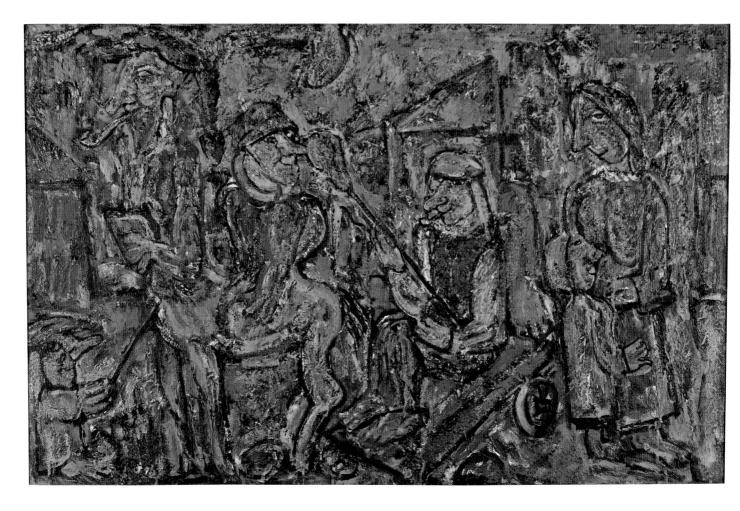

FIG. 263. Antanas Martinaitis, *Mystical Composition*, 1984.
Oil on panel, 58.5 × 92.6 cm. Dodge Collection, ZAM, 00392.

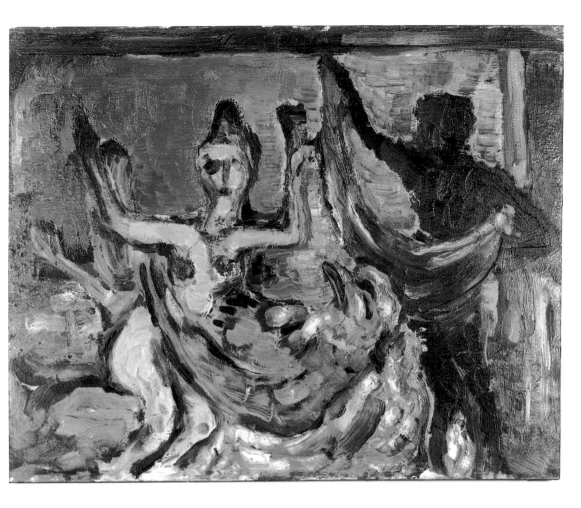

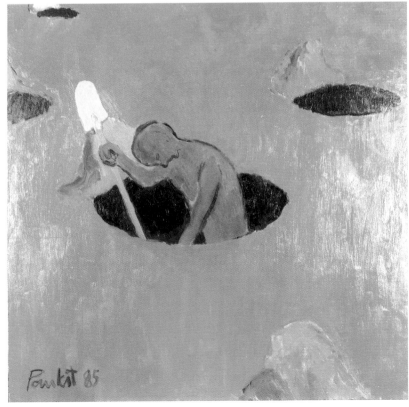

FIG. 264. [ABOVE] Algimantas Skačkauskas, (Untitled), 1980. Oil on canvas, 79.5 × 100 cm. Dodge Collection, ZAM, 08744.

FIG. 265. [RIGHT] Vygantas Paukštė, *Digging Holes to Plant Trees*, 1985. Oil on canvas, 116 × 120.5 cm. Dodge Collection, ZAM, 14523.

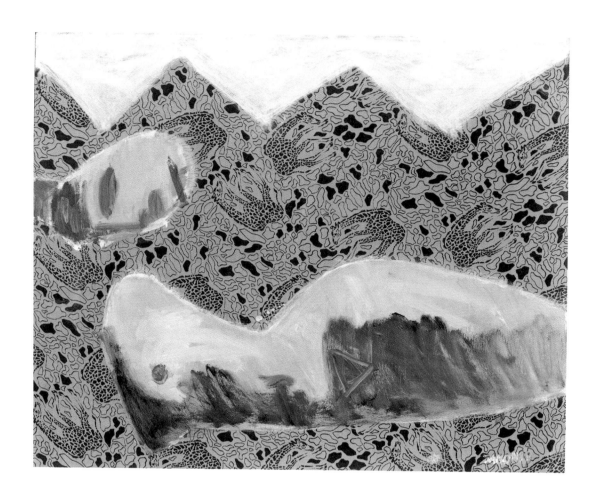

FIG. 266. Gintaras Palemonas Janonis, *The Girl and a Head*, 1980. Oil on cloth, 64 × 81.5 cm. Dodge Collection, ZAM, 04228.

radical Lithuanian artists of the sixties through eighties.[25] His words may help us draw conclusions about the development of Lithuanian art in the course of the past century. Under the powerful pressures of the Soviet ideological system, creativity survived only through artists' hope for the return of truth and the restitution of basic human rights. Silent concentration on their creative work and patient waiting became a way of life for many artists. They expressed their ambiguous situation (conformism on the one hand, and, on the other, potential dissidence in spite of constant supervision and pressure)—which was complicated by shifting moods of conformity and reconciliation—in their work. Feelings, thoughts, and experience influenced each other, sometimes opposed each other, and sometimes converged and merged. The young generation of the eighties was influenced by the 1960s work of

Antanavičius, Kuras, and Kisarauskas. In their creative work, catharsis took the shape of nostalgia, sorrow, and skepticism. Being behind the Iron Curtain created a feeling of inferiority, backwardness, and isolation from the art world. Since foreign modern art did not usually get exhibited in Vilnius, Lithuanian artists were used to visiting art shows in neighboring countries, such as Soviet Belorussia and Poland (fig. 268). On the other hand, contact between artists and well-known Lithuanian jazz musicians (for example, painters Algimantas Kuras and Valentinas Antanavičius and jazzman Vladimir Tarasov) stimulated them to share information about the contemporary art movement and enriched their knowledge of the current situation in various spheres of art (fig. 269). Innovation—steps toward being "contemporary"—meant a development of local artistic movement along with belated attempts to

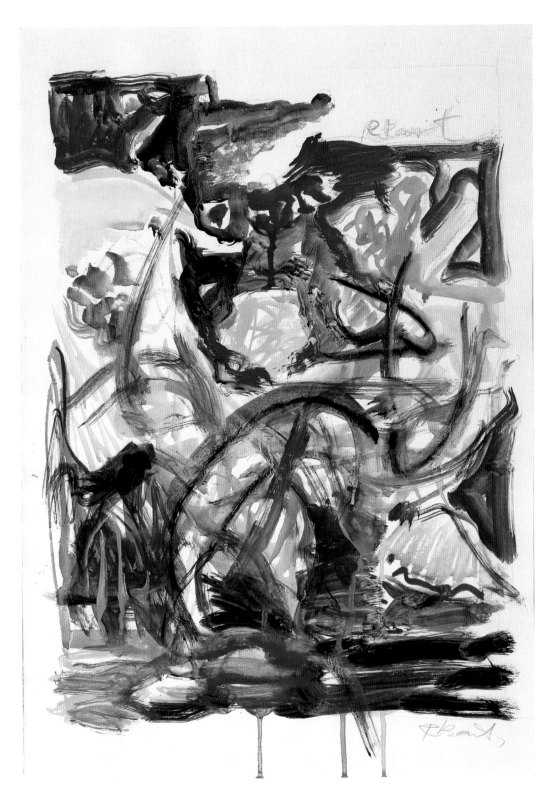

FIG. 267. Ričardas Bartkevičius, *The Narcissus*, 1985.
Watercolor on paper, 61.5 × 42.9 cm. Dodge Collection,
ZAM, 01464.

FIG. 268. [LEFT] Valentinas Antanavičius at
the German art exhibition in Minsk, 1984.

FIG. 269. [BELOW] *Left to right*: Algimantas Kuras,
Vladimir Tarasov, and Valentinas Antanavičius at
Tarasov's country house in Belorussia, 1988.

approach and understand the phenomena of world art. Such efforts were reassuring; they pointed Lithuanian art into the future and expanded the possibilities of artistic expression under the repressive conditions of Soviet rule.

The exhibition of works by Šarūnas Sauka and Algimantas Skačkauskas at the National Library and the exhibition of zincographic montages by Mindaugas Navakas at the Artists' Union in Vilnius, both closed down in 1985, were the last exhibitions banned by the authorities. The closures can be considered the final steps of the dying regime. Glasnost and perestroika were beginning in Lithuanian art. Major social and spiritual absolution was bound to follow. The atmosphere of art exhibitions became milder, although not without occasional conflicts, restrictions, and bans. Fear was weakening, and the feeling of individual freedom got stronger. The tempo of the emergence of new ideas, artistic choices, and examples of radical art was particularly rapid. In my opinion, the installation with red stars and raw pigs' heads by "Post Ars" group member Česlovas Lukenskas (presented at the group's exhibition at the Kaunas Department of the Artists' Union in 1989) put an end to the march of Soviet ideology through the territory of Lithuanian art—let's hope, for all time.

NOTES

1. *XX a. lietuvių dailės istorija. III. 1940–1960* (A history of twentieth-century Lithuanian art, vol. 3, 1940–1960) (Vilnius: Academy of Science of Lithuanian Soviet Socialist Republic, Institute of Culture and Art, 1990), 19.

2. For example, one Moscow art critic called paintings by Čiurlionis exhibited at a major exhibition of Lithuanian art in Moscow "a poetry of hopelessness" and "wanderings on the roads of decadent symbolism." See F. Roginskaya, "Lietuvių tautos dailė," in *Lietuviu literatūros ir meno dekada Maskvoje. 1954* (Vilnius: 1956), 206.

3. Irena Kostkevičiūtė, "Dailė tarp prievartos ir pasipriešinimo. Istoriniai metmenys" (Art between oppression and resistance. Historical outline), *Literatūra ir menas*, May 16, 1992.

4. Vyt. Mackevičius, "Piešimo problema mūsų dailėje" (A problem of drawing in our art), *Literatūra ir menas*, May 14, 1950.

5. These decrees were launched against the magazines *Zvezda* and *Leningrad* in 1946, and against Vano Muradeli's opera *Great Friendship* in 1948.

6. *XX a. lietuvių dailės istorija. III*, 208.

7. The concept "silent modernism" has come to be used in Lithuanian art criticism in recent years to define different art phenomena from 1962 to the mid-eighties. In 1997, an exhibition called *Quiet Modernism in Lithuania, 1962–1982* was held in Vilnius.

8. J. Mackonis, "Prieš ribotą realizmo supratimą" (Against a narrow understanding of realism), *Literatūra ir menas*, October 13, 1956. The same author encouraged artists to pay more attention to their "individual creative style" (*Literatūra ir menas*, January 14, 1956).

9. Augustinas Savickas, "Tradicija ir novatoriškumas" (Tradition and innovation), *Tiesa*, December 20, 1959.

10. Archives of Lithuanian literature and art, Vilnius, keeping no. 146, inventory 1, file 245.

11. See Elena Kornetchuk, "Soviet Art under Government Control: From the 1917 Revolution to Krushchev's Thaw," in *From Gulag to Glasnost: Nonconformist Art from the Soviet Union*, eds. Alla Rosenfeld and Norton T. Dodge (New York: Thames and Hudson, 1995), 43.

12. Ibid., 218.

13. Algimantas Kuras, "Iš gyvenimo užrašų" (From notes of life), *Literatūra ir menas*, April 6, 1991.

14. Minutes of the session of the board of the Artists' Association of the Lithuanian Soviet Socialist Republic, June 7, 1973; from the archives of Linas Katinas.

15. *Tylusis modernizmas Lietuvoje, 1962–1982* (Quiet modernism in Lithuania, 1962–1982) (Vilnius: Tyto Alba, 1997), 11.

16. Viktoras Liutkus, "Valentinas Antanavičius: Žaidimas gali būti rimtas dalykas" (A game can be a serious thing), *Lietuvos aidas*, January 26, 1993.

17. Ibid.

18. Alfonsas Andriuškevičius, "Herojiškos formos ankštose erdvėse" (Heroic forms in narrow spaces) *Pergalė* 6 (1981): 152.

19. Jolita Mulevičiūtė, "Man menas—malda, katarsis, apsivalymas" (For me, art is a prayer, catharsis, and absolution), *Kultūros barai* 12 (1990): 29.

20. Viktoras Liutkus, "Jaukus daiktų pasaulis" (A cozy world of things), *Kultūros barai* 10 (1985): 35.

21. "Maksimaliai nutolęs ir minimaliai įsijautęs" (At most remote and at least one's part felt), *Kultūros barai* 1 (1993): 20.

22. Lionginas Šepetys, "Komunistiniai idealai ir modernizmo kaukė" (Ideals of communism and mask of modernism), *Literatūra ir menas*, January 30, 1982.

23. Gražina Kliaugienė, "Pabaltijo tapybos trienalė" (Triennial of painting of the Baltic States), *Pergalė* 4 (1982): 148.

24. *Šarūnas Sauka* (Vilnius: Contemporary Art Center, 1998), 11.

25. Jolita Mulevičiūtė, "Man menas," 30.

Kestutis Kuizinas

LITHUANIAN ART FROM 1988 TO THE PRESENT

THE LAST DOZEN YEARS have seen sudden and radical changes that shattered the existing structure of the Lithuanian art world. The sweeping changes that occurred during this relatively short period affected not only the dominant art trends, artistic idioms, and generations of artists, but also art institutions, art criticism, the art market, and, finally, the audience for contemporary art. The political, economic, and cultural systems also have changed since 1988. Today's situation in Lithuanian art can be called "the end of a new beginning" that followed independence from the Soviet regime in 1990. The local art scene and its problems have become similar to those of Western countries whose experience served as a model for all efforts of renewal. Lithuania slowly has turned from a closed country into an open society, and the high winds of internationalization have finally reached the local art scene.

The period under discussion can be divided into three sub-periods: "Revival" (1988–91), "Reforms" (1992–93), and "Stabilization" (1994 to the present). The "Revival" period marked the end of Soviet rule in Lithuania and continued until the declaration of the country's political independence in 1990 and its international recognition in 1991. Precipitating the start of this process was the glasnost policy set by Gorbachev, which included the lifting of information and communication barriers with the outer world. These years saw a wave of national revival and the first mass meeting for Lithuania's independence. High civic and social consciousness, typical of this chaotic period of change and economic difficulties, prevailed in all spheres of life. During these years, the first experiments in performance art and happenings took place in Lithuania. Different political movements and art groups were formed. It was a time marked by great ex-

pectations, faith, and national optimism. Trust in the official structures of the past was lost. Art exhibitions boasted numerous national symbols such as crosses, "Pensive Christs," and patriotic themes.[1]

The second period, "Reforms" (1992–93), saw the restoration of the foundations of an independent state and the legitimization of social and political reforms. At that time, official institutions of power and their doctrines underwent dramatic changes. Enthusiasm for the creation of a new society was mixed with confusion. Deep inner contradictions were laid bare, and the confrontation of ideological attitudes provoked a struggle between the old and the new. In the art world, these changes were reflected in the establishment of new institutions, changes in teaching curricula, and the emergence and consolidation of new art forms. In 1992, such important institutions as the Vilnius Contemporary Art Center and the Soros Foundation for Contemporary Art were established. During the same period, a network of private galleries[2] was formed and new art publications appeared, such as *7 meno dienos* (7 days of art; established 1992) and *Meno savaite* (Art weekly; established 1992). At the Vilnius Art Academy, the first teachers from the West—including Kes Zapkus from New York, Yngve Zakarias from West Berlin, Stephen Anaya from Los Angeles, André Klein from Amsterdam, Alexandre Castan from Paris, and Jean-Baptiste Joly from Stuttgart—introduced an innovative curriculum and methodology that spread fresh ideas and approaches. By the end of 1992 and continuing for several years, artistic circles in Lithuania were involved in debates about these changes.

Society's consolidation and the focus of all efforts on the common goal of restoring independence marked the first period of national revival. During the second period, a reverse process took place. Lithuanian art of this stage was no less revolutionary than that of the "Revival" period. People heatedly discussed the purpose of reform and the new cultural policy, as well as the very definition of contemporary art. The main participants of the discussions were the new generation of officials of the Lithuanian Ministry of Culture, the heads of the new art centers and foundations, numerous art professionals, and the established artists who lost the stature they had gained in the Soviet period. These artists no longer had exclusive rights to premium exhibition spaces supported by the state, lucrative government commissions, and easy access to art materials. During the first months of 1993, numerous publications criticized or strongly supported the exhibition policy of the Contemporary Art Center. Another new element in artistic life—the Soros Foundation—was met with criticism for its particular attention to the recent art forms of video, installation, and performance art.

Despite these conflicts and numerous attempts to reverse the recent policy changes, a young generation of Lithuanian artists emerged. Many of these artists studied abroad[3] and were invited to represent their country in important international exhibitions. Large exhibitions of Western art were brought to Lithuania for the first time as part of projects organized by the British Council, the Association Française d'Action Artistique (a special division of the French Foreign Affairs Ministry responsible for promoting French arts abroad), the Institut für Auslandsbeziehungen (the German equivalent, based in Stuttgart), and similar institutions. These factors markedly influenced public opinion and contributed to establishing programs that increased exhibition opportunities for local artists. In other words, new factors and principles regulating art that had never been in force in Lithuania under the Soviet system were gradually established and put to use.

These changes took place in all of Lithuania's regions, institutions, and spheres of artistic life at different times and in varying degrees. Therefore, it is difficult to precisely date the end of the "Reforms" period, although one can safely assume that the first signs of the "Stabilization" period became visible with the country's economic revival that started in the mid-1990s.

In 1994–95, the increases in the basic indexes of economic progress—curbing inflation, raising living standards, and so on—exerted a positive influence on the development of artistic activity. The increased contribution of state institutions to organizing and supporting exhibitions and projects of contemporary art should be particularly stressed. In 1992–93, the Contemporary Art Center (the largest Lithuanian art institution) was limited to accepting foreign projects organized abroad (mainly traveling exhibitions) and holding exhibitions of local artists. The changes of the following years allowed the institution to create large and ambitious international projects. In exhibitions such as *Funny versus Bizarre*, *Ground Control*, and

Cool Places, well-known Western artists as well as local artists presented their works.[4]

During the past five years, the very language of contemporary art, with its characteristic forms and expressions, was finally legitimized in Lithuania. The validity of photography and performance, installation, video, and conceptual art was no longer disputed. A more or less unanimous view on what is regarded as contemporary art was established.

The principles of nonpolitical selection and free competition, which along with the laws of free market economy transformed the closed dominion of art, created confusion and resistance in artistic circles, a turmoil similar to that of the first years of privatization. The change of the long-established relations between artists and institutions was hard on not only the artistic elite formed in the Soviet Union (whose members lost their positions and privileges under the new conditions), but also on many other artists, especially of the middle and older generations, who suddenly lost even those minimal forms of incentives and guarantees that they enjoyed in Soviet times.

During the Soviet period, one of the most important incentives was the opportunity to participate in group exhibitions held in spacious exhibition halls maintained by the state and organized by the Artists' Union and Ministry of Culture. These exhibitions featured a variety of genres, which guaranteed nearly all artists the possibility of official presentation of their works to the public at large. However, such exhibitions mixed very skilled and creative artists with artists of lesser quality. This tradition of large, official, state-supported exhibitions continued for several years after the restoration of independence, but the better artists gradually began to avoid such events, and art critics started looking for new ways to invigorate artistic life. As early as 1989, twelve unofficial leaders of the Lithuanian art world founded Group 24, the first independent art group after World War II. Exhibitions of conceptual art organized by art critics and held in exhibition halls became more frequent. Artists started to form groups, such as Angis and Post Ars, and to exhibit their works separately from shows organized by the Artists' Union. Curated shows, compiled mostly by art critics or artists themselves, involved preselected and specially invited participants. Although the concept of an exhibition curator was still being defined in Lithuania at that time, the idea of curated shows clearly revealed the longing for selective origin in the art culture, when apparent democracy gradually gives way to a sense of mutual trust and responsibility. This condition of trust and sincere acceptance of each other's work, rather than the realization of joint programs, was the foundation of most art groups.

The weakening tradition of republic exhibitions (and, consequently, the role of the Artists' Union as the main initiator of such broad survey exhibitions), the emergence of new art institutions, and other similar factors encouraged not only the formation of new art groups but also the restructuring of the local art world. In organizing large exhibitions, the model of collective responsibility, which included artists' committees and juries of ministry experts, declined in importance, and a new process of selection based on artistic quality came into play. Therefore, a demand for curators, gallery personnel, art foundations, and information centers and the like started to grow. Lithuanians began to adopt Western ideas about the organization and regulation of the art process and the relationship between artists and their environment.

However, it took a long time for new principles to take root in the daily lives of Lithuanian artists. As late as the beginning of the 1990s, many established Lithuanian artists failed to understand the importance of verbalizing and documenting one's artistic concepts. Even today, the majority of artists of the older generation find the principles of the competitive art market unacceptable. A firmly established belief that artists should not openly care about their career (a nineteenth-century conception of the artist as isolated genius, and similar psychological barriers) drove many outstanding artists into utter resignation. However, the younger generation of artists quickly and easily adapted. They began to document their projects, work closely with curators, apply for financial support from various foundations at home and abroad, and learn foreign languages.

The refusal of many older artists to comply with the new rules of artistic life gave an advantage to artists who began their careers at the end of the Soviet period. The new generation, represented by Gediminas Urbonas (b. 1966), Audrius Novickas (b. 1968), Eglė Rakauskaitė (b. 1967), Deimantas Narkevičius (b. 1964), Arturas Raila (b. 1962), and Aidas Bareikis (b. 1968), quickly liberated themselves from the limiting historical-political context. Supportive art critics included

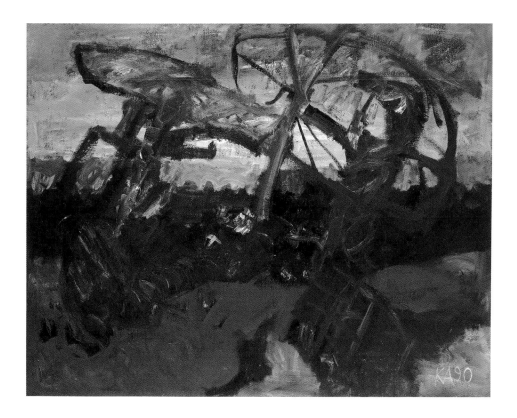

FIG. 270. Algimantas Kuras, *Situation on Territory* N, 1990. Oil on canvas, 52 × 117 cm. Courtesy: Vilnius Contemporary Art Center Archive, Lithuania.

Alfonsas Andriuškevičius, Birutė Pankunaitė, Erika Grigoraviciene, Lolita Jablonskienė, Raminta Jurenaitė, and Agnė Noruisytė. The beliefs of the older generation of artists are difficult for exhibition curators and art experts from the West to comprehend even today. Conservative artists and art administrators continued to look suspiciously at the processes of contemporary art and the changing model of an artist's behavior. Their conservatism was based on their long-term resistance and effort to retain national and cultural identity.

Leafing through the catalogues of major exhibitions held in Lithuania between 1988 and 1992, one notices that the local artists' circles focused their debates not on new art trends but on the two generations of artists mentioned above and their ideologies. The younger generation was represented by art oriented toward international standards of contemporary art, while the older generation, conventionally called a generation of "myth-metaphor," was defined by a unique Lithuanian aesthetic and local traditions. The art of the former group was influenced by postmodernism, while that of the latter depended on the understood ethical code established by artists in the period of resistance that proclaimed nonpolitical artistic quality, untainted by Soviet ideology. "Quality" in the art of the generation of "myth-metaphor" was defined as a combination of meaningful content and perfect artistic skills—a technically impeccable search for representation of fundamental spiritual values in art.

The features of the generation of "myth-metaphor" were most distinctly embodied in the activity of Group 24. The creative work of this group, based mainly on the artistic traditions of prewar independent Lithuania, constituted a basis for evaluating significant works of art that had been created in Lithuania during the many years of cultural isolation. Like other groups established later, such as Angis and Group 1, Group 24 was inspired not so much by the artists' wish to be together, but by an inner necessity to separate themselves from the chaotic context of the Soviet period of art. Self-identification performed an important role within the havoc of cultural epochs and the change of values (fig. 270). "He could also be a member of Group 24" was a popular joke in the early 1990s, referring to some artist who would supposedly complete an an-

FIG. 271. [TOP] Česlovas Lukenskas, *Alteration of Stars*, 1990, installation at the *POST ARS. Exhibition—Action* at the Kaunas Architects' House.

FIG. 272. [BOTTOM] Aleksas Andriuškevičius, *Cultural Body #2*, 1990. Photograph by G. Zinhevicius. Courtesy: Vilnius Contemporary Art Center Archive, Lithuania.

thology of "high" Lithuanian art.[5] According to Sandra Skurvidaitė, a young art critic, "Group 24 replaced an aesthetic standard with a certain principle of quality, similar to a 'code of honor in a brotherhood of knights.' Group 24 could sit around King Arthur's table and perform their rituals or initiate new members; I suppose the rules would be similar." Thus, the inseparable link of artistic quality and ethical principles is an important feature of this generation. Today many members of Group 24 are professors at the art academy,[6] and their art is properly considered the classic example of traditional Lithuanian painting and sculpture of the 1980s.

The Post Ars group, formed in 1989, acted as a link between traditional art and present-day art. The first appearance of this group, consisting of Kaunas artists Česlovas Lukenskas (b. 1959), Aleksas Andriuškevičius (b. 1959), and Robertas Antinis (b. 1946), triggered a strong reaction from the local audience. Held at the Kaunas Architects' House in 1990, the exhibition *POST ARS. Exhibition—Action* featured installations by Post Ars that openly violated the formal principles of traditionalism and the ethical taboos of the Lithuanian "closed society." The protest of Kaunas artists at the entrance to the Post Ars exhibition gallery was provoked not so much by the five-pointed stars arranged from raw pigs' heads, as in the work of Lukenskas (fig. 271), as by an installation with bread loaves nailed to the wall by Andriuškevičius. Post Ars performances were the first manifestations of such art in Lithuania. The early work of Post Ars—documented only by photographs—included body art, process art, earth art, and other Western trends of the late 1960s and early 1970s (fig. 272). Later, Post Ars staged complex performances in large areas involving many participants. Unlike the program of Žalias lapas (a more flexible and playful performance group that was active at the same time), the work of Post Ars contained more elements of open nonconformism. The drastic activity of the group somewhat belatedly filled a gap in nonconformist underground art in Lithuania.

In 1990, Alfonsas Andriuškevičius, the ideologist of Group 24, started to lead seminars on art criticism at the Vilnius Art Academy. He encouraged young art historians to take an interest in nontraditional art and, as an art editor of the cultural weekly *Šiaurės Atenai*, eagerly published essays by young critics. The extraordinary attention of young critics to the activities of Post Ars, Žalias Lapas, and similar groups in Lithuania le-

FIG. 273. Mindaugas Navakas,
(Untitled), 1993. Rusted steel, height
6.5 m. Courtesy: Vilnius Contemporary
Art Center Archive, Lithuania.

gitimized the first expressions of nontraditional art in a monotonous context of art and art criticism. In the summer of 1992, the largest exhibition center in the Baltics—the Vilnius Art Exhibition Palace—changed its name (and, with that, its orientation) to the Contemporary Art Center. Very symbolic for that time was the center's first exhibition, *Good Evils*, which presented paintings, objects, and installations by students of the local art academy created under Kestutis Zapkus, a guest professor from New York.

Historically, the most suggestive and interesting examples of nontraditional art in Lithuania have been expressed in sculpture or three-dimensional assemblages. In painting (a traditionally strong genre in Lithuania), artists focused their efforts on discussions of stylistic and formal issues, whereas in sculpture,

artists actively developed new processes. This strength was well illustrated by the exhibition *Between Sculpture and Object in Lithuanian*, held at the Contemporary Art Center and curated by Raminta Jurenaitė. This exhibition aimed at demonstrating the possibilities of contemporary sculpture with regard to both new materials and technologies, and to pose the questions what is sculpture today, and what are the limits of this traditional genre? An undisputed leader of this innovative sculptural movement was Mindaugas Navakas (b. 1952; fig. 273), one of the few Lithuanian artists of the middle generation whose artistic pursuits have always been timely. Thanks to his ability to express his ideas in a new way, the sculptor has succeeded in riveting the attention of both art critics and artists. Like the work of many younger artists, Navakas's work un-

FIG. 274. [TOP] Deimantas Narkevičius, *New Balance*, 1994. Scales, 48 × 17 × 45 cm. Courtesy: Vilnius Contemporary Art Center Archive, Lithuania.

FIG. 275. [BOTTOM] Eglė Rakauskaitė, *Fur Coat for a Child*, 1996. Natural female hair, height 50 cm. Courtesy: Vilnius Contemporary Art Center Archive, Lithuania.

derwent several basic transformations. Having started with minimalist forms, he did not stop experimenting with the possibilities of material and volume. A new addition to Navakas's conceptual and often paradoxical artistic solutions is one of his latest projects—a sound-and-slide installation presented at the exhibition *Twilight* held at the Contemporary Art Center in 1998.

The exhibition *Between Sculpture and Object in Lithuania* included works by Navakas, Gediminas Urbonas, Deimantas Narkevičius (fig. 274), Arturas Raila, and other younger artists who had recently completed their studies in sculpture. These sculptors and various other painters, such as Eglė Rakauskaitė, Žilvinas Kempinas, Gintaras Makarevičius, Dainius Liškevičius, and Svajonė and Paulius Stanikas, have been active for the past decade and are largely responsible for the panorama of contemporary Lithuanian art. Their artistic idiom formed under circumstances quite different from those of previous generations. This generation could travel freely, continue art studies abroad, and take part in international exhibitions.

The most typical features of the art of this generation became distinct in the first half of the 1990s, when the roads of Lithuanian traditional art and the new art diverged. On one side remained the closed structure of fine arts with all the inherited problems of "originality," "nationality," "depth," relation of "form and content," and so on. On the other side were issues of the interaction of arts, globalization of culture, relations between the individual and society, and other urgent problems of contemporary life (fig. 275). Despite their traditional educational background, artists of the youngest generation freely choose means of expression and deal with the same problems of contemporary art that many countries of the world face. This globalization of Lithuanian art is confirmed by both the successful participation of young Lithuanian artists in important international exhibitions such as the São Paulo, Istanbul, Venice, and Manifesta biennials and the interesting and complicated issues of their latest works revealed in the major recent exhibitions in Lithuania (*Twilight*, *After Painting*, and *Cool Places*), all held at the Contemporary Art Center in 1998.

NOTES

1. Pensive Christ, an image of a sad and thoughtful Jesus sitting in the pose of Auguste Rodin's *Thinker*, is part of iconography often found in Lithuania and Poland. The theme of "Pensive Christ" is especially characteristic of Lithuanian folk sculpture of the early twentieth century.

2. The private galleries Vartai (1991), Langas (1992), Jutempus (1993), and Lietuvos aidas (1993) were formed in Vilnius.

3. In 1991 and 1992, Gediminas Urbonas (b. 1966) studied at the Salzburg Summer Academy for Arts in Austria, attending the workshops led by Hermann Nitsch and Ulricke Rosenbach. In 1991, Saulius Mazylis (b. 1961) studied at Hoelbeak Art School in Denmark. From 1991 to 1993, Audrius Novickas (b. 1968) studied at Prague Academy of Fine Arts in Milan Knizak's workshop and also attended Salzburg Summer Academy courses in 1991. In 1992, Deimantas Narkevičius (b. 1964) studied at the Delfina Studio Trust in London. From 1993 to 1995, Julius Liudavicius (b. 1969) and Aidas Bareikis (b. 1968) studied at Hunter College of City University of New York.

4. *Funny versus Bizarre* was held at the Vilnius Contemporary Art Center and the Arsenals in Rīga during 1997. International participants included Herrik Plenge Jakobsen, Peter Land, Annika von Hausswolff, Magnus Wallin, Tobias Berstrup, and Palle Torsson. *Ground Control* was held at the Vilnius Contemporary Art Center and Gateshead in the United Kingdom in 1997. English participants included Lucy Gunning, Fiona Banner, and Scanner. The Contemporary Art Center in Vilnius staged *Cool Places* in 1998. International participants included Olafur Elliasson, N55, OLO, Miriam Backstrom, Ingar Dragse, and Michael Elmgreen.

5. Group 24 consisted of unofficial leaders of the art scene of that time. It was an elite union based on mutual respect and common agreement about certain standards of artistic quality. But of course the list of Group 24 members did not include every favorite and recognized artist. Therefore, on certain occasions, such as during the opening of an exhibition of a famous artist with an artistic background similar to that of Group 24 members, critics often said he could also be a member of Group 24.

6. This group includes Arvydas Šaltenis (b. 1944), rector; Kostas Dereškevičius (b. 1937), vice-rector; Alfonsas Andriuškevičius (b. 1940), head of the art history and theory department; Gediminas Karalius (b. 1942), head of the sculpture department; and Povilas Ričardas Vaitekūnas (b. 1940), head of the painting department.

APPENDICES

Appendix A
Major Events in Estonian History and Culture

BEFORE THE 20TH CENTURY

3rd Millennium B.C.E.

Finno-Ugric peoples, ancestors of the Estonians, settle in present territory of Estonia

1st Century C.E.

The attacking Goths rearrange the map of Europe, pushing the first Estonians north to approximately the same territory as today

Finno-Ugric peoples reach Finland for the first time

Tacitus and other Roman writers describe "Aesti" as living on Baltic and trading in amber

11th Century

1030 Kievan Rus expands into areas inhabited by Finno-Ugric peoples, destroying Tarbatu (Tartu) and building the fort of Yuriev (Jurjev) in its place

1061 Estonians attack and destroy Yuriev (Jurjev)

12th Century

The Arab cartographer Ai Idrys marks Tallinn on his map as Kolyvan, describing it as a seasonal stronghold

Battles against Moscovy take place. Local tribes take Pskov, and the Russians burn Tartu and Otepää

13th Century

1202 The pope calls for a crusade against the pagans around the Baltic Sea. Bishop Albert founds the order of the Knights of the Sword, which leads to four decades of bloody battles and shifting alliances between Estonians and their neighbors

1217 Estonians are crushed at the battle of Fellin (Viljandi)

1219 King Voldemar II of Denmark chooses northern Estonia as his stronghold. He founds Räval, which is later named Tallinn

1290 Estonian tribes are finally subjugated. Teutonic knights control the south of present-day Estonia, and the Danes control the north

14th Century

Estonian towns become important trading links between east and west and grow in size and strength. The Estonians, however, remain serfs to German landowners

1343 St. George's Day Uprising against German and Danish rule takes place in Estonia. The rebels are finally crushed in 1345

1346 As a result of the uprising, Danish king sells Reval (Tallinn) and surrounding area to Teutonic knights

15th Century

Teutonic knights retain power over Estonia. However, their power is waning and gives way to the growing influence of Sweden and Russia

16th Century

1525 First book in Estonian language is printed

1558 Ivan the Terrible advances claims on Estonia.

His armies invade and devastate Baltic provinces. War with Russia continues until 1583, when Russians are finally defeated by the Swedes. Population falls by more than a half

17th Century

Swedish period in Estonian history is marked by cultural advancement and the spread of education. By the end of the century, nearly every parish has a school

1632 Dorpat (Tartu) University is founded

1645 Denmark cedes Saaremaa to Sweden

18th Century

1710 Peter the Great conquers the Baltic provinces from the Swedes. Tartu University is closed down

1721 The conquest of Estonia by Russia is formalized by the Treaty of Nystad, in which the Russian monarchy guarantees the Baltic German nobility privileges and local authority. The Baltic Germans become the backbone of Russian civil service in Estonia

1739 The first Estonian Bible is published

19th Century

1801 The first Estonian poet, Kristjan Jaak Peterson, is born

1802 Tartu University reopens

1803 A school of drawing opens at Tartu University

1816 Baltic German nobility abolishes serfdom in Estonia but does not grant the land to the peasants. Influenced by romanticism, German scholars call for the betterment of the peasants' situation. So-called Estophiles study the local language and found consciousness-raising societies. Literacy spreads, and Estonian-language periodicals appear. The few Estonians who are able to better their situations assimilate into German society

1830 First land reform takes place in Estonian provinces, according to which land is distributed to the peasantry

1855 Johann Köler, the first Estonian professional artist, graduates from the St. Petersburg Academy of Fine Arts

1857 Johann Woldemar Jannsen begins publishing the first Estonian-language weekly, the *Perno Postimees* (Perno postman)

1861 The *Kalevipoeg*, the Estonian national epic, by Friedrich Kreuzwald is published

1865 The Vanemiune theatrical society is founded in Tartu, and Estonia Society is established in Tallinn

1869 The first song festival takes place in Estonia

1870 Performances at the Estonian-language theater start

1872 The Estonian Literary Society is founded

1878 Carl Robert Jakobson begins publishing the newspaper *Sakala*, which becomes Estonia's most radical newspaper of the time

1881 Drawing school of Tartu University is closed

1883 The first upper-level high school for Estonians, the Hugo Treffner Gymnasium, opens. The language of instruction, however, remains German and later changes to Russian

1884 Estonian Students' Society consecrates blue-black-white tricolor, which later is adopted as the Estonian national flag. Intense Russification begins under Tsar Alexander III

1888 Jakob Hurt initiates the movement aimed at collecting folk poetry and national antiquities

1899 Twin brothers Kristjan and Paul Raud leave Düsseldorf Academy and move to Munich. Symbolism becomes their primary object of interest

Consultant: Anu Liivak

THE 20TH CENTURY

	ESTONIAN HISTORY	ART INSTITUTIONS	CULTURAL SCENE	ART SCENE
1900	Estonia is turning into one of the most industrialized areas of the Russian Empire			
1902			One of the first buildings in national romantic style, the Building of the Estonian Student Society (EÜS), is designed and built by Georg Hellat in Tartu	The symbolist period in Kristjan Raud's work starts
1903		A studio school is established in Tallinn by Ants Laikmaa, giving many young Estonians a chance to learn art		Ants Laikmaa and his students exhibit their work at the Provincial Museum in Tallinn
1904				Kristjan Raud opens his art studio in Tartu
1905	Russian Revolution of 1905 brings together democratically thinking Estonian intellectuals; national consciousness grows rapidly alongside growing social awareness		"Noor Eesti" (Young Estonia) literary society comes out with the slogan "Let us remain Estonians, but let's become Europeans" and is responsible for introducing new symbolist, impressionist, and expressionist elements into literature	Jaan Koort begins to study sculpture and painting at the Paris École des Beaux Arts Nikolai Triik, Konrad Mägi, and Aleksander Tassa begin to study art in Paris, marking a general loss of interest in academism
1906			Estonian language education is restored, and the first girls' Estonian language school is founded The Estonia theater in Tallinn and Vanemuine theater in Tartu turn into professional theater companies The Vanemuine theater in Tartu (destroyed in World War II), designed by Finnish architect Armas Lindgren, opens its doors	The first general Estonian art exhibition takes place in Tartu
1907				Nikolai Triik returns from a trip to Norway with elements of art-nouveau stylization
1908			The first movie house opens	
1909			The Estonian National Museum, initiated by Kristjan Raud and Oskar Kallis, opens	

	ESTONIAN HISTORY	ART INSTITUTIONS	CULTURAL SCENE	ART SCENE
1911				Nikolai Triik goes to Berlin (where he stays until 1913) and experiences the influence of German expressionism Ado Vabbe begins his studies at Ažbe's school in Munich at the time Der Blaue Reiter group is organized by Wassily Kandinsky and Franz Marc
1913			The theater and concert hall "Estonia" (partially rebuilt after World War II), designed by Armas Lindgren and Wivi Lönn, opens Eliel Saarinen plans an impressive reconstruction for the center of Tallinn called Big Tallinn	Ants Laikmaa returns to Estonia from abroad
1914	World War I begins	The Tallinn Art School is established as a source of comprehensive art education	Johannes Pääsuke completes the first Estonian documentary film, *Tartu and Its Moods*, and the first Estonian movie, *Bearhunt in Pärnumaa*	Ado Vabbe's exhibition is held at the Vanemuine theater in the university town of Tartu, the center of Estonian artistic life
1917	Bolshevik Revolution in Russia takes place		The literary group "Siuru" is established and introduces innovative approaches to literature through its pacifist ideals. Members of the group include Friedebert Tuglas, Marie Under, Henrik Visnapuu, Johannes Semper, August Gailit, Artur Adson, August Alle, and Johannes Vares-Barbarus	Vabbe travels in Italy, where he comes in contact with Italian futurism
1918	The Republic of Estonia is declared in Tallinn on February 24	The Pallas Art Society is founded in Tartu		
1919	A radical land act on the nationalization of German noblemen's land and the founding of new farms is passed	The Estonian Museum is founded in Tallinn The Pallas Art School is founded in Tartu The Conservatoire is founded		
1920	In the Tartu Peace Treaty of 1920, Soviet Russia recognizes the independence of Estonia, thereby ending Estonia's war of independence	The Tallinn Art School becomes the State School of Applied Arts		

	ESTONIAN HISTORY	ART INSTITUTIONS	CULTURAL SCENE	ART SCENE
1921	Estonia becomes a member of the League of Nations			German expressionist artist Georg Kindt starts teaching printmaking at Pallas Paintings by Otto Dix are exhibited at Pallas Eduard Viiralt leaves for Dresden
1922		Estonian Writers' Association is founded	The literary magazine *Looming* is established	
1923				Artists practicing ideas of cubism and constructivism—including Arnold Akberg, Edouard Ole, and Märt Laarman—form the Group of Estonian Artists
1924	Economic crisis ensues; Communists attempt a coup d'état		Poet Johannes Vares-Barbarus publishes his *Geometrical Human*	
1925		The State Cultural Endowment Fund is founded		Eduard Viiralt moves to Paris
1926			Regular broadcast of radio programs begins	
1928	A new currency, Estonian kroon, is introduced			*The Book of New Art* is published by a group of Estonian artists
1929				An exhibition of Estonian art takes place in the Kunsthall in Helsinki
1934		The Tallinn Art Hall opens	The Tallinn Art Hall (architects Edgar Johan Kuusik and Anton Soans) and the Pärnu Beach Hotel (1935–37, by Olev Siinmaa and Anton Soans) are the most remarkable monuments of the functionalist style that dominates 1930s architecture	
1938			Ilmar Laaban's collection of surrealist poetry, *Intermezzo in Ice*, is published	

	ESTONIAN HISTORY	ART INSTITUTIONS	CULTURAL SCENE	ART SCENE
1939	A secret agreement between Nazi Germany and the Soviet Union is signed by Molotov and Ribbentrop Estonia is forced to sign the treaty with Soviet Russia that allows the latter to establish military bases in Estonia		Herbert Read's *Art Now: An Introduction to the Theory of Modern Painting and Sculpture* is published in Estonian	The group exhibition of Adamson-Eric, Aleksander Vardi, Jaan Grünberg, Kristjan Teder, Kaarel Liimand, and Karl Pärsimäe at the Tallinn Art Hall marks the influence of the School of Paris on the Estonian art scene An extensive exhibition of contemporary French art takes place at the Tallinn Art Hall
1940	The Red Army occupies Estonia. The Estonian Socialist Republic is established, making Estonia a member of the Soviet Union	The Soviet Estonian Artists' Congress takes place in Tallinn The Pallas Art School becomes Konrad Mägi State Art School The State School of Applied Art in Tallinn is given Jaan Koort's name		
1941	Deportations start: 10,205 Estonians are deported to Siberia Nazi occupation begins	The Tartu Art Museum is founded		
1942			Estonian artists and writers, mobilized by the Red Army, gather in Yaroslavl, Russia	
1943		The Pallas Art School reopens Artists' Union of the Estonian Soviet Socialist Republic is founded in Yaroslavl, Russia		The 600th anniversary of St. George's Day Uprising is celebrated with an extensive thematic Estonian art exhibition in Yaroslavl
1944	Nazi occupation ends, and Soviet occupation is reestablished Estonians in extensive numbers immigrate to the West	The two major art schools are renamed Tartu State Art Institute and the Tallinn Institute of Applied Art		An exhibition of Estonian art of World War II is held Artists from Yaroslavl return to Estonia and take over leading positions in Estonian art life

	ESTONIAN HISTORY	ART INSTITUTIONS	CULTURAL SCENE	ART SCENE
1945	Stalinist repressions start. In ten years, 50,000 Estonians will face repression	The first decision of the government and Communist Party on the subject of art is published. It defines Socialist Realism as the only acceptable method of art, condemns what it believes to be idea-less, apolitical attitudes of modern art, and encourages artists to create works that glorify the Socialist lifestyle. Following this decision, the first Estonian Soviet Socialist Republic congress declares, "Who is not with us is against us"		
1946				Estonian emigrant artists form their own organization in Germany. Until 1950, over 60 exhibitions of the work of Estonian artists take place there
1949				Artists Ülo Sooster, Henn Roode, Valdur Ohakas, Enn Saarts, and Heldur Viires, graduates of the Pallas Art School, are arrested, accused of decadence and bourgeois nationalism, and sent to prison camp
1950		Tartu State Art Institute is declared a distributor of formalist anti-Soviet ideas, and it closes The Estonian State Art Institute is formed in Tallinn		
1953	Khrushchev comes to power			
1955			A decision of the Central Committee of the Communist Party ends the period of Stalinist classicism in architecture	
1956	Khrushchev thaw (1956–68) starts, and exchange of information is reestablished with the West	The Society of Estonian Artists is formed in Toronto, Canada	Art, architecture, and design magazines from Socialist countries become available	Ülo Sooster and his friends are released from prison camp

	ESTONIAN HISTORY	ART INSTITUTIONS	CULTURAL SCENE	ART SCENE
1957	The Sixth World Festival of Youth and Students is held in Moscow, accompanied by numerous international art exhibitions. Jackson Pollock's students demonstrate his dripping techniques at one of them	A more liberal concept of Socialist Realism is developed at the Artists' Congress of the Soviet Union		Ülo Sooster leaves Estonia for Moscow

Lola Liivat-Makarova attends the youth festival and adopts Pollock's drip technique |
| **1958** | | First edition of art quarterly *Kunst* is published | Library of the Academy of Sciences begins to receive international art and architecture magazines | The Estonian Art Museum hosts the first postwar retrospective exhibition of the work of Eduard Viiralt

The Tallinn Art Hall shows the first exhibition of young artists

Ülo Sooster, Yuri Sobolev, and Ernst Neizvestny meet at the Artisticheskoe Café in Moscow |
| **1959** | The U.S. Day of Technology and Culture takes place in Moscow, allowing Soviet citizens (including many Estonians) to see the achievements of Western technology and modernist artworks | | The first international Tallinn Jazz Festival takes place | Ülo Sooster starts working at the Znamia Publishing House

Olav Maran exhibits *View*, his first surrealist painting

Ilmar Malin makes his first automatic drawings |
| **1960** | | | A new wave of poets—including Paul-Eerik Rummo, Mats Traat, Enn Vetemaa, Jaan Kaplinski, and Hando Runnel—becomes known as the "Cassette generation" because their work is published in separate, small booklets of similar size and design, the series of which are collectively called "cassettes." The editions sell out immediately and are widely discussed in cultural circles

Arvo Valton and Mati Unt conduct innovations in prose writing

Arvo Pärt writes dodecafonic music; Veljo Tormis attempts innovating modern musical language in choral music

The Song Festival Amphitheater (by Alar Kotli and Henno Sepman) and the Flower Pavilion manifest the return of Estonian architecture to modernist ideals | Ilya Kabakov, Vladimir Yankilevsky, Victor Pivovarov, and Anatolii Brussilovsky join the group of artists at the Artisticheskoe Café

Henn Roode paints his *Marketplace* in constructivist style

Exhibition of young artists takes place at the Song Festival ground |

	ESTONIAN HISTORY	ART INSTITUTIONS	CULTURAL SCENE	ART SCENE
1961	Yuri Gagarin flies in outer space, supporting the Soviet ideological postulate that there is no limit to human ability	The Society of Estonian Artists is formed in Sweden	Televisions become more widely available, yet remain a powerful means of mass propaganda entirely controlled by the state. In the area around Tallinn, however, people watch Finnish TV, which is called "the window to Europe," and gives people an exceptional possibility to get more objective information on global affairs	A retrospective exhibition of Arkadio Laigo is held
1962	At the Manege exhibition in Moscow, Nikita Khrushchev declares abstract art dangerous and detrimental to society	Kaljo Põllu becomes the director of the Art Cabinet of Tartu University. Under his leadership, it becomes an important meeting place for young artists and art fans		A retrospective exhibition of Addo Vabbe is held
1963		The authorities ban the annual Tallinn Art Hall exhibitions of young artists because they feel that too many ideologically doubtful works are shown Roger Garaudy's book *Realism Without Borders* is banned	The first rock concert of international calibre by Italian singer Marino Marini is held in Estonia, creating a breakthrough for Estonian pop music. The first rock group "Juuniorid" (The Juniors) is formed	Henn Roode begins to paint abstractions
1964	Khrushchev is expelled from power and Leonid Brezhnev takes over, beginning a period of stagnation that lasts until 1985 Regular ferry traffic between Tallinn and Helsinki begins. Tourists bring with them contacts and information			A retrospective exhibition of Hendrik Olvi is held Students' art group ANK 64 is founded by Jüri Arrak, Kristiina Kaasik, Malle Leis, Tõnis Laanemaa, Marju Mutsu, Tiiu Pallo-Vaik, Vello Tamm, Enno Ootsing, and Tõnis Vint ANK initiates lectures on 20th-century art at the art institute ANK exhibition takes place at the Tartu University café
1965			Many architects visit the exhibition of contemporary American architecture in Moscow	A retrospective exhibition of Johannes Greenberg is held ANK undertakes a trip to St. Petersburg in order to meet with Mikhail Chemiakin and Evgenii Rukhin

	ESTONIAN HISTORY	ART INSTITUTIONS	CULTURAL SCENE	ART SCENE
1966			The first performance of the theater of the absurd is staged	Many abstract paintings are exhibited at Elmar Kits's solo exhibition
				Estonian Youth Art Exhibition is organized, as qualifying round for the *Youth Exhibition of the Soviet Union* becomes a public stage for radical experimentation
1967			The last and largest Tallin Jazz Festival takes place. Many international guests participate. (The festival is then banned for 23 years.) The concert takes place at the Brotherhood of the Black-heads' House, where the works of Sooster, Yankilevsky, and Kaba-kov are displayed	An interest in abstract art reaches its peak in Estonia
				Arvo Pärt, Toomas Velmet, Mart Lill, Ivalo Randalu, Lille Randma, Kuldar Sink, and Tarmo Lepik participate in the first happenings in Estonia
				The Visarid group, led by Kaljo Põllu, is formed in Tartu. Members include Kaur Alttoa, Peeter Lukats, Jaak Olep, Rein Tammik, Enn Tegova, and Peeter Urbla. The group translates Western theoretical writings on modern art and reproduces them via the samizdat method. In the period 1968–71, five collections of translations are published
				ANK undertakes a trip to Moscow to meet with Ülo Sooster, Yuri Sobolev, Ilya Kabakov, and other artists of their circle.
1968	The Soviet Union invades Czechoslovakia, eliminating all hopes of democratization. The invasion signals a sudden and alarming increase in societal stagnation		Censorship in literature increases dramatically, resulting in the development of underground literature. J. B. Isotamm, H. Runnel, J. Kaplinski, and H. Kiik distribute their works in manuscript form	An atmosphere of disappointment ensues. Artists Elmar Kits, Henn Roode, and Olav Maran turn to figurative style and object art
			The first Soviet rock festival, organized by Estonia's rock musicians, takes place in Tallinn's Kosmos movie theater. The festival is the only one of its kind for a long while	Thirty Estonian artists, including ten members of ANK, visit the Second Krakow Print Biennial
				The first Tallinn Print Triennial takes place
				Ando Keskküla, Leonhard Lapin, Gunnar Meyer, and Andres Tolts, inspired by pop art, found the group Soup '69

	ESTONIAN HISTORY	ART INSTITUTIONS	CULTURAL SCENE	ART SCENE
1969				Members of Soup '69 initiate art exhibitions of university students without judging committees at the art institute. Exhibitions are held in 1969, 1970, and 1971, with numerous happenings and events occurring in conjunction
				Ülo Sooster dies. Tallinn and Moscow artists meet at his funeral
				Leonhard Lapin and Tõnis Vint visit Moscow artists for the first time
1970				The exhibition *Estonian Progressive Artwork* is held in Pegasus Café at the Writers Association Headquarters. Members of ANK 64, Visarid, and Soup '69 participate
				Jüri Okas starts recording happenings and land-art projects on 8-mm film
1971			Raul Meel publishes his first collection of concrete poetry	The first photorealist composition in Estonia is painted by Tonu Virve
1972				Rein Tammik, Urmas Ploomipuu, Ando Keskküla, and Urmas Pedanik turn to photorealism
1973			*Art and Home* magazine, edited by Andres Tolts, is launched. It introduces new ideas in modern design, interior design, contemporary art, and architecture	A semi-official exhibition, *Saku 1973*, held at the Saku Agriculture Institute in the suburbs of Tallinn, receives severe official criticism
				Vladimir Makarenko introduces Leonhard Lapin to Pavel Kondratjev, a student of Kazimir Malevich. Malevich's ideas provide Lapin with resources that allow him to continue his experiments with suprematism
1975				The *Harku 1975* exhibition is held at the Harku Experimental Biology Institute near Tallinn. This exhibition is the final dazzling manifestation of the creative searches that began in the 1960s

	ESTONIAN HISTORY	ART INSTITUTIONS	CULTURAL SCENE	ART SCENE
1976				*Estonian Monumental Art Exhibition*, displaying works of non-commissioned architects, is held
1977			Arvo Pärt's *Tabula Rasa*, dedicated to musicians Tatiana Gridenko and Gidon Kremer and conductor Eri Klas, and Alfred Schnittke's *Concerto grosso No. 1* are performed for the first time in Estonia at the Tallinn Politechnical University	Norton Dodge organizes the exhibition *New Art from the Soviet Union*, which features numerous works by Estonian artists A geometric print exhibition is held at the Artists' Association Hall in Tallinn
1978				*Exhibition of New Architecture* is held in the foyer of the Estonian Academy of Sciences, marking the formation of the school of Tallinn architects
1979				Raul Meel, Jüri Okas, Tõnis Vint, and Leonhard Lapin show their works at the Rīga Planetarium
1980	Tallinn hosts the sailing events of the Moscow Olympic Games Russification reaches its peak A group of intellectuals signs *The Letter of 40* in a desperate attempt to direct the world's attention to Estonia's plight		Conductor Neeme Järvi moves to the United States Composer Arvo Pärt emigrates	Leonhard Lapin's multimedia performance, *Multiplied Person*, which is set to the poetry of Vares-Barbarus, is put on at the Estonian Youth Theater in Tallinn The first environmental installation in Estonia, by Jüri Okas, is displayed at the Tallinn Art Hall Siim-Tanel Annus holds his first ritual performances
1983				The exhibition *The Estonian Artists' Group and the Geometric Tradition in Estonian Art* is held at the Estonian Art Museum The Tartu exhibition features the abstract expressionist works of Kaarel Kurismaa, Ado Lill, and Lola Liivat Kaarel Kurismaa displays his kinetic objects at Tallinn's Museum of Applied Arts

	ESTONIAN HISTORY	ART INSTITUTIONS	CULTURAL SCENE	ART SCENE
1984				The exhibition *Nine Architects from Tallinn*, organized at the Art Salon, travels to the Finnish Museum of Architecture in Helsinki. In conjunction with the exhibition, a special issue of the leading Finnish art magazine, *Taide*, is dedicated to Estonian art and architecture *Photography and Art*, a joint exhibition of works of Estonian and Russian avant-garde, is held at the Tartu Art Museum. Participants include Erik Bulatov, Ilya Kabakov, and Francisco Infante
1987	Students and intellectuals initiate a successful protest movement against Moscow's plans to start a large-scale, ecologically disastrous mining project in northeastern Estonia MRP-AEG group demands the disclosure and publication of the 1939 Molotov-Ribbentrop Pact The first open mass demonstration against Soviet rule in Estonia takes place on the day marking the anniversary of Molotov-Ribbentrop Pact	The Cultural Board of Creative Associations is founded and unites the intellectuals critical of the situation with those willing to head the independence movement The Estonian Heritage Society, which facilitates political mobilization of national sentiment, is organized		Exhibitions of works by Jüri Okas and Leonhard Lapin are held at the Estonian Art Museum

	ESTONIAN HISTORY	ART INSTITUTIONS	CULTURAL SCENE	ART SCENE
1988	Militia using clubs and dogs disrupts a demonstration in Tartu commemorating the Tartu Peace Treaty of 1920 A demonstration to mark the Estonian Independence Day takes place in Tallinn Former political prisoners, human rights activists, representatives of youth groups, and intellectuals found the Estonian National Independence Party The Supreme Council of the Estonian Soviet Socialist Republic adopts a declaration of independence and proclaims the Estonian Soviet Socialist Republic a sovereign state		The "Singing Revolution" begins: an annual city festival of music turns into a nightlong songfest of national sentiment. In its footsteps, numerous night song festivals take place in Tallinn and Tartu	Exhibition of young artists, *I Have Never Been in New York*, takes place at the Song Festival Amphitheater
1989	"The Baltic Chain," a human chain reaching 600 km from Tallinn to Vilnius, marks the fiftieth anniversary of the Molotov-Ribbentrop Pact. Over 1 million people take part in the event, making it the largest demonstration organized in postwar Europe			Raul Meel's exhibition at the Estonian Art Museum takes place The exhibition and conference *Following the Idea of Avant-Garde*, devoted to the radical art of the previous years, points to the shift to postmodernism in Estonian art The exhibition of Estonian post–World War II art, *Structure and Metaphysics*, is held at the Pori Art Museum, Helsinki Taidenhall, and Rovaniemi Art Museum. It subsequently travels to Kiel, Germany, Stockholm, and Kalmar, Sweden
1990	Elections to the Congress of Estonia and to the Supreme Council are held Confrontation increases between the Baltic states and Moscow Interfront makes an attempt to take over the Estonian government and parliament building on Toompea Hill	The first private gallery, *Vaal* (The whale), opens. It organizes the display of works of Estonian artists at such international exhibitions as *ARCO* in Madrid, Spain, and *Art Cologne* in Köln, Germany Open Estonia Foundation, initiated by the American philanthropist George Soros, opens		Leo Lapin, Vilen Künnapuu, Jaan Ollik, Toivo Raidmets, Eero Jürgenson, and Raoul Kurvitz present their installation at the annual Arts Night on Helsinki Esplanade Retrospective exhibition of the group Soup '69 takes place at the Tallinn Art Hall

	ESTONIAN HISTORY	ART INSTITUTIONS	CULTURAL SCENE	ART SCENE
1991	Lithuanian Bloody Sunday occurs A treaty on Baltic interstate relations is signed between the Russian Federal Socialist Republic and the Republic of Estonia—a compromise to prevent the occurrence of Bloody Sunday in Estonia A coup d'état takes place in Moscow The Supreme Council of Estonia declares the country's independence Estonia, Latvia, and Lithuania join the United Nations The Soviet Union recognizes the independence of Estonia, Latvia, and Lithuania	The Tallinn Art Hall begins functioning as an independent institution The Estonian Architecture Museum is founded		
1992	The Estonian kroon replaces the Soviet ruble The first democratic parliamentary and presidential elections take place		An Estonian cultural festival is held in Karlsruhe, Germany The Estonian national team takes part in the Olympic games	Peeter Linnap initiates a photo festival that will later give birth to international Saaremaa Biennials
1993		The Soros Center for Contemporary Arts opens		The first annual exhibition of the Soros Center for Contemporary Arts takes place. The Center's annual exhibitions strongly promote innovative spirit and experimentation with new media in the Estonian art scene
1995		The Estonian Cultural Endowment Fund is launched		*Interstanding*, the first exhibition of media art and an international symposium organized by the Soros Center, takes place The feminist exhibition *Est-fem* marks the beginning of feminist discourse
1996				The exhibition *Art Axis Tallinn-Moscow, Moscow-Tallinn*, devoted to nonconformist art and displaying the works of Ülo Sooster, Vladimir Tarasov, Vladimir Yankilevsky, Ilya Kabakov, and others, takes place at the Tallinn Art Hall

	ESTONIAN HISTORY	ART INSTITUTIONS	CULTURAL SCENE	ART SCENE
1997				The second *Interstanding* exhibition takes place
				Estonian artists take part in the Venice Biennial
				Siim-Tanel Annus, Raoul Kurvitz, and Jaan Toomik represent Estonia at the Venice Biennial
1998				Tallinn Print Triennial becomes truly international
1999				Ando Keskküla, Jüri Ojaver, and Peeter Pere represent Estonia at the Venice Biennial

Compiled by Anu Liivak
Translated by Riina Kindlam

Appendix B
Major Events in Latvian History and Culture

BEFORE THE 20TH CENTURY

2nd Millennium B.C.E.

Proto-Baltic tribes of kurši, latgaļi, sēļi, zemgaļi, and līvi, ancestors of the Latvians, move to the Baltic coast

12th Century C.E.

The first German monks arrive in the territory of Latvia to preach Christianity

1186 Bishop Meinard builds the first stone church in Ikskile (Ikšķile)

1198 The Second Crusade begins. Rīga is mentioned for the first time as a place-name or settlement

13th Century

1201 Bishop Albert founds Rīga. This event marks the beginning of the domination of German culture in Latvia that will last until the 19th century

Castles of the Teutonic order are built throughout Latvia, in Cēsis, Sigulda, Koknese, Limbaži, and Turaida

1209 St. Peter's Church in Rīga is built

1211 Dome cathedral is built, and the school at the Dome cathedral is founded

1224–27 The first article on the ancient history of Latvia, "Heinrici Chronicon Lyvoniae," is written by Heinrici, a German monk

1226 St. Jacob's Church in Rīga is built. A school is opened at St. George's Church (Jura baznīca)

1237 The Livonian order is founded as a branch of the Teutonic order

Construction of feudal castles begins in Rīga, Ludza, Aizpute, Dundaga, Ēdole (1265), and Ventspils (1250)

1260 Battle of Durbe takes place

1282 Rīga joins the Hanseatic League

1289–90 Crusaders conquer the entire territory of Latvia

16th Century

1521 The portal of the House of Blackheads in Rīga in late Gothic style is constructed

1521–22 Reformation spreads in Livonia

1524 The first public library opens in Rīga, and Protestant activities start

1558–83 Livonian war is waged

1560 Schools are founded in Liepāja and Grobiņa

1561 Reformation spreads further in Latvia. Rīga gets the rights of a free city

Kurzeme Princedom is established, with Jelgava city as the main city

1581 After a defeat in the Livonian war, the territory of Latvia is annexed by Poland

1582–1621 Sigismund II August, the king of Poland, rules over Latvia after the Livonian war

1583 Plusa peace agreement between Russia and Sweden is signed. Livonian war ends. Livonia is divided among Poland, Sweden, and Denmark

A school for Protestant children opens

1584 The construction of Bauska castle in late Gothic style with elements of Renaissance begins

17th Century

1621 Sweden occupies Rīga and the northern part of Latvia

1621–1710 Swedish rule is established in Latvia

1635–36 The German doctor-traveler Olearius visits Latvia and records facts about 17th-century Latvia in his diary

1638 *Lettus*, a work about Latvia by Georg Manzel (1593–1654), is written

1649 *Historia Lettica*, by monk Paul Einhorn, is written

1680 The first German-language newspaper in Latvia, *Rigische Novellen*, is published

1683 The first Latvian dictionary, *Dictionaricum polono-latino-lottavicum*, with fourteen thousand words, is published in Vilnius

1683–1702 Ernest Glück (1652–1705) works in Alūksne. He founds the first Latvian schools in Vidzeme and translates catechism and the Bible into Latvian. His daughter Marta Skavronska marries Peter I and later becomes known as Russian Empress Ekaterina I

1685–91 The first Bible in Latvian is prepared and published

1688 The first dictionary in four languages, *Vocabularium in vier Sprachen: teutsch, lateinisch, polnisch und lettisch*, is published

1697 Baroque style becomes dominant in Latvia. Decorative wooden sculpture becomes widespread in Kurzeme. Nikolaus Söffrens the Younger (1662–1710) creates altars in St. Anna's Church in Liepāja and in Ugāle Church

18th Century

1700–1721 The Great Northern War begins. Estonia and Vidzeme are annexed by Russia

July 14, 1710 The Russian army wins over Sweden, and Rīga is handed over to Russians

1721 The treaty of Nystad is signed. Kurzeme Princedom and Latvia's northern part are incorporated into Russia as Livonia Province

Late 1720s Anna Ivanovna, the empress of Russia, lives in Jelgava. Prince Ernst Johan Biron becomes a favorite of hers and is appointed duke of Kurzeme Princedom. Under his supervision, royal palaces are built in Rundāle (1736) and in Jelgava (1738) by Bartolomeo F. Rastrelli (1700–1771)

1736–68 Rundāle palace construction takes place

1738–72 Jelgava palace is built according to the project of the architect, Bartolomeo F. Rastrelli

1761 *Neue vollasständigere lettische Grammatik* by Gotthard Friedrich Stender (1714–1796) is published

1770s Artist Friedrich Hartmann Bariesen (1724–1796) lives and works in Kurzeme Princedom

1771 The first volume of *Sammlung verschiedener liefländischer Monumente, Prospecte, Münzen, Wappen etc.* by Johann K. Brotze (1742–1823) is published. The final, tenth volume will not appear until 1818

1772 Latgale is joined to Russia

1773 The first museum in Latvia, the Dome Museum (presently the Museum of the History of Rīga and Navigation), opens

1774 *Jaunās ziņģes* (New popular songs), a first book of poems edited by G. F. Stender, is published in Latvia

Late 1770s The most popular architect of classicism, Christoph Haberland (1750–1803), builds several houses in classicist style in Rīga and several churches in Latvia (Valka 1785, Alūksne 1788)

1775 "Academia Petrina" in Jelgava (Mitava) is established

1778–79 A book of folk songs that contains eleven Latvian folk songs, *Volkslieder* by Johann Gottfried Herder (1744–1803), is published in Germany

1781 A book of Immanuel Kant, *Critics of Clear Mind*, is published for the first time in Rīga

1782 The first ABC book for learning Latvian, edited by G. F. Stender, is published

The German Theater of Rīga opens

1787 The first German elite club, Muße, opens

1789 The two-volume *Lettisches Lexicon* by Gotthard Friedrich Stender is published

1795 Kurzeme Princedom is joined to Russia as Kurzeme Province

1797 *Die Letten* by Garlieb Merkel (1769–1850), which contains facts about the lifestyle of Latvians, is published

1798–99 Garlieb Merkel writes the two-volume *History of Livonia*

19th Century

Early 1800s Friedrich Wilhelm Brederlo (1779–1862) assembles a private art collection (presently owned by the Museum of Foreign Art in Rīga) that contains pieces of 17th-century art

1806 The first collection of poetry in German by Blind Indriķis is published in Latvia

1812 Napoleon invades Russia. The French army occupies Lithuania and Kurzeme. Rīga suburbs are burned down

1815 The Literary and Art Society of Kurland, *Kurländische Gesellschaft für Literatur und Kunst*, is founded

1817 Serfdom is abolished in Kurzeme Province

1818 The Literary and Art Society of Kurland founds the Museum of Kurland

1819 Serfdom is abolished in Vidzeme Province

1822–1915 The first newspaper in the Latvian language, *Latviešu avīzes*, is published

1837–39 German composer Richard Wagner (1813–1883) works as musical director of German Theater of Rīga

1837–58 Painter Johann Leberech Eggink (1784–1867) works in Kurland Gymnasium in Jelgava. He painted *Tsar Aleksander I gives freedom to the peasants of Baltic provinces* (1824) and *Odissay and Nausikaya* (1824)

1839 A college for teachers opens in Valka. Jānis Cimze (1814–1881) works there

1841 A college for teachers opens in Irlava

1842 A first show of the works of Baltic artists, among them Johann Heinrich Baumann (1753–1832) and Karl Gotthard Grass (1767–1814), takes place in the House of Blackheads in Rīga

1856 The first collection of poetry in Latvian—Juris Alunāns's *Dziesmiņas* (Songs)—is published

The Latvian newspaper *Mājas Viesis*, associated with the neo-Latvian movement and with the emergence of national consciousness, is launched by Juris Alunāns, Krišjānis Barons, Krišjānis Valdemārs, and others

1857–62 The first railroad Riga-Dinaburg-Oryol-St. Petersburg-Dinaburg-Warsaw is constructed

1860 Artist Jānis Staņislavs Roze (1823–1897) is granted the title of Academician of the St. Petersburg Academy of Fine Arts for his *Self-Portrait*. He becomes one of the most popular portraitists of the 19th century

1862 The Rīga Polytechnic School (now Technical University of Rīga) is founded. Between 1881 and 1887, chemist and Nobel Prize winner Wilhelm Ostwald (1853–1932) works there

1862–65 The newspaper *Pēterburgas avīzes* is published in St. Petersburg

1863 The German Theater of Rīga moves into a newly built opera house (presently the City Opera House)

Late 1860s The development of professional Latvian art begins. Latvian artists study at the St. Petersburg Academy of Fine Arts

1868 The Rīga Latvian Society and Rīga Latvian Theater are founded

1869 The Art Gallery of Rīga (later incorporated into the Rīga City Art Museum) is founded

1870 The society *Kunstverein* is founded. It organizes numerous international art exhibitions in Rīga at the beginning of the 20th century

1872 Jānis Cimze starts publishing collections of Latvian folk songs, *Dziesmu rota*

1873 Elise Jung-Stilling's drawing school is founded. In 1906, it is transformed into the Rīga Art School

Kārlis Hūns (1831–1877) joins the Latvian national activists, one of the first artists to make such an open political move

The First Song Festival takes place. It features music of Latvian composers and includes the song "Dievs, svētī Latviju" (God bless Latvia) by Baumaņu Kārlis, which in 1918 becomes the national anthem

1879 The first Latvian novel, *Mērnieku laiki* (Times of land surveyors), by brothers Reinis and Matīss Kaudzīte is published

The first union of architects is founded by the first Latvian architect with academic training, Jānis Baumanis (1834–1891). The union publishes the almanac *Jahrbuch für bildende Kunst in den Ostsee-provinzen* between 1907 and 1913

1880 The Second Song Festival takes place in Rīga

1880s–90s Wide-scale city construction and expansion takes place in Rīga, forming Boulevard Circle around the old city. The new buildings, in art-nouveau style, are designed by Michail Eisenstein, Eižens Laube, Wilhelm Bockslaff, Konstantīns Pēkšēns, Wilhelm Neumann, and others

1883 The Russian Theater opens in Rīga

1887 *Grundriss einer Geschichte der bildenden Kunste in Liv-, Est- und Kurland vom Ende des 12 bis zum Ausgang des 18 Jahrhunderts*, by architect and art historian Wilhelm Neumann (1849–1919), is published

1888 The Third Song Festival takes place in Rīga

The epic *Lāčplēsis* by Andrejs Pumpurs is published

1890s Ruķis, the society of Latvian artists that includes Ādams Alksnis (1869–1897), Jānis Rozentāls (1866–1916), Jānis Valters (1869–1932), Arturs Baumanis (1867–1904), Richard Zariņš (1869–1939), Teodors Zaļkalns (1872–1976), and Gustavs Šķilters (1874–1954), is founded in St. Petersburg

1893 The first Latvian opera, *Spoku stunda* (Ghost hour) by Jēkabs Ozols (1863–1902), is performed

1894 *Latvju dainas*, the first volume of Latvian folk songs (systemized by Krišjānis Barons), is published

1895 The Fourth Song Festival takes place in Jelgava

Benjamin Bloom (1861–1919) founds a private school of drawing and painting

1896 The Tenth Ethnographical Congress, which features an art exhibition, takes place. At the congress, the works of the best Latvian painters—Jānis Rozentāls, Jānis Valters, Vilhelms Purvītis (1872–1945), and Ādams Alksnis—are shown for the first time

1897 Jānis Valters and Vihelms Purvītis graduate from the St. Petersburg Academy of Fine Arts and exhibit their works

1898 Valters, Purvītis, and Rozentāls, along with their teacher, Russian painter Arkhip Kuindzhi (1841–1910), and other students, go on a tour around Europe

The Rīga Art Salon opens

1899 *Gaismas pils* (Palace of light), a ballad with words by poet Auseklis and music by composer Jāzeps Vītols (1863–1948), is performed

Gustavs Šķilters graduates from Baron Stiglitz School of Technical Drawing and visits Paris, where he studies in Auguste Rodin's studio

Consultant: Irēna Bužinska

	LATVIAN HISTORY	ART INSTITUTIONS	CULTURAL SCENE	ART SCENE
1900				Teodors Zaļkalns graduates from Baron Stiglitz School of Technical Drawing and visits Paris, where he studies in Auguste Rodin's studio
1901	700th anniversary of the founding of Rīga is celebrated			A retrospective exhibition of Baltic artists is dedicated to the 700th anniversary of Rīga. On display are 308 paintings and 42 sculptures Rīga Art Salon holds a show of Jānis Valters (1869–1932), Richard Zariņš (1869–1939), Jūlijs Madernieks (1879–1955), and Jānis Lībergs (1862–1933)
1902			Premiere of play *Skroderdienas Silmačos* (Tailor's days in Silmaci) by Rūdolfs Blaumanis (1863–1908)—the most popular play in Latvia—takes place in Rīga at the Latvian Theater	Exhibition of Jānis Valters's works takes place in Jelgava
1903			A collection of poetry of Jānis Rainis, *Tālas noskaņas zilā vakarā*, is published	Rīga Art Salon holds a show of Arnold Böcklin (38 works are displayed)
1904			Composer Emīls Dārziņš (1875–1910) writes the song "Lauztās priedes" (Broken pine trees)	Private studio of Jūlijs Madernieks opens (existed until 1914)
1905	First revolution takes place in Russia. Latvian intellectuals write petition to the Tsar	Rīga City Art Museum (presently State Museum of Art) is founded. Architect and first director of the museum is Wilhelm Neumann (1849–1919)	The New Latvian Theater is closed down for staging a revolutionary play (*Sidraba šķidrauts* by Aspazija) A collection of poetry by Jānis Rainis, *Vētras sēja*, is published. He and his wife, Aspazija, emigrate to Switzerland	Exhibition of Baltic artists is dedicated to the opening of Rīga City Art Museum
1906		Rīga City Art School is founded		Painter Jānis Rozentāls opens his private studio (lasted until 1910)
1908			The New Rīga Theater reopens	Wilhelm Neumann's art dictionary, *Lexikon Baltischer Künstler*, is published
1909			Jēkabs Duburs (1866–1916) and Ernests Kārkliņš (pseud. Zeltmatis; 1868–1961) organize Latvian drama courses—the first special school for actors in Latvia	Show of Parisian artists featuring works by Maurice Denis, Félix Vallottin, Pierre Bonnard, and others takes place at the Rīga City Museum

	LATVIAN HISTORY	ART INSTITUTIONS	CULTURAL SCENE	ART SCENE
1910	Tsar Nikolai II visits Rīga to commemorate the 200th anniversary of the joining of Rīga and Latvia to Russia and to unveil the monument to Peter I (dismantled in 1914 at the beginning of World War I; later, in its place, the Monument of Freedom was built)	Baltic Art Society, *Baltischer Künstler-Verband*, is founded	Fifth Song Festival takes place in Rīga The poem *Ave sol!* by Rainis is published	Exhibition of Jānis Rozentāls takes place at the Rīga City Art Museum First joint exhibition of Latvian artists (33 artists, 417 works) takes place Exhibition of artists from St. Petersburg group, *The Union of Youth*, is organized by Voldemārs Matvejs, who writes especially for the exhibition a manifesto, *Russian Secession*—the first manifesto of avant-garde art
1911		Latvian Art Society is founded	Premiere of the play *Uguns un nakts* (Fire and night) by Rainis takes place at the New Rīga Theater. Stage designer is Jānis Kuga (1878–1969), and director is Aleksis Mierlauks (1866–1943)	Second joint exhibition of Latvian artists (33 artists, 132 works) takes place
1912			Book publishing house Valters & Rapa is established Staging of the opera *Jevgenij Onegin* by Pyotr Tchaikovsky marks the opening of the private music studio of Pāvuls Jurjāns (1866–1943), Latvijas Opera	Third exhibition of Latvian art (47 artists, 187 works) takes place, for the first time in Rīga City Art Museum
1913		Artist Vilhelms Purvītis is nominated as Academician of St. Petersburg Academy of Fine Arts		Baltic Art Society organizes third (March) and fourth show (October) in Rīga City Art Museum
1914	World War I begins		Performance of Rainis's play *Pūt, vējiņi!* (Blow, wind!) takes place at the New Rīga Theater	Fourth joint exhibition of Latvian art (46 artists, 167 works) takes place Posthumous exhibition of Voldemārs Matvejs's (1877–1914) works (186 works) is organized
1915	The first detachment of Latvian Riflemen is established		The last of the six volumes of *Latvian Folk Songs* edited by Krišjānis Barons is published	Show of Latvian art (27 artists, 155 works) takes place in Petrograd
1916				Show of Latvian art (29 artists, 269 works) takes place in Moscow

	LATVIAN HISTORY	ART INSTITUTIONS	CULTURAL SCENE	ART SCENE
1916–1917		The Rīga Art School is closed, but some Latvian artists—Jēkabs Kazāks (1895–1920), Valdemārs Tone (1892–1958), Romans Suta (1896–1944), and Kārlis Johansons (1892–1929)—continue their studies at Penza Art School		
1917	Revolutions in Russia in February and October. Part of Latvian Riflemen take the side of the Soviets			
1918	In March–November, German occupation regime is established in all the Baltic republics Proclamation of the independent Republic of Latvia on November 18 The Liberation War in the Baltic countries begins (and lasts through 1920)	In Petrograd, Lenin publishes the edict "About Monuments of the Republic"		Teodors Zaļkalns, Kārlis Zāle, and Jānis Roberts Tillbergs (1880–1972) start making monuments for propaganda purposes
1919	Government led by Pēteris Stučka proclaims victory of the Soviets in Latvia Newspaper *Segodnja*, the largest Russian newspaper outside Russia, is launched	Vilhelms Purvītis becomes a director of the Rīga Art Museum (a position he holds until 1940)	Latvian Opera opens its season with the performance of Richard Wagner's play *Lidojošais holandietis* (Flying Dutchman) Drama Theater is founded in Rīga Several establishments of higher education (Latvia University, Latvia Conservatory) are founded. The National Theater opens, and the Art Academy is founded	Artist Jāzeps Grosvalds (1891–1920) publishes an article, "L'Art Letton," in French in Baltic countries magazine *Revue Baltique*, edited in Paris. The aim of the article is to introduce Europe to the art of an independent country

	LATVIAN HISTORY	ART INSTITUTIONS	CULTURAL SCENE	ART SCENE
1920	Peace agreement between the Republic of Latvia and Soviet Russia is signed LETA telegraphic agency is established in Latvia	The Rīga Group of the Society of Artists is founded, with Jēkabs Kazaks, Valdemārs Tone, Oto Skulme, Uga Skulme, and others as members The Foundation of Culture is established State Museum of Art is founded	Performance of the first Latvian opera, *Baņuta* by Jānis Kalniņš (1890–1966), is staged at the Opera House Art Theater opens in Rīga with a production of Rainis's *Indulis un Ārija*, directed by Eduards Smiļģis (1886–1966)—one of the best theater directors in Latvia in the 20th century Jānis Rainis and his wife, Aspazija, return to Latvia Premiere of the performance of Rainis's *Jāzeps un viņa brāļi* (Joseph and his brothers), directed by Aleksis Mierlauks, takes place at the Rīga Drama Theater Choir of Teodors Reiters (1884–1956) is founded	First exhibition of the members of the Rīga Group in Rīga City Art Museum Art magazine *Ilustrēts Žurnāls* is launched
1921			Rainis becomes a director of the Drama Theater	
1922	Postwar reconstruction of Latvia		Performance of J. Mediņš's (1890–1966) opera *Dievi un cilvēki* (Gods and people) is staged at the Latvian Opera Second edition of *Latvian Folk Songs* is released by Valters & Rapa *Latviešu literatūras vēsture* (History of Latvian literature) by Teodors Zeiferts (1865–1929) is published	Sculptor Kārlis Zāle works in Berlin. He edits the art magazine *Laikmets* (Epoch), in which articles by Ivan Puni, Viktor Shklovski, and Fernand Léger are published The first monument (dedicated to Latvian soldiers who died for independence) by Emīls Melderis (1889–1979) is unveiled in Valka
1923				Romans Suta's 60 *Jahre lettischer Kunst* (60 years of Latvian art) is published in Potsdam

	LATVIAN HISTORY	ART INSTITUTIONS	CULTURAL SCENE	ART SCENE
1924		Museum of Latvian History is founded Ethnographical Museum is founded in Rīga	Guest performances of Kaunas Drama Theater from Lithuania take place in Latvia The three-volume *Latvju raksti* about Latvian ornaments is published	Exhibition of Rīga Group takes place in Tartu and Tallinn with Estonian artists Edouard Ole and Juhan Raudsepp participating Joint exhibition of Rīga Group and the Polish group BLOK (Katarzyna Kobro, Władysław Strzemiński, and Aleks Rafalowicz) takes place Artists including Aleksandrs Drēviņš (1889–1938) and Gustav Klucis (1895–1938) stay in Russia Group Sadarbs that includes A. Annuss (1893–1984), Kārlis Miesnieks (1887–1977), Ludolfs Liberts (1895–1959), Jūlijs Madernieks, and Eduards Vītols (1877–1954) is founded Baltars Workshop (Romans Suta, Aleksandra Beļcova, and Sigismunds Vidbergs) is organized. Works of workshop members get international attention at the 1925 *Exposition internationale des arts decoratifs et industriels modernes* in Paris Construction of Brother Cemetery by sculptor Kārlis Zāle (1888–1942) begins
1925		Art department is established at the Cēsis City Art Museum	Ansis Gulbis (1873–1936) publishing house begins publication of the eleven-volume collected works of Jānis Rainis, *Dzīve un darbs* (Life and work) Anna Fjodorovna, ballerina of Mariinsky Theater, starts performing at the Latvian Opera First radio broadcast in Latvia takes place	J. Dombrovskis's *Latvju māksla* (Latvian art) — first book about professional Latvian art — is published Society of artists, writers, and musicians Zaļā vārna is organized. Its membership includes artists Jānis Plēpis (1909–1947), Pēteris Upītis (1899–1989), Oļǵerts Ābelīte (1909–1972), and Aleksandrs Junkers (1899–1976)
1926			Grāmatu draugs publishing house begins Sixth Song Festival takes place in Rīga	Artist Oto Skulme starts working as stage designer

	LATVIAN HISTORY	ART INSTITUTIONS	CULTURAL SCENE	ART SCENE
1927			Ansis Gulbis publishing house begins publication of *Latviešu konversācijas vārdnīca*, the first academic encyclopedia in Latvian (21 vols.) Alfrēds Kalniņš (1879–1951) composes the symphonic score *Ballet Suite*	Exhibition of Latvian art takes place in Stockholm *Latvju māksla* by Boriss Vipers (1888–1967) is published
1928		Society of the Graphic Artists of Rīga is founded. Its members include Romans Suta and Ansis Cīrulis (1883–1942)	*Daugava*, one of the most popular magazines dedicated to literature, culture, and art, is launched The Symphonic Orchestra of Latvia Radio is created	Artist Ludolfs Liberts starts working in the Opera House. By 1938, he will design sets for 35 plays Sigismunds Vidbergs (1890–1970) illustrates Pier Luis's *Sixteen Songs of Bilitis* (published by ARS)
1929		Fourth competition for the Monument to Freedom project (previous in 1922, 1924, 1925) is won by Kārlis Zāle	Russian choreographer Mikhail Fokin works at the Latvian Opera	The first monument made by a Latvian artist, Teodors Zaļkalns, to Rūdolfs Blaumanis is unveiled in Rīga Latvian artists/stage designers participate in an exhibition of theater art in Helsinki. Participants include Jānis Kuga, Eduards Vītols, Niklāvs Strunke, Ludolfs Liberts, Herberts Līkums, Romāns Suta, and Aleksandrs Spertāls
1930			Andrejs Upītis's *Žanna d'Arka* (Joan of Arc) is performed at the Drama Theater First volume of Andrejs Upīts and Rūdolfs Egle's collective work, *Pasaules literatūras vēsture* (History of world literature), is published	
1931			Seventh Song Festival takes place in Rīga	Sigismunds Vidbergs illustrates *Kamasutra* (published by ARS)
1932			A ballet school opens at the Latvian Opera Mikhail Tschechov participates in the Drama Theater productions of *Hamlet* and Strindberg's *Erik XIV*	Māksalas society is founded. Its membership includes Ansis Artums, Arturs Aglītis, Kārlis Neilis, Oskars Norītis, and Jūlijs Viļumainis
1933			*Zvejnieka dēls* (Fisherman's son) by Vilis Lācis (1904–1966) is published Eighth Song Festival takes place	Retrospective exhibition of Latvian art takes place in Oslo. Kārlis Hūns, Jānis Rozentāls, Jūlijs Feders, and Jānis Valters participate

	LATVIAN HISTORY	ART INSTITUTIONS	CULTURAL SCENE	ART SCENE
1934	Authoritarian regime of Karlis Ulmanis is installed in Latvia		Adaptation of Vilis Lācis's novel *Zvejnieka dēls* is staged at the Drama Theater *Latiešu lirika*, an anthology of Latvian poetry edited by Rūdolfs Egle, is published by Ansis Gulbis	Exhibition of Latvian art takes place in Moscow and Leningrad The three-volume *Mākslas vēsture* (History of art), edited by Vilhelms Purvītis, is published
1935		The Art Museum is founded in Tukums	The first Latvian ballet, *Mīlas uzvara* (Victory of love)—composed by Jānis Mediņš and with stage design by Ludolfs Liberts—is performed	The Monument of Freedom is unveiled in Rīga Art magazine *Senatne un Māksla* (Ancient times and art) is launched
1936			Institute of Latvian History is founded. It publishes on a regular basis a collection of documents, *Latvijas vēstures avoti* (Sources of Latvian history)	Exhibitions of Latvian art take place in Helsinki, Tartu, Tallinn, Warsaw, and Krakow Latvia takes part in international art exhibits in Brussels and the following year in Paris. A dish set by Jēkabs Bīne and glassworks by Iļģuciems factory receive Grand Prizes
1937			Boriss Vipers's *Latvijas māksla baroka laikmetā* (Latvian art in the Baroque era) is published The conductor of the Berlin National Opera, Leo Bleh (1871–1958), begins working at the Latvian Opera	Exhibitions of Latvian art take place in Kaunas, Wien, Prague, and Budapest
1938			Ninth Song Festival takes place in Rīga	An exhibition of Latvian art is organized in Copenhagen
1939	Nonaggression pact between Germany and the Soviet Union (Molotov-Ribbentrop Pact) is signed. Estonia, Latvia, and part of Lithuania pass to the sphere of influence of the Soviet Union World War II begins on September 1 German residents of Latvia (52,000 people) emigrate to Germany		Latvian Ballet goes on a tour in Poland Latvian feature film *Zvejnieka dēls* (Fisherman's son), based on the novel by Vilis Lācis and directed by Vilis Lapenieks, is made	Exhibition of Latvian art is organized in London and at the Musée du Jeu de Paume in Paris

	LATVIAN HISTORY	ART INSTITUTIONS	CULTURAL SCENE	ART SCENE
1940	The Soviet Union advances an ultimatum to the Baltic countries. Occupation of Latvia, Estonia, and Lithuania ensues, and a puppet government is put in place The independence of the Baltic countries is extinguished, and Soviet regime is enforced Latvia is incorporated into the Soviet Union		Symphonic Orchestra is founded Regional song festival is organized in Latgale The Union of Writers of Latvian Soviet Socialist Republic is founded. Newspapers *Soviet Latvia* (in Russian), *Karogs* (Flag; still in existence), and *Literatūras Avīze* (Newspaper of literature) are founded	Boriss Vipers's *L'Art Letton* is published by the publishing house Tâle
1941	Mass deportations (of 15,000 people) take place German army occupies Baltic countries			
1944	Russian army enters Latvian lands. Rīga is taken back Mass emigration (160,000 people) of Latvians to the West because of fear of new repressions	Latvian Academy of Art's name is changed to State Academy of Art of Latvian Soviet Socialist Republic. Oto Skulme becomes its headmaster. Subjects such as History of the Communist Party and the History of Marxism-Leninism are now required		Such great painters as Vilhelms Purvītis (Germany), Ludolfs Liberts (United States), Valdemārs Tone (Great Britain), Augusts Annuss (United States), and Jānis Jīdemanis (Canada) emigrate
1945		The Intermediate Specialized School of Handcrafts is established The Theater of Operetta is founded (it existed until 1989)	Weekly newspaper *Literatūra un Māksla* (Literature and art) is first published. Its main goal is "reeducation" of Latvian intelligentsia Andrejs Urītis's *Zaļā zeme* (Green land)—an epic of village life and social nonsense at the end of the 19th century, is awarded State Prize of the Soviet Union	
1946	Soviet government establishes collective farms in Latvia	The Academy of Sciences of Latvian Soviet Socialist Republic is created		
1947			Jānis Rainis's play *Uguns un Nakts* (Fire and night) is a hit. Director Eduards Smiļģis's work is exceptional *Rainis* by Yuri Raizman, the first movie to be filmed after the war, is finished	

	LATVIAN HISTORY	ART INSTITUTIONS	CULTURAL SCENE	ART SCENE
1948			The Festival of Latvian Literature and the Arts takes place in Moscow Vilis Lācis finishes writing his trilogy *Vētra* (Storm), which follows the lives of generations in the first half of the 20th century. It is awarded State Prize of the Soviet Union First postwar Festival of Song. Dance becomes a part of festival program	"Reeducation" of painters such as Konrāds Ubāns (1893–1981) and Leonīds Āriņš (1907–1991) starts. Many are denied important positions and not allowed to teach
1949	Second wave of mass deportations (43,000 people) takes place		Anna Sakse finishes *Pret kalnu* (Against the mountain), a socially critical novel that praises socialism and shows hardships of development	
1950			The monument dedicated to Lenin is erected in Rīga French Group is banned. Painter Kurts Fridrihsons, actor Miervaldis Ozoliņš, writer Alfrēds Saune, and translators Maija Silmale and Jeva Lase are arrested for reading French literature and charged with anti-Soviet propaganda Festival of Song takes place	
1951			First Latvian-Soviet ballet, *Brīvības sakta* (Brooch of liberty), is staged. Māris Liepa, excellent dancer of Latvian descent, performs; he becomes part of the Great Moscow Theater as of 1960	
1953	Stalin dies. Repression lessens. Some of detained people are rehabilitated, and some are allowed to return from Siberia			

LATVIAN HISTORY	ART INSTITUTIONS	CULTURAL SCENE	ART SCENE
1954		Latvian TV begins	
		Director Edgars Jons starts working in the Opera Theater. He is the first to direct operas by Wagner in the postwar period and also directs Prokofiev's *War and Peace* and Strauss's *Salome*	
		First movie is filmed at the Rīga movie studio—*Salna pavasari* (Spring frosts), based on the novels of Rudolfs Blaumanis. Actress Vija Artmane becomes popular	
1955		Second Festival of Latvian Literature and the Arts takes place in Moscow	
		Monuments of independent Latvia are destroyed. Instead, monuments to the revolution of 1905, Lenin, and fallen Russian soldiers are erected	
		Festival of Song and Dance takes place	
		Debut of Gundārs Priede, one of the most famous dramatists of Latvia in the 20th century. Audiences respond emotionally to his plays *Jaunākā brāta vasara* (The summer of younger brother) and *Vikas pirmā balle* (The first dancing party of Vikka's)	
1956	Plenum of Central Committee of Communist Party discusses the problem of liquidating Stalin's personality cult in Latvia	Smiļģis directs Rainis's play *Spēlēju, dancoju* (I was playing, dancing) in the Theater of Arts	Twenty-eighth international Biennial opens in Venice. Works from the Soviet Union are introduced again, after a 22-year-long absence. Eduards Kalniņš's *Tauntās buras* (New sails) and Jānis Osis's *Latviešu zvejnieki* (Latvian fishermen) are included
			The first exhibition of works by young painters (134 artists, more than 400 paintings) takes place in the State Museum of Latvian and Russian Art (now the State Museum of Art). Discussions concerning ideological reeducation of youth are held
			First exhibition of portraits (129 artists, 309 works) is held

	LATVIAN HISTORY	ART INSTITUTIONS	CULTURAL SCENE	ART SCENE
1957	First Congress of the Union of Painters takes place in Moscow. Latvia is represented by Eduards Kalniņš (1904–1988), Artūrs Lapiņš (1911–1983), and Leo Svemps (1897–1975)	Rīga's orchestra is founded under the leadership of composer and pianist Raimonds Pauls, who is considered the most famous Latvian composer outside of Latvia. His popularity jumps when his songs are sung by Alla Pugacheva in the mid-1970s	*Masters of Latvian Painting*, the first short film about Latvian artists, is made. Screenwriter is art critic Jānis Pujāts (1925–1988) Based on the novel of Vilis Lācis, the movie *Fisherman's Son* is filmed again The collection *Latviešu tēlotāja māksla* (Latvian fine arts) is published	Latvian sculptor Teodors Zaļkalns (1876–1972) is awarded title of People's Artist of the Soviet Union for his service to the development of art, the first Latvian artist to be awarded the title The exhibition of fine arts dedicated to the 40th anniversary of October Revolution opens at the State Museum of Latvian and Russian Art The Sixth World Festival of Youth and Students opens in Moscow. The exhibition of young painters of the Soviet Union includes 45 artists from Latvia
1958	The new subway station opened in Moscow has artwork on the walls done from sketches of Ģirts Vilks (1909–1983)		The ballet *Bolero*, directed by Edgars Jons and staged by Helēna Tangijeva-Birzniece, plays at Opera Theater	The first republic-wide exhibition of watercolors (61 artists, 330 works created after 1945) opens at the State Museum of Latvian and Russian Art. Included are works by Romis Bēms (1928–1993), Egons Cēsnieks (1927–1993), Nikolajs Petraškevičs (1909–1974), Jānis Brekte (1920–1985), and Kārlis Sūniņš (1907–1979)

	LATVIAN HISTORY	ART INSTITUTIONS	CULTURAL SCENE	ART SCENE
1959	The first Painters' Days, a propagandistic attempt to popularize art, are celebrated Nearly 2,000 Communist Party workers are retired through rapid change in government in Moscow. Party members indifferent toward national interests replace them. The June 23 celebration of Līgo, the national holiday of Latvia, is later canceled	The art criticism department (already established 1944–51 at the Latvian University) is opened at the State Academy of Arts	The exhibition of Soviet science, techniques, and culture (82 paintings, 134 graphical works, and 29 sculptures) takes place in New York. Works by Eduards Kalniņš and Jānis Osis are included The quarterly magazine *Māksla* (The art) is first published Romualds Grīnblats's ballet *Rigonda* is staged	For the first time, in the State Museum of Latvian and Russian Art, works of Latvian "Red Riflemen" are exhibited. Included are pieces by Aleksandrs Drēviņš (1889–1938), Voldemārs Andersons (1891–1942), Vilhelms Jakubs (1899–1942), and Gustav Klucis (1895–1938). More than 300 paintings are shown An exhibition of works by Valdemārs Tone (112 works) takes place at the State Museum of Latvian and Russian Art. The artist emigrated to Great Britain in 1944 and died there in 1958. The exhibition is a rare case of an emigrated artist's works being shown to the public (in 1972, KGB didn't allow an exhibition of Tone's works) An exhibition of Russian and Soviet art takes place in London. The paintings of Eduards Kalniņš and Jānis Osis are presented
1960	Fifth Congress of Painters of Latvian Soviet Socialist Republic takes place. Leo Svemps (1897–1975) is chosen to be chairman		Documentary filmmaking rapidly develops as part of Rīga's movie studio, which comes to be known as "Rīga's school" (including Aivars Freimanis, Uldis Brauns, and Herc Franks) Festival of Song and Dance takes place	Painters' Days, dedicated to paintings, are organized. Ten exhibitions take place in Rīga and throughout Latvia Combined exhibition of fine arts of Latvian, Lithuanian, and Estonian Soviet Socialist Republics takes place in the central exhibition hall in Moscow. This event is dedicated to the 20th anniversary of Soviet government in the republics. Latvia is represented by 350 artists
1961			More than 20 exhibitions take place during Painters' Days	
1962			*Einsteiniata*, a collection of poems by Otārs Vācietis (one of the most famous Latvian poets of the second half of the 20th century), is published	

	LATVIAN HISTORY	ART INSTITUTIONS	CULTURAL SCENE	ART SCENE
1963	Second Congress of Union of Painters of the Soviet Union takes place in Moscow. The main theme, "About communistic idealism of Soviet art and top-level skill," is reported by the secretary of management, E. Belasheva	A special building for Rīga's movie studio is built Photo studio "Rīga" is established	*Interpres Foto* (held in the State Museum of Latvian and Russian Art) and other large international exhibitions contribute to the growing popularity of photo exhibitions. *Interpres* is also one of Latvians' few possibilities to encounter Western culture	Leo Svemps is awarded the title of People's Painter of the Soviet Union
1964		The House of Knowledge and Planetarium start their activities in Rīga. A church was reconstructed as the House of Knowledge and Planetarium by executive order of the Soviet Minister of Culture Furtseva after her visit to Rīga in 1962		
1965		The Park of Statues, with small monuments mainly dedicated to Party and political activists, is created in Rīga. A monument by sculptor Kārlis Zemdega (1894–1963) is dedicated to the memory of Jānis Rainis	The opera *Zelta Zirgs* (Golden horse; based on the play by Rainis) by Arvīds Žilinskis is staged. Jānis Zābers, who plays Antiņš extremely well, later becomes one of the most popular singers in postwar Latvia Festival of Song and Dance takes place	
1966	As part of the growth of heavy industry in the mid-1960s, a hydroelectric power station is built in Pļaviņas. However, before that, large areas around the river Daugava are flooded, and damage to the landscape is beyond repair			First republican exhibition of posters takes place in the State Museum of Latvian and Russian Art An exhibition of Jānis Rozentāls, in honor of the artist's 100th birthday, takes place in the State Museum of Latvian and Russian Art

	LATVIAN HISTORY	ART INSTITUTIONS	CULTURAL SCENE	ART SCENE
1967		The Garden of Culture is built in Rīga, near the Palace of Pioneers (now the Palace of the President)	Documentary film 235.000.000, about the Soviet Union, made by Herc Franks, adds to the fame of Rīga's documentary films production Imants Ziedonis's *Motocikls* (stage writer Pēteris Petersons, composer Imants Kalniņš) is staged	Memorial ensemble is built in Salaspils, on the site of the concentration camp where 100,000 people died. The creators are sculptors Lev Bukovsky, Jānis Zariņš, and Oļģerts Skarainis and architects Gunārs Asaris, Oleg Zakamennijs, and Ojārs Ostenbergs. (In 1970, the creators of this memorial are awarded the Lenin Prize) An exhibition of works (54 sculptures and 17 pictures of monuments) by Teodors Zaļkalns, one of the founders of Latvian professional sculpture, takes place in the State Russian Museum in Leningrad
1968				First exhibition of design takes place in the House of Knowledge Seventh exhibition of works by young painters is scheduled to be shown at the State Museum of Latvian and Russian Art. However, some works are recognized as "weak"; as a countermove, artists decide not to open the exhibition (though catalogues have been printed)
1969		The museum dedicated to the memory of Latvian "Red Riflemen" opens in Rīga (now the Museum of Occupation)		
1970	Latvia, along with rest of the Soviet Union, celebrates the 100th birthday of Lenin		Festival of Song and Dance takes place Musical comedy *Vella Kalpi* (Devil's servants; Latvian version of Dumas's *Three Musketeers*) is filmed at Rīga's movie studio	First solo exhibition of Gustav Klucis from the collection of the State Arts Museum takes place
1971			During Painters' Days, eleven general, seven group, and solo exhibitions are presented	Teodors Zaļkalns, at the age of 95, is awarded title of "Hero of Socialist Labor" — "for great achievements in the development of professional art." He is the only Latvian artist ever awarded the title

	LATVIAN HISTORY	ART INSTITUTIONS	CULTURAL SCENE	ART SCENE
1972	Eighth Congress of Latvian Union of Painters takes place. Painter Edgars Iltners is chosen to be chairman		Ninth republic-wide exhibition of young painters takes place. First examples of cinematography are presented, as well as stylistic improvisations of different styles *Pūt, vējiņi!* (Blow, wind!; based on Rainis's play) is filmed Aleksandrs Čaks's *Spēlē, Spēlmani* (Play on, player!) is staged by Pēteris Petersons; Ilmārs Blumbergs (b. 1943) does the stage design	Artist Andris Grinbergs (b. 1946) manages happening in Latvia, *The Wedding of Jesus Christ*. His happening and all his art go against official art regulations. The history of his works becomes known only in the mid-1980s after perestroika
1973			Name of Painters' Days is changed to Art Days 100th anniversary of the Song Festival. The regular festival and special exhibitions dedicated to the anniversary take place The musical play *Īsa pamācība mīlēšanā* (Short guidance to love), with music by Raimonds Pauls, is a hit and becomes a classic of the genre	Through the initiative of Latvian immigrant painter Valdis Āboliņš (1939–1984), an exhibition of 20 modern painters takes place—the first exhibition abroad assembled outside of Soviet jurisdiction
1974			Architect Hardijs Lediņš (b. 1955) organizes first disco club in the Student Club of Rīga's Polytechnic Institute First color TV program is broadcast S. Cielava's *Latvian Painting in the Era of Bourgeois Democratic Revolutions, 1900–1917*, with facts withheld in Soviet years, is published	Painters Miervaldis Polis (b. 1948) and Līga Purmale (b. 1948) organize exhibition in the central Club of Polygraphists—the first exhibition without official sanction from the State Academy of Arts
1975	Thirty-five countries sign final pact on European security and cooperation			
1976			Art Theater stages Ibsen's *Brand* (stage director Arnolds Liniņš and designer Ilmārs Blumbergs)	

LATVIAN HISTORY	ART INSTITUTIONS	CULTURAL SCENE	ART SCENE
1977 Congress of the Union of Painters of Latvian Soviet Socialist Republic takes place	Art Theater moves to the new building at 75 Lenin Street (now Brīvības Street)	Rīga serves as host city for Soviet Union–wide movie festival Anniversary of October Revolution serves as a reason to organize Festival of Avant-Garde Music in the Student Club of Rīga's Polytechnic Institute. Initiators are Ingrīda Zemzare, Guntars Pupa, Hardijs Lediņš, and Juris Boiko For the first time, the main part of the Art Days celebration takes place outside the walls of museums or exhibition halls—at the Doma square *Daugava*, a magazine about literature and art, is first published in Russian Festival of Song and Dance takes place	For "discreditation" of the Soviet government, painter Jurģis Skulme is arrested and sent to prison Valdis Āboliņš is given permission to invite Maija Tabaka (b. 1939) to West Berlin for one year, during which Tabaka creates a collection of unmatched surrealistic paintings called *Narcotic Jungle* Edgars Iltners is awarded the title of People's Painter of the Soviet Union
1978		Juris Boiko (b. 1955) and Hardijs Lediņš (b. 1955) create handwritten magazine *Zirgābols* (Horse's apple). Later they are "invited" to be cross-examined by the KGB *Theater*, by Jānis Streičs and starring Vija Artmane, is filmed. The movie is very popular throughout the Soviet Union	Indulis Zariņš is accepted as a member of Academy of Arts of the Soviet Union Private exhibition of Māris Ārgalis (b. 1954) takes place at the House of Knowledge Valdis Celms (b. 1943), Andulis Krūmiņš (b. 1947), and Artūrs Riņķis (b. 1942) organize the collective exhibition *Form—Color—Dynamics* in Rīga's Museum of Architecture and City building
1979			During Art Days, a collective exhibition of works by Estonian artists Raul Meel, Leonhard Lapin, Tõnis Vint, and Jüri Okas is organized by Jānis Borgs in the House of Knowledge. Though the exhibition is permitted, information about it is controlled furiously, and only one newspaper, *Rīgas Balss*, has an article about it During Art Days, only painters of the union present their works at the Doma square, while all young and other artists exhibit in Jāna Sēta, the old town Maija Tabaka has an exhibition of 35 works at the House of Painters in West Berlin. The initiator is, once again, Valdis Āboliņš

	LATVIAN HISTORY	ART INSTITUTIONS	CULTURAL SCENE	ART SCENE
1980	Olympic games take place in Moscow. Latvian athletes receive four gold, seven silver, and two bronze medals—a record not yet beaten!		Estonian artist Tõnis Vint and director Ansis Epners create a documentary film about Latvian ornaments, *Lielvārdes josta* (The belt of Lielvārde)	Painter Indulis Zariņš is awarded the Lenin Prize, the only Latvian painter to be awarded this honor
1981			Rainis's play *Joseph and His Brothers* (A. Liniņš as stage writer, I. Blumbergs as set designer) is staged in the Art Theater *Ilgais ceļš kāfrās* (Long road in dunes; Aloizs Brenĉs, producer), the only movie of Rīga's studio that has more than one part, is filmed	Fifth exhibition of paintings of Baltic republics is held in Vilnius. The main prize is awarded to the young painter Ivars Heinrihsons (b. 1948).
1982	Tenth Congress of Latvian Union of Painters takes place. Džemma Skulme (b. 1925) is chosen to be chairman		*Strēlnieku zvaigznājs* (Constellation of stars), by Juris Podnieks, is part of the "second wave" of Rīga's documentary films	In the Museum of Paintings of Latvia, a small exhibition of works by Jānis Ferdinands Tīdemanis (1897–1964) takes place (despite his emigration to and death in Canada) During Art Days, young artists such as Ieva Iltnere (b. 1957), Jānis Mitrēvičs (b. 1957), Aija Zariņa (b. 1954), and Valdis Rubulis (b. 1957) each paint their own car—one of many ways of active propaganda of the arts Artists Hardijs Lediņš and Juris Boiko create the club *Nebijušu sajūtu restaurācijas darbnīca* (Workshop for the restoration of nonexistent sensations). It incorporates earth art, photography, video, music, computer imagery, product design, and culture into its performances and exhibitions, expanding both the means and the semantics of Latvian art
1983	Demonstration against the United States' putting nuclear warheads in the West Berlin takes place			Art Days are organized under the title "Painters for the World." Rīga is declared the center of Art Days
1984			As part of Art Days, nearly 100 artists participate in the exhibition *Nature—Environment—Man* at St. Peter's Church. Life-size installations and a "tableau vivant" of da Vinci's *Last Supper* serve as exhibition centerpiece	

	LATVIAN HISTORY	ART INSTITUTIONS	CULTURAL SCENE	ART SCENE
1985	Unscheduled meeting of Central Committee of Communist Party of the Soviet Union chooses new chairman: Mikhail Gorbachev. Perestroika begins	The park of sculptures, Dainu Kalns, opens in Turaida	Exhibition dedicated to 150-year birthday of Krišjānis Barons, collector of Latvian native songs, is held in the exhibition hall "Latvija" Latvian painters take part in World Festival of Youth and Students in Moscow For the first time, the musical festival "Bildes" (Pictures) takes place at the Student Club of Rīga's Polytechnic Institute. Artists play and sing, while musicians show their creative work	During Art Days, Andris Breže (b. 1958), Ojārs Pētersons (b. 1956), Ivars Mailītis (b. 1956), and Juris Putrāms (b. 1956) organize an exhibition in the Museum of Gustavs Šķilters, but the Ministry of Culture considers the project dangerous and forbids it
1986	The group to protect human rights is created in Lupāja		Journalists Dainis Īvāns and Arturs Snips from the newspaper *Literatūra un Māksla* (Literature and art) protest the building of another hydroelectric power station on the river Daugava. Mass campaign for the collection of signatures against the building starts *Latvian Fine Art, 1860–1940*, prepared by the Institute of Language and Literature of Academy of Arts of Latvian Soviet Socialist Republic, is published by Zinātne	The painter Miervaldis Polis (b. 1948) organizes his performance *Egocenter* During Art Days, exhibition in the tunnel passage near the railroad station takes place. Some painters, including Aija Zariņa and Dzintars Zilgalvis (b. 1956), paint the walls Aija Zariņa's exhibition of paintings in the House of Painters provokes discussions about "feminist" and "childishly naïve" style
1987	Police prevent the group Helsinki-86 from putting flowers on the Monument of Freedom	Latvian Fund of Culture is set up The exhibition hall "Arsenāls" (since January 2001, Exhibition Hall of the State Museum of Art) opens	Installations are created in the parks of Rīga *Vai Viegli būt jaunam* (Is it easy to be young?), directed by Juris Podnieks, has a wide audience throughout the Soviet Union Action of all professional photographers of Latvia, *One Day in Latvia*, takes place First edition of the independent magazine *Auseklis* is prepared, but the government forbids distribution The magazine about culture, *Avots* (Spring of water), is printed in both Russian and Latvian. It is the first magazine to include émigré literature and theoretical articles about art. By 1987, its circulation is 90,000	At the exhibition of young painters in the exhibition hall "Latvia," Ojārs Pētersons, Juris Putrāms, Kristaps Ģelzis, and Andris Breže show large-scale (200 × 110 cm) screen prints Artist Miervaldis Polis performs *Bronze Man in Rīga*

1988

LATVIAN HISTORY

The Union of Writers meets with heads of other creative arts unions

Journalist Mavriks Vulfsons reports that there was no Socialist revolution in 1940

Latvian People's Front is organized

LNNK (Latvian National Independent Committee) is created

CULTURAL SCENE

On the TV program *Labīvakar* (Good evening) broadcast live, people talk for the first time about before-forbidden subjects

To commemorate the anniversary of deportations of 1949, artists put flowers on the statue of Sorrowful Mother in Brother Cemetery

The midsummer-night celebration of Jāni's Day is allowed

At Folklore Festival "Baltica 88," folk groups with the old flag of independent Latvia participate

The rock opera *Lāčplēsis* by Zigmārs Liepiņš (composer) and Māra Zalīte (poet) becomes the symbol of aspiration toward restoration of independence

"Arsenāls," a forum of cinema, takes place. Many noncommercial and experimental movies are shown

To celebrate 100th birthday of Kārlis Zāle, creator of the Monument of Freedom and Monument of Liberty, his works are presented at the State Museum of Arts

The editing of the ten-volume *Latvian Soviet Encyclopedia* is completed. Information about Latvian Soviet Socialist Republic appears in volume 5, book 2

ART SCENE

The exhibition of leading Latvian painters in Moscow, entitled *Post-Traditionalism*, takes place

Solo exhibition of Latvian immigrant painter Valdis Āboliņš (1934–1984) takes place in the State Museum of Art

In West Berlin, *Rīga: Lettische Avant-Garde*, the first exhibition of Latvian modern art, is organized, and works of unofficial art are shown

The festival of modern culture "Artcontact-88" features both Latvian and Russian, official and unofficial painters. Poetry evenings and rock concerts take place as well. The festival proves unsuccessful

	LATVIAN HISTORY	ART INSTITUTIONS	CULTURAL SCENE	ART SCENE
1989	Unscheduled Congress of Latvian Fund of Culture declares fund's separation from Soviet Fund of Culture On the 50-year anniversary of Molotov-Ribbentrop Pact, more than 2 million people create a chain, Tallinn-Rīga-Vilnius, which is known as Baltic Road For the first time since World War II, people celebrate Christmas without fear Travel abroad is now allowed but only with Soviet passport Contacts with foreign and Latvia-emigrated intelligentsia are permitted Berlin Wall is destroyed	In the building of the Church of St. George in old Rīga, Museum of Decorative Handicrafts opens. It becomes a member of the Union of Art Museums of Latvia that was created in 1965	First world meeting of Latvian writers in Stockholm takes place Raimonds Staprāns's play *Four Days in July* premiers in the Palace of Rīga on the anniversary of deportations of 1941 Latvian-American music group "Ĉikāgas Piecīši" (Five from Chicago) enjoys its first successful tour	The exhibition *Contemporary Soviet Painters from Riga* takes place at the Edward Nakhamkin Fine Art Gallery in New York
1991	OMON kills five people, including film producers Andris Slapiņš and Gvido Zvaigzne Coup d'état takes place in Moscow The independent Republic of Latvia is reestablished Monument to Lenin in Rīga is dismantled Flags of independent Baltic countries are hoisted at the United Nations in New York		First worldwide Congress of Latvian Scientists takes place in Rīga	Exhibition of the works of Gustav Klucis (more than 100 works) from the State Museum of Art takes place in Kassel, Germany Large-scale exhibition of West German art, *Interferenzen: Kunst aus Westberlin 1960–1990*, is organized in Latvia First show of Latvian art bringing together artists from Latvia and Latvian immigrants takes place
1992	Constitution of the First independent Republic is adopted		Nordisk Information Kantor (Scandinavian countries), Soros Foundation Latvia, the British Council, United States Information Center, and Goethe Institute open branches in Rīga First festival of ancient music in Rundāle and Bauska takes place Second festival of video art of Baltic countries and France takes place	Rīga Gallery opens (director Inese Riņķe) Latvians Juris Poga and Ivars Mailītis design the pavilion of the former Soviet Union for Expo '92 in Barcelona

	LATVIAN HISTORY	ART INSTITUTIONS	CULTURAL SCENE	ART SCENE
1993	First election to Saiema (parliament of Latvia) in Second Republic. Guntis Ulmanis becomes president of Latvia Money reform takes place, and Latvian currency is introduced Private property is restored	Soros Center for Contemporary Arts/Latvia opens in Rīga, with Jānis Borgs as its first director Private galleries Daugava and Bastejs open in Rīga. They organize art exhibitions in Rīga, Köln, Basel, Madrid, and Sollentuna First competition *Gada glezna* (Painting of the year) is organized by gallery ASŪNA and HANSA-BANKA	First festival of opera music takes place in the Sigulda castle	*Equi-librium*, a contemporary art exhibition, is curated by Helēna Demakova Exhibition of Latvian and Estonian classical modernist art (1910–35) is organized in Stockholm at the Liljevalchs Konsthall
1994	Soviet army leaves the territory of Latvia and Estonia			Artist Oļegs Tillbergs participates in XXII Biennale de São Paulo and gets Ars Fennica Prize The first exhibition of contemporary art, *ZOOM FACTOR*, is organized by Soros Center for Contemporary Arts/Rīga. Juris Boiko is curator Sculptor Ojārs Feldbergs organizes an open-air museum of contemporary art on his private estate, Pedvāle First exhibition of installations at the State Museum of Art takes place Second exhibition of contemporary art, *STATE*, is organized by Soros Center and curated by Ivars Runkovskis
1995	Latvia becomes a member of European Council		The encyclopedia *Māksla un arhitektūra biogrāfijās* is published The renovated Opera House opens	Third exhibition of contemporary art, *MONUMENT*, is organized by Soros Center and curated by Helēna Demakova
1996			Ballet dancer Lita Beiris organizes the first festival of ballet, "No klasikas līdz avangardam" (From classic to avant-garde) Center of electronic media, E-LAB, is founded	Fourth exhibition of contemporary art, *GEO-GEO*, is organized by Soros Center and curated by Jānis Borgs Personal show of artist Kristaps Ģelzis, *VIRTUALE*, opens at the State Museum of Art

LATVIAN HISTORY	ART INSTITUTIONS	CULTURAL SCENE	ART SCENE	
1997		Magazine *MĀKSLA+* replaces magazine *MĀKSLA*	Fifth exhibition of contemporary art, *OPERA*, is organized by Soros Center and curated by Solvita Krese. Opera of Hardijs Lediņš and Kaspars Rolšteins, *Rolstein on the Beach*, is performed	
1998		Latvian Institute is founded in Rīga Second show of Latvian art in Rīga (with more than 300 artists exhibiting) is curated by Ilze Konstante and Inga Šteimane Opera of Zigmārs Liepiņš, *Parīzes Dievmātes katedrāle* (Notre dame of Paris), is performed Ilmārs Blumbergs designs Verdi's *Aida*	Sixth exhibition of contemporary art, *VENTSPILS. TRANSIT. TERMINAL*, is organized by Soros Center in Ventspils Ēriks Božis participates in *Manifesta* in Luxembourg. His solo exhibition opens at the Moderna Museet, Stockholm Show of Gustav Klucis's works, *Between Love and Power*, is organized at the State Museum of Art The forum of cinema "Arsenāls," dedicated to the 100th birthday of Sergej Eizenstein, takes place in Rīga Latvia participates in Expo '98 in Lisbon, Portugal Art magazine *STUDIJA* is launched	
1999	President of Latvia Vaira Vīķe-Freiberga becomes the first woman president in Eastern Europe		Guntis Berelis's *Latviešu literatūras vēsture* (History of Latvian literature) is published	Latvia participates in Venice Biennale for the first time. Inta Ruka (photos), Anita Zabiļevska (video), and Ojārs Pētersons (installation) exhibit their works Exposition *Stories, Storytellers* is curated by Helēna Demakova
2000		Seventh opera festival takes place in Sigulda For the twenty-fifth time in Liepāja, music festival *Liepājas dzintars* is organized	Agnese Bula participates in *Manifesta* in Ljubljana, Slovenia Project entitled N.E.W.S. of ten Baltic countries that includes exhibition, video program, and seminars is realized at the Culture and Art Project NOASS in Rīga Latvia participates in Expo 2000 in Hanover, Germany	

Compiled by Irēna Bužinska
Translated by Natalia Kariaeva and Stanislav Belenitsky

Appendix C
Major Events in Lithuanian History and Culture

BEFORE THE 20TH CENTURY

2nd Millennium B.C.E.

Ancestors of Lithuanians move to the Baltic coast

11th Century C.E.

1009 Lithuania is first mentioned in the Quedlinburg Chronicle

12th Century

German and Scandinavian crusaders invade the Baltic region

13th Century

1202–37 "Brothers of the Militia of Christ" (Knights of the Sword), followed later by the Teutonic knights, attempt to conquer and convert the Balts

1251 Grand Duke of Lithuania Mindaugas (1200–1263) is baptized according to the Latin ceremonies; the first Lithuanian bishopric is founded; a cathedral is built in Vilnius

1253 Grand Duke Mindaugas is crowned king of Lithuania

14th Century

14th century–early 15th century Brick gothic castles for Lithuanian rulers are built in Vilnius, Grodno, and Trakai

1316 Beginning of the reign of Lithuanian Grand Duke Gediminas (Gedymin), who conquers huge Slav territories to the east

1323 Grand Duke Gediminas invites European merchants to his new capital. The date of the invitation is considered to be an accepted date for the founding of Vilnius

1386 Grand Duke of Lithuania Jogaila (1351–1434) becomes king of Poland

1387 Christianization of ethnic Lithuania begins

1388 The Vilnius bishopric is founded. Jogaila endows the construction of the Vilnius Cathedral

15th Century

1410 Polish-Lithuanian armies, jointly led by Jogaila and Grand Duke Vytautas, decisively defeat the Teutonic knights at the battle of Tannenberg/Grünwald/Žalgiris. Vytautas "the Great" brings the Grand Duchy to the apogee of its power. During the reign of Grand Duke Vytautas the Great (1392–1430), his lands stretch from the Baltic Sea to the Black Sea

1417 The church congregation in Constance establishes the Samogitian bishopric

16th Century

1510–30 The Reformation movement begins in Lithuania

1539–42 The school of Abraomas Kulvietis—the first school of higher education in Lithuania—operates in Vilnius

1547 The first Lithuanian book—*Catechismus* by the evangelical Lutheran priest Martynas Mažvydas—is published in Königsberg

1561 Sweden takes Estland (the north of present-day Estonia), and Poland takes Livonia (southern Estonia and northern Latvia). The Teutonic order dissolves. Its last

Grand Master, Gotthart Kettl, becomes Duke of Courland

1568 Union of Lublin completes incorporation of Lithuania into Polish-dominated commonwealth

1569 Invited by Vilnius Bishop Walerian Protasevičius, the Jesuits come to the Grand Duchy of Lithuania

1570 The Jesuit College is established in Vilnius

1572 The extinction of Jogaila's line results in the political and cultural marginalization of Lithuania. Polish becomes the state language

1579 The Jesuit College is converted into a university (academy)

1584–93 The Jesuit Church of the Body of God (architect Giovanni Maria Bernardoni, 1541–1605), the first baroque church in the Grand Duchy of Lithuania, modeled on Il Gesu Church in Rome, is built in Nesvyžius under the endowment of Nicholas Kristupas Radvila the Orphan

1595 *Postil*, by preacher Mikalojus Daukša (1527–1613), is published; it is the first Lithuanian book printed in Lithuania

17th Century

1602 Casimir, son of the ruler of Poland and Lithuania, Casimir Jagiellon, is canonized

1604–18 The Jesuit Church of St. Casimir, the earliest baroque church in Vilnius, is built

1620 Philologist and preacher Konstantinas Sirvydas (1581–1631) publishes the Polish-Latin-Lithuanian *Dictionary of Three Languages*, and in 1629 compiles and publishes a collection of sermons, *Punktai sakymų*

1623–36 On the initiative of the ruler of Lithuania and Poland, Sigismund Vasa, St. Casimir's Chapel, one of the most beautiful royal endowments in Vilnius, is appointed in the Vilnius Cathedral (architect Constantino Tencalla)

1654–67 Lithuania's and Poland's wars against Moscow are fought

1668–75 The Church of St. Peter and St. Paul and the Monastery of the Lateran Canons are built in Vilnius (architect Jan Zaor) under the endowment of the Hetman of the Great Lithuanian Duchy and Vilnius Voivode Michael Casimir Pac. Important interior decorators include Italian sculptors Pietro Perti and Giovanni Maria Galli

1667–74 The Church of the Visitation of the Holy Virgin Mary and the Camaldolite Monastery, one of the most remarkable Lithuanian baroque ensembles, are built in Pažaislis under the endowment of the Chancellor of the GDL Christopher Sigismund Pac. Gianbattista Frediani di Luka is architect, with stucco work by

Giovanni Merli and frescoes by Michel Archangelo Palloni

18th Century

1714 Kristjonas Donelaitis, author of the poem *The Seasons* (published in 1818), is born

Mid-1700s Architect Jan Krzysztof Glaubitz (mentioned from 1737, d. 1767), one of the most outstanding creators of Vilnius baroque architecture, works in Vilnius

1770s On the initiative of Vilnius Bishop Ignacy Massalski, the Vilnius Cathedral is reconstructed in the classicist style. The reconstruction project is by architect Laurynas Gucevičius (1753–1798), with sculptural décor by Italian sculptor Tomasso Righi and paintings by Pranciškus Smuglevičius (1745–1807)

1773 The Jesuit order is abolished, and the Educational Committee, the first secular ministry of education, is established. Chairs of Architecture (1793), Drawing and Painting (1797), Sculpture (1803), and Carving (1805)—generally known under the name of the Vilnius Art School—are established at the University of Vilnius. Pranciškus Smuglevičius is invited to work as the head of the Chair of Drawing and Painting

May 3, 1791 The new Constitution of Lithuania changes the structure of the state, and Lithuania becomes a constitutional monarchy

1795 Third Partition of Polish-Lithuanian Commonwealth takes place. The Livonian wars against Russia and Sweden drain the commonwealth's resources. Weakened by internal dissension, it is ultimately partitioned between Russia, Austria, and Prussia. The whole of present-day Lithuania, except Memel (Klaipéda), falls into Russian hands. Užnemunė falls into Prussian hands

19th Century

1812 Napoleon's army marches into Lithuania

1817 The illegal anti-tsarist youth organization "Filaretai" is organized at Vilnius University; one of its founders is Polish poet Adam Mickiewicz

1820 The first exhibition of students' works of art takes place at Vilnius University

1822 The first poetry book by Adam Mickiewicz, marking the beginning of the romanticist period, is published in Vilnius

1831 The first national uprising against tsarist Russia takes place. Tsarist rule brings strict censorship and intensifying Russification. The rising intelligentsia nurtures a national ideal based on the rebirth of the Lithuanian language

1832 Vilnius University is closed down

1848 In Paris, the doctor Jonas Kazimieras Wilczinski (1806–

1885) begins publishing the *Vilnius Album*, a periodical that contains images of Lithuanian cultural monuments, historical sites, and portraits of famous Lithuanians

1855 The Vilnius Museum of Antiquities is founded

1863 Second uprising against tsarist Russia is defeated. A forty-year-long ban on publishing in the Latin script is imposed. It forces contraband publishers to smuggle books in from Königsberg. Lithuanian language is eliminated from schools. Various manifestations of national culture are persecuted and destroyed

1864 Count Muravyov, nicknamed "Hangman," is dispatched to Vilnius to restore order. Thousands of Lithuanians are forced to emigrate to North America

1865 The Vilnius Museum of Antiquities is reorganized, and the unwanted artworks are removed from its art department. The Archaeological Commission is dismissed

1866 A school of drawing headed by the Russian artist Ivan Trutnev opens in Vilnius

1875 Mikalojus Konstantinas Čiurlionis, an outstanding Lithuanian painter and composer, is born

1880 Mykolas Elvyras Andriolis (1836–1893) wins fame in Lithuania for the illustrations of *Conrad Valenrod* (1880) and *Pan Tadeusz* (1882) by Adomas Mickevičius

1883 Jonas Basanavičius (1851–1927), the leader of the national patriotic movement "Aušrininkų" (Daybreaks), publishes the first Lithuanian-language newspaper, *Ausra* (Daybreak), in Rusnė, Tilžege; publication continues until 1886

1889 Vincas Kudirka (1858–1899), the leader of the national patriotic movement "Varpininkų" (Bell ringer) begins to publish the Lithuanian-language newspaper *Varpas* (The Bell), in Rusnė, Tilžeje; in the sixth issue (September 15, 1898), Kudirka publishes the text and music for "Tautinë giesmë," which later becomes the national anthem

Consultants: Dalia Tarandaitė
and Dr. Eligijus Raila

	LITHUANIAN HISTORY	ART INSTITUTIONS	CULTURAL SCENE	ART SCENE
1900				The Lithuanian exposition at the Paris world exhibition opens
1904	The national movement is legalized	Lithuanian artists studying in Krakow found society "Rūta," the first indication of Lithuanian national art The Juozas Montvila drawing class is founded in Vilnius from Ivan Trutnev's private class in 1893		
1905	The Russian Revolution causes social disturbances The Great Lithuanian Seym in Vilnius (the leader Jonas Basanavičius) programs the fight for independence			
1907		Lithuanian Art Society, Lithuanian Science Society, and Vilnius Science Friends Society are founded in Vilnius Vilnius Science and Art Museum Society and Museum are founded		The first exhibition of Lithuanian professional (23 artists) and folk (68 artists) art is held in Vilnius. Works of romantic, realistic, symbolistic, and impressionistic styles are included. The exhibitions (8 in Vilnius, 3 in Kaunas, and 1 in Rīga) take place until 1914
1908		Vilnius Art Society is founded (until 1914, it organizes international art exhibitions in Vilnius)		
1911				Mikalojus Konstantinas Čiurlionis dies. Posthumous exhibition (265 works) is held in Vilnius
1912		The committee of National House, the Lithuanian culture and art center, is founded in Vilnius The Art School is founded in Vilnius		Posthumous Čiurlionis exhibitions are held in Moscow and St. Petersburg
1913				An exposition of Čiurlionis's works is held in Vilnius
1914	World War I begins			

	LITHUANIAN HISTORY	ART INSTITUTIONS	CULTURAL SCENE	ART SCENE
1916				The Antanas Vivulsky monument *Three Crosses* is inaugurated in Vilnius
1917	The Russian Revolution occurs At the Lithuanian conference in Vilnius, the Lithuanian Council (with leader Antanas Smetona) is founded			
1918	The Lithuanian Council signs the State Restoration Act in Vilnius The first government of independent Lithuania is formed Soviet troops invade Lithuania and capture Vilnius The Lithuanian-Byelorussian Soviet Republic is founded Poland lays claim to Lithuania's territory Lithuanian volunteers begin the "independence war" against Bolsheviks			
1919	Kaunas is proclaimed a provisional capital	The art department at Stephan Bathory University in Vilnius is founded	Intellectuals are invited to participate in Lithuania's foreign politics: poet symbolist Jurgis Baltrušaitis is appointed as representative of Lithuania to Moscow; Oscar Milosz, to Paris; modernist prose writer Jurgis Savickis, to Denmark, Norway, and Sweden; and modernist prose writer Ignas Šeinius, to Stockholm	Jan Bulhak, master of photographic landscape in Lithuania, starts teaching photography at Stephan Bathory University in Vilnius

	LITHUANIAN HISTORY	ART INSTITUTIONS	CULTURAL SCENE	ART SCENE
1920	The Constituent Assembly is elected The parliamentary Republic of Lithuania is proclaimed Aleksandras Stulginskis, a representative of the Christian Democratic Party, is elected president A peace treaty with Soviet Russia is concluded Detachments of the Polish army led by General Zeligowski capture Vilnius Active policy of Polonization is launched: of 256 Lithuanian schools open in 1925, only 2 remain in 1938	The Lithuanian Society of Art Creators is founded in Kaunas	The State Theater and an actors' training school are founded in Kaunas	The exhibition of Lithuanian art is held in Kaunas
1921	Kaunas has a population of 90,300	Lithuanian Seimas establishes the Čiurlionis Gallery, conferring on it the status of a state gallery and establishing the structure of its collections	Scholarly journals *Logos* (philosophy), *Kosmos* (natural science), and *Soter* (religion), edited by Pranas Dovydaitis, are launched The first annual exhibition of Lithuanian agriculture and industry is held in Kaunas	
1922	Lithuania joins the League of Nations United States of America recognizes the governments, but not the statehood, of the three Baltic republics The Constituent Assembly adopts the Constitution of Lithuania Having received compensation from Soviet Russia, the government introduces the national currency, litas The Land Reform Law is adopted	Kaunas Art School is founded	Kaunas University is founded (renamed Vytautas Magnus University in 1930) The Union of Lithuanian Writers and Journalists is founded Poet futurists Kazys Binkis, Juozas Tysliava, and others publish a manifesto opposing Lithuanian symbolism and naive rustic sentimentalism. They publish the journal *Four Winds* (1924–28) Obligatory primary education is based on the principles of religion and nationality	

	LITHUANIAN HISTORY	ART INSTITUTIONS	CULTURAL SCENE	ART SCENE
1923	Food-processing industries are established; wood, leather, and metal-processing industries are under formation, with products exported to Germany and England	Constructivist Vytautas Kairiūkštis opens a youth painting studio at Vytautas Magnus's high school in Vilnius		The *New Art* exhibition opens in Vilnius Corso Cinema with the participation of Lithuanian artist Vytautas Kairiūkštis, Polish suprematists based in Vilnius (Władysław Strzemiński, Maria Puciatycka) and Warsaw (Henrik Stażewski, Karol Kryński, Mieczysław Szczuka, Teresa Żarnover), constructivists, and purists
1924	The League of Nations signs an agreement returning the Klaipėda region to Lithuania		The Catholic-oriented journal of culture and social life, *Židinys*, edited by Vincas Mykolaitis-Putinas and Juozas Girnius, is launched	
1925		Building Inspection publishes *An Album of Sample Buildings and Decoration in Lithuania* to promote the use of elements of folk art in décor The temporary building of the Čiurlionis Art Gallery opens		Mstislav Dobuzhinsky designs his first stage sets for the performance of Tchaikovsky's *Queen of Spades* at the State Theater in Kaunas
1926	A military coup d'état results in the introduction of dictatorship by Antanas Smetona, the leader of the Tautininkai (Nationalist) Party	Justinas Vienožinskis leads the activities of the Art Council at the Ministry of Education of the Republic of Lithuania Lithuanian Art Society is restored in Kaunas Ministry of Education establishes grants for college graduates to continue study abroad. Taking into account the practical demands of the growing consumer society, artists are encouraged to study various branches of applied art	Film studios Lietfilmas and Akis are founded; the Lithuanian radio starts broadcasting on a regular basis	
1927		The Art Council publishes a memorandum in "Pradai ir Žygiai" (Origins and deeds), presenting an outline of possible and desirable trends of state cultural politics and naming institutions necessary for its implementation	The weekly periodical of art criticism *7 meno dienos* (7 days of art) begins its run. It is published until 1934	

	LITHUANIAN HISTORY	ART INSTITUTIONS	CULTURAL SCENE	ART SCENE
1928			In Paris, Tysliava, a member of the "Four Winds" group, publishes an international journal of literature, art, music, and photography entitled *Muba*	The art-deco style dominates at an exhibition of Lithuanian posters, as well as in the press, advertising, and design
1929			Premiere of *Šarūnas* by Krėvė at the Kaunas State Theater, which legitimates the modern stylistics of the psychological realistic theater, combined with music by Juozas Gruodis and expressive stage design by Adomas Galdikas	Artist Mstislav Dobuzhinsky, member of "The World of Art" group, settles in Kaunas The exhibition of German expressionism prints is held in Kaunas
1930		The Independent Artists' Union is founded XXVII Book Lovers' Society is founded in Kaunas	Pro-Marxists publish the anti-fascist magazine *Trečiasis frontas* (The third front), futuristically rejecting the program of national art	The first exhibition of works by young artists in Kaunas opens
1931	Kaunas reaches the population of 110,000 as farmers' children move to the city to acquire education The social structure changes with the appearance of the industrial class, bureaucracy, and the intelligentsia The Lithuanian army is formed		First issue of the journal *Naujoji Romuva*, edited by Juozas Keliuotis (who sought a synthesis of traditional Catholic culture and Western modernism), is released	In Kaunas, the first solo exhibition of Stasys Ušinskas, stage designer, painter, and stained-glass artist who studied in Paris with Fernand Léger and Alexandra Exter, is held. His works are marked by an innovative synthesis of analytic cubism, art deco, constructivism, and neo-classicism The first exhibition of Vilnius artists is held in Kaunas Construction of the functionalist Post Office by Feliksas Vizbaras and the "Pienocentras" building by Vytautas Landsbergis-Žemkalnis begins in Kaunas
1932		Painter Neemijus Arbitblatas opens the first private art gallery in Kaunas The club-salon Parnassus meets regularly	Premiere of Shakespeare's *Hamlet*, directed by Mikhail Chekhov, with stage design by Mstislav Dobuzhinsky Lithuanian Writers' Union is founded Composer Gruodis, the writer Karys Boruta, and poets Karys Inčiūra, Jonas Aistis, Bernardas Brazdžionis, and Antanas Miškinis combine traditions of folk art with modern expression	The exhibition of the ARS group opens. The group includes sculptor Juozas Mikėnas, painters Viktoras Vizgirda, Antanas Gudaitis, Galdikas, Antanas Samuolis, Dobuzhinsky, graphic artists Telesforas Kulakauskas and Vytautas Kazimieras Jonynas. The exhibition is dominated by constructive expressionistic landscapes, still lifes with folk sculptures, and portraits The first exhibition of documentary photographs by Petras Babickas takes place at the Independent Artists' Society

	LITHUANIAN HISTORY	ART INSTITUTIONS	CULTURAL SCENE	ART SCENE
1933	Steponas Darius and Stasys Girėnas fly across the Atlantic from the United States to Kaunas	The Lithuanian Photo-Artists' Union is founded; journalistic and ethnographic photographs prevail	Kaunas Conservatoire is founded	
1935	President Smetona decrees "To Maintain the Nation and the State"	Lithuanian artists urge the state to establish a cultural foundation that would distribute state funds for various cultural events and create a department for art propaganda The Museum of Religious Art opens in Kaunas Lithuanian Artists' Union is founded (46 members)		Čiurlionis Gallery for 134.64 litas acquires Picasso's etching *Three Bathing Women* from the French exhibition held in Kaunas and print *In the Shade of Trees* by Viktoras Petravičius for 150 litas
1936	A new law of political parties comes into force. All parties except the Tautininkai are banned	Lithuanian Seimas establishes the Vytautas Magnus Museum, legitimating the coexistence in one building of the Vytautas Magnus Museum of War and the Vytautas Magnus Museum of Culture belonging to the Ministries of Education and Land Guard	Lithuania joins the International Society of Contemporary Music Journal *Logos* publishes an article on Martin Heidegger's philosophy by Girnius	Ušinskas establishes a puppet theater in Kaunas The opera *Three Talismans* by Antanas Račiūnas premieres at the Kaunas State Theater. It is directed by Pavlovsky, with stage design by Liudas Truikys. It is characterized by musical constructivism
1937			Regular broadcasts of Lithuanian music concerts take place in Europe and the United States In Lithuania, 19 dailies, 38 weeklies, and 100 monthly journals are published; 25 private publishing houses are in operation	Permanent exhibition of Čiurlionis's works opens at the Vytautas Magnus Museum of Culture in Kaunas XXVII Book Lovers' Society publishes the book *Swan, Wife of the King*, illustrated by Viktoras Petravičius in the spirit of modern expressionism and folk primitivism At the Lithuanian section of the Baltic pavilion at the Paris world exhibition, *Art and Technology in Contemporary Life* features 44 artists who win 58 awards

	LITHUANIAN HISTORY	ART INSTITUTIONS	CULTURAL SCENE	ART SCENE
1938	A new Constitution of Lithuania is adopted	The Society of Lithuanian Women Artists is founded Lithuanian Artists' Union splits into the sections of individualists and realists	"Nonette" by the founder of microtone music, Jeronimas Kačinskas, is performed at the new music festival in London. Together with the *Electric Poem* by expressionist Vytautas Bacevičius, this composition represents the most radical tendencies of modern Western music opposing Gruodis's concept of moderate national modernism	The first Lithuanian sound film, *A Fat Man's Dream*, directed by Henrikas Kačinskas, with puppets by Ušinskas, is made
1939	Signing of a treaty transfers the Klaipėda region to Germany Germany and the Soviet Union divide Eastern Europe with the signing of the secret Molotov-Ribbentrop Pact Germany subjects Lithuania to the zone of influence of the Soviet Union Upon the signing of a treaty imposed on Lithuania by the Soviet Union, Vilnius is returned to Lithuania in exchange for establishing Soviet military bases in Lithuania			The first exhibition of artworks that received or were nominated for awards by the Savings Bank takes place in Kaunas The Lithuanian pavilion at the New York World Fair opens
1940	The Soviet army crosses the border of Lithuania, Lithuanian president flees abroad, and Moscow representative Vladimir Dekanozov arrives in Kaunas The Lithuanian Communist Party (LCP) is legalized A law is passed to reorganize the Lithuanian army Unions, parties, and Lithuanian embassies abroad are liquidated The activity of societies is banned and periodicals are suspended The law of elections into the new Seimas is announced	The state establishes itself as the primary patron of art and provides financial support to artists The mechanism of art management and control is centralized Club–reading rooms and Houses of Culture are opened Branches of the Artists', Composers', and Writers' Unions monitored from Moscow are established in Vilnius and locally supervised by Kazys Preikšas, the ideological secretary of the Central Committee of the Lithuanian Communist Party	Panevėžys Drama Theater, led by Jouzas Miltinis, who studied at the Sorbonne in Charles Dullin's studio, is founded In preparation for a *Decade of Lithuanian Art in Moscow* (autumn 1941), many ideologically committed works are commissioned Publishing and printing houses and large bookstores are nationalized. The LSSR State Publishing House is founded An obligatory course on Marxism-Leninism is introduced at the Vilnius and Kaunas Universities The department of theology-philosophy at the Kaunas University is closed	The "Agitation and Propaganda Brigade," aimed at involving artists in the struggle against the former regime, is founded

	LITHUANIAN HISTORY	ART INSTITUTIONS	CULTURAL SCENE	ART SCENE
1940	The 2,000 leaders of non-Communist parties are arrested Having rigged the elections (participation rate 15–16 percent), a newly elected Seimas proclaims Lithuania a Soviet republic Lithuania is incorporated into the Soviet Union Vilnius is proclaimed the capital of the Lithuanian Soviet Socialist Republic (LSSR) Annexation and the first occupation begin Western states do not recognize Lithuania's incorporation into the Soviet Union, and the Lithuanian embassies to the Holy Seat in Vatican (ambassador Stasys Lozoraitis) and England do not cease their activity The new Constitution of Lithuania modeled after the Stalinist Constitution of the Soviet Union is adopted Nationalization of industry, commercial enterprises, land, and banks is proclaimed In autumn, the underground resistance organization "Front of Lithuanian Activists" (LAF) is formed	Kaunas Art School is reorganized into the Institute of Applied Decorative Arts in Kaunas	Religion lessons are eliminated from school curricula, and nationalist writers are excluded from teaching programs Vilnius State Academic Drama Theater opens. It is led by Romualdas Juknevičius, who had studied in Moscow with Meyerhold	

	LITHUANIAN HISTORY	ART INSTITUTIONS	CULTURAL SCENE	ART SCENE
1941	30,000 people are deported from Lithuania to Siberia and the northern Soviet Union	Vilnius Art Museum is founded in Vilnius (since 1966, Lithuanian Art Museum)	The modernist trends of "degenerate art" are not tolerated	
	The Nazi occupation is accompanied by an armed resistance movement led by LAF	The Nazi authorities officially limit the activity of institutions of culture, art, and education		
	Provisional government of Lithuania is formed but soon ceases its activity			
	Retreating Soviet army kills the local populations in Rainiai and Panevėžys			
	Together with the LSSR government, 23,000 people evacuate into other parts of the Soviet Union			
	The Nazi government issues an order to kill the Jews in Lithuania; approximately 120,000 Jews are killed. Those who survive are driven into Vilnius, Kaunas, and Šiauliai ghettoes. During the war, approximately 90 percent of Lithuania's 240,000 Jews are killed			
	Between 1941 and 1944, 75,000 Lithuanians are taken to Germany for compulsory work, and 20,000 are made to join the German army			
1942		Bureau of the Writers' Union of the LSSR is formed in Moscow	Lithuanian exhibitions, concerts, and performances are held, the network of Lithuanian schools is restored, and the number of Lithuanian publications increases in comparison with the period of Soviet occupation	Expressionist paintings by Gudaitis are removed from an exhibition at the Vilnius Art Museum
			The Vilnius ghetto theater holds more than 200 concerts and revue performances	
			Premiere of Peretz Hirshbein's play *Green Fields*	
			Kaunas ghetto has an orchestra led by Misha Hofmeker	

	LITHUANIAN HISTORY	ART INSTITUTIONS	CULTURAL SCENE	ART SCENE
1943	The Central Committee for the Liberation of Lithuania is founded	Lithuanian schools of higher education are closed down due to the failure of mobilization into SS units; lessons and studies are continued in teachers' private apartments around the city	Journal *Kūryba* (editor Keliuotis) is published The weekly *Literatūra ir menas* (Literature and arts) and the journal *Pergalė* are published in Moscow Sruoga is imprisoned in the Stuttgart concentration camp for spreading information heard on the foreign radio	The exhibition *Red Terror* is held at the Vilnius Art Museum. In addition to works by Lithuanian artists, documentary material on the Rainiai massacre is exhibited The sculptor Bronius Pundzius carves the busts of the pilots Darius and Girėnas on a Puntukas boulder
1944	With the front line approaching, 70,000 (76 artists) Lithuanians retreat to the West The Soviet army marches into Vilnius, marking the beginning of the second occupation of Lithuania Repressive organizations NKVD ("Narodnij komitet vnutrenich del"; People's Committee of Inner Affairs) and KGB are reintroduced in Lithuania Enlistment into the Red Army starts The first groups of Soviet supporters are formed Moscow attempts to establish "the national church," i.e., separate it from the Vatican, in Lithuania Soviet troops and guerrillas hiding in forests and waiting for the Allies wage a partisan war	Vilnius State Art Institute is restored A new statute conforming to the standards of Soviet schools of higher education is adopted The system of studying with individual teachers is abolished in favor of focus on Marxism, Leninism, and political economies	Poems by partisans, teachers, and students who waged guerrilla warfare in the forests are published in about 40 clandestine papers	"Silent writers" Jonas Graičiūnas, Viktoras Katilius, Stasys Anglickis; composer Juozas Nabažas; and artists Truikys, Ušinskas, and Kairiūkštis refuse to participate in the public artistic activity and decide "not to soil their hands"

1945 170,000 Poles leave Lithuania for Poland

Council of Ministers (CM) of the LSSR founds the Board for Art Affairs, which organizes and controls the development of culture

The Statute of the Artists' Union is adopted. It mandates Socialist Realism as the only creative method

The legacy of national art is divided into realist (democratic) and formalist (reactionary) on the basis of the artistic form; impressionism is regarded as formalist art, "a conflict-free theory"

Central Committee (CC) of the Communist Party of the LSSR and the Council of People's Commissars establishes an official exhibition committee

Branch of Marxist-Leninist University is founded at the Artists' Union of the LSSR

By a decision of the People's Commissariat of the LSSR, societies of artists, writers, and musicians of LSSR are established; they exercise financial control over creative unions

The mechanism of local censorship forms. Book publishing, musical records, and exportation of artworks are regulated by Moscow

Works by writers who have retreated to the West, as well as periodicals published in the interwar period, are destroyed

Those active in the cultural life during the Nazi occupation are persecuted

A protest statement of the "Lithuanian National Council" entitled "Appeal to the Nations of the World" is issued. Boruta is arrested due to his involvement in the case

Academy of Sciences is restored in Vilnius

In camps in Germany, Lithuanian schools and a drama theater are founded, national song bands are formed, and 192 Lithuanian newspapers are published

Putinas's small poem *Vivos plango, mortous voco* — an indictment of totalitarianism — is written in the language of biblical prophets; unsigned copies of the work spread among Vilnius University students and partisans

At the Composers' Union, hearings of officially commissioned compositions are held

	LITHUANIAN HISTORY	ART INSTITUTIONS	CULTURAL SCENE	ART SCENE
1946	12,000 Germans leave Lithuania for Germany	Decisions of the Central Committee of the All-Union Communist Party (Bolsheviks) with regard to the magazines *Zvezda* and *Leningrad* require struggle against any expressions of formalism and lack of ideology; much criticism is directed at Lithuanian art schools Moscow appoints deputy directors for teaching and instruction affairs to the Vilnius Art Institute and Kaunas Institute of Applied Decorative Arts	Sruoga publishes *The Forest of Gods*, a grotesque story about human existence at the Stuttgart concentration camp Ideological secretary of the Lithuanian Communist Party criticizes literary works by Sruoga, Antanas Miškinis, and Eduardas Mielželaitis and threatens to take measures against writers who do not actively support the Soviet regime Special stocks are established in major libraries State Academic Opera and Ballet Theater moves to Vilnius LSSR film studio is founded With Jonynas's efforts, the Institute of Applied Art (École des Arts et Metiers) is founded in the French occupational zone	Scholarly conference at the Vilnius Art Institute and the Artists' Union discusses the struggle against formalism, "bending knees" to the Western bourgeois art, and expressions of cosmopolitanism in artists' work. The works of Čiurlionis and the ARS group are criticized Meeting of Artists' Union members denounces expressions of formalism, lack of ideology, and hypocrisy. It criticizes the work of many artists, some of whom are dismissed from the Artists' Union Truikys's studio at Kaunas Institute of Applied Decorative Arts is closed down
1947	Small businesses (mainly consumer services) are nationalized. Light and food industries remain the key branches of the economy At the end of the year, food rationing is stopped, and an all-Union monetary reform is carried out The All-Union Communist Party (AUCP) reaches a secret decision regarding the establishment of collective farms in the Baltics CM LSSR and CC LCP affirm the definition of a "kulak" 70,000 farmers are deported		Antanas Sniečkus denounces "bending knees to the bourgeois culture" The 400th anniversary of *Catechismus* by Martynas Mažvydas, the first Lithuanian book, is celebrated *Žaldokynė* by Borisas Dauguvietis, directed by Kazimiera Kymantaitė, is staged at the Vilnius Academic Drama Theater	An art exhibition commemorating the 70th anniversary of Stalin is held at the Vilnius Art Museum Cult of new heroes; Milkėnas erects a monument to the Soviet Lithuanian partisan Marytė Melnikaitė; Vera Stroyeva produces the film *Marytė*, and Račinskas stages the opera *Marytė*

	LITHUANIAN HISTORY	ART INSTITUTIONS	CULTURAL SCENE	ART SCENE
1948	Decision of CC LCP and CM LSSR "On the founding of collective farms in the republic" By a decision of CM LSSR, churches and church buildings are nationalized (approximately 130 churches are converted into warehouses and dancing halls)	Decision of the Central Committee of the AUCP with regard to opera *The Great Friendship* by Muradeli outlines the ways of developing Soviet music on the basis of ideology and nationality and reveals the anti-democratic essence of formalism Lithuanian composers are criticized for failing to create Soviet operas and ballets and write full-fledged songs for the masses	Discussion of the decision on Muradeli's opera at the Composers' Union; formalist features are found in instrumental works by Gruodis, Stasys Vainiūnas, Juozas Karosas, Balys Dvarionas, young composers Račiūnas, Julius Juzeliūnas and Jonas Pakalnis; composers are blamed for their "political backwardness" and lack of attention to mass genres Miškinis edits the illegal paper *The Scout of Freedom* and is arrested for a memorandum addressed to the United Nations Council and the pope Composer Jonas Pakalnis is killed under vague circumstances Balys Dvarionas's musical school in Vilnius is founded	
1949	A new wave of deportation in the Kazahia Soviet Socialist Republic: 40,000 farmers are deported; at the end of the year, 62.4 percent of all peasants are made to join collective farms	Department of Propaganda and Agitation of the CC LCP discusses the tendencies of formalism in the work of artists in the Artists' Union and the importance of the urgency of themes By a decree of the Board of Art Affairs of the Council of Ministers of the LSSR, art institutions are encouraged to fight apolitical tendencies and formalism Committee supervising the work of young artists is set up at the Artists' Union		Kazys Varnelis, an American Lithuanian, paints the first geometrical abstraction After being deported, Miškinis writes *Psalms* on shreds of sacks, revealing the author's inner resolution to resist occupation

	LITHUANIAN HISTORY	ART INSTITUTIONS	CULTURAL SCENE	ART SCENE
1950	28 percent of Lithuanian pupils are members of the Lithuanian Communist Youth Union	A session of workers of culture and art at the Artists' Union with the participation of representatives of Central Committee of the Lithuanian Communist Party and the Council of Ministers of the LSSR is devoted to the discussion of the article by Aleksandr Kamensky on Čiurlionis's work entitled "To Overcome the Influence of Formalism" (*Literatūra ir menas*, no. 38). The majority agrees that the Marxist attitude toward the artist's work requires one to look for progressive features and folk and national elements	Filming of the newsreel "Soviet Lithuania" begins Collection of poems *Elegies* by Algimantas Mackus is published in the United States. It is devoted to searching for one's home and mourning the nation's fate given into the hands of death Having returned from deportation, poet Kazys Jakūbėnas is killed under vague circumstances	The Antanas Vivulsky monument *Three Crosses* is blown up in Vilnius
1951		By a decision of the Council of Ministers of the LSSR, Kaunas and Vilnius art schools are joined into Vilnius Art Institute	In the United States, poet Antanas Vaičiulaitis is appointed the head of Lithuanian programs on "The Voice of America" Six times daily, foreign news and poems by writers in exile are broadcast to Lithuania	Workers at the Kaunas Čiurlionis Art Museum refuse to carry out Moscow's orders and remove Čiurlionis's works from the permanent exhibition. Lithuanian Republic flags and state awards are held in special stocks
1952		The first Congress of the Artists' Union (120 members) takes place	Exiled poet Jonas Aistis works for the information service of Radio Free Europe Anthology of Lithuanian poetry, *Žemė* (Earth), is published in the United States	
1953	Stalin dies The partisan war ends. In postwar Lithuania, about 50,000 people die a violent death, among them 20,000 partisans The Central Committee of the Lithuanian Communist Party sanctions the process of Lithuanization	The Board for Art Affairs is reorganized into the Ministry of Culture of the LSSR		An exhibition of Povilas Karpavičius's color photographs made by means of the original isopolychromic technology is held

	LITHUANIAN HISTORY	ART INSTITUTIONS	CULTURAL SCENE	ART SCENE
1954	688 churches (from 1,200 in 1938) are open in Lithuania One ecclesiastical seminary out of four remains Individual homesteads are liquidated		Letter from Lithuanians deported to Mordovia is addressed to Putinas, blaming him for collaboration with the Soviet regime First conference of the Santara-Šviesa Federation is held by Lithuanians in exile in the United States; the policy "Face to Lithuania" is adopted	The LSSR decade of literature and art is organized in Moscow American-Lithuanian Galdikas starts to paint expressionist abstractions
1955		Decision of the Central Committee of the Communist Party with regard to excessive decoration in building design and construction is passed		
1956	20th Congress of the Communist Party of the Soviet Union (CPSU) takes place The "thaw" begins Soviet troops suppress the liberation movement in Hungary and Poland 250,000 newcomers move to Lithuania: Soviet specialists, army officers and soldiers, the planning immigration continues until the 1980s On the eve of All Souls' Day, cemetery in Vilnius marks Lithuania's independence and the events in Hungary	LSSR state awards are established A branch of the Lithuanian Art Museum, the Vilnius Picture Gallery, opens in the Vilnius Cathedral and features an exhibition of early Lithuanian art	Revival of the national theater begins	A series of books on Lithuanian folk art are published First discussion about content and form, artistry and innovation (Savickas, Juozas Mackonis, Vladas Drėma, and others) takes place

	LITHUANIAN HISTORY	ART INSTITUTIONS	CULTURAL SCENE	ART SCENE
1957	Ministries of Industry and Construction subordinated to Moscow are replaced by regional Councils of People's Economy	The Artists' Union of the LSSR acknowledges mistakes made in assessing artistic heritage Čiurlionis Gallery is founded in Chicago	Historical drama *Herkus Mantas* by Juozas Grušas, directed by Henrikas Vancevičius, is performed at the Kaunas State Drama Theater Decade of Polish culture in Lithuania and days of Lithuanian culture in Poland are held Vytautas Rimkevičius's novel *Students*, which describes the demonstration marking Lithuania's independence on the eve of All Souls' Day in 1956, is published Lithuanian television broadcasts begin The Journalists' Union is founded, with a section of documentary photography	Lithuanian artists take part in an international exhibition in Moscow held on the occasion of the Sixth International World Youth and Students Festival Antanas Kmieliauskas is dismissed from the Artists' Union for carving a sculpture of St. Christopher, patron saint of Vilnius, in the courtyard of St. Nicholas's Church
1958	Urban population constitutes 38.6 percent; only 13 of every 1,000 of the population receive higher education	Central Committee of the Communist Party of the Soviet Union issues a special decision "On the correction of mistakes in assessing the operas *The Great Friendship*, *Bogdan Khmelnitsky*, and *With All My Heart*" Artists' Union starts to hold artists' creative workshops in Palanga	Arthur Miller's *Death of a Salesman* is staged at Panevėžys Drama Theater; director Miltinis establishes a new modernist style of acting with stress on an actor's psychological suggestion and improvisational elements The historical opera by Juzeliūnas based on Putinas's novel *Rebels* about the 1863 uprising is criticized for its anti-Russian interpretation. The composer refuses to make corrections, so the premiere does not take place until 1977 Novel *White Shroud* by American-Lithuanian Antanas Škėma is published. It is characterized by elements of expressionism and stream of consciousness	In the Palanga artists' colony, monumentalist Vytautas Povilaitis paints the first postwar abstraction in Lithuania Albertas Vesčiūnas exhibits abstract expressionist paintings in West Berlin *Ancient Symbolism in Lithuanian Folk Art* by American-Lithuanian archaeologist Marija Gimbutas spreads among artists and people interested in the humanities Romas Viesulas is awarded a Guggenheim Fellowship in graphic arts and creates a cycle of lithographs, "songs," combining stylistic features of folk art and abstract expressionism Exhibition of American-Lithuanian artists takes place at the Riverside Museum in New York

	LITHUANIAN HISTORY	ART INSTITUTIONS	CULTURAL SCENE	ART SCENE
1959	Council of Ministers of the LSSR consists exclusively of Lithuanians Some intellectuals start to believe in "socialism with a human face" and hope for liberalization, social and psychological adaptation to the Soviet system Society for Friendship and Cultural Links with Foreign Countries is founded 19,000 of the about 400,000 people deported return to Lithuania The first foreign tourists are allowed to come to Vilnius, and contacts between Lithuanians in exile and their relatives are reestablished	In carrying out the decision of the 21st Congress of the Communist Party of the Soviet Union to raise the aesthetic consciousness of the working class, universities, folk theaters, and collective farm museums are founded	Teachers of Lithuanian Literature of Vilnius University are accused of nationalism *Metmenys*, a journal edited by sociologist Vytautas Kavolis of Lithuanians in exile, is published in the United States	The first "Artist's Day" is celebrated, featuring a variety of thematic paintings: *At the Collective Farm Market* by Vincentas Gečas and *The Tragedy of Pirčiupis* by Augustinas Savickas The first exhibition of young artists' works is held at the Vilnius Art Museum Associative abstract collages created by stage designer Juzefa Čeičytė in 1957 are exhibited at the Kaunas Drama Theater
1960	Construction of Kaunas hydroelectric power station is completed	The Ministry of Culture of the LSSR provides instructions for the promotion of the decorative arts Decision No. 490 of the Council of Ministers of the LSSR provides royalties on commissioned drama and music works and their public execution, a practice that stays in force until 1988 Čiurlionis's boarding school opens in Vilnius. It later becomes "a stronghold of modernism" due to the efforts of progressive teachers	Book publishers begin to employ the principle of "lightning rod," using one object to divert attack from another. In art albums, Lenin's portrait appears first; in poetry collections, poems celebrating the Soviet way of life precede more "dangerous," modernistic work Poetry collection *Spring Watercolors* by Judita Vaičiūnaitė is published. It is characterized by a subjective visual world perception influenced by modern art, jazz, and urban environments	Art exhibition of Lithuanian artists devoted to the 20th anniversary of the LSSR is held in Vilnius Opening of the remodeled functionalist café Neringa, designed by architects Algimantas and Vytautas Nasvyčiai First assemblages by Vincas Kisarauskas are created The newly constructed and furnished Church of the Holy Virgin Mary, Queen of Peace, in Klaipėda is closed down and sculptures by Vytautas Šerys are destroyed First issue of nonperiodical serial publication *Dailė* (Art) is published Sculptors Antanas Mončys and Vytautas Kasiulis create modernist works in the style of "École de Paris" in Paris; in Australia, painter Henrikas Salkauskas and sculptor Vytautas Jomantas work in abstract expressionism First romantic abstract works influenced by serial electronic music by American-Lithuanian painter Kestutis Zapkus appear

	LITHUANIAN HISTORY	ART INSTITUTIONS	CULTURAL SCENE	ART SCENE
1961		Chair of Industrial Art at the State Art Institute is founded	Poetry collection *Seven Haymakers* by Vytautas Bložė explores surrealism and makes dramatic statements about the absurd postwar existence Benjaminas Gorbulskis's "Concert for Clarinet and Orchestra," the first work of avant-garde dodecaphonic structure, premiers	Lithuanian Art Museum organizes exhibition *Friendship of Nations*, which travels to 42 railroad terminals in train cars Kisarauskas's illustrations to Julius Janonis's poem *Poklius Lurks Every Day* are criticized American-Lithuanian photographer Algimantas Kezys creates his first works, revealing urban environments in a documentary style
1962	All-Union law prohibits the construction of private houses in cities of the union republics; in Vilnius, single people are not entitled to a separate apartment	Khrushchev attacks Russian artists at the exhibition in the Manege in Moscow. State art policy becomes stricter The Museum of History of Religion and Atheism in St. Casimir's Church in Vilnius opens	The first jazz concert takes place in Vilnius *In the Middle of a Large Field* by Romualdas Lankauskas, a novel structured in a Hemingway-like style, is criticized for the pacifistic depiction of Lithuania's behavior in World War II The anthology *Literature and Theater* is published Poem "Man" by Mieželaitis is awarded the Lenin Prize Musicologist Vytautas Landsbergis corresponds with the leader of the Fluxus movement, George Mačiunas, who sends to Lithuania Fluxus boxes and records of avant-garde music that Lithuanian students play during lectures. Maciunas is interested in coming to the LSSR and Soviet Union with Fluxus concerts	Gudaitis, a member of the ARS group, is criticized for exhibiting a coloristic, narrative triptych devoted to Čiurlionis, because of its deviation from Socialist Realism The first solo exhibition by Kisarauskas features constructively expressive allegoric compositions on religious and mythological themes Publication begins on a serial, *Lithuanian Graphic Art*
1963		Session of creative workers of the republic devoted to issues of ideology and creative work (with the participation of Sniečkus and Barkauskas) is held. Plenums are devoted to issues of ideology and creative work at the Writers' Union, Theater Society, and AU	A jazz club is founded New buildings of Republic Library open	

LITHUANIAN HISTORY	ART INSTITUTIONS	CULTURAL SCENE	ART SCENE
1964 60 percent of the population are Lithuanians; 2.5 percent are Communist Party members	Discussions of the reform of the Art Institute take place: Moscow institutions attempt to eliminate the Faculty of Visual Art	Jonas Avyžius's novel *A Village at a Crossroads*, about collectivization, is published	Exhibition of abstract landscapes and still lifes by Algirdas Petrulis is held at the Writers' Union Club Exhibition of abstract paintings by writer Romualdas Lankauskas takes place at the Writers' Union Club
1965 Central Committee of the CPSU makes a decision to give more independence to industrial enterprises and apply the self-governing principle Supreme Council of LSSR specifies Article 143 of the Criminal Law on the separation of the church from the state After the general installation of radio, 700,000 radio sets and 150,000 television sets operate in Lithuania Soviets approve of consecration of bishop Juozas Matulaitis Labukas in Rome		First large dodecaphonic work, the symphony "Dramatic Frescoes" by Eduardas Balsys, has distinct tendencies of serialism and polystylistics Robertas Verba produces the lyrical documentary *Son and Earth* State Youth Theater in Vilnius is founded The first public annual "Spring of Poetry" takes place Cultural journal *Kultūros barai* is launched	Exhibition of fauvistic landscapes and still lifes by Juozas Čeponis takes place at Vilnius, Tauras, and Pionierius Cinemas Set designs in the constructivist style for Verdi's *Traviata* by Truikys are marked by an abstract musical synthesis
1966 Twenty-one scientists address Antanas Sniečkus, the secretary of the Communist Party of LSSR, drawing his attention to ecological problems and opposing the construction of an oil refinery in Jurbarkas	Decision No. 481 of the Central Committee of the Communist Party of the Soviet Union and Council of Ministers makes monuments to the classics of Marxism-Leninism and busts of veterans of World War II and Lithuanian culture workers obligatory in major cities of the union republics. The monuments are built by the Communist Party of the Soviet Union, the Council of Ministers, and the Central Committee of the Communist Party of the LSSR	*A Staircase to Heaven*, the film by Raimundas Vabalas, is released. Using Aesopian parallels, the director reveals the problems of the complicated postwar life Students of the Music Faculty of Vilnius Teachers' Training College (Landsbergis's pupils) organize a Fluxus event	Painter Leopoldas Surgailis exhibits his expressive improvisations on the theme of Lithuanian folk sculptures at the Writers' Union Club Exhibition of Valentinas Antanavičius's paintings at the Republic Library in Vilnius reveals the artist's tendency to transform the human figure in a surrealistic and dramatic way The series of books *Lithuanian Painting* is published Rehabilitation of the ARS group: first exhibitions of artists in exile—Vizgirda at the Vilnius Art Museum and Samuolis at the Kaunas Čiurlionis Art Museum—take place

1967

In Sigitas Geda's poem *Strazdas* about the 19th-century Lithuanian poet Antanas Strazdas, metaphoric signs of the nation's identity are merged with cosmological myths and ritual aesthetics

Anthology of Lithuanian Photography begins publication

Lionginas Šepetys, the Minister of Culture of the LSSR, writes *An Outline of Modernism*

A monthly journal of literature, art, and social-political life, *Nemunas*, begins circulation

Orator, Maniac, Prophet Jonah by Kazys Saja is performed at the Vilnius Academic Drama Theater, directed by Kazimiera Kymantaitė. The one-act plays are full of Aesopian references to the absurdity of the occupational regime

In the Palanga artists' colony, textile artist Kazimiera Zimblytė creates monotype prints in a constructivist style

Architect Linas Katinas paints an abstract cycle, *The Sea*, which he exhibits at the Writers' Union Club in 1968

Art Exhibition Palace (architect Vytautas Čekanauskas) opens in Vilnius

Exhibitions of officially disfavored artists begin to be held at the house of Judita Šerienė and sculptor Vytautas Šerys at Užupio St. 2 in Vilnius

Camaldolite Monastery in Pažaislis is returned to the M. K. Čiurlionis Art Museum that had earlier housed a mental hospital. Ričardas Vaitekūnas and Antanas Martinaitis both have studios there (Vaitekūnas until 1971 and Martinaitis until 1975)

Young artists, writers, and musicians gather and openly discuss the issues of cultural and social life in apartments of interwar intellectuals and artists: Aldona Liobytė, Gudaitis, and Keliuotis in Vilnius; Truikys, Vaclovas Šiugždinis, Grušas, and Kazys Šimonis in Kaunas; Father Stanislovas in Paberžė's parsonage

1968

LITHUANIAN HISTORY

The Soviet Union's invasion of Czechoslovakia ends post-Stalinist optimism

Elektrėnai thermoelectric power station is completed; construction begins on Kėdainiai chemical plant and Jonava factory of nitric fertilizers

CULTURAL SCENE

The informal "Ramuva" movement is founded. Its members travel in the countryside, collect old people's memoirs and objects of folk art, hold folk-song parties, and celebrate Christian and pagan holidays. It remains active until the National Revival

Jutinas Marcinkevičius's historical drama *Mindaugas* is performed at the Vilnius Drama Theater and the Kaunas Drama Theater

The Mammoth Hunt by Kazys Saja, directed by Jonas Jurašas, is performed at the Kaunas State Drama Theater. His conceptual political-ideological theater upholds the tradition of the Aesopian language as a metaphorical symbolic element

The film *Feelings* by Almantas Grikevičius (script by Vytautas Žalakevičius) is banned in the Soviet Union due to its indirect references to postwar struggles

"Youth '68," the first jazz festival, takes place in Elektrėnai

The monthly cultural paper *Akiračiai* (Horizons) of the Santara-Šviesa Federation is launched

ART SCENE

The first biennial of Baltic painting takes place at the Art Exhibition Palace in Vilnius

Algimantas Stoškus's spatial-musical composition of thick stained glass, *Vilnius*, is included in the Lithuanian section of the Soviet exhibition in London

Kmieliauskas's abstract expressionist paintings are exhibited

Exhibition of textile artist Zimblytė's semantically generalized and abstract paintings and collages at the Vaga publishing house is closed due to formalism and lack of conflict in the works

Painter Kisarauskas's first reviews of paintings by Zimblytė and Katinas, although not officially published, are read by the art community

Exhibition of Antanas Martinaitis's expressionist landscapes and interior paintings is held at the Writers' Union Club

Ex librises by Antanavičius, Kisarauskas, and Kmieliauskas are exhibited at the 22nd International Congress in Como-Villa, Italy; works of this genre used to reach international exhibitions directly by mail, escaping Moscow's censorship. This means of participation gains popularity among graphic artists and photographers

Kings, an associative, sculptural composition of welded brass plates by Vladas Vildžiūnas, is set up despite opposition at the new Čiurlionis Gallery in Kaunas

Elena Gaputytė, a Lithuanian conceptual sculptor living in Britain, meets with other Lithuanian sculptors at the Artists' Union

Minimalist sculpture *Ritual* by emigrant sculptor Antanas Brazdys is erected in London

	LITHUANIAN HISTORY	ART INSTITUTIONS	CULTURAL SCENE	ART SCENE
1969	Population reaches the prewar level: 3.08 million, 75 percent Catholic	By a decision of the Council of Ministers of the LSSR, the Society of Photographic Art—the first in the Soviet Union—is founded	Important links are established with neighboring Poland: Polish TV starts broadcasting to Kaunas and its environs, and the Polish press reaches Lithuania. Composers go to "Warsaw Autumn" and other festivals Film *June, Beginning of Summer* by Verba is banned in the Soviet Union due to its pessimistic industrial theme and its lack of conflict Arūnas Žebriūnas's film *The Beautiful*, a poetic story about the life of teenagers, is released	Exhibition of Čiurlionis's works at the Kaunas Čiurlionis Art Museum takes place Exhibition of nudes, *Blossoms among Blossoms*, by Rimtautas Dichavičius is closed Sculptor Teodoras Kazimieras Valaitis paints organic abstract compositions and creates sketches of constructivist and expressionist sculptures Graphic artists take part in international poster and print biennials in Poland
1970		*The Way of Lenin*, exhibition devoted to the 100th anniversary of Lenin's birth, is held at the Art Exhibitions Palace in Vilnius Institute for Restoration of Cultural Monuments is founded	Monumental works on Lithuanian mythology are created at Vilnius University *The House of Menace* by Juozas Glinskis is performed at the Kaunas State Drama Theater. A mental institution represents the chaos of history to which the conscience of the epoch, the poet Strazdas, is confined *Šventežeris* by Kazys Saja—a satirical drama about the effect of land reclamation in a village—is staged at the Kaunas State Drama Theater After a single performance, *The Pantheistic Oratorium* by Bronius Kutavičius is banned and becomes an unofficial symbol of Lithuanian music (and recognized as the most popular composition of contemporary Lithuanian music in a 1996 opinion poll)	Legitimization of the "austere" thematic genre (paintings by Silvestras Džiaukštas and Leonardas Tuleikis) and abstract urban industrial landscape (Jonas Švažas) In some state institutions, small exhibition spaces are used for displaying works not accepted into official exhibitions Exhibition of abstract paintings by Žilius is held at the Artists' Union in Vilnius Exhibition of minimalist interior landscapes by Vaitekūnas is mounted at the Artists' Union in Kaunas Children's book department of the Vaga publishing house commissions young artists for book illustrations
1971	17,054 people sign a mass petition for the freedom of religion		The first republican music festival, "Musical Autumn," is held Viacheslav Ganelin's jazz trio (with Vladimir Tarasov and Vladimir Czekasin) is formed. Their jazz concerts take place at Neringa Café Production of Andrew Lloyd-Webber's rock opera *Jesus Christ Superstar* by students of the Faculty of Architecture of the Vilnius Civil Engineering Institute is banned	Sculptor Vildžiūnas corresponds with the major Lithuanian-born modern sculptor Jacques Lipchitz

LITHUANIAN HISTORY	ART INSTITUTIONS	CULTURAL SCENE	ART SCENE
1972 In protest against the occupants' illegal actions, Romas Kalanta publicly immolates himself in Kaunas. Mass demonstrations are suppressed	CC LCP decides "to explore the reality of Socialist life, to conquer the still recurring tendencies of idealization of the past and belittling the social contradictions of the past" While selecting works for the traditional Baltic triennial of painting, judges reject several works by Gudaitis because of their encoded social meanings. The painting department of the Artists' Union sends a letter of protest to Sniečkus, the secretary of the Communist Party of the LSSR	First issue of the illegal publication *Chronicle of the Lithuanian Catholic Church* appears, letting Lithuanians in exile and the world learn about the religious, political, and cultural oppression in Soviet Lithuania The poet Jonas Juškaitis decentralizes the traditional structure of poetry in his *A Blue Violet Lit My Fate* The poet Tomas Venclova uses expressive phonetic consonances and speaks about the occupation in "Linguistic Signs" Jurašas writes an open letter to the Ministry of Culture and Lithuanian Theater Society in *Literatūra ir menas* weekly, in which he openly refuses to work under conditions of repression and censorship Grušas's historical drama *Barbora Radvilaitė* is performed at the Kaunas Drama Theater	Interior designer Eugenijus Cukermanas starts to paint abstract compositions Sculptor Šerys creates an altar of modernist expression for the Šakiai Church Marija Rožanskaitė creates pop art composition *1941* devoted to mass deportation First samizdat reviews about works by Antanavičius, Gudaitis, Katinas, and Kuras by art critic Alfonsas Andriuškevičius are disseminated
1973 The 65th anniversary of the founding of Vilnius is celebrated	Vilnius Photographic Gallery opens	First public performance of *First Symphony* by Osvaldas Balakauskas, characterized by structural avant-gardism, takes place	First group exhibition of Algimantas Kuras, Arvydas Šaltenis, Algimantas Švėgžda, Kostas Dereškevičius, and Algirdas Taurinskas paintings devoted to a new expressionist elegiac view of urban environment is organized in AU salon in Vilnius Kisarauskas creates lithographs for *Anabasis* by Saint-John Perse, translated by Venclova

	LITHUANIAN HISTORY	ART INSTITUTIONS	CULTURAL SCENE	ART SCENE
1974	Antanas Sniečkus, secretary of the Communist Party of LSSR since 1941, dies. He is said to have gained privileges for Lithuania, hardly obtainable under the Soviet system, thanks to his useful long-term contacts in the Kremlin		The poet Mindaugas Tomonis is put into a mental hospital for using the phrase "the red flag is the executioners' flag" and killed in 1975 under vague circumstances Society of Photographic Art starts to hold yearly autumn plein-air sessions in Nida *The Ruler* by Putinas is performed at the Šiauliai Drama Theater, with minimalist stage design and costumes by Dalia Mataitienė	The exhibition of Lithuanian visual art entitled *Always on Guard*, devoted to the LSSR militia, is organized at the Art Exhibition Palace in Vilnius Exhibitions of abstract paintings by Katinas and Žilius are held at the sports hall of the Institute for City Construction and Design Glavlit prohibits Algimantas Kunčius's exhibition of photographs of village people and churches entitled *Sundays*
1975			Historical drama *Mažvydas* by Marcinkevičius is performed at the Kaunas Drama Theater Romualdas Granauskas's three-sentence novel *The Sacrifice of a Bull* is written Jurašas emigrates to the West	Photographer Kunčius starts a cycle of non-narrative, fragmentary photographic landscapes entitled *Reminiscences* Happenings by Robertas Antinis are staged at the first gathering of creative youth in Birštonas
1976	The Helsinki group of human rights opens its office in Lithuania	Žilius, who had been accused of formalism and dismissed from the Artists' Union, sends a letter to the first secretary of the Lithuanian Communist Party, asking for permission to leave the country since he does not understand and accept the method of Socialist Realism. He emigrates in 1978	The Department of Light Music (pop and jazz) is established at B. Dvarionas's musical school	An exhibition of expressionistic drawings full of Aesopian references by Edmundas Saladžius devoted to the Duseikiai mental hospital is held at the Art Workers' Palace in Kaunas First exhibition of abstract paintings by architect Cukermanas is held at the Artists' Union in Vilnius

	LITHUANIAN HISTORY	ART INSTITUTIONS	CULTURAL SCENE	ART SCENE
1977		Decision of the Central Committee of the Communist Party of the Soviet Union "On the Work with Creative Youth" is passed	A meeting with Jonas Mekas, poet, film director, and founder of anti-Hollywood independent avant-garde cinema in New York, is held at the Art Workers' Palace in Vilnius	On the initiative of the Artists' Union and the city of Klaipėda, summer symposiums of granite sculpture are held; the works created display a large variety of genres ranging from symbolic realism (Vyšniauskas) to minimalist abstraction (Navakas, Urbanavičius) and are exhibited in the city park until 1991

Group exhibitions of "unofficial" paintings ranging from expressionism and abstraction to pop art are held; public discussion and meeting with the artists moderated by art critic Andriuškevičius take place at the Art Workers' Palace in Vilnius

Vildžiūnas travels to the United States bronze foundries, where he casts his first constructivist sculptures and holds four exhibitions in private galleries. After his return in 1978, he holds an exhibition and shows tapes filmed during his visit at the Art Workers' Palace in Vilnius. He attempts to seek technological and visual freedom in bronze casting that was officially accessible only to ideological, state-commissioned works. The first attempts of collective casting take place in Jeruzalė, at the workshops of sculptors Vildžiūnas, Mazūras, and Navakas |
| 1978 | A secret council of the CPSU in Tashkent prescribes a wider use of the Russian language in preschools and secondary and higher schools | | Kutavičius's oratorium *The Last Pagan Rites*, words by Geda, is performed in the Baroque Hall in Vilnius; his *Dzūkai Variations* is performed at the "Warsaw Autumn" festival

Duokiškis Ballads, the ironic play about postwar Lithuania by Saulius Šaltenis, is performed at the Kaunas Drama Theater

A Walk in the Moonlight by Glinskis is staged by Jurašas at the Theater for the New City

Algirdas Patackas starts to publish a samizdat literary anthology, *Under the Roof* | Exhibition of Zimblytė's painted bands takes place at the Rakitin private gallery in Moscow

Happenings take place in the Jeruzalė gardens and in Marija Ladygaitė and Vladas Vildžiūnas's apartment. The first conceptual open-air installations are set up by Zimblytė, Gediminas Karalius, and Mazūras

Pop-art illustrations to Goethe's *Faust* are created by Vytautas Kalinauskas |

LITHUANIAN HISTORY	ART INSTITUTIONS	CULTURAL SCENE	ART SCENE
1979 The war between the Soviet Union and Afghanistan begins 60 percent of the population lives in cities, the remaining 40 in the country Limited distribution of furniture, food, books, and cars contrasts with the privileges of the Party nomenclature (special stores, hospitals, etc.). Artists who are not members of the Artists' Union cannot buy materials in the special stores	The 400th anniversary of the founding of the University of Vilnius is commemorated; on the university campus, Konstantinas Bogdanas's sculptural group *Lenin Speaking with Kapsukus* is unveiled The gallery of American Lithuanian collector Mykolas Žilinskas opens; in addition to early art, works of 19th- and 20th-century modernists are displayed	The distribution of the already published *Lithuania's History* by Kojelavičius is halted Bronius Radzevičius's novel *On the Roads of Dawn* is characterized by self-reflection full of existential anxiety Antanas Martinaitis's neoromantic ecological composition, *Music of the Last Gardens* (inspired by ARS painter Samuolis's work *The Apple Tree*), Mekas's films, and Lorca's poetry are featured at the festival of Soviet-Lithuanian music devoted to the 60th anniversary of the Soviet Union	The exhibition that takes place alongside the University of Vilnius jubilee features the first postmodernist sculpture by Petras Mazūras, *Nike* First exhibition of metals and small sculptures at the Art Exhibition Palace in Vilnius takes place. Surrealistic sculptures by Gediminas Karalius, abstract sculptures by Vlieders Urbanavičius, and figurative sculptures by Stepanos Šarapovas are exhibited for the first time First biennial of young Baltic artists, *Youth '79*, is held at the Art Exhibition Palace in Vilnius Art Exhibition Palace employees hold shows of works discarded by commissions in the depositories Moscow conceptualists Ilya Kabakov and others work with Lithuanian graphic artists in the Palanga artists' colony The first abstract compositions are created by painters Laima Drazdauskaitė, Dalia Kasčiūnaitė, and Rūta Katiliūtė An unsanctioned field for creative work is discovered by artists. Sculptors begin to create works that are characterized by abstract form and religious symbolism First exhibition of "illuminated constructions" by American-Lithuanian sculptress Elena Urbaitytė is organized in New York

	LITHUANIAN HISTORY	ART INSTITUTIONS	CULTURAL SCENE	ART SCENE
1980	Mažeikiai oil refinery is put into operation		Regular jazz festivals in Birštonas begin Authors of the dissident press Gediminas Iešmantas and Povilas Pečeliūnas are sentenced to eight and eleven years of prison for poems, short stories, and articles stating that Lithuania is occupied The first rock opera, *Love and Death in Verona*—directed by Eimuntas Nekrošius, composed by Kęstutis Antanėlis, with words by Geda—is performed at the Vilnius Youth Theater The Vilnius Quartet performs a commissioned composition, *Anno cum tettigonia*, by Kutavičius at the music festival organized by Krzysztof Penderecki in Poland	Subjectively figurative photographs by Vytautas Balčytis, Remigijus Pačėsa, and Alfonsas Budvytis are exhibited for the first time at an exhibition of young photographers. Gintautas Trimakas and Alvydas Lukys create works of a similar trend at the Vilnius Civil Engineering Institute's Photographers' Club Exhibition of sacral paintings by Vaidotas Žukas is mounted at the Artists' Union
1981				Exhibition of abstract sculptures by Navakas, surrealistic paintings by Petras Repšys, and hyperrealistic paintings by Švėgžda is held at the Vilnius Photographic Gallery Antanavičius organizes an exhibition of assemblages in Vilnius Conservatoire First conceptual photographs—travel cycles by Algirdas Luckus—are created

	LITHUANIAN HISTORY	ART INSTITUTIONS	CULTURAL SCENE	ART SCENE
1982			The public premiere of *The Pantheistic Oratorium* (1970) by Kutavičius is performed by the Vilnius New Music Ensemble (founded by Šarūnas Nakas), which spreads unofficial music in Lithuania and abroad The commissioned opera *God's Lamb* by Feliksas Bajoras (based on a short story by Raimondas Šavelis), sung by the composer, is criticized for incorrectly revealing the postwar atmosphere; it premiered in 1991 at the Vilnius Academic Opera and Ballet Theater The cantata "Cantus ad futurum" by composer Martinaitis becomes the manifesto of the new neo-romantic generation Production of the film *Flight Across the Atlantic* by Vabalas, which has been banned by Moscow for five years, becomes a social action: people donate money and lend props	First exhibitions of socially grotesque paintings by Raimundas Sližys and photographs by Algirdas Šeškus, figurative prints by Švėgžda, and photographs by Pačėsa are held in the Vilnius Photographic Gallery Exhibitions of abstract paintings by Cukermanas are held at the Supreme Council of the LSSR and the Birštonas jazz festival Exhibition of paintings by postmodernists-subjectivists Bronius Gražys, Henrikas Natalevičius, Mindaugas Skudutis, Sližys, and Romas Vilkauskas takes place at the Šiauliai Exhibition Palace
1983	The first reactor of Ignalina nuclear power plant is launched			
1984			The opera *Thrush, a Green Bird* by Kutavičius is performed at the Kaunas State Drama Theater First concert of the socially provocative rock group "Antis" of professional architects, led by Algirdas Kaušpėdas, is held at the Kaunas Artists' Union	Exhibition of paintings by Sližys is held at the Supreme Council of the LSSR Metaphysical minimalist collages by Zimblytė are hung in the interior of the funeral home designed by architect Česlovas Mazūras

LITHUANIAN HISTORY	ART INSTITUTIONS	CULTURAL SCENE	ART SCENE
1985 Mikhail Gorbachev is elected Secretary General Policy of perestroika and glasnost is introduced	Financial mechanism for promoting the official culture is formed. Official works are bought in larger numbers and for larger sums: Lithuanian Art Museum acquires the abstract sculpture *Leaf* by Urbanavičius (1978, colored wood, aluminium) for 500 rubles and Lenin's bust by Bronius Vyšniauskas (epoxide resin) for 2,000 rubles	*The Chattering Machine* (1984–86) by composer Rytis Mažulis and *Merz-machine* (1985) by Nakas mark the appearance of a new generation of anti-sentimentalists *Texts about Texts*, the collection of critical articles by Venclova, is published in the United States	Repšys's frescoes on mythological themes, *The Season* (begun in 1977), are finished at the Vilnius University Center for Lithuanian Studies Exhibitions of paintings by Šarūnas Sauka and Algimantas Skačkauskas are closed Exhibition of Sauka's paintings is held in the basement of the Artists' Union *Dog Suite*, an exhibition of expressionistic lithographs by Saladžius that ironically depict the reality of Soviet life, is held at the Kaunas Art Workers' Palace Sculptor Navakas's *Vilnius Notebook*, an exhibition of zincographic montage projects representing abstract sculpture grotesquely placed on the roofs and facades of representational buildings, is held at the Artists' Union. It is closed after two hours The works by Jonas Gasiūnas, Henrikas Čerapas, Rimvydas Jankauskas-Kampas, and Ričardas Bartkevičius combining abstract expressionist style with elements of the "new savages" are featured at the exhibition of the Young Artists' Section of the Artists' Union at the Art Workers' Palace in Vilnius
1986		"Young Music" days are held in Druskininkai, where new music by young composers is performed	
1987 A first public meeting in commemoration of the anniversary of the Molotov-Ribbentrop Pact is held in Vilnius		First march of rock groups across Lithuania takes place Krzystof Droba commissions Balakauskas to create *Le silence* for the "Warsaw Autumn" festival	First art project is held in a public space: exhibition of figurative photographs by Lukys and abstract concrete sculptures by Navakas in the Alumni Courtyard in Vilnius

1988

LITHUANIAN HISTORY

The initiative group of Sajūdis, the Lithuanian Reform Movement—consisting of scholars in the humanities, writers, artists, philosophers, and intellectuals—is founded

The "singing revolution" begins

Some 250,000 people gather in a protest demonstration to mark the anniversary of the Molotov-Ribbentrop Pact in Vilnius

15,000 people join hands in a human chain around Ignalina nuclear power plant

The Lithuanian national flag is raised on Gediminas Tower in Vilnius

First congress of the Sajūdis emphasizes the necessity to restore Lithuania's independence

Vilnius Cathedral is returned to the Catholic church

Supreme Council of the LSSR recognizes the Lithuanian language as the state language, the national flag (tricolor) as the state flag, and "The National Hymn" by Vincas Kudirka as the state anthem

The 20th Congress of the Lithuanian Communist Party declares the LCP independent from the CPSU and founds the Lithuanian Democratic Labor Party (LDLP in 1990)

ART INSTITUTIONS

Ministry of Culture of LSSR announces a public competition for a monument to the founder of Vilnius; simultaneously it commissions monuments to Lenin erected in Alytus (Jokūbonis), Kapsukas (now Marijampolė; Arūnas Kynas), Birštonas (Vyšniauskas), and Jurbarkas (Juozas Lipas)

Art historian Vladas Drėma sends a letter to the Ministry of Culture with regard to the destruction of cultural monuments in the Soviet period

CULTURAL SCENE

Large-scale publishing of the uncensored press by the Sajūdis starts

Sietynas, the first cultural anthology not approved by the Glavlit (a major censoring organization), is published

Lithuanians at the Laptev Sea by Danutė Grincevičiūtė, the first memoirs of deportation, are published in the *Pergalė* journal

Eternal Light, a film about postwar Lithuania by Algimantas Puipa with script by Šavelis, premiers

ART SCENE

The first art gallery at the Kaunas Architects' House opens

Happening festival is held in Anykščiai

First curated exhibitions are held on the initiative of the Ministry of Culture: *Myth in Lithuanian Painting* (curator Andriuškevičius); *Folk Art Tradition in 20th-Century Lithuanian Art* (curator Raminta Jurenaitė) at the AEP in Vilnius; *Human Signs. Sculpture, Drawings, Photographs* (curators Rasa Andriušytė, Elona Lubytė) in Klaipėda

First exhibition of Lithuanian artists in exile is held at the Art Exhibition Palace in Vilnius

First group of student-actionists "Žalias lapas" (Green Leaf) is formed in Vilnius, developing the ideas of Joseph Beuys and Mačiunas in Lithuania

	LITHUANIAN HISTORY	ART INSTITUTIONS	CULTURAL SCENE	ART SCENE
1989	Marking the anniversary of the 1941 deportations in Vilnius, on the initiative of artists and society at large, the monument *Three Crosses* by Antanas Vivulsky is re-erected In commemoration of the 50th anniversary of the Molotov-Ribbentrop Pact, 700,000 Lithuanians participate in "The Baltic Way," a general protest action of the three Baltic states, which takes place on the Vilnius-Tallinn highway	Lithuanian national awards of literature, art, and architecture are founded Artists' Union of the LSSR declares itself independent from the Artists' Union of the Soviet Union Students at the State Art Institute protest the conservative studio program; a new one, with Karalius, Vildžiūnas, Navakas, and Vaitekūnas included as staff, is initiated	The Writers' Union starts to publish the monthly journal of culture, *Krantai* Founding of the first commercial radio station "M-1" is established A festival of music by exiled composers entitled "The Return" is held in Vilnius	Group 24 is formed. It unites artists and art critics of different stylistic orientation who are in opposition to official art in the Soviet period A brutal action with crucified bread loaves and raw pork introduces "Post Ars," a group of artists of the middle Soviet generation who reject traditional conservative art and hold collective actions, installations, and performances in Kaunas
1990	Sajūdis candidates are elected to the Supreme Council of the LSSR The Supreme Council of the LSSR restores the independent state of Lithuania Vytautas Landsbergis is elected chairman of the Supreme Council The Supreme Council issues a decree of the restitution of the Catholic church The Soviet Union imposes an economic blockade on Lithuania	The state gives up control of the development of art and tries to create a new mechanism for promotion and support of art Article 16 of the income law of private persons establishes the 13 percent income tax—i.e., royalty rate—for authors and their heirs The Lithuanian government abolishes the Glavlit of the LSSR and founds a committee for press control The Open Society Fund of Lithuania is founded The State Art Institute is renamed Vilnius Art Academy The Lithuanian Art Museum opens in Lemont, Illinois	The first Lithuanian Culture Congress takes place in Vilnius The cultural newspaper *Šiaurės Atenai* begins publication The journal *Naujasis Židinys* begins publication. In 1991, it merges with *Aidai*, which had been published in exile	Vaivada's 1963 monument to Kapsukas is removed in Vilnius A public competition for a monument commemorating those lost in the mass deportations is held in Vilnius

	LITHUANIAN HISTORY	ART INSTITUTIONS	CULTURAL SCENE	ART SCENE
1991	Soviet President Gorbachev issues an ultimatum demanding the restoration of the Soviet constitution in Lithuania			

Using violence against unarmed civilians, Soviet troops assault the TV tower and radio and television offices, killing 14 people and wounding 700 in Vilnius

Iceland is the first country to recognize the Republic of Lithuania

At the Medininkai border checkpoint, militiamen of the special militia unit (OMON) kill 7 border guards

Agrarian reform takes effect

The United States recognizes Lithuania

Russia recognizes Lithuania

Lithuania is readmitted into the United Nations | The "Program of Development of Lithuanian Culture," oriented to decentralization, autonomy of cultural subjects, and financing of state culture, is approved

The Lithuanian section of International Art Critic Association (AICA) is founded

The first private Jūratė Stauskaitė Art School is founded in Vilnius

The sculpture *Park of Europe's Center* by Gintaras Karosas is founded near Vilnius

Nordic Information Office is founded in Vilnius | The Lithuanian Copyright Protection Association Agency is founded. It will join the Bern Convention in 1994

Composers' Union separates from the Composers' Union of the Soviet Union and resumes its membership in the International Society of Contemporary Music

International music festival "Gaida" takes place | A public competition for a monument commemorating the people who defended Vilnius Telecenter is held |
| **1992** | Declaration of friendly relations and cooperation between Lithuania and Poland is signed in Vilnius

Lithuania joins the International Monetary Fund

Constitution of Lithuania is adopted by a referendum

Composer Balakauskas becomes ambassador to France (a position he holds until 1994) | The government of the Republic of Lithuania establishes state grants to artists and scholars. Candidates are selected by a board of experts of the Ministry of Culture and the Council of Culture and Art

Art Exhibition Palace in Vilnius is reorganized into the Contemporary Art Center (CAC), presenting both traditional and new art forms | The cultural newspaper *7 meno dienos* (7 days of art) again begins publication

Second Symphony by Balakauskas is performed at the ICMS Session in Warsaw

Film director Šarūnas Bartas (*Three Days*) participates in the film festivals in Berlin | Antanavičius is awarded Lithuanian National Prize for Culture and Art

American-Lithuanian painter Zapkus teaches at the Vilnius Art Academy. His students join the group "Good Evils" (Žilvinas Kempinas, Patricija Jurkšaitytė, Evaldas Jansas, and others), marking the coming of a new internationally oriented generation; exhibition is held at the Contemporary Art Center

The ARS group 60 years' jubilee exposition takes place at the Čiurlionis Art Museum in Kaunas |

LITHUANIAN HISTORY	ART INSTITUTIONS	CULTURAL SCENE	ART SCENE
1993 Algirdas Brazauskas, leader of the LDLP, defeats Stasys Lozoraitis, a diplomat in exile, in the presidential election Lithuania joins the Council of Europe The national currency—the litas—is reintroduced The last Soviet military unit is withdrawn from Lithuania Pope John Paul II visits Lithuania	With the adoption of the Value-Added Tax law, value-added tax is imposed on works sold at galleries and production of art workshops, which does not encourage the emergence of a free art market. The process is further hindered by the absence of a permanent exhibition of contemporary art A branch of the Open Society Fund, the Soros Center for Contemporary Arts is founded in Vilnius The noncommercial interdisciplinary gallery Jutempus opens The Lithuanian Comity of the International Comity of Museums (ICOM) is founded A branch of the British Council and the America Center opens in Vilnius	The journal *Naujoji Romuva* begins publication First conference of Santara-Šviesa Federation in Vilnius is held The first international theater festival "LIFE," organized by Rūta Vanagaitė, takes place (subsequent festivals are held in 1995, 1996, and 1997)	Tomsky's monuments to Chernechovsky (1950) and Lenin (1951) in Vilnius are dismantled Annual project in urban space "Straight Line—Cross—Section," curated by artist Redas Diržys, takes place in Alytus *Between Sculpture and Object in Lithuania*, the first Soros Center exhibition, curated by Jurėnaitė, takes place Gediminas Urbonas's sculpture *The Four Exposures* is exhibited at the *Artscape Norland* in Rognan, Norway The *New Art* 70 years' jubilee exposition is held in Lodze Art Museum and Lithuanian Art Museum American-Lithuanian jeweler Aleksandras Šepkus is awarded the title Best New York Designer
1994 Lithuania signs a treaty with NATO, joining the Partnership for Peace program	The Lithuanian Association of Art Creators, which joins eight creative unions, is founded The Photo Study in the Vilnius Art Academy is founded (now the Chair of Photography and Media Art)	Film director Bartas (*Corridor*) participates in the film festivals in Berlin 691 private publishing houses are registered in Lithuania The French Cultural Center opens in Vilnius Lithuania has seven radio stations and six television companies, including one state TV 321 periodicals are published	The first new media group, "Group of Academic Training," is formed Project in urban space "Sculpture in the Old Site," curated by sculptor Algis Lankelis, takes place in Vilnius Urbonas and Sauka works are exhibited at the XXII São Paulo Biennial

	LITHUANIAN HISTORY	ART INSTITUTIONS	CULTURAL SCENE	ART SCENE
1995	Lithuania signs an association agreement with the European Union	A new State Commission for Protection of Monuments is founded The Lithuanian Art Historians Society is founded		Project in urban space "The Mundange Language," curated by sculptor Lankelis, takes place in Vilnius Artūras Raila and Evaldas Jansas launch their first social projects On the initiative of photographer Saulius Paukštys, a monument to Frank Zappa (sculptor Bogdanas, architect Ozarinskas) is erected in Vilnius The exhibition *Recent Documents: New Tendencies in Lithuanian Art*, curated by Kestutis Kuizinas, is held in Balzek Culture Museum, Chicago The exhibition *From Gulag to Glasnost: Nonconformist Art from the Soviet Union* is held at the Zimmerli Art Museum in New Jersey Navakas participates at the Kwangju Biennial in Korea Photographer Snieguolė Michelkevičiūtė presents his cycle *Women about Men* at the Istanbul Biennial
1996	Twenty-eight parties take part in the elections to the Seimas	The Lithuanian Association of Galleries is formed, joining 36 galleries, 17 of which are located in Vilnius Fifteen private film studios are in operation	Committee for the Support of the Press, Radio, and Television is established Neo-romanticist composer Martinaitis writes compositions for the Franciscan community, including *The Hymn to the Sun* Director Eimuntas Nekrošius is awarded the Milano Picolo "UBU" theater prize for his production of Chekhov's *Three Sisters*	Project in urban space "The Forgotten Present," curated by Lankelis, Audrius Novickas, and Paul Rodgers, takes place Chapel of St. George's Convent in Kaunas is designed by Ksenija Jaroševaitė and Urbanavičius *"Personal Time": Art of Estonia, Latvia and Lithuania, 1945–1996*, curated by Jurėnaitė, shows at the "Zachęta" Gallery of Contemporary Art, Warsaw, Poland and Central Exhibition Hall "Manege" in St. Petersburg *New Lithuania* contemporary art exposition in Gdansk, Poland, is curated by Evaldas Stankevičius

	LITHUANIAN HISTORY	ART INSTITUTIONS	CULTURAL SCENE	ART SCENE
1997		Experts of the European Council analyze Lithuania's cultural policies and present recommendations for improvement	Creative unions and foundations set up information centers with Internet information about the development of culture in Lithuania Performances by director Oskaras Koršunovas based on the works of Charms and Vvedinskij are shown at the Avignon Festival Film director Bartas (*The Home*) participates in the program "Other Cinema" at the Cannes film festival	Jonas Mekas is awarded Lithuanian National Prize for Culture and Art There are 24 art groups of traditional and new orientation that hold exhibitions and actions; about 200 people participate in their activities *Quiet Modernism in Lithuania, 1962–1982*, curated by Lubytë, opens at the Soros Center for Contemporary Arts Egle Rakauskaitė (installation *Expulsion from Paradise*) participates at the Istanbul Biennial The first Lithuanian and British new media project, "Ground Control," begins
1998	Valdas Adamkus, an American-Lithuanian environmentalist, is elected president of Lithuania	Lithuanian Interdisciplinary Art Union is founded The Lithuanian cultural attaché is founded in France and Sweden The Goethe Institute is founded in Vilnius	The Nekrošius theater studio "Menos fortas" (Art fort) is founded in Vilnius	Petras Repšys is awarded Lithuanian National Prize for Culture and Art Kuizinas, Narkevičius, and Stankevičius curate *Twilight*, an international new media exhibition at the Soros Center for Contemporary Arts Lolita Jablonskienė curates *After Painting* at the Soros Center for Contemporary Arts Kuizinas curates *Cool Places*, the Triennial of Contemporary Baltic Art at the Soros Center for Contemporary Arts Svajonė and Paulius Stanikai's *Your Father, Your Sister, and Your Daughter* shows at the studio in the Vilnius Art Factory The Urbonas project "tvvv space" airs on Lithuanian television *Art Deco in Lithuania* exhibition takes place at the M. K. Čiurlionis Art Museum in Kaunas, curated by Giedrė Jankevičiūtė *Reconnaissance*, ten sculptures by Navakas, is installed in the Helersdorf district in Berlin Deimantas Narkevičius participates at the European Biennial of Contemporary Art in Luxembourg

	LITHUANIAN HISTORY	ART INSTITUTIONS	CULTURAL SCENE	ART SCENE
1999	The U.S. business Williams International is privatized as the enterprise "Mažeikių nafta" (the oil of Mažeikiai) Lithuania is invited to join the European Union Lithuania negotiates for membership to the NATO bloc	The Lithuanian cultural attaché is founded at the European Council in Brussels The UNESCO chair of Political and Cultural Management is founded in Vilnius Art Academy The first private "Art Projects Studio" by Ieva Kulzinienė is founded in Vilnius The American-Lithuanian painter and collector Kierys Varnelis's private museum is founded in Vilnius The French-Lithuanian sculptor Antanas Mončys's museum is founded in Palanga The Italian Cultural Institute is founded in Vilnius	Nekrošius performs *Othello* in Venice The Nekrošius performance of *Macbeth* is awarded "The Golden Mask" award by Russian theater critics	*Lithuanian Art, 1989–1999: The Ten Years* shows at the Soros Center for Contemporary Arts. Curators are Kuizinas, Narkevičius, Stankevičius, Jonas Vlatkevičius, and Raimondas Malašauskas Rakauskaitė and Navakas represent Lithuania at the 48th exhibition of modern art in Venice (the first time Lithuanian artists have taken part) Katinas, Navakas, and Savickas are awarded Lithuanian National Prize for Culture and Art The projects *The Fat* (curated by Lankelis, Novickas, and others) and *Identification in the City* (an art-on-the-trolleybus project curated by Laima Kreivytė, Rokas Dovydėnas, and others) take place in Vilnius The exhibition *Christianity in Lithuanian Art* takes place at the Lithuanian Art Museum
2000	International Congress on the Evaluation of Crimes of Communism begins its work in Vilnius Seimas elections are held The Lithuanian Democratic Labor Party and Lithuanian Social Democratic Party form a new left coalition	The Soros Center for Contemporary Arts becomes the Contemporary Art Information Center in Lithuanian Art Museum The private Augustinas Savickas Art Gallery and People's Art School is founded in Vilnius The private "Grūto" park of demoted Soviet monuments is founded near Druskininkai by Jonas Malinauskas The Swedish Cultural Institute is founded in Vilnius	Lithuanian Young People's Day takes place Lithuania hosts "Days of European Heritage," a program organized by the European Council A new archaeological exhibition, "Pre-Historic Lithuania," opens in Vilnius The national opera *The Bear* from the Prosper Mérimée novel (composer Kutavičius, librettist Aušra Marija Sluckaitė-Jurašienė, director Jurašas, scene designer Navakas) premiers at the Vilnius Festival Director Oskaras Koršunovas premiers Michail Bulgakov's *Master and Margarita* at the Avignon Festival	Raila participates at the *Manifesta 3*, the European Biennial of Contemporary Art in Ljubljana Lithuania has a pavilion at Expo 2000 in Hanover, Germany Exhibition of M. K. Čiurlionis opens at the Musée d'Orsay in Paris Kasčiūnaitė, Cukermanas, and Venclova are awarded Lithuanian National Prize for Culture and Art

Compiled by Elona Lubytė
Translated by Aušra Simanavičiūtė

Selected Bibliography

XX a. lietuvių dailės istorija. III. 1940–1960 (A history of twentieth-century Lithuanian art, vol. 3, 1940–1960). Vilnius: Academy of Science of Lithuanian Soviet Socialist Republic, Institute of Culture and Art, 1990.

33 izstāžu apvienotais katalogs. Rīga: Labrīt], 1993.

101: Eesti Maalikunstnike Liit, 1977 (Estonian Painters' Association, 1977). Tallinn: Eesti Maalikunstnike Liit, 1997.

1995 Saaremaa Biennial. Exhibition catalogue. Tallinn: Center for Contemporary Photography, 1995.

Ābols, Ojārs. "Līdzsvars un formu harmonija." *Māksla* 4 (1962).

"Actualités: Lettonie." *Design industrie. Esthétique industrielle* 92 (September–October 1968): 51–52.

Ado Lill. Exhibition catalogue. Tallinn: Estonian Art Museum, 1994.

Aleksandravičius, E., and A. Kulakauskas. *Carų valdžioje: XIX amžiaus Lietuva* (Under the reign of Tsars: Lithuania in the nineteenth century). Vilnius: Baltos Iankos, 1996.

Aleksandrev, L. "Rabota nad sozdaniem promyshlennykh obraztsov (Rizhskoe spets. khudozhest.-konstruktorskoe byuro)." *Vosprosy izobretatel'stva*, n. 9.

Ando Keskküla. Exhibition catalogue. Tallinn: Estonian National Art Museum, 1986.

Ando Keskküla, Jüri Ojaver, Peeter Pere. Veneetsia biennaal (Venice Biennial) exhibition catalogue. Tallinn: Center for Contemporary Arts, 1999.

Andres Tolts. Exhibition catalogue. Tallinn: Eesti Kunstimuuseum, 1999.

Andriuškevičius, Alfonsas. "Herojiškos formos ankštose erdvėse" (Heroic forms in narrow spaces). *Pergalė* 6 (1981): 152.

Andriuškevičius, Alfonsas, ed. *72 lietuvių dailininkai apie dailę* (72 Lithuanian artists on art). Vilnius: VDA, 1998.

Apinis, Jēkabs, et al. *Latvijas telotajas maksla pieci gadi, 1934–1999*. Rīga: Latvijas rakstu un mākslas kemeras izdevus, 1939.

Ārgalis, Māris. *Modeli*. Rīga: Latvijas PSR Mākslas fonds, 1978.

ARS. Parodos katalogas (ARS. Exhibition catalogue). Kaunas: Čiurlionis Gallery, 1932.

Artists Skulmes: Twentieth-Century Latvia. Exhibition catalogue. Rīga: Jumava, 2000.

Art of Soviet Estonia from 1940 to 1965. Vol. 2 of *The History of Estonian Art in Two Volumes*. Tallinn: Kirjastus Kunst, 1970.

Baigell, Renee and Matthew, eds. *Soviet Dissident Artists: Interviews after Perestroika*. New Brunswick, N.J.: Rutgers University Press, 1995.

Bankovskis, Pēteris, and Gundega Repše. "Die Frauenfrage." In *RIGA: Lettische Avantgarde/Latviešu avangards*, eds. Indulis Bilzens et al., 19–22. Berlin: Elefanten Press, for Neue Gesellschaft für bildende Kunst, 1988.

Belmane, A., and I[nāra] Ņefedova, eds. *Latviešu tīlotāja māksla*. Rīga: Liesma, 1970.

Bernstein, Boris. *Peeter Ulas*. Tallinn: Kunst, 1984.

Beryozkin, Viktor. *Ilmārs Blumbergs*, ser. Mūsu mākslinieki. Rīga: Liesma, 1983.

Bērziņš, Boriss. *Parasts Akmens*. Rīga: Boriss Bērziņs, 1992.

Bilzens, Indulis, and Maruta Schmidt, et al., eds. *RIGA: Lettische Avantgarde/Latviešu avangards*. Exhibition catalogue. Berlin: Elephanten Press, for Neue Gesellschaft für bildende Kunst, 1988.

Bilzens, Indulis, et al., eds. *Valdis Abolins, Miss Vietnam mit rohem Hering im Mund: Fluxus, Realismus und die Riga-Konnekschen*. West Berlin: Elefanten Press, 1987.

Bišmanis, M[aija] S. "?" In *Reconstructing Identity: Latvian Women Artists*. Regina, Saskatchewan: Mackenzie Art Gallery, 1996.

Boiko, Juris. "Ne tas, ko tu redzi, ne tas, ko tu gribi." *Diena*, May 30, 1991.

Borgs, Janis. "Aktuella knoststromniga i Baltikum." *Artes: Tidskirft for Litteratur, Kohst och Musik* 3 (1981).

Boyars, Yuri. "Nationality and Minority Policies in Latvia." *Baltic Observer*, September 24–30, 1992, p. 11.

Boym, Svetlana. *Commonplaces: Mythologies of Everyday Life in Russia*. Cambridge, Mass.: Harvard University Press, 1994.

Budrys, Ignas. "Nejaugi viska dareme blogai?" (Did we do everything wrong?) *Evening News*, February 2, 1993.

Burāne, Ingrīda, ed. *Latvian Painting/Lettische Malerei. 70 Years of the Latvian Academy of Arts*. Cologne: Unicord, n.d.

Celms, Valdis. "The Dialectic of Motion and Stasis in Kinetic Art." *Leonardo: International journal of contemporary visual artists* 27, no. 5 (Oxford): 387–390.

Cherry, Kelly. *The Exiled Heart: A Meditative Autobiography*. Baton Rouge: Louisiana State University Press, 1991.

Contemporary Soviet Painters from Riga, Latvia. New York: Eduard Nakhamkin Fine Arts, 1989.

Dodge, Norton T., ed. *Baltic Art during the Brezhnev Era: Nonconformist Art in Estonia, Latvia and Lithuania*. Exhibition catalogue for the John B. Aird Gallery, Toronto, Canada. Mechanicsville, Md.: Cremona Foundation, 1992.

Dubiņš, Herberts. "Gleznieciski būtiskais." *Māksla* 3 (1969): 10–11.

Dyogot, Ekaterina. *Contemporary Painting in Russia*. Roseville East, New South Wales: Craftsman House, 1995.

Eesti Arhitektuuri ajalugu (The history of Estonian architecture). Tallinn: The Academy of Science of Estonian Soviet Socialist Republic, 1965.

Eesti graafika, 1970–1971 (Estonian prints, 1970–1971). Tallinn: Kunst, 1973.

Eesti graafika, 1982–1989 (Estonian prints, 1982–1989). Exhibition catalogue. Tallinn: Kirjastus Kunst, 1992.

Eleventh Tallinn Print Triennial, The. Exhibition catalogue. Tallinn: The Association of the Print Triennial, 1998.

Enckell, Carolus. "Tallinnalaisia Impressioita." *Taide* 4/84: 18–21.

Feinstein, Stephen C. "The Avant-Garde in Soviet Estonia." In *New Art from the Soviet Union*, eds. Norton Dodge and Alison Hilton. Washington, D.C.: Acropolis Books, Ltd., 1977.

Fleck, Robert. "A Dialogue Between Consideration and Thought." In *Ēriks Božis*, ser. Moderna Museet projekt, catalogue no. 276, pp. 12–15. Stockholm: Modern Museet, 1998.

Flint, David. *The Baltic States—Estonia, Latvia, Lithuania*. Brookfield, Conn.: Millbrook Press, 1992.

Gassner, Hubertus, and Roland Nachtigäller, eds. *Gustav Klucis*. Retrospective. Stuttgart: Verlag Gerd Hatje, 1991.

Gerchuk, Iurii. "The Aesthetics of Everyday Life in the Khrushchev Thaw in the USSR (1954–64)." In *Style and Socialism: Modernity and Material Culture in Post-War Eastern Europe*, eds. David Crowley and Susan Reid. London: Berg, 2000.

Golovsky, Val S. *Behind the Soviet Screen: The Motion Picture Industry in the USSR, 1972–82*. Ann Arbor: Ardis, 1986.

Gough, Maria. "In the Laboratory of Constructivism: Karl Ioganson's [Kārlis Johansons's] Cold Structures." *October* 84 (Spring 1998): 90–117.

Grupė 24. Tapyba. Piešiniai. Exhibition catalogue. Vilnius: Dailės parodu rūmai, 1990.

Hain, Jüri. "ANK 64." *Kunst* 50, no. 1 (1977): 44.

——. "Üks kollektiivne kogemus kuuekümnendatest." *Kunst* 71, no. 1 (1988): 28–30.

——. "Vaikelu igavikuline mõõde." *Kunst* 67, no. 2 (1985): 42–47.

Hajenko, Svetlana. "Aleksandrs Dembo." In *Sava krāsa varavīksnī*, ed. Karmella Skorika, 71–72. Rīga: AGB, 1997.

——. "Semjons Šegelmans." In *Sava krāsa varavīksnī*, 79–83.

Harku, 1975–1995. Exhibition catalogue. Tallinn: Tallinn City Gallery, 1995.

Helme, Sirje. "Aeg Herald Eelma joonistustes: emotsioon 1975. aasta personaalnäituseslt." *Kunst* 50, no. 1 (1977): 30.

——. "The avant-garde and the end of the century. The '80s in Estonian art" (in Russian). *Iskusstvo* 7/1990.

——. "The Visarid Artists' Group." In *Visarid*. Exhibition catalogue. Tallinn: Eesti Kultuurkapital and Soros Center for Contemporary Arts, 1997.

——. "Raul Meel Arkaadia teel." *Vikerkaar* (September 1988): 36–38.

——. "Raul Meel on the Road of Arcadia." *Taide* 6/90.

——. "Siim Annuse loomingust." *Sirp ja Vasar*, November 6, 1981, pp. 8–9.

——. "Sinirand polegi sinine" (The blue beach is not blue). *Kunst Art Magazine* 1 (1992): 44–45.

——. "Viron taide valinauhassa." *Taide* 3/87: 38–44.

Helme, Sirje, ed. *Interstanding 2*. Exhibition catalogue. Tallinn: Center for Contemporary Art, 1999.

Helme, Sirje, and Jaak Kangilaski. *Short History of Estonian Art*. Tallinn: Kunst Publishers, 1999.

Henrihs Vorkals, Andris Breže, Ojārs Pītersons, Juris Putrāms. Exhibition catalogue. Rīga: Latvijas PSR Mākslas fonds, 1987.

Hindrey, Karl August. "Kunstinäitus Vanemuises" (An art exhibition in Vanemuine theater), *Postimees*, February 22, 1914.

Jameson, Fredric. *Postmodernism, Or, the Cultural Logic of Late Capitalism*. Durham, N.C.: Duke University Press, 1991.

Jānis Mitrēvics. Exhibition catalogue. Rīga: Soros Center for Contemporary Arts, 1994.

Jaunystė: Katalogas pirmoji Pabaltijo jaunųjų dailininkų vaizduojamosios dailės paroda. Vilnius: Lietuvos TSR Dailės muziejus, 1979.

Joonsalu, Mare, Reet Mark, and Tiiu Talvistu. *Elmar Kitse Fenomen/Phenomenon of Elmar Kits, 1913–1972*. Tartu: Tartu Art Museum, 1994.

Jurenaite, Raminta. "Ar ne per greit uzmirstam vakarykste diena?" (Isn't it we forgot yesterday too fast?) *Literature and Arts*, February 27, 1993.

Jurkus, Paulus. "Art in Independent Lithuania after World War II." In *Encyclopedia Lithuania*, vol. 1. Boston: J. Kapočlaus Publishing House, 1970.

Juske, Ants. "Eesti kunst aastal 1996" (Estonian art in the year 1996). *Kultuurimaa*, September 4, 1996.

———. "Eesti performance" (Estonian performance). *Favoriit* (November 1993).

———. "Hüperrealismi kajastusi Eesti kunstis." *Sirp ja Vasar*, July 7, 1987, p. 8.

———. "Peatükk Eesti moodsa kunsti ajaloost—Kaarel Kurismaa." *Vikerkaar* (September 1993): 41.

———. "Ruum ja pilt Ando Keskküla maali-piltides." *Kunst* 71 (1988): 10.

———. "Tammiku teine tulek." *Eesti Päevaleht*, December 17, 1998.

Kabakov, Ilya. *Ülo Soosteri piltidest: Subjektiivseid markmeid* (On Ülo Sooster's paintings: Subjective notes). Tallinn: Kirjastus Kunst, 1996.

Kalnacs, Janis. "Nomals latviesu grafikis" (A forsaken Latvian graphic artist). *Literatura un maksla* 15, no. 2513 (April 16, 1993): 4.

Kalniete, Sandra. *Latvju tekstilmāksla*. Rīga: Liesma, 1989.

Kartna, A. *Soviet Estonian Art*. Tallinn: Kirjastus Eesti Raamat, 1968.

Keliuotis, J. "Pasikalbėjimas su Nepriklausomųjų dailininkų draugijos pirmininku A. Valeška" (Conversation with Chairman of the Society of Independent Artists A. Valeška). *Naujoji Romuva* 8 (1932).

Kivimaa, Katrin. "Interview with Olav Maran." *Kunst* 2 (1994): 34–41.

Kivimäe, Juta. "Between Modernity and Identity: Nationalist Dominance in the Late 1930's and the Phenomenon of Kristjan Raud." In *Modernity and Identity: Art in 1918–1940*, 156–170. Vilnius: Institute of Culture and Art, Vilnius Academy of Fine Arts Press, 2000.

Klaviņa, Antra. "Sechs." In *Karyatiden: Sech Malerinnen aus Riga*, ed. Juris Boiko. Bonn: Frauen Museum, 1992.

Kliaugienė, Gražina. "Del ko pesasi menininkai?" (Why are the artists quarreling?) *Lietuvos aidas*, February 27, 1993.

———. "Nuo ko mus reikia gelbeti?" (From what do we have to be saved?) *Lietuvos aidas*, April 16, 1993.

———. "Pabaltijo tapybos trienalė" (Triennial of painting of the Baltic States). *Pergalė* 4 (1982): 148.

Komissarov, Eha. *Mare Vint*. Tallinn: Kirjastus Kunst, 1991.

———. "Soup '69—20 aastat hiljem." *Kunst* 76, no. 1 (1991): 17–19.

Konstante, Ilze. *Leo Mauriņs. Gleznas, interjeri*, ser. Mūsu mākslinieki. Rīga: Liesma, 1992.

Konstants, Zigurds. *Auskelis Bauskenieks*. Rīga: Liesma, 1990.

———. *Jānis Pauļuks*. Rīga: Liesma, 1992.

———. *Maija Tabaka*. Rīga: Liesma, 1992.

Kornetchuk, Elena. *Dzemma Skulme and Juris Dmiters: Contemporary Latvian Artists*. Pittsburgh: International Images, Ltd., 1986.

———. *Malle Leis: Contemporary Estonian Painter*. Pittsburgh: International Images, Ltd., 1989.

———. *The Supernatural World of Juri Arrak*. Sewickley, Penn.: International Images, Ltd., 1987.

Kostin, Vladimir. "Baltijas republiku *mākslas* skate Maskavā." *Māksla* 1 (1974).

Kostkevičiûtë, I. *Jonas Švažas*. Vilnius: Vaga, 1985.

Kostkevičiûtë, Irena. "Dailë tarp prievartos ir pasipriešinimo. Istoriniai metmenys" (Art between oppression and resistance: Historical outline). *Literatūra ir menas*, May 16, 1992.

Krastiņš, Jānis, et al. *Latvijas arhitektūra no senatnes līdz mūsdienām*. Rīga: Baltika, 1998.

Kristeva, Julia. "Women's Time." *Signs: Journal of Women in Culture and Society* (trans. Alice Jadine and Harry Blake) 7 (1981).

Krull, Hasso. "Mari Kurismaa piltidest." *Vikerkaar* 1 (1995): 51.

Kuizinas, Kęstutis. "Implications of Context (In Lithuanian Contemporary Art)." *Kontura* 31/32 (1994).

Kuizinas, Kęstutis, and Regina Noruišytė. *Group 24*. Vilnius: Contemporary Art Center, 1996.

———. *Group 24*. Vilnius: Contemporary Art Center, 1997.

Kukk, Piret. "Pilte väikesest inimesest." *Noorte Hääl*, February 28, 1982, p. 2.

Kunstirühmitus Visarid—The Visarid Artists' Group, Tartu, 1967–1972. Tallinn: Tallinn Art Hall, 1997.

Kuras, Algimantas. "Iš gyvenimo užrašų" (From notes of life). *Literatūra ir menas*, April 6, 1991.

Kynas, Arunas. "Ir ziurovai turi teise" (And spectators have their rights). *Literature and Arts*, January 23, 1993.

Laasi, Evald. "Mõnede lünkade täiteks." *Sirp ja Vasar*, November 27, 1987, p. 3.

Lace, Rasma, and Tatjana Kaãalova, eds. *Latvijas PSR Valsts mākslas akademija*. Rīga: Liesma, 1969.

Lācis, M[intauts], ed. *Vide—Dizains—Kvalitāte*. Exhibition catalogue. Rīga: LPSR Mākslas fonds, 1977.

Ladjevardi, Hamid, ed. *Baltic Art: Contemporary Paintings and Sculptures*. Washington, D.C.: U.S.-Baltic Foundation, 1999.

Lamberga, Dace. *Jĕkabs Kazaks*, ser. Mākslinieki un darbi, no. 8, p. 21. Rīga: Latvijas enciklopēdija, 1995.

———. *Klusā daba*. Rīga: Liesma, 1986.

Landsbergis, Vytautas. *Čiurlionio dailė* (The art of Čiurlionis). Vilnius: Vaga, 1976.

Lapin, Leonhard. *Kaks Kunsti: valimik ettekandeid ja artikleid kunstist ning ehituskunstist, 1971–1995*. Tallinn: Kunst, 1997.

———. *Kontseptsioonid ja Protsessid, 1979–1980, 1980–1995*. Tallinn: L. Lapin, 1997.

———. "Perifirija un centrs." *Literatūra un māksla* 8/2455 (March 6, 1992).

———. "Soup 69." Chap. 4 of *Pimeydestä valoon: Viron taiteen avantgarde neuvostomiehityksen aikana* (in Finnish with English summary). Helsinki: Otava, 1996.

———. "Space and Ritual." In *Catalogue of Forty-Seventh Biennial in Venice*. Tallinn: Estonian Cultural Endowment, 1997.

——. "Startinud kuuekümnendatel, mälestusi ja mõtteid." *Kunst* 68, no. 1 (1986): 17–23.

——. *Tühjus ja ruum—Void and Space*. Tallinn: Estonian Art Academy, 1998.

Latvijas glezniecība, 1945–1985 plus. Exhibition catalogue. Rīga: Doma, 2000.

Leonhard Lapin: Architecture, Graphics. Exhibition catalogue. Helsinki: Aalvar Aalto Museum, 1991.

Leonhard Lapin: maal, graafika, skulptuur, arhitektoon/ Painting, Graphic, Sculpture, Architectonic (in Estonian and English). Exhibition catalogue. Tallinn: Estonian Art Museum, 1997.

Lettisk avantgarde, 1910–1935. Copenhagen: Rundertarn, 1992.

Levin, Mai. "Maalija Tiit Pääsuke." *Sirp ja Vasar*, June 27, 1975, p. 8.

——. "Marju Mutsu." *Sirp ja Vasar*, January 29, 1982, p. 8.

——. "Silvi Liiva Graafika." *Kunst* 49, no. 2 (1976): 53–57.

Levin, M., M. Lumiste, and L. Viiroja, eds. *Kunstikteadus, Kunstikriitika 4*. Tallinn: Kirjastus Kunst, 1981.

Lieetuviu daile, 1975–1995. Vilnius: Akademija, 1997.

Lietuvių grafika: 1968, 1969, 1970. Vilnius: Vaga, 1971.

Lieven, Anatol. *The Baltic Revolution: Estonia, Latvia, Lithuania and the Path to Independence*. New Haven and London: Yale University Press, 1994.

Liivak, Anu. *Olav Maran*. Exhibition catalogue. Tallinn: Tallinn Art Hall, 1993.

Liivak, Anu, ed. *Tallinn-Moskva/Moskva-Tallinn, 1956–1985*. Tallinn: Tallinn Art Hall, 1996.

Liivak, Anu, and Sigrid Saarep, eds. *ANK '64*. Exhibition catalogue. Tallinn: Tallinn Art Hall, 1995.

Liivat, Lola. "Kollaazh kahe näituse teemal." *Sirp ja Vasar*, January 29, 1997.

Liivrand, Harry. "Näitused." *Sirp ja Vasar*, March 25, 1988.

——. "Vestlus Ado Lillega" (Conversation with Ado Lill). *Kunst* 70, no. 2 (1987): 34–35.

Lithuanian Art, 1989–1999: The Ten Years. Exhibition catalogue. Vilnius: Contemporary Art Center, 1999.

Liutkus, Viktoras. "Iroonia ja grotesk Baltimaade maalikunstis" (Irony and grotesque in the painting of the Baltic countries). *Kunst* (February 1988).

——. "Jaukus daiktų pasaulis" (A cozy world of things). *Kultūros barai* 10 (1985).

——. "Valentinas Antanavičius: Žaidimas gali būti rimtas dalykas" (A game can be a serious thing). *Lietuvos aidas*, January 26, 1993.

Liutkus, Viktoras, and Kestutis Kuizinas. "Kreivi keliai" (Crooked ways). *Evening News*, February 2, 1993.

Lola Liivat: abstraktsionist. Exhibition catalogue. Tartu: Tartu Art Museum, 1998.

Lotman, Juri. *Kultuurisemiootika: tekst—kirjandus—kultuur*. Tallinn: Olion, 1990.

Lubytë, Elona, ed. *Tylusis modernizmas Lietuvoje, 1962–1982* (Quiet modernism in Lithuania, 1962–1982). Vilnius: Tyto alba, 1997.

Luuk, Tamara, and Ain Kalep. *Ilmar Malin: inimesed, sümbolid, olevused*. Tallinn: Kunst, 1988.

Mackevičius, Vyt. "Piešimo problema mūsų dailėje" (A problem of drawing in our art). *Literatūra ir menas*, May 14, 1950.

Mackonis, J. "Prieš ribotą realismo supratimą" (Against a narrow understanding of realism). *Literatūra ir menas*, October 13, 1956.

Mäetammest, Marko. "Autodest ja subjektiivsest formalismist" (About Marko Mäetamm, cars, and subjective idealism: An interview by Piret Räni). *Eesti Aeg*, March 8, 1995.

Mailand-Hansen, Christian. "Kunst fra Baltikum." *Siksi* 2 (1990).

Mangolds, Boris. *Stepping Out of Line: Contemporary Photography from Latvia*. Exhibition catalogue. Millersville, Penn.: Millersville University, 1992.

Mansbach, S. A. *Modern Art in Eastern Europe: From the Baltic to the Balkans, ca. 1890–1939*. Cambridge, Eng.: Cambridge University Press, 1999.

Maran, Olav. "Kujutamisest kujutavas kunstis." *Noorus* 11 (1966): 66–68.

Matti Miliuse kunstikogu. Tallinn: Tallinna Raamatutrükikojas, 1998.

"Miervaldis intervē Poli" (Miervaldis interviews Polis). *Māksla* 1 (1988): 16–20.

Mulevičiūtė, Jolita. "Apie arsininkų pažiūras" (About the views of the Ars group). *Menotyra* 2 (1995): 37.

——. "Man menas—malda, katarsis, apsivalymas" (For me, art is a prayer, catharsis, and absolution). *Kultūros barai*, 12 (1990): 29.

Mutt, Mihkel. "Etendus kahes 'osas.'" *Sirp ja Vasar*, December 18, 1987, p. 9.

Mythos und Abstraktion: Aktuelle Kunst aus Estland/Myth and Abstraction: Actual Art from Estonia/Müütos ja abstraktioon: Tänapäeva Kunst Eesli. Exhibition catalogue. Karlsruhe, Germany: Badischer Kunstverein, 1992.

Nagys, Henrikas. "Foreword." In *Second Lithuanian International Art Exhibition*. Toronto: O'Keefe Centre for the Performing Arts, 1963.

Navakas, Mindaugas. "Apie kelius" (About the ways). *Literature and Arts*, January 30, 1993.

——. "Open Letter to A. Kynas." *Literatūra ir menas*, February 13, 1993.

Nefedova, Inara. *Džemma Skulme*. Rīga: Liesma, 1981.

——. *Latviešu glezniecības meisterdarbi*. Rīga: Liesma, 1988.

Nodieve, Aija. *Latvieši jaunākā glezniecība* (The new Latvian painting). Rīga: Liesma, 1981.

Olep, Jaak. "Barokne Tammik." *Areen*, January 15, 1999.

Oväntat möte: Estnisk och lettisk modernism fràan mellankrigstiden (in Swedish with English summary). Exhibition catalogue. Stockholm: Liljevalchs Konsthall, 1993.

"Padomju Latvijas republikāniskas mākslas izstādes un to dalībnieki stājgleznotāji." In *Latviešu Padomju glezniecība*, ed. Skaidrīte Cielava, 253–283. Rīga: Latvijas Valsts izdevniecība, 1961.

Pejić, Bojana, and David Elliott, eds. *After the Wall: Art and Culture in Post-Communist Europe*. Stockholm: Moderna Museet/Modern Museum, 1999.

Pihlak, Evi. "Andres Tolts: meie maailma avardajana." *Sirp ja Vasar*, September 19, 1986, p. 8.

———. *Ilmar Malin*. Exhibition catalogue. Tallinn: Estonian Art Museum, 1981.

———. "Inimesed, esemed, värvid." *Kodumaa*, December 1, 1982, pp. 1, 4.

———. *Maal, seigraafia, akvarell* (Painting, serigraph, watercolor). Tallinn: Kirjastus Kunst, 1988.

———. "Objektid helendavas ruumis." *Kodumaa*, June 13, 1984, pp. 1–7.

———. "Puhtavormiline loodus." *Kodumaa*, April 13, 1983, pp. 1, 7.

———. "Taevas, tornid ja maa." *Vikerkaar* 7 (July 1987): 65–75.

Pihlak, Evi, and Reet Varblane. *Ado Vabbe*. Tallinn: Kunst, 1993.

Pill, Mari. "Ülo Sooster, novaator ja traditsioonide kandja." *Kunst* 68, no. 1 (1986): 25–27.

Pilvre, Barbi. "Märtrid, amatsoonid, meesteõgijad" (Martyrs, amazons, man-eaters). *Eesti ekspress*, August 25, 1995.

Placāns, Andrejs. *The Latvians: A Short History*. Stanford, Calif.: Hoover Institution Press, Stanford University, 1995.

Polis, Miervaldis. "The Bronze Man of Riga: Everyone Can Be a Monument" (interview with Kimmo Sarje). *Siksi* 2 (1990): 10–11.

Põllu, Kaljo. *Kodalased: Thirteen Reproductions*. Tallinn: Kunst, 1978.

———. "Op-kunstist." *Tartu Riiklik Ülikool*, March 17, 1967, pp. 3–4.

———. *Ten Expeditions to the Finno-Ugrians*. Tallinn: Olion, 1990.

Pukk, Piret. "Universaalne geomeetria." *Ehituskunst* 2/3 (1982–83): 75.

Radzevicius, Auris. "Suo laukinis" (Wild dog). *Literature and Arts*, February 20, 1993.

Raiskuma, Ieva. "Mailīši, Bites & Co." *Liesma* 10 (1994): 5ff.

Rajavee, Holger. "Harku 75." *Postimees*, March 4, 1996.

Raudam, Toomas. "Punane joon." Interview with Kaljo Põllu. *Kunst* no. 1 (1995): 44.

Raul Meel. Exhibition catalogue. Tallinn: Estonian National Art Museum, 1989.

Raul Meel. Leonhard Lapin. Exhibition catalogue. Le Cateau-Cambrésis (Nord): Musée Matisse, Musée Départemental, 1994.

Raun, Toivo. *Estonia and the Estonians*. Stanford, Calif.: Hoover Institution Press, Stanford University, 1987.

Reihmane, Laima. *Latviešu padomju stājgrafika*. Rīga: Liesma, 1982.

Repše, Gundega. *Pieskārieni. Kurts Fridrihsons*. Rīga: Jumava, 1998.

Roode, Henn. "Mõttekilde joonistustest." *Kunst* 73, no. 1 (1989): 27.

Rosenfeld, Alla, and Norton T. Dodge, eds. *From Gulag to Glasnost: Nonconformist Art from the Soviet Union*. New York: Thames and Hudson, 1995.

Rottenberg, Anda, et al., eds. *Personal Time: Art of Estonia, Latvia and Lithuania, 1945–1996*, 3 vols. Warsaw: The Zacheta Gallery of Contemporary Art, 1996.

Rozanskaite, Marija. "Gal ismoksime gerbti vieni kitus" (Shall we learn to respect each other). *Vakarines naujienos*, February 2, 1993.

———. "It Is Better to Work Than Have Discussions." *Literatūra ir menas*, February 13, 1993.

Rudzīte, Ksenija. *Zenta Logina: Kosmiskie loki. Glezniecība, meti gobelēniem, telpiskie objektie*. Rīga: Zentas Loginas fonds, 1999.

Rujaline roostevaba maailm/Rocking Rustfree World in Estonian Art of the '70s. Tartu: Tartu Kunstimuuseum, 1998.

Saar, Johannes. "Hegel, Annus, Subbi, Priimägi." *Postimees*, February 14, 1997, p. 14.

———. "Iidolid, iidolid, hellad velled . . ." (Idols, idols, good fellows . . .). *Postimees*, December 29, 1995.

———. "Repliik. Harku 75." *Postimees*, March 4, 1996.

Saar, Johannes, ed. *Eesti kunstnikud—Artists of Estonia*. Tallinn: Soros Center for Contemporary Arts, 1998.

Šarūnas Sauka. Exhibition catalogue. Vilnius: Contemporary Art Center, 1998.

Šepetys, Lionginas. "Komunistiniai idealai ir modernizmo kaukë" (Ideals of communism and mask of modernism). *Literatūra ir menas*, January 30, 1982.

Seventieth Anniversary of the New Art Exhibition. Wilnius, 1923, The. Lodz: Muzeum Sztuki Lodz, 1993.

Shashkina, Maria. *Toomas Vint*. Tallinn: Kunst, 1993.

Šidlauskas, Rimantas. "Pirmoji dailės paroda Lietuvoje prieš 170 metų" (The first art exhibition in Lithuania 170 years ago). *Kultūros barai* 6 (1990): 23.

Silins, Janis. *Latvijas māksla, 1800–1914*, 2 vols. Stockholm: Daugava, 1979–1980.

———. *Latvijas māksla, 1915–1940*, 3 vols. Stockholm: Daugava, 1988–1993.

Silvi Liiva. Tallinn: Soros Center for Contemporary Arts, 1997.

Sirje Runge. Exhibition catalogue. Tallinn: Estonian National Art Museum, 1986.

Sobchack, Vivian. *The Address of the Eye: A Phenomenology of Film Experience*. Princeton: Princeton University Press, 1992.

Sobolev, Mari. "Abstraktne ilu ajaloo küüsis" (Abstract beauty in the hands of history). *Eesti Sõnumid*, March 21, 1995.

———. "Kuuldused maalikunsti surmast on enneaegsed" (Rumors of the death of painting are premature). *Eesti Sõnumid*, March 10, 1995.

Soikans, Juris. *Rudolfs Pinnis, gleznotājs. No Aiviekstes līdz Sēnai*. Rīga: Puse, 1993.

Soosaar, Martti. *Ateljee-etüüde 2*. Tallinn: Kunst, 1990.

Sowjetkunst heute. Malerei, Graphik und Skulptur aus der Neuen Galerie-Sammlung Ludwig, Aachen, und aus der Ludwig-Stiftung für Kunst und Internationale Verständigung, Aachen. Köln: Museum Ludwig, 1988.

Šteimane, Inga. "Dažreiz viņu saprot jeb Miķeļa Fišera message-art." *Studija* 6 (1999): 26–35.

Straka, Barbara. *Das Gedächtnis der Bilder. Baltische Photokunst heute*. Exhibition catalogue. Kiel: Nieswand, 1993.

Straka, Barbara, and Kurt Nievers, eds. *The Memory of Images: Baltic Photo Art Today*. Kiel: Nieswand Verlag and Ars Baltica, 1993.

Struktuuri/Metafyysika (Structure/metaphysics). Exhibition catalogue. Pori, Finland: Pori Art Museum, 1989.

Substance-Unsubstance. Exhibition catalogue. Tallinn: Soros Center for Contemporary Arts, 1994.

Suits, G. "Noorte Püüded" (The aspirations of the young generation). *Noor-Eesti* 1 (1905): 3–19.

Suta, Tatjana. *Romans Suta*. Rīga: Liesma, 1975.

Svabs, I. "Vytvarnici na pomoc konstrukterum." *Tvar* (Prague) 14, no. 5/6.

Svede, Mark Allen. "All You Need is Lovebeads: Latvia's Hippies Undress for Success." In *Style and Socialism: Modernity and Material Culture in Post-War Eastern Europe*, eds. David Crowley and Susan Reid. London: Berg, 2000.

———. "Curtains: Décor for the End of Empire." In *Socialist Spaces in Eastern Europe and the Soviet Union, 1947–1991*, eds. David Crowley and Susan Reid. London: Berg, 2002.

———. "Twiggy & Trotsky: Or, What the Soviet Dandy Will Be Wearing This Five-Year Plan." In *Dandies: Fashion and Finesse in Art and Culture*, ed. Susan Fillin-Yeh. New York: NYU Press, 2000.

———. "What Next? New Art in Latvia." *Dialogue: Arts in the Midwest* (January–February 1992).

———. "Women Painting." In *Women Painting Women*, eds. Christopher Torchia and Barbara Eagle. New York: Mimi Ferzt Gallery, 1996.

Tabaka, Maija. "Laiks, mans lielais ienaidnieks." *Diena, Sestdiena* supplement, April 17 and 24, 1993.

Tamruchi, Natalia. *Moscow Conceptualism, 1970–1990*. Roseville East, New South Wales: Craftsman House, 1995.

The Tenth Tallinn Print Triennial. Exhibition catalogue. Tallinn: Association of Estonian Printmakers, 1995.

Thorsten von Stryck, Friedrich. "Meie kunsti-elu" (Our art-life). *Vaba Sõna* 3 (1914): 104–106.

Tiit, Ene. "Eesti Rahvastik ja selle probleemid." *Akadeemia* 8–9 (1993): 1654–1679, 1847–1866.

Treier, Heie. "Ado Lill. Abstraktsionismi metamorfoosid ajas." *Eesti ekspress*, no. 23 (June 17, 1994): B5.

———. "Leonhard Lapin vestleb: Pilgud kuldsete kuuekümnendate fassaadi taha." *Kunst* no. 1 (1993): 34–36.

———. "Naine ja Meri." *Kunst* 74, no. 2 (1989): 40–44.

Troitsky, Artemy. *Back in the USSR: The True Story of Rock in Russia*. London: Faber & Faber, 1988.

Unerwartete Begegnung: Lettische Avantgarde, 1910–1935. Berlin: Wienand Verlag, for the Neue Gesellschaft für bildende Kunst, 1990.

Üprus, Helmi. *Päikeswmängud*. Tallinn: Kirjastus Kunst, 1976.

Urbla, Peeter. "Tundelise inimese otsingul." *Sirp ja Vasar*, April 7, 1978, p. 8.

Uued põlvkonnad 2 (Collection of articles). Tallinn: ENSV TA Ajaloo Instituut, Kunstiajaloo Sektor, 1988.

Vabbo, Ado. "Ado Vabbo about Himself." *Tartu kunstimuuseumi Almanahh* 2 (1967): 65.

Vaitkunas, Arunas. "Kur veda dailininku kryziaus keliai?" (Where are stations of the cross leading artists?) *Literature and Arts*, February 27, 1993.

Valeska, Adolfas. *Lithuanian Art in Exile*. Munich: T. J. Bizgirda, 1948.

Varblane, Reet. "Avangardism ja traditsionaalsus Ado Vabbe Loomingus." *Looming* 10 (1994).

Vasilenko, V. M., et al., eds. *Sovetskoe dekorativnoe iskusstvo, 1945–1975*. Moscow: Iskusstvo, 1989.

Veidemann, Rein. "Kuuekümnendate põlvkond eesti kultuuris ja ühiskonnas." *Sirp* 16, no. 33 (August 1991): 2–3.

Veiveryte, Sofija. "Teptuko niekas neatims" (Nobody will take away my brush). *Evening News*, February 2, 1993.

Vienožinskis, Justinas. *Straipsniai. Dokumentai. Laiškai. Amžininkų atsiminimai* (Articles. Documents. Letters. Contemporaries' memoirs). Vilnius: Vaga, 1970.

Vilkelyte, Daiva. "Vilnius Artists Quarrel Over a Shrinking Cake." *The Baltic Independent*, February 19–25, 1993.

Vilks, Ģirts, and Emīlija Jaunzeme, eds. *Latviešu padomju scenogrāfija*. Rīga: Liesma, 1981.

Vint, Tõnis. "Ene Kulli märkidest maailm." *Vikerkaar* 12 (1989): 36–37.

———. "Hermetria ja rühm 22." *Sirp ja Vasar*, February 3, 1989, p. 8.

———. "Jaapani peremärgid." *Kunst ja Kodu* 2 (1976): R25.

———. "Kalevan kirjat ja I Ching." *Taide* 4/84: 22–29.

———. "Reval. Tallinn. Üks linn, kaks saatust/Reval. Tallinn. One city, two fates." *Ehituskunst. Estonian Architectural Review*, no. 22/23 (1998): 77–79.

Wheeler, Daniel. *Art since Mid-Century, 1945 to the Present*. New York: Vendome Press, 1991.

Zapkus, Kes. "Sovietine kulturos provincija" (Soviet province of culture). *Lietuvos aidas*, April 16,1993.

Zeberiņš, Indrikis. *Kas velas ar lmani krampjos vilkties?* Rīga: Maksla, 1992.

Zirnītis, Pēteris, ed. *Rūdolfs Pinnis: Glezniecība* (Rūdolfs Pinnis: Paintings). Rīga: Liesma, 1990.

Ziterova, Ninel. "Jüri Kase näitus Kadriorus." *Sirp ja Vasar*, June 26, 1987.

———. "Uue maailma loomine: Jüri Kask." *Kunst* 72, no. 2 (1988): 26–31.

Žižek, Slavoj. "Enjoy Your Nation as Yourself!" In *Tarrying with the Negative: Kant, Hegel, and the Critique of Ideology*. Durham, N.C.: Duke University Press, 1993.

Compiled by Natalia Kolodzei

About the Contributors

Alfonsas Andriuškevičius (Lithuania) graduated from Vilnius University and is an associate professor at the Vilnius Academy of Arts. His interests range from art theory and art criticism to contemporary Lithuanian art. He is the author of several books published in Lithuanian, among them *Beauty and Art in Lithuania in 1918–1940* (1989) and *Lithuanian Art, 1975–1995* (1997), and the editor of *72 Lithuanian Artists on Art* (1998).

Irēna Bužinska (Latvia) received her M.A. from the Latvian Academy of Arts (Rīga). She works at the Latvian State Museum of Art in Rīga as a public relations officer and a curator. Since 1997, she has served as a reporter and member of the editorial board of *MARE ARTICUM*, the international art magazine of the states of the Baltic region, and has been a member of the Latvian Artists' Union. She has published more than 250 articles and reviews on contemporary art and Russian and Latvian avant-garde art, in particular on Latvian modernism and the heritage of Voldemars Matvejs. Ms. Bužinska has curated more than thirty-five exhibitions at the Latvian State Museum of Art and served as a guest curator for many exhibitions in Latvia and abroad.

Norton T. Dodge (U.S.A.), Professor Emeritus at St. Mary's College of Maryland, studied Russian at Cornell University, where he graduated with highest honors. He then earned his M.A. in Russian regional studies at Harvard and also obtained there his Ph.D. in economics in 1960. In 1962, while teaching comparative economics at the University of Maryland, he began collecting Soviet nonconformist art that was created during the period from Stalin's death to Gorbachev's glasnost. Since then, much of his life has been devoted to expanding and exhibiting the collection and honoring the courage and talent of the nonconformist artists. In 1991, he and his wife, Nancy, donated the collection, which now numbers more than twenty thousand works—including several thousand from Estonia, Latvia, and Lithuania—to the Zimmerli Art Museum at Rutgers University, New Brunswick, New Jersey.

Sirje Helme (Estonia) holds an M.A. in art history from Tartu State University. She is the director of the board of Kunst Publishers and the director of the Soros Center for Contemporary Arts, Estonia. Ms. Helme is the author of numerous articles of art criticism published in Estonia, Finland, Russia, Lithuania, Denmark, and Germany. The book she co-authored in 1999 on the history of Estonian art develops a new concept of postwar art in Estonia. She lectures on Estonian postwar art and twentieth-century art at the Estonian Art Academy and Tartu University. Ms. Helme is also active as a curator. She has curated a number of exhibitions both in Estonia and abroad and supervised the Estonian exposition at the 48th and 49th Venice Biennials.

Juta Kivimäe (Estonia) received her degree in history and art history from Tartu University and did her M.A. at the Tallinn Pedagogical University. She is the director of the sculpture department at the Art Museum of Estonia and has organized a number of exhibitions, compiled several catalogues, and published essays and art reviews in Estonian art magazines and cultural annals.

Eha Komissarov (Estonia) received her degrees in history and art history from Tartu University and is a senior curator of the Contemporary Art Center at the Art Museum of Estonia. Her membership in the Association Internationale des Critiques d'Art (AICA) dates from 1992. Ms. Komissarov has contributed to art catalogues and art magazines and curated several major exhibitions. Active as a critic, she is well known on the contemporary Estonian art scene. In 1994, Ms. Komissarov was awarded the Kristjan Raud Annual Art Prize.

Kestutis Kuizinas (Lithuania) studied art history and the theory of art at the Vilnius Academy of Arts. Since 1992, he has served as the director of the Contemporary Art Center in Vilnius. His membership in AICA dates from 1994. He has curated a number of exhibitions in Lithuania and abroad, including *Cool Places* and *The Seventh Triennial of Contemporary Baltic Art*; *Lithuanian Art, 1989–1999* (both held at the Contemporary Art Center, Vilnius), *Works by Deimantas Narkevičius*, the Lithuanian Pavilion at the 49th Venice Biennial, and others.

Anu Liivak (Estonia) received her degree in art history from the Ilya Repin Institute of Painting, Sculpture, and Architecture (Academy of Fine Arts, St. Petersburg) and an M.A. from the Estonian Academy of Art. She is the director of the Tallinn Art Hall Foundation and a member of AICA. She lectures on art management at the Estonian Art Academy. Ms. Liivak's research interests center around various aspects of Estonian art of the second half of the twentieth century, about which she has published several articles. She has curated many projects in Estonia as well as abroad.

Viktoras Liutkus (Lithuania) received his degree in art history from Vilnius University. From 1991 until 1995, he served as president of AICA's Lithuanian section. Mr. Liutkus's numerous articles on Lithuanian modern art have appeared in Lithuanian, Russian, Estonian, and Polish publications. He is also the author of a monograph on the works of Viktoras Vizgirda. Mr. Liutkus has curated a number of exhibitions of Lithuanian modern art in Lithuania, Latvia, Poland, Hungary, and Sweden.

Elona Lubytė (Lithuania) received her degree in art history from the Lithuanian State Art Institute (presently the Vilnius Academy of Arts) and completed her doctorate in social sciences, management, and administration at the Vilnius Gediminas Technical University. Currently, she works as a curator of contemporary Lithuanian sculpture at the Lithuanian Art Museum. She has organized a number of exhibitions and is the author of numerous articles on contemporary Lithuanian art and art management. Since 1991, she has been a member of the Lithuanian section of AICA.

Alla Rosenfeld (U.S.A.) has served as curator of Russian and Soviet nonconformist art at the Zimmerli Art Museum of Rutgers University since 1992. She is currently director of the Russian and Soviet nonconformist art department at the Zimmerli and also teaches Survey of Russian Art and Russian Avant-garde Stage Design, 1905–1935, at Rutgers University. Previously, Ms. Rosenfeld was, for varying numbers of years, the full-time lecturer at the IBM Gallery of Science and Art in New York; guest curator at Castle Gallery, College of New Rochelle, New York; and the gallery director in Greenwich, Connecticut. Ms. Rosenfeld earned her M.A. in art history from the Ilya Repin Institute of Painting, Sculpture, and Architecture (Academy of Fine Arts, St. Petersburg). She is currently a Ph.D. candidate at the graduate school of the City University of New York, specializing in modern and contemporary European art. Ms. Rosenfeld co-edited, with Mr. Norton T. Dodge, the catalogue *From Gulag to Glasnost: Nonconformist Art from the Soviet Union* (published by Thames and Hudson in 1995) and edited the catalogue *Defining Russian Graphic Arts, 1898–1934* (published by Rutgers University Press in 1999).

Eda Sepp (Canada) is an art historian with graduate degrees from the University of Toronto. She has taught art history at York University and the Scarborough College of the University of Toronto. She has curated exhibitions in Canada on Canadian, Baltic, and Estonian art and published articles on Canadian and Estonian art and feminist theory. She co-founded the Women's Studies Resource Center in Tallinn, Estonia, in 1997 and compiled its book collection of about three thousand scholarly feminist books. In 2000, she founded and co-edited the first academic journal on gender studies in Estonia.

Mark Allen Svede (U.S.A.) is an independent scholar and curator specializing in Latvian visual and material culture. His recent essays on topics including hippie fashion, dandyism in Soviet-era performance art, underground film, and anti-Soviet architectural practices have been published by Berg, Macmillan, New York University Press, and Thames and Hudson. After Svede's 1987 curatorial debut, *Contemporary Art from the Baltic States* (Ohio State University Gallery of Fine Arts), his projects broadened in scope to include collaborations with Rīga-based artists, film restoration, and a documentary short about Latvian performance (co-directed with Julius Ziz; in production at Anthology Film Archives, New York). Since 1991, he has advised the Dodge Collection of Nonconformist Art from the Soviet Union regarding its Latvian acquisitions. Mr. Svede is completing his doctorate in art history at Ohio State University, where he was named the first Arthur M. Schlesinger, Sr., Graduate Fellow.

Museum Staff

ADMINISTRATIVE

Phillip Dennis Cate, Director
Gregory J. Perry, Associate Director

Rebecca Brenowitz, Public Relations Assistant
Bernadette Clapsis, Accountant
Rose Cofone, Director of Development
Ulla-Britt Faiella, Receptionist
Sara Gendlek, Special Events Coordinator
Judy Santiago, Principal Secretary/Security Coordinator
Marguerite M. Santos, Business Manager
Stacy Smith, Coordinator, Andrew W. Mellon Program and
Special Projects

CURATORIAL

Jeffrey Wechsler, Senior Curator

Gail Aaron, Curator, The Rutgers Collection of Original
Illustrations for Children's Literature
Ashley Atkins, Graduate Curatorial Assistant
Dorothea Dietrich, Director, Morse Research Center for
Graphic Arts and Curator of Prints and Drawings
Romina M. Gutierrez, Graduate Curatorial Assistant
Natalia Kariaeva, Graduate Curatorial Assistant
Shalaka Karbhari, Curatorial Assistant
Victoria McGrath, Graduate Curatorial Assistant
Alla Rosenfeld, Director, Department of Russian and Soviet
Nonconformist Art
Jane A. Sharp, Research Curator, Dodge Collection of
Nonconformist Art from the Soviet Union
Laureen Trainer, Acting Curator of Education
Wendy White, Assistant Curator of Prints and Drawings
Midori Yoshimoto, Graduate Assistant for Japonisme

REGISTRARIAL

Cathleen Anderson, Registrar
Leslie Kriff, Associate Registrar
Lynn Ferrara, Assistant Registrar

EXHIBIT INSTALLATION/PREPARATION

Edward Schwab, Operations Manager/Coordinator of
Installation
Mark Argue, Assistant Coordinator of Installation
Patrick Lukasak, Assistant Coordinator of Installation
Ryan Stalcup, Installation Preparator
Roberto Delgado, Preparator of Art on Paper

MEMBERSHIP/VOLUNTEERS/AUDIENCE SERVICES

Faye Fayerman, Director, Membership, Volunteers and
Audience Services
Lynn Biderman, Museum Store Manager
Carolina Alvarado, Assistant to the Director of Membership,
Volunteers and Audience Services

ZIMMERLI ART MUSEUM BOARD OF OVERSEERS

Michael Angelides
Michelle Angelides
Norma Bartman
Nancy Ruyle Dodge
Norton Dodge
Richard Drill
Joyce Glasgold
Sue Gran
Carleton Holstrom, *Chairman*
Hamid Ladjevardi
Deborah Lynch
Adrienne E. Machaver

Allan Maitlin
Sandy O'Connor
William O'Grady
Frank Pallone, Jr.
Robert S. Peckar
Lisa Pretecrum
George Riabov
Norman Shaw
Mindy Tublitz
Nancy Voorhees
Ralph Voorhees

Student Member

Melanie Halkias

Honorary Member

Mrs. David A. Morse

Ex Officio

Michael Carroll
Phillip Dennis Cate
Kevin J. Collins
Cynthia Jacobson
Joseph Seneca

Index